# VINCENT
# VAN GOGH

*«Eh bien, mon travail à moi, j'y risque ma vie et ma raison y a sombré à moitié.»*

VINCENT VAN GOGH   July 1890

MARC EDO TRALBAUT

E 6 3

# VINCENT
# VAN GOGH

A STUDIO BOOK · THE VIKING PRESS · NEW YORK

CREATED AND PRODUCED BY EDITA LAUSANNE

(8)759.9492
T

Published in 1969 by The Viking Press, Inc.
625 Madison Avenue, New York, N.Y. 10022
Library of Congress catalog card number: 76-87251

EDITA S.A., 3 rue de la Vigie, LAUSANNE
Printed and bound in Switzerland

# CONTENTS

# PREFACE

by the nephew of Vincent van Gogh

What a fascinating book ! This handsome work will surely delight a very large number of readers; for more than fifty years of enthusiastic and detailed research are reflected in this thorough and copiously illustrated biography.

I have introduced many of Marc Edo Tralbaut's books in the past. But when my old friend asked me to write a preface for his latest work, I hesitated at first—and for good reasons.

An author should need no introduction when his books have been published in many languages and he is well known in Europe and America, when he has received many honours—the Visser-Neelandia Prize being only the latest—and when a professor of Jean Leymarie's stature has dubbed him "The Learned Van Goghian". Tralbaut's reputation alone is enough to guarantee the value of this work.

But I hesitated only for a moment, for I realized that it was imperative that I should mention something of which the reader might well be unaware. In 1966 Marie-Louise Theyssens, a student at the Antwerp Institute of Librarians, Archivists and Museum Staffs, submitted a bibliographical thesis on the works of Marc Edo Tralbaut. Her bibliography listed twenty-five books, about one thousand two hundred and fifty articles appearing in newspapers and journals, and six plays, one of which was about my Uncle Vincent and was entitled *In the Shadow of the Crows*.

When Miss Theyssens was being awarded her degree, M. Prosper Arents, one of the members of the examining board, and the author of the best life of Rubens, described Dr Tralbaut as "The Balzac of Art-Historians", as a tribute to the wealth and diversity of his writings on the subject.

The reader will realize now why I thought it needless to offer any introduction to the latest publication in Marc Edo Tralbaut's massive work on Vincent van Gogh—he has already written more than a hundred books or articles on the subject. Indeed my late wife used to say of him: "Tralbaut has been bitten by the van Gogh bug !"

It was when Marc Edo Tralbaut was a student in 1917 that he first read Vincent's letters to my father which had been published by my mother in 1914. From then onwards he devoted his life to analyzing every aspect of the painter's life and work.

There are strange coincidences in the lives of some men. One should not attach too much importance to them, let alone consider them as acts of providence, but sometimes they are worth mentioning. Here are two which the reader will certainly appreciate.

My friend's great-grandfather was a shipowner with a fleet of more than sixty barges and canal-boats. He gave each of his sons two boats when they married. The boats he gave to Louis Tralbaut, the author's father, were called *Le Pays du Froment* (Wheatlands) and *Théo*, although there was nobody of this name in the family. Thus it came about that Marc Edo Tralbaut was born on the *Théo* at two o'clock in the morning on Friday January 3, 1902.

At that moment the boat was going up the river Oise and was passing Auvers-sur-Oise, the village where Vincent van Gogh had died twelve years before. There was no landing-place at Auvers, so the boat went on upstream to Isle-Adam, where the child's birth was registered. Two days later, on Sunday January 5, the newborn child who was to become the author of this book passed Auvers-sur-Oise again on his way to be baptized in the church at Pontoise.

My own coincidence occurred thus: not long ago at Zaandam, the village in the north of Holland where my wife Nelly was born, I used to see two big sandbarges passing through the lock every day. I do not know who owned them, but the names of his barges pleased me. They were *Nelly* and *Vincent.*

Willem Kloos, the celebrated Dutch poet, once defined art as "the most individual expression of the most individual emotion". From the point of view of a person looking at a work of art—and the reader of such a book as this is one—this aphorism could be paraphrased to state that he experiences the most individual emotion arising from the most individual observation. This is exactly applicable to my friend Tralbaut's book. Every reader will make his own choice of what he finds most interesting and will interpret it to suit himself. This book, besides telling the story of the life of the man and the painter, abounds in observations upon the history of art, the techniques of Vincent van Gogh's painting and the evolution of his style. There is no lack of choice.

I can only wish the author and the publisher the success they deserve: the author for the way in which he has carried out his task, the publisher for the care he has taken to ensure that the form of the book shall be worthy of its contents.

*V. W. van Gogh.*

President of the Vincent van Gogh Foundation

8

# INTRODUCTION

How well do we really know Vincent van Gogh? Marthe Robert, writing about Vincent's alleged madness, said recently that it "defies explanation". All things considered, this phrase is well justified, and it applies not only to the artist's madness but to his life and work in general.

My friend Jean Leymarie, whose writings on van Gogh are some of the most penetrating and profound that have been published upon the Dutch painter, entitled his recent book *Who was van Gogh?* If we knew the answer there would have been no need to ask the question. Yet when it is posed by one of the most learned experts upon this artist there seems ample justification for others to attempt to provide the answer.

It seems to me that even after hundreds of exhibitions have been held in both hemispheres, thousands of books or articles have been published in many languages, films, both fictionalized and documentary, have been widely shown, all devoted to his life and art, Vincent van Gogh remains as he was in his lifetime, unloved and misunderstood.

This view is not universal. Marc-Gilbert Sauvajon has maintained that van Gogh is so well-known and his letters have been so widely read, that one cannot present him to the public without making oneself slightly ridiculous. "It would be like presenting Christ to Christians or attempting to break down the most widely open door in the history of art." Sauvajon believes that there is nothing more to be said about the life and work of this artist. I am far from sharing his view. The fact that van Gogh's name is now known all over the world does not mean that he is really known as a man and as a painter. The public admires van Gogh's pictures, but how many of them know anything of his wretched life or of his artistic ideals? Jean Leymarie has pertinently concluded that van Gogh's life was a "panting and despairing quest for a lost identity". And this is exactly what remains to be discovered and analyzed.

Much research has been done on the psychology of van Gogh, the most notable studies being those of A. J. Westerman Holstijn, Charles Mauron, G. Kraus, Gilberte Aigrisse, Heinz Graetz, B. Lubin, Humberto Nagera and Marthe Robert. These have opened many doors, but there are still discoveries to be made.

Both the art historians and the psychoanalysts who have studied Vincent's life and work have come upon questions which they could not answer. This book does not claim to answer all these questions; for, after fifty years of research about van Gogh and his work, I know that I am still far from satisfying my curiosity on every point. I have tried to set out the present position and hope that the unpublished papers that I have quoted, and the new views that I have been able to put forward may justify this enterprise.

This is not a new retelling of the life of an unfortunate painter who has attracted a thousand and one biographers and historical novelists. The best biography of Vincent is his own and consists of the seven hundred and fifty or more letters that constitute his correspondence. My aim is merely to provide a commentary upon the important facts of Vincent's life, and to throw new light upon it where I can; for it would be presumptuous to explain every instance of strange behaviour or every unusual situation.

At each of the retrospective exhibitions of van Gogh's work that I have organized (at the Salle des Fêtes in Antwerp in 1955; at the De Beyerd Cultural Centre in Breda and at the Villa Hügel at Essen-Bredeney in 1957; at the Amsterdam Municipal Museum in 1958; and at the Musee Jacquemart André for the Institut de France in 1960), I have hung the following words in large letters at the entrance: "These eyes have discovered a new vision of the world; now we see it with those eyes." I cannot claim these words as my own. They derive from a sentence in the artist's own correspondence. In October 1888 Vincent wrote to his sister Wilhelmien: *The great majority of the painters, because they aren't colourists in the true sense of the word, do not see these colours there, and they call a painter mad if he sees with eyes other than theirs.* In these lapidary words Vincent has defined the whole magic of painting.

In the captions to the reproductions of the paintings and drawings the following abbreviations have been used: A.I.v.G. = Archives Internationales de van Gogh; F = J. B. de la Faille, *L'Œuvre de Vincent van Gogh, catalogue raisonné* (Van Oest, Brussels and Paris, 1928); H = J. B. de la Faille, *Vincent van Gogh* (Hyperion, Paris, 1939).

When there is no number it is because the works in question have not been catalogued. In the dimensions the height always precedes the width. The dimensions in inches of the works of van Gogh that appear in this book will be found in an index in the back of the book.

<div align="right">Marc Edo Tralbaut</div>

## ACKNOWLEDGEMENTS

I could not have undertaken to compile so large a work without the kind assistance of many people and institutions, both public and private. Without their valued collaboration this book could not have been as comprehensive and ambitious as it has proved. Unfortunately I cannot list all the museum directors, university professors, archivists, librarians, collectors and private individuals, but I thank them all most sincerely. There are, however, three people who must be mentioned. First, there is my old friend Dr Vincent Willem van Gogh, the painter's nephew, godson and namesake. Several times in the past he has written prefaces to my works upon his uncle, and he has had the great kindness to continue this tradition by writing the preface to this book. He has graciously made available the literary and pictorial resources of the Vincent van Gogh Foundation, of which he is president. I must also record my profound gratitude to Mr R. W. Oxenaer and Miss Ellen Joosten, the director and chief curator of the Kröller-Müller State Museum at Otterlo, who have provided the photographs of the pictures in their museum which are reproduced in this book.

Dr Jan Hulsker's careful researches have also been extremely useful. Every author of a serious study of Vincent must refer to Hulsker's chronology of Vincent's letters.

The photographs are the property of the author and have been taken for the Archives Internationales de van Gogh by Mesdames Garner (Idyllwild, California, U.S.A.) and Hillen (Amsterdam) and by Messrs Audouard (Saint-Rémy-de-Provence), Barral (Arles), Bernard (Arles), Blanchard (Kingston-on-Thames, England), Demeyer (Amsterdam), Dingjan (The Hague), Huigen (Amsterdam), Joacim (Antwerp), Looybuyck (Antwerp), Otter (Assen, Netherlands), Routhier (Paris), Sterck (Lokeren, Belgium), Tralbaut, jr (Mortsel, Belgium), Vandenbrink (Otterlo, Netherlands) and Vandeperre (London). To all these collaborators I also express my warmest gratitude.

# A SENSITIVE
# AND SOLITARY CHILD

Vincent van Gogh wrote a very brief summary of his life in 1876, long before he had decided on an artistic career. This document is a translation—the original probably no longer exists—of a letter written in English on June 17, 1876 to a Methodist minister called Jones who practised at Isleworth. Vincent was then at Welwyn in England, visiting his sister Anna, and in a letter to his brother Theo he enclosed a Dutch translation of this application to Mr Jones for a post as his assistant, in which he wrote: *My father is a clergyman in a village in Holland.*

Vincent thus tells us his father's profession but not the name of his parish. This was Etten. Earlier, from 1849 to 1871, Pastor Theodorus van Gogh had been a pastor at Zundert; then he was at Helvoirt from 1871 to 1875; and at the end of that year he was called to Etten. He remained there for seven years until August 1882, when he settled in his last parish, Nuenen, where he was to die suddenly of a stroke two and a half years later, on March 26, 1885. These four parishes were all in North Brabant, in the south of Holland. Vincent's father lived for thirty-six years in this area, and his son always maintained that his family came from Brabant, so it might be natural to suppose that Pastor Theodorus was a native of this province. But he did not in fact originate in the country "south of the Great

Rivers". He was born at Benschop, about seven miles from Utrecht, where his father Vincent had been summoned to exercise his ministry on October 13, 1816.

The early history of the van Gogh family is fragmentary and obscure. In the fifteenth century several people of this name appeared in the history of the Church, but their relationship with Vincent is problematical. The van Gogh family tree begins in the seventeenth century and shows that since that time Vincent's ancestors were mainly concerned in two professions and were usually either ministers of religion or dealers in art. David van Gogh, baptized in The Hague on October 16, 1697, was a goldsmith's wire-drawer, as was his son Jan van Gogh, baptized in the same city on March 1, 1722: his grandson, Johannes van Gogh, born in The Hague on August 29, 1763, at first practised the same profession as they had done, but then began to teach the catechism and became lay-preacher in the church in his native city. Johannes's son, Vincent van Gogh, born in The Hague on February 11, 1789, was a pastor by profession and the paternal grandfather of the painter.

Pastor van Gogh had six sons, of whom the eldest, Hendrick Vincent, born at Ochten on May 15, 1814, was first a bookseller in Rotterdam and then an artist in Brussels. The second, Johannes, born at

Benschop on August 19, 1817, became a vice-admiral: the third, Willem Daniel, born at Benschop on September 25, 1818, was a government tax-collector: the fourth, Vincent, born at Benschop on March 28, 1820, was an art-dealer: the fifth, Theodorus, born at Benschop on February 8, 1822, a pastor; and the sixth, Cornelius Marinus, born at Breda on March 15, 1824, was also an art-dealer.

Of these six sons only Theodorus, Vincent's father, followed the same profession as his father. One of the painter's uncles, Vincent, was to have a great influence on his young nephews, Vincent and Theo. In May 1846 this elder Vincent made his first visit to Paris and became acquainted with Petit and Goupil, with whom he regularly did business. The Paris merchants were astonished when they saw that he was a young man of only twenty-six, for they had thought that they had been doing business with his father, also called Vincent. Their commercial relations were none the worse for this, and twelve years later, in 1858, when he was thirty-eight, the Dutchman's little art-dealing business became an associate of the great firm of Goupil & Cie. This business still exists today, under the name of Boussod & Valandon, the founder's sons-in-law. Uncle Vincent was obliged to retire from the management of the business because of his poor health, but he still retained a financial interest in it.

In order not to be too far away from his elderly father and Theodorus, who was his favourite brother, Uncle Vincent settled in a handsome property at Prinsenhage near Breda. The affection which linked those two brothers was even further strengthened when they married sisters. This brotherly love foreshadows the affection which was to form a bond between two similarly named brothers, Vincent and Theo, in the next generation.

As a rule Uncle Cent, as he was familiarly called, spent the winter with his wife at Mentone, where the benign climate was better suited to his delicate health. On his return to Prinsenhage, where he built a gallery to display his pictures, he would teach his young nephews Vincent and Theo the business of art. He had no children and would have thought himself happy if he could establish his nephew and namesake as a successor to whom he could hand over his art-dealer's business. He may even have thought of making him his heir.

## THE RESULTS OF AN ITINERANT VOCATION

The circumstances that led Pastor Theodorus to settle at Groot-Zundert in North Brabant need some explanation, for they were more complex than one might suppose. The simple explanation of the move to Brabant might seem to be that Dutch ministers, like any other priests, often changed their parishes as they were promoted—or even demoted—in their careers. The Pastor Theodorus's presence in this remote region must, however, be seen in the context of the schisms which then prevailed in the Dutch Reformed Church. For there is no doubt that it was matters of doctrine that determined the Minister's career and thus the painter's birthplace.

As Protestantism took root in the Netherlands, it began to suffer from the growing pains which afflict every movement of reform: at one time there were no less than a dozen different sects in Holland. When Vincent's father completed his theological studies there were three main and clearly distinct branches: the orthodox, the evangelical and the modern movements, each of which was subdivided into smaller sects. At this period, the middle of the last century, the enthusiasm of the Religious Revival was especially strong in Scotland, Switzerland, France and Holland. The evangelical movement, generally known as the "Groningen Party" was centred between the two extreme wings, the orthodox on the right and the modernists on the left.

Although we learn from his family and colleagues that Pastor Theodorus van Gogh belonged to the Groningen Party, its members appear not to have been particularly sympathetic towards him. Maria Johanna van Gogh, one of Theodorus's sisters, tells us in her journal that "Dorus was not in favour with those of Groningen, which explains why to begin with he waited in vain for an appointment." The students at Utrecht, the university where Theodorus studied, had rebelled against "those of Groningen", and as a result the revivalist faction viewed with mistrust any young priests who they thought might have come under this evil influence. Thus when Theodorus van Gogh was looking for a position he did not receive a single invitation even to act as a substitute preacher in the most god-forsaken corner of Holland. Finally on January 11, 1849, despite the opposition of Groningen, he was appointed to

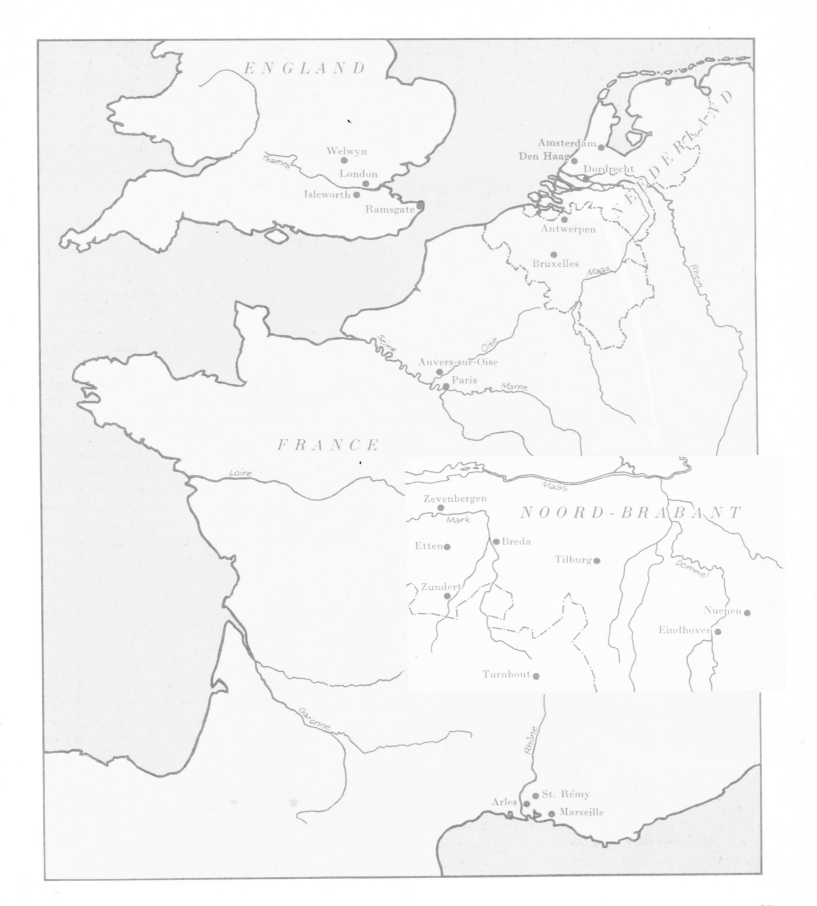

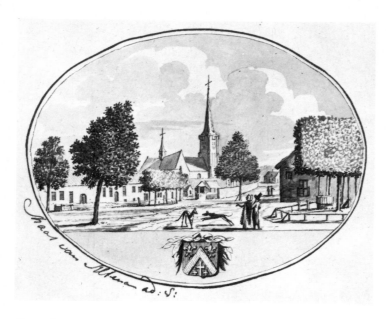

Groot-Zundert as it was in the olden days (north-west side), seen from the door of the inn. With the Nassau coat-of-arms underneath. Indian ink and wash. Archives of the district of Zundert, Netherlands.

the living of Zundert, a village that was flattered by the name of Groot-Zundert, even though it had no more than some hundred inhabitants. At that time he was twenty-seven years old and living at Breda with his father, Vincent. According to his sister everyone said that he was "well-behaved and good-mannered" and that he was "well-bred and well brought-up". His induction took place on April 1, 1849, and he was confirmed by his father, Pastor Vincent, who took as his text the fifth verse of the second chapter of St Paul's Epistle to the Philippians: "Let this mind be in you, which was also in Christ Jesus." There were no less than sixty visitors to the presbytery that day, and they included several Catholics. Zundert village band also came to play as a gesture of the people's goodwill towards their pastor and to welcome him to his parish.

Thus, although the painter was later to pride himself more than once on his origins in Brabant, neither Vincent van Gogh's parents nor his ancestors had their roots in this frontier province in Flanders. In fact the name of van Gogh, mentioned for the first time at the beginning of the fifteenth century, probably derives from Goch (sometimes also spelt Gog), a village which lies in Westphalia not far from the German frontier with Holland. The name van Gogh would thus be one of those family names which indicate the town or village from which the person in question or one of his ancestors came. The names of Breugel and Bosch, to take two other artists of universal renown, derive in exactly the same way from the places in which they originated. The first was in fact born at Breugel, the second at 's-Hertogenbosch, popularly known as Den Bosch, or simply known as Bosch.

## THE PASTOR AND HIS FLOCK

Although modest in size, Zundert has always had a certain international importance, for it is one of the gateways into the Netherlands, and through it have passed such men as the Tsar of Russia, Napoleon, Dutch princes and many other historical figures. In the days of the stagecoach, travellers from Paris to Amsterdam would rest and change horses at this little village twenty-one miles north of Antwerp. Later, with the advent of railways, Zundert was bypassed and its name was soon completely forgotten. But today when one drives along the road between the French and Dutch capitals one passes through Zundert once more, about five miles north of the border between Belgium and Holland. The inhabitants of this village, which had been almost totally forgotten for so long, have now found a most pleasant way of bringing their district to the attention of strangers with the flower festivals which they have organized in recent years and which have proved very popular. Every year, on the first Sunday in September, more than a hundred thousand people come from all directions to watch the procession of decorated wagons.

In the centre of Zundert, on the right of the main road opposite the little town hall, there is a house bearing a commemorative plaque between the door and one of the windows. Here, until 1903, stood the presbytery to which Pastor Theodorus came to live after being inducted into his new living.

Although Zundert had few houses and a small population, it was not without reason that the village was dignified with the name of Groot-Zundert. The area of the parish is considerable, extending south to Wernhout, and to the north as far as

Rijsbergen. It gives us some idea of the distance that the new pastor regularly had to cover, when we learn that it took him two hours to walk from one end of his parish to the other. Fortunately Pastor Theodorus happened to enjoy long walks.

## FAMILIAR COUNTRY

At the time when the pastor settled at Zundert, the stagecoach run by the coaching firm of van Gend & Loos (which still exists, though naturally with more modern means of transport) still passed the presbytery twice a day on its way to and from Antwerp; on occasions the picturesque postcoach with its four horses might even stop a couple of paces from the presbytery.

In point of fact Zundert's new pastor never felt thoroughly at home in North Brabant, which had a character all its own. For one thing, it was a region where the people's daily lives were closely linked to the land, which was their only means of livelihood. Their strong attachment to their native soil was in sharp contrast to the attitude of citizens in the merchant cities in the northern provinces. In addition they lived a less ordered and inhibited life

Groot-Zundert in 1780 (north side). Drawing by J. Bulthuis. Municipal Museum, Breda, Netherlands.—In the foreground the presbytery of the Dutch Reformed Church can clearly be seen as the second house on the left.

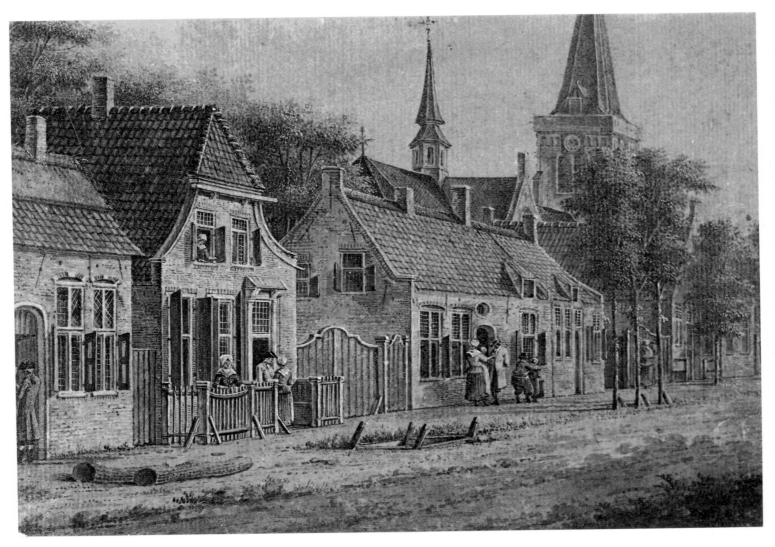

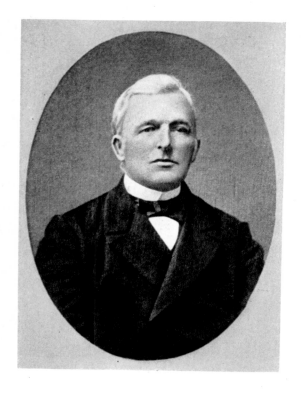

Pastor Theodorus van Gogh. Dutch Reformed Church, Etten, Netherlands.—Pastor Theodorus van Gogh, Vincent's father, was born on February 2, 1822, and died on March 26, 1885. At the age of twenty-seven he was appointed pastor at Zundert, where the Protestant congregation consisted of 56 out of the 114 people living in the village. His own father, Pastor Vincent van Gogh, the pastor of Breda, performed the induction service.

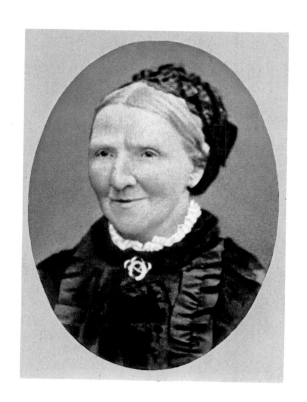

Anna Cornelia Carbentus. Collection of Pastor J. P. Scholte-van Houten, Lochem, Netherlands.—Anna Cornelia Carbentus, Vincent's mother, was married in May 1851 to Pastor Theodorus van Gogh. She was born on September 10, 1819 and died in 1907. She had a great love of nature and a ready pen; it was from her that Vincent derived his talent as a writer.

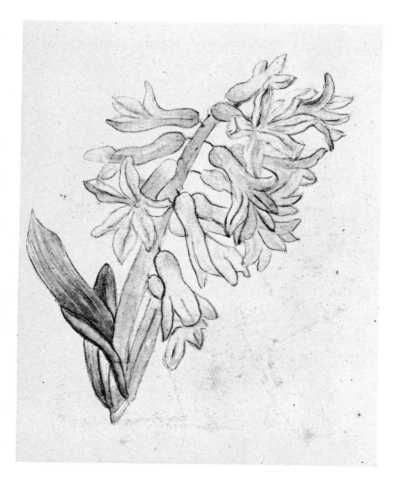

than the people farther north, who had been particularly influenced by the austerity of Calvinism. Their passions often led them into such excesses as smuggling and poaching, and, on days of village fairs and festivities, into violent brawls, debauchery and even crime.

Theodorus's father, Pastor Vincent van Gogh, had lived for twenty-seven years in Breda, eleven miles from Zundert, so the new pastor was not moving into altogether unfamiliar country.

## A MAN OF GOOD WILL

The new pastor was a rather small man, not in very good health. Illness had interrupted his studies in Utrecht for a while; and again, in April 1843, during the Easter vacation, he had become seriously ill after walking forty-five miles from Utrecht to Breda. His brother Vincent, the art-dealer, was also of a somewhat weak constitution, and we shall find that Vincent, the painter, had several serious and sometimes obscure illnesses. How much they may have been hereditary as well as due to self-neglect will be discussed later.

The pastor's pleasant and considerate manners made him well-liked not only by his own congregation but also by all who lived in his parish. He achieved his life's ambition of having what the Dutch poet Ter Haar called "a post in the wilderness".

As a preacher he impressed his listeners less with his eloquence than with his particularly gentle voice. It was this which led Maria Johanna to write in her journal with sisterly tact: "The sermon at his installation was very sweet and warm-hearted, and it pleased enormously." The pastor was well aware of his limitations as a preacher and had no illusions about his prospects of being advanced to a town or even to a more important village than Zundert. His ambition did not reach so high. His belated appointment to a living may also be attributed to his lack of eloquence in the pulpit. But his pleasant personal relations and his deep love of his fellow-men largely compensated for his lack of gifts as a speaker. When, many years later, Vincent was dismissed from his post as a preacher in the Borinage district of Belgium, the *éminences grises* there blamed it partly on his awkwardness in public speaking, a defect which could well have been inherited from his father.

Some forty-five years ago Dr Benno J. Stokvis spent much time, during his research on Vincent van Gogh's parents, questioning local people. He found that with one exception everybody, Catholics no less than members of the Reformed Church, had the happiest recollections of their pastor. He was known by some as "the handsome dominie", and everywhere he was spoken of with a degree of regard, respect and affection that was quite out of the ordinary. One old Catholic woman said: "We thought so much of him that we would have gone through fire and water for him." The widow De Bie-van Aalst, who kept a grocer's shop opposite the presbytery, attested that the pastor would often give money to Mother van Aalst so that she could distribute food to the poor

Bunch of flowers. Pencil drawing by Anna Cornelia Carbentus, 15 × 9 cm, signed at bottom right "A. Carbentus". Page from an album with flowers. Water-colour by Anna Cornelia Carbentus, 12.5 × 8 cm, signed at bottom right "A. C. Carbentus, 5 Maart 1844". The flowers depicted are violets, myosotis, sweet peas and lily of the valley. Vincent's mother painted this water-colour when she was twenty-five years old, and her aptitude as a painter is clearly apparent. The picture belonged to Wilhelmien, Vincent's youngest sister. After her death she left it to her sister Anna. Still-life with flowers. Water-colour by Anna Cornelia Carbentus, 25 × 20 cm. Opposite page: Pink hyacinth. Water-colour by A. C. Carbentus, 17 × 12 cm. Collection of Pastor J. P. Scholte-van Houten, Lochem, Netherlands.

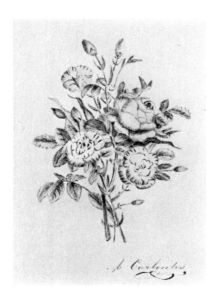

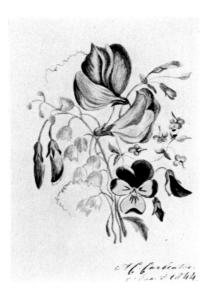

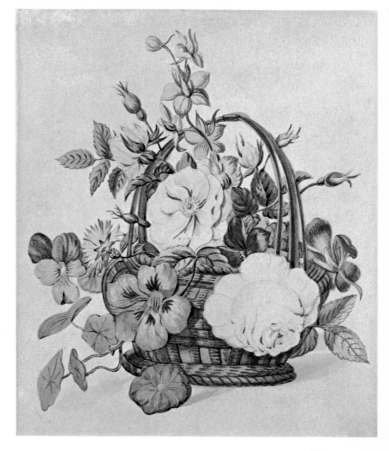

Death of the first Vincent Willem van Gogh (March 30, 1852) as recorded in the register in the archives of the district of Zundert, Netherlands.—In the left-hand margin is the word *levenloos*, that is "lifeless" or born dead. At the bottom left-hand corner is the father's signature "Th[eodoru]s van Gogh".

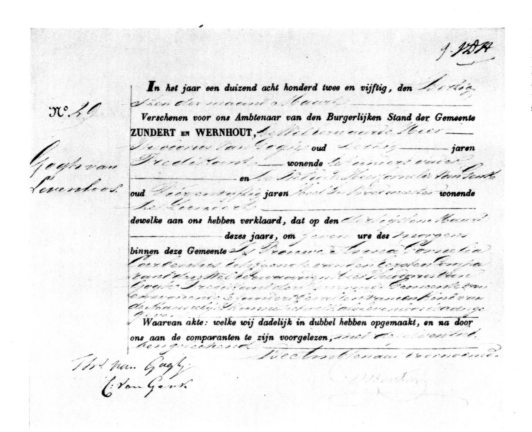

The little church and graveyard at Zundert. Photograph A.I.v.G.—The picturesque little church, in which Vincent and Theo were baptized, was built in 1806. Vincent Willem, the child born dead on March 30, 1852, was buried in the graveyard beside the church.

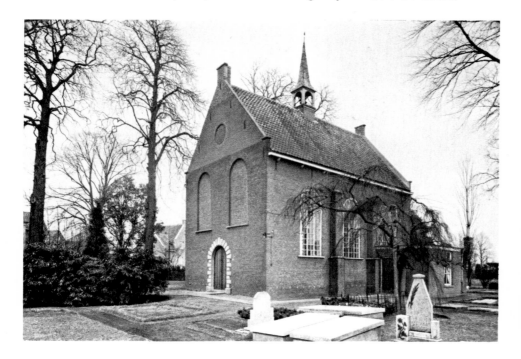

Tombstone of the first Vincent Willem van Gogh (born and died in 1852). Photograph A.I.v.G.—From his earliest youth Vincent regularly saw the tomb of his still-born brother and namesake whenever he went to church with his father. Did this constant confrontation with the idea of death influence his nature? The inscription in Dutch on the tombstone is from Luke, xviii, 16: "Suffer little children to come unto me, and forbid them not: for of such is the kingdom of God."

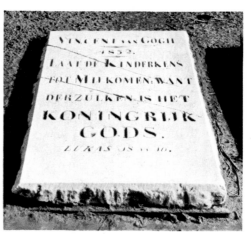

18

Birth-register entry for Vincent Willem van Gogh (March 30, 1853). Archives of the district of Zundert.—A comparison between this document and that recording the birth and death of the first Vincent Willem shows that chance has decreed not only that the two children should be born on the same date, March 30, but also that they both had the same serial number, 29. The register is signed by the registrar, the father, the doctor and a witness. This document also tells us that Vincent was born at eleven o'clock in the morning, for those who may wish to cast his horoscope.

The house in which Vincent van Gogh was born. Photograph in the collection of J. Beljaars, Nieuw-Ginniken, Netherlands.—He was born in the room with the flagpole under the window. This photograph was taken on May 9, 1902. The house then still looked as it did at the time when Vincent was born. The presbytery had been somewhat altered since J. Bulthuis originally drew it, but the general shape was retained. In 1903 the house was pulled down.

Entry recording Vincent van Gogh's baptism in the baptismal register, running from 1817 to the present day. Parish records, Dutch Reformed Church, Zundert.—The baptism of the second Vincent took place on April 24, 1853.

Catholic families. The same phrase crops up continually: "He was the image of goodness." And the widow S. Aertsen-Honcoop even went so far as to say: "It's a certain fact we shall never have another pastor like him in Zundert."

The only criticism of Pastor Theodorus came from the former mayor of Zundert, Mr van de Wall, whose parents were close friends of the van Gogh family and owned Wallstein, a property on the outskirts of the village, where they sometimes entertained the pastor and his family. Van de Wall told Stokvis: "Pastor van Gogh was a severe man, a proper little Protestant pope."

The pastor was a serious man, and serious men often seem to be severe. But the second part of van de Wall's statement is harder to explain. It could well be that Pastor Theodorus, while conscientiously defending his religious minority, was occasionally obliged to fight on his fellow-Protestants' behalf, perhaps even to argue their case point by point. Seen in this light, the ex-mayor's equivocal view should not be allowed to lessen, let alone contradict, the other posthumous tributes to Theodorus van Gogh's tolerance and generosity, qualities inherited by Vincent and Theo.

A HAPPY MARRIAGE

The Reformed community at Zundert welcomed their new pastor with satisfaction, but they would have preferred a married incumbent to a bachelor. Until Theodorus should find his bride, his favourite sister, Maria Johanna, set up house with him at the presbytery and ran the household. This she continued to do for two years until 1851, when Theodorus married Anna Cornelia Carbentus, who was two and a half years older than he was and who came from The Hague. The evidence of various people who knew her shows that she was a remarkable and lovable woman. She died in 1907 at the age of eighty-six, and her daughter-in-law, Johanna van Gogh-Bonger, Theo's widow, wrote in 1914 in her introduction to *The Letters of Vincent van Gogh to his Brother* that this splendid woman retained her energy and spirit to the very end, although by that time she had lost her husband and her three grown-up sons. Her unusually warm heart and keen mind were constantly in evidence. She had a deep love of nature, especially for flowers and of plants.

The pastor shared this passion of his wife's, and was likewise a devoted botanist. His daughter Elizabeth Huberta has described in an interview how her father in his old age would often bend down to peer at little plants which were coming into flower at the beginning of spring.

Anna Cornelia Carbentus was also remarkably skilful with her fingers. Her manual dexterity was very striking until almost the day of her death. She handled her knitting-needles at a terrifying speed, and pen with no less skill. She was always able to express herself clearly and easily. Johanna van Gogh-Bonger tells that one of her favourite expressions was "I just send you a little word", and that for many years these charming "little words" brought gaiety, hope and courage to hosts of correspondents, not least to Johanna herself.

There is an interesting connection between the mother who was such a fluent and well-loved letter-writer, and the son whose letters were perhaps a continuation of a tradition that she had begun, but Vincent's letters displayed greater intelligence, wisdom and penetration, more concern, emotion and even passion. Without Vincent's extraordinary talent as a letter-writer, we should never have had that astonishing human and artistic document, that staggering self-confession, unique in the history of art, which his letters provide.

Vincent's mother had other abilities, no less relevant to his development; she drew and painted in water-colours with undeniable talent. Knowing her deep interest in nature it is easy to guess that the subjects she preferred would have been plants and flowers. In 1956 I discovered a family album in

Vincent van Gogh (*circa* 1866). Photograph in the collection of Pastor J. P. Scholte-van Houten, Lochem.—This portrait remained unknown until the author found it in 1956 among the Scholte-van Houten family papers which Mrs Scholte-van Houten had inherited from her mother, Anna van Gogh, Vincent's sister. When the author showed it to Picasso on January 6, 1958, he exclaimed: "What a striking ressemblance to the young Rimbaud, especially the keen and penetrating eyes!"

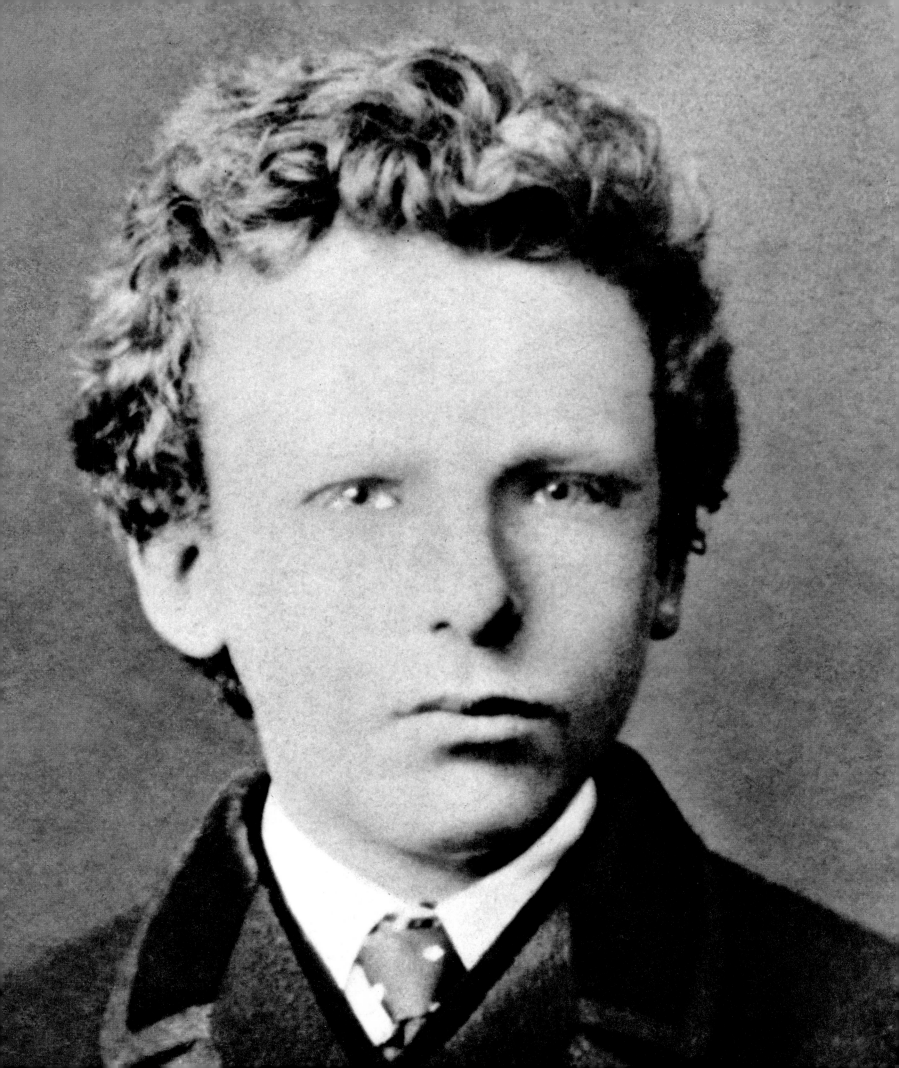

which four leaves were covered with her sketches. The first is dated March 5, 1844, and was therefore executed when she was twenty-five, seven years before she married Pastor Theodorus.

Anna helped her husband in the performance of his duties in the most exemplary fashion. Wherever she went she was always most welcome and she was as much loved as the pastor himself—more so by van de Wall, who said that she "was very gentle". The widow S. Aertsen-Honcoop remembers that his wife regularly accompanied the pastor when he visited the sick, and that it was she who prepared presents of food for the poor, heedless of whether they were Protestants or Catholics.

## A SERIES OF QUESTION-MARKS

Eleven months after the pastor and his wife were married their first son, Vincent Willem, was born. But he did not live. Anna Cornelia was then thirty-three and was thus hardly a young mother. At the moment when they had hoped to find their wishes granted the van Goghs could only weep over the cradle so carefully and lovingly prepared for the awaited baby. In the margin of the birth register kept by the civil authorities at Zundert the registrar has written "levenloos" (lifeless). In *The Letters of Vincent van Gogh to his Brother Theo* it is stated that the infant lived for several weeks. But the official document could not be more categorical on this point. Vincent Willem's remains were interred in the little graveyard beside the church, and the bereaved parents had an inscribed freestone slab placed over their child's grave.

A year later, to the very day, on March 30, 1853, Theodorus van Gogh, who had still not entirely recovered from this disappointment, went to the town hall to register the birth of another child, who was also called Vincent Willem. Besides this coincidence, which is disconcerting enough, there is another which is no less odd. On the two documents the two Vincents, the stillborn and the healthy, are registered under the same serial number, 29.

Humberto Nagera, the author of a psychological study of Vincent van Gogh, recalls that the number 29 was to appear again on the death certificate of Vincent van Gogh, who died on July 29, 1890.

Nagera also points out other coincidences which may be less significant. For instance, the little clock in the upper left-hand corner of van Gogh's POTATO-EATERS shows that it is twenty-five minutes to midnight (unless, of course, Vincent intended it to be seven o'clock, for the large and small hands on the clock are not easy to distinguish!). Now if we add twelve to twenty-five we get thirty-seven, which was Vincent's age when he committed suicide.

## A CHILD CONCEIVED IN SADNESS

Quite apart from the coincidence of the dates and the serial numbers on the register, Vincent's birth was marked by other unhappy omens. The painter was conceived while his parents were still in mourning for their first child. It is now generally admitted that a man's life should not be considered as beginning at the moment of birth, but at the moment when he was begotten, and that the unborn child, from its earliest development, is subject to the physical and mental state of the mother who bears it. Likewise the father's health and spirits also influence the future child. It is therefore easy to see how his parents' state of mind could have been partly responsible for the darker side of Vincent van Gogh's nature.

The substitution of a dead child by another has been the subject of several psychological studies. One of these is Albert C. and Barbara S. Cain's "On Replacing a Child" in the *Journal of the American Academy of Child Psychiatry* for July 1964. The authors show how in certain families the replacement child becomes the victim of important changes that the parents have suffered. Nagera refers to this study and concludes that the morbid anxiety that Vincent was to experience at certain moments of his life after he had left the family home was determined by these circumstances. "Their impact on his personality", he says, "left clear imprints." Nagera recalls in his paper several instances in which psychoanalytical research has established that, in a family where the first child was dead, the second always considers himself in his neurosis to be responsible for the first child's death, even if he himself had not been born at the time, and that the forces of the unconscious generate strong feelings of guilt, which play an important part in forming the person-

ality. Considerable distress is evident every time that events occur which resuscitate this conflict, at the birth of other brothers and sisters, for instance, or when they fall ill. If we read between the lines of the uninterrupted confession which Vincent's letters provide, we find that his life was governed by various processes of repression, and that, moreover, fantasies of guilt caused by the death of the first child frequently appear right up to the very end of his life. This feeling of guilt showed itself for the last time, at a subconscious level, in the suicide which liberated him from the world, and indeed was one of the motives for it.

## FACE TO FACE WITH DEATH

The second Vincent van Gogh's entry into the world was therefore marked with a far from promising sign. And there was another psychic factor which must have influenced the child. As I have already mentioned, his parents, no doubt with the most admirable of motives, had perpetuated the memory of the first Vincent by placing upon his tomb a stone engraved with his name.

The Protestant cemetery at Zundert lies only a stone's throw from the presbytery where the second Vincent grew up. And as soon as the little boy could read his own name he could see it written on his brother's tomb every Sunday when his mother and father took him to church.

When Nel van Gogh-Vandergoot, the painter's nephew's wife, visited Zundert with her husband, she was shocked to see this epitaph. "Poor little Vincent!" she exclaimed. "What a terrible sensation must have taken hold of him when he saw his own name on this tomb!"

It is hard to realize quite how distressing an effect this sight would have had on the mind of a child emerging into conscious life. It is almost as if Vincent were born under the grim sign of the most inscrutable of all mysteries, and there is little doubt that his terror of and maybe even self-identification with death at such an early and impressionable age greatly influenced the development of his character.

Yet this is only one aspect of the sad story. Even more far-reaching might be the child's impression that he was, in effect, only a substitute. This could

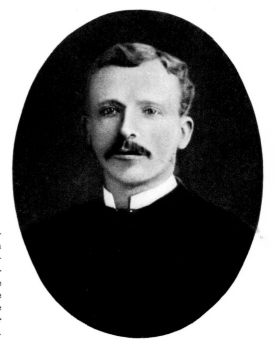

Theo van Gogh. Photograph Vincent van Gogh Foundation, Amsterdam.—This photograph was taken in the last years of his life (1888-1890), when he worked in Paris for Boussod, Valadon & Cie.

have aroused a gradually increasing sense of guilt, as well as an impulse to bring himself to notice by the most complete of sacrifices, in order to regain his lost identity by taking the place of the dead. He may indeed have come to feel that the second Vincent van Gogh existed only as a function of the first—in other words he did not exist at all.

This sequence of unusual events brings to mind Rimbaud's pregnant phrase "*Je est un autre*"—"I is another". One may well wonder whether all the vicissitudes in the painter's life, and which revolve around the painter's categorical refusal to be an imitator of any kind, are not the outward manifestation of his subconscious struggle against the fate of being a mere replacement of his dead brother.

Yet another point arises in this context. When Theo was born, four years after Vincent, it would perhaps have relieved, if only partially, his sense of guilt; in which case his feeling of immeasurable gratitude could well have been the beginning of the deep and remarkable friendship between the two brothers. For, as we shall see, the links that were forged between Vincent and Theo van Gogh were far stronger than any of the ordinary bonds of blood, so that their names will always remain inseparable in the history of art.

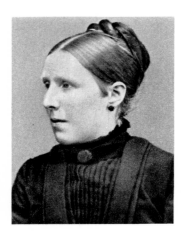

Anna Cornelia van Gogh. Photograph in the collection of Pastor J. P. Scholte-van Houten, Lochem.—She was born at Zundert on February 17, 1855, and died at Dieren on September 20, 1930. Vincent speaks of her in his letters to Theo. During his stay in England, when he was living with the Rev. Mr Jones, the Methodist minister at Isleworth, he went to Welwyn, 25 miles from London, to visit his sister Anna, who was teaching French at a boarding school there. She was the mother of Mrs J. P. Scholte-van Houten.

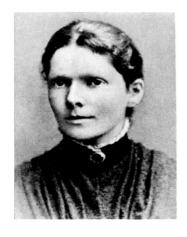

Elizabeth Huberta van Gogh. Photograph in the collection of Pastor J. P. Scholte-van Houten, Lochem.—She was born at Zundert on March 16, 1859, and died at Baarn on November 29, 1936. She was the painter's middle sister, six years younger than he was. Later she was to marry a writer on law called du Quesne. She had literary talent and published her *Personal Recollections of Vincent van Gogh* in 1910.

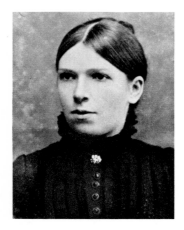

Wilhelmien Jacoba van Gogh. Photograph in the collection of Pastor J. P. Scholte-van Houten, Lochem.—She was born at Zundert on March 16, 1862, and died at Ermelo Veldwijk on May 17, 1941. She was the painter's youngest sister, and she drew well. To her Vincent wrote a series of letters, of which twenty-three have survived. A few years after Vincent and Theo died she was interned in an asylum for psychiatric cases, where she died at an advanced age. For some time she was a conspicuous figure in the Dutch feminist movement.

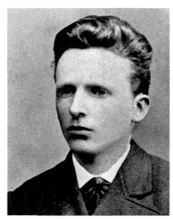

Cornelis Vincent van Gogh at the age of eighteen. Photograph in the collection of Pastor J. P. Scholte-van Houten, Lochem.— He was born at Zundert on May 17, 1867, and died at Pretoria in South Africa about April 24, 1900. He was 14 years younger than Vincent and was known as "Cor". After his marriage fell through he enlisted as a volunteer in the Boer army in South Africa. His name appears on the roll of those killed in battle, although it has been said he committed suicide. If so, perhaps there was a tendency to suicide in the family.

## HE WHO WAS ANOTHER

What is known of Vincent's childhood? The opinions of his contemporaries are not only at variance with one another, but sometimes even contradictory, and of course many of them were set down long after the event. So long as the painter remained unknown, nobody took any interest in the circumstances of his life. When the efforts of his sister-in-law, Johanna van Gogh-Bonger, who with courage and pertinacity had always tried to draw attention to the merits of the man and his work, began to bear fruit, it was already too late to find out much about him as a child. By then most of the people who had known him at Zundert before 1865 were dead and gone. And those few who remained had only the vaguest memories of the young child.

At the time when Stokvis undertook his enquiries, no more than half a dozen such witnesses were still alive. Ex-mayor van de Wall recalled that Vincent did not come with his parents when they visited the property of Wallstein. He did not play like other children, but read all sorts of books quite insatiably. And there had never been any kind of complaint about his conduct at the village school.

Vincent's name appears on the Zundert district records, which are still preserved. It is on the rolls for the second, third and fourth terms of 1861. There are also about ten other lists of pupils to whom school prizes were given. They cover the period from January to October 1861, and confirm that Vincent was registered at the village school.

The widow De Bie-van Aalst recalled that as a boy Vincent was quiet and good-natured, but that as a rule he did not mix with other children. She also remembered Theo, usually known as Ted, as physically tougher, better developed, noisier and more talkative than his brother.

The widow S. Aertsen-Honcoop, who worked for the van Goghs for a year and a half, said: "There was something strange about him. He did not seem like a child and was different from the others. Besides, he had queer manners and was often punished. He was covered with freckles. His hair was as red as fire. He looked like his mother. He wasn't at school for very long." This woman was a serving-maid in the presbytery and was in a good position to see exactly what went on inside the household. She found that Vincent was the least agreeable of the children and did not think that he would come to much good. She had no idea that he would become an artist whose fame was already beginning to spread far and wide when she was being questioned.

There is also a report from Carl van Ginneken, a schoolmate of Vincent's, who remembered how silent this straightforward lad was. Van Ginneken did not think that Vincent, with his red hair and freckles, was an attractive-looking boy, and he could certainly not be called handsome.

Kees Doomen, the son of Jan Doomen mentioned by Vincent in his letters to Theo, could only remember that he had often seen him at his father's house when his own father was working for the van Gogh's as a gardener. J. Franken, the son of the carpenter who worked for the pastor, and who as a boy would sometimes also do jobs for the van Goghs himself, tells how Vincent often came to the old carpenter's shop to amuse himself by making things. He was clever with his hands and the carpenter always spoke highly of him. When young Franken worked at the presbytery, Vincent liked to come and watch. Franken's evidence is especially valuable for he recalls having seen Vincent drawing both in pencil and colour. He more than once heard the pastor speak of his son's special aptitude for drawing. There is no doubt that he was proud of his son's precocious talent, for we know that he framed and put the date on the drawing of a FARM AND WAGON-SHED that Vincent had done when he was eleven years old and which he had given his father as a present on his forty-second birthday.

The Honcoop brothers often went to the presbytery, and the elder Honcoop boy was once asked by the pastor to go and fetch Vincent, who was then about fourteen years old, from Tilburg. The two boys travelled by train from Tilburg to Breda, from which they had a three-hours' walk to Zundert. Vincent was carrying a fairly large and heavy parcel. After a while Honcoop offered to carry it for him. But Vincent answered sturdily and simply: *No thank you, everyone must carry his own parcel*. This phrase engraved itself on the Honcoops' memories and eventually became proverbial at Zundert. Already Vincent had shown the strength and independence which were to remain throughout his life a conspicuous part of his character.

More than a quarter of a century ago I had a conversation with Hendrik Hoppenbrouwers, who had once been the sexton at the Catholic church at Zundert. He was two years younger than Vincent. "He was an ugly red-headed boy", he told me, "who liked to go by himself on many long walks across the fields. At school we were in the same class, or rather in the same classroom; Vincent actually belonged to the class above me, but we were so short of space, that about a hundred and fifty boys and girls were all together in the charge of Dirks, the schoolteacher, who was always thirsty and regularly going absent. Vincent was a good pupil and read a great deal. We were beaten from time to time, but on other occasions we also got up to mischief together. All the same, as I said before, Vincent went off on his own for most of the time and wandered for hours together around the village, and even quite a long way from it."

In her *Personal Recollections of Vincent van Gogh*, the painter's sister, Elizabeth Huberta, describes Vincent's character at the age of seventeen. At the same time she also gives some information about him at an earlier age. She tells us that he was, "As broad as he was long, his back slightly bent, with the bad habit of letting the head hang; the red blond hair cropped close was hidden under a straw hat: a strange face, not young; the forehead already full of line, the eyebrows on the large, noble brow drawn together in deepest thought. The eyes, small and deep-set, were now blue, now green, according to the impressions of the moment." In another chapter Elizabeth Huberta says that the look in Vincent's keen and penetrating eyes was exactly that of his mother, whom he resembled in many other ways. "But in spite of all awkwardness and the ugly

exterior, one was conscious of a greatness, through the unmistakable sign of the deep inner life. Brothers and sisters were strangers to him as well as his own youth. Hardly matured, his genius was already being felt, although unknown to himself; as a child, who does not understand what its mother is, yet answers to her call."

## A TROUBLESOME BOY

Johanna van Gogh-Bonger does not conceal the fact that Vincent was not a very well-behaved child. In her introduction to her brother-in-law's letters to her husband she reveals an incident which Elizabeth Huberta makes no mention of: "As a child he was of a difficult temper, often troublesome and self-willed; his upbringing was not fitted to counterbalance these faults, as the parents were very tender-hearted, especially toward their eldest. Once Grandmother van Gogh, who had come from Breda to visit her children at Zundert, witnessed one of little Vincent's naughty fits. Having learned from experience with her own twelve babies, she took the little culprit by the arm and, with a sound box on the ears, put him out of the room. The tender-hearted mother was so indignant at this that she did not speak to her mother-in-law for a whole day, and only the sweet-tempered character of the young father succeeded in bringing about a reconciliation. In the evening he had a little carriage brought around, and drove the two women to the heath where, under the influence of a beautiful sunset, they forgave each other." This little domestic drama was certainly not the only one of its kind that occurred between this difficult boy and his over-indulgent parents in the van Gogh's home at Zundert and he was the cause of constant quarrelling in the family.

Even though we have little information about the first years of Vincent's life—for his sister and his sister-in-law give an incomplete picture—two distinct impressions emerge from the descriptions by those who saw him growing up. Unlike most other boys, Vincent turned almost deliberately and systematically in upon himself. His mother shared this view of him, and there is no doubt that his obstinate, self-willed nature, which would brook no compromise, did not leave a very favourable memory among his relations and acquaintance. The more Vincent's mother scolded him the more perverse and defiant the boy became.

Everyone who knew Vincent personally, whether they met him once or many times, agreed that he was serious and earnest to an extraordinary degree. Nobody seems ever to have seen a smile on his lips, indeed they were usually clenched obstinately shut. So it is hardly surprising that all his contemporaries, as old Hoppenbrouwers remarked to me, wondered if he was really a child at all. He certainly never showed any of the boisterous lightheartedness and openness normal in children of his age.

Although this morose and withdrawn boy was self-willed and sometimes even bad-tempered, at the same time he was intelligent, given to dreaming and easily moved to pity. He was a stranger even to his closest relatives, and he always seemed to be out of his element. He must have been one of those boys of whom it is truly said they are "born old". It is hard to believe that he could ever have been at a childish stage of intelligence. Exceptional forces dwelt in his soul, forces which were to drive him to the heights of human endeavour. From his earliest youth his independence of spirit was in utter contrast to that of his companions. When he was baptized in the Dutch Reformed Church at Zundert, the gift that he was given by some invisible fairy godmother was the gift of indomitable energy, which was to drive him on in spite of the many setbacks he was later to encounter in his life.

From this all else follows. In later years it was to be said that Vincent was a madman and that his parents had sent him away to a lunatic asylum at Geel; that he was a buffoon who painted peasants whose faces were more like animals' heads than human countenances; that he was an imposter who wore a peasant's blue smock in order to draw attention to himself; a saint who slept on straw so that injured miners might use his bed; a dreamer with utopian notions of goodness and of a real Christian solidarity put into practice; an innocent idealist sacrificing himself without hesitation for the good of his neighbour; an exceptional being, firmly believing in real brotherhood, total and universal. All the variations on this theme show that, whatever Vincent van Gogh may have been, he was utterly unlike anyone else.

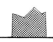

**VINCENT WILLEM**
artist
born March 30, 1853 at Zundert
died July 29, 1890 at Auvers-sur-Oise

ANNA CORNELIA 1955-1930
THEODORUS, known as THEO, 1857-1891
ELIZABETH HUBERTA 1859-1936
CORNELIS VINCENT, known as COR, 1867-1900
WILHELMIEN JACOBA 1862-1941

**THEODORUS**
pastor
born February 8, 1822 at Benschop
died March 26, 1885 at Nuenen

**ANNA CORNELIA CARBENTUS**
born September 10, 1819 at The Hague
died April 29, 1907 at Leiden

JOHANNA WILHELMIEN 1812-1883
HENDRICK VINCENT 1814-1877, bookseller, then artist
DOROTHEA MARIA 1815-1882
JOHANNES 1817-1885, vice-admiral
WILLEM DANIEL 1818-1872, tax-collector
VINCENT 1820-1888, art-dealer
ELIZABETH HUBERTA 1823-1895
CORNELIUS MARINUS 1824-1908, art-dealer
GEERTRUIDA JOHANNA 1826-1891
MARIA JOHANNA 1831-1911

**VINCENT**
pastor
born February 11, 1789 at The Hague
died May 7, 1874 at Breda

**ELIZABETH HUBERTA VRIJDAG**
born April 27, 1790 at Rotterdam
died March 7, 1857 at Breda

MARIA JOHANNA 1786-1847
DOROTHEA MARIA 1790-1815

**JOHANNES**
gold wire-drawer
teacher of the catechism
born August 29, 1763 at The Hague
died January 12, 1840 at The Hague

**JOHANNA VAN DER VE(E)N***
baptized June 30, 1750 at Heusden
(near Mechelen)
died February 21, 1821 at The Hague

**JAN**
gold wire-drawer
baptized March 1, 1722 at The Hague
died March 13, 1806 at The Hague

**MARIA STALVIS (STATWIAS?)****
baptized May 1, 1740 at The Hague
died February 21, 1821 at The Hague

VINCENT 1729-1802

**DAVID**
gold wire-drawer
baptized October 16, 1697
died August 31, 1740

**ALIDA VERMEULEN**
died July 30, 1770

**VINCENT**
baptized September 30, 1674 at The Hague
died January 1746 at The Hague

**JOSINA BIJLEVELT**
baptized January 12, 1676 at The Hague
died October 31, 1754 at The Hague

**GERRIT GERRITSZOON VAN GOCH**
living at The Hague in 1660

**ANNA VAN DUYNEVELT**

\* Johanna van Gogh-Bonger, the painter's sister-in-law, gives this name as van der Vin in her introduction to *The Letters of Vincent van Gogh to his Brother*. But even if this is a misreading, there is still doubt whether it was Ven or Veen, both spellings appearing in the old documents.

\*\* In her introduction Johanna van Gogh-Bonger gives the spelling Stalvius instead of Stalvis, but once again the spelling seems to be different in different documents.

**GERRIT VAN GOCH**
a soldier in 1635
died 1648 at The Hague

**ÆLTJE CENTEN**

At the age when most children cling to their mothers' skirts, little Vincent preferred to be alone in the garden, in the woods or in the meadows, where he could observe nature in its many moods and forms. The opening bud of a flower or a beetle pursuing its own mysterious movements revealed to him the miracles of creation. He used to spend hours on end gazing at everything that moved in the sky or on the earth. Elizabeth Huberta wrote: "With a thousand voices nature spoke to him, while he listened."

It was not surprising that such a sensitive nature as his should feel such a need for solitude. His walks sometimes led him right out into the wilds of Kalmthout Heath, a good six miles from his father's house. Twenty-five years later, when he was living in the south of France, Vincent was still the boy who had walked alone in Brabant, and he longed to see his native country again. His nostalgia was for part of the world that had been a paradise for him.

Although even as a child Vincent was quite out of the ordinary, such signs of genius as one might be able to discern in him at that age gave little inkling of the direction in which he would go. Whereas Mozart, for instance, showed his exceptional musical ability from a very early age and at once began to follow this path, Vincent did not discover and follow his true vocation until he had been struck by tragic circumstances. It is true that even from the beginning he always took particular pleasure in drawing.

His sister Elizabeth tells us that when he was still quite young Vincent got hold of some putty from a painter who was working at the pastor's house and made a very careful model of an elephant with it. Johanna van Gogh-Bonger tells us the sequel to the story: when the boy noticed that it had attracted his parents' attention he immediately destroyed it on the grounds that they were making too much fuss about it.

This anecdote may seem commonplace enough, but in fact it is an early and typical example of the way Vincent reacted at certain critical moments throughout his eventful life. Nagera indeed maintains that the ambivalent feelings that the boy displayed on this occasion appeared many times during the course of his life. In his study of van Gogh he devotes an entire chapter, entitled "Fear of success and fear of failure", to the subject.

Once when Vincent was only about eight years old he drew a picture of a cat climbing a leafless appletree against a background of the garden in winter. Once again his mother was much taken with the drawing, and once again, as with the elephant, Vincent destroyed it. Despite this ambivalence there was no doubt that he loved drawing, and he mentions the fact several times in his letters to Theo. Nevertheless this early ambition was often superseded by other ways of expressing himself which indicate his passionate desire to prove himself and show that he could do well. It is clear that he derived his desire to draw from his mother, whose water-colours reveal considerable ability and taste.

The juvenile drawings which have been attributed to Vincent do not as a rule convince one of their authenticity, and some are extremely suspect. But there is one about which there can be no doubt whatsoever. Vincent drew it when he was eleven years old, on the occasion of his father's forty-second birthday, and I came upon it among the relics preserved by Pastor J. P. Scholte-van Houten and his wife, who is the daughter of Anna van Gogh. I am quite certain that this early drawing is not a copy of another picture, but an original composition. The family were so pleased with it that they had it framed, and kept it as one of their treasures. It is the earliest of Vincent's pictures that we know.

This drawing of a FARM AND WAGON-SHED is most interesting. Vincent has recorded a corner of the village that he knew well. Even at this age he has chosen to represent elements of his spiritual world, which we shall find in his later work. It has been maintained that when van Gogh began painting he was obliged to overcome very indifferent natural abilities. But in fact his natural aptitude for drawing and painting were by no means inconsiderable. One can see at once from his drawing that it is full of very real promise. Anyone who has tried to draw or paint, and has experienced the difficulty of composing the successive planes into their proper order of depth and distance will appreciate its merit.

André Maurois has rightly said that good taste is no more nor less than a natural desire to understand, love and seek for beauty. And in this respect Vincent was already well-endowed as a boy. His innate talent

was such that when he abandoned all prospects of entering the ministry in order to take up an artistic career he lost little time in creating works of considerable merit, such as his pictures of the sowers and the road beneath snow at Etten.

## A YOUNG NATURALIST

Elizabeth Huberta has other things to tell us about her brother. She writes "Without a greeting the brother passed by, out of the garden gate, through the meadows, along the path that led to the stream. The children noted whither he was going, because of the bottle and fishnet he carried. It did not occur to any of them to call after him, 'May I come too?' Yet they knew only too well how clever he was at catching water insects; he would show his trophies to the children on his return. Such jolly little and big beasties! There were broad beetles with their glossy backs; and others with great round eyes, and crooked legs, that nervously wriggled the minute they left the water.

"All the beetles, even those with the terrible long feelers, had names,—such horribly long names one could never remember,—and yet their brother knew them all. And then, after he had prepared them, he would carefully pin them in a little box, which first had been beautifully lined with snow-white paper, and neatly labelled with the names pasted above each insect—even the Latin names!"

Later in her memoirs Elizabeth Huberta tells us that he knew all the places where wild flowers grew. He would leave the straight highroads that ran out of the village and seek out the paths where the people of Zundert seldom set foot. There he would patiently watch the wild life. He knew just where the birds made their nests and how to approach them without scaring away the sitting hen.

In her introduction to Vincent's letters to Theo, Johanna van Gogh-Bonger also writes that Vincent as a boy showed a great love of animals and plants, and that he would collect specimens of all kinds.

Whether we consider van Gogh as a "naturalist" depends how this word is defined. The dictionary defines a naturalist as "one who believes in or practices naturalism; students of animals and plants", and in both these senses he may be said to qualify,

especially if we take "naturalism" to mean "a form of art the object of which is to reproduce nature faithfully" rather than in the philosophical sense.

There is no doubt that Vincent van Gogh's love of nature was an early and profound feature of his character. Later he became a true naturalist, not only because of his passion for collecting insects, especially beetles, but also because of everything that nature meant to him in his life and work.

Vincent probably acquired his love of nature from his parents, who enjoyed the countryside and went for at least an hour's walk every day. This habit does not, of course, explain how Vincent came by his vocation as a naturalist, even though these open-air excursions would certainly have encouraged any leanings in that direction. We also know that Vincent's mother was a competent artist long before her marriage, from the pictures of hers that I discovered among the family treasures of the Scholte-van Houtens which they inherited from Anna van Gogh, Vincent's eldest sister. These four little pictures, one of them in water-colour, are careful and conscientious attempts to reproduce flowers in every detail, which is not without its significance in relation to her son's predilection for nature and naturalism.

## NATURE AND NATURALISM

Whether or not her son's love of nature was hereditary or acquired, when he decided to become an artist this naturalistic tendency reappeared in full strength and showed itself in all his work.

The paintings and drawings in which his knowledge of nature was most clearly shown were not done to illustrate some point in a botanical or entomological exercise. Vincent did not need a microscope, his eyes were keen enough without one. He looked at things from very close to, and this sometimes had important results. During the van Gogh exhibition at Antwerp in 1955 I was able to compare a naturalistic drawing done in his Saint-Rémy period and modestly entitled FLOWERING STEMS, with the Dutch botanist Rembert Dodoens's botanical drawing published in 1608. The plant depicted has been said in the Netherlands to be a *Capsula bursa pastoris*; it has also been said to be an *Artemisia*; in the catalogue of an exhibition

at Berne it is described as a *Südliche Bisamhyazinthe*. But in fact I found that Vincent's drawing was so much the work of a naturalist, in the true sense of the word, that it can easily be recognized as a *Muscari comosum* in the great family of Liliacae. It is as exact a picture of the plant as the one by Dodoens which illustrates Linnaeus's classification.

## THE GROWTH OF A PREDILECTION

If we consider Vincent as a born naturalist, it is not because his work is in the same category as any landscape painting in which there are trees, shrubs and flowers, or still-life displaying fish or lobsters. The flowers which Vincent painted at Nuenen to express his grief when he was mourning for the death of his father are analysed with complete botanical precision. And one must also remember the birds' nests which he painted at Nuenen, and which can be considered as the creations of a naturalist *par excellence*. This particular interest of Vincent's was also in evidence when he wandered on his lonely walks around Zundert, when he used to strengthen the birds' nests threatened by the wind, noticing the intricate way they were made by the clever intertwining of twigs and straw and admiring the colours and markings of the eggs. Stuffed birds also found a place in Vincent's pictures; they are to be seen on two canvases and a drawing, representing a kingfisher, a green parrot and an owl.

A childhood schoolmate. Photograph A.I.v.G.—Hendrik Hoppenbrouwers, at the age of ninety-eight, was the only one of Vincent's contemporaries from Zundert who was able to appear at the celebrations of the centenary of van Gogh's birth. The others had long been dead.

During the two years he spent in Paris the number of still-lives of flowers he painted was considerable. In most of them the accent is upon the beauty of their colouring, but one can easily perceive his intention to penetrate their botanical details, an indication that this long-standing habit was not dead. One of Vincent's still-lives consisted of a pot containing nothing but grasses. In his painting of plants, the purely aesthetic qualities went hand-in-hand with remarkable naturalist's penetration. His powers as an illustrator were such that his work could have been successfully used in a botanical manual.

At Arles Vincent saw fruit-trees that he had always known well, pear-trees, apple-trees and cherry-trees, but the strong Midi sun made their colours particularly radiant. The discovery of the south contributed other new elements, a sort of visual refreshment and a deepening and strengthening of his feeling for nature. It is to this that we owe that splendid branch of blossoms in a glass which small though it is, shows great genius.

The revelation of what Vincent called his "Japan in Provence" brought him into contact with a whole range of plants that he had not known before, olive-trees, almond-trees and cypresses. There is one quite magnificent painting of an almond branch which could only be the work of an artist who had been a devoted naturalist from his birth. Then there are the famous sunflowers, which Vincent observed at every stage of their life, when in their glory, and when wilting away with the stalk bending humbly towards the ground.

## RAPID RETURN TO AN OLD LOVE

In two of these pictures of sunflowers, those which are probably the least popular, the painter seems to have examined his models from very much closer range. The details have been enlarged in such a way that the spectator can see the things that a botanist would enjoy with the aid of an magnifying glass. One can see the seeds with the naked eye, and this masterpiece could well serve as an exact representation to illustrate the work of a scientist. The young naturalist who had contemplated the mysteries of nature at Zundert had here returned to the things he loved as a boy.

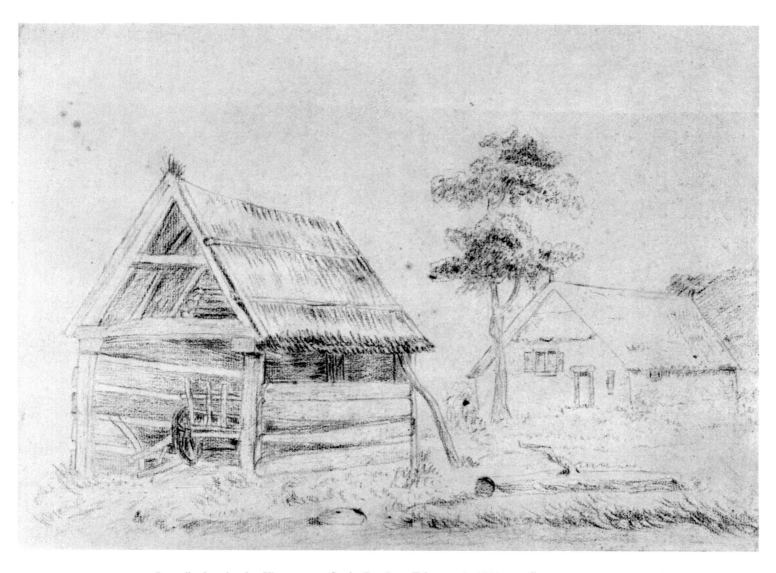

FARM AND WAGON-SHED. Juvenile drawing by Vincent van Gogh, Zundert, February 8, 1864, pencil, wove paper, watermarked "V d L", 20 × 27 cm, unsigned. Collection of Pastor J. P. Scholte-van Houten, Lochem.—On the back Vincent's father has written "February 8 1864, Vincent". February 8 was Pastor Theodorus van Gogh's birthday, and in 1864 he was forty-two years old. Vincent gave it to his father as a birthday present.

Thus we can say that at Saint-Rémy-de-Provence Vincent's naturalism, which had never entirely disappeared, returned and blossomed. Numerous pictures and dozens of drawings show that this was so and that his attention was mainly concentrated on studying the trees, shrubs, plants and flowers that he saw around him. When he walked in the Alpilles he sought subjects for his pictures, made sketches or painted canvases. In such surroundings the countryside as a whole meant more than the individual elements of which it was made up. When he painted magnificent views with rocks and cypresses, he was proving himself to be a naturalist in the widest sense of the word, a man moved by a vast love of nature. When he did not go out he contented himself with depicting subjects inspired by the park of the asylum of Saint-Paul-de-Mausole where he lived. There were, for instance, the irises, which clearly enchanted him. I remember being struck by an ingenious juxtaposition in a German specialist journal on photography: Vincent's irises and a photograph of an iris were printed side by side in full colour. The accompanying text pointed out that the painter's flowers mirrored every feature of the real ones, a very

convincing demonstration of van Gogh's talent as a naturalist. Vincent likewise painted many pictures of other flowers as well as bushes and trees, and also of butterflies and beetles. These have little in common with the still-lives that almost every artist paints at one time or another. There are certain works in which his passion as a naturalist leads him to create masterpieces in this field. The most remarkable of the paintings in this category are the death's head moth, the chestnut leaf, the grape-hyacinth flowers, the study of wild arum, commonly known as lords-and-ladies, and the periwinkle. Finally there is the caterpillar on a leaf, which seems to be the most successful work of art of them all. It is no accident that a Japanese textile mill has chosen this particular drawing as a decorative motive on one of their products, for the Japanese artists have always excelled at naturalism in painting. Indeed it was their naturalism, particularly in their paintings of flowers and blossom, quite as much as their colour sense, which attracted Vincent to the work of the Japanese artists and which came to influence much of his own later work. There are many similar examples of naturalistic painting in his Arles period which foreshadow the Saint-Rémy-de-Provence drawings.

This discussion of Vincent as a naturalist and the various forms in which this predilection appeared has been something of a digression and has anticipated the chronology of this study. But if we were to follow Vincent's psychological development and artistic emergence as closely as they deserve, this excursion into the future was the only way to show the breadth of his love of nature.

## GOODBYE TO HOME

On October 1, 1864, Vincent, who was then eleven years old, took leave of his family for the first time in his life. The pastor and his wife had decided that their eldest son had nothing more to learn from the village school under a master who was far too often drunk. They were also concerned lest their boy should be coarsened by constant association with the village children, most of whom were rough and unmannerly, sharing few of Vincent's interests. A practical solution was at hand: they would send him to a boarding-school run by a Protestant, Jan Provily, at Zevenbergen, nineteen miles from Zundert, beyond Etten, where Theodorus was later to live. According to the register of population in the

THE DOG. Juvenile drawing by Vincent, Zundert, December 28, 1862, pencil, laid Holland paper, watermarked lion "L d B", 18 × 28.5 cm. Kröller-Müller State Museum, Otterlo, Netherlands.—In a lecture on van Gogh's early development given at the State Institute for the History of Art at The Hague and published in a limited edition by Wereldbibliotheek, Amsterdam and Antwerp in 1957, I cast doubt on the authenticity of this drawing. Some of the lines, I argued, are so strongly expressed that it is hard to believe that they were drawn without hesitation by a child of nine and a half. Comparison with FARM AND WAGON-SHED, which is undoubtedly authentic, is most instructive in this respect. Even if it is a copy from another drawing my arguments apply.

archives of the commune, this institution was in Zandweg. In a general report on lower schools in 1863, I have found that this "special school" was not subsidized, and that besides providing the basic education it also offered more extended courses. Jan Provily was authorized to teach French, English, German, mathematics and natural sciences; his son, Cornelis Piet, only French and German.

Vincent remained at this school for nearly two years, that is to say until August 31, 1866. In his book *Hoofdstukken uit de Psychoanalyse* ("Chapters in Psychoanalysis") Professor A. J. Westerman Holstijn relates that his parents had known the Provilys and that he had taken advantage of this family friendship to find out whether they remembered anything about Vincent. But they were then in their nineties and had only the very vaguest memories of him, which perhaps just showed that he had never caused them any trouble. He was an ordinary boy whom they had thought nothing of until many years later he happened to become famous.

I have ascertained that Jan Provily was registered with the civil authorities as "teacher of children". He was sixty-four years old when Pastor Theodorus van Gogh sent his son to the school. He died at Zevenbergen in 1874. These dates agree with the tombstone in the graveyard at Zevenbergen. Jan Provily could therefore never have known of Vincent's artistic career.

Thus it is clear that Professor Westerman Holstijn did not talk to Jan Provily and his wife, but to their son, Cornelis Piet, who had succeeded his father as schoolmaster, and his wife, Frederika Gustina Blank, who died at Haarlem in 1934 at the age of ninety-eight. This does not, of course, alter the evidence, such as it is, because the younger Provily, who helped his father in running the school, had also known van Gogh as a boy. A schoolfellow of Vincent's, Frans Adriaan de Klerk, said only that "he was a silent boy". Nor do we have much more information about Vincent's sojourn at Tilburg, where he continued his studies after leaving Zevenbergen. I have discovered in the communal archives that Vincent was registered on September 15, 1866 with one Hannik (this name is sometimes spelt Hannick) at "Korvel 57" and he left on March 14, 1868, having thus remained at Tilburg for eighteen months. Another entry in the archives makes it clear

THE MILK-JUG. Juvenile drawing by Vincent, Zundert, September 5, 1862, pencil and light wash, laid Holland paper, 27.8 × 22 cm. Kröller-Müller State Museum, Otterlo, Netherlands.—My objections to the attribution of the drawing on the opposite page to Vincent as a boy apply also to this one. It is hard to believe that a child of nine would have a sure enough hand to draw the curves of the handle so firmly. On the other hand the static nature of the subject would not pose the same problems of expression as a living creature like a dog.

that the reason for his lengthy stay there was that Hannik's establishment, like Provily's, was one to which Protestant families in North Brabant sent their sons in order to receive higher education.

It seems odd that the school year should really have ended as early as March 14 and also that Vincent should have broken off his studies at the age of fifteen. His engagement as a boy employed in his uncle's art gallery at The Hague explains nothing, because Vincent spent another fifteen months with his parents at Zundert before he went there. According to the register of population he returned to Zundert on March 14, 1868, and did not leave until July 30, 1869.

## THE PSYCHOLOGICAL CONSEQUENCES OF LEAVING HOME

We have no evidence whether Vincent was a good or bad pupil. But if we consider the remarkable ease with which he was able to express himself in later years, both in conversation and in his letters, and sometimes in French and English as well as in Dutch, we must suppose that his education at these two establishments bore fruit.

Some doubt has been cast, and not without reason, on Elizabeth Huberta's recollections, but we know that she is right in claiming that her brother understood and spoke French as fluently as he did his mother-tongue. She could almost have said the same about English. The sermon which Vincent preached in England is still extant; it forms part of the letters addressed to Theo, and it is good proof of Vincent's ability to express himself in English. This proficiency in languages was certainly due to his education under Provily and Hannik, for where else could he have learnt it?

One might suppose that Vincent did not really mind being sent by his family to Zevenbergen. Given his extremely solitary nature, one might expect that he would be resigned or almost indifferent to having to adapt himself to new surroundings. But in a letter to Theo which describes his parting he explains his real feelings.

*It was an autumn day*, he wrote to his young brother, who had left the family home in his turn to go and work in the Brussels branch of Goupil & Cie, the art-dealers, *when I stood on the steps before Mr Provily's school, watching the carriage in which Pa and Mother were driving home. One could see the little yellow carriage far down the road—wet with rain and with spare trees on either side—running through the meadows.*

*The grey sky above it all was mirrored in the pools.*

*And about a fortnight later I was standing in the corner of the playground when someone came and told me that a man was there, asking for me; I knew who it was, and a moment later I fell on Father's neck.*

This was not the first time that he had recalled this moment. A few months earlier than this letter, immediately after his arrival at Ramsgate, he had written to his parents: *When we passed Zevenbergen I thought of the day you took me there, and I stood on the steps at Mr Provily's looking after your carriage on the wet road; and then of that evening when my father came to visit me for the first time. And of that first homecoming at Christmas!*

When we come upon these cries from the heart, which had been stifled for nearly ten years, we can see why Nagera stresses their importance. Vincent's first separation from his home and his family was to have lasting effects on his psychological development in a world in which he seemed to have no place.

THE BRIDGE. Juvenile drawing by Vincent, Zundert, January 11, 1862, pencil, laid Holland paper, 12 × 36.5 cm. Kröller-Müller State Museum, Otterlo.—The same question arises once again: can this really be the work of a nine-year-old boy? As regards the subject it is a fact that Vincent was always very interested in bridges. There are many examples in his work. It may perhaps be a psychoanalytical symbol of the artist's personality, for he was always concerned with the notion of unity.

# GOUPIL'S APPRENTICE

When Vincent had finished his studies at Hannik's school at Tilburg the time had come for him to choose a profession. We know nothing about the discussions that led to his choice, nor whether Vincent had any say in the matter when his future was being decided upon. No doubt they weighed the pros and cons of the two possible professions, the Church and art-dealing; and perhaps they felt that as there had been three successes in one generation they could trust Vincent to follow in his uncle's footsteps.

Upon Uncle Cent's recommendation Vincent became the youngest employee of the Dutch branch of Goupil & Cie, whose place of business was at No. 14 Plaats, The Hague, opposite the Binnenhof, the Netherlands Parliament, and only a couple of hundred yards from the Mauritshuis with its remarkable collection of paintings.

My old friend Gerben Colmjon, who was an associate of the State Institute for the History of Art at The Hague from 1955 to 1957, knew Johan Tersteeg for twenty-eight years, and he was the son of H. G. Tersteeg, head of the branch of Goupil & Cie at The Hague. I once asked him what his impressions were of the relations between the father and Vincent. The younger Tersteeg's memories went back to the summer of 1882, when he was in his ninth year, besides what he learnt from his father.

Young Vincent entered the service of Goupil & Cie in 1869. When he arrived there he did not find, as almost all the more romantic accounts of his life pretend, a strait-laced old gentleman, but a very young head of the business, who was twenty-four and thus only eight years older than Vincent.

H. G. Tersteeg had been married hardly a year before. The publication of the banns was announced in *Dagblad van Zuid-Holland en 's-Gravenhage* on August 21, 1868, and was illustrated with a little portrait of the bridegroom, who then lived on an upper floor of the building occupied by Goupil & Cie. His children were born there: Elizabeth, nicknamed Betsy in 1869; Johan, the only son, mentioned above, in 1873; and Marietje some years later. The two elder children knew Vincent well during the painter's second period at The Hague from December 1881 to September 1883. By this time Betsy was twelve years old and Johan nine.

Vincent's young employer was an interesting man in his own right. He had begun his career in a business in Amsterdam which imported English books, and he was not a salesman concerned only with buying and selling. He was a keen reader, and he attached great importance to the contents of the books that he put on the market. This is clear from the text of a lecture that he gave to the Society for

*den Haag 24 Maart 1873*

*Waarde Theo,*

*Zou je eens willen nazien of er te Brussel nog een schilderij is van Schotel.*

*Dat is 6 Mei 1870 van hier in commissie gezonden, maar misschien heeft hem het reeds naar Parijs terug gezonden.*

*Is dat echter het geval niet zorg dat dat het onmiddelijk naar hier gezonden wordt.*

The beginning of the correspondence. Vincent van Gogh Foundation, Amsterdam.—This is one of the very first letters that Vincent wrote from The Hague, where he was employed in Goupil & Cie's art-dealing business, to Theo who had been taken on by the Brussels branch of the same establishment. The gallery at The Hague had been founded by Vincent's uncle, as can be seen on the firm's printed letter-heading.

Bookshop Employees (which he himself had recently founded) at Amsterdam in 1866, when he was only twenty-one years old, and which was printed in its entirety in *De Uitgever* ("The Publisher") for July, August and September 1952. From this we can see that he was a young man of great promise and good education, who had read widely in several languages. Those who knew him agreed that he had a keen and informed mind and was a man of great integrity. We may therefore suppose that Tersteeg had a warm welcome for the young Vincent, who shared many of his tastes. Nor could he have overlooked Vincent's exceptional aptitude for everything to do with painting, not only its technique but also its content. These gifts would certainly have made Tersteeg confident that his new employee had the qualities necessary to repeat his uncle's success.

For more than four years he did not disappoint these hopes, and the management of Goupil & Cie thought so highly of his conscientiousness and competence that they considered him a worthy candidate for a post in their London branch. Johanna van Gogh-Bonger tells us that when Vincent left Tersteeg gave him a most splendid testimonial. Tersteeg also wrote to Vincent's parents and said that everybody, amateurs of the arts and customers as well as painters, liked to deal with their son, and that he would be much missed.

Tersteeg was also right in thinking that Vincent would succeed in his chosen profession—even though he did not realize at the time that this profession would not be the same as his own.

## REPORT ON A NEW PUPIL

Many authors have taken an adverse view of Vincent's period with Goupil & Cie at The Hague. One of them even pretended that H. G. Tersteeg would order Vincent to sweep the floor, to dust the objects exhibited for sale and to clean the shop-windows with a wash-leather. As if Tersteeg would have forgotten that he was humiliating a lad who was his own employer's nephew, and who indeed might possibly become his own superior if anything were to happen to Uncle Cent!

Another equally fanciful writer would have us believe that Goupil & Cie was only a little shop where students and painters bought their brushes and paints, much after the fashion of Père Tanguy's shop in Paris. It is true, of course, that Goupil & Cie sold canvas, stretchers and picture-frames, and that part of their business was in photographic reproductions. Vincent mentions in a letter to Theo that sometimes they sold a hundred in a day. The main business was, however, in oil-paintings and water-colours. A photograph of the interior of the shop shows that it was really a large-scale enterprise.

Other writers have pretended that Goupil & Cie was interested only in mediocre and ultra-conventional works. Henri Perruchot, whose deft compilations are riddled with errors, writes in his life of van Gogh: "The house of Goupil only sold works with pretensions to class, signed by members of the institute, winners of the Prix de Rome, by artists of renown, a Henriquel-Dupont or Calamatta, painters or lithographers whose talents and efforts were encouraged by public taste and official bodies. Vincent looked at these over-polished works, scrutinised and analysed them." The falsity of this is apparent the moment one attempts to form a picture of exactly what the circumstances of Vincent's artistic apprenticeship were and to assess the influence of this period upon his artistic education.

H. G. Tersteeg's son has bequeathed the accounts of the branch of Goupil & Cie that his father directed to the State Institute for the History of Art at The Hague. The "bought" and "sold" ledgers show that Vincent was able to study and admire other things besides pictures produced by artists with little talent and no taste. The inventory taken on April 1, 1861, contains 192 oil-paintings, most of them by contemporary painters, Dutch romantics, and French classicists and romantics, who at that time did not enjoy universal renown, but who have since come to occupy a worthy place in the history of art.

Their first Troyon arrived in 1864; others followed in 1866. Vincent often speaks of this painter in his letters to Theo, which is hardly surprising. An Israëls was sent from Paris, and in 1865 they sent five Mauves to Brussels; from Paris they got a Jacob Maris and a Willem Maris. There were 155 watercolours listed on the same inventory, among them a small seascape by Jongkind. During Vincent's first year of apprenticeship the firm bought a Diaz and several pictures of The Hague School, which had not at the time come into fashion. In 1870 the collection gained a Diaz, a Corot, eleven pictures by The Hague School and a Gerard Bilders. In 1871 there are five pictures by Diaz, a Daubigny and sixteen canvases by The Hague School, among which there was a Thijs Maris. In 1872 the number of examples of The Hague School increased to 35, including four by David Artz, thirteen paintings by Anton Mauve and *The Bridge* by Jacob Maris. Before he left Goupil's establishment at The Hague, Vincent had an opportunity of seeing *The Port of Amsterdam* and *The Windmills* by Jacob Maris in 1873. It is clear from Vincent's letters that he was not wasting his time when he studied the drawings and paintings in oil and in water-colour which he had before his eyes every day. One can even go so far as to say that the four years spent working for Goupil were of prime importance in his education in the widest meaning of the word.

Among Goupil's customers private collectors were rare, and purchasers chiefly belonged to the Court (the King was personally involved more than once) and the aristocracy. Vincent also had many opportunities of dealing with the well-known artists who frequented Goupil & Cie; these conversations with artists who were experienced in their craft made an important contribution to the development of an apprentice who was eager for advice and information.

At the same time, Vincent would regularly visit museums and galleries where he could study the paintings and drawings that especially interested him. His correspondence tells us that his desire for information took him to Amsterdam, London and Paris—quite enterprising for a boy of nineteen.

The business Vincent worked for was one that made no concessions to mediocrity.

## A UNIQUE HUMAN DOCUMENT

Vincent had already been living at The Hague for three years when he had a visit from his brother Theo, who was then fifteen years old. Theo was attending an educational establishment at Oisterwijk, not far from Helvoirt, where Theodorus van Gogh had been appointed pastor at the beginning of 1871. Theo was destined to play a leading role in Vincent's life. At an early age this quiet and well-behaved younger brother seemed to be the only one who was able to make Vincent happy. As the years passed their bonds strengthened and the relationship between the brothers became exceptionally close.

Theo stayed for two days with Vincent at his lodging with the Rooses in the Beestenmarkt. The two brothers walked out together as far as the mill at Rijswijk, a suburb of The Hague, where they rested for a while and drank a glass of milk. It was on this occasion that they made a vow to remain

true to their friendship, come what may. A year later, when Vincent was in London, he remembered this vow and promised to send Theo a photographic reproduction of Weissenbruch's picture of the mill at Rijswijk, adding: *That Rijswijk road holds memories for me which are perhaps the most beautiful I have.* Many years later, in the unhappiest hours of his life, Vincent once again reminded Theo of his vow at Rijswijk.

When Theo returned from this visit Vincent wrote him the first of the letters that has been preserved. It began as no more than the sort of correspondence that one would expect to find between two brothers, one of whom had been learning his way in the art-dealing business while the other was still at school. But on January 1, 1873, the situation was totally altered because Theo was also taken on by Goupil & Cie at their branch in Brussels. Thenceforth Vincent could write to his brother about their common calling: painting and drawing. As soon as he heard the good news Vincent hastened to write to Theo: *I am so glad that we shall both be in the same profession and in the same firm. We must be sure to write to each other regularly.*

The two brothers kept their word. Their correspondence, which has been translated and published in many languages, begins very simply with a line of thanks for the happy hours they had spent together, despite the rainy weather. The first letter was followed by six hundred and fifty others, some very extensive and all of them enthralling.

Vincent's literary gifts are clear from the very beginning. His letters are always lucid and they express his feelings with precision and subtlety. One might perhaps wish for their form to be more polished—but this could only be at the expense of the directness and honesty of these confessions. Vincent is admittedly no elegant stylist; he handles language as a workman does his tools, he knows exactly what he wants to do and he does it. It is often said that as soon as a painter writes about his art he becomes subjective. I do not think anyone has ever accused Vincent of that. In January 1932 Raoul Dufy said to the art correspondent of *Le Figaro Littéraire*, "I paint because I do not know how to write. That is the truth." This certainly was not true of van Gogh, who could express himself vividly both as a painter and as a writer. If he had never

handled a brush, he would still have shown himself to be a writer of remarkable range and with an especial gift for observation and description.

In his book *De la palette à l'écritoire* André Lhote wrote: "No artist has left such moving documents as van Gogh did with his endless correspondence written to his brother." Meyer Schapiro praises the letters in even higher and more specific terms, calling them "a vast work of self-revelation, which may be set beside the works of the great Russian writers, masters of the confessional genre in literature."

## THE BUDDING ILLUSTRATOR

When he was taken on by Goupil & Cie at The Hague, Vincent could obviously no longer remain under his father's roof at Zundert. His parents found him good lodgings with the Roos family at No. 32 Lange Beestenmarkt, where his brother Theo was later also to live. The Rooses were a pleasant middle-class family, and Vincent soon made friends with their nephew, Willem Valkes. On Sundays in spring and summer, when the weather was fine, Vincent and Willem would go rowing together.

The lodgings in the Roos household were comfortable enough, but there was no intellectual stimulus of any kind. Fortunately Vincent's mother, who came from The Hague, kept in close touch with several members of her family there, as well as with various childhood friends and acquaintances. Vincent was therefore often able to visit the Haanebeek and van Stockum families, his aunt Fie Carbentus and her three daughters, one of whom was later to marry Anton Mauve. In June 1873 Vincent was transferred to the London branch of Goupil & Cie, then to the head office in Paris, and then back to London; he was to live at Ramsgate and Isleworth in England, and at Dordrecht and Amsterdam in Holland. But despite these many moves, when he wrote to Theo, who was taking his place at The Hague, he was constantly asking him to give his warmest regards to all the people he had known in that city.

From Paris he wrote on December 10, 1875: *Give my very best love to the Roos family. Both of us have enjoyed many good things in their house, and they have proved faithful friends.* And when he was staying in Amsterdam he wrote on December 9, 1877, to say

H. G. Tersteeg. Photograph in the collection of Mrs Tersteeg, The Hague.—When Vincent started work at Goupil & Cie's art-dealing business at The Hague in 1869, he met H. G. Tersteeg, who had been head of the firm for two years. Vincent was then sixteen and H. G. Tersteeg, who had been born in 1845, was twenty-four. This photograph shows him at that time.

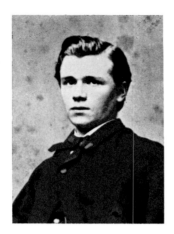

Vincent van Gogh at the age of about eighteen. Photograph Vincent van Gogh Foundation, Amsterdam.—This portrait was taken at the time when Vincent was working at the branch of Goupil & Cie's gallery at The Hague.

Interior of Goupil's gallery. Photograph in the collection of Mrs Tersteeg, The Hague.—At the age of sixteen Vincent gained his knowledge of the art of painting, drawing and engraving in these rooms.

The front of Goupil's gallery. Photograph in the collection of Mrs Tersteeg, The Hague.—The gallery was at Plaats no. 14. The shop-front has been altered many times since then.

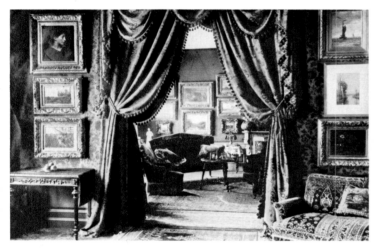

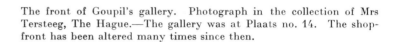

Uncle Vincent. Photograph Vincent van Gogh Foundation, Amsterdam.—Of all the painter's relatives he was the one who exerted the greatest influence on the painter.

that he intended to visit The Hague and hoped he might be able to spend one or two nights at the Rooses' and also visit some of his old friends. Indeed there are few letters in which he does not ask Theo to give his regards to the Rooses and those he had known when he was lodging there. The Rooses were very simple and ordinary people, but already Vincent had begun to show that he usually preferred the company of the poor to that of the rich.

In The Hague Vincent also formed a close friendship with H. G. Tersteeg and his family, whom he saw every day at Goupil & Cie because they lived above the shop. Their first child, Elizabeth, was born during Vincent's first year with the firm, and there is no doubt he was devoted to the little girl.

This is evident from his letters. On November 19, 1873, for example, he wrote from London, *tell Betsy Tersteeg something about me when you see her*. Three years later he sent his regards to her on May 6, 1876, from Isleworth. This might not mean much if Vincent had not also filled three small sketchbooks with pictures for the little girl.

Some years ago Anna Szymanska, the Polish art historian, was employed by the Netherlands government to work for several months in the State Institute for the History of Art at The Hague, and during her stay in Holland she came upon these three sketchbooks. This was not a sensational discovery, as Anna Szymanska modestly admits. The owner of the three books, Mrs van Rijswijk, Betsy Tersteeg's daughter, knew perfectly well that they were the work of Vincent van Gogh and that he had given them to her mother. Nevertheless it was a most interesting one.

A CONFIRMATION OF HIS NATURALISM

Anna Szymanska points out that these drawings are unique because they are the only examples yet found of Vincent's work at this period. These sketches provide a yardstick by which we can measure Vincent's artistic development during the period between 1869 and 1880. Hitherto his production in these years has not appeared in the catalogues or in any discussion of his graphic art. The drawings in these three little books are more than youthful scribbles designed only to amuse or entertain a child.

The letter in the third sketchbook was not dated; but as Vincent spoke in it of leaving for England with his sister Anna, we can place this document without difficulty. In his letter to Theo of June 16, 1874, Vincent wrote that he intended to go on holiday in Holland on June 25 or 27; on July 10 he wrote that he and Anna were going to stay a day longer and would arrive in London on Wednesday morning. From London he confirmed their arrival on July 21. The letter to Betsy was therefore written some time between June 27 and July 12, 1874.

The three little books are bound up in the same covers with another child's book, which was written and illustrated by Betsy Tersteeg herself when she was ten years old. Included with them there is also a portrait by Vincent of her younger brother who died young. Inside the cover H. G. Tersteeg has written in his unmistakable handwriting: "Drawn for Betsy Tersteeg by Vincent van Gogh, Amsterdam, 1873." He is obviously mistaken about the place, for in 1873 Vincent was still lodging at The Hague and did not go to Amsterdam until 1877.

The forty drawings that Vincent did for Betsy reflect his strong feeling for naturalism which was discussed earlier. Thirty of them represent animals and plants, and several others are directly concerned with nature. A drawing of an OLD WOMAN KNITTING AT THE WINDOW is the first appearance of a subject that later became particularly dear to him.

Two sketches represent passing vehicles, and on one of them there is a stagecoach. It looks as if the tired horse on the right has just been relieved and a man is leading it to the nearby stables. Perhaps it may be a memory of Zundert, where Vincent regularly saw the coach-horses being changed only a few steps from the house. Much later, at Arles, Vincent always took an interest in the stagecoach, which changed horses next to the famous Café de Nuit, quite close to the Yellow House and the Tarascon viaduct, at the entrance to the town. Later still, on the eve of his death, he painted a delightful landscape, seen from Dr Gachet's house, with a horse-drawn coach on the road at the bottom making towards the village of Auvers-sur-Oise.

In another sketch Vincent has drawn a church with a spire. This theme will recur many times: one of the first drawings he did at Etten, after he had decided on an artistic career, was of the church where

HET BINNENHOF, THE HAGUE.  The Hague, 1870-1873, ink and pencil, 22 × 17 cm, F 837.  Vincent van Gogh Foundation, Amsterdam.—This drawing, which de la Faille mistakenly entitles "Beside the Canal" in his catalogue, certainly dates from the time when Vincent was employed by Goupil & Cie at The Hague.  The place still exists.  The picture is strictly representational.

his father officiated. And later he drew many village churches almost everywhere: in the northerly province of Drenthe, at Zweeloo, Nuenen, Antwerp, Saint-Rémy-de-Provence and Auvers-sur-Oise. Another sketch, of a country building, recalls the drawing that Vincent did at the age of eleven for his father's birthday present.

We also find, and it is by no means the least of the sketches, that Vincent has drawn a WAGTAIL ON ITS NEST; this immediately recalls his interest in birds' nests during his Nuenen period. Vincent had therefore already chosen some of the subjects that were to remain a constant factor in his pictures after he had definitely decided to be a painter. Although they are only at a rudimentary stage, these drawings show certain characteristics of his style that occur in his later work. He is constantly seeking after the most effective line. As a rule Vincent is content to draw very clearly and cleanly the outline of the people or objects he is depicting. Only in a few cases does he venture on an effect of light and shade, and the hatching rather like drops of water that we find on the picture he gave his father and on many other drawings done throughout his artistic career.

## HEAVEN ON EARTH

Vincent arrived in London in June 1873, when he was barely twenty. His first lodgings were comfortable, if noisy. His two landladies were kind, but they had two parrots which they adored, and the other lodgers were three Germans who were very fond of music and played the piano and sang continually. At first Vincent enjoyed his life with them. Uncle Cent had given Vincent introductions to his

On the left: WAGTAIL ON ITS NEST. Pencil, 17.9 × 10 cm. Vincent van Gogh Foundation, Amsterdam. Below: SPIDER ON ITS WEB, BEES AND FLIES. Pencil and ink, 16.3 × 10.3 cm. Vincent van Gogh Foundation, Amsterdam.

HORSE-DRAWN COACH AND, ON THE RIGHT, MAN LEADING A HORSE BY THE BRIDLE.   Pencil, 17.9×10 cm.   Vincent van Gogh Foundation, Amsterdam.

friends and connections in London.   In order to meet them, and to keep up with the fashion, Vincent bought a top-hat—*you cannot be in London without one*, he wrote.   Whether he completed the picture with an umbrella we do not know, but no doubt he looked just as a young English businessman should look.   He had always gone on long walks, so he enjoyed his long daily walk from the suburb where he lived to Goupil's premises, which were in Southampton Street, Strand, in the heart of the city.   It took him three-quarters of an hour to get there.

But after a while he wearied of the two ladies and their parrots and music-mad Germans.   Vincent earned ninety pounds a year, which was not bad for a young man of his age, but life in London was far from cheap.   He had to pay eighteen shillings a week for his lodging, without washing, and this was too much for his modest purse.   Moreover he wanted to save some money to send home to his

parents.   He therefore moved in August and lodged with Mrs Loyer, the widow of a French émigré. She had a daughter called Ursula, and the two women ran a school for little boys.

Vincent was very happy in his new surroundings. It was a gay household and the daughter was very attractive.   What more could he want?   But then the most natural thing in the world happened: poor Vincent fell in love with Ursula.

At Goupil & Co, Vincent gave every satisfaction, just as he had done at The Hague.   He was serious and hardworking, patiently and helpfully dealing with the requests, and even sometimes the whims, of customers who were occasionally more than he could bear.   He realized that in his profession the customer was always right, and he gave way with good grace.   Ursula's presence every evening and every Sunday only increased the strength of his love, and he hoped for rapid advancement at Goupil's so

that he might get married. These days with the Loyers were certainly the happiest of Vincent's life.

*I never saw or dreamed of anything like the love between her [Ursula] and her mother*, he wrote to one of his sisters. *Love her for my sake*.

As he had not yet declared his love, he said nothing about it to his parents. But his letters to them revealed his happiness all the same. *I have splendid lodgings* he wrote, exclaiming: *Oh fullness of rich life, your gift O God*. He was head over heels in love for the first time in his life.

## UNREQUITED LOVE

At Christmas Mrs Loyer and her daughter gave a party, and Vincent was invited. It was an unforgettable evening for him; and he wrote later to Theo, *I hope you had as happy a Christmas as I had*. At Goupil his services were rewarded, and on the first of January his salary was increased. The tone of his letters continued to be gay and lively. But in July, when he was about to go home to see his family in Holland, there was a sudden change. Before he left England he told Ursula of his love for her. Her answer could hardly have been more discouraging; she told him that she was already engaged to one of Mrs Loyer's previous lodgers.

It was a shattering blow. All his future plans were in ruins, but he still did not intend to give up the happiness that he had dreamt of for so long. He tried to persuade her to break off her engagement, but all his love was thwarted by her categorical refusal to do so. He had already thought of her as his bride, and this repulse left an indelible impression upon him. He lost all his illusions. The sad end of his idyllic dream seems to have been the first event in the drama which was to reach its final catastrophe in the hapless lover's death sixteen years later. It was suggested earlier that Vincent may have suffered in his earliest childhood from an unsuspected mental depression; in which case Ursula's refusal may have aroused dormant neurotic tendencies, in particular a inferiority complex in regard to women. But whatever the truth of the matter, Vincent had not shed all his tears when he was in his cradle. This blighted love destroyed all Vincent's joy in life, and his eyes lost their sparkle. When he arrived in Holland

to spend a holiday with his parents, they hardly recognized this lean, silent, gloomy boy, who seemed unable to recover from the terrible blow that he had suffered. It was all very well for them to say that they would be happier to see him elsewhere and not at the Loyer's, because the house was overcrowded, and "it was not a family like others". Vincent remained inconsolable.

He was obliged to go back to London after his annual leave, and he took his sister Anna with him; for she was looking for a position in England as a schoolmistress teaching French. Vincent could no longer stay at the Loyer's; he took furnished lodgings in *a house quite covered with ivy*, which Johanna van Gogh-Bonger cites as "Ivy Cottage, 395 Kensington New Road".

His father wrote: "His living at the Loyers' with all those secrets has done him no good." And he was glad that Vincent was there no longer. Everybody was worried about his lonely and secluded life. Uncle Cent insisted that he should mix more with other people, "That's just as necessary as learning your business". Vincent's spirits remained low, and his letters to his parents became infrequent.

He lived alone and shared in no family life. He did not go out, turned more and more in on himself and towards religion. Eventually he began to mix with people, but his spirits were still dark and gloomy.

## THE END OF AN IMPOSSIBLE SITUATION

Vincent was no longer so successful at selling pictures, and the management began to complain. Uncle Cent hoped that a change of surroundings would do him good, and in October 1874 he arranged for his nephew to be transferred for a while to the head office in Paris. At first Vincent refused to go; he sulked and would not write to his parents, but in the end he agreed. All the same he would have preferred to stay in London and dream of Ursula.

At the end of December, he returned to London, moved into the same room and led the same solitary life as before. He did not go out but read a great deal. For the first time people began to think of him as an eccentric. Five months later he was sent much against his will to Paris for the second time, where he was put in charge of the picture galleries.

This job did not interest Vincent, who felt much more at ease in his little room in Montmartre with a view on to a small garden full of ivy and Virginia creeper; he preferred this atmosphere to fashionable Paris. Every morning very early before going to Goupil's, and every evening when he came home from work, he would read the Bible with his friend Harry Gladwell, a young man of eighteen who was the son of a London art-dealer, and who also worked at Goupil's. At the gallery Vincent's work left a great deal to be desired; the management realized that they would have to take a firm line with him because he had got into the bad habit of criticizing engravings that he did not like when customers were present.

His employers' chief complaint was that he had left Paris just before the Christmas and New Year holiday to go to Etten, where his father had been appointed pastor on October 22. In his letters to Theo he gives the impression that he took it all very lightly, but in his heart he knew that the clouds were beginning to gather about his head. In a letter of January 10, 1876, he tells Theo that he has had a serious interview with M. Boussod, the head of the firm, who told him that he must leave Goupil's on April 1. He took it very philosophically: *When the apple is ripe, a soft breeze makes it fall from the tree.* He admitted that he had done things that were wrong and did not attempt to defend himself.

His uncle Vincent, who was a partner in the business, was thus put in a somewhat awkward position, because he saw his eventual successor, and perhaps even his heir, leaving the business.

Vincent's parents saw that their son was running into difficulties at Goupil's, and indeed in the art-dealing business as a whole. Vincent spent Christmas at Etten and talked the matter over with his father and mother, who loved him too much to persuade him to remain in a business that he had come to dislike. Above all they wished for his happiness, but he had not yet decided in what direction he wanted to go. The pastor wrote to Theo, "I almost think that Vincent had better leave Goupil within two or three months; there is so much good in him, yet it may be necessary for him to change his position. He is certainly not happy."

Vincent was twenty-three years old. He had no job, and he could no longer count on Uncle Cent for support. His parents, however good their inten-

THE CANAL. The Hague, 1870-1873, drawing in ink and pencil, 25 × 25.5 cm. F839. Vincent van Gogh Foundation, Amsterdam.

tions, could no longer help him either. They had spent all their resources in educating their children, and Vincent had had his share: 820 guilders a year hardly enabled them to make ends meet.

## AN UNSUSPECTED INNER LIFE

Several possibilities were suggested: he might take a post in a museum, or start his own small art-dealing business, as his uncles had done before him. He would then be able to satisfy his artistic inclinations and would not have to sell any pictures that he did not like. Theo, who though he was only nineteen had already become everybody's adviser and helper, suggested that Vincent should become a painter, as his widow Johanna van Gogh-Bonger records in her memoir. Perhaps Theo was influenced by what Vincent had confided to him over the last eighteen months. On June 16, 1874, Vincent told him: *Lately I took up drawing again, but it did not amount to much.* On July 31, 1874, he wrote: *since I have been back in England, my love for drawing has*

VIEW OF LONDON. Vincent van Gogh Foundation, Amsterdam.—On July 24, 1875, Vincent wrote to Theo from Paris: "A few days ago we received a picture by de Nittis, a view of London on a rainy day, including Westminster Bridge and the Houses of Parliament. I used to pass Westminster Bridge every morning and every evening, and I know how it looks early in the morning, and in winter in snow and fog." In the top left-hand corner of his letter he sketched this view of the place he had been speaking about. The effect of depth achieved in this simply-drawn sketch shows his natural skill as a draughtsman.

*stopped, but perhaps I will take it up again some day or other.* On April 18, 1875, Vincent sent his brother a little drawing of Streatham Common *a large grassy plain with oak trees and gorse.* He had sketched it on the title-page of Edmond Roche's poems.

Vincent's inclination and aptitude had not escaped his mother. "Vincent", she wrote "made many a nice drawing: he drew the bedroom window and the front door, all that part of the house, and also a large sketch of the houses of London which his window looks out on; it is a delightful talent which can be of great value to him."

And Vincent himself wrote: *how often I stood drawing on the Thames embankment, on my way home from Southampton Street in the evening and it came to nothing. If there had been somebody then to tell me what perspective was, how much misery I should have been spared, how much further I should be now!* He may well have already thought of making painting his career when he was in London.

In the end van Gogh returned to England in order to be nearer Ursula. He would work as a teacher.

Humberto Nagera, in his chapter on "Fear of success and fear of failure", notes various typical failures and naturally includes Vincent's dismissal from Goupil's; though dismissal is not entirely the right word, since Vincent clearly provoked it himself. He knew perfectly well that in doing this he was forgoing his uncle's inheritance. Did he sacrifice all this just because Ursula Loyer had refused to marry him? There is no doubt that this blow upset his balance and made him wonder what was the use of going on. Nevertheless it did not totally destroy all his ambitions—quite the contrary. Vincent immersed himself in the Bible and soon was in a state of religious exaltation. His letters to Theo hardly speak of art at all now, but are full of references to the Old Testament and to the Gospel.

While he was absorbed in his own happiness Vincent said nothing whatever about his duty "to realize great things for humanity" in Renan's phrase which Vincent had quoted in his last letter from London after the crisis with Ursula. The prospect of founding his own family kept his thought upon himself. But when the dream vanished, he discovered that there were other goals to which he vowed to devote himself body and soul.

There is no doubt that being thwarted in love was the cause of a sudden and deep change in Vincent, bringing into play subconscious psychological forces which had not yet been visible. Nagera writes: "One cannot escape the impression that there were specific factors, specific phantasies and unconscious conflicts, which forced him from one failure to another—quite independently of the serious emotional disturbance that overcame him in London which was in itself an important contributory factor to his inability to reach whatever aims he set himself, to make use of his great potential and undoubted intellectual capacities or to relate to others."

Vincent had unconsciously understood that by selling pictures and other works of art and eventually becoming rich like his uncles, he would not realize great things for humanity. He feared that success in the art business would only take him further from his goal. He was instinctively afraid of sinking into the vulgarity of business life, and it was in order not to enjoy that purely material success that he turned his back on the Goupils and their like. There is one revealing phrase in a letter to Theo. *I believe and I hope that I am not what many people think I am at this moment.*

Unless we consider it from this psychoanalytical point of view, it is hard to understand this complete change of course, in which Vincent abandoned a career that seemed so promising and embarked on an adventure into new and unknown territory.

# BACK TO SCHOOL

When Vincent abandoned his career in art-dealing he broke irrevocably with his past, though he had no clear plan for his future. He merely knew that he had to remake his life. "Nothing", Alfred de Musset wisely remarked, "makes a man greater than sorrow..." But before this could apply to Vincent he still had to find his vocation, and the difficulties ahead of him were such that one might well wonder whether he would ever overcome them.

He searched the English newspapers in the hope of finding an advertisement, preferably for a post as a teacher. From January 1876 onwards this preoccupation is often reflected in his letters to Theo. His chances of success were slim, and he seemed like a shipwrecked mariner reaching for a mirage.

But on April 4, 1876, when he was on the point of leaving Paris, he received a letter from England. A schoolmaster at Ramsgate wrote suggesting that he should come for a month, unpaid, on trial. Thereafter it would depend on what services he proved able to perform.

Vincent was delighted and wrote: *At all events I shall have board and lodging free.* He arrived at Ramsgate at about one o'clock on the afternoon of April 17; but when he went to the schoolmaster's house at 6 Royal Road he found that Mr William Stokes was in London. The schoolmaster's son received him, and after dining with Mrs Stokes he was shown the place where he would work. It was a small boarding-school with only twenty-four boys between ten and fourteen years old.

Vincent lodged with a seventeen-year-old assistant teacher and four boys in a house nearby, where he had a small room of his own. The harbour full of boats was close by. There were *many bugs*, Vincent tells us, *but the view from the school window made one forget them.* In the evening he went to church with the boys, who had to go to bed at eight and rise at six.

Four days later Mr Stokes returned; he was a man of medium height with a bald head and whiskers, and his pupils seemed to like yet respect him. He told Vincent that after the holidays he intended to move the school to Isleworth, a village on the Thames about ten miles west of the centre of London. He would also reorganize the school somewhat, and perhaps enlarge it.

Meanwhile Vincent taught elementary French and began studying German with one of the boys. He also taught arithmetic, heard their lessons and gave dictation. After school hours he had to keep an eye on them, and *Last Saturday night I helped six of the young gentlemen to take a bath; I did it for my own pleasure and because I wanted them to be ready in time. Not because I had to do it. I also try to make them*

SQUARE AT RAMSGATE (right-hand page). May 31, 1876, pen and ink, 5.5 × 5.5 cm. Vincent van Gogh Foundation, Amsterdam.—A comparison between this sketch, and the actual place photographed seventy years after Vincent passed through Ramsgate (photograph above, A.I.v.G.) shows with what sureness he was able to express the essential features of a landscape. The drawing was made from one of the windows of the boys' school where Vincent was employed as a teacher.

read. *I have some books that are well suited for boys.* After he had been at Ramsgate for three weeks, he wrote rather mysteriously in one of his letters to Theo: *These are really very happy days I spend here day by day, but still it is a happiness and quiet which I do not quite trust, though one thing may result from another. Man is not easily content; first he finds things too easy, and then again he is not contented enough. But this is in parentheses; we must not talk about it, but continue quietly on our way.* It seemed as if he was going to change direction again.

## A SERIOUS WALK

As usual his mother realized what was happening, and wrote: "I wish he could do work connected with nature or art." Her own interest in these two subjects told her what would make her son happy. But Vincent's religious obsession was still much in evidence. At the end of May he suddenly told Theo

that he hoped soon to walk to London to see Harry Gladwell and various other friends he had there.

The memory of Ursula Loyer may well have been one of his motives for this journey, and his religious frame of mind was another. A few days earlier he had confided to Theo: *There is such a longing for religion among the people in the large cities... There is something touching about those thousands of people crowding to hear these evangelists.* To fill this need must have seemed a worthier task than keeping unruly boys in order and seeing that they bathed.

So one Monday morning in June he set out from Ramsgate to walk to London. *It is a long walk,* he wrote; *when I left it was very hot, and it stayed so until the evening, when I arrived in Canterbury. I went still a little farther that same evening, till I arrived at a few large beech and elm trees near a little pond; there I rested for a while. At half past three in the morning the birds began to sing at sight of dawn and I set off again. It was fine to walk then. In the afternoon I arrived at Chatham. There one can see in the distance between partly flooded low-lying meadows, with elm trees here and there, the Thames full of ships. I believe the weather is always grey. I met a cart which took me a few miles further, but then the driver went into an inn and I thought that he would stay a long time, so I continued on my way. I arrived in the familiar suburbs of London toward evening.* He stayed in London for two days, visiting various people, including the Gladwells. Harry's father, he tells us with touching candour, *kissed me good night that evening and it did me good.* There was also the clergyman to whom he had written the letter applying for what he described to Theo as *a position between clergyman and missionary among the working people in the suburbs of London.* He sent Theo a translation of this letter in which he had said: *But the reason which I would rather give for introducing myself to you is my innate love for the Church and everything connected with it. It may have slumbered now and then, but is always roused again.*

This is a clear enough expression of his religious vocation. To Theo he explained exactly what he had in mind. He wanted to be *a London missionary; one has to go around among the labourers and the poor to preach the Bible, and as soon as one has some experience, talk with them, find foreigners who are looking for work or other persons who are in difficulties*

48

*and try and help them, etc., etc.* He felt that his ability to speak a number of languages, and his experience in mixing with working people in Paris and London, might help to qualify him for the post.

After his brief stay in London Vincent set off to visit his sister at Ivy Cottage at Welwyn where she had been teaching French for several months. He had wanted to start his journey in the evening *but,* he said, *they kept me back literally by force because of the pouring rain.* So he arose at four o'clock the next morning, walked through London to Hertfordshire and reached Welwyn at five in the afternoon, having completed some thirty miles or more. It was a happy reunion and Anna wrote to Theo: "You can well imagine how delightful it was meeting Vincent again."

## THE WISH TO SERVE

Meanwhile William Stokes had installed his boarders in Isleworth. Vincent wrote that *Mr Stokes says he definitely cannot give me any salary because he can get teachers enough just for board and lodging.* He did not blame the schoolmaster, indeed he accepted his terms and continued to live for a couple of weeks in the handsome house in Twickenham Road where the school now was.

When Vincent set out to find a new means of livelihood, it seemed there were few opportunities that suited his present vocation. But on July 1 things were settled. He was engaged as a sort of curate by the Rev. Mr Jones, a Methodist minister who lived at Holme Court, Isleworth.

Vincent had long realized that he could not be an art-dealer and at the same time satisfy his conscience. And there were other forces that influenced his decision to leave the world of commerce and serve his fellow-men. First of all there was the family tradition with its three generations of pastors, and then the life he had known as a clergyman's son had always been frugal and austere. His tendencies towards sincere religious devotion had been heightened by his rejection by Ursula Loyer, and from the letters he wrote to Theo this would seem to have turned him more and more towards the Bible. Furthermore, at Ramsgate Vincent had been teaching the boys Old Testament history, and so, in accepting the position Mr Jones offered him he was,

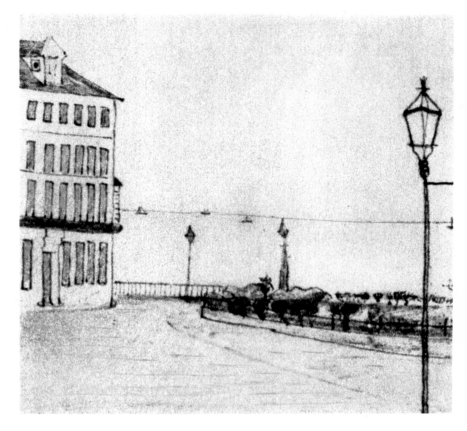

despite his lack of formal training, well prepared for the task he had to do. And he must have rejoiced in the prospect of one day following in his father's footsteps and becoming a pastor.

## EMERGENCE FROM THE COCOON

Vincent had come a long way towards the goal he had set himself when he left Goupil & Cie. One Sunday Mr Jones asked him to preach a sermon; and after he had done so he wrote home triumphantly: *Theo, your brother has preached for the first time, last Sunday, in God's dwelling, of which is written, "In this place, I will give peace." . . . May it be the first of many.*

We should not underestimate the psychological importance of this occasion. Hitherto Vincent's need to assert himself had always been frustrated, but now after so many vain attempts he must have felt that he had found his true self. No wonder he wrote to Theo with such pride and enthusiasm: *When I was standing in the pulpit, I felt like somebody who, emerging from a dark cave underground, comes*

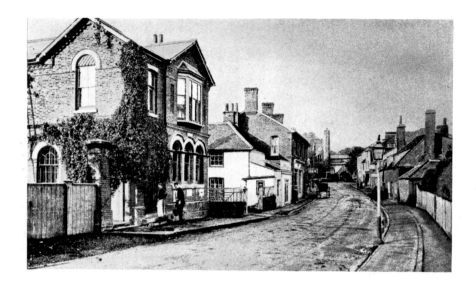

The main street of Welwyn (above). Photograph A.I.v.G.—Ivy Cottage (right, photograph A.I.v.G.) was at the end of the main street of Welwyn. When Vincent left Ramsgate, he set out for London on foot. He reached Canterbury the first night. The next day at midday he reached Chatham, and in the evening he was in the outskirts of London. He stayed two days in the capital and then set out for Welwyn in Hertfordshire. He left London at four o'clock in the morning, and at five o'clock in the afternoon he knocked on the door of Ivy Cottage, where there was a small boarding-school at which his eldest sister taught French.

*back to the friendly daylight.* At last, after the years in the wilderness, Vincent felt that he had an identity of his own. His humiliations were over.

We can easily assess Vincent's ability as a preacher because this first sermon has been preserved in a copy that he sent to Theo. The text, now printed in the first volume of his *Letters*, shows the strength of his faith as well as considerable power in expressing himself in the English language. Vincent certainly preached other sermons, for he mentioned his texts in his letters, but whether they were ever written down we do not know.

The mental depression which Vincent had felt for many months was gone. From his correspondence we learn how he preached the word of God in various scattered churches, how he visited the poor and taught boys from the poorer districts of London, comforted the distressed and the sick. He was in his element serving his fellow-men. It is interesting to note that Vincent's brothers and sisters were driven by the same urgent desire to serve mankind and they all involved themselves in causes or sacrificed themselves to ideals. In this respect Vincent was by no means an exception in his family.

A DISTASTEFUL TASK

Every morning Vincent gave lessons to the boys in Mr Jones's school, and, after lunch, he continued his teaching unless he was sent out into town. On Sundays he preached in two nearby Methodist chapels at Petersham and Turnham Green. This was the side of the job he liked and excelled at, but there was another, less attractive task he was called upon to perform. On October 7 Mr Jones asked Vincent to go to London to collect some of the money that his pupils' parents owed him. Vincent discharged his task satisfactorily, and he enjoyed walking to London; nevertheless this new task was to spell the end of his days at Isleworth. The sight of human misery in the East End of London only increased Vincent's desire to serve his fellow-men, and this he felt he could not do while collecting Mr Jones's debts. Instead of taking money from the wretched he wished to help them in their sufferings. Thus despite his joy at preaching, Vincent was not happy; and he saw the direction in which he should be going.

At the end of the year he crossed the North Sea to visit his parents at Etten. The whole family,

The church by the Thames. Photograph A.I.v.G.—This church, now roofless after being deliberately set alight, lies about a hundred yards from The Rev. Mr Jones's house. Vincent preached his first sermon there on Sunday November 4, 1876. He wrote about it to Theo.

Mr Jones's house. Photograph A.I.v.G.—When Vincent decided to leave Mr Stokes's school to find a more worthwhile employment he was taken on as a sort of curate and assistant teacher by Mr Jones, a Methodist minister. Mr Jones lived at Holme Court, Isleworth.

including Theo, had gathered together for the Christmas holiday, and once again Vincent's future was discussed. His present prospects did not seem good, either spiritually or materially, although Mr Jones had been paying him a small salary, and it was decided that he should not return to Isleworth. Vincent parted with Mr Jones on good terms, just as he had done with Mr Stokes, and indeed Johanna van Gogh-Bonger tells us that the minister was later to stay with the van Goghs at Etten and to meet Vincent in Belgium.

Vincent never saw London—nor for that matter Ursula Loyer—again. We know that while he was in England he had visited Mrs Loyer for the last time on the day after her birthday, but whether he saw Ursula then we do not know. No doubt his religious feelings kept those of his heart in check, even if the wound had still not healed.

## THE BOOKSHOP IN DORDRECHT

On New Year's Eve, when Theo had returned to The Hague, Vincent wrote to him of the prospect of a job in Holland: *There are many things that make it*

*desirable; being back in Holland near Father and Mother, and also near you and all the others. Then the salary would certainly be better than at Mr Jones's, and it is one's duty to think of that, because later in life a man needs more.*

*As to the religious work, I still do not give it up. Father is so broad-minded and so many-sided, and I hope in whatever circumstances I may be, something of that will unfold in me.*

When it had at last been decided that Vincent should not return to work for Mr Jones in England his father had at once got in touch with his brother, Uncle Cent, who, though he had hardly forgiven his nephew for his disappointing conduct at Goupil & Cie, could not refuse to help Pastor Theodorus. He approached D. Braat, whose brother Frans worked at Goupil & Cie's head office at Paris and was thus in effect one of Uncle Cent's employees. D. Braat ran Blussé & van Braam's bookshop at Dordrecht and was willing to give Vincent a chance there as a book-seller's clerk.

At the beginning of the New Year Vincent went to Dordrecht and took lodgings with the Rijken family in Tolbrugstraatje. Mr Rijken was a corn and flour merchant, and his wife took in five or six lodgers.

AUSTIN FRIARS CHURCH. Isleworth, April-December 1876, ink, 10 × 17 cm. F 826. Private collection, Netherlands.—At the bottom Vincent has written "This little church is a remarkable relic of an ancient foundation of Augustinians (Austin Friars) going back at least to 1354 if not to the previous century. From 1550, as a result of a voluntary gift by Edward VI, the Low German Church held its religious meetings here."

She seems to have taken a motherly interest in her young paying-guests, springing to Vincent's defence when he was teased by the other lodgers, who soon realized that he was an eccentric.

Vincent himself was quite aware that he was different from others and he wrote to Theo from Dordrecht: *Do not mind being eccentric; keep yourself to yourself, and distinguish between good and evil for your own sake even if you do not show it outwardly.* He appears to have been delighted with his new lodgings, for the window looked on a garden with pine trees and poplars and the backs of old houses covered with ivy. He seems always to have had a special fondness for ivy, and in his letter he quotes from Dickens: "*A strange old plant is the ivy green*"; and in another letter from Dordrecht Vincent wrote: *It is good to love flowers, and ivy, and fir trees, and hawthorn hedges—they have been with us from the very beginning.* This explicit statement of Vincent's love of nature is confirmed by vivid descriptions of the Dutch landscape with its birds and trees in almost every one of these letters. *The storks are here already,* he wrote on March 16, *but I have not heard any larks yet. The sky is often stormy, and then one sees swarms of rooks and starlings.*

When Vincent arrived at the Rijkens' there was not a room free for him, so P. C. Görlitz, a young teacher who was later to become history master at the high school at Nijmegen, was asked if he would share his room with the new arrival. "Oh, yes," replied Görlitz, "provided he is a decent fellow." So it was that Vincent and the young teacher became room-mates and in due course friends.

Görlitz has left his impressions of Vincent in a letter written to M. J. Brusse, which he wrote in 1914 and which is amply confirmed by an earlier letter to Frederik van Eeden written in 1890. He wrote: "He was a singular man with a singular appearance into the bargain. He was well made, and had reddish hair which stood up on end; his face was homely and covered with freckles, but changed and brightened wonderfully when he warmed into enthusiasm, which happened often enough. Van Gogh provoked laughter repeatedly by his attitude and behaviour—for everything he did and thought and felt, and his way of living, was different from that of others of his age. At table he said lengthy prayers and ate like a penitent friar: for instance, he would not take meat, gravy, etc. And then his face had always an abstracted expression—pondering, deeply serious, melancholy. But when he laughed, he did so heartily and with gusto, and his whole face brightened." Such, according to his loyal contemporary, was Vincent van Gogh at the age of twenty-four.

Yet Vincent's heart was still in England. He wrote to Uncle Cent: *I am most anxious to see you and Aunt and talk with you both.* Later he added: *I like being in Holland again, although the work across the Channel, notwithstanding all the trouble and profound disappointment, was dear to me. It is still—despite the disappointment and relative failure this time, I am deeply attached to it.* It is clear that he had not forgotten Ursula and her rejection of him; and he pleaded guilty to his dereliction of duty, but with extenuating circumstances.

At the same time Vincent was obviously overjoyed to be back in the same country as Theo: *We are such old friends!* And it appears not to have been too difficult for him to write to Mr Jones *telling them I was not coming back. . . . I wished them to remember me and asked them "to wrap my recollection in the cloak of charity".*

Soon after he had taken his new job selling books at Blussé and van Braam, there was a flood—a familiar risk in Holland. After torrents of rain had fallen in the night Vincent wrote: *Everybody in Rijken the grocer's house, where I live, was busy carrying the things from the shop upstairs, as the water in the house had risen to three feet. There was no little noise and bustle: on all the ground floors people were busy carrying things upstairs, and a little boat came floating through the street.*

The water also seeped up into the place where Mr Braat stored his paper: *Mr Braat says that it will cost him a lot of money. We have been busy a day and a half carrying everything upstairs into another house. Working with one's hands for a day is a rather agreeable diversion—if only it had been for another reason.* The flood at least broke the routine. As a rule Vincent started work at eight in the morning. From one o'clock until three he had a lunch-break at the Rijkens', and then worked again until six. He usually went back to the shop after supper and stayed there until after midnight. He kept to himself, and apparently seldom exchanged a word with anybody in the bookshop. Braat's daughter said that he never visited her parents, who lived above the shop as the Tersteegs did at The Hague, and that he never spoke a word to her when she passed his little desk in the bookshop. Braat maintained that

nobody but Görlitz had known Vincent at all at Dordrecht, so much more reserved did he become during the short time he spent there.

Vincent was not interested in learning the book trade. Instead of getting on with his work he was almost always to be found translating the Bible into four parallel columns of French, German, English and Dutch. Sometimes Braat caught him making little pen-and-ink sketches.

When he went home to the Rijkens' in the small hours he read the Bible or drew pictures. *I read it daily*, he told Theo, *but I should like to know it by heart and to view life in the light of that phrase, "Thy word is a light...".* He became more and more devout. At Paris he had gone with Harry Gladwell to as many churches as possible. Now he never went to less than three services on a Sunday—sometimes even four.

Görlitz has told how Vincent would go not only to the Dutch Reformed Church, but also to Lutheran and Catholic services. And when Görlitz expressed his astonishment, Vincent replied: *Do you really think that God cannot be found in the other churches?* Vincent lived an ascetic life, permitting himself only one luxury, his pipe, which he smoked continually.

His strange habits did not please his landlord, who was apt to find him dressed in a peasant's blue smock and hard at work reading or drawing in the middle of the night. What was even worse was his way of nailing his pictures to the walls. "Mind my wallpaper!" the landlord would cry in alarm. Fortunately his strange lodger did not stay long.

## IN HIS FATHER'S STEPS

In order not to worry his parents Vincent did not admit that he was unhappy at the bookshop, and unsuited to the work there. As at his job at Goupil he was apt to tell customers frankly what he thought of the prints that were on sale, and it was not always complimentary. As Görlitz remarks, "he was unfit for business". He longed to become a "worker for Christ", a "sower of the word", and to follow in his father's footsteps: *As far as one can remember, in our family, which is a Christian family in every sense, there has always been, from generation to generation, one who preached the Gospel. Why shouldn't a member*

*of that family feel himself called to that service now, and why shouldn't he have reason to believe that he may and must declare his intentions and look for the means to reach that goal ?*

Braat realized that Vincent's heart was not in his work and asked him the reason.

*I want to be a pastor like my father,* he said.

"But, my dear boy", was Braat's rather tactless reply, "don't you think it's too bad that after so many years your father has not been able to get anything better than Etten and De Leur?"

Vincent was furious, the only time that Braat had ever seen him angry, and retorted *My father is in the right place! He's a true shepherd.*

There was little sign that work in the bookshop had weakened Vincent's religious resolve. Quite the contrary, he was still determined to become a priest.

Meanwhile Görlitz went to apply for a post as schoolmaster at De Leur and stayed a night with the van Goghs at Etten. He told Vincent's parents that their son was really very unhappy at Dordrecht and that he was determined to become a preacher. The van Goghs were touched by this news and agreed that Vincent could go to Amsterdam and prepare for the state examination that would allow him to enter the university and study theology. If all went well he would soon become a preacher like his father, and his short period in the bookshop at Dordrecht would be remembered only as a sad interlude on his path to God.

Once again the family rallied round. Vincent's Uncle Jan, the commandant of the naval dockyard, was now a widower, and his children were grown up and had left the family home; he easily found room for his nephew in his big house by the dockyard.

Another of Vincent's uncles, Pastor Stricker, a well-known preacher in Amsterdam, welcomed him warmly and kept a close eye on his studies. It was he who arranged that Dr M. B. Mendes da Costa, the celebrated young professor of classics, should teach Vincent Latin and Greek, and that the professor's nephew, Teixeira da Mattos, a teacher at the Jewish school, should instruct him in mathematics. Vincent was always sure of a welcome at his Uncle Cor's picture-gallery in the Leidsestraat. In Amsterdam he was not alone in a large city as he had been in London, Paris and in Dordrecht, but among friends and friendly relations.

## A NEW CAREER

At first all went well, and Vincent set to work optimistically on the new road he had chosen. *I see that it is not easy, and it will get more and more difficult, but still I hope firmly to succeed,* he wrote to Theo. He seemed to be on an even keel again. He got on wonderfully well with his Uncle Jan, the old sailor who had sailed all the seas, and now enjoyed taking Vincent on walks about the town and even on his tours of inspection of the naval vessels in the yard. Uncle Jan was an open, straightforward man whose wisdom was often expressed in colourful proverbs and figures of speech. "The devil," he would say, "is never so black that you can't look into the whites of his eyes." This turn of phrase was shared by all the older van Goghs, and Vincent's father was always telling his children to "Be as honest as doves and as wary as serpents." This biblical Bunyanesque language was clearly much to Vincent's taste at the time, and his own letters are full of quotations from the scriptures and references to *The Pilgrim's Progress*.

The sympathy and encouragement of his relations in Amsterdam had broken his old loneliness and isolation and encouraged him in his determination to succeed. His letters are full of heartfelt prayers that he will pass his examinations and will one day become one of God's ministers, despite all the difficulties to be overcome. He had high hopes for a future devoted to the Church.

Vincent at once took to Mendes da Costa, who was only two years older than himself, and the two men soon became friends. Mendes da Costa has left us a vivid and psychologically perceptive description of Vincent at this time: "Notwithstanding his lank reddish hair and his many freckles, his appearance was far from unattractive to me. In passing, let me say that it is not very clear to me why his sister speaks of his 'more or less rough exterior'; it is possible that, since the time when I knew him, because of his untidiness and his growing a beard, his outward appearance lost something of its charming quaintness; but most decidedly it can never have been rough, neither his nervous hands, nor his countenance, which might have been considered homely, but which expressed so much and hid so much more...."

He goes on to describe how Vincent would attempt to mitigate the professor's displeasure. "At the time I... had my study on the third floor. In my mind's eye I can still see him come stepping across the square from the Nieuwe Herengracht Bridge, without an overcoat as additional self-chastisement; his books under his right arm, pressed firmly against his body, and his left hand clasping the bunch of snowdrops to his breast; his head thrust forward a little to the right, and on his face, because of the way his mouth drooped at the corners, a pervading expression of indescribable sadness and despair. And when he had come upstairs, there would sound again that singular, profoundly melancholy, deep voice: *Don't be mad at me, Mendes; I have brought you some little flowers again because you are so good to me. ...* To be angry... would have been impossible... he was consumed by a desire to help the unfortunate. I had noticed it even in my own home, for not only did he show great interest in my deaf and dumb brother, but at the same time he always spoke kindly to... an aunt of ours... an impecunious, slightly deformed woman who was slow-witted, 'and spoke with difficulty, thus provoking the mockery of many people." She used to call Vincent "Mister van Gort". He did not mind, and would say: *Mendes, however much that aunt of yours may mutilate my name, she is a good soul, and I like her very much.*

The thirty long letters that he wrote to Theo between May 1877 and May 1878 show that despite his determination it was impossible for Vincent to keep his nose to the grindstone all the time. He was constantly walking about Amsterdam, looking for rare books in the bookshops, going out of the city on country excursions, and drawing large-scale maps. It is true that he rose very early and never went to bed before midnight, but even so one wonders how he could have hoped to find the time to absorb the languages, history, geography and mathematics which he needed in order to pass his examination.

## A RETURN TO HIS NATURAL BENT

The letters that he wrote from Amsterdam, despite their constant preoccupation with religion, contain a surprisingly large number of descriptions of pictures. These descriptions, moreover, are of considerable aesthetic value. His passion for drawing is equally in evidence. On June 12, 1877 he wrote: *Now and then when I am writing, I instinctively make a little drawing, like the one I sent you lately: this morning, for instance, Elijah in the desert, with the stormy sky, and in the foreground a few thorn bushes. It is nothing special, but I see it all so vividly before me.* And on December 4 of the same year he admitted: *Today while I was working I had in front of me a page from the* Cours de Dessin Bargue *(the drawing examples) part 1, No. 39, "Anne of Brittany".* Throughout the letters of this period there are vivid and pictorial descriptions of scenes in town and country, which later would have been the subject of Vincent's pencil and brush as well as his pen.

It is hardly surprising that Vincent was unsuccessful at his academic studies. Mendes da Costa gives a frank account in his article published in *Het Handelsblad* on December 2, 1910: "*Mendes*, he would say—we did not 'mister' each other any more—*Mendes, do you seriously believe that such horrors* [i.e. Latin and Greek] *are indispensable to a man who wants to do what I want to do: give peace to poor creatures and reconcile them to their existence here on earth?*" The teacher knew in his heart that Vincent was right, but he put up as good a defence as he could muster. Vincent only replied: *John Bunyan's* Pilgrim's Progress *is of much more use to me, and Thomas à Kempis and a translation of the Bible; and I don't want anything more.*

CHAPELS AT PETERSHAM AND TURNHAM GREEN. Isleworth, November 25, 1876, ink, 4 × 10 cm. Vincent van Gogh Foundation, Amsterdam.

Etten and its environs. Map by Vincent and Cor van Gogh, Etten, July 22, 1878, ink, 15 × 9.5 cm. Vincent van Gogh Foundation, Amsterdam.—Vincent was twenty-five when he made this map, and Cor was eleven. One can see at once which part of the map was drawn by which brother. On it is written: "This was made by Vincent and me in the fir-woods. I'm going to bed. Good night."

Nevertheless Vincent tried to pursue his studies in order not to disappoint his parents, and Mendes da Costa has described how when his pupil felt that he had failed in his duty he "took a cudgel to bed with him and belaboured his back". At other times he would deliberately get himself locked out of his Uncle's house and spend the night "on the floor of a little wooden shed, without bed or blanket. He preferred to do this in winter...." It was this behaviour which upset Mendes da Costa, who had to be propitiated with snowdrops; and the professor recognized this self-chastisement for what it was: an instance of Vincent's masochism.

Vincent seemed to be getting nowhere with his studies and was as far as ever from satisfying his ambition to help his fellow-men. Eventually his parents and his uncles had to admit what Mendes da Costa had long ago predicted, that his pupil would never pass his examinations. There was nothing else for it; Vincent would have to return to his parents at the presbytery at Etten.

Ostensibly Vincent abandoned his theological studies in order to become a mission worker, but he may also have been unconsciously leaving the door open for his artistic aspiration, which, as we shall see, did not conflict with his desire to serve his neighbour.

There is a revealing phrase in the first of the letters he wrote to Theo from Amsterdam. While talking about the task ahead of him, Vincent says: *A great deal of study is needed for the work of men like Father, Uncle Stricker and so many others, just as for painting.* He was thinking of ambitions, and his own repressed ambition—painting—sprang to his mind. Obviously there was a bitter conflict in his mind between what he was doing and what he wanted to do. and it was this no doubt that paralysed his efforts in Amsterdam, well-intentioned though they were.

The usual arguments put forward about Vincent's academic failure cannot be sustained. He was very intelligent and would normally have mastered the curriculum of the state examination. It was not the difficulty of his task nor the fact that he was twenty-four that handicapped him. It was simply that he could not concentrate properly because artistic interests prevented him from doing so. Yet in his fourth letter from Amsterdam, at the very beginning of his studies, he writes prophetically of *the fear of failure, of disgrace.*

# THE COURAGE OF DESPAIR

Although Vincent had abandoned the attempt to reach the Church along the usual path of Latin, Greek and mathematics, he still hoped to be able to serve his fellow-men by the light of the Gospel alone. But, as his father explained to him, even a missionary must have some training; and it was essential that he should settle down to a proper course of study. At heart Vincent's parents were afraid that he would never be able to adapt to an academic routine but they agreed that they should give him a chance. Pastor Theodorus knew of a school for training mission-workers at Laeken near Brussels which had been founded by the Rev. N. de Jong two years earlier and decided to investigate it.

In July 1878, the Rev. Mr Jones came over from Isleworth to visit Theodorus van Gogh at Etten, and one Sunday the two clergymen went to Brussels, taking Vincent with them. They found that the school had certain advantages; the course there lasted only three years, half the time that comparable studies would take in Holland, and ability in public speaking was more important than knowledge of the classics and theology.

Vincent spent the whole of July at Etten preparing for his entrance to the school. He worked in a little room with a pleasant outlook on to the garden, and he began writing some compositions which he thought might prove useful to him later. It was perhaps his inclination rather than his duty that made him choose Rembrandt's painting of *The House of the Carpenter* as the theme for one of them. His letters of this time are full of references to other pictures and his usual extraordinarily pictorial descriptions of landscapes. He also admitted to Theo: *The other day I made a little drawing after Emile Breton's* A Sunday Morning, *in pen, ink and pencil.* And his first letter from Laeken, written on November 15, 1878, after a gap of nearly three months, included a drawing: *I enclose that hasty little sketch* AU CHARBONNAGE. *I should like to begin making hasty sketches of some of the many things that I meet on my way, but as it would probably keep me from my real work, it is better not to start*—a pious wish that he was soon to break.

## A STRANGE SCHOLAR

Vincent went to Laeken on Sunday August 25 to begin a three-month period on trial. His behaviour there has been described, long after the event, in two articles. The first was signed by "Fr. G." of Brussels and appeared in *Ons Tijdschrift* some time before 1912 (it is reprinted in an unidentified press-cutting dated April 12, 1912). The second consisted of

57

recollections by the Rev. J. Chrispeels published in the *Christelijk Volksblad* on the occasion of the 1926 Van Gogh Exhibition in Brussels.

At this time there were only three pupils at the training school. "Fr. G." describes how Pastor Theodorus presented a sandy-haired, somewhat round-shouldered young man, who wanted to be a pupil, and who seemed well-informed and warm-hearted. But "he did not know what submission was". Both writers describe how he insisted on writing with his book held humbly on his knees like a medieval novice, and when the master asked him to sit at a table he replied: "This is good enough for me." He took no more interest in academic study than he had done at Amsterdam. Once when a master asked him if a word were nominative or dative, he answered: "I really don't care, sir!"

He was clearly frustrated by the lack of opportunity for drawing. Once in a French lesson when the word *falaise* (cliff) was being explained, he asked: *Sir, will you allow me to draw* une falaise *on the blackboard*. But the master refused. As soon as the lesson was over Vincent went straight to the blackboard and began to draw a cliff. Chrispeels describes what happened: "A younger pupil tugged at van Gogh's jacket from behind to make fun of him. Van Gogh sprang round with an expression on his face I shall never forget, and dealt his teaser such a blow that he did not come back for more. Oh! that face blazing with indignation and wrath!"

It seemed shocking to his fellow-pupils that some-one seriously devoted to God could behave so brutally. But this was only the first murmur of the fury, and indeed madness, that were to come later.

## IN DARKEST NIGHT

After three months of trial, Vincent was told that he had failed and would have to leave. Nothing was said about his odd behaviour, merely that he had no talent for impromptu speaking. Vincent was so shattered that he was almost driven to a state of nervous collapse. His father was sent for and took the first train to Brussels.

All Pastor van Gogh's sympathy and understanding were needed before Vincent could overcome his despair and continue his religious vocation And he chose to do so among people who also lived in the depths of darkness, if not of despair. On November 15, 1878, he wrote to Theo: *Experience has shown that the people who walk in the darkness, in the centre of the earth, like the miners in the black coal mines, for instance, are very much impressed by the words of the Gospel, and believe them, too. Now in the south of Belgium, in Hainaut, near Mons, up to the French frontiers—aye, even far across it—there is a district called the Borinage, which has a unique population of labourers who work in the numerous coal mines. . . . I should very much like to go there as an evangelist.*

He was convinced that he must continue his work among the poor folk in the Borinage, where they worked in their satanic mines under a yellow-grey sky between the black pyramids of the mine-tips at the pit-head, in air that was foul with fume and smoke.

For thirty Belgian francs a month he could lodge with a pedlar called van der Haegen at 39 rue de l'Eglise at Pâturages not far from Mons. The house no longer exists; it was pulled down when the road was widened some years ago. Vincent spent his days visiting the sick, and in the evening he gave lessons to his landlord's children. He also gave Bible readings, especially at the "salon du bébé" in the rue Dubois at Wasmes on the edge of Colfontaine woods.

He had been much distressed by what he had once seen of the poverty in the East End of London. Now he was no less shocked by the indescribable conditions in which the miners lived in the black country of the Borinage. In a later letter, written after he had been in the Borinage for several months, he gave Theo a graphic and moving description of the miners and their life. *Most of the miners*, he wrote, *are thin and pale from fever; they look tired and emaciated, weather-beaten and aged before their time. On the whole the women are faded and worn. Around the mine are poor miners' huts, a few dead trees black from smoke, thorn hedges, dunghills, ash dumps, heaps of useless coal, etc. Maris could make a wonderful picture of it.* Vincent already visualized it as a picture himself and promised to send Theo a sketch.

A miner who had worked thirty-three years in the Marcasse pit took him more than two thousand feet down underground and explained everything to him. A picture of the coal-face would, he thought, *be something new and unheard of—or rather, never before seen. Imagine a row of cells in a rather narrow, low*

*passage, shored up with rough timber. In each of those cells a miner in a coarse linen suit, filthy and black as a chimney-sweep, is busy hewing coal by the pale light of a small lamp. . . . The water leaks through in some, and the light of the miner's lamp makes a curious effect, reflected as in a stalactite cave.*

Several years later he was reminded of this curious light when he stepped into a peasant's cottage after dark, saw the faces round the lamp, and was inspired to paint THE POTATO-EATERS.

The miners who were not at the coal-face loaded the coal into small casts on rails. *This he wrote, is mostly done by children, boys as well as girls. There is also a stable yard down there . . . with about seven old horses which pull a great many of those carts to . . . the place from which they are pulled up to the surface. Other miners repair the old galleries to prevent their collapse or make new galleries in the coal vein. As the mariners ashore are homesick for the sea, notwithstanding all the dangers and hardships which threaten them, so the miner would rather be under the ground than above it. The villages here look desolate and dead and forsaken; life goes on underground instead of above. One might live here for years and never know the real state of things unless one went down in the mines.*

By going down the mine, and meeting the people as an equal—or even, perhaps, as an inferior—he had come to know and understand their character. *People here are very ignorant and untaught—most of them cannot read— but at the same time they are intelligent and quick at their difficult work; brave and frank, they are short but square-shouldered, with melancholy deep-set eyes. They are skilful at many things, and work terribly hard. They have a nervous temperament—I do not mean weak, but very sensitive. They have an innate, deep-rooted hatred and a strong mistrust of anyone who is domineering. With miners one must have a miner's character and temperament, and no pretentious pride or mastery, or one will never get along with them or gain their confidence.*

A TEMPORARY POST

From the very beginning Vincent realized that to these people spiritual instruction was just fine words and that they needed his works rather than his faith. The Mission School committee that was responsible

Uncle Jan. Photograph Vincent van Gogh Foundation, Amsterdam.—Vincent stayed with this uncle, his father's eldest brother, who was a vice-admiral commanding the naval yard at Amsterdam, when he entered the university in that city in order to study theology.

for practical evangelization promised Pastor van Gogh that Vincent could have a temporary post in January 1879. They kept their word and sent Vincent to Wasmes on trial for a term, paying him fifty Belgian francs a month. This was all he needed, and he set devotedly to work. There were no limits to his charity. He gave all he had, his clothes, his shoes and even his bed. He thought his lodging with a baker called Jean-Baptiste Denis, modest though it was, was too luxurious for him and went and lived in a filthy hovel, where he lay on straw like a beast. When Madame Denis asked him why, he replied: *Esther, one should do like the good God; from time to time one should go and live among His own.*

M. Bonte, who had arrived as pastor at the neighbouring village of Warquignies the year before, welcomed Vincent warmly. Many years later he told my old friend Louis Piérard: "The clothes he wore outdoors revealed the originality of his aspirations; people saw him issue forth clad in an old soldier's tunic and a shabby cap, and he went about the village in this attire." Soap was considered a sinful luxury, and even when Vincent was not covered with coal-dust he usually had a dirtier face than the miners. Madame Denis said that he was wrong to dash out of the house in the morning to visit the wretched without even time to wash himself or to do up his shoelaces; Vincent replied: *Oh, Esther, don't worry about such details, they don't matter in heaven!*

M. Denis, son of the couple with whom Vincent lodged, wrote to M. Piérard in a letter: "Having arrived at the stage where he had no shirt and no socks on his feet, we have seen him make shirts out of

sacking." When Madame Denis said: "Monsieur Vincent, why do you deprive yourself of all your clothes like this—you who are descended from such a noble family of Dutch pastors?" Vincent replied: *Oh, Esther, the Good Samaritan did more than that! Why not apply in life what one admires in the Bible?*

At this time there were a series of firedamp explosions in the mines. Vincent mentions one in the Marcasse mine, J.-B. Denis speaks of one in pit No. 1 belonging to Charbonnage Belge, and Piérard of three others at the Agrappe and the Boule pits at Frameries. Many miners were badly burnt. Vincent worked unceasingly to help the injured, tearing his remaining linen into bandages and steeping them in olive oil and wax in order to treat the miners' burns.

## IN THE STEPS OF ST FRANCIS

Vincent's charity was not confined to mankind. He respected the lives of animals, even the lowest of them. He would pick up a straying caterpillar and carefully place it on a branch. It was the same for all the other animals. He would even buy cheese and milk and put it out in his hut for the mice to eat and drink, while he himself lived happily on bread and water. People treated him as a madman or a simpleton, but they loved him all the same.

An old woman who knew Vincent well told me long ago, "There aren't any more men like that nowadays." He used to go into houses and say to the women, *Rest a while; I will do your washing for you.* Some have even claimed that Vincent performed some remarkable conversions while he was at Wasmes. It is told that one day he visited a man who had been injured in the Marcasse pit, an incurable alcoholic who was an unbeliever and a blasphemer, and who greeted him with a volley of oaths and abused him as a "rosary-mumbler", even though he was a Protestant. But Vincent, with his gentleness and serenity, succeeded in converting the crazed old miner. His reputation for sanctity was marred by one serious fault: everyone agreed that he was an incorrigible smoker.

Naturally enough his behaviour got him into trouble. When the Rev. Emile Rochedieu came to inspect Vincent's work he considered the young man's zeal and self-denial most excessive. He reported to the Church council at Wasmes, which reprimanded Vincent and said that unless he behaved himself he would have to leave. For a while all was well, but Vincent soon fell into his old ways. He thought he was on the right road because he was acting according to his conscience. But when his period of probation was over the authorities had had enough. His behaviour in neglecting himself was unworthy of the dignity of his ministry.

The black-earth country. Photograph A.I.v.G.—The high slag-heaps outlined against the sky are a salient feature of this dark landscape.

The text of the official report on van Gogh's period of probation in the Borinage has long been known. Louis Piérard printed it in its entirety in his book *La Vie tragique de Vincent van Gogh* in 1924, and it was included in the Van Gogh Exhibition in Paris in 1937 and subsequently in the complete edition of the *Letters*, though this did not prevent Pastor E. Pinchal rediscovering it, and announcing the fact with some publicity in 1962.

These synodal reports are usually drawn up and signed by one person and then approved by the committee or Church council before being submitted to the Synod. The 23rd report of the Synodal Evangelisation Committee for 1879-1880 is, however, signed by three people: the president, the Rev. Emile Rochedieu of Brussels; the vice-president, the Rev. G. J. Blom of Ghent; and the secretary, the Rev. L. Andry of La Bouverie. The passage concerning Wasmes reads: "The experiment of accepting the services of a young Dutchman, Mr Vincent van Gogh, who felt himself called to be an evangelist in the Borinage, has not produced the anticipated results. If a talent for speaking, indispensable to anyone placed at the head of a congregation, had been added to the admirable qualities he displayed in aiding the sick and wounded, to his devotion to the spirit of self-sacrifice, of which he gave many proofs by consecrating his night's rest to them, and by stripping himself of most of his clothes and linen in their behalf, Mr van Gogh would certainly have been an accomplished evangelist. Undoubtedly it would be unreasonable to demand extraordinary talents. But it is evident that the absence of certain qualities may render the exercise of an evangelist's principal function wholly impossible. Unfortunately this is the case with Mr van Gogh. Therefore the probationary period—some months—having expired, it has been necessary to abandon the idea of retaining him any longer."

It was the same story once again. There had never been any doubt that Vincent was an indifferent public speaker. The training school at Brussels had turned him down for the very same reason, and he himself had admitted to Theo in a letter of August 26, 1876, from Isleworth: *You see I do not speak without difficulty.* No doubt there was some justification in the official reason, but what his superiors really disapproved of was Vincent's filthy appearance.

"Le salon du bébé." Photograph A.I.v.G.—Vincent preached on several evenings at places on the outkirts of the village. There was hardly room for a hundred people. One of the houses was known by the local working people as the "baby-room". This building in the rue Dubois has now been made into two workers' houses. Two doors have been fitted in where the entrance to the "baby-room" used to be. The difference between the doorsteps can be seen in the photograph.

This humiliating dismissal was yet another bitter blow for Vincent, who felt himself abandoned on all sides. But he refused to give up his mission. He walked from Wasmes to Brussels to see the Rev. Mr Pietersen, one of the committee which had originally accepted him for the training school at Brussels, to discuss his own situation with him. The good pastor's daughter, who opened the door to him, was so shocked by his appearance that she called her father and ran away in dismay. Mr Pietersen nevertheless received him kindly, and being a serious amateur artist himself, looked with great interest at Vincent's drawings of miners in the Borinage. Indeed Johanna van Gogh-Bonger says "they probably talked as much about drawing and painting as about evangelization". The pastor understood Vincent better than most of his cloth seem to have done, and he wrote shrewdly to the young man's parents at Etten: "Vincent strikes me as somebody who stands in his own light." He also encouraged Vincent to stay in the Borinage and continue his work there on his own account, even though he no longer had the support of the Church.

Vincent therefore moved to Cuesmes, another village in the Borinage, where he lodged in a little house half of which was inhabited by an evangelist called Frank, and half by Charles Decrucq, a miner, and his family. He once went down the mine with Decrucq and a foreman called Vernay. They have described his reactions: "When he saw how we worked like slaves in the mines, for twelve hours a day, and for a daily wage that ranged from 2.51 to 3.44 Belgian francs, he was furious and exclaimed: *How can they treat God's creatures like this?* And he

ZANDMENNIK'S HOUSE. Pencil drawing, 23 × 29.5 cm. Collection of S. and C. Delsaut, Cuesmes, Belgium.—At the time when he drew MAGROT'S HOUSE, Vincent also drew ZANDMENNIK'S HOUSE. Zandmennik was a seller of sand, probably of Flemish origin as his nickname indicates, for in that language *zand* means "sand" and *mennik* "little man".

Decrucq's house (left). Photograph A.I.v.G.—After he had been lodging for some time with Jean-Baptiste Denis, Vincent moved in August 1879. He gave Theo his address as "c/o M. Frank, evangelist at Cuesmes (near Mons)". A year later he wrote in a letter of August 20, 1880, "c/o Charles Decrucq, rue du Pavillon, 3 Cuesmes". These are both the same address. The contemporary picture which appears on the right has settled this point.

Decrucq's house (right). Drawing by an unknown artist done in Vincent's time. Collection of S. and C. Delsaut, Cuesmes, Belgium.— This shows that what is called "Decrucq's house" is in two parts. The miner lived in the right-hand half with his family. M. Frank lived in the left-hand part, in the far left room of which Vincent lived after the missionary had left. Since then the left-hand part has been pulled down, and the rest is so ruined that it has had to be shored up.

MAGROT'S HOUSE. Drawing by Vincent van Gogh, pencil, 23 × 29.5 cm. Collection of S. and C. Delsaut, Cuesmes, Belgium.—This drawing of the house in which Magrot, known as the witch, lived was done by Vincent when he was living with the Decrucq family. The Delsauts are closely related to the Decrucqs, and the drawing has never left the family. Magrot's house was about 200 yards from the Decrucq house.

went to the bosses of the mines, who, incidentally, out of every 100 francs of net receipts paid 60.9 francs in wages and 39.1 francs to the shareholders; he wanted to get a juster share for us, but they only insulted him. They said: 'We'll have you shut up in the madhouse, M. Vincent, if you don't leave us in peace.' A miner's strike broke out shortly afterwards; we wanted to set fire to the mine, but M. Vincent persuaded us against violence. He told us not to be unworthy men, for brutality destroys everything that is good in man."

The Decrucqs were particularly attached to Vincent because of the way he nursed their little son when he was desperately ill with typhoid fever. The little boy recovered, only to die in a firedamp explosion in the Marcasse mine at the age of eight —children still worked in the pits at that age in those days. He drew a portrait of Madame Decrucq returning from the pit, but it has not survived. The Decrucqs' daughter has given a terrible account of Vincent's appalling misery and poverty at this time. Despite the bitter weather he had given away his last shirt. He gave away to beggars the pittance that his brother sent him, he lived on crusts or frost-bitten potatoes and often went without eating for days together. At night he could be heard weeping in the barn where he slept.

One day, with only ten francs in his pocket, he decided to go and see Jules Breton, a French painter whom he much admired, and who had just built himself a new studio at Courrières, about thirty-five miles away. But when he got there he was daunted to find that the place seemed very unsympathetic and forbidding compared with Breton's simple and attractive pictures. Not daring to introduce himself, he turned round and sadly walked back to Cuesmes.

A LIGHT IN HIS DARKNESS

At first Vincent went on with his preaching; but his unhappy clashes with his ecclesiastical superiors had made him aware of the vast difference that can exist between the letter and the spirit of the Gospel. The lack of understanding shown him by his fellow-men, his inability to adapt to the society to which he belonged or to form close human contacts gradually turned him away from religion.

Rejected by the Church authorities, he at last said goodbye for ever to his vocation as a preacher.

Even in this "saddest, most hopeless time of his never very fortunate life" as his sister-in-law called it, and despite all his failures, he was beginning to find his way on to the right road. He had begun to realize from bitter experience that he could never follow in his father's footsteps. Now he was on the point of following in his mother's and serving mankind through his art. He had tested his spirit in passionate meditation and daily charity, and in this fire Vincent van Gogh had forged what was to prove a unique artistic integrity.

He had never been able to resist the temptation to draw, even on margins and scraps of paper. In London he had often sat by the Thames and sketched the view. At Ramsgate he had drawn the harbour outside his window. In the Borinage he had found time to draw large maps of the Holy Land (his father had ordered four at ten guilders each). He had drawn the miners and their clothes and tools, and his letters to Theo, sparse though they were at this period of his life, show that his interest in art was

Denis's house. Photograph A.I.v.G.—At first Vincent lodged with Jean-Baptiste Denis, whose house was in the rue du Petit-Wasmes, as Vincent noted at the foot of a letter. Later J.-B. Denis moved house to what is now rue Wilson, where there is commemorative plaque which reads: "During the years 1878 to 1879 the Dutch painter Vincent van Gogh (1853-1890), who was then a lay-preacher and later became one of the greatest painters of his time, lived in this house"

The entrance to the Agrappe mine. Photograph A.I.v.G.—This mine lay in the Frameries area. Explosions of fire-damp were frequent. The older people in the Borinage district often called it "the coffin" or "the common grave". There was a terrible disaster while Vincent was there, and he made heroic efforts to relieve the injured.

Marcasse (pit no. 7). Photograph A.I.v.G.—Marcasse was one of the most dangerous mines in the whole of the Borinage. There were many disasters there: explosions, fire and flood. Vincent went to the bottom of this mine, 2,300 feet down, and stayed there six hours.

Grisœil (pit no. 10). Photograph A.I.v.G.—Another pit worked by the miners to whom Vincent preached the gospel.

The Sack (pit no. 1). Photograph A.I.v.G.—Behind Denis's house was pit no. 1, usually known locally as "The Sack". Vincent passed close to this mine when he went to visit the miners' families.

Denis's house

Entrance to the Agrappe mine

Marcasse (pit no. 7)

Grisoeil (pit no. 10)

The Sack (pit no. 1)

not dead—quite the contrary. His devotion to Rembrandt was as sincere as his love of Christ, and in a long letter written at this time he seems to be groping his way towards art as a kind of religious vocation. It is one of the few complex and even obscure letters that he ever wrote.

Drawing was for him a liberation. *I look at things with different eyes than I did before I began to draw*, he told Theo. He had at last found his true vocation, which had been hidden for too long, and a new life began. The aim remained the same. Only the means had changed. Indeed art became Vincent's religion. He was to say of his painting: *I want to give the wretched a brotherly message. When I sign myself "Vincent", it is as one of them.*

Vincent was twenty-seven, he had no money, and he realized that if he were to launch himself on a new career he would have to do so entirely by his own efforts. He began by doing exercises from a popular drawing manual, the *Cours de Dessin Bargue*, which he had used three years before in Amsterdam: *For the moment my aim must be to learn to make some drawings that are presentable and saleable as soon as possible.* Then he would go back to the Borinage and draw from life. Meanwhile his little room in the Decrucq's house was too small and too ill-lit for his studies, and he did not want to take a larger room which they offered, but which they really needed; so he moved to Brussels. Madame Bonte, the widow of the pastor of Warquignies, has described his departure: "On the evening when he left Vincent came to say good-bye to us. He was terribly pale, and he said to us with profound sadness: *Nobody has understood me. They think I'm a madman because I wanted to be a true Christian. They turned me out like a dog, saying that I was causing a scandal, because I tried to relieve the misery of the wretched. I don't know what I'm going to do. Perhaps you are right, and I am idle and useless on this earth!* Then he went away, all alone, his feet bare, and with his bundle on his shoulder. The children ran after him shouting: 'He's mad! He's mad!' My husband made them stop, and he said to me: 'We have taken him for a madman, and perhaps he's a saint!'"

With Vincent, out of sight was never out of mind. His childhood at Zundert was vividly recalled at Saint-Rémy, and his twenty-two months in the Borinage left just as permanent an impression.

Some seven years after he had left it, when he was at Arles, he met a Belgian poet and painter, Eugène Boch, who came from La Louvière not far from where he had been living. They became friends, and Vincent painted an excellent portrait of him. When Boch returned to the Borinage, Vincent wrote to him: *My dear friend Boch, Many thanks for your letter which pleased me very much. I congratulate you on not having hesitated this time and on having attacked the Borinage. There you have a field where you will be able to work all your life—the extraordinary scenery as well as the figure. The pit girls in their pit rags especially are superb. If you should ever go to Petit Wasmes, please inquire whether Jean-Baptiste Denis, farmer, and Joseph Quinet, miner, are still living there, and tell them from me that I have never forgotten the Borinage and that I should still be delighted to see it again... Everything you'll do will interest me extraordinarily, because I love that dismal country of the Borinage, which will always remain unforgettable to me, so much.*

Despite the misery that he had suffered there, he even had thoughts of returning: *I have nearly made up my mind, when I go to Paris next year, to push on as far as Mons. And perhaps even as far as my native country to do some spots that I know already. In the same way in the Borinage Marcusse, or from Antoine to Petit Wasmes. And further the Cour de l'Agrappe in Frameries where you are now. As a matter of fact it was in the Borinage that I first started to work from nature. But of course I destroyed it all a long time ago.*

Boch, however, might paint these places, and Vincent continued: *But it stirs my heart that these spots are going to be painted at last. You will see how easily ideas will come to you.* He concluded: *Well, I hope we'll meet again next year. Above all don't forget to let me have your address when you move, or to give me your exact permanent address in La Louvière, if my memory serves me well, for it will be excellent to work continuously in the mining district, and also to see something quite different come to the country of the oleanders and the sulphur sun. Is your sister going to do the miners too? Surely there is work enough for two.*

Those bitter months in the Borinage had served their purpose, and their memory, as of other pain, remained fresh in Vincent's mind. Yet out of the dark skies of Belgium's "black country" he was finding his way to a happier future in the sun.

# BEGINNINGS AS AN ARTIST

Each of Vincent's many changes of direction may seem at first to be a surprise, but on studying his life more closely one finds that every important decision that he took was heralded by a casual reference in his letters to his own future. Although they may seem trivial, these remarks show how his mind was working and the decisions that he was on the point of making.

It was already clear that Vincent had made a general change of direction. After his long and tortured letter written in July 1880, in which he seemed to be trying to convert a religious vocation into an artistic one by sheer force of intellect and will, his next four letters made no reference to religion or to God except in a telling simile: *some more advanced artist ... would be as one of God's angels to me.* They were concerned almost entirely with art, interspersed only by occasional moving references to the plight of the miners. He had set out on a new path and there was no looking back.

Then he began to give explicit hints that he meant to move. On September 24, 1880, he wrote to Theo from Cuesmes: *I should like to take a small worker's house; it costs about 9 fr. a month.* In his next letter, dated October 15, he begins: *As you see, I am writing you from Brussels. I thought it better to change my domicile for the present.*

Vincent had suddenly decided to move from Cuesmes to Brussels because, as has been mentioned in the previous chapter, the light in his little room was too poor. In order to do his exercises he had sometimes had to work in the garden, *but now that I am as far as the portraits after Holbein in the third part of the* Cours de Dessin, *it has become impossible.*

Working conditions were much better in the room Vincent took in a small hotel at 72 boulevard du Midi in Brussels, though he would need more space as soon as he decided to draw from a model. His intentions in moving were clear. There was no opportunity in the Borinage to meet any other painters. He had been obliged to be entirely self-taught and could not discuss his work with anyone else. In Brussels, he called on Mr Schmidt, head of the branch of Goupil & Cie there, and *asked him if he could help me make an arrangement with some artist so that I could continue my study in a good studio; for I feel that it is absolutely necessary to have good things to look at and also to see artists at work. Then I am more aware of what I lack, and at the same time I learn how to do better.*

Mr Schmidt received him cordially, and Vincent was hopeful that *the thing could be satisfactorily arranged.* All the same he felt that Mr Schmidt *looked at me with some suspicion, because formerly I*

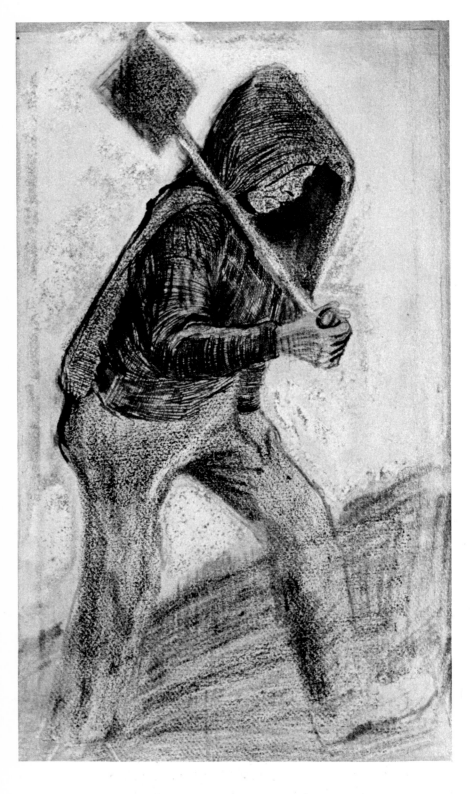

was with Goupil & Cie, left, and have now returned to the art field. Vincent's tattered and disreputable clothes may also have had their effect. He therefore begged Theo to write and put in a word on his behalf.

Theo did so with his usual promptitude, and, as a result, Vincent went first to see the Dutch painter Willem Roelofs, who advised him to draw "principally from nature", by which he meant from a plaster cast or a model. Roelofs, as others had done, urged him *so earnestly to go and work at the academy, either here or at Antwerp, or wherever I can, that I felt obliged to try to get admitted . . . though I do not think it so very pleasant.* But there was one important advantage compared with, say, Amsterdam, which Vincent underlined in his letter: *Here in Brussels the teaching is free of charge.* In order to enter he had to have the mayor's permission and to be registered. While waiting for a reply to his application he drew from morning till night, convinced that at last he had found what he had been looking for.

He worked hard at drawing the anatomy of the human body, beginning with *a rather large-size skeleton with pen and ink on five sheets of Ingres paper,* and continuing by building up the muscles until he had formed the whole human body, as depicted in John's *Sketches of Anatomy for Artists' Use.*

Then he would proceed with animal anatomy at the veterinary school, where he hoped to get pictures of the anatomy of *a horse, a cow, or sheep,* and to treat them in the same way.

Vincent realized that there was much to be done: *It is a hard and difficult struggle to learn to draw well.* He was determined, and he had no illusions. He wrote to Theo: *Good intentions are not sufficient without some opportunity for development. As to your thinking I should not want to be among mediocre artists, what shall I say? It quite depends on what you call mediocre. I shall do what I can, but I do not at all despise the mediocre in its simple sense. And one certainly does not rise above the mark by despising what is mediocre. In my opinion one must at least begin by having some respect for the mediocre, and know that it already means something, and is only reached with great difficulty.*

In a later letter he explained the extent of the difficulty: *Not only does drawing figures and scenes from life demand a knowledge of the technique of drawing, but it also demands profound studies of*

*literature, physiognomy, etc., which are difficult to acquire.* It was obvious that Vincent was determined to meet these demands and in his letters to Theo he made frequent references to the books he had been reading and the impressions they had left on him.

Vincent's way of life was only slightly better than in the Borinage. He lived chiefly on dry bread *and some potatoes or chestnuts which people sell here on the street corners... by taking a somewhat better meal in a restaurant whenever I can afford it I shall get on very well.* The fifty francs a month he paid for his lodgings included no more than some bread and a cup of coffee each morning, noon and evening.

For the moment he was busy copying and copying, working on Millet's *The Diggers* and *The Woodcutter,* some Holbeins in *Models from the Masters* and, of course, the inevitable *Cours de Dessin Bargue* and *Exercices au Fusain.*

But he did not lose sight of the reason for all this study. His concern as an artist was still largely with the poor and the wretched. His models were *a porter, a miner, a snow shoveller... old women... an old porter or some working man.* And there were many drawings of the miners.

He painted a landscape of a heath, he hoped to get some soldiers to sit to him, and he was beginning to enjoy himself and think well of the world in general.

THE MINERS' RETURN. Borinage, after April 1881, pen, pencil and brush, 43 × 60 cm. F 832.     Kröller-Müller State Museum, Otterlo.

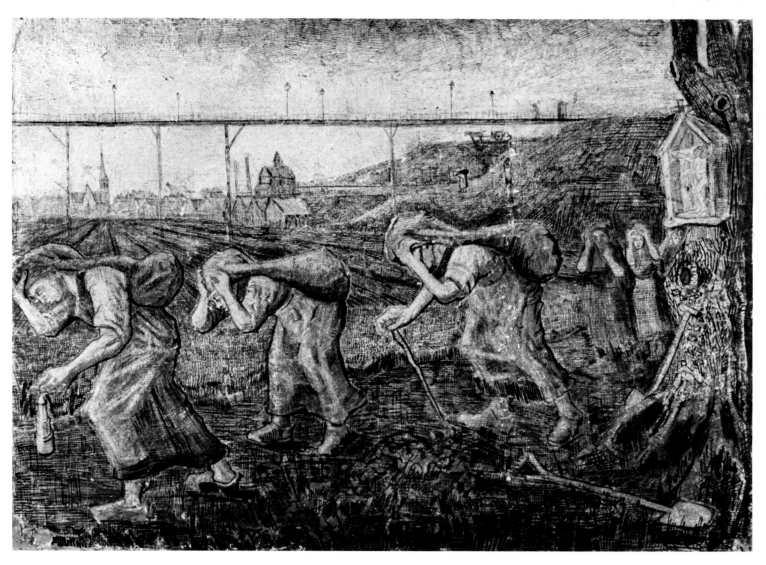

## THE BIRTH OF A FRIENDSHIP

After a while he realized that he could no longer go on looking like a beggar as he done in the Borinage. He confessed to his parents that he had felt obliged to to buy two coats and two pairs of trousers second-hand, to say nothing of underwear and shoes. He sent them a sample of the cloth by way of justification, adding the plea: *Do not accuse me of extravagance, for really the contrary is rather my fault of character*, which was true enough. Even wearing these new clothes, Vincent can hardly have looked like an ordinary citizen.

Vincent does not tell us in his letters whether he was admitted to the Brussels Academy, and Johanna van Gogh-Bonger categorically says that he was not, but I have found in the archives that he was registered on September 15, 1880—presumably the entry was back-dated to the beginning of term, since Vincent said that he was still waiting for an answer to his application when he wrote to Theo on November 1. We do not know what classes he attended or who taught him, though he gives a hint as to this when he mentions that *the painter who gives lessons now is making a very good picture of a Blankenberg fisherman.*

He does not seem to have been looking for academic instruction so much as for a fellow-student with whom he could discuss art. Theo soon put him in touch with another Dutch student, Anthon G. A. Ridder van Rappard, who was *a fine-looking man*, as Vincent and his photograph testify, and five years younger than Vincent. Van Rappard was living at 6a rue Traversière, and *judging from the way he lives, must be wealthy.* This luxury can hardly have been to Vincent's taste, but they seem to have talked amicably enough. Of his work Vincent saw *only a few small pen-and-ink landscapes.* These he subsequently described as *very witty and charming, but... a little more passion, please.* He wrote to Theo: *I do not*

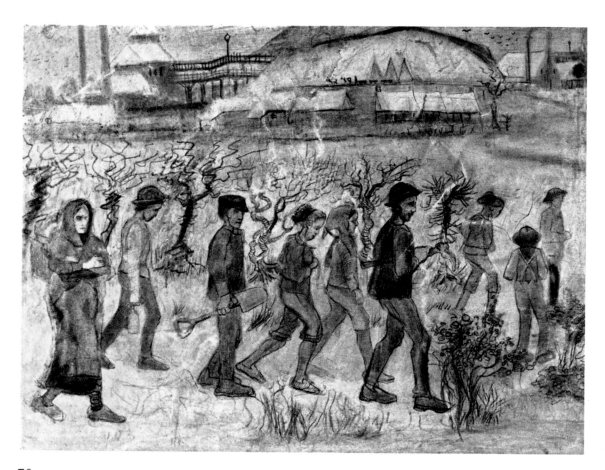

MEN AND WOMEN MINERS GOING TO WORK. Borinage, August 1880, pencil, slightly heightened in colour, 44.5 × 54 cm. F 831. Kröller-Müller State Museum, Otterlo.—"I have sketched a drawing representing men and women, going to the shaft in the morning through the snow." (Letter from Vincent to his brother).

70

know whether he is the person with whom I might live and work, because of financial reasons. But certainly I shall go and visit him again. He impressed me as one who takes things seriously. Despite the "financial reasons" they became friends and remained so for more than five years. While he was in Brussels Vincent constantly visited van Rappard's studio, which was larger and had more amenities than his own humble lodging.

The friendship, the only one that Vincent enjoyed at this time, was eventually to break up through van Rappard's tactlessness in criticizing Vincent's work in a very unsympathetic way and in circumstances which will be discussed in a later chapter. When his old companion died, van Rappard wrote to Vincent's mother: "I remember as if it happened yesterday the moment of our first meeting in Brussels when he came into my room at nine o'clock in the morning, how at first we did not get on very well together, but so much the better after we had worked together a few times. . . . Whoever had witnessed this wrestling, struggling and sorrowful existence could not but feel sympathy for the man who demanded so much of himself that it ruined body and mind. He belonged to the breed that produces the great artists."

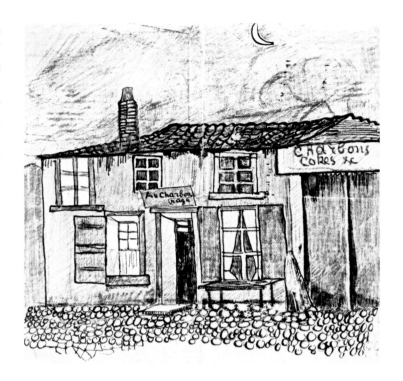

"AU CHARBONNAGE". Brussels, November 1878, black chalk and pen, 14 × 14 cm. Vincent van Gogh Foundation, Amsterdam.—From Laeken, a little suburb of Brussels, Vincent wrote to Theo on November 15, 1878: "The little drawing 'Au Charbonnage' is not particularly remarkable, but I made it because one sees here so many people who work in the coal mines, and they are a rather distinctive type. This little house stands not far from the road; it is a small inn which adjoins the big coal shed, and the workmen come to eat their bread and drink their glass of beer there during the lunch hour."

RETURN TO ETTEN

After a few months in Brussels Vincent decided to leave the city. There were various minor reasons: he was not making as much progress as he had hoped, his room was too small and ill-lit, there were objections when he tried to mask part of the window or to put up his etchings or drawings on the wall. Moreover he was beginning to find that life in a large city like Brussels was too severe a strain on his limited financial resources.

When he heard van Rappard was going back to Holland in May, he decided: *I shall have to move; I should like to work a while in the country—at Heyst, Kalmthout, Etten, Scheveningen, Katwijk . . . preferably a place where there is a chance of coming into contact with other painters, and if possible of living and working together, because it is cheaper and better.* Etten, where he could live at home for nothing, would have obvious advantages, even though he would find no artistic companionship there.

On Tuesday, April 12, 1881, after he had been in Brussels for six months, he finally made up his mind and wrote to his brother: *As I heard from Father that there is a chance of your being in Etten next Sunday and that it would be well for me to be there also, I start thither today.* No doubt Theo's reason for being at Etten was that it would be Easter Sunday, but Vincent, as at so many of the previous crises in his life, was going there because it was home.

IN SEARCH OF SUBJECTS

Vincent soon saw that he would not get much farther with the Bargue course of drawing, although he was to continue with it intermittently for a long time, as well as copying Millet and others.

OLD BRETON WOMAN SLEEPING IN CHURCH (after Félicien Rops). Brussels 1880, pencil, heightened in white, 26.5 × 19.5 cm. F 835. Vincent van Gogh Foundation, Amsterdam.

miner's grey linen suit, straw hat and wooden shoes, and even a yellow oilskin and sou'wester. Women's dresses would also be needed.

He did not want to return home only because, as he wrote to Theo, it would be financially much easier: *the cheapest way would perhaps be for me to spend this summer at Etten.* But he also continued: *I can find subjects enough there.* No doubt his father's influence in the village would help to persuade people to sit to him. And in his last letter from Brussels he mentions two drawings that he had begun at van Rappard's—*I must somehow have the necessary models to finish them.*

Vincent set to work and soon began to achieve encouraging results. He had long shown a strong natural sensibility and taste; at Goupil's he had educated himself in drawing and engraving, and in Brussels he had taught himself anatomy and perspective, and he may also have had some lessons from the painter Madiol.

While he was at Etten he felt the need for the kind of professional advice and instruction that he had been able to get at Brussels. In order to find it, he went on a trip to The Hague and sought out his old employer, H.G. Tersteeg, and the successful painter of The Hague School, Anton Mauve, who was related to Vincent's mother by marriage. They both encouraged him, and saw no objection to his copying Millet.

But Vincent himself was not really satisfied with this kind of work. He wanted to draw the life around him as he saw it. He was determined that his art should always be based on a true appreciation of life, but it was not often easy to make his models conform to it. He wrote from Etten to Theo: *I think I shall find a good model here in Piet Kaufman, the gardener, but I think it will be better to let him pose with a spade or plough or something like that—not here at home, but either in the yard or in his own home or in the field. But what a tough job it is to make people understand how to pose. Folks are desperately obstinate about it, and it is hard to make them yield on this point: they only want to pose in their Sunday best, with impossible folds in which neither knees, elbows, shoulder blades nor any other part of the body have left their characteristic dents or bumps.*

His sister Wilhelmien came to stay, and the same preoccupation with realism governed the way he posed her for his drawing: *I put a sewing-machine*

In a letter to his parents from Brussels he was quite explicit about it: *Drawing the model with the necessary costumes is the only true way to succeed. Only if I study drawing thus seriously and thoroughly, always trying to portray truly what I see, shall I arrive; and then, notwithstanding the inevitable expenses, I shall make a living by it.*

He was perfectly serious about the need for the *right costumes*, and one of the reasons he put forward as an excuse for buying two new suits was that when they were worn out he could dress his models in them. He wanted to make a *small collection of workmen's clothes.* This would include a Brabant blue smock, such as Vincent himself liked to wear, a

into my drawing. *Nowadays there are no more spin-ning-wheels, and it is a great pity for painters and draughtsmen; but something has come in its place that is no less picturesque, and that is the sewing-machine.*

His love of the country, in which he had spent his youth, provided him with many deeply felt subjects. In his second letter from Etten he writes: *Every day that it does not rain, I go out in the fields, generally to the heath. I make my studies on a rather large scale, like the few you saw at the time of your visit; so I have done, among other things, a cottage on the heath, and also that barn with a thatched roof on the road to Roozendaal, which locally they call the Protestant barn. ... Then the mill right opposite it, in the meadow, and the elm-trees in the churchyard. And another of woodcutters, busy on a wide patch of ground where a large pine tree has been cut down. I also try* to draw the implements, such as a wagon, plough, harrow, wheelbarrow, etc., etc. *The one with the wood-cutters turned out best of all. ...*

When it did rain, or for some reason he preferred not to go out, he drew the interiors of the workshops in the village, a forge, a carpenter's shop and a workshop in which they made wooden shoes. He found that they entailed their own problems of drawing and especially of rendering the perspective. If he was obliged to work at home he spent his time copying drawings by Holbein or, following Theo's advice, drawing portraits with the aid of photographs.

Whenever Vincent was at Etten, whether for a long or a short period, he always found time to explore the countryside. During this stay he made many excursions of this kind. He was now in his element and had found what he had been looking for.

DIGGERS (after Millet).  Borinage or Brussels, November 1880, pencil (shaded with stump) and a little charcoal, 37 × 62 cm.  F 829. Kröller-Müller State Museum, Otterlo.—In August 1880 Vincent told Theo that he was doing drawings based on several of Millet's works.

## WORKING TOGETHER

His life at Etten became even more agreeable when his parents invited van Rappard to come and stay two weeks at the presbytery. The two friends went out to the heath near Seppe several times, as well as to *the so-called Passievaart, a big swamp.* Van Rappard painted a large picture, three feet by eighteen inches, which Vincent admitted was *not bad,* as well as some ten small sepias in the Liesbosch. While van Rappard was painting, Vincent did a pen-and-ink drawing of another part of the swamp *where all the water lilies grow.* They also went to Prinsenhage together, but found that Uncle Cent, as so often happened, was ill in bed.

All these excursions satisfied a desire of Vincent's which will be found through much of his career, the desire for artistic companionship and collaboration. This feeling is well expressed in a later letter to Eugène Boch, quoted in the previous chapter, where Vincent wrote: *Is your sister going to do the miners too? Surely there is work enough for two.* The letter continues: *I think it is a very pleasant thing for you to be both painting in the same house.* The idea persisted until his catastrophic break with Gauguin at the Yellow House at Arles destroyed this illusion for ever.

Van Rappard also had happy memories of his stay at Etten, as can be seen from the letter that he wrote Vincent's mother after the painter's death: "Our excursions to Seppe, Passievaart, Liesbosch—I often look through my sketchbooks for them." For Vincent this was not only a happy time but also a very productive one. If one compares the pictures he had done in the Borinage and in Brussels with those he did in Holland one can see how much progress he has made. This is particularly noticeable in his pictures of water lilies in a swamp, some studies of sowers, and in his wonderful representation of the road in the snow.

This must not be forgotten if one is to make any considered judgement of his art. Some critics and art historians have maintained that van Gogh could not draw. This nonsensical view is only possible because of the complex situation, partly advantageous and partly unfavourable, in which Vincent found himself when he applied himself to art. Van Gogh's apprenticeship was radically unlike that of other artists, and his aims were entirely different. As a rule the young pupil is taught at an academy the "secrets of the kitchen"; the professor shows him how to prepare each kind of dish, and the pupil learns to master their various techniques. Only then does he begin to use those techniques to express his own character—when he has found it. It usually takes some time for a pupil to shed his academic style and acquire his own manner. During this apprenticeship the young painter does not as a rule have to obey the dictates of his own character, for it is not usually formed until he has learnt to paint.

Vincent was twenty-seven when he decided to be an artist. At that age most young men with similar ambitions have already left their academies and art schools some years ago. This was only one way in which Vincent was different.

## FINDING HIS OWN CHARACTER

Vincent's first aim was to "serve" mankind, even though he had relinquished his religious ambitions. He intended his art to add to the dignity of man, and not merely to be a means of earning his living. It was a high and rare ambition. Moreover there was bound to be a conflict between any artistic technique, whether taught in an academy or learnt from a manual, and Vincent's strong and ever-growing sensibility.

He had already learnt a great deal from his experience of art-dealing and from his consuming interest in pictures as well as from his wide reading—all of which had helped to form his character. Thus Vincent was in a position where his intellectual development would enable him to progress more rapidly than a beginner, but the nature of his vision would be strictly governed by his wide knowledge of the essential elements of art. He was trying to do two incompatible things at the same time.

ON THE ROAD. Brussels, January 1881, black chalk, 9.5 × 5.4 cm. Vincent van Gogh Foundation, Amsterdam.

As a result of this duality it is not always easy to tell which faults arise from deliberate negligence and which from inability to avoid them. It is often difficult to tell where a work belongs in the artist's development. Technique may be sacrificed because of internal tensions, and the level of his apparent ability sometimes varies wildly from day to day.

This is not to deny that a strict critic will find many failings in Vincent's early drawings which, naturally enough, are full of the results of his

ignorance and initial awkwardness. He was well aware of this himself, and his letters to Theo are full of frank admissions of his inability to overcome the problems he was always encountering. Obviously it would take Vincent some time to master his art. Yet, even among his work done at Etten, there are some pictures which, though awkward and hesitant in some respects, are much more than promising and herald a painter of genius.

## VINCENT'S DRAUGHTSMANSHIP CONSIDERED

In ROAD IN THE SNOW AT ETTEN and the drawing of *another part of the swamp*, Vincent's reference to which has already been quoted, one cannot expect to find such skill as to defy all criticism. But they do show how far he has already succeeded. His step is firm and certain, and there is not the least hesitation in his line. Nor has he tried to gloss over his own lack of skill. This seems to show that Vincent was aware of his own technical inexperience, and, without waiting to acquire an easy mastery of execution, he has preferred to aim high at expressing his character and his personal vision rather than to attempt a type of academic polish that is often empty.

Yet Vincent was building his future. Each line that he drew brought him nearer, so he hoped, to a professional ability that would enable him to earn his own living and not have to depend on his brother's generosity. This was a constant theme in his letters to Theo. He was determined to improve his technical skill as fast as he could, though never aiming at virtuosity. He was very different from the usual beginner in the academies of his day who scrupulously followed his teacher's instructions and was proud of his careful and correct drawing, spiritless though it might be.

These pictures are quite different from the sketches of his youth, which were merely pictorial illustrations of things he wished to describe, not that they lacked talent. ROAD IN THE SNOW AT ETTEN shows a clear intention to avoid impersonality. The early drawings are also personal, though not perhaps deliberately so, and the personality they reveal had not at that stage become conscious of its creative powers. But ROAD IN THE SNOW AT ETTEN was not drawn

THE PRESBYTERY AT ETTEN. Etten, 1881, pen, 9 × 14 cm. Private collection, Netherlands.

for amusement. It is the highly-charged work of a man of twenty-seven who felt that he had not a moment to lose, a man who had lost many battles but was determined to win the last one. Vincent took himself and his work seriously. Though he realized how much was still to be accomplished he knew how far he had already come. In September 1881 he wrote to Theo: *I have learned to measure and to observe and to seek for broad lines. So what seemed to be impossible before is gradually becoming possible now, thank God. I have drawn five times over a man with a spade, a digger, in different positions, a sower twice, a girl with a broom twice. Then a woman in a white cap, peeling potatoes; a shepherd leaning on his staff; and, finally, and old, sick farmer sitting on a chair near the hearth, his head in his hands and his elbows on his knees. And of course I shall not stop here—when a few sheep have crossed the bridge, the whole flock follows. Diggers, sowers, ploughers, male and female, they are what I must draw continually. I have to observe and draw everything that belongs to country life—like many others have done before, and are doing now. I no longer stand helpless before nature, as I used to. . . . The drawings I have done lately have little resemblance to those I used to do.*

In all these drawings one feels the tension between the human emotion and the still imperfect means of expressing it. It is all too easy to point out faults

76

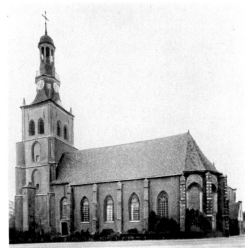

THE CHURCH AND PRESBYTERY AT ETTEN. Etten, 1881, pencil, 9 × 17.5 cm. Vincent van Gogh Foundation, Amsterdam. The Protestant church at Etten. Photograph A.I.v.G.—Of the two buildings that Vincent once drew, only the church still remains. A comparison between the drawing and the photograph shows how the artist has simplified the details.

in draughtsmanship, yet it is folly to do so at the expense of the emotional content. The greatest technical skill cannot save a work that lacks real feeling; but it is possible to create a masterpiece without perfect technique.

We shall find this same feature in much of van Gogh's later work. Unless it is properly appreciated one cannot hope to understand his artistic intentions.

A STORM IN THE HEART

Vincent's life was a series of crises alternating with periods of relative calm. The spring at Etten began peacefully while Vincent worked hard, but a new storm was on the way. His mother's elder sister had also married a Protestant clergyman, Pastor Stricker, who had, as we have seen, introduced Vincent to Professor Mendes da Costa in Amsterdam. The Strickers had a daughter, Kee, who was a little older than Vincent. Like her mother she had married a pastor, and Vincent described visiting them when he was at Amsterdam and the idyllic picture the family made. But Pastor Vos had died young, leaving Kee with a little son about four years old. Vincent's parents took pity on their widowed niece and invited her and the child to spend the summer with them in the country, and she accepted.

Although Kee was not a particularly handsome woman, she had fine eyes; and their expression must have been heightened by the poignancy of her grief. It was hardly surprising that Vincent, with his natural sympathy for unhappy or lonely people, was touched and affected by her.

"Quite absorbed in her grief over the loss of her husband", wrote Johanna van Gogh-Bonger, "she was unconscious of the impression which her beauty and touching sorrow made on the cousin who was a few years her junior." She adds that Kee later said: "He was so kind to my little boy." The sketchbooks drawn for Betsy Tersteeg have already shown Vincent's fondness for children and how much he loved to please them.

Kee, Vincent and the little boy went on pleasant walks together, and naturally enough he drew her portrait. Johanna van Gogh-Bonger wrote that this portrait "seems to have been lost". But my friend Walther Vanbeselaere in his *catalogue raisonné* of Vincent's Dutch period has shown it still exists, and I share his view. It is reproduced here on page 82.

Kee's natural gratitude aroused quite unfounded hopes in Vincent's heart, and as he fell in love with her he saw the world in a new and happier light. His powers of work multiplied.

At the beginning of the affair he said nothing to Theo. But several weeks later, after he had spoken

to his parents, he explained himself in a letter to him. Writing of his recovery from his former unhappy love, he said: *I got a deeper insight into my own heart and also into that of others. Gradually I began to love my fellow men again, myself included, and more and more my heart and soul—which for a time had been withered, blighted and stricken through all kinds of great misery—revived. And the more I turned to reality, and mingled with people, the more I felt new life reviving in me, until at last I met her.*

Three other significant comments made to Theo at this time are: *When a man falls seriously in love, it is the discovery of a new hemisphere. . . . Life has become very dear to me, and I am very glad that I live. My life and my love are one. . . . Since I really loved, my work has borne more of the marks of reality.*

One cannot help wondering whether this sudden love was not basically a compensation for having been rejected by Ursula Loyer, whom he had still been hoping to see in London just before he went to Cuesmes. Even while he was falling in love with Kee he harked back to this old love: *When I was younger, I once half-fancied myself in love, and with the other half I really was; the result was many years of humiliation. May all this humiliation not have been vain. I speak as one who has been down, from bitter experience and hard lessons.*

Seven years after Ursula refused him, Vincent was still filled with bitterness and still could not erase from his mind the suffering she had caused him.

His talk of "half-fancied" love seems to be an attempt to minimize the importance of his first rebuff because he was now replacing Ursula by Kee.

In a letter written at this time he asked: *What kind of love did I feel when I was twenty?* And he replied: *It is difficult to define—my physical passions were very weak then, perhaps because of a few years of great poverty and hard work. But my intellectual passions were very strong. . . .*

It is at once apparent that there was a strong sensual element in Vincent's feelings for his cousin, which is understandable enough since at twenty-eight he probably had little real sexual experience, although we cannot be certain, for his subsequent remarks on the subject are rather obscure.

After much hesitation Vincent somewhat awkwardly told Kee of his love. She was still deeply rooted in the past and her reply was firm: "No, no, never." She left for Amsterdam and refused to have any dealings with her lover. She would not even read the letters with which he bombarded her.

## PERSEVERING IN VAIN

Ursula Loyer's refusal seems to have taught Vincent nothing about women. He was obstinately determined to try to make the young widow change her mind. He told Theo: *If I saw that she loved another man, I should go far, far away. If I saw that she took a man she did not love for his money, I should plead guilty to short-sightedness on my part, and I would say, I have mistaken a picture by Brochart for one by Jules Goupil, a fashion print for a figure by Boughton, Millais or Tissot. Am I as shortsighted as that ? ? ?*

His passion was only increased by her refusal, and his letters to Theo become a torrent of protestations. He talked of her as an iceberg that he would thaw with the warmth of his heart. He would never *accept the yoke* of despair. Yet he seemed to be almost glorying in the impossibility of his task. He was perhaps in the familiar situation of a man who is in love not with a woman but with his own love.

He asked his parents and his brother to help him to overcome her resistance. His parents did not understand his attitude and thought his behaviour "indelicate" and "untimely". Vincent explained his parents' motives as follows: *Kee herself thinks she will never change her mind, and the older people try to convince me that she cannot ; yet they are afraid of that change. The older people will change in this affair, not when Kee changes her mind, but only when I have become somebody who earns at least 1000 guilders a year.* And indeed it was true that Vincent still had no means of earning his own living and depended on his brother and his parents.

As he persisted in his attitude there was ill feeling and even argument at the presbytery. On November 18, 1881, Vincent wrote to Theo: *Well, I am quite willing to believe that at times I have not been able to curb my indignation when I heard "indelicate" and "breaking ties". . . . Be that as it may, in his fit of passion Pa muttered nothing less than a curse. However, I already heard something of the sort last year, and, thank God, far from being really damned, I*

*developed new life and new energy within myself. So I am fully convinced it will be the same now, or more so, and more strongly than last year. Theo, I love her—her, and no other—her, forever. And . . . and . . . and . . . Theo, although as yet it never "seems" to be in full activity, there is a feeling of deliverance within me and it is as if she and I had stopped being two, and were united forever and ever. Did you receive my drawings?*

Despite his rejection—or perhaps because of it—Vincent had already sublimated his love; and though nothing had happened between them, though he had been refused, he felt *united forever and ever.* He went on working, but he admitted that: *I am sorry to say that there is still something harsh and severe in my drawings, and I think that she, her influence, must come to soften this.*

He wrote letters to his uncle, Pastor Stricker, but without result. In despair he turned to his brother: *Theo, I want money for the trip to Amsterdam; if I have but just enough, I will go. Father and Mother have promised not to oppose this if only I leave them out of the matter, as it were. Brother, if you send it to me, I will make lots of drawings for you of the Heike, and whatever you want.*

When the money did not come at once he wrote yet again on the evening of Friday, November 18: *Well, old boy, as soon as you send me the money for the journey, you will receive at once three drawings—* DINNER TIME, LIGHTING THE FIRE, ALMSHOUSE MAN. *So send the money if you can, for the journey will not be entirely in vain. If I have only 20 or 30 francs, I can at least see her face once more.*

Theo duly sent the money, and Vincent at once took the train to Amsterdam. He went to the Keizersgracht where the Strickers lived and rang the bell. He was told that the family was still at dinner, and shortly afterwards that he might come in. Kee was not there, nor was there any place laid for her. But he was convinced that they had just removed it to conceal the fact that she had been in the room.

*Where is Kee?* he asked.

"Kee is out," his aunt replied.

After a while he asked again: *Where is Kee?*

His uncle said: "Kee left the house as soon as she heard that you were here."

It was several months before Vincent told Theo what happened next: *I put my hand in the flame of*

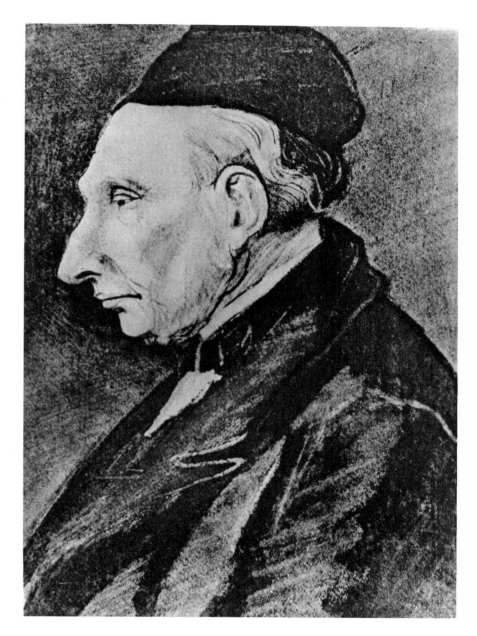

THEODORUS VAN GOGH. Etten, June-July 1881, black chalk heightened with white, 33 × 25 cm. Nieuwenhuizen Segaar Collection, The Hague.

*the lamp and said, "Let me see her for as long as I can keep my hand in the flame"—no wonder that Tersteeg perhaps noticed my hand afterward. But I think they blew out the lamp and said "You will not see her." Well, it was too much for me, especially when they spoke of my wanting to coerce her. . . . Then, not at once, but very soon, I felt that love die within me; a void, an infinite void came in its stead.* Thus Vincent's second love ended in failure.

THE SOWER. Etten, 1881, black chalk heightened with a wash of Indian ink, blue water-colour and green and white gouache, 60 × 45 cm. Private collection, Netherlands.—It is typical work of an advanced beginner, whose strong feeling is expressed in the outlines.

Kee later told Vincent's mother: "He fancied he loved me." Johanna van Gogh-Bonger is convinced that it was a real and lasting love, and that "If she had returned his love, it would perhaps have spurred him on to acquire a social position—he would have had to provide for her and her child." But in that case he would have had to abandon his art, which was already showing clear signs of genius.

Vincent's impulsive act in attempting to burn his hand shows his adventurous and even violent temperament, and it is another example of the masochism which had been in evidence earlier in his life. When his passion was at its height nothing could stop him. This second refusal left much deeper scars

than the first because it entailed greater sensuality and passion. For a while at least, he gave up all ideas of marriage and turned to casual liaisons to relieve his desires and his growing sense of loneliness.

## A LATER MEMORY

Vincent had to come to terms with Kee's refusal. He realized that it was immutable, but he never quite forgot the face he had tried so hard to see at Amsterdam. Seven years later in November and December 1888, at Arles, he painted one of his most masterly landscapes, A WALK IN ARLES (RECOLLECTIONS OF THE GARDEN AT ETTEN). At this time Gauguin was staying with him at the Yellow House. Now Vincent, unlike Gauguin, was a realist. Like his masters Millet, Courbet and Charles de Groux he painted what he saw around him. He had not, in any of his works that he had painted hitherto, used his imagination in the way that Gauguin did. But influenced by Gauguin, Vincent changed his manner and tried to some extent at least to paint a picture not based on life. A WALK IN ARLES is a most instructive example: he composed a picture that he could not see, mingling his memories of Etten with the landscape of Arles. In this amalgam of north and south he used people and plants taken from life to which quite imaginary details were added. Gauguin had just painted Bretons in a Provençal vineyard; why should Vincent not put Arles people in a Dutch garden?

He wrote to sister Wilhelmien about this picture: *Let us suppose that the two ladies out for a walk are you and our mother; let us even suppose that there is not the least, absolutely not the least vulgar and fatuous resemblance—yet the deliberate choice of the colour, the sombre violet with the blotch of violent citron yellow of the dahlias, suggests Mother's personality to me. The figure in the Scotch plaid with orange and green checks stands out against the sombre green of the cypress, which contrast is further accentuated by the red parasol —this figure gives me an impression of you like those in Dickens's novels, a vaguely representative figure.*

The usual theory is that this is a portrait of Vincent's mother and sister. Vincent himself, who was always straightforward and honest in all that he said, has suggested that we *suppose* that it is,

"WORN OUT". Etten, September 1881, pen and water-colour, 23.5 × 31 cm. F 863. Private collection, Netherlands.—This work once belonged to Vincent's friend van Rappard. Vincent wrote from Etten to his brother Theo, in September 1881: "I have drawn ... an old, sick farmer sitting on a chair near the hearth, his head in his hands and his elbows on his knees."

ROAD IN THE SNOW AT ETTEN. Etten, 1881, black chalk heightened with colour, 39 × 60 cm. Private collection, Netherlands.—For several decades this picture, which is altogether remarkable for a beginner, was hidden by its owner, the late Minus Oistrijk, who wrapped it in sacking and hid it under a heap of coal, for fear that it should be stolen. After his death I was able to arrange for it to be exhibited at the Retrospective Exhibition of van Gogh in 1960 at the Musée Jacquemart André, Paris.

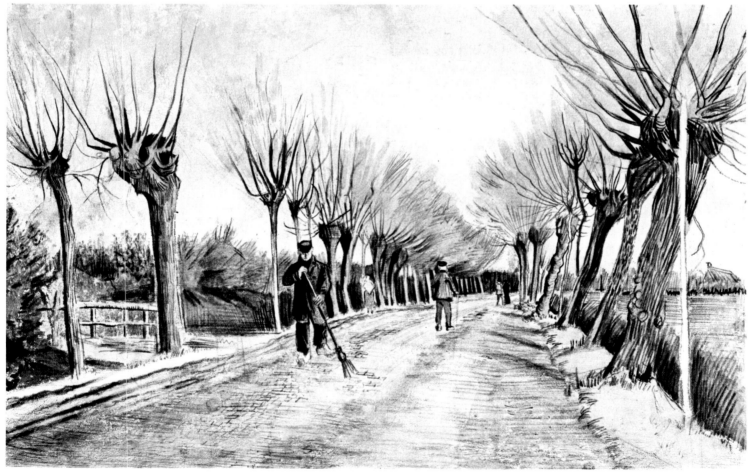

PORTRAIT OF KEE VOS-STRICKER. Etten, June-July 1881, pencil, 35 × 24 cm. F 849. Kröller-Müller State Museum, Otterlo. Photograph of Kee Vos-Stricker in the collection of Pastor J. P. Scholte-van Houten, Lochem.—This is not, as has sometimes been thought, a portrait of Wilhelmien van Gogh, but of Kee Vos-Stricker the painter's cousin. During the sumer of 1881 she lived at the Presbytery at Etten. Vincent fell passionately in love with her, but she refused him. After his dramatic encounter with Ursula Loyer in London seven years before, it was the second time he was crossed in love.

and that the colour *suggests Mother's personality to me*. Yet I am convinced that this is not a portrait of his younger sister. It is a likeness of the young widow whom he had loved so unhappily seven years before at Etten.

## AN ENIGMA

If the younger of the two women in this fascinating picture is compared with portraits of his sister and his cousin there can be no doubt about it. The shape of their heads was quite different. Wilhelmien had a round or rather oval chin, Kee's was distinctly pointed. Wilhelmien's mouth was lively but determined, though not in the least sulky; Kee's looked almost sullenly clenched. Vincent has accentuated the hard lines of sadness on her face. It is a striking likeness. The same features, the same eyes, eyebrows, nose, mouth and chin, even the same slightly wavy hair will be found on the portraits and photographs of Kee.

One cannot be certain of Vincent's reason for suggesting to his sister that she should "suppose"

that the younger woman in the picture was herself, when in fact it was a portrait of her cousin. A man's motives can never be established for certain. But there would seem to be two possibilities: either Vincent was deliberately concealing something of which he was consciously aware, and which he had no particular reason to hide—and this seems unlikely—or he unconsciously substituted Kee's face for his sister's, because it had left such a deep and permanent mark on his memory.

He could not possibly have forgotten what his sister's face looked like and confused it with Kee's. It was seven years since he had seen his cousin, but he had seen Wilhelmien only twelve months before when they both stayed in Theo's apartment in the rue Lepic in Paris. One would therefore logically expect that he would have a clearer memory of her face than of Kee's.

When Vincent painted A WALK IN ARLES he had not yet had his first attack of madness, though he had already begun to feel the nervous depression that was to lay him low a few days later.

We cannot say why Vincent chose this moment to remember Kee. We only know that he painted two portraits of her: one in 1881 in black and white, the other in oils in 1888. The second forms part of one of his most striking masterpieces.

Pastor Stricker and his wife. Photographs in the collection of Pastor J. P. Scholte-van Houten, Lochem.—Pastor Stricker, a well-known man in Amsterdam, was the father of Kee Vos-Stricker and Vincent's uncle through his marriage to Vincent's mother's elder sister.

82

# A BREAK
# WITH THE PAST

It was not long before Theo was again surprised by his brother's behaviour. Vincent had launched himself into a new project which had important consequences. Early in December 1881 he wrote to Theo: *As you see, I am writing from The Hague. I have been here since Sunday. You know Mauve had planned to come and stay in Etten for a few days. I was afraid that something would prevent it or that the visit would be too short, and I thought, I will try it in another and I hope better way. I said to Mauve, Do you approve of my coming here for a month or so, and occasionally troubling you for some help and advice? After that I shall have overcome the first petites misères of painting, and then I shall go back to the Heike.* Dr Jan Hulsker, who has published one of the most thorough studies of Vincent's period at The Hague, has shown that the Sunday in question was November 28.

Anton Mauve gave Vincent a friendly welcome and sat him down before *a still life with a pair of old wooden shoes and some other objects.* At first Vincent stayed at an inn nearby, but he soon found himself a modest studio of his own into which he was able to move by January 1, 1882.

*The light comes from the south,* he wrote, *but the window is large and high, and I think the room will look quite pleasant after a while.* His new quarters were at 138 Schenkweg near the Ryn station and only ten minutes' walk from Mauve's house. Dr Hulsker has shown exactly where this house stood, but the area is unrecognizable today because of the extensive rebuilding it has since undergone.

His needs were modest enough: *I will take the simplest furniture, a wooden table and a few chairs. I would be satisfied with a blanket on the floor instead of a bed*—as he had been in the Borinage. *But Mauve wants me to get a bed, and will lend me the money if necessary.* And in due course Mauve did lend Vincent a hundred guilders to help pay for accommodation and furniture of various kinds.

There was no end to Mauve's kindness at this stage in their relations. *Sometimes my clothes need repairing,* Vincent told Theo, *and Mauve has already given me a few hints about that too, which I shall certainly carry out; but it cannot all be done at once. You know my clothes are chiefly old things of yours which have been altered for me, or a few have been bought ready-made and are of poor material. So they look shabby, and especially all my dabbling in paint makes keeping them decent even more difficult; it is the same with boots. My underwear is also beginning to fall apart.*

Vincent remained at The Hague until September 1883, and it was partly in this first simple studio (he later moved into the attic of the house next door) that he painted the first of the several hundred works

"THE GREAT LADY". The Hague, 1882, pen and pencil, 19 × 10.5 cm. Vincent van Gogh Foundation, Amsterdam.—This is what Vincent wrote in a letter to Theo: "The little sketch enclosed is scrawled after a larger study which has a more melancholy expression. There is a poem by Thomas Hood, I think, telling of a rich lady who cannot sleep at night because when she went out to buy a dress during the day, she saw the poor seamstress—pale, consumptive, emaciated— sitting at work in a close room. And now she is conscience-stricken about her wealth, and starts up anxiously in the night. In short, it is the figure of a slender, pale woman, restless in the dark night."

(not counting those which he destroyed or which have been lost) that constitute the Hague period of his work and may be considered as the foundation upon which all the rest were built.

RELIGIOUS CRISIS

Vincent did not at first tell Theo his real motive for moving to The Hague. But the postscript to a letter that he wrote to van Rappard on December 3 is quite explicit: *I left Etten because I had too much botheration with my father about all kinds of things that are really not worth talking about, about going to church and such things, which, even though I was working hard and much, got me into a mood of boredom and chilliness that was all wrong. Therefore I have settled down here, and I am glad I am in different surroundings. Of course, now I have rather a lot of financial worries, but after all it is better than those everlasting bickerings and squabbles.*

It seems extraordinary that the young man who not so long ago would insist on going to several services every Sunday should now talk in such an offhand way about "going to church and such things". Various incidents had combined to undermine Vincent's religious convictions.

He had been much disillusioned to hear his father swear in anger. He had worshipped his father at one period in his life, and had identified the man with his calling, and indeed with his faith itself. The behaviour of the Synod had already shaken his convictions. When he first embraced an artistic career in the Borinage it was as if he had been converted to a new faith, the religion of art. He did not at that time abandon the Church of his fathers so much as to ignore it. His mind was devoted to a new purpose.

His religious enthusiasm had disappeared. Now he was further affected by Pastor Stricker's severe and hostile attitude as well as his own quarrels with his father about Kee. Her refusal had thrown him into the blackest pessimism and made him feel that he had been abandoned by God. This may explain why he wrote so bitterly: *There really are no more unbelieving and hard-hearted and worldly people than clergymen and especially clergymen's wives (a rule with exceptions). But even clergymen sometimes have a human heart under three layers of steel armour. And*

"SORROW". The Hague, April 1882, pencil 46 × 30.5 cm. F 929. Collection estate of H. P. Bremmer, The Hague.

WOMAN PEELING POTATOES. The Hague, 1883, conté crayon, 59.5 × 37.5 cm. Collection of Paul Citroen, Wassenaar, Netherlands.

Vincent's studio. Vincent van Gogh Foundation, Amsterdam.—In a letter to Theo Vincent described the studio that he wanted to install in a neighbouring house: "It is arranged thus: the studio, larger than mine, the light very good."

85

Vincent, the former missionary who had once spent so many hours reading the gospels, counselled his brother: *I think you will derive more profit from rereading Michelet than from the Bible.*

## AN UNHAPPY CHRISTMAS

This conflict between Vincent and his father, who was a more orthodox Protestant than ever, came to a head on Christmas day.

Vincent admitted to Theo: *I had a violent scene with Father, and it went so far that Father told me I had better leave the house. Well, he said it so decidedly that I actually left the same day. The real reason was that I did not go to church, and I also said that if going to church was compulsory and if I was forced to go, I certainly should never go again out of courtesy, as I had done rather regularly all the time I was in Etten. But oh, in truth there was much more at the back of it all, including the whole story of what happened this summer between Kee and me. I do not remember ever having been in such a rage in my life. I frankly said that I thought their whole system of religion horrible, and just because I had gone too deeply into those questions during a miserable period in my life, I did not want to think of them any more, and must keep clear of them as of something fatal. Was I too angry, too violent? Maybe—but even so, it is settled now, once and for all.*

On January 5, 1882, Theo, having learnt what had happened at Etten on Christmas day, wrote to Vincent criticizing his conduct: "Confound it, what made you so childish and impudent as to embitter and spoil Father's and Mother's life in that way? . . . Is it not bitterly hard for Father when he sees himself counted for nothing by somebody who calls himself more liberal, and whom he perhaps now and then envies for his clearer insight?"

Vincent answered him at once on the same sheet of paper, and explained his attitude to religion: *Liberal: in point of fact I hate this word, although I am obliged to use it myself now and then for want of a better one. The fact is that I do my best to think things out and to listen to the promptings of reason and common sense when in action. And trying to reduce a person to a mere nothing would be exactly contrary to this. It is quite true that once in a while I said to Pa, "Do try to think such and such a matter out," or, "To my way of thinking this or that doesn't hold water"; but this is not counting a man for nothing. I am not Father's enemy if I tell him some home truths occasionally—not even when I used some salty language in a fit of rage. Only it didn't help me, and Pa took offence. In case Pa alluded to my saying that the morality and religious system of ordained clergymen are not worth a fig to me since I have come to know so much of the other side of the picture, I decidedly will not take this back, for I really mean it. However, when I am in a quiet mood, I don't speak of it; but when they want to force me to go to church or attach value to doing so, it is only natural that I tell them, This is out of the question.*

Vincent did not act lightly, or in a fit of sudden anger. He had unconsciously left his religion behind him some months ago. Now he made up his mind and deliberately abandoned the religious beliefs which had once sustained him and led him to behave with a rare and unselfish humanity.

He did not turn back, and left his father's house to settle in The Hague; but before the door slammed behind him he had begun a personal adventure which was to have important consequences.

## BRIEF ENCOUNTER

It is difficult to compare Vincent's love for Kee with that for Ursula because of the different nature of the evidence. He left practically no record of what he felt about Ursula and how her refusal affected him. We must rely almost entirely upon the comments of his family, none of whom had met her or seen the two young people together. With Kee, on the other hand, the record of Vincent's passion has survived, if not in his letters to her, at least in his declarations to Theo. She was, moreover, a close relative whom his family knew well. Whereas Ursula's refusal turned him in upon himself, Kee's "No, no, never" drove him to violent action.

YOUNG GIRL KNEELING IN FRONT OF A COT IN WHICH A BABY IS SLEEPING. The Hague, April 1883, charcoal heightened with white, 48×32 cm. F 1024. Vincent van Gogh Foundation, Amsterdam. —The girl, is probably Sien's younger sister and in the cot is Sien's baby, Willem.

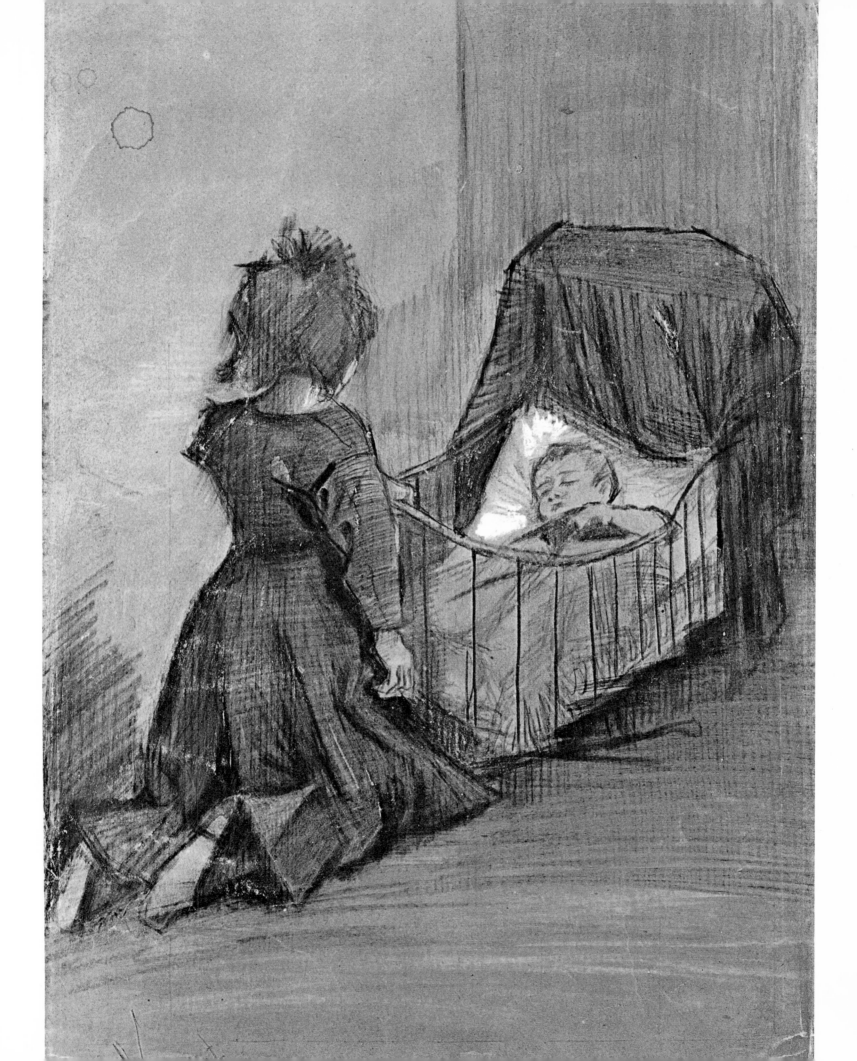

J. H. Weissenbruch. Photograph A.I.v.G.—From his earliest letters to Theo, Vincent showed a great admiration for Weissenbruch's work. He made his acquaintance at The Hague and called him "Merry Weiss". Vincent willingly admitted that he had profited from the older man's experience, and Weissenbruch appreciated Vincent's daring attempts. He greatly admired "SORROW".

George Hendrik Breitner. Photograph A.I.v.G.—At The Hague Vincent made the acquaintance of a young painter called Breitner. For some time they went on excursions together and sketched landscapes. It became clear later on that Breitner had no inkling of Vincent's artistic genius.

Anton Mauve. Photograph A.I.v.G.— At Etten Vincent hoped he would make quicker progress if he took lessons from an experienced artist. So he went to The Hague, where Mauve, a member of The Hague School, lived. Vincent admired Mauve's work but they soon quarrelled. Yet when Mauve died in 1888, Vincent dedicated one of the finest canvases of his Arles period to his memory.

J. van der Weele. Photograph A.I.v.G.—Towards the end of 1882, Vincent was visited by the painter van der Weele, whose studio he had already seen. This young fellow-painter encouraged Vincent's work.

The Hague district hospital. A.I.v.G.—Towards the end of 1882, Vincent was admitted to this hospital, which still exists, but is here shown in an engraving of the period.

Extract from the patients' register. Archives of The Hague district hospital.—Vincent van Gogh, then aged twenty-nine, and living at No. 133 Schenkweg, was admitted as no. 349 on June 7, 1882, in Ward VI, bed no. 9, and left on July 1. According to the diagnosis he was suffering from gonorrhea, and he was given injections of zinc sulphate. He was in hospital for twenty-three days.

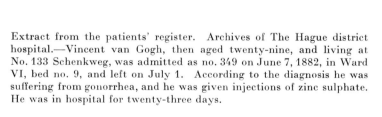

Furthermore his passion for Kee had a much stronger sensual element than his love for Ursula seven years before. Kee's refusal left his physical desires unabated, and this had serious results. Vincent did not turn in upon himself but looked for another woman. He wrote to Theo: *I am a man, and a man with passions; I must go to a woman, otherwise I shall freeze or turn to stone.* And he added: *One cannot live too long without a woman with impunity.*

He did not, as he wryly admits, have far to look. The woman that he found was not young nor beautiful, she was tall and well built with hands that had done much work, but *She was not coarse or common,* and there was something very womanly about her. Life had not spared her, yet, as Vincent said: *Every woman at every age can, if she loves and is a good woman, give a man, not the infinity of a moment, but a moment of infinity.* He added in the same letter: *You see I am not quite an innocent greenhorn or a baby in a cradle. It is not the first time I was unable to resist that feeling of affection, aye, affection and love for those women who are so damned and condemned and despised by the clergymen from the pulpit. I do not damn or condemn them, neither do I despise them. I am almost thirty years old—would you think that I have never felt the need of love?*

He was attracted to her not only because of his own sensual needs, but also because she represented the same kind of poverty and misery that he had tried to serve in the Borinage and to depict in his artistic work since then.

## THE NEED FOR LOVE

Such was Vincent's reaction away from the idealized love of Kee to an affection for the outcasts of society, so despised by the Church. *The clergymen*, he wrote, *call us sinners, conceived and born in sin, bah! What dreadful nonsense that is. Is it a sin to love, to need love, not to be able to live without love? I think a life without love a sinful and immoral condition.* One immediately recalls Jesus's question: "Which of you convicteth me of sin?" Vincent continues: *If I repent anything, it is the time when mystical and theological notions induced me to lead too secluded a life. Gradually I have thought better of it. When you wake up in the morning and find yourself not alone, but see there in the morning twilight a fellow-creature beside you, it makes the world look so much more friendly. Much more friendly than religious diaries and whitewashed church walls, with which the clergymen are in love.*

MAN WITH CLAY PIPE AND BANDAGED EYE. The Hague, December 1882, black chalk, wash and heightened with white, 45 × 27.5 cm, F 1004. Kröller-Müller State Museum, Otterlo.

MAN WITH A WALKING-STICK. The Hague, October 1882, pencil. 48.5 × 26 cm, F 958. Collection estate of H. P. Bremmer, The Hague,

OLD PENSIONER. The Hague, October 1882, pencil, 47.5 × 26 cm, F 960. Vincent van Gogh Foundation, Amsterdam.

OLD PENSIONER HOLDING A GLASS IN HIS RIGHT HAND AND A HAND-KERCHIEF IN THE LEFT HAND. The Hague, October 1882, pencil, 49 × 25 cm. F 959. Kröller-Müller State Museum, Otterlo.

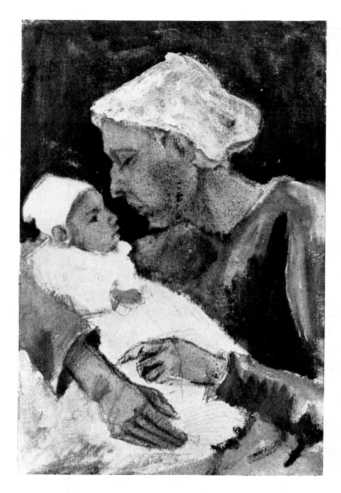

MOTHER AND CHILD (right). The Hague, spring 1883, charcoal, pencil, heightened with white and bistre wash, 53.5 × 35 cm, F 1067. Vincent van Gogh Foundation, Amsterdam.

MOTHER WITH HER CHILD ON HER RIGHT ARM. The Hague, April 1883, watercolour, pencil, heightened with white oil-paint, 40.5 × 24 cm, F 1061.

WOMAN SEATED ON AN UPTURNED BASKET AND CRYING. The Hague, March-April 1883, black chalk, wash, heightened with white, 47.5 × 29.5 cm, F 1060.

MOTHER WITH CHILD ON HER KNEE. The Hague, spring 1883, black chalk, wash, heightened with white, 41 × 27 cm, F 1066.

These three drawings are in the Kröller-Müller State Museum, Otterlo.

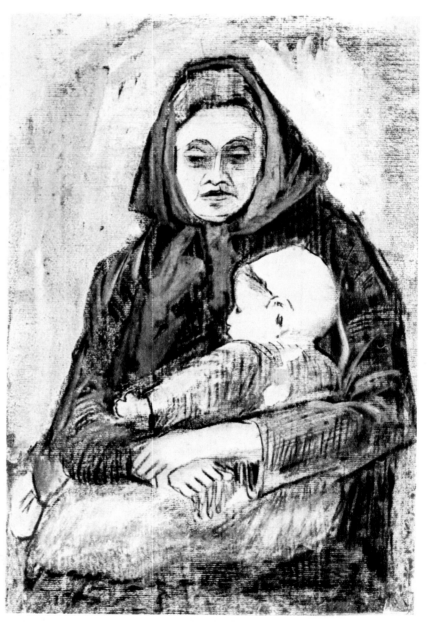

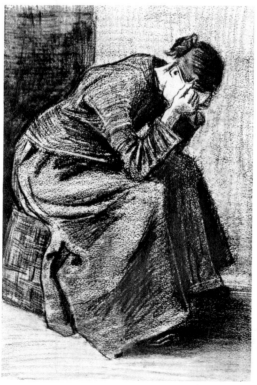

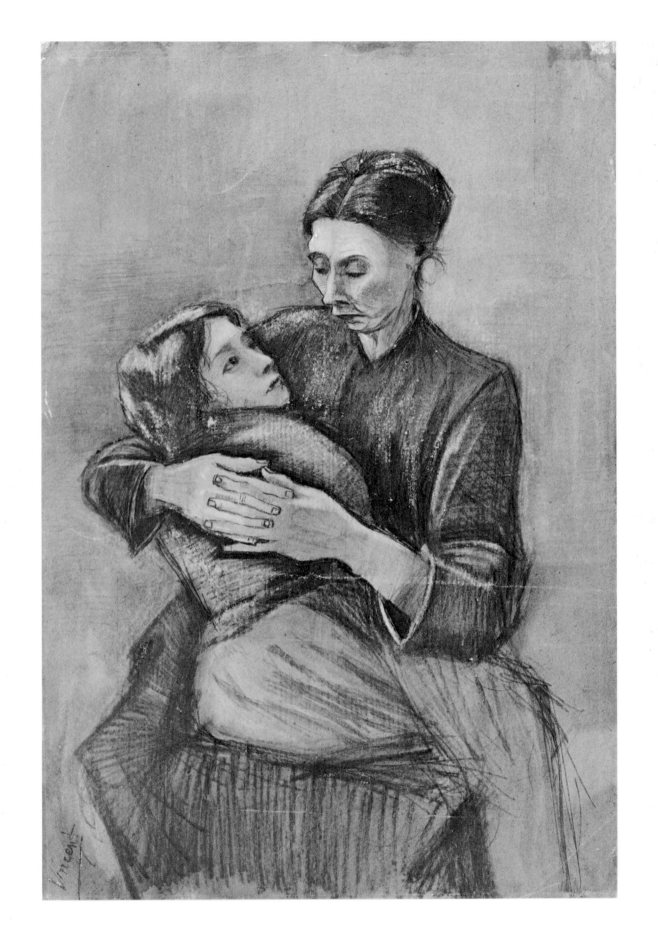

91

He seems suddenly to have broken out of the strait-jacket of artificial morality which had for so long bound his natural human feelings.

The nameless prostitute did not steal his money. *Oh, he who regards all such women as cheats,* Vincent exclaimed, *how wrong he is, and how little understanding he shows! She was good to him, very good, very kind.* They did not spend much money together. *Listen,* he said to her, *you and I don't need to make ourselves drunk to feel something for each other; just put what I can spare in your pocket. And I wish I could have spared more,* for she was worth it.

They talked about her wretched life, and, still feeling bitter towards his family, Vincent added: *I had a more interesting conversation than, for instance, with my very learned, professorial uncle.* No doubt he would have added his learned parsonical father if he had not wanted to preserve Theo's respect. *Now I tell you all these things,* he explained, *hoping that you will see that though I have some sentiment, I don't want to be sentimental in a silly way; that I want to preserve some vitality and keep my mind clear and my health good in order to be able to work.*

The woman lived in *a modest simple room* with a *quiet grey tone, yet warm like a picture by Chardin.* In his description it seems more like one of his own pictures, such is the plain realism combined with warm affection: *a wooden floor with a mat and a piece of old crimson carpet, an ordinary kitchen stove, a chest of drawers, and a large simple bed—in short, the home of a real working woman. She had to stand at the wash-tub the next day. Very good, quite right. She would have been as charming to me in a black petticoat and dark blue camisole as she was now in a brown or reddish-dress grey. And she was no longer young, was perhaps as old as Kee, and she had a child—yes, she had had some experience of life, and her youth was gone, gone!*

Vincent did not mention this woman again in his letters, and there is no way of finding out more about her. Some of van Gogh's biographers have identified this faded prostitute with the woman who shared his life a few weeks later. But personally I think that Dr Jan Hulsker is right in thinking that the letters make it clear that they are two different people. The unknown prostitute had soothed the pain left by Kee. She had provided what

MEN AND WOMEN WORKING. The Hague, April-May 1883, pen and pencil, 11.3 × 21 cm, F 1030. Vincent van Gogh Foundation, Amsterdam.

Vincent called *the stimulus, the spark of fire we want, that is love, and not exactly spiritual love.* Henceforth he was rarely to find it except with prostitutes.

## ARTISTIC COMPANIONSHIP

Vincent's quarrel with his father was not his only motive for leaving Etten. In that lonely village in the heaths of North Brabant there were no other artists with whom he could discuss his work, which was essential if he was to make rapid progress, and he was obliged to make a lengthy journey to The Hague in order to do so. Although Kee's refusal had not had the same kind of dispiriting effect that Ursula's had done, but had served only to increase his artistic determination, he still needed understanding and encouragement in his new career as well as technical advice upon which he could rely.

When, some ten months after the event, Vincent described in the words already quoted in the previous chapter how he *felt that love die* he added a few lines later: *I threw myself into my work with all my strength.*

In this way Kee's blunt refusal to marry him may be said to have hastened his artistic development.

He had learnt all that he could teach himself. He now wanted to be sure that he was on the right road and to have his own judgement confirmed by another artist, preferably someone with experience and formed views whose work was on the same lines as his own. Vincent thought first of van Rappard, but he did not live in the neighbourhood. He had, of course, met many artists when he worked for Goupil & Cie, and he expected to renew their acquaintance. But first he turned to Anton Mauve.

## VINCENT AND MAUVE

There is no doubt that Mauve felt well-disposed to Vincent: he helped him as an artist and lent him money so that he could take a studio nearby. Vincent sincerely admired Mauve and never forgot the help he had received from this generous and talented painter at a crucial moment in his life. Even when their personal relations were most embit-

THE SAND-PIT WITH MEN AT WORK. The Hague, April-May 1883, pencil, 10.5 × 21 cm, F 1028. Vincent van Gogh Foundation, Amsterdam.

H. G. Tersteeg. Photograph in the collection of **Mrs** Tersteeg, The Hague.—This photograph was taken about fifteen years later than the portrait that **appears** on page 39.

tered, Vincent never faltered for a moment in his admiration for Mauve's work. Seven years later, after Mauve had died, Vincent expressed these feelings by dedicating a masterpiece to his memory.

Until he went to The Hague and benefited from Mauve's instruction, Vincent had been working mainly in monochrome, drawing in pencil or pen and ink. There was a good reason for this. Although the content and subject of his work arose from the highest motives, his first intention was to be what would now be called a commercial artist. He wanted to learn to draw well enough to be able to earn money from the illustrated magazines. He admired the work of the English and French wood-engravers, and often referred to them in his letters.

Mauve's advice helped Vincent to make rapid progress, and there are many passages in his letters of the beginning of 1882 that bear witness to this. *Drawing*, he wrote, *becomes more and more a passion with me, and it is a passion just like that of a sailor for the sea.* He continued: *Mauve has now shown me a new way to make something, that is, how to paint water-colours. Well, I am quite absorbed in this now and sit daubing and washing out again; in short, I am trying to find a way. "Because one must make efforts like those of the lost souls. Because there is something diabolical about executing a water-colour. Because there is something good in every energetic motion."*

LOOSDUINEN SEEN FROM A SAND-DUNE. The Hague, 1883, pencil, 26.5 × 45.5 cm, signed at bottom left. Groningen Museum, Netherlands.

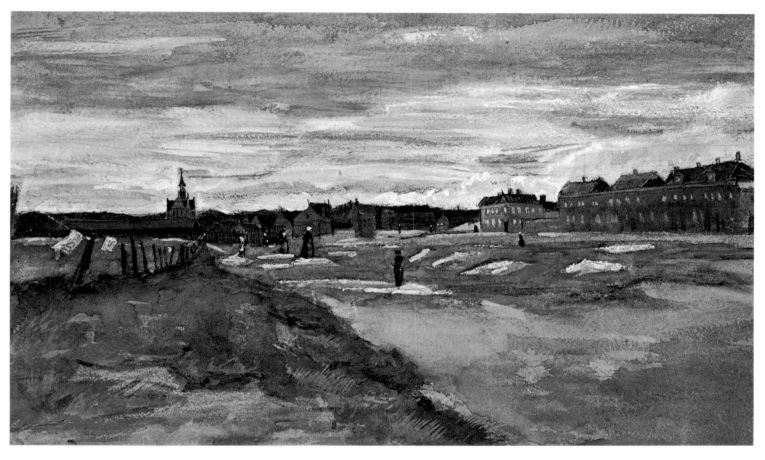

WASHING AT SCHEVENINGEN. The Hague, July 1882, water-colour on torchon-paper, 32 × 54 cm, F 946. Private collection, Netherlands.—On the back of this picture there is a sketch of a woman's head. This water-colour belonged to Margot Begemann, who was given it by Vincent.

One can see at a glance that his water-colour of a Scheveningen woman is the result of remarkable skill acquired in a very short time. From then onwards Vincent began to do more work in colour, though his passionate interest in theories of colour did not come until later. He remarked at the time that he was glad he had stuck relentlessly to drawing figures, rather than landscape, in which he was apt to get bogged down. Some of his figures show that he was right. But, of course, not all his work at this period shows similar progress.

These happy relations between the master and his pupil did not last very long. We have only Vincent's version of how their friendship broke up, and one must not forget his difficult and unusual character which could try even the most understanding of men. According to Vincent's account, around the end of January Mauve's attitude to him began to change, and he suddenly became as unfriendly as he had been welcoming. Vincent's explanation was that Mauve's own work was not going well and that he had fallen ill. He had already once said to Vincent: "I am not always in a mood to show you things: sometimes I am too tired, and then you will damn well have to wait for the right moment." One evening soon afterwards Mauve began to imitate Vincent in what the young man thought was a spiteful way, saying "Your face looks like this," "You speak like this." In the letter in which Vincent described this incident he added: *But he is very clever at those things, and I must say that it was like a good caricature of me, but drawn with hatred.* In a later letter he told Theo that he replied: *My dear friend, if you had spent rainy nights in the streets of London or cold nights in the Borinage— hungry, homeless, feverish—you would also have such ugly lines in your face and perhaps a husky voice too.*

95

## THE PAINTER AND
## THE RESPECTABLE GENTLEMAN

Mauve continued to be hostile. When Vincent called he was told that the painter was out. And naturally Mauve never came to Schenkweg. But one day the two men met by chance on the dunes, and it was clear how deep the rift had become. Mauve said that he would never retract. When Vincent asked him to come and see his work and talk things over, Mauve said: "I will certainly not come to see you, that's all over. You have a vicious character." Deeply hurt, Vincent turned and walked away.

Vincent, for all his faults, was a man of uncommon integrity, honesty and generosity. Why did Mauve call him vicious? No doubt his self-control was impaired by his illness, and no doubt Vincent, for reasons that have already been discussed, was, though desperately willing to learn, a very intractable pupil.

THE SOUP-KITCHEN. The Hague, spring 1883, black chalk. Private collection, Netherlands.

Vincent had, at about this time, been urging Theo to become a painter, and he wrote: *What you have learned at Goupil's, your knowledge of many things, will simply enable you to overtake many who "started early". For those early beginners often have a sterile period, remaining on the same level for years; someone who begins energetically later on need not go through such a period.*

One of the subjects of Vincent's disagreement with Mauve was drawing studies from plaster casts, for, although Vincent came to loathe working from such dead objects and did not use them at this time, he did possess a few casts of feet and hands.

He explained to Theo that: *Once he spoke to me about drawing from casts in a way such as the worst teacher at the academy would not have spoken; I kept quiet, but when I got home I was so angry that I threw those poor plaster casts into the coalbin, and they were smashed to pieces. And I thought, I will draw from those casts only when they become whole and white again, and when there are no more hands and feet of living beings to draw from. Then I said to Mauve, Man, don't mention plaster to me again, because I can't stand it. That was followed by a note from Mauve, telling me that he would not have anything to do with me for two months.*

Towards the end of this period Vincent wrote to Mauve to congratulate him on a large canvas that he had just finished. Mauve did not reply, and Vincent wrote in his last letter: *Let us shake hands and not feel animosity or bitterness toward each other, but it is too difficult for you to guide me and it is too difficult for me to be guided by you if you require "strict obedience" to all you say—I cannot give that. So that's the end of the guiding and being guided. But it does not alter my feeling of gratefulness and obligation toward you.*

Mauve did not reply to this letter either.

## SELF-RESPECT

Mauve was peculiarly unfortunate in the incident of the casts. Vincent could not produce a living picture from a dead object, and to attempt to do so would have betrayed all his artistic principles. When he said *I cannot give that* it was final. All his work was to be inspired by strict fidelity to nature. His aim was to penetrate the spirit of the subjects he depicted. And casts have none. Later, when he had

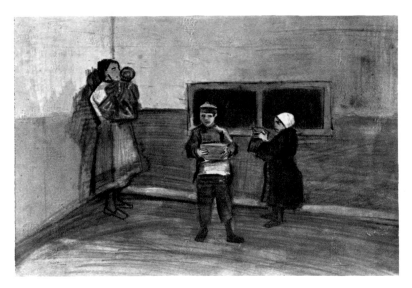

The idea of drawing a soup-kitchen, as we see from his letters to Theo, occupied Vincent for several weeks in the spring of 1883 at The Hague. He first did a sketch in the cookhouse where the soup was doled out. He sketched a second plan for such a picture in a letter which is reproduced here (letter no. 272, Vincent van Gogh Foundation, Amsterdam). He did the final picture in pencil, chalk and gouache, heightened with white and to different proportions, 33 × 49 cm (collection of M. A. Menko, Enschede, Netherlands). The enlarged details show the liberties that Vincent was already beginning to take.

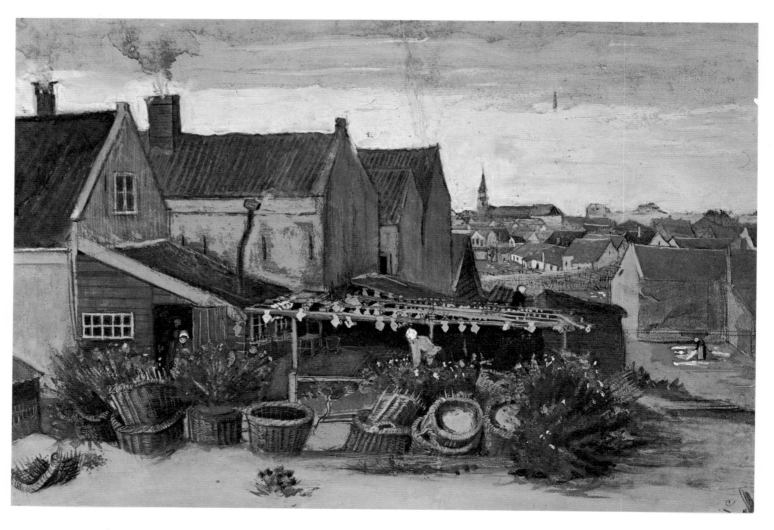

FISH-DRYING AT SCHEVENINGEN. The Hague, July 1882, water-colour 35.5 × 52 cm, F 945. Collection estate of H. P. Bremmer, The Hague.

seen some really good casts of important classic sculpture, he revised his view of them a little.

Mauve was also offended because Vincent had said: *I am an artist*. This he took to be blatant arrogance. But Vincent was not claiming to have reached his goal—only that he was sincerely in search of it. Even so Vincent's artistic vision already far surpassed that of his master, and today Mauve's name is remembered only because of his pupil's fame. Yet Vincent liked Mauve and admired his work. He was deeply hurt by being cast off by the man who had originally said to him: "You need money, I will help you earn money, you may be sure that now your hard years are over and the sun is rising for you—you have worked hard and honestly deserve it."

## DISAPPOINTED HOPES

When Vincent went to The Hague in December 1881, he hoped not only to meet other artists, but also to be able to sell his work to H. G. Tersteeg, under whom he had once worked at Goupil & Cie and with whom Theo had close business connections.

Both brothers were still on good terms with the Tersteeg family, and Johan Tersteeg has told how in the summer of 1882 he and his sister Betsy, then aged nine and thirteen, went for a walk with Vincent in the Frankenslag quarter, which had not then been built up. The sun was blazing, and the two children chose a path in the shade, but Vincent walked bareheaded along the top of the dunes. Betsy was

worried that their friend might get sunstroke, and asked: "Why do you walk in the sun all the time, Vincent?" He replied: *It is a sacrifice I must for art*. Even if somewhat ironic, this reply seems a little absurd. But one must not forget his masochism, or fail to appreciate his determination to enjoy the view of the sunlit countryside.

Vincent's relations with Tersteeg himself soon deteriorated, and this art-dealer, capable and diligent though he was, begins to appear in a rather unattractive light. Although Theo had written: "Tersteeg has been almost like an older brother to us, try to stay friends with him," Vincent could not help reproaching him and wrote: *For years I personally have seen only his unfriendly and harsh side. In all those years, between the time when I left, or got my dismissal from Goupil and the time when I began to draw (which I acknowledge was a mistake not to have done at once), in those years when I was abroad without friends or help,* *suffering great misery (so that in London I often had to sleep in the open air, and did so three nights in succession in the Borinage), did he ever give me a piece of bread? Did he ever encourage me, he who knew me of old, did he ever lend me a helping hand when I almost broke down? I think not. Did he ever help me in any way? No, except when he lent me the Bargues after I had literally implored him four times. When I sent him my first drawings, he sent me a paintbox but not a cent of money. I readily believe those first drawings were not worth any money; but, you see, a man like Tersteeg might have argued, "I know him of old, and I will help him get on," and he might have known I needed it so badly in order to live. When I wrote him from Brussels, "Wouldn't it be possible for me to work in The Hague awhile and have some intercourse with painters?" he tried to put me off, and wrote, "Oh no, cetainly not, you have lost your rights"; I had better give lessons in English and French; of one thing he was sure,*

MR ENTHOVEN'S FACTORY. The Hague, March 1882, water-colour, 35.5 × 49.5 cm, F 926. Collection estate of H. P. Bremmer, The Hague.

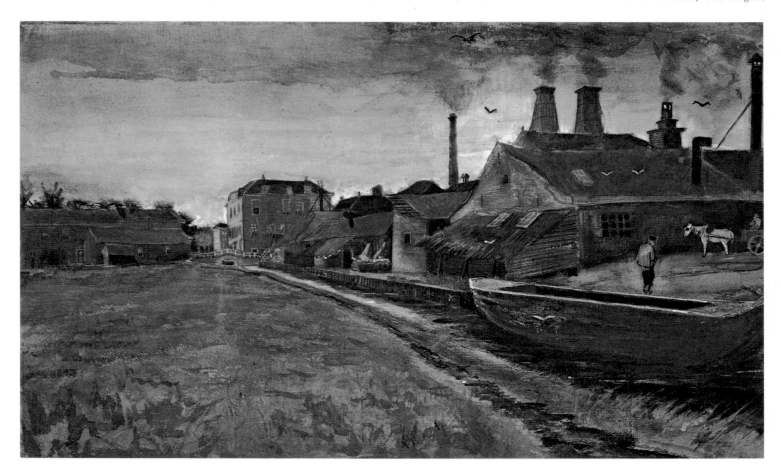

99

*I was no artist. Or I had better try to get copying work from Smeeton and Tilly, though the latter was not exactly in my neighbourhood, and besides, in Brussels several lithographers had refused me this; there was no work, business was slow, was the answer. When I showed him drawings again last summer he said: "I hadn't expected this." But he didn't help me, and didn't take back what he had said before. When I came to The Hague after all, without asking his advice, he tried to cut me out; I hear he laughed at my becoming a painter. I perceived that Mauve thought me a greenhorn. . . .*

Tersteeg was not content to mock at Vincent's ambition to be a painter. He also used threats and said: "Mauve and I will see to it that you don't receive any more money from Theo." Vincent felt he was being betrayed, and realized that it was Tersteeg who had set the weak Mauve against him. Tersteeg did absolutely nothing to help Vincent in the way of business, despite the artist's affection for his children, so it is not surprising that van Gogh's biographers have usually painted him in most unflattering colours.

Tersteeg never attempted to justify his dispute with Vincent, trusting to his own good reputation and the fact that the painter was generally thought to be mad. Tersteeg was a handsome man, always beautifully turned out with his elegant top-hat, his leather gloves and his cane. He was so reserved as to be known as "the closed book", and in every respect was at the opposite pole from Vincent, who looked like a vagabond at this period at The Hague.

Tersteeg was convinced that Vincent was mad, and was taking advantage of his brother. This is what he told his son Johan, who shared his father's view. He had noticed Vincent's strange behaviour when he first knew him, and believed it was due to an inferiority complex inherited from his father. But none of this excuses Terteeg's cold and tyrannical treatment of a man who was only eight years younger than himself.

There is, indeed, little doubt that Vincent felt uncomfortable in this little artistic world. With his careless and unorthodox way of dressing, his gruff voice, his penchant towards the poor and ugly parts of the city, he must have scandalized his brother painters just as he had scandalized the art-dealers and pastors with whom he had been associated before.

He was himself fully aware of his unprepossessing appearance and realized that he did not fit well into this new milieu. He suffered a great deal because of this but, as he explained to Theo, he could not change the way he was. Only in his shabby old clothes and only when he was working among the poor and downtrodden did he feel really at ease.

STRANGE TREATMENT

Tersteeg pretended that he was trying to help Vincent, whom he considered to be a young man of good family who was lowering himself by associating with common people. He maintained that by criticizing Vincent and cutting off his money he would force him to take up some useful employment, though this hardly agrees with his theory that Vincent was mad, for one cannot starve a madman into sanity.

When, in his pompous and business-like way, Tersteeg talked about useful employment he meant of course that Vincent should be prepared to earn his own bread and not rely on Theo to finance him. Vincent tried to justify to himself and to his friends and relations his own moral attitude on this score. In one of his letters to van Rappard he explained that to him it seemed less a matter of earning one's bread than of meriting it. If he went on working hard, he added hopefully, his work would soon bring him in some money. To Theo he confided that he looked forward to the day when his art would support him, just as the work of a blacksmith or a doctor supported them.

Vincent's distrust of Tersteeg soon began to verge on persecution mania. He was never very articulate in his speech at the best of times, and he now found it almost impossible to argue with him. He wrote to Theo: *When I go to see Mauve or Tersteeg I cannot express myself as I should wish, and perhaps I do myself more harm than good. When they are more accustomed to my way of speaking, they will no longer take offence.*

In the end Vincent came to the conclusion that, despite Tersteeg's refined manners and superficial elegance, there was something false about him: *Without doubting for a moment that his Honour is a clever man, another question is important to my*

VINCENT'S PERSPECTIVE FRAME. The Hague, August 1882, pen, 5.5 × 11 cm, Vincent van Gogh Foundation, Amsterdam.—Vincent based this screen on an original idea of Albrecht Dürer's. He used it out of doors, while Dürer did so only when working in the studio.

THE BEACH AT SCHEVENINGEN. The Hague, Autumn 1882, pen, 8.5 × 6 cm. Vincent van Gogh Foundation, Amsterdam.—In a letter to Theo Vincent drew this sketch of himself using his perspective frame.

THE FIRST PALETTE.—At the beginning of August 1882 Vincent began working in oils. He wrote to Theo: "Then, for oil painting, I now have everything which is absolutely necessary, and also a stock of paints, large tubes (which are much cheaper than the little ones); but you will understand that I limited myself to the simple colours in water colour as well as in oil: ochre (red—yellow—brown), cobalt and Prussian blue, Naples yellow, sienna, black and white, completed with some smaller tubes of carmine, sepia, vermilion, ultramarine, gamboge. But I refrained from choosing 'nice' colours, which one ought to mix oneself. I believe this is a practical palette with healthy colours." On his sketch of this palette, Vincent has written in the names of the colours in French, although the rest of the letter is, of course, in Dutch.

*respecting him. Is he a good man? That is to say, a man who does not nurture hatred, grudges, chicanery, sarcasm in his mind merely on principle. That is the question.* Vincent was right. Tersteeg was not a good man—as we shall find again on a later occasion.

## A COMPROMISING MODEL

Mauve and Tersteeg did not turn against Vincent only because they thought him an obstinate and pretentious ne'er-do-weel. They thought that he was concealing something shameful which he would not admit, although, on the contrary, Vincent was almost proclaiming it from the house-tops. In January he had met a woman who was pregnant and had been abandoned by the man whose child she bore, but for one reason or another Vincent did not reveal this to Theo until May. She was wandering the streets trying to earn her bread *you understand how*, as he wrote to Theo in this same letter.

He took her on as a model and worked with her all winter, sharing his food with her and protecting her from cold and hunger. He made her take baths and eat nourishing food and went with her to Leiden to register at the maternity hospital there. *It seems to me*, he wrote, *that every man worth a straw would have done the same in such a case. What*

WOMAN IN THE WOODS. The Hague, August 1882, water-colour, 34.5 × 24 cm, F 949. Collection of G. Cramer, The Hague.

*I did was so simple and natural that I thought I could keep it to myself. Posing was very difficult for her, but she has learned; I have made progress in my drawing because I had a good model. The woman is now attached to me like a tame dove. For my part, I can only marry once, and how can I do better than marry her? It is the only way to help her; otherwise misery would force her back into her old ways, which end in a precipice. She has no money, but she helps me earn money in my profession. . . . I thought I would be understood without words. I had not forgotten another woman for whom my heart was beating, but she was far away and refused to see me; and this one walked the streets in winter, sick, pregnant, hungry—I couldn't*

*do otherwise. Mauve, Theo, Tersteeg, you have my bread in your hands, will you take it from me, or turn your back on me? Now I have spoken, and await whatever will be said to me next.*

Dr Jan Hulsker has succeeded in identifying this woman and finding various details about her life. Her name was Clasina Maria Hoornik, but Vincent always called her Sien, the familiar version of her Christian name. She was born at The Hague on February 22, 1850, and was thirty-two when she met Vincent. She was the eldest of her parents' eleven legitimate children. She did not tell Vincent that she had had two illegitimate children in 1874 and 1879, who had since died. He only knew of the five-year-old daughter who lived with Vincent and her.

Filled with pity for this woman, a human wreck who was also addicted to drink, Vincent did not merely take care of Sien but he even thought of marrying her. It is easy to see how shocked his family of clergymen and art-dealers and all their friends would be at him living with a prostitute.

Vincent knew that he was compromising himself in the eyes of respectable citizens, but he did not see what harm there could be in his act of charity. He believed that he could not have done otherwise and that he could lead Sien to a better way of life.

He did his best to make Sien happy and to take care of her, no matter what might be said of him. His family's lamentations and Theo's warnings did not move him, although he had no money but what his brother sent him. He was convinced that he was right and would not accept that his behaviour was scandalous and shameful.

At one point Theo was obliged to warn him that his family was considering having him sent to the lunatic asylum at Geel near Antwerp. This news clearly alarmed him, but it did not make him change his plans for a moment.

THE REASONS FOR HIS ATTITUDE

The psychological motives for Vincent's behaviour were inspired partly by what he had been reading and partly by the overpowering desire to help the unfortunate.

In 1876 when he was in Paris he had read "Janet's Repentance", the third of George Eliot's tales in

102

*Scenes of Clerical Life*. It tells of the life of a clergyman who visited the people in the most wretched streets in a town and who died at the age of thirty-four. During his long illness he was cared for by a woman who had been formerly addicted to drink, but had been persuaded by the clergyman to overcome her passion and thus find peace. He had been much struck by this story, and seems here to be following this truly Christian example.

He also saw himself reflected in Zola's *Le Ventre de Paris* in which Madame François finds poor Florent lying unconscious in the road where the greegrocers' carts were passing, and she picks him up and takes him home in her cart even though the other green-grocers cry "Let the drunkard lie!" *See, Theo,* he wrote, *. . . I have done, and will do, for Sien what I think someone like Madame François would have done for Florent if he had not loved politics more than her. Look here, that humanity is the salt of life ; I should not care to live without it, that's all. I care as little about what Tersteeg says as Madame François cared about the other women and greengrocers when they cried, "Let him be, we have no time," and about all the noise and gossip. Then I must tell you that it will not be long before Sien earns her own bread by posing. My very best drawing,* SORROW—*at least, I think it's the best I've done—well, she posed for that, and in less than a year I shall draw the figure regularly. I promise you*

*that. For understand clearly that however much I may like landscapes, I love drawing the figure more. But it is the most difficult, and therefore costs me more study and work, and also more time. But don't let them tell you she keeps me from my work; at the studio you will see for yourself how things are. If it were true that I worked less for her sake, yes, then you would be right; but indeed, now it is exactly the reverse.*

In the same letter he speaks of his conception of love of his fellow-creatures: *I have always felt and will feel the need to love some fellow-creature. Preferably, I don't know why, an unhappy, forsaken or lonely creature. Once I nursed for six weeks or two months a poor miserable miner who had been burned. I shared my food for a whole winter with a poor old man, and heaven knows what else, and now there is Sien.*

Vincent's magnanimity was universal, and one is reminded of Raskolnikov throwing himself at Sonia's feet in *Crime and Punishment* and saying: "If I throw myself at your feet it is not because I wish to kneel to you, but I am prostrating myslf before the misery of all mankind."

Vincent was not the only one to act unselfishly. Sien also served him well, continually posing for him, sometimes with her children, and Vincent's drawing benefited greatly. Though sometimes crudely expressed some of these drawings have an emotive quality that was later to develop even more. Sien posed for "SORROW" and "THE GREAT LADY", two women who appear painfully naked before us, without physical charm, their poor bodies revealing with a shock the sufferings of a wretched and obscure life.

These powerful drawings are not the only evidence to contradict Tersteeg's gratuitous contempt for Vincent's draughtsmanship. There are many others, in particular some sketches of old men from the almshouse which are seen with a penetrating eye and drawn with a firm hand.

SOME FRIENDLY PAINTERS

Despite the behaviour of Tersteeg and Mauve there were fortunately other painters who were more friendly. Vincent's first introductions were to De Bock and Bakhuyzen, then he met Willem Maris. Soon afterwards he had a chance of showing his work to Bosboom. At the beginning of February he made friends with G. H. Breitner, who was later to become one of the most important Dutch painters.

For a while Breitner and Vincent often went sketching together. Some of their works show the qualities they shared, especially their choice of subject-matter, for instance in Breitner's *Distribution of Soup* and Vincent's THE SOUP-KITCHEN. Breitner, who became famous long before Vincent, never suspected van Gogh's genius, but then there were very few of his contemporaries who did so.

A most notable exception was J. H. Weissenbruch. When Vincent began working in the art-dealing business he greatly admired this artist of The Hague School who was already very well known. Thirteen years later they talked seriously about their work and visited one another's studios.

Weissenbruch, unlike Mauve or Tersteeg, was a gay companion who appreciated Vincent's self-taught but solidly based efforts. And Vincent was much stimulated by being encouraged by a practised painter, and he gladly admitted that he learnt much from the pictures painted by "Merry Weiss".

One of Weissenbruch's pictures was of great sentimental if not artistic importance in Vincent's life. This was the painting of the mill at Rijswijk where the two brothers had made their vow of eternal friendship. Vincent had sent a reproduction of it to Theo from London.

When Mauve had doubts about the young man's aptitude he asked Weissenbruch for his opinion. This was most favourable. Weissenbruch, though he claimed to be known as "the merciless sword" in his criticism of pictures, said that he had told Mauve: "He draws confoundedly well, I could work from his studies myself." When Vincent showed him his pen drawings, he said: "These are the best." When Mauve was ill, it was to Weissenbruch that Vincent went for news of him. Weissenbruch also had a considerable influence upon his work. In the painting THE BEACH AT SCHEVENINGEN the treatment of atmosphere and light clearly shows that Vincent had put Weissenbruch's advice to good use.

Van Rappard paid him a visit in May and was warmly welcomed, but for the most part their friendship was kept up by correspondence, which Vincent found helpful and encouraging.

Vincent infected van Rappard with his enthusiasm for wood-engravings, not as a form of art that they

should partake in, but as things to be collected and enjoyed. By June, Vincent had gathered together *about a thousand sheets — English (especially Swain's), American and French ones.* They had, of course, been paid for ultimately by Theo; *so this* Vincent wrote, *is something which belongs to you, though you don't know it. I only regret that I could not buy Doré's "London" recently—the Jew asked 7.50 guilders, but I could not afford it.*

He bought many copies of the *Graphic* and the *London News*, which were then illustrated by means of wood-engravings. Vincent greatly admired the artists who contributed to these magazines, although only a few of them are known today. He had already seen some of the illustrations when he was in London but it was not until this period at The Hague that he started his own collection. Although there is a great deal of variety in the subjects he collected, it is interesting that many of them have in common what

could be called social insight. It is not surprising that this element was appreciated by Vincent, feeling as he did strong bonds of sympathy with the poor and the underdog.

He explained further to Theo his obvious admiration of contemporary English authors and artists. He was attracted, he said, *because of their Monday-morning-like soberness and studied simplicity and solemnity and keen analysis, as something solid and strong which can give us strength in the days when we feel weak.* It was the wood-engravings, however, that held his particular interest, and his letters to his brother at this time are full of references to the subject and of descriptions of the latest additions to his collection.

Later he had plans for publishing engravings of artists' work in the magazines, but he deplored the fact that most painters other than van Rappard and himself would turn their noses up at them: *The an-*

LYING COW. The Hague, 1882, oil on canvas on panel, 30 ×50 cm.                    Private collection, Paris.

swer that many a painter here in Holland gives to the question "What is a wood-engraving?" is, "They are those things you find in the South Holland Café." So they class them with the drinks. And those who make them, perhaps with the drunkards.

Towards the end of the year he also made friends with H. J. van der Weele whose breadth of vision was, as we shall see, very helpful to him.

## AN INSIDIOUS AFFLICTION

There were more shocks for Theo. During the first fortnight of June 1882 he received a letter from Vincent which was written from the City Hospital of The Hague, which was—and indeed still is—at 83 Brouwersgracht, also known as Zuid-Wal.

This was his first serious illness. No doubt he had the usual childhood illnesses, but there is no actual mention of him being ill until July 1881, when he told Theo he had stayed in bed and had had a long talk with Dr van Gent. On January 22, 1882, he wrote to Theo: *This morning I felt so miserable that I went to bed; I had a headache and was feverish from worry. . . . And then I got up, but went back to bed* **again;** *now I feel a little better.* Four days later he wrote: *What I had already feared when I wrote you last has*

really happened, meaning that I have not been well, and have been in bed for almost three days with fever and nervousness, now and then accompanied by headache and toothache. It is a miserable condition and is caused by overexertion. And in the same letter: *But sometimes, like now, a heavy depression comes over me, and then it's hell.*

Then, with no other warning, he wrote in June from hospital: *For three weeks now I have been suffering from insomnia and low fever, and passing water was painful. And now it seems that I really have what they call the "clap", but only a mild case.*

He was in hospital for twenty-three days, being treated for gonorrhea with quinine pills and injections of pure water and alum water. Perhaps the earlier depressions he had suffered were the first symptoms of his infection.

In his letters he gives painfully detailed accounts of the treatment that he had to undergo. *Perhaps,* he wrote, *they are less afraid to hurt the patients a little here than in the more expensive wards, and, for instance, they often put a catheter into the bladder quickly, without "ceremony" or fuss. Well, so much the better, I think, and I repeat, I find it just as interesting here as in a third-class waiting room. If I could only work! But I must submit. I have a book by Dickens and my books on perspective with me.*

There may be a touch of masochism here, and also an expiation of his guilt. Moreover, while he was still in hospital Sien had to go into the maternity hospital, and he was aware that she deserved more sympathy than he did: *What are the sufferings of us men*, he wrote, *compared to that terrible pain which women have to bear during childbirth?*

Although Vincent did not conceal from Theo the nature of his illness, and he must have realized its origin, he did not show the least sign that he thought Sien was responsible, or even that Theo might blame her for it. On the contrary, his love and sympathy for her increased as the time for her child to be born came nearer, and he was touchingly anxious that she should also have Theo's understanding.

Just before Sien had to leave for hospital she came one day to tell him that a parcel had been left at the studio and that it proved to contain clothing and cigars as well as ten florins in a letter from his parents. They were more kindly disposed to him than he realized; and soon afterwards he had a short and no doubt rather strained visit from his father.

When Pastor Theodorus had first learnt that his son's model was such a disreputable woman he was much worried, and Johanna van Gogh-Bonger tells us that he wrote to Theo: "I hope there is no harm in this so-called model. Bad connections often arise from a feeling of loneliness or dissatisfaction."

## LIFE WITH SIEN

Vincent was hardly recovered when Sien, who was already in the maternity hospital at Leiden, gave birth to a son on July 2, 1882. He was called Willem. Vincent visited her in hospital, and was deeply moved by her happiness. *But what I most astonished at*, he wrote, *is the child; although it has been taken with forceps, it was not injured at all. It was lying in its cradle with a wordly-wise air.*

He had already begun to make new arrangements for accommodation. *So that she may find a warm nest*, he explained to Theo, *after she returns with so much pain*, he moved to a larger apartment where there was a studio, a little kitchen and a bedroom in the loft. Vincent was overjoyed with it: *If I had planned this new house myself with fitting it up as a studio in mind, I couldn't have done better than the way it is now.*

He had always wanted to have *a studio with a cradle, a baby's high chair—where there is no stagnation, but where everything pushes and urges and stirs to activity... the house is neat and bright and clean and well kept, and I have most of my furniture, beds and painting materials. It has cost what it has cost—indeed I shall not minimize it—but then your money has not been thrown away. It has started a new studio which cannot do without your help even now, but which is going to produce even more drawings....*

Sien settled in with him, and a new life seemed to be beginning. Vincent worked from morning to night, and she sat to him whenever she had the time. For the first time in his life, and almost the last, he really felt that he had a home of his own: and he had a passionate desire to believe in its permanence. His relations with Sien were a *reality*, and *The Studio looks so real, I think*, he wrote. He described it in detail to Theo, and it was the setting for many of his drawings, with its *plain greyish-brown paper, a scrubbed wooden floor, white muslin curtains at the windows, everything clean. And, of course, studies on the wall, an easel on both sides, and a large white deal working table. A kind of alcove adjoins the studio, there I keep all the drawing boards, portfolios, boxes, sticks, etc., and also the wood-engravings. And in the corner a closet with all the bottles and pots, and then all my books. Then the little living room with a table, a few kitchen chairs, an oil stove, a large wicker easy chair for the woman in the corner, near the window that overlooks the wharf and the meadows, which you know from the drawing. And beside it a small iron cradle with a green cover.*

He could not look at the cradle without emotion, and in his marvellous drawings of Sien's baby in it we can share something of what he felt. In this unlikely household he found a passionate domesticity, and it inspired some of his most moving work.

But this happiness did not last long. Tersteeg paid a call. He was horrified by what he saw, and in his most supercilious and lofty manner demanded to know: *What was the meaning of that woman and that child? How could I think of living with a woman, and children into the bargain? Wasn't it just as ridiculous as driving my own four-in-hand all over town? Had I gone mad? It was certainly the result of an unsound mind and temperament.*

Not content with this personal attack he went on to disparage Vincent's pictures and to say not only that

108

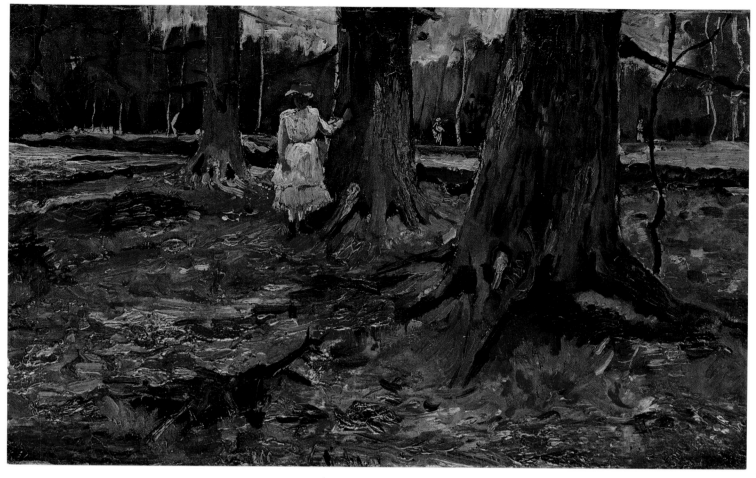

YOUNG GIRL IN THE WOOD AT THE HAGUE. The Hague, September 1882, oil on canvas, 39 × 59 cm, F. 8, H 10. Kröller-Müller State Museum, Otterlo.—The theme of a girl in white against a tree was inspired by the English illustrator Perry McQuoid. Vincent wrote to van Rappard around September 15 1882: "I think I have already given it [another engraving by McQuoid] to you, as well as the 'Girl in White' leaning, against a tree." On the left: detail of the girl's dress (×16).

he would not buy them but he would also warn his fellow art-dealer, Vincent's Uncle Cor, against ordering any more drawings of the town.

NEW MEDIA

Though Vincent was distressed and exasperated by Tersteeg's behaviour, he was not discouraged about the prospects of earning his living as an artist or as an illustrator. He went on piling up drawings that were full of life. And in August, after this long and hard preparation, he turned suddenly to oils. After mentioning this briefly in a letter to Theo, he dashed off yet another: *You must not take it amiss if I write you again—it is only to tell you that painting is such a joy to me.*

These first pictures were *thickly painted* and sticky, but he boldly claimed: *I am sure no one could tell that they are my first painted studies... I think the reason is that before I began to paint, I had been drawing so much and had studied perspective in order to build up the composition of the thing I saw.*

He had found perspective particularly difficult at first. He was constantly reading about it, and he had been delighted when he learned about *an instrument for studying proportion and perspective, the description of which can be found in a book by Albrecht Dürer, and which the old Dutch masters also used.*

Vincent had a perspective frame made by a carpenter and a blacksmith, and soon he was using it constantly. He drew a diagram of it and a little sketch of himself using the device.

During Vincent's period at The Hague he made notable advances in different kinds of artistic technique. Mauve introduced him to water-colours, he tackled oils for himself, and before the end of 1882 he had started to draw lithographs, including a fine one of his drawing of Sien, pregnant and naked, which he entitled "SORROW".

Vincent was right to be pleased with his first canvases, for they show he was still struggling to master the medium, yet they have some unexpected qualities. THE BEACH AT SCHEVENINGEN, LYING COW, and YOUNG GIRL IN THE WOOD AT THE HAGUE, to mention only three, show that Vincent could have made a fortune if he had not insisted on being a pioneer but been content to produce seascapes and landscapes of this kind. He would have been an ornament to The Hague School instead of annoying some of its more influential members by his daring innovations.

I am convinced, and it cannot be stressed too often, that Vincent had little interest in the skill of others and was not put out by his own reputation for lack of ability. He was seeking, utterly alone, for a type of ability which no one before him had set as a precedent for future artists.

Vincent's character, which was both so tender and so firm, was already breaking free from the safe and easy road of tradition. He was determined to go his own way and develop his own personal style, whatever it might cost him.

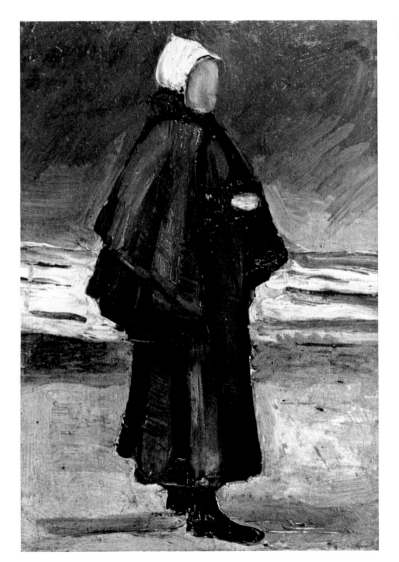

FISHERWOMAN ON THE BEACH. The Hague, August 1883, oil on canvas on panel, 51 × 33 cm, F 6, H 3. Kröller-Müller State Museum, Otterlo.

PEASANT AT WORK. The Hague, August 1883, oil on wood, 31 × 29.5 cm, F 12, H 13. Private collection, Germany.

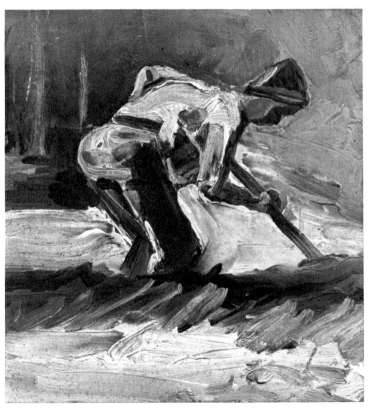

# AUTUMN
# IN DRENTHE

On Tuesday September 11, 1883, Theo received the first letter that Vincent wrote to him from Hoogeveen in the province of Drenthe in the north of Holland. He had known all about the impending move, indeed he had encouraged it, for it would mean that Vincent would have to leave Sien. His departure from The Hague had put an end to a troublesome situation, and had answered his family's prayers.

Naturally Vincent would not have abandoned a woman for whose sake he had suffered considerable odium unless he had very good reasons. What had happened? Somerset Maugham has said that there is no viler form of cruelty than that of a woman towards a man who loves her but whom she does not love: she can forgive the man for doing her harm, but never for the sacrifices he has made for her sake. This was the situation in which Vincent found himself.

His love for Sien, the ugly, worn-out prostitute, was absolutely sincere. In January 1878 his Uncle Cor had asked him, apropos of a nude by Gérôme, whether he would not be attracted by a beautiful woman. Vincent replied: *I would feel more attraction for, and would rather come into contact with, one who was ugly or poor or in some way unhappy, but who, through experience and sorrow, had gained a mind and a soul.* This was a remarkably accurate, if idealized, picture of how Vincent was to see Sien.

He admitted that he had never felt any passion for this woman and that he felt none when he left her; but they had needed one another. His feeling for her when they met was one of pity, and so it remained to the end—to the exclusion of all else.

## THE SCALES FROM HIS EYES

Nevertheless, in his own strange way, he loved her. But eventually he realized his illusions about her. Sien did not love him. She was not even really grateful to him for having come to her rescue. She had merely taken advantage of his innocence to extricate herself from her difficulties.

At first she sat to him. But she was lazy, and soon she went back to drinking and smoking cigars. Vincent found that the family life which he had so enjoyed at first had now become intolerable. Instead of a "warm nest" kept by a kind and biddable woman, he had to live in a squalid studio with a coarse and dirty pock-marked hag, who spoke vilely and stank of liquor and tobacco; who involved him in her shady dealings and even relapsed into her old ways of prostitution.

Vincent was always trying to prevent her from seeing so much of her mother. He wrote to Theo:

*You will get a small proof of how infirm the woman's character is when I tell you that notwithstanding her recent positive promise not to go to see her mother again, she has been there after all. I told her that if she could not keep such a promise for even three days, how could she expect me to think her capable of keeping a promise of faith for ever. For I think this very mean of her, and must almost suppose that she belongs more to those people than to me. Then she says that she is very sorry again, but—tomorrow she will do it again, that's what I'm beginning to think, but she says—"Oh no." In this sense I am almost sorry that I take things seriously. When I made her promise, I said to her, "It is a kind of prostitution when you go there for three reasons: first, because you used to live with your mother, and she herself encouraged you to walk the street; second, because she lives in a slum, which you, more than anyone else, have reason to avoid; and finally, your brother's mistress lives in the same house."*

And she would reply: "Yes, I am careless and lazy and I have always been that way, and it can't be helped," or, "Yes, it's true I'm a whore, and the only end for me will be to drown myself."

This prophecy came true. Dr Jan Hulsker has shown that twenty years later, on November 12, 1904, she was drowned. Three years previously she had gone through a marriage of convenience merely in order to legitimize her children.

On September 20, 1883, when he had just left Sien, Vincent wrote to Theo: *Women like her can be thoroughly bad (I do not speak here of the Nanas, hot blooded and voluptuous, but of the more nervous, reflective temperaments among them), women like her quite justify Proudhon's saying, "Woman is the desolation of the just"; they do not care at all for what we call reason, and they act straightway and wickedly against it.*

He had lost many illusions. When he had set up house with Sien and the children he had hoped that he would be able to support her with the money he earned by selling his drawings. But in nearly two years he had received no more than sixty guilders: ten from Tersteeg for one little drawing, and fifty from Uncle Cor for two sets of views of The Hague. This was no more than he could have earned in three weeks when he was a junior employee at Goupil's gallery in London. So all he had were the 150 francs that Theo sent him every month. This monthly allowance corresponded to slightly more than sixty guilders, but it was still less than he had earned in London, ten years earlier. It was not nearly enough to support them all and pay for his materials.

Vincent realized that it could not go on. He had done good work at The Hague. He had begun to master oils and water-colours, and his draughtsmanship had taken great strides forwards. He had even enjoyed some of his artistic ventures, but now it seemed as if all this good work might be wasted.

Theo paid a second visit in the summer of 1883, saw that things were going from bad to worse and that Vincent was running into debt, and urged him to leave Sien. Vincent, despite his scruples, had to admit that Theo was right, and wrote in a postscript to a letter: *No long ago you wrote me, "Perhaps your duty will make you act differently." That is a thing I thought over at once, and because my work so indubitably demands my going away, my opinion is that my work is my duty, even more immediate than the woman, and that the former must not suffer because of the latter.*

Nevertheless Vincent defended Sien to the end: *I think she has, for the moment, no better friend than me, who would help her with all my heart if she would let me. But she does not seek my confidence, and makes me absolutely powerless by trusting those who are really her enemies. I am amazed that she doesn't see that she acts wrongly—or doesn't want to see it, for that's what I sometimes think. The period when her faults made me angry is over, I went through it last year. Now when I see her falling into the same errors, I am no longer astonished, and if I knew it would save her, I think I would put up with them. Because my opinion of her is such that "quand bien même" I do not think her bad, she has never seen what is good, how can she be good. I mean she is not responsible, like somebody who understands the distinction between good and evil. That understanding only comes to her very vaguely and confusedly through intuition. I think if she knew what was right, she'd do it. . . . I am so anxious to save her that if, for instance, I could do so by marrying her, I would marry her even now.*

He also quoted Zola's remark in *L'Assommoir*: "Yet these women are not bad, the impossibility of living a straight life in the midst of the gossip and calumny of the suburbs is the cause of their faults and their fall." Such influences upon the character are now a commonplace of sociology and criminology.

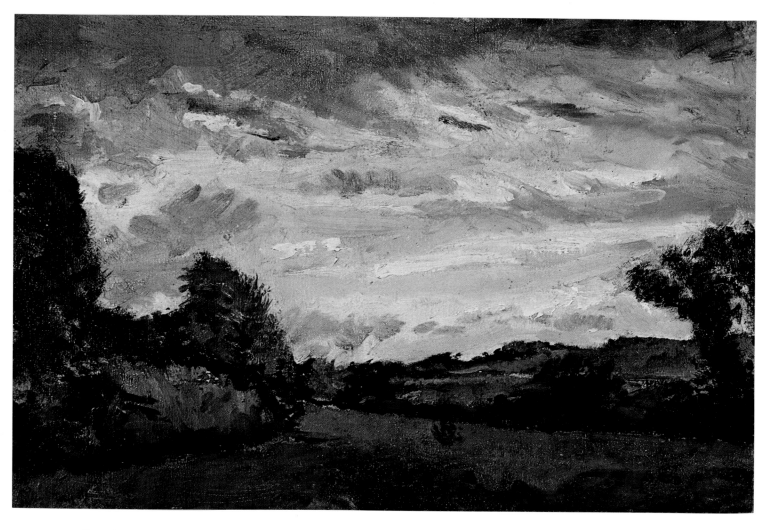

THE HEATH.   Drenthe, September 1883, oil on canvas, 33.5 × 48.5 cm, F 15 b, H 17.   Collection of Mrs A. M. Sythoff-Burgerhout, Netherlands.

## AN IMPORTANT ADMISSION

Sien's ingratitude, despite the risks he had run of forfeiting Theo's allowance, disillusioned him.   He spent a day preparing her for what was to come and explaining that he must leave, that she must try to work and pay off her debts.   And he urged that they should part on good terms.   He was clearly anxious about her.   Fortunately soon afterwards Sien's young daughter Maria Wilhelmina was entrusted to her grandmother, Maria Wilhelmina Pellers, and little Willem was handed over to his mother's brother, Pieter Anthonie Hoornik.

Vincent then terminated the lease on the studio. He had told Theo of two plans for the future:

either he would settle in Drenthe, where he hoped to make great progress in painting; or he would go to England, where he thought it might be easier to sell his work.   Perhaps he thought of becoming one of those black-and-white illustrators whose work, engraved by Swain's, he so much admired.

This second alternative was certainly based on commercial motives; there is no reason to think that he was influenced by any recollection of Ursula Loyer, for it was Kee who was most in his mind after he had parted from Sien—not that he mentions her name. *If I had had other chances*, he wrote to Theo, *had been in different circumstances, and if nothing decisive had happened, of course it would have influenced my actions.*   And he goes on: *A simple word about it*

Turf-thatched cottage with goat. Photograph in the collection of Margrit de Sablonière, Leiden, Netherlands.—In a letter to Theo, Vincent wrote: "While I was painting that cottage, two sheep and a goat came to browse *on the roof* of the house. The goat climbed on to the top and looked down the chimney."

LITTLE COTTAGE. Drenthe, October 31, 1883, pen, 4.5 × 5 cm. Vincent van Gogh Foundation, Amsterdam.—Vincent wrote: "I went again and again to look at it in the evening, and I found this cottage on a muddy evening after the rain; seen on the spot, it is splendid."

Peat-workers. Photograph in the Drenthe Provincial Museum, Assen, Netherlands.—Here men and women and children are all working together.

The old windmill near Schut. Photograph in the Drenthe Provincial Museum, Assen, Netherlands.—Vincent called it "a curious old mill".

THE PEAT-BOAT. Drenthe, October 1883, oil on canvas on wood, 33 × 45 cm, F 21, H 26. Collection of J. van Hoey Smit, Rockanje, Netherlands.

114

THE JEWISH CEMETERY. Drenthe, October 1883, pen, 10 × 14 cm. Vincent van Gogh Foundation, Amsterdam. Photograph A.I.v.G. —One of his walks took Vincent to Pette, near the Ruinen district, where he suddenly came upon the old Jewish cemetery. In the background of both the drawing and the photograph one can see a church tower behind the trees.

Lifting bridge at Hooge-veen. Photograph in the Drenthe Provincial Muse-um, Assen.—When Vin-cent was living at Hooge-veen there were many lifting bridges over the canal in the town centre.

Scholte hotel. Photo-graph A.I.v.G.—Vincent lodged in a little hotel near the canal and fa-cing the lifting bridge in Nieuw-Amsterdam. The proprietor of the hotel is second from the left.

PEASANT BURNING WEEDS. Drenthe, October, 1883, oil on wood, 30.5 × 39.5 cm, F 20, H 24. Private collection, Netherlands. Pen sketch in letter, 4.5 × 5.5 cm. Vincent van Gogh Foundation, Amsterdam.

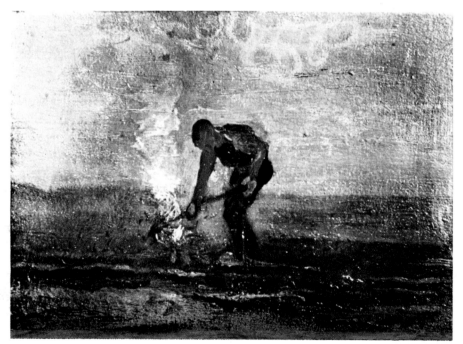

115

IN THE FIELD. Drenthe, September 1883, oil on canvas, 27 × 35.5 cm, F 19, H 23.　　　Vincent van Gogh Foundation, Amsterdam.

*during our walk made me feel that absolutely nothing is changed within me in that respect, that it is and remains a wound which I carry with me; it lies deep and cannot be healed. After years it will be the same as it was the first day. And finally: Since then, things have happened which would not have occurred if at a certain moment I had not been confronted firstly by a decided "no", and secondly by a promise that I should keep out of her way.*

Quite clearly he is talking about Kee, and this confirms the lasting wound which her "No, never" left in him, and which I have already mentioned in connection with A WALK IN ARLES.

## THE ROAD TO DRENTHE

As usual Vincent's move to Drenthe was foreshadowed by what seemed at first to be a casual mention. Then he began to go into it more fully, and finally he committed himself.

In August 1883 he wrote to Theo, without mentioning any particular place: *But a simple thought, which seems good to me just because of its simplicity, is that I should take no step other than going and living more cheaply somewhere in the country where the scenery is striking.* He did not specify what sort of scenery he sought, or where he was likely to find it.

116

A few days later he returned to the subject and laid his cards on the table. Van Rappard had been to see him and they had discussed the matter: *We spoke about Drenthe*, Vincent wrote, mentioning the place for the first time. *He is going there again one of these days, and he will go even farther, namely to the fishing villages on Terschelling. Personally I should love to go to Drenthe, especially after that visit from Rappard. So much so that I have already inquired if it would be easy or difficult to move the furniture there. ... Life is so much cheaper there that I think I should economize at least 150 or 200 guilders a year, especially on rent.* He had a map of Drenthe, a lonely inland area in the north-east of Holland, where there are no large cities and few towns, a flat rural landscape of black earth. On the map Vincent noticed there was a big white patch, with no names of villages, crossed only by the Hoogeveen canal, which ended suddenly, leaving nothing in the centre but the words, "peat fields". He had once read in an English review about a painter who had taken refuge in the peat fields to recover from a period of troubles, and who found himself inspired to portray the real nature of this sad landscape.

He was attracted to the landscape—though nobody without a painter's eye would have said that *the scenery is striking* in Drenthe. But he had another mo-tive. The area to which he was going was inhabited only by peasants, and it was the hard life of these people which Vincent had always wished to depict, whether the setting for his work was the mines of the Borinage, the almshouses of The Hague or the peat fields of Drenthe.

He also had reason to hope that he might not be quite alone: *I suppose if I settled down there, Rappard would visit that same neighbourhood even more often than now, so that we could profit a little from each other's company. As I told you, it was especially since his visit and our talking about the work that my mind became fixed on Drenthe.* He was also delighted to learn from van der Weele that the landscape there was beautiful and full of character. And Theo encouraged him to abandon his life in The Hague for every reason.

## TOWN VERSUS COUNTRY

There was also a more subtle and complex motive besides his desire to leave Sien and live among the peat-workers. He told Theo that he meant to work very hard in Drenthe: *I must do that in order to renew myself.* In a previous letter he explained that if he was to make any progress he would have to

FARM LABOURERS. Drenthe, October 1883, pen, 5 × 13 cm. Vincent van Gogh Foundation, Amsterdam. "Today," Vincent wrote, "I have been walking behind the ploughers who were ploughing a potato field, with women trudging to pick up a few potatoes that were left."

LIFTING BRIDGE (right). Drenthe, October 1883, water-colour, 38.5 × 81 cm, F 1098. Groningen Museum, Netherlands. Photograph (left) A.I.v.G.—From his window on the first floor of the Scholte hotel, Vincent had a typically Dutch view of the lifting bridge across the canal. On the left one can see the front of the van Dalen hotel, which has since been rebuilt, but can also be seen on Vincent's water-colour. He wrote in his correspondence about this picture: "Since then I have made a large painted one, and a large sketch of a drawbridge, and even a second painted one of it with another effect." This work is in fact a fairly large one.

*live with a farmer for a time, far, far away in the country—far away, alone with nature.* In another letter he says *I think this country* [round The Hague] *is beautiful too, but I want to be close to nature—far from the town. What we must try to do is to make my work more virile.*

Vincent's artistic life consisted of a fairly regular alternation between the town and the country. The sequence so far had been: Brussels, Etten, The Hague, Drenthe. With his move to Nuenen he remained in the country, but then he went to Antwerp and Paris, where he remained for two years. Then to Arles, a small town in the south of France

which still has much of the atmosphere of the country about it. This is certainly what it represented for Vincent, as can be seen from the number of landscapes he painted there. His voluntary confinement in the asylum at Saint-Rémy-de-Provence continued this country phase, but in the end he returned to Auvers-sur-Oise near Paris.

Born at Zundert in the country, Vincent was never at home for long in a town. His simple habits of dress and food were out of place there, and townspeople disapproved of him. After a while in town his longing to be alone in the country became an obsession, and he had to leave. But after a time in the

MAN WITH HARROW. Drenthe, November 1883, pen, 9 × 13 cm. Vincent van Gogh Foundation, Amsterdam. Photograph A.I.v.G.—This sketch appears in a letter, but without comment. This type of harrow is no longer used today, but a peasant in Drenthe showed me how to use it.

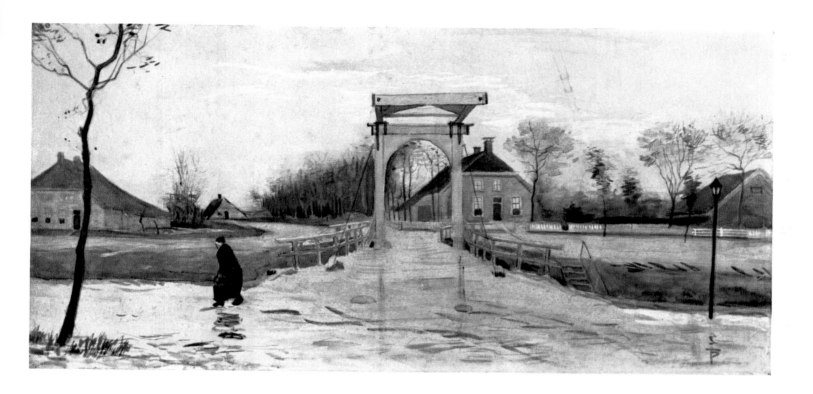

country he eventually became lonely and needed the company of artists like himself. This, as a rule, he could only find when he was living in a city.

## GOODBYE TO THE HAGUE

On Tuesday September 11, 1883, Vincent took the train for Hoogeveen. He was probably already dressed for Drenthe in the brown "peat-carrier's suit" which Dr A. L. C. Furnee has said that he always wore when he went out painting with the doctor's brother (who was a surveyor and amateur artist to whom Vincent wrote a letter that has survived). Vincent described leaving The Hague in a letter to Theo from Hoogeveen: *Of course the woman and her children were with me to the last, and when I left, the parting was not very easy. I have left her with all kinds of things as well as I could, but she will have a hard time.*

It was dark by the time he arrived at Hoogeveen, where he lodged with one Albertus Hartsuiker for a guilder a day. Today Hoogeveen is a little industrial town with the typical low houses, wide streets and cold cleanliness of the Dutch provinces. The house in which Vincent lived still exists in Pesserweg

not far from the station. When Vincent wrote his first letter he was *sitting in a large inn-parlour, like those in Brabant, where a woman is sitting peeling potatoes, a rather pretty little figure.*

The day after he arrived he got up very early to explore the neighbourhood. The village was in those days no more than a long row of *many new houses and a few more beautiful old ones* along the canal, cut by other canals leading to Meppel, Dedemsvaart, Coevorden and Hollandsch Veld.

Along the canals *one occasionally sees a curious old mill, farmyard, wharf, or lock, and always the bustle of peat barges.* By the village quay there were *very quaint peat barges, and figures of bargemen's wives dressed as they are here in the hayfield—very picturesque.* Vincent was much attracted by it all.

## A WONDERFUL LANDSCAPE

He was constantly walking about the countryside, and soon began his first picture, a cottage made of sods of turf and sticks. *Inside those cottages, dark as a cave, it is very beautiful;* and he promised Theo he would paint several pictures of them. The little Drenthe cottages made a great impression on Vincent

and five years later, when writing to his brother from Saintes-Maries, he was to compare the little houses in the old town with the mud cottages in Drenthe. His love of this humble, unassuming form of dwelling-place is clear from a letter he wrote to Emile Bernard in October 1889: *As for myself, however, the most admirable thing I know in the domain of architecture is a rural cottage with a moss-covered thatched roof and a blackened chimney.*

On his walks he was much struck by coming upon peat barges in the very middle of the heath, *drawn by men, women, children, white or black horses.* The heath was magnificent, and the sheepfolds and shepherds even more beautiful than those in Brabant. He was fascinated by the beauty of the place. Yet in the noonday sun it became wearying and hostile like a desert: *Painting it in that blazing light and rendering the planes vanishing into infinity makes one dizzy.* But, as when he walked with the young Tersteegs, no doubt it was a sacrifice he was glad to make for art.

On one of his walks he came upon *one of the most curious cemeteries I ever saw.* It was just a little patch of heath surrounded by a thick hedge of small pine trees. The graves were thickly overgrown with grass and heather, but one could still read the names painted on the white posts that marked them.

He was greatly impressed by the figures of the peasants that he saw at work far out in the peat fields. *I saw splendid figures ...* he wrote, *striking because of a sober quality. A woman's breast, for instance, has that heaving movement which is quite the opposite of voluptuousness, and sometimes when the creature is old or sickly, arouses pity or respect.* He found the melancholy healthy, as in Millet's drawings. He noted that *the men here wear short breeches, which show the shape of the leg and make the movements more expressive.* Impressive as these figures looked against the flat fields and the sky, Vincent remarked that: *In many faces one can see that the people are not in good health ... perhaps because of foul drinking water. I have seen a few seventeen-year-old girls, or even younger, who look very fresh and beautiful, but generally they look faded at a very early age. But this does not interfere with the noble aspect of some figures.*

There was no limit to the subjects to be painted, and there was much work to be done: *For it is so beautiful here that it will require a lot more study to render it,*

*and only very elaborate work can give an exact idea of the way things are basically in their serious, sober character. I have seen superb figures, but I repeat, a scenery that has so much nobility, so much dignity and gravity, must be treated after deep reflection and with patience and steady work. Therefore, I must attack things as if I had come here merely to get a glimpse of them; but if everything goes well, and if we have some luck, it goes without saying that I shall stay here.*

It was difficult to persuade the people to let him draw them. *At first,* he wrote, *I had some bad luck here with my models on the heath; they laughed at me and made fun of me, and I could not finish some studies of the figure I had started because of the unwillingness of the models, notwithstanding that I had paid them well, at least by local standards.*

To avoid this kind of complication, he was driven to drawing peasants inside a barn, but there he found the light was poor. Before Vincent had been a fortnight at Hoogeveen all sorts of worries that he had hoped to leave behind came flooding back. He decided to take a journey down the canal on a peat-boat. He left Hoogeveen at one o'clock in the afternoon and reached Nieuw-Amsterdam at about six. It seemed, as he told Theo, *an endless expedition.*

*I see no possibility,* he wrote, *of describing the country as it ought to be done; words fail me.* Nevertheless he went on to do so; and his description in words exactly complements his drawings of the subject: *Level planes or strips of different colour, getting narrower and narrower as they approach the horizon. Accentuated here and there by a peat shed or small farm, or a few meagre birches, poplars, oaks—heaps of peat everywhere, and one constantly meets barges with peat or bulrushes from the marshes. Here and there lean cows, delicate of colour, often sheep—pigs. The figures which now and then appear on the plain are generally of an impressive character; sometimes they have an exquisite charm. I drew, for instance, a woman in the barge with crape around her golden head-plates because she was in mourning, and afterward a mother with a baby; the latter had a purple shawl over her head.*

Opposite the quay where the barge tied up there was a small hotel run by Hendrik Scholte. He went in. The landlord looked at the shabby visitor coldly and was on the point of showing Vincent the door when his wife took pity on him. When Scholte learnt

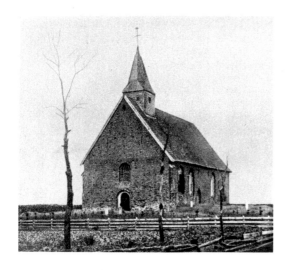

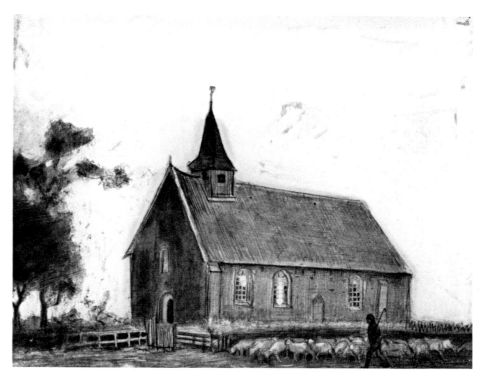

THE LITTLE CHURCH AT ZWEELOO. Drenthe, November 1883, pencil on sepia paper heightened with white, 24 × 30 cm, F 877 (misattributed to Etten). Collection of Miss G. P. van Stolk, Rotterdam. Photograph in Drenthe Provincial Museum, Assen.—On Thursday November 22, 1883, Vincent went in an open cart with his landlord to Zweeloo.

that he was the son of a pastor in Brabant he changed his mind and agreed to let him have a room. *I now have a pretty large room (where a stove has been put),* Vincent told Theo, *which happens to have a small balcony, from which I can see the heath with huts. In the distance I see a very curious drawbridge.*

Vincent often went out on to the balcony. One evening when the whole village was quiet he was so enchanted by the silver moonlit landscape that it was late before he went to bed.

The Scholte girls were scared by the sight of Vincent in a long dark passage at night, though Zowina-Clazina, the elder, later admitted that he was harmless. Scholte could not make much of Vincent's conversation; he told his children that the man was an artist but that he knew nothing about his pictures. The girls were still quite small. The younger girl, whose portrait Vincent painted, was only about two years old. She used to ride on his back, while he went on all fours, neighing like a horse, and her mother held her to keep her from falling off. With the older children he used to play trains, not that any of them knew what a railway was. He would seat the children on a row of chairs, while he sat on the front one, using a garden fork as a

connecting rod between the imaginary wheels. The passengers took hold of the fork, and their hands all went round and round together as the train got up steam and raced off to distant and unknown places.

Vincent's pictures of the Drenthe landscape show that the sad aspect of the countryside attracted him most. On Thursday November 22 he went to Zweeloo, an extremely old village where the first traces of human habitation date back to 7000 B.C. It had attracted many painters: Mauve, van Rappard, Ter Meulen, Jules Bakhuyzen and the German artist Max Liebermann, who had recently painted washerwomen there. Vincent had heard rumours that Liebermann might still be there.

His visit to Zweeloo was the climax of his period in Drenthe. He set off in an open cart at three o'clock in the morning with his landlord, who was going to the market at Assen. The account that he gave to Theo is one of his finest passages of descriptive writing: *At the first glimpse of dawn, when everywhere the cocks began to crow near the cottages scattered all over the heath and the few cottages we passed—surrounded by thin poplars whose yellow leaves one could hear drop to earth—an old stumpy tower in a churchyard, with earthen wall and beech*

121

*hedge—the level landscapes of heath or cornfields—it all, all, all became exactly like the most beautiful Corots. A quietness, a mystery, a peace, as only he has painted it. . . . The sky, smooth and clear, luminous, not white but a lilac which can hardly be deciphered, white shimmering with red, blue and yellow in which everything is reflected, and which one feels everywhere above one, which is vaporous and merges into the thin mist below—harmonizing everything in a gamut of delicate grey. I didn't find a single painter in Zweeloo, however. . . . A black patch of earth—flat—infinite—a clear sky of delicate lilac-white. The young corn sprouts from that earth, it is almost mouldy-looking with that corn. That's what the good fertile parts of Drenthe are basically; the whole in a hazy atmosphere. The poor soil of Drenthe is just the same—but the black earth is even blacker still—like soot—not lilac-black like the furrows, and drearily covered with ever-rotting heather and peat. I see that everywhere, the incidentals on the infinite background: on the moors, the peat sheds, in the fertile parts, the very primitive gigantic structures of farms and sheepfolds, with low, very low little walls and enormous mossy roofs. Oak trees all around them. When one has walked through that country for hours and hours, one feels that there is really nothing but that infinite earth—that green mould of corn or heather, that infinite sky. Horses and men seem no larger than fleas. One is not aware of anything, be it ever so large in itself; one only knows that there is earth and sky.*

It passed like a dream, and Vincent quite forgot to eat or drink all day.

But winter had come now, and Vincent wrote: *The painting out-of-doors is over, it is already too cold of late.* Although the Scholtes were cheerful and friendly, everything seemed to be conspiring against him. Not only in his emotional life was he thwarted: his career as a painter was threatened. He could earn nothing, and Theo's situation at Goupil & Cie, upon which he depended for money, seemed to be precarious. Vincent was lonely, discouraged about work, and worried about money. He was near a nervous collapse. As long ago as October 13 he had already discussed with Theo the possibility that he might have to return to his parents at Nuenen, adding: *It doesn't matter in the least where I am.* By the end of the year it was time for him to move on to a new stage of his life.

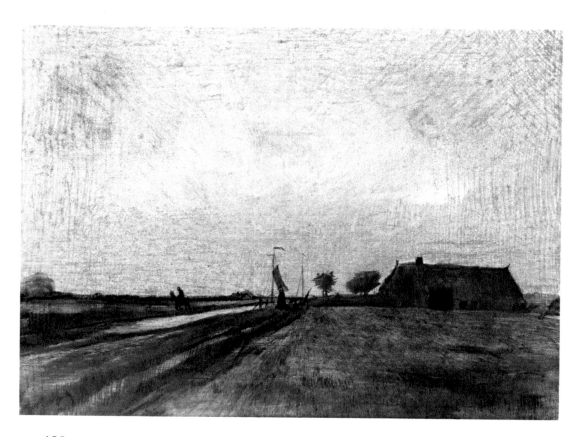

SUNRISE ON THE PLAIN. Drenthe, November 1883, Indian ink and wash, 28 × 40 cm, F 1104. Private collection, England.

122

# RETURN TO NUENEN

At the beginning of December 1883 Theo received a letter from Nuenen in North Brabant. *Dear Brother,* Vincent wrote, *Perhaps you were rather astonished when I told you briefly that I intended to go home and that I should write you from here.*

Vincent had in fact warned Theo of his plans long ago. In the letter of October 13 quoted at the end of the previous chapter he had written: *I should wish that we both understood that circumstances urgently demand that Brabant no longer be closed to me. I myself think it best not to go there if it can be avoided, but in case of a calamity, as Father has a house there rent-free, I might save the rent I am obliged to pay here.*

Vincent was concerned that Theo might lose his job at Goupil & Cie and that he would then only be able to live by selling his pictures: *If it is urgent that we must earn money, I see a chance of it in that way, if they have patience at home, if they realize what is necessary, and especially if the whole family helps in the question of posing for me.... Of course I would not ask anything unreasonable.*

Now that Vincent had broken with Sien, his father had forgiven him, and had several times sent him a little money. All the same Vincent wondered: *Can one live together in such a case?* He thought one could: *Yes, for a time, if it must be, and if both sides feel that everything must be subordinated to what the*

force majeure *of circumstances demands. I wish that had been understood at the time; besides, I did not take the initiative in going away; but when I was told to go, I went.*

He told Theo that he would write to his father: *In case Theo considers it advisable that my expenses be reduced to the lowest limit and I should have to live at home for a while, I hope, for myself as much as for you, that we shall possess the wisdom not to make a mess of things, and that, ignoring the past, we shall resign ourselves to what the new circumstances may bring.*

Originally Vincent did not intend to stay long at Nuenen. In his last letter to Theo before he went there he had written: *In case nobody should be willing to return to Drenthe with me later on, I may try to find some credit for the purpose of settling there.* And in his first letter from Nuenen he said: *I want to see what I think of it after having been here about a week.* His intentions are also clear from the manner in which he had left the Sholtes. One of the daughters said: "He departed as strangely as he had come, without saying goodbye to anyone. His room, which he called his studio, was full of drawings, pictures, pots of paint and all sorts of things. For years we did not touch them. On someone's birthday or other celebration we would sometimes give a drawing to some member of the family; but to tell the truth

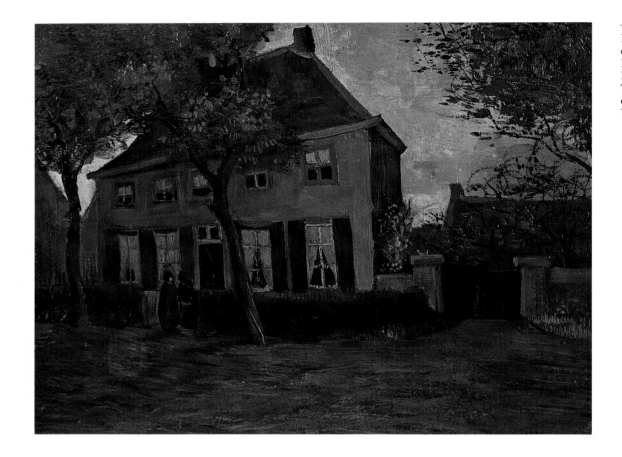

THE PRESBYTERY AT NUENEN. Nuenen, Autumn 1883, oil on canvas, 33 × 43 cm, F 182, H 199. Vincent van Gogh Foundation, Amsterdam.— The painting shows the degree of power of expression that Vincent had already reached.

nobody thought anything of those strange things. My elder sister, Jowina-Clazina, finally burnt the whole lot in the stove." Jowina-Clazina was the same sister that was nicknamed Zwaantje, and who was mentioned in the previous chapter.

If Vincent had not thought he was coming back, he would certainly have said goodbye and taken at least some of his things with him, even though he was far from well. During his last three weeks in Drenthe he had had a bad cold and had been very anxious and depressed. He also needed company. *Drenthe is splendid*, he wrote, *but one's being able to stay there depends on many things, depends on whether one is able to stand the loneliness.*

He had good reason for returning home—the last time he was ever to do so. Yet he was anxious and unwell, and he had unhappy memories of his last visit home: *My journey began with a good six-hour walk across the heath—to Hoogeveen. On a stormy afternoon in rain and snow. That walk cheered me greatly, or rather my feelings were so in sympathy with nature that it calmed me more than anything.*

He was glad to return to the friendly countryside of Brabant where his parents received him very kindly, not that the old animosities had entirely vanished. He put off his return to Drenthe.

## CONTINUED PROGRESS

During the three months Vincent spent in Drenthe he had made some experiments in introducing "local colour" into his painting. The landscape was eminently suited for this purpose, and he had been most enthusiastic about it: *And then when twilight fell—imagine the quiet, the peace of it all! Imagine then a little avenue of high poplars with autumn leaves, imagine a wide muddy road, all black mud, with an infinite heath to the right and an endless heath to the left, a few black triangular silhouettes of sod-built huts, through the little windows of which shines the red light of the little fire, with a few pools of dirty yellowish water that reflect the sky, and in which trunks lie rotting; imagine that swamp in the evening*

twilight, with a white sky over it, everywhere the contrast of black and white. And in that swamp a rough figure—the shepherd—a heap of oval masses, half wool, half mud, jostling each other, pushing each other—the flock. You see them coming—you find yourself in the midst of them—you turn around and follow them. Slowly and reluctantly they trudge along the muddy road. However, the farm looms in the distance—a few mossy roofs and piles of straw and peat between the poplars. Such experiences could not fail to influence his art.

Johanna van Gogh-Bonger has written that "the trip to Drenthe proved a failure", and it is true that Vincent did fail in his object of meeting Liebermann or van Rappard, that he did have difficulty in getting models and in painting out-of-doors so late in the year. Nor did he produce a great deal of work during those three months. We do not know how much was burned in the Scholtes' stove, but only forty-two pictures are known because they survive or are illustrated by sketches in his letters. But these pictures should not be disregarded, for they reveal an important technical development which Johanna van Gogh-Bonger has overlooked.

Before his Drenthe period Vincent was under the influence of The Hague School, having been introduced to water-colours by Mauve and being much attached to Weissenbruch. From the beginning Vincent's strong character and subtle intuition had led him to take his own liberties, and his work can also be distinguished by the vigour of his brushwork. In his work done in Drenthe one can see at once that he has darkened his palette considerably, though this tendency had already appeared to a much slighter degree in the cloudy sky in THE BEACH AT SCHEVENINGEN. There it was probably due to chance; in the pictures painted at Hoogeveen it was the deliberate and systematic result of his observation of the landscape. It is a new beginning, not a gradual development of his previous style. From Vincent's first picture painted in Drenthe, COTTAGES ON THE HEATH to THE POTATO-EATERS, which was the masterly result of his studies at Nuenen, there is a constant progress in the depth of his vision.

From the point of view of Vincent's artistic technique his visit to Drenthe was a prelude to his Nuenen period, just as Antwerp was a prelude to the period he spent in Paris.

His father's house at Nuenen in Brabant. Photograph A.I.v.G.—The house where Vincent lived with his parents from December 1883 to November 1885 was built in 1776 and was in a very dilapidated state.

## HISTORY REPEATS ITSELF

Vincent decided that after all he might stay at Nuenen and continue the work he had begun in Drenthe, becoming, like Millet whom he so much admired, a peasant among the peasants. But now everything would depend on his parents' attitude. They had seen him throw up a promising career as an art-dealer and not only fail miserably to qualify as a preacher, but also turn against religion itself and live in sin with a prostitute. They could be forgiven for being pessimistic about his future as an artist.

He had hardly settled at the presbytery when trouble began. Vincent felt that his parents would never be able to understand him. Although he had hoped to write more calmly from home, his second letter to Theo from Nuenen was full of bitter torment: *I was lying awake half the night, Theo, after I wrote you last night. I am sick at heart about the fact that, coming back after two years' absence, the welcome home was kind and cordial in every respect, but basically there has been no change whatever, not the slightest, in what I must call the most extreme blindness and ignorance as to the insight into our mutual position. And I again feel almost unbearably disturbed and perplexed.*

Vincent could not forgive his father for what had happened before: *The fact is that things were going*

His mother convalescing. Photograph A.I.v.G.—This portrait was taken a short time after the accident which befell the artist's mother.

He seemed almost to be looking for a quarrel. He had long believed that "one grows in the storm", a French proverb that he had quoted in a letter of October 30, 1877, and he ended his letter to Theo in desperation: *Well, old fellow, try to help me get away from here if you can.*

In his next letter he was able to see himself more objectively and perhaps even with a resigned humour: *They feel the same dread of taking me in the house as they would about taking a big rough dog. He would run into the room with wet paws—and he is so rough. He will be in everybody's way. And he barks so loud. In short, he is a foul beast. All right—but the beast has a human history, and though only a dog, he has a human soul, and even a very sensitive one, that makes him feel what people think of him, which an ordinary dog cannot do. And I, admitting that I am a kind of dog, leave them alone.*

Then: *The dog feels that if they keep him, it will only mean putting up with him and tolerating him "in this house", so he will try to find another kennel.*

NO COMPROMISE

Once again Theo wrote urging Vincent to treat their father with more consideration, and once again Vincent defended himself, but he acknowledged what Theo had done for him: *But you know, don't you, that I consider you to have saved my life. I shall never forget that; though we put an end to relations which I am afraid would bring us into a false position, I am not only your brother, your friend, but at the same time, I have infinite obligations of gratitude to you for the fact that you lent me a helping hand at the time, and have continued to help me.*

And he added in English: *Money can be repaid, not kindness such as yours.* He was thinking of going to van Rappard and even to Mauve, whom he had now completely forgiven. In his next letter he told Theo, with some irony, how Mauve had said, *You will find yourself if you go on painting.* And he commented bitterly: *I have found myself—I am that dog.*

He went on: *The shaggy shepherd dog which I tried to describe you in yesterday's letter is my character, and the life of that animal is my life, that is to say, omitting the details and only stating the essentials. This may seem exaggerated to you—but I will not take it*

extremely well until the moment when Father—not just in the heat of passion, but also because he was "tired of it"—banished me from the house. It ought to have been understood then that this was supremely important to my success or failure—that things were made ten times more difficult for me by this....

Besides his strained relations with his parents Vincent was desperately anxious about his future career. Theo's continued failure to sell any of his pictures made him begin to doubt even his brother. He felt that his own family was much less sympathetic than the van Rappards were to their son, and he turned to Theo and demanded: *I ask you point-blank how we stand— are you a "van Gogh" too? I have always looked upon you as "Theo". In character I am rather different from the various members of the family, and essentially I am not a "van Gogh".*

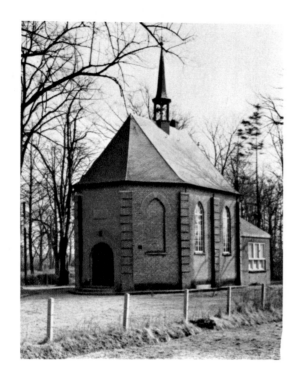

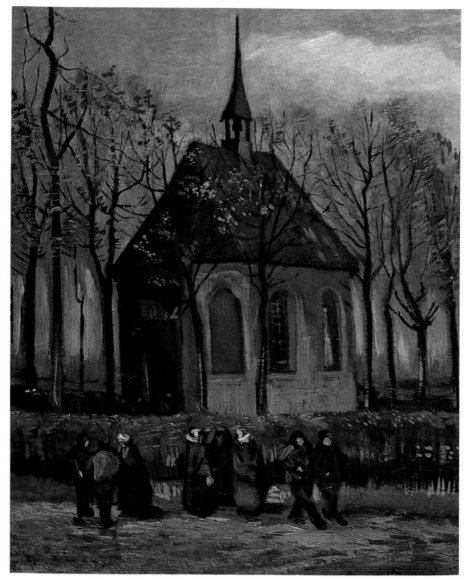

COMING OUT OF THE CHURCH AT NUENEN. Nuenen, January 1884, oil on canvas, 41 × 32 cm, F 25, H 29. Vincent van Gogh Foundation, Amsterdam. Photograph A.I.v.G.—When his mother broke her leg and had to remain in bed, he gave her this present because she was "amused with trifles", as he wrote to Theo. A comparison between the photograph and the painting shows how the artist was prepared to alter nature when he wished; in particular in the proportions between the portal and the façade of the octagonal building, and between it and the tree on the left.

back. *Without being personal, just for the sake of an impartial character study, as if I did not speak about you and me but about strangers, for the sake of analysis, I point out to you once more how it was last summer. I see two brothers walking about in The Hague.... One says, "I must maintain a certain standing, I must stay in business, I don't think I shall become a painter." The other says, "I am getting to be like a dog, I feel that the future will probably make me more ugly and rough, and I foresee that 'a certain poverty' will be my fate, but, but I shall be a painter." So the one—a certain standing as an art dealer. The other— poverty and painter.... I tell you, I consciously choose the dog's path through life; I will remain a dog, I shall be poor, I shall be a painter, I want to remain human—going into nature.*

Tersteeg and his father had tried to persuade Vincent that it was his duty to earn money, and that his life would then become straight. He felt that once he had made his life straight he might even be able to earn some money. In any case their advice was the last thing that Vincent was likely to accept. He could not possibly have betrayed his ideals in order to make money. Tersteeg's attitude was no surprise, but Vincent had expected more of his father, whom he felt to be *the kindest of cruel men.*

127

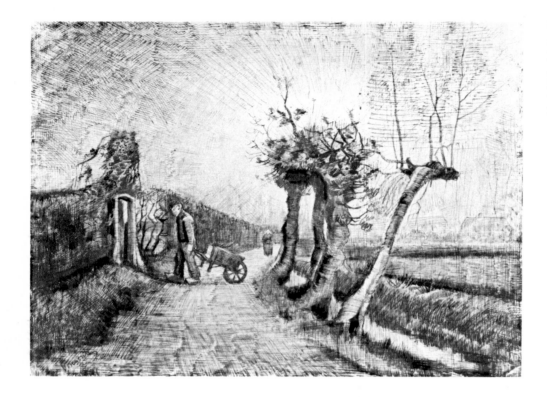

BEHIND THE PRESBYTERY GARDEN. Nuenen, March 1884, pen and Indian ink, 40×53 cm, F 1129. State Museum, Amsterdam.—The trees on the right of the picture appear again in AUTUMN LANDSCAPE. They have been cut down since the war. The door on the left is the one through which Vincent must have passed to go into the country.

Vincent had almost decided to leave home again when, in yet another discussion with his father, he said: *I have been here two weeks, and do not feel a bit more advanced than the first half-hour; now if we had understood each other better, we should have things arranged by now—I have no time to lose, and I must make a decision. A door must be either open or closed.*

They ceased the futile debate and set to work to clear out *the little room where the mangle stands*, to make a studio for Vincent. Both Theo and van Rappard wrote to Vincent encouraging him to stay at home. At last he began to settle down, and he even wrote to Theo: *I hereby declare that, for myself, I agree with Rappard when he says, "Stay at home for a long time"—he stresses this.* For the moment the storm was over. Vincent settled down to work, but he never became fully reconciled with his father.

## A BACKWARD GLANCE

Now that Vincent had somewhere to work he went back on a visit to The Hague to collect his studies and prints and other things that he had left behind. He paid a cordial and encouraging call on

van Rappard—encouraging for both of them since Vincent wrote that he thought his studies were *very good.* And he also went to see Sien. He did not want to begin living with her again, but he was shocked at the state she was in; her health had relapsed, and her baby was in a decline. All his feelings of pity welled up again; *I see in her a woman, I see in her a mother, and I think every man who has the least manliness in him must protect such a one if there is an occasion for doing so. I have never been ashamed of it, nor ever shall be.*

When he came home to Nuenen again Vincent was overcome with remorse about the way she had been abandoned. Of his own conduct he wrote: *As to my opinion how far one may go in a case of helping a poor, forsaken, sick creature, I can only repeat what I told you already on a former occasion: infinitely.*

He even went so far as to blame Theo for his part in it: *I tell you without reserve that you have this much in common with Father, who often acts in the same way, that you are cruel in your worldly wisdom. Cruel, I repeat the word, for what can be more cruel than depriving such an unfortunate and withered woman and her little child of support. Don't think you will be able to delude yourself into the belief that it was*

128

nothing, or only my imagination. Don't think it will help you if you reason that it was only a question of a faded whore and of bastards. So much the more motive for deep compassion—which I showed for that matter. I have only just noticed that during all that time you have not written a single word about her, and that you did not reply when I wrote you that I had heard from her.... Oh, I know that to a certain extent you did it with good intentions—I know how you always try to keep the peace with everybody (which I don't believe can be done)—I know that even in this case you prob-ably haven't got the faintest notion that you did some-thing that was not right—but being good friends with the world and following our consciences just don't go together—you do not give your conscience its due.

He talked wildly of refusing Theo's allowance: As regards the money—brother—you will understand that I no longer take any pleasure in it, won't you?... I took pleasure in it because it served to keep not only myself but also these poor creatures safe. But he ended in a somewhat calmer mood: This is a sad letter at the end of the year—sad for me to write, sad for you

AUTUMN LANDSCAPE. Nuenen, November 1885, oil on canvas, 64 × 89 cm, F 44, H 49. Kröller-Müller State Museum, Otterlo.—My investigations have enabled this landscape to be located exactly: the four trees are behind the presbytery garden, alongside a little path.

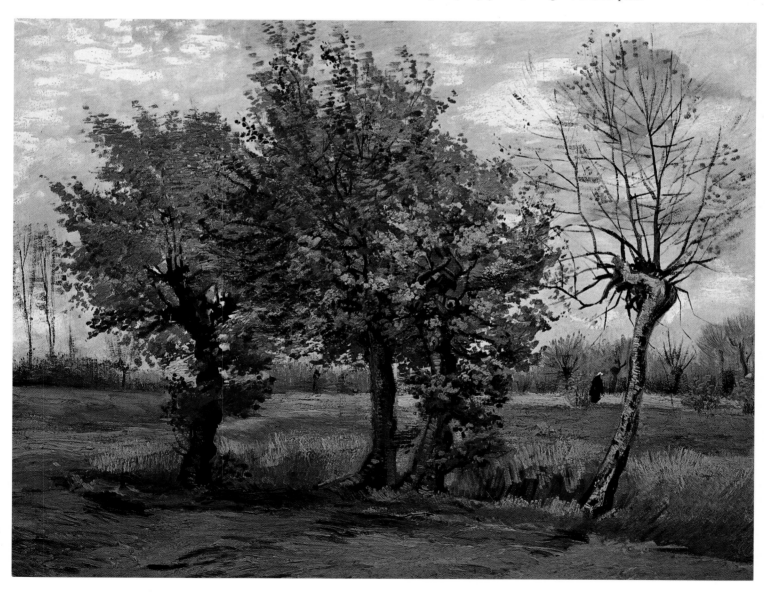

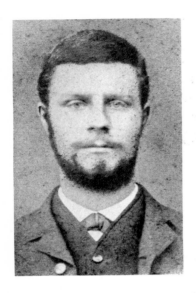

Anthon G. A. Ridder van Rappard. Photograph A.I.v.G. —At the end of October 1884 Vincent invited van Rappard to spend a fortnight with him at his parents' presbytery at Nuenen. They went on long walks together in the neighbourhood of the village. During one of these excursions, Vincent composed a landscape of an avenue in the height of autumn, which he was later to heighten with some touches of white when he was in Paris. This picture is now in the Boymans-van Beuningen Museum at Rotterdam. The record of the friendship between Vincent van Gogh and van Rappard is preserved in their correspondence.

sions at The Hague, that he had already done watercolours of weavers, a timber auction, a gardener and an interior with a little seamstress, of which he sent some pen-and-ink sketches.

## THE USES OF ADVERSITY

Just when it seemed that Vincent's relations with his family might break into open warfare (for there were to be further misunderstandings with Theo over money, about which Vincent was morbidly sensitive) an accident occurred which changed his feelings about his parents. On January 17, 1884, he wrote a brief note to Theo: *Something has happened to Mother. On getting off the train at Helmond, Mother hurt her leg.* Vincent was painting at a farm when he was sent for. The doctor diagnosed a broken thigh-bone near the pelvis and hip-joint. *I was present at the setting*, wrote Vincent, *which came off comparatively well.* He reassured Theo that there was no real danger, but it might take her quite a long time to recover. His real fondness for his mother and his constant desire to help the suffering, together with his experiences of nursing the sick in the Borinage, all combined to make him an excellent nurse. His letters to Theo are full of concern for her and news of her progress. And to amuse her with what he called "trifles" he painted a picture of *the little church with the hedge and the trees.*

*to receive (although you are at liberty to dismiss it from your thoughts ; that is something you must decide for yourself), but it is worse for the poor woman. Goodbye.*

This painful correspondence shows to what extraordinary lengths Vincent could go when driven by compassion and remorse—and the almost incredible forbearance that Theo showed him.

Despite his parents' lack of any real understanding of his artistic aims and the distraction of his long arguments with them, Vincent was able to concentrate on painting in colour. He told his friend Furnée, a surveyor with whom he had gone on painting excur-

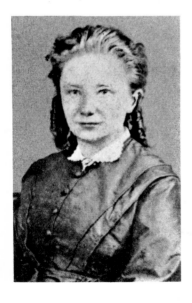

Nuneville, Photograph A.I.v.G. —This house, recently restored, still stands beside the presbytery at Nuenen. The name, of course, means "town of Nuenen". Margot Begemann lived here with her parents.

Margot Begemann. Photograph A.I.v.G.—She was the only woman who really loved Vincent, and even tried to kill herself for his sake. He gave her his water-colour, WASHING AT SCHEVENINGEN (page 95).

130

Weavers at their looms were the subject he was chiefly interested in during these months. He painted at least ten pictures in oil or water-colour of weavers at work. The weaver represented something which he lacked, the ability to earn a living working at his craft in a little room of his own.

Compared to the weavers' snug cottages, his studio was, as he told Theo, *immediately adjoining coal hole, sewers and dung-pit.* Soon afterwards he was able to report that *I just finished arranging a spacious new studio I have rented. Two rooms—a big one, and a smaller one adjoining.* He did not tell Theo that he was renting the studio from Schafrath, the verger of the Catholic church. Despite this implied snub to the Protestant pastor, Vincent's mother came in her wheel-chair to visit his new studio.

Vincent was attracted by the weavers not only because they were workpeople, like the miners in the Borinage, and were able to live upon their work in a way that he could not. In some of his pictures he included alongside the loom a high-chair with a baby sitting in it. And in a letter to Theo at this time he wrote unkindly, but with understandable passion, that though his brother might give him money, he could not give him a wife, children or work.

## THE BEAUTY OF BRABANT

Vincent arranged with Theo that he would send him all his pictures every month to do whatever he liked with them, and Theo would send him 150 francs in return. This seemed more like a business deal and less like charity, and Vincent's letters lost their recent tone of asperity.

He even began to enjoy living in Brabant. *The Brabant of one's dreams,* he exclaimed in a moment of rare exultation, *reality almost comes very near to it sometimes.* He also found that he liked the people better than those at Etten and began to think again of staying there permanently.

At Jan Baaiens's shop in Eindhoven, where Vincent bought his paints, he met a retired goldsmith called Hermans, who had three times amassed an important collection of antiques and sold it again. He was a rich man and was moving into a new house, once again full of antiques. He was decorating it with murals himself, and had already begun to paint

SPRING (THE SOWER). Nuenen, August 1884, pencil and pen, 6 × 14 cm, F 1143. Collection of J. van Hoey Smit, Rockanje, Netherlands.

SUMMER (HARVESTING POTATOES). Nuenen, August 1884, pencil and pen, 6 × 13.5 cm, F 1141. Collection of J. van Hoey Smit, Rockanje.

AUTUMN (THE PLOUGH). Nuenen, August 1884, pencil and pen, 6.5 × 16.5 cm, F 1142. Collection of J. van Hoey Smit, Rockanje, Netherlands.

WINTER. Nuenen, August 1884, pencil and pen, 5 × 14 cm, F 1144. Collection of J. van Hoey Smit, Rockanje, Netherlands.

twelve panels.  He intended to complete it with various panels of saints.  Vincent *begged him to consider whether the appetite of the worthy people who would have to sit down at that table would not be more stimulated by six illustrations taken from peasant life ... at the same time symbolizing the four seasons.*

The goldsmith visited Vincent's studio and was enthusiastic about the project but insisted on painting the panels himself.  Vincent gave him preliminary sketches of a sower, a ploughman, a shepherd, harvesters, potato diggers and an ox-wagon in the snow.  He spent a week of August out in the fields drawing the harvesters and sent a sketch in a letter of the drawing for the panel.

It is interesting to compare this sketch with HARVESTING WHEAT IN THE ALPILLES PLAIN which Vincent painted at Arles in June 1888 (reproduced on page 245).  The two figures in the right-hand side

THE LOOM.  Nuenen, May 1884, oil on canvas, 70 × 85 cm, F 30, H 33.  Kröller-Müller State Museum, Otterlo.—Vincent wrote to van Rappard: "There in the centre of it sits a black ape or goblin or spook that clatters with those sticks from early morning till late at night."

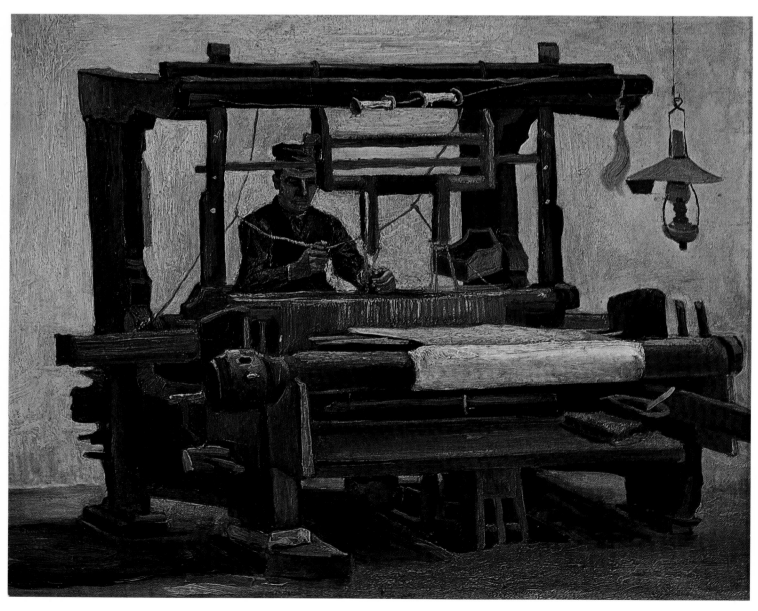

of the sketch are very similar to the woman tying sheaves and the reaper in the Arles painting. In both of them the influence of Millet, which dominated the whole of Vincent's career, is clearly to be seen. The scene in the fields at Nuenen, with its seven people all busily at work, has been sketched in a masterly fashion which shows Vincent's aptitude as a decorative artist as well as his skill in suggesting their attitudes in a few hasty strokes of the pen.

## ATTEMPTED SUICIDE

During her slow convalescence, Vincent's mother was often visited by Margot Begemann, the youngest of the Begemann daughters, who lived at Nuneville next door. She was ten years older than Vincent, and though not a beauty, she was attractive, good-natured and hardworking. Very soon they became friends, and Vincent would go on walks with her and visit the poor of the parish. Then their feelings became deeper, though in this case it was not Vincent who fell in love with her, but Margot with him. Nevertheless he might well have married her if there had not been obstacles in their way. Margot's father needed her to help run his business, and her sisters became jealous and cast such doubts upon Vincent's reputation that they drove her into a nervous collapse. Several times Margot told him that she wanted to die, and Vincent was worried enough to consult a doctor about her.

He warned her brother Louis about her condition and said that the Begemanns had been very unwise to upset her so. But they only told him to be patient and to wait two years before marrying. This he refused to do, saying that if they were to marry it should be at once or not at all.

Three days later, when they were walking in the country, Margot suddenly fell to the ground. At first Vincent thought the attack would pass, but she got worse, was shaken by spasms and almost lost the power of speech. He realized the truth.

*Did you swallow something?* he asked.

"Yes", she screamed, and insisted that he told nobody about it.

*That's all right,* he replied, *I'll swear anything you like, but only on condition that you throw that stuff up immediately....*

The weaver at his fireside. Photograph A.I.v.G.—The man seated on the right is Dekker, the weaver whom Vincent depicted several times in his studies of weavers at their looms. Here he is at home. The house still exists not far from the centre of Nuenen.

INTERIOR OF WEAVER'S HOUSE. Nuenen, February 1884, pen, 32 × 40 cm, F 1118. Vincent van Gogh Foundation, Amsterdam.—The child in the high chair is a good example of Vincent's human feeling. Through the window in the background one can see the square tower which the artist has depicted many times.

But, as Vincent recounted, *vomiting only partially succeeded, so I went to her brother Louis, and I told Louis what the matter was, and got him to give her an emetic, and I went to Eindhoven immediately to Dr van der Loo. It was strychnine she took, but the dose was too small, or perhaps she took chloroform or laudanum with it as a narcotic, which would be the very counter-poison against strychnine. However, she took the counter-poison which the doctor prescribed in time. She was immediately sent off to a doctor in Utrecht.... I think it probable that she will get entirely well again, but I am afraid a long period of nervous suffering will follow—in what form—more or less serious—that is the question. Her family were censorious and unkind to her. Only Louis who knew the truth was sensible and sympathetic.*

Vincent was desperately worried at what had happened. He did not know what line to take with the Begemanns and he was afraid that his parents would try to find out the truth. He visited Margot at Utrecht and consulted the doctor at length. He was enormously touched when Margot said to him: "I too have loved at last" as though this were a triumph. Nobody had ever loved him in this way before.

Vincent told Theo: *With much forethought I have always respected her on a certain point that would have dishonoured her socially (though if I had wanted it, I had her in my power), so that socially she can maintain her position perfectly.*

Her doctor, who had known Margot since she was a child, told Vincent that her health was greatly shaken, she had always had and would always have a very weak constitution. *She is too weak to marry, at least now,* Vincent reported, *but at the same time a separation would be dangerous too.*

Despite all the rumours and scandal that were inevitable in a small place like Nuenen, Vincent was determined to remain friends with Margot. She did not return to Nuenen until the end of the year, but in September Vincent was asked to do a drawing or a painted study for twenty guilders. He rightly suspected that this was a secret attempt by Margot to make him a present, and he refused to accept the money, desperately though he needed it, and sent her the picture for nothing.

Vincent summed up the situation in a letter to Theo: *As to a scandal, I am now somewhat better prepared to meet it than I used to be. No fear of Father and*

The factual evidence. Photographs A.I.v.G.—A comparison between the painting and the reality—this photograph was taken from the same place where Vincent painted his picture—shows a typical example of Vincent's very personal form of representation. The little ladder on the left has been removed, but the rest of the structure, which has not been noticeably changed during the years, is clearly recognizable. The owner, Piet van Hoorn, was born in 1874 and is still alive; he was ten years old when he saw the painter at work in the road in front of the mill.

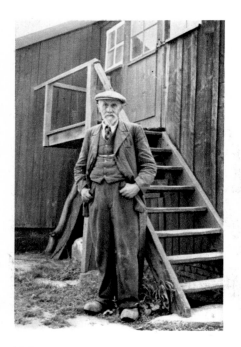
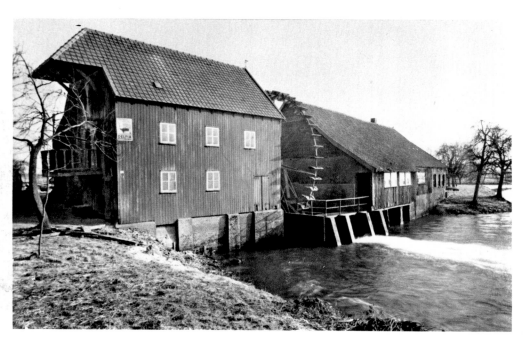

134

*Mother leaving, for instance. . . . Both she and I have sorrow enough, and worries enough, but neither of us feels regret. Look here, I certainly believe, or know for sure, that she loves me. I certainly believe, or know for sure, that I love her, I have been sincere.*

## AN ARTIST LIKE WAGNER?

Vincent made friends with various people in Eindhoven. Besides Hermans, the goldsmith already mentioned, there was Vandersanden, the organist at St Catherine's Church, to whom he went in order to learn music. He had been studying the theory of colours as put forward by Delacroix and others, and was intoxicated by the subject as if by a new faith. *The laws of colour are unutterably beautiful*, he wrote, and he had become convinced that there was a close relation between colour and music, *in Dupré's colour*, for instance, *there is something of a splendid symphony.* Thus he decided he could not fully understand colour until he had mastered music. This anecdote has been told by Dimmen Gestel, and also by Anton Kerssemakers, who says that when during his lessons Vincent kept comparing the notes of the piano "with Prussian blue and dark green . . . all the way to cadmium yellow, the good man thought he had to do with a madman, in consequence of which he became so afraid of him that he discontinued the lessons".

Though Vincent soon realized that learning music would only distract him from painting, he long retained his views about the correspondence between the two arts. Thus in the autumn of 1888 he wrote to Vincent from Arles: *But I have got back to where I was in Nuenen, when I made a vain attempt to learn music, so much did I already feel the relation between our colour and Wagner's music.*

In the spring of the same year he had made a specific comparison in a letter to his sister Wilhelmien: *By intensifying all the colours one arrives once again at quietude and harmony. There occurs in nature something similar to what happens in Wagner's music, which, though played by a big orchestra, is nonetheless intimate.*

It was when Vincent was living with Theo in Paris in 1886 that he took the greatest interest in Wagner, for at that time echoes of the "Battle for

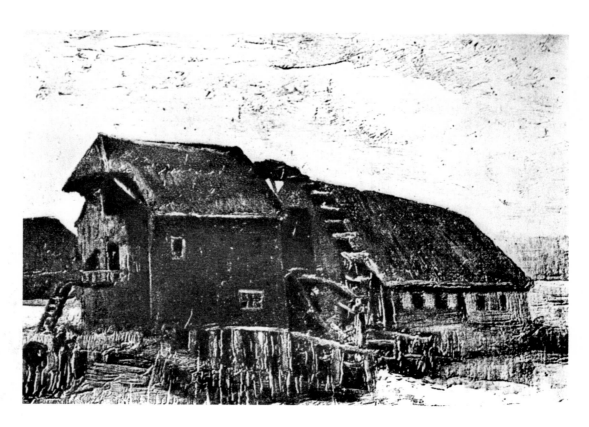

THE WATERMILL AT OPWETTEN. Nuenen, November 1884, oil on canvas on wood, 45 × 58 cm, F 48, H 52. Collection of A.T. Smith, London.—This picture has recently been attributed to a different date. It used to be dated as spring 1885. But when one looks at the picture itself one can see no trace of spring. The sky is overcast and the landscape rather dreary. All through his life, Vincent was always particularly interested in windmills and watermills. We shall find other examples in Paris and in Arles.

Wagner" in the pages of the *Revue Wagnérienne* were still resounding. It had started ten months before, on June 8, 1885, when the first number of that journal was handed out at the entrance to the Concerts Lamoureux.

While Vincent was in Paris he went to several Wagner concerts with Theo. He was not interested in the composer's mythical Valhalla, which was hardly calculated to appeal to his own devotion to realism, but in the new tonalities in the score, and he recognized the real importance of Wagner in the history of music. In 1888 Vincent wrote to Theo from Arles that he had been reading a book on Wagner. *What an artist—one like that in painting would be something*, he exclaimed. *It will come.* Not long afterwards he wrote again: *I have read another article on Wagner —"Love in Music"—I think by the same author who wrote the book on Wagner. How one needs the same thing in painting.*

Vincent was to provide it himself.

## AN UNSUSPECTED TALENT

Vincent made other useful acquaintances at Jan Baaiens's shop in Eindhoven, for its clientèle included various "Sunday painters". In November he told Theo that he had met three people there who

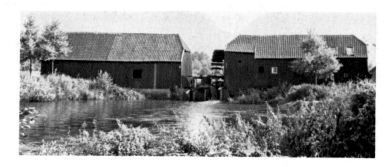

Photograph A.I.v.G.—This watermill is at Nuenen itself. Only one of the two original wheels, the one on the right, still survives.

wanted to learn to paint and that he had agreed to teach them how to do still-lives. No doubt this would have astonished Mauve and Tersteeg, with whom, oddly enough, Vincent had at that very moment been trying to make his peace. He particularly wanted to return to Mauve's studios for some more lessons; once again they said, no; but Vincent was not discouraged. As to his own pupils, Vincent was anxious only to help, and glad enough if they repaid him in kind by replenishing his supplies of paints. By now Vincent had made so much progress that there was in any case little that Mauve could teach him. Within four months he was to produce

GENNEP WATERMILL. Nuenen, November 1884, oil on canvas on board, 87 × 151 cm, F 125, H 125.          Private collection, U.S.A.

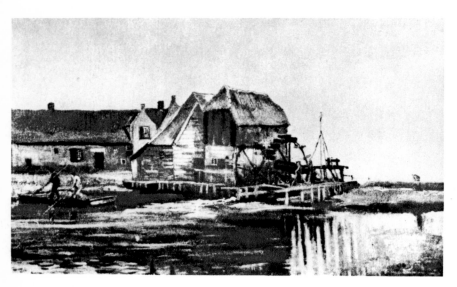

Photograph A.I.v.G.—The watermill, known as Gennep or Gestel mill, was for many years in a deplorable condition, but was restored in 1963. Vincent went with Anton Kerssemakers to the very spot from which this photograph was taken in order to paint his picture: "Though it has been freezing pretty hard here... I am still at work out of doors, on a rather large study... of an old windmill."

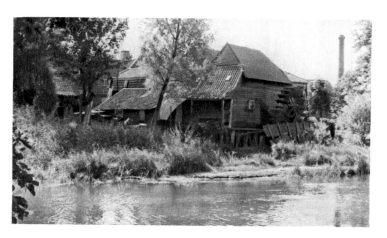

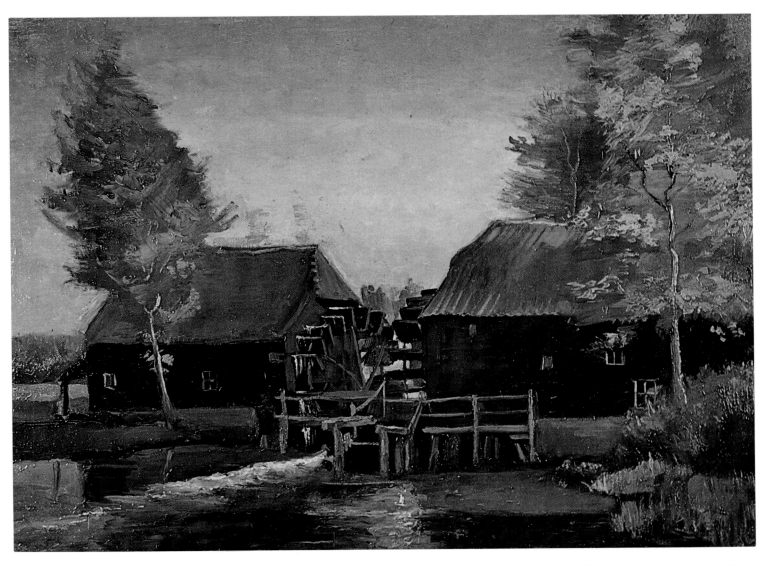

KOLLEN WATERMILL. Nuenen, November 1884, oil on board, 56 × 59 cm, F 48 b, H 51. Private collection.—Vincent told van Rappard: "Since your departure I have been working on a watermill—the one I inquired about in that little bar near the station."

THE POTATO-EATERS, a work generally considered to be the origin of the Expressionist movement.

Vincent's other two pupils, besides Hermans the retired goldsmith, were a post-office worker named van de Wakker and the son of a printer of cigar-bands named Dimmen Gestel, whose account of Vincent's relations with the organist has already been mentioned. Later Vincent acquired a third: this was Anton Kerssemakers, a successful tanner in his forties, who was a keen amateur painter. Kerssemakers had been painting landscapes on the walls of his office instead of covering them with wallpaper,

and Baaiens had brought Vincent to see them. At this time, despite the hard frost out of doors, Vincent was painting the picture of GENNEP WATERMILL reproduced on page 136, and this, he wrote, *procured me a new friend in Eindhoven.* Kerssemakers soon became a devoted pupil, and on Vincent's first visit to his studio painted a still-life and promised to paint thirty more of them that winter.

Vincent's activities as a teacher are not as well known as they should be. He took his teaching seriously, and his pupils made good progress. Five years of hard work had not been wasted.

137

When one of them questioned the way he ignored the usual techniques, Vincent became angry. *I scorn your technique*, he cried. *I owe what I know to my penknife; I put it in every possible position and drew it. That's how you learn.* He insisted that the first thing to be done in painting was to measure the proportions carefully. One of his favourite themes became almost an obsession: *Don't forget that you have no light on your palette; you must therefore paint everything darker than it really is in order to make it natural.*

Hermans worked hard at still-lives, his collection doubtless providing much of the material, but Kerssemakers, who soon learned to handle colour, was the most promising of the pupils. Vincent and Kerssemakers became close friends and would often paint similar subjects. I have seen a number of Kerssemakers's landscapes which include old watermills. Vincent's influence can be noticed at once.

Twenty-seven years later Kerssemakers wrote some reminiscences of Vincent and published them in *De Groene*, an Amsterdam weekly, on April 14 and 21, 1912. He tells how Vincent was recommended to him by his house-painter. This was Jan Baaiens, whose paint shop supplied ordinary house-

Anton Kerssemakers. Photograph A.I.v.G.—Kerssemakers, a tanner by trade who was an enthusiastic amateur painter, is seen sitting at his easel in the studio where Vincent painted the old Eindhoven station in the snow. This station no longer exists, and where it stood there is now a statue belonging to Philips, the great Dutch electrical company.

Postcard. Estate of Anton Kerssemakers, Eindhoven, Netherlands. On the front: the address of Kerssemakers, to whom Vincent was giving painting lessons. On the back: Vincent says that he cannot come and paint because he is in the middle of some studies of people planting potatoes. At the bottom right is a pen-sketch of one of them.

138

THE OLD STATION AT EINDHOVEN. Nuenen, 1884, oil on canvas, 15 × 26 cm. Collection of H. Korting, Gilze, Netherlands.—The present owner of this picture is related to Anton Kerssemakers, in whose studio it was painted, and to whom Vincent gave it.

hold paint as well as artists' oils. He was no expert, and the consistency of the paint he supplied to artists was often unsatisfactory, but it was all that Vincent could afford.

Kerssemakers has told how he kept a little study which Vincent had done at his house to instruct his pupil, and one can see from THE OLD STATION AT EINDHOVEN reproduced on this page the trouble he had with this poor paint. It was a view through the window of the countryside with melting snow; and the white paint ran all over the landscape. Yet though it was painted so quickly and in such difficult conditions, this picture conjures up in a few brushstrokes the sad grey day under a sky dark with impending snow: it is a typical example of Vincent's skill.

Kerssemakers admits that to begin with he did not appreciate Vincent's work or understand what he was trying to do. He thought Vincent was unable or too impatient to draw but Vincent only laughed and and said: *Later on you will think differently.*

Once Vincent suggested that Kerssemakers should paint some still-lives instead of landscapes. *After you have painted some fifty of them*, he said, *you will see how much progress you have made. And I am willing to help you and to paint the same subjects along with you, for I myself still have a good deal to learn, and there is nothing to equal this for learning to put things in their right positions, and for learning to get them properly separated in space.* Vincent's modest attitude should not mislead us into underestimating his ability as a teacher.

VINCENT AND THE POSTMASTER

Willem van de Wakker worked in the telegraph office at Nuenen, though he lived at Eindhoven. He spent his spare time painting, and when he sent some of his pictures to Baaiens to be framed Vincent happened to see them and asked about the man who

The Fowler. Painting by Anton Kerssemakers, oil on canvas, 54 × 64 cm, formerly initialled at bottom right, "A.K." Collection of A. Glasbergen, Eindhoven.—In his memoirs published in *De Groene Amsterdammer* on April 14 and 21, 1912, Kerssemakers told how Vincent would take the brush out of his pupil's hands to add his own corrections to the canvas on the easel.

Below and on the right, enlarged details of Anton Kerssemakers's canvas. One can see Vincent's characteristic touches where he has painted the branches which form the fowler's hide, as well as other retouching elsewhere. This example is not unique.

STILL-LIFE WITH EARTHENWARE POT, BOTTLE AND CLOGS. Nuenen, 1885, oil on panel, 39 × 41.5 cm, F 63, H 64. Kröller-Müller State Museum, Otterlo.—On the basis of a remark by Vincent in a letter to Theo about Chardin, whose transparent painting does recall this still-life, Vanbeselaere rightly dated this work March 1885.

had painted them. *Send him to me*, he said. Baaiens did so, and van de Wakker went to Vincent's studio which has been well described by Kerssemakers: "A great heap of ashes around the stove, which had never known a brush or stove polish, a small number of chairs with frayed cane bottoms, a cupboard with at least thirty different bird's nests, all kinds of mosses and plants brought along from the moor, some stuffed birds, a spool, a spinning wheel, a complete set of farm tools, old caps and hats, coarse bonnets and hoods, wooden shoes, etc., etc. Paint-box and palette he had had made in Nuenen according to his directions, as well as a perspective frame; this consisted of an iron bar with a long sharp point, on which he could mount, by means of screws, an empty frame like a small window."

Vincent and van de Wakker became friends. The telegraphist has described how he would often meet Vincent on his way from Eindhoven to Nuenen and back. He did not find the artist an easy master to work for: he could be sarcastic and would swear like a trooper if his pupil made a mistake or left any of his painting gear behind. Vincent hated unnecessary argument. Once he set out to do something he would not stop until he had done it. He worked very fast, with strong, broad strokes, never corrected his work or went back to it afterwards. He chose the ugliest peasants as his models, and he paid them not in cash but in kind with packets of coffee.

Van de Wakker thought Vincent's relations with other people were rather odd. Despite his somewhat unattractive traits he had no difficulty in influencing

WOMAN IN A RED BONNET. Nuenen, April 1885, oil on canvas, 42.5 × 29.5 cm, F 160, H 159.
Vincent van Gogh Foundation, Amsterdam.

HEAD OF A YOUNG PEASANT IN A PEAKED CAP. Nuenen, April 1885, oil on canvas, 36 × 26 cm.
Private collection, Paris.

those he met. His keen eyes were strangely powerful and compelling. The postmaster for whom van de Wakker worked was a difficult man who did not like his employees to have time off. Vincent was constantly annoyed because his pupil did not have enough time to paint. One day, when they were working together out-of-doors, Vincent said to him: *The postmaster should give you time off tomorrow from two to five o'clock.* Van de Wakker replied that there was little chance of it. *He must*, replied Vincent, *I will go and see him.* The next day he went to the post office, asked to see the postmaster, and with a nod at van de Wakker said: *I need that man this afternoon.* "I need him more", replied the postmaster. Vincent looked at him severely and replied: *You heard what I said; I need him and you will arrange it.* Then he turned and left without another word. Soon afterwards the postmaster went to van de Wakker and said: "That man really does seem to need you: I'll see to your work this afternoon."

## WORK AND CREDITORS

Van de Wakker knew of Vincent's financial difficulties and wished to help him. One day he asked: "How's business? Can you still pay Baaiens?" Vincent replied: *Yes, so far; and when I can't I shan't mind making him wait. He has made enough out of me already.* Vincent took the same line in a letter to his brother, so that one might suppose he was being dishonest. But as a rule he paid his debts the moment he had the money to do so, and was glad to be rid of them. As always for him his work came before everything else.

Van de Wakker reveals an odd aspect of Vincent's realism. One day when he was drawing out-of-doors the midges kept settling on his paper, and he was squashing them dead as soon as they did so. Van de Wakker asked him if this was not spoiling his picture, and Vincent replied at once: *At least they'll be able to see that I drew it out-of-doors!* And this was what

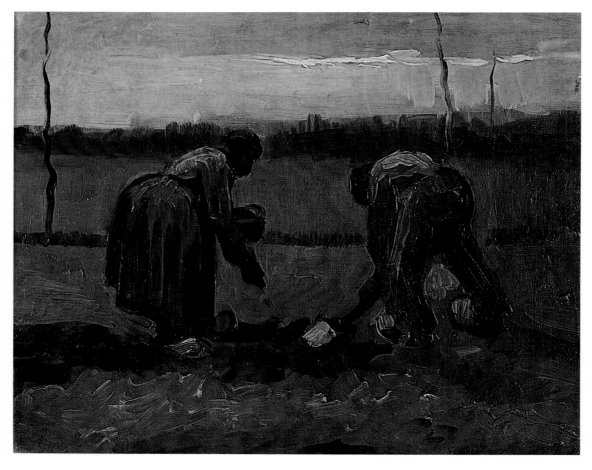

WORK IN THE FIELDS. Nuenen, April 1885, canvas, 31 × 39.5 cm, F 129b, H 192. Kunsthaus, Zürich. Photograph A.I.v.G.—The enlarged detail (right) of the top of the peasant's foreshortened body, is an instructive example not only of the sureness of Vincent's brush-strokes, but also his mastery of foreshortening.

144

he wanted them to know: that, like his hero Millet, he drew from nature with his subject before his eyes.

One day, when Vincent and van de Wakker were leaving a country inn called "De Blanken Opkamer", the landlord asked: "Could you do a little portrait of my old father?" *No*, replied Vincent laughing, *I don't do little portraits.*

Vincent's other pupil, Dimmen Gestel, frequently visited the studio at Nuenen. When he entered it for the first time he was astonished to see a pile of drawings "as high as the table". They were drawn with lithographic chalk and were all of peasant folk, most of them bent over working in the fields.

Gestel was impressed by Vincent's extraordinary energy and the speed at which he worked. Very early in the morning Vincent would begin a landscape of the heath with a flock of sheep and a shepherd. The picture would be finished by noon, and after lunch Vincent would go back to the heath to paint one or even two more large canvases.

During his last months at Nuenen Vincent was working so feverishly that he had no time to entertain his friends. He wrote to Gestel: *My studio is always wide open for you, but it's no good asking me to entertain you, I haven't the time.*

Gestel records that Vincent used to say: *If you can paint a potato well you can paint a tolerable sheep.* And also: *There's no better lesson than painting out-of-doors.* Vincent's remarks about his pupils' pictures were often harsh, but they were sound. His views would be closely argued; if one did not agree with him, he would soon cease to be friendly; but he became devoted to the good pupils who did.

Gestel was to become a talented painter, who later admitted that he had not valued his master's lessons properly at the time, for he was still shackled to the academic traditions against which Vincent was fighting. Vincent, for his part, benefited by the human contact with his pupils which was as necessary to him as the air he breathed.

## THE LONELY VICTIM

Vincent would often walk, sometimes with Kerssemakers, to a church in the middle of the fields which was being demolished by *the vandals of Nuenen*, as he called them. *They are busy pulling down the old tower in the fields*, he told Theo. *So there was an auction of lumber and slates and old iron, including the cross. I have finished a water-colour of it, in the style of the lumber auction, but better I think; I also had another large water-colour of the churchyard, but so far it has been a failure. Yet I have it well in my head ... what I want to express—and perhaps I shall get it on to the third sheet of paper.*

This deserted church was an impressive medieval building that looked larger than it really was, and Vincent was strangely attracted to it. In the studio Kerssemakers saw at least ten studies of it that Vincent had painted in various seasons and weathers. After Vincent's death in 1890 van Rappard wrote in a letter to his mother: "And what beautiful studies he made of the old church tower in the churchyard. I always remember a moonlight effect of it which particularly struck me at that time. When I think of those studies in these two rooms near the church, so many memories are conjured up."

Though Kerssemakers and van Rappard admired these pictures they probably did not realize why Vincent was so attracted to the subject. He felt pity for the old church — pity despite the fact that it was a thing of stone — for it seemed to him to have a sort of immemorial wisdom, which was very close to him and almost echoed his own life. His fellow-men treated him much as the "vandals" treated the church. He too felt he was being slowly destroyed. For this reason these pictures do not seem like ordinary landscapes; they are more like self-portraits that express the painter's own unhappiness.

Vincent's ability to identify himself completely with something external, which might be a person, an animal, a plant or even an object, was an essential part of his genius.

PEASANT MOWING. Nuenen, August 1885, black crayon, 41 × 51 cm, F 1318. Vincent van Gogh Foundation, Amsterdam.—This drawing is remarkable for the stability of the body, the balance of which is preserved in a masterly way, though leaning to the right.

146

## A STRANGE COMPLEX

It was not only the crumbling church that attracted Vincent, he was also drawn to the old cemetery that was being gradually overgrown. In his picture of the graveyard *where peasants have been laid to rest in the very fields which they dug up when alive,* he tried to explain the simplicity of death and burial. Even from his childhood Vincent had always been very attracted by country graveyards, which he found as plain and humble as the peasants buried in them.

In one of his first letters from Etten, dated April 3, 1877, he wrote: *It was very early when I arrived at the churchyard in Zundert; everything was so quiet. I went over all the dear old spots, and the little paths, and waited for the sunrise there.* Eighteen months later, when he was preparing for his mission work in the Borinage, he explained why he was so fond of graveyards: *It always strikes me, and it is very peculiar, that whenever we see the image of indescribable and unutterable desolation—of loneliness, poverty and misery, the end or extreme of all things, the thought of God comes into our minds. At least it does with me. . . .* Perhaps it was inherited from his father, who used to say: "There is no place I like to speak in better than a churchyard, for we are all standing on equal ground. . . ."

In the same letter he writes: *Where the road to Mont St. Jean begins there is another hill, the Alsemberg. To the right is the cemetery of St. Gilles, full of cedars and ivy, from which one can see the whole city.*

And in August 1883, when Vincent was at The Hague and Theo was at Nuenen, he wrote: *I wish we were walking there together in the old village churchyard.*

I have already mentioned the abandoned Jewish cemetery that he found near Hoogeveen in Drenthe. During his first period working at Goupil & Cie in Paris he visited the Père Lachaise cemetery and felt *an indescribable reverence for its marble tombs.* Later, when he was again in Paris, he did a drawing and a water-colour of THE COMMON GRAVE. At Arles he painted several canvases of Les Alyscamps.

PEASANT WOMAN PUTTING CORN IN SHEAVES. Nuenen, August 1885, black crayon, 43.5 × 54 cm, F 1262. Vincent van Gogh Foundation, Amsterdam.—Vincent has succeeded perfectly in ordering the spatial relationships to suit the demands of his model's unusual attitude.

All Vincent's pictures of the old church at Nuenen also include the graveyard. And in two of them there are crows flying round the church-tower. No doubt he had seen them doing so, and he had painted a similar subject in The Hague and in Drenthe. Yet in this particular context, where the church is seen as the victim of wanton destruction, the crows have a special symbolic meaning, which he had already mentioned in a letter to Theo: *In translating ancient Roman history I read how, as a sign and proof of approval and blessing from above, a raven or an eagle sometimes settled on certain persons' heads.*

This symbolism of black birds wheeling in the sky, which probably arose from chance observation and reading, intensifies the threat to the tower. And, if it was indeed a reflection of himself, these crows boded ill for the future. They appear again, most ominously, when they are a vital part of one of the last pictures that Vincent ever painted, CROWS ON THE CORNFIELDS.

## AN UNCOMMON SENSIBILITY

Once when he was out walking with Kerssemakers Vincent suddenly stopped and stared at the glorious sunset, using "his two hands to screen it off a little . . . his eyes half-closed". *God bless me,* he exclaimed, *how does that fellow—or God, or whatever name you give him—how does he do it? We ought to be able to do that too. My God, my God, how beautiful that is! What a pity we haven't got a prepared palette ready, for it will be gone in a moment.* He urged Kerssemakers to sit down beside him, and said: *Take care you never forget to half-shut your eyes when you are painting in the open air. Once in a while those clodhoppers in Nuenen say that I am mad when they see me shuffling about over the moor, and stop, and crouch down in a half-sitting position, every now and then screwing my eyes half-shut holding up my hands by my eyes, now in this way, now in that, in order to screen things off. But I don't give a damn about that, I just go my own way.*

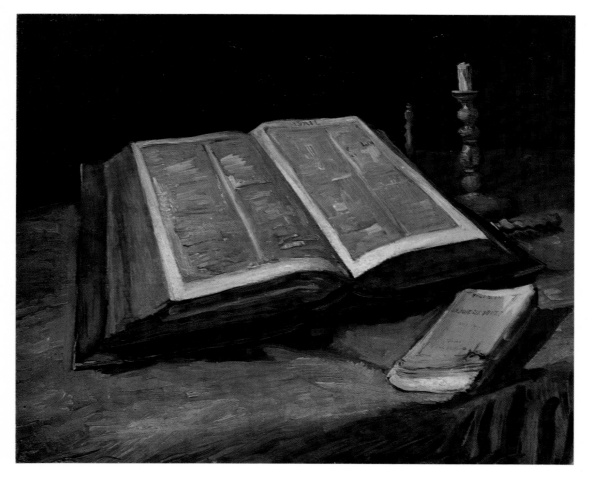

STILL-LIFE: OPEN BIBLE AND CANDLE. Nuenen, October 1885, oil on canvas, 65 × 85 cm, F 117, H 121. Vincent van Gogh Foundation, Amsterdam.—"In answer to your description of the study by Manet," Vincent wrote to his brother, "I send you a still-life of an open—so a broken white—Bible bound in leather, against a black background, with yellow-brown foreground, with a touch of citron yellow. I painted that in *one rush,* on one day. This to show you that when I say that I have perhaps not plodded entirely in vain, I dare say this because at present I find it quite easy to paint a given subject unhesitatingly, whatever its form or colour may be."

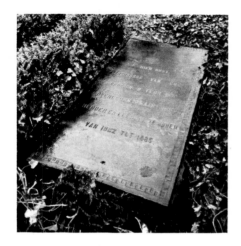

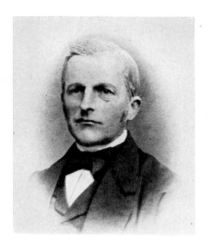

Vincent's father died suddenly of a stroke and was buried in the Protestant cemetery at Nuenen. The inscription on his tomb reads: "Here lies Theodorus van Gogh, born February 8, 1822, died March 26, 1885. Pastor and teacher at Nuenen from 1882 to 1885." (Photograph A.I.v.G.). After his father's death, Vincent did a still-life of a VASE OF HONESTY. (Vincent van Gogh Foundation, Amsterdam.) He told Theo: "I am still greatly under the impression of what has just happened—so I have worked on quietly these two Sundays. Enclosed you will find a scratch of a man's head and of a still life with honesty, in the same style as the one you took with you; in the foreground are Father's tobacco pouch and his pipe. If you care to have it, you may of course, and welcome."

Many years ago Piet van Hoorn, the old miller at Nuenen, told me something of his memories. When he was young he lived with his parents, who ran the mill at Opwetten, and when he was ten or twelve years old he saw the artist painting his famous picture of the mill. He showed me exactly where Vincent had put his easel, and was delighted when I produced a reproduction of the picture itself.

Piet van Hoorn, like Vincent, enjoyed walking about the countryside and often met the man who was invariably known as the "red-head" or the "little painter fellow" ("schildermenneke"). He mimicked the painter's gait and manner in a most amusing fashion; and one can picture Vincent absorbed in his task and unaware of Piet and doubtless other small boys watching and mocking him.

Van Hoorn described going into the painter's studio. Often it might be a quarter of an hour before Vincent realized that anyone had trespassed through his door. He would sit on a chair some distance from his easel and examine the picture for a great while. Suddenly he would leap up, paint two or three strokes, and then return to his chair. Not until he was satisfied with the results would he speak.

## CONTEMPLATING THE MASTERS

Other striking examples of Vincent's phenomenal powers of concentration are recorded by Kerssemakers. The two friends decided to visit the State Museum at Amsterdam, but as Kerssemakers could not spend the night away from home they arranged that Vincent should go the day before and they would meet in the third class waiting-room of the Central Station at Amsterdam. "When I came into this waiting-room", wrote Kerssemakers, "I saw quite a crowd of people of all sorts, railway guards, workmen, travellers, and so on and so forth, gathered near the front windows of the waiting-room, and there he was sitting, surrounded by this mob, in all tranquillity, dressed in his shaggy ulster and his inevitable fur cap, industriously making a few little city views (he had taken a small tin paintbox with him) without paying the slightest attention to the loud disrespectful observations and critical remarks of the esteemed public. As soon as he caught sight of me, he packed up his things quite calmly, and we started for the museum. Seeing that the rain was coming down in torrents, and van Gogh in his fur cap and shaggy

ulster soon looked like a drowned tomcat, I took a cab, at which he grumbled considerably, saying, 'What do I care about the opinion of all Amsterdam, I prefer walking: well, never mind, have it your own way.' " In the museum he spent most of his time sitting contemplating *The Jewish Bride* by Rembrandt Kerssemakers could not tear him away and went off to look at the other rooms on his own. *You will find me here when you come back,* Vincent assured him. When Kerssemakers eventually returned and suggested that it was time to get a move on, Vincent looked very surprised and said: *Would you believe it—and I honestly mean what I say—I should be happy to give ten years of my life if I could go on sitting here in front of this picture for a fortnight, with only a crust of dry bread for food?* At last, however, he got up to go. *Well, never mind,* he said, *we can't stay here forever, can we?*

Later they visited other museums in Holland and Belgium, and in Antwerp Vincent caught sight of Franz Hals's picture of a fisherboy carrying a basket on his back. "Suddenly", wrote Kerssemakers, "he disappeared from my side, and I saw him run to the picture; and of course I ran after him. When I reached him, he was standing in front of the picture with folded hands as if in devout prayer, and muttered, *God . . . damn it, do you see that?* After a while he said, *That is what I call painting, look*— and, following with his thumb the direction of the broad brush-strokes—*he was one to leave what he had once put down alone,* and indicating the gallery with a wide, all-embracing gesture: *All the rest belongs to the periwig-and-pigtail period.*

## WHAT NEED OF A SIGNATURE?

One day Kerssemakers asked him why he did not sign his name in full, and Vincent replied: *Van Gogh is such an impossible name for many foreigners to pronounce; if it should happen that my pictures found their way to France or England, then the name would certainly be murdered, whereas the whole world can pronounce the name Vincent correctly.*

It is hard to convict Vincent of vanity when one considers that his works are now scattered over the world and his surname is mispronounced in a hundred different ways.

Kerssemakers has another anecdote on the question of signing pictures. When Vincent was on the point of leaving Nuenen he went to say goodbye to Kerssemakers and brought him as a present "a beautiful autumn study, not yet entirely dry, finished entirely in the open air". It was a very large picture, three feet four inches by two feet eight inches in size, which his friend has described thus: "This autumn picture is still in my possession; it is painted in a very light range of colours, and the subject is very simple; in the foreground three gnarled oaks, still full of leaves, and one poor bare beggar of a pollard birch, in the background a tangled wilderness of various trees and shrubs, partly bare, shutting off the horizon, and in the centre the little figure of a woman in a white cap, just dashed off in three strokes of the brush, but having a beautiful effect, as he would have said himself."

The three oaks and the birch in AUTUMN LANDSCAPE grew beside a path behind the presbytery. Vincent also did a superb drawing of them from a different viewpoint, upon which one can see the little wooden gate opening on to the path.

Kerssemakers was struck by the atmosphere of autumn in the oil-painting, which was painted in broad strokes with a rich impasto, but he noticed that it was not signed. He mentioned this with some surprise to Vincent, who said that he might do so one day, adding: *I suppose I shall come back someday, but actually it isn't necessary; they will surely recognize my work later on, and write about me when I'm dead and gone. I shall take care of that, if I can keep alive for some little time.*

## THE ARTIST'S TRADEMARK

Vincent and Kerssemakers were working one day in the tanner's studio, both painting the same still-life of a pair of wooden shoes and some pots. Kerssemakers was having difficulty in getting any relief into his picture, when Vincent walked over and said: *Look here, now you put—no, you needn't be afraid I'll spoil your drawing—a vigorous dark transparent touch there and there—*and he began attacking his pupil's little canvas with his broad brush. *Do you see?* he went on. *Like that. Look, now the other part comes to the front. It is wrong to go brushing away on the same*

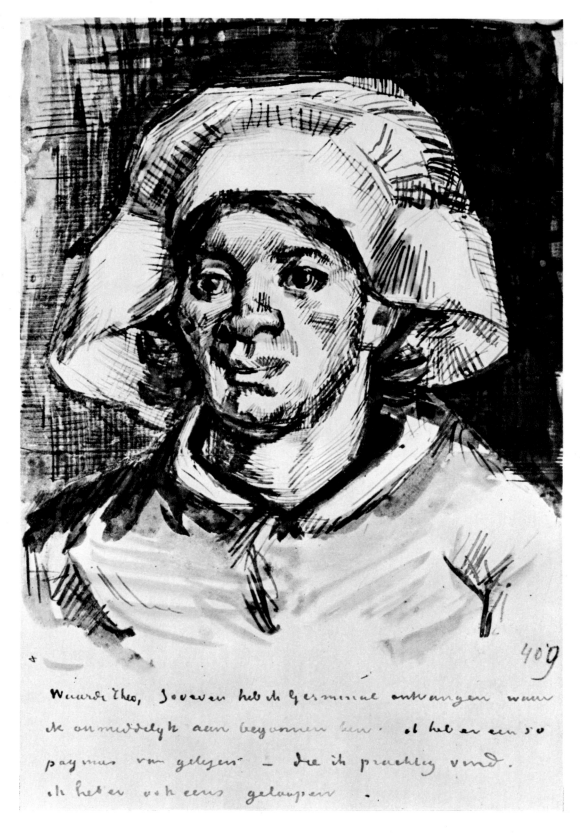

BRABANT PEASANT WOMAN. Nuenen, June 1885, pen and wash, 15.5 × 13 cm. Vincent van Gogh Foundation, Amsterdam.—The talent that Vincent had already acquired as a draughtsman is convincingly shown in this drawing of a woman's head, which he had also just painted in oil.

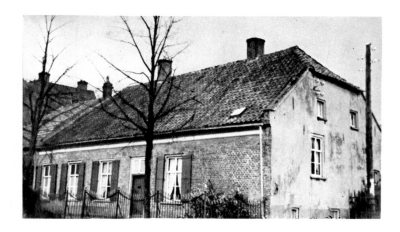

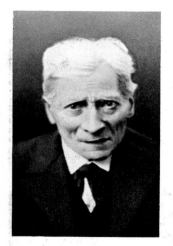

The verger's house. Photograph A.I.v.G.—After continual arguments with his father, Vincent left the presbytery, where he had already drawn studies of peasants, men and women. He then set up his studio in the house of the Catholic verger, Schafrath (left). On the right is the plan of the studio that he sketched in one of his letters. There he painted his famous POTATO-EATERS. At this time Vincent had more or less broken with his family, and only went to the presbytery for meals.

*spot, you must set it all down at once and then leave it alone; don't be afraid, and don't try to make it pretty.*

The same thing might happen when they were painting out-of-doors. On Kerssemakers's picture, *The Fowler*, of his uncle, the priest, out in the fields, one can clearly see where Vincent has painted in corrections in order to show his pupil how it should be done. There is the characteristic mixture of colours which he uses to reproduce the yellow and brown leaves on the bushes, the long green line painted horizontally across the picture to draw the background of the picture towards the horizon; the strong and sure brush-strokes are certainly not Kerssemakers's.

Although Vincent had an extraordinary awareness of the value of his own work, he still followed the rule of life that he had set forth to Theo when he was living at The Hague: that he preferred to live unknown and disregarded. The fact that he did not sign the painting that he gave Kerssemakers indicates this; and most of his pictures are unsigned.

For sixty years it was thought that Vincent had not signed THE POTATO-EATERS, the undoubted masterpiece of his Dutch period. But in fact he put his name on the back of the chair on the left so discreetly that nobody noticed it, though it had been exhibited for decades, until the painter's nephew's wife, Nel van Gogh-Vandergoot, to whom this book is dedicated, discovered it in 1953 after the centenary exhibitions when a chance ray of sunlight picked it out in the living-room at Laren.

## EVIDENCE OF MASOCHISM

Vincent lived in poverty. Kerssemakers has said that "he was starving like a true Bohemian". The widow of Schafrath the sexton told Dr Benno

J. Stokvis that when Vincent was living with her he slept on a bed in the corner of an empty attic under the tiles, although he had the use of two rooms, one of them very big and comfortable. But to have slept anywhere but in the attic would have been pampering himself.

Van Gogh led a simple life. He was rarely either light-hearted or ill-tempered. He had an enormous capacity for work, he set out to look for his subjects at dawn, and walked along the side of the road alone, deep in thought, staring at the ground. As a rule he went to bed at ten o'clock at night, usually having smoked his pipe before he retired.

He prepared his own food, heated his own coffee on a little stove, and ate nothing but dry bread with an occasional piece of cheese. *It won't go bad on the road*, he used to say.

Kerssemakers has described how once in summer before they set off on a painting excursion together, he invited Vincent to have a meal at an inn. If

THE COTTAGE AT NIGHTFALL. Nuenen, May 1885, oil on canvas, 64 × 78 cm, F 83, H 93.    Vincent van Gogh Foundation, Amsterdam.

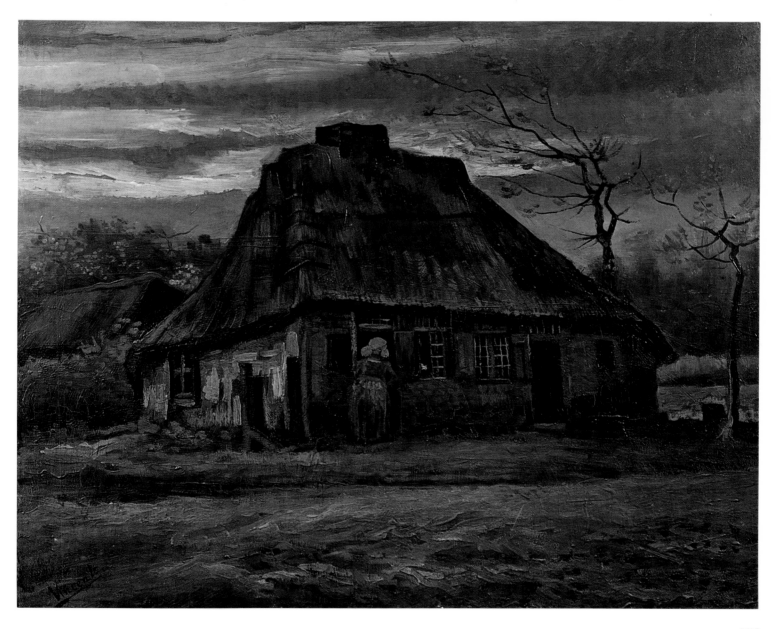

they ate a lot, he suggested, they would be able to keep going till the evening. "The table", Kerssemakers goes on, "was well furnished with various kinds of bread, cheese, sliced ham and so on. When I looked, I saw he was eating dry bread and cheese, and I said, 'Come on Vincent, do take some ham, and butter your bread, and put some sugar in your coffee; after all, it has to be paid for whether you eat it or not.' 'No', he said, 'that would be coddling myself too much: bread and cheese is what I am used to', and he calmly went on eating. On the other hand he liked to have some brandy in his flask on his rambles, and he would not have liked to do without it; but as far as I know this was the only luxury he permitted himself."

Van de Wakker tells a similar story. His mother invited Vincent to dinner and prepared a sumptuous spread, but when he came in and saw all the food he was quite shocked. "Have you done all this for me?" he asked. "I never eat anything but dry bread; I don't need all this good food." And he insisted on them giving him some crusts of bread.

Such extraordinarily plain living is surely a form of masochism.

## THE GRIM REAPER

During the winter Vincent worked on studies of heads of peasants. He was busy on one of them on March 26, 1885, when the news came that his father had collapsed and died of a heart-attack on the doorstep of the presbytery.

With their usual obtuseness the people of Nuenen thought that Vincent, the "schildermenneke" whose work they did not begin to understand, was in some way to blame for his father's death. At Etten Pastor Theodorus would say to Vincent "You're murdering me", or "You're poisoning my life", when his son put forward painful arguments that he could not answer. As he went on "reading the paper and smoking his pipe in complete tranquillity", Vincent did not take these remarks seriously. At Nuenen their relations were no better, and Vincent was careful to say no more to van de Wakker than *My father is a good pastor*.

Vincent wanted only to be able to treat his father as a friend, which, as he told Theo, would be easier if the old man were not so afraid of his son's "French errors". The sight of a book by Michelet, Victor

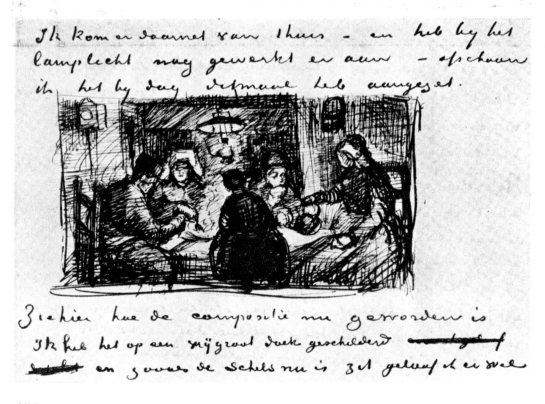

SKETCH OF A MASTERPIECE. Nuenen, April 1885, pen, 5 × 8.5 cm. Vincent van Gogh Foundation, Amsterdam.— Here we see how Vincent sketched the composition of his famous picture in a letter to his brother.

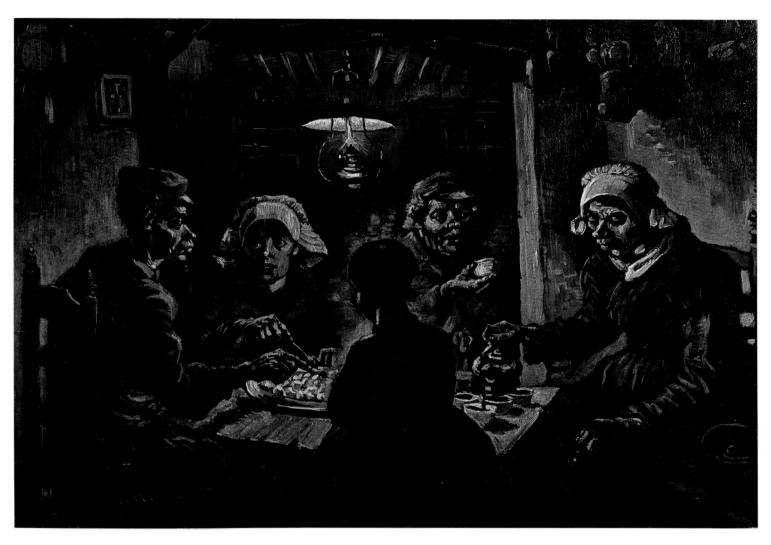

THE POTATO-EATERS.   Nuenen, April 1885, oil on canvas, 82 × 114 cm, F 82, H 1, signed on the back of the chair.   Vincent van Gogh Foundation, Amsterdam.—"I have tried to emphasize that those people, eating their potatoes in the lamp-light, have dug the earth with those very hands they put in the dish, and so it speaks of *manual labour*, and how they have honestly earned their food." (Vincent to Theo.)

Hugo or Zola in his son's hand was enough to make him think of murder and revolution.   To Vincent, Zola was a hero who had suffered for justice as well as being the greatest of realists.   When Zola was twenty he had said: "I do not want to walk in anyone's footsteps."   Shortly after his father died, Vincent read Zola's description of the poor mining folk of the Borinage, and he was most enthusiastic about it.

But the chief cause of the rift between father and son was the bitter quarrel over religion that has already been discussed.

They would sometimes argue for three or four hours together.   Pastor Theodorus hated these arguments, but Vincent would not give in, and for the conservative pastor almost everything that his son did or thought seemed to be an outrage to convention and a threat to his dignity among the people of Nuenen.   He felt so strongly that until Vincent turned up there one morning he had never mentioned his existence to anybody, not even to the Begemanns, who were neighbours and close friends.

Begemann was an "elder" of the Protestant church, and no doubt his critical eye made the pastor still more embarrassed at having so prodigal a son. Meanwhile Vincent's eccentric behaviour made his reputation worse than ever.   Van de Wakker tells

155

how at Eindhoven there was a tailor who had vainly been trying to sell some lilac cloth with yellow spots. Van de Wakker recalled Vincent's fondness for daring combinations of light colours and said: "I'll tell you what to do. Van Gogh is coming to see me tomorrow. Put that cloth in your window, and I'll bet you he buys it." Vincent did—for thirty-five guilders. His parti-coloured suit shocked the good people of Nuenen, and once again distressed his father and mother.

After Margot Begemann's attempted suicide, her family refused to visit the van Goghs for fear of meeting Vincent. Yet again the pastor suffered. Dealings with Vincent were always difficult. Sometimes he would not speak for days and would only communicate with his family by letter. His mother wrote to Theo: "How is it possible to behave so unkindly? . . . Here it is always the same, and he never speaks to anyone."

Vincent would not sit at table for his meals like other people. He had to have two chairs: one to sit upon and the other to hold the picture he was working on so that he could look at it while he ate.

Yet throughout everything his parents wished him well. On December 20, 1883, soon after Vincent had returned to Nuenen, his father wrote to Theo: "We undertake this experiment with real confidence, and we intend to leave him perfectly free in his peculiarities of dress, etc. The people here have seen him anyhow, and though it is a pity he is so reserved, we cannot change the fact of his being eccentric. . . ." And this goodwill continued to the end. Two days before he died he wrote to Theo: "This morning I talked things over with Vincent: he was in a kind mood and said there was no particular reason for his being depressed. . . . May he meet with success anyhow."

A TROUBLED CONSCIENCE

Vincent was much moved by his father's sudden death. Soon after his arrival at Nuenen, when telling Theo of his differences with his father, he wrote: *Father's grey hairs make it clear to me that, forsooth, perhaps we have not so much time left for a reconciliation.* Van de Wakker told Stokvis that after the death of his father Vincent drew a picture of him in his coffin. No such drawing seems to have survived.

At the beginning of April 1885, only a few days after his father's death, we have the first record of Vincent's reaction. To begin with he could not work as usual, but he hoped to sketch the churchyard when the weather improved. His tone was calm, almost cold, with that numbness that often follows a death, but was so unlike Vincent's passion on lesser occasions. His next letter showed the same state of mind. *I am still greatly under the impression of what has just happened,* he wrote, enclosing a sketch of a still-life he had just painted. It was of a vase of honesty flowers, with his father's pipe and tobacco-pouch in the foreground. Dr Umberto Nagera, whose psychological study of van Gogh has been quoted earlier, rightly considers that, despite the shock of his father's death and the many disputes that had preceded it, Vincent reveals in this picture no trace of guilt or remorse. What significance the choice of flowers may have depends on the choice of language. They are called "Judas pennies" in Dutch and "Pope's pennies" in French. All of which have very different implications.

Many years later, at Arles when Christmas was approaching, he painted two pictures of empty chairs, remarking to Theo: *the last two studies are odd enough.* One of the chairs was Gauguin's, and Vincent must have felt that his friend would soon be leaving the Yellow House and his chair would remain empty. But why the second chair? Nagera, after detailed and careful analysis, concludes that it is a symbol of his father's death.

Vincent had always been moved by the image of a chair left empty by somebody one had loved. He has described how his father visited him in Amsterdam, and when he *had seen Father off at the station and had watched the train go out of sight, even the smoke of it, I came home to my room and saw Father's chair standing near the little table on which the books and copybooks of the day before were still lying; and though I know that we shall see each other again pretty soon, I cried like a child.*

He had also been much impressed by an anecdote about Luke Fildes, who illustrated Dickens's last unfinished book, *Edwin Drood,* and came into the novelist's room on the day he died. Fildes saw the empty chair and drew a picture of it for *The Graphic* in memory of Dickens: *Empty chairs* commented Vincent in a letter to Theo from The Hague, *there are*

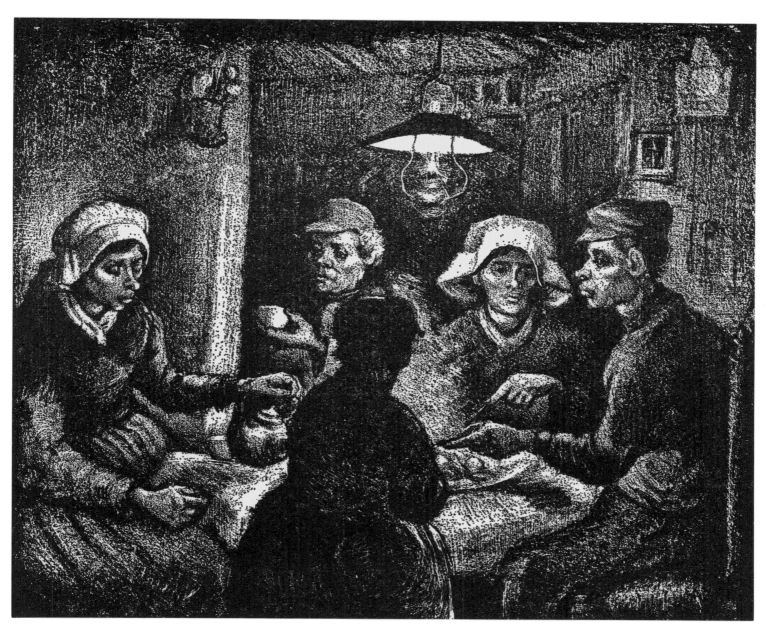

VINCENT AS LITHOGRAPHER. Eindhoven, April 1885, 25.5 × 30.5 cm, F 1661.—This lithograph was done in Gestel's studio at Eindhoven from the final version of THE POTATO-EATERS. Vincent intended to make a whole series of lithographs on themes derived from peasant life. He sent a print to van Rappard, who criticized the composition in disagreeably severe terms. This eventually led to the break-up of their friendship.

*many of them, there will be even more. . . .* This is how we should understand the chairs he painted at Arles.

In the picture painted at Nuenen the pipe and tobacco-pouch represent his father's death. On the empty chair painted at Arles Vincent's pipe and tobacco point to his own death. At Nuenen he had been able to repress his feeling of guilt, but at Arles he could no longer hide his responsibility.

The still-life of the VASE OF HONESTY was painted in April 1885. In the October Vincent did a still-life which he described to Theo as: *an open—so a broken white—Bible bound in leather, against a black background, with yellow-brown foreground, with a touch of citron yellow. I painted that in one rush, on one day.*

Several writers have remarked on the contrast in this picture between the Old Testament, open at the book of Isaiah, and the title on a copy of Zola's *La Joie de Vivre;* the allusion is obvious enough, since the novelist's works were a bone of contention between father and son. Psychologically this picture seems to represent a half-way stage between the VASE OF HONESTY and the empty chair. In the autumn of 1885 he did not yet feel guilt at his father's death, but he was already beginning to need to justify the disputes which may perhaps have hastened it.

## A RASH AMBITION

After his father's death Vincent immersed himself in his work more deeply than ever. Soon he was to attempt to solve his problems with colour in the way that Rembrandt had done, even though he was too modest perhaps even consciously to admit that this was what he was trying to do.

One day when Vincent was working out-of-doors with van de Wakker, he told his friend that he had spent an evening in the de Groots' little cottage, where he often used to work: he had gone in to rest awhile. They were all sitting round the table under the lamp and were about to start their evening meal.

He was struck by the magical effect of the light. He had seen a similar sight in a mine in the Borinage, and he had never forgotten it. Now, as then, he was moved by the commonplace daily human tragedy, which no one before him had seen and depicted.

He began painting his first study at once. He wanted to show the true values of the darkness around the little lamp in the cottage and yet to make the people and their background clear. He was in fact trying to make darkness visible, as Rembrandt and other great masters had done, but in his own way. He was attempting to emulate Rembrandt's chiaroscuro with Franz Hals's vigour and boldness of line. And his success was such that if THE POTATO-EATERS were the only picture he ever painted it would be enough to establish him as a pioneer of genius.

More than two years later, after his style had radically changed, he wrote to his sister Wilhelmien: *What I think of my own work is this—that that picture I did at Nuenen of those peasants eating potatoes is the best one after all.*

## DRAWING UPON STONE

Dimmen Gestel was, as I have mentioned, the son of a printer who specialized in printing cigar-bands, which were then done by lithography, and his father therefore had large numbers of lithographic stones. Vincent had been interested in lithography for some time, and he had done some lithographs when he was at The Hague. But he had not hitherto had an opportunity to print lithographs when he was living at Nuenen. When he had finished painting THE POTATO-EATERS, he came and asked for a "small" lithographic stone which turned out to be so big and heavy that he needed help to carry it to the railway station. Some time later he returned with the stone having drawn THE POTATO-EATERS on it in lithographic chalk. Kerssemakers says that he made twenty prints of it and gave one to each of his pupils. Kerssemakers's own copy was printed on such poor paper that it became hopelessly tattered.

One Sunday afternoon Gestel went with his brother and a lithographer to Vincent's studio. "We were received", he wrote, "by Vincent in his studio, which he had in the house of the sexton of the Roman Catholic Church at Nuenen. . . . There he was standing before us, that short, square-built little man, called by the rustics '*het schildermenneke,*' 'the little painter fellow'. His sunburned, weather-beaten face was framed in a somewhat red and stubbly beard. His eyes were slightly inflamed, probably from his painting in the sun. If it had not been Sunday, he would certainly have been wearing his

blue blouse. Now he was dressed in a short, thick pea-jacket, the kind bargemen generally wear. While he was talking about his work, he mostly kept his arms folded across his chest." In the evening all four of them went for a walk to the churchyard.

Among the women who posed for Vincent's many studies of peasants' heads, there is one face which often recurs. It is that of Gordina de Groot, the unmarried daughter of the family who inspired THE POTATO-EATERS. The village gossips said that she was Vincent's "Dulcinea", as Kerssemakers put it.

The "schildermenneke" was not only alleged to have had illicit relations with her; it was even said that he was the father of her unborn child. This did not worry Vincent, who wrote to Theo: *However, as I am quite innocent, the gossip from that quarter leaves me perfectly indifferent; as long as they don't hinder me in my painting I don't take any notice of it whatever. With the peasants to whom the accident happened, where I often used to paint, I have remained on good terms, and I am as welcome in their home as I used to be.*

*The priest disapproved, and even went so far as to promise the people money if they refused to be painted: but they answered quite spiritedly that they would rather earn money from me than beg some from him.*

Fortunately for Vincent the real culprit turned out to be a member of the priest's congregation. Nevertheless, Kerssemakers maintained that it was the priest's influence that eventually forced Schafrath to make Vincent leave his studio.

## THE END OF A FRIENDSHIP

Vincent sent a lithograph of THE POTATO-EATERS to van Rappard, who did not like it at all. The subject had been treated too superficially; the people's movements had not been properly studied,

BIRDS' NEST. Nuenen, September 1885, pencil, 13 × 16.5 cm. Vincent van Gogh Foundation, Amsterdam.—Below this sketch Vincent has noted: "In the winter, when I have a little more time, I shall do some drawings on the theme of nests and the birds in them. It is a subject which has always been close to my heart, especially those nests inhabited by men, the huts on the heath and their inhabitants."

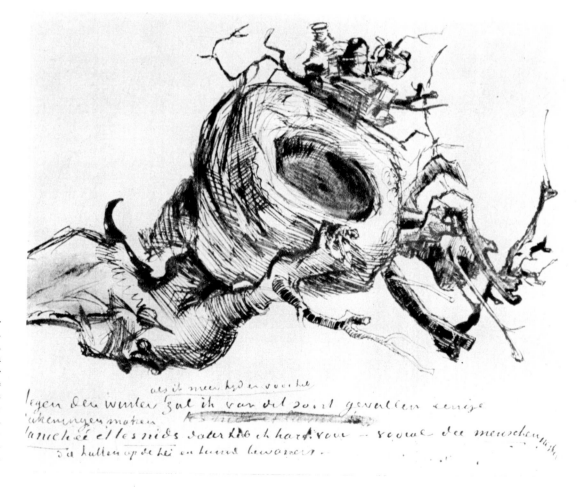

and their positions were awkward; the woman's little hand in the background was unrealistic; there was no proper connection between the kettle, the table and the hand on the handle; and what was the kettle doing floating in the air? Why had the man on the right no knee, belly or lungs? Why was his arm a yard too short and he had only half a nose? Why did the woman on the left have a nose like a cube on the end of a tobacco-pipe? Van Rappard was shocked that Vincent should mention himself in the same breath as Millet and Breton, and he concluded: "In my opinion art is too sublime a thing to be treated so nonchalantly."

Vincent was much hurt and replied: *I have just received your letter—to my surprise. You are herewith getting it back.* There was no immediate break in their relations, but their friendship cooled, and their correspondence soon petered out.

When even van Rappard, who had hitherto admired his honest efforts, spoke of THE POTATO-EATERS with scorn, Vincent felt more misunderstood than ever. Van Rappard did not realize that Vincent had been guided not by intuition but by his intelligence in creating this picture.

After Vincent died, van Rappard wrote to his mother: "Though Vincent and I had been separated the last years by a misunderstanding which I have often regretted—I have never ceased to remember him and the time we spent together with great sympathy. Whenever in the future I shall remember that time, and it is always a delight for me to recall the past, the characteristic figure of Vincent will appear to me in such a melancholy but clear light, the struggling and wrestling, fanatic, gloomy Vincent, who used to flare up so often and was so irritable, but who still deserved friendship and admiration for his noble mind and high artisitic qualities."

After completing THE POTATO-EATERS, Vincent tried to carry his experiments in chiaroscuro a stage further. He was particularly fascinated by the earthiness of potatoes, and he tried to portray the warmth and symbolic strength of birds' nests. They represented for him the family home that he did not have. Thus he spoke of the cottages around Nuenen as those *"peasants' nests" which remind me so much of the wren's nest.*

A longing for a home of his own had kept him attached to Sien and her two children for many months. Now he felt the need of a home more than ever. No other artist has expressed its absence more forcefully or given so free a rein to his disordered spirit. Despite his cool relations with van Rappard, he sent him a basket full of birds' nests: nests of thrushes, blackbirds, golden orioles, goldcrests and finches.

During his walks around Nuenen, Vincent discovered a large number of birds' nests. He told Theo of *a long ramble made with a peasant boy to find a wren's nest* one Sunday. They found six nests. *And they were all nests which the young birds had left, so one could take them without too many scruples.*

He would also buy other birds' nests from boys in the village. Before and just after the Second World War I spoke to several of them: Johannes de Looyer, Ricus Dekkers (son of the weaver whom Vincent often painted), Karel van Engeland, Jan-Franciscus de Rooy, Hannes van de Velden, van Bakel, as well as Piet de Hoorn, the miller already mentioned. They were then boys of eleven, ten, seven, nine, twelve, eight and eleven respectively. Usually they were paid five or six cents a nest, but Ricus once got half a guilder for a swallow's nest, and Piet earned a flat rate of twenty-five cents because he always brought the surrounding branches and leaves as well as the nest. This explains why he visited the studio so often.

A series of unfortunate events at Nuenen—Margot's attempted suicide, his father's death, the malicious rumours about Gordina de Groot's baby, the quarrel with van Rappard, the priest's animosity and his notice to quit Schafrath's studio—made Vincent feel that he was doomed to misfortune there, and that he had better leave. When he said goodbye to the Schafraths, he told them that he would probably be away for only a fortnight. He left all his belongings behind, except for the pictures that he had sent to Theo. His mother, who was also on the point of leaving Nuenen, removed Vincent's furniture and his pictures. But as she did not know what to do with it all she decided in the end to send it to a carpenter at Breda.

In this way a vast quantity of canvases and large studies were eventually consumed by a papermill. Hundreds of sketches and drawings were piled on Couvreur's pedlar's barrow and were sold in the market at five or ten cents each. Few buyers realized the value of what they had bought.

# THE ANTWERP PERIOD

Vincent had long since decided that Antwerp would be his next destination. His first reason for going there was that he thought it was a place where he might be able to sell some of his pictures. In February 1884, barely two months after he had left Drenthe, he wrote to Theo: *Perhaps I will try to sell something in Antwerp ;* and in his next letter: *Rappard said, Don't go to Antwerp unless you are sure you will find something there.* Theo would certainly have recognized this as the beginning of an ambition that was not yet formulated.

Vincent continued to talk of going there to sell pictures. *What I said about my trying to do something with my work for instance in Antwerp—this is definitely my intention.* By October 1884 his intentions were clearer. He had already bought John Marshall's *Anatomy for Artists* and other books used by the Academy at Antwerp; and he wrote to Theo: *For if I went to Antwerp, of course I should want to work hard there, and should need models, which I am afraid would be too expensive at the moment. But in general Rappard too advises me to do it, not right away, but after having painted here for a few more months, then to try to get a* pied-à-terre *there in order to paint some studies from the nude. But if I paint about thirty studies of heads here first I shall be able to get more out of Antwerp.*

A month later he told Theo that his friend Hermans, the retired goldsmith at Eindhoven, had promised to give him the money for a return ticket so that he could take a trip to some city with museums and galleries. *If I want to go to Antwerp,* Vincent wrote, *I can take him at his word, and this winter I will try to manage to get some connections there, though that may not succeed all at once either.* The "connections" he had in mind were of course dealers who might buy his pictures, as well as other artists. He also wanted to find somewhere in Antwerp where he could live and work.

The idea persisted, and it was frequently mentioned in his letters from Nuenen. For the moment he was busy with his studies which eventually became THE POTATO-EATERS. But after his father's death he raised the subject again: *If I work hard every day, by that time I can have another twenty studies for you, besides twenty more to take to Antwerp if you like.*

By November 1885 Vincent had made up his mind that he must get away from Nuenen, now that winter had come. *I certainly intend to go to Antwerp,* he declared. He was only waiting for Theo's allowance to come so that he could go. And when it came he wrote: *You will be able to understand that I shall leave next Tuesday if you consider, firstly, that I am simply longing for it, secondly, that I risk getting stuck here*

*with my work through lack of models, while working out-of-doors has stopped because of the cold.* He had made the choice between staying in Nuenen with a safe studio but with no subjects to portray or going to Antwerp, where although he would not have a studio ready for him at least he hoped to find enough models to enable him to continue working.

Although we cannot be certain exactly when Vincent left Nuenen and went to Antwerp, it was probably three days later than he had told Theo. His second communication from Antwerp is dated only *Saturday evening,* and in it he wrote: *Try and send your letter off on the first.* It was therefore the last Saturday in November (the 28th), and he probably arrived the day before on the 27th.

## A NEW ROOST

Vincent took a little room at 194 rue des Images above a colour-shop. He paid twenty-five francs a month for it. Since 1920 the address has been No. 224, and the street has been renamed Longue rue des Images to distinguish it from the Courte rue des Images. Two months later, on February 18, 1886, Vincent wrote mysteriously in the postscript to a letter to Theo: *I do not trust the people whom I live with, so if you send a letter with money in it, as you did recently, it is safer to have the letter registered.* We cannot tell exactly what happened, for the clues are inconclusive. In a pocket notebook that Vincent carried at this time, there are two phrases that refer to the police: "Bureau 3e wijk" (Office Third Division) on one page and its address, "Everdijst 28", on another. The records of this police station have disintegrated in a damp cellar and no longer exist—and in any case Vincent's lodging in the Longue rue des Images would have been in the Fifth Division, not the Third.

Vincent's little room was between the second and third floors; but it no longer exists, as the house has been rebuilt. We can, however, tell exactly where it was from a picture that Vincent painted of the view from his window. Vincent described his room thus: *My studio is not bad, especially as I have pinned a lot of little Japanese prints on the wall, which amuse me very much. You know those little women's figures in gardens, or on the beach, horsemen, flowers, knotty thorn branches. . . . I feel safe now that I have a little den where I can sit and work when the weather is bad. . . . My little room is better than I expected, and it certainly doesn't look dull . . . as to my lodgings, I am well off, as by spending a few francs more I have got a stove and a lamp. I shall not easily get bored, I assure you.* Vincent had not given up the habit of pinning prints to the walls, however much his landlords might dislike it.

## THE HUMMING CITY

Vincent already knew Antwerp because he had been there with Kerssemakers. But strangely enough he never mentioned this to Theo at the time. Nor do any of the twenty-three long letters that he wrote from Antwerp hint that he had been there before. He told Theo that he was much struck by Franz Hals's painting of the *Fisherboy* as though it was the first time that he had seen it.

He hastened to see some pictures that had interested him since he was employed by Goupil & Cie at The Hague. The old citadel (known as the Steen) and the Cathedral with its tall spire, both of which he was soon to draw, were not his first concern. He went to the Town Hall and saw Baron Leys's paintings on the walls of the dining-

162

hall, which he had long wanted to see: *The Walk on the Ramparts, The Skaters, The Reception, The Table* and *St Luke*. Then he went to the Musée d'Art Ancien, and the Musée Moderne. In the first he saw works by Rubens, Hals, Jordaens, van Goyen, Ruysdael, Quentin Matsys, van Eyck and many others. In the second he was attracted to pictures by Mols, Braekeleer, De Cock, Lamorinière, Coosemans, Asselbergs, Rosseels, Baron, Munthe, Achenbach, Leys, Ingres, David and Verboeckhoven.

Vincent arrived in Antwerp as if it were his first taste of civilization. He was determined to learn all he could in a short time. He was eager to make himself capable of gaining his own place in the museums.

He was also attracted by the old town, especially those parts where the life of the quays mingled with the commerce of the city. He had been struck by this in Amsterdam on August 5, 1877: *I like to walk on old, narrow and more or less gloomy streets, with drugstores, lithographic and other printing offices, sea-chart shops, and stores with ship's victuals, etc . . . everything is interesting there.*

The dockside quarter in Antwerp reminded him of a seaport, and in his second letter, probably written, as I have said, on November 28, he described the city: *As to the general view of the harbour or a dock— at one moment it is more tangled and fantastic than a thorn hedge, so confused that one finds no rest for the eye, and gets giddy, is forced by the whirling of colours and lines to look first here, then there, without being able, even by looking for a long time at one point, to distinguish one thing from another. But when one stands on a spot where one has a vague plot as foreground, then one sees the most beautiful quiet lines, and the effects which Mols, for instance, often paints. Now one sees a girl who is splendidly healthy, and who looks or seems to look loyal, simple and jolly; then again, a face so sly and false that it makes one afraid, like a hyena's. Not to forget the faces damaged by smallpox, having the colour of boiled shrimps, with pale grey eyes, without eyebrows, and sparse sleek thin hair, the colour of real pigs' bristles or somewhat yellower; Swedish or Danish types. It would be fine to work there, but how and where? For one would soon get into a scrape. However, I have trudged through quite a number of streets and back streets without adventure, and I have sat and talked quite jovially whith various girls who seemed to take me for a sailor.*

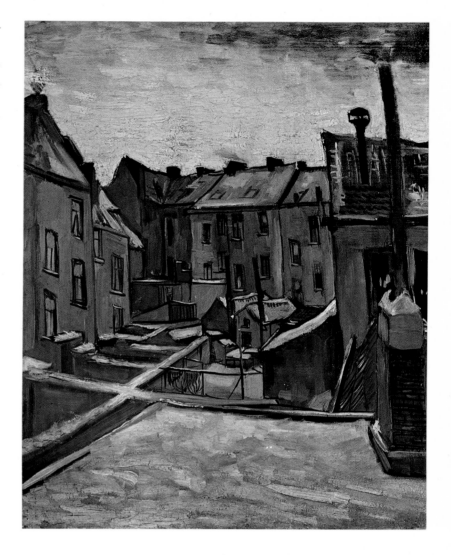

BACKS OF OLD HOUSES IN ANTWERP. Antwerp, end of November or beginning of December 1885, oil on canvas, 44 × 33.5 cm, F 260, H 260. Vincent van Gogh Foundation, Amsterdam.—Vincent painted this picture from a window between the first and second floors of the house at No. 224 in the Longue rue des Images in Antwerp.

He was no less fascinated by the beer-drinkers of Antwerp than he had been by the potato-eaters of Nuenen. In the narrow dockside streets he looked into the taverns where he saw: *Flemish sailors, with almost exaggeratedly healthy faces, with broad shoulders, strong and plump, and thoroughly Antwerp folk, eating mussels, or drinking beer, and all this will happen with a lot of noise and bustle—by way of contrast —a tiny figure in black with her little hands pressed against her body comes stealing noiselessly along the grey walls. Framed by raven-black hair—a small*

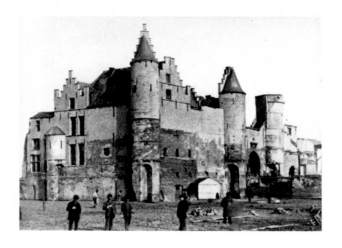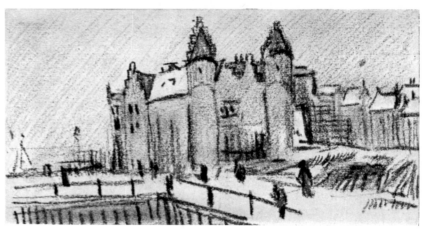

THE STEEN. Antwerp, December 1885, black chalk heightened in colour, 9.5 × 16.5 cm, F 1350. Vincent van Gogh Foundation, Amsterdam.— Vincent has unwittingly provided valuable evidence of the history of Antwerp in these two pictures, for he has drawn this historic building when the nearby part of the Scheldt was just about to be filled in. Several weeks later the newly-built quays completely changed the appearance of the place. The photograph (Antwerp City Archives), dates from the same period as Vincent's drawings, and a comparison of the three pictures on these pages shows once again Vincent's respect for reality, for instance in his interest in the street-lamps, which lasted throughout his career.

*oval face, brown? orange-yellow? I don't know. For a moment she lifts her eyelids, and looks with a slanting glance out of a pair of jet black eyes. It is a Chinese girl, mysterious, quiet like a mouse—small, bedbug-like in character. What a contrast to that group of Flemish mussel eaters.*

There was drama and action around him as well as colour and mystery. He was walking along a dockside street when he heard a sudden loud noise of cheering and shouting. *In broad daylight,* he wrote, *a sailor is being thrown out of a brothel by the girls, and pursued by a furious fellow and a string of prostitutes, of whom he seems rather afraid — at least I saw him scramble over a heap of sacks and disappear through a warehouse window.*

He went to a popular dance: *It was most interesting and they behaved quite decently. However, that will not be the case at all those balls. Here, for instance, nobody was drunk, or drank much. There were several very handsome girls, the most beautiful of whom was plain-faced. I mean, a figure that struck me as a splendid Jordaens or Velasquez, or Goya—was one in black silk, most likely some barmaid or such, with an ugly and irregular face, but lively and piquant à la Franz Hals. She danced perfectly in an old-fashioned style. Once she danced with a well-to-do farmer who carried a big green umbrella under his arm, even when he waltzed very quickly. Other girls wore ordinary jackets*

*and skirts and red scarves; sailors and cabin boys, etc., the funniest types of pensioned sea captains, who came to take a look, quite striking. It does one good to see folks actually enjoy themselves.*

He was delighted by all this colour and bustle. He had known the riverside parts of London, and knew some of the Dutch ports well, but Antwerp seems to have attracted him more than any of them. *Antwerp is beautiful in colour,* he concluded, *and it is worth while just for the subjects.*

He visited four dealers and persuaded some of them to try to sell his pictures on commission. He had set up a studio, bought paints and begun to work.

A MEETING BETWEEN TWO WORLDS

In one of his last letters from Nuenen, Vincent mentioned that he wanted to see the works of Rubens. In Amsterdam he had already seen some examples in the State Museum in October; and he told Theo in passing: *I saw a sketch by Rubens and a sketch by Diaz almost at the same time; they were not alike, but what they have in common is the belief that colour expresses form if well applied and in harmony.*

This was the first mention of Rubens in Vincent's correspondence, although he had cited the names of hundreds of other painters before. The reason why

164

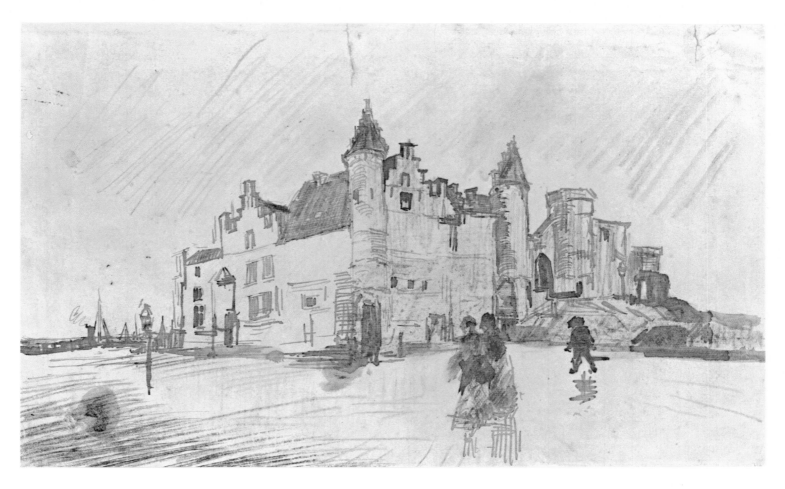

THE STEEN (another version).  Antwerp, December 1885, pen and colour, 13 × 21 cm, F 1351.  Vincent van Gogh Foundation, Amsterdam.

he hitherto ignored one of the greatest painters in history is not difficult to find.  Many of Rubens's pictures seem at first to belong to an unreal mythological world, very different from the humble and realistic subjects of Vincent's pictures.  Indeed it was this very world which he felt that he was battling against, like Millet, Courbet and de Groux.  There could hardly be a greater contrast between Peter Paul Rubens, the aristocratic diplomat, dressed in sumptuous velvet and lace, shining buckles on his shoes, an elegant feather in his wide-brimmed hat, a welcome visitor at the courts of emperors and kings, and Vincent van Gogh, the despised "peasant" in his ragged blue smock, his fur hat and his worn-out shoes.

Vincent had spent three days in Amsterdam, and although his chief admiration was for Rembrandt and he was impressed by the skill of Franz Hals, he must also have seen four paintings by Rubens.  Two of these belonged to the State Museum and two were on loan from the municipality.  The first two were *Jesus Carrying the Cross*, a study for the big canvas commissioned by Grimbergen Abbey and now in the Royal Museum of Fine Arts in Brussels, and *Cimon and Pera* which shows a young woman suckling her father in prison.  The other two pictures were portraits of Hélène Fourment and Anne of Austria.

## A REVELATION

Vincent's letters at this time were much concerned with colour, and, in discussing Hals's use of it, he wrote: *Well, Franz Hals is a colourist among colourists, a colourist like Veronese, like Rubens, like Delacroix, like Velasquez.*  This, once again, is a passing mention, but Rubens is bracketed with the greatest

of painters. Then in November 1885 he wrote about Goncourt's praise of Boucher and added: *I do not fear a single moment that de Goncourt would deny the superiority of, for instance, Rubens. Rubens who was even more productive than Boucher, not less than he, but even more so, as a painter of nude women. Which very often in Rubens does not prevent the poignant pathos and intimacy I mean, especially in those portraits of his wives, in which he is then himself, or surpasses himself.*

Vincent had clearly been impressed by the two portraits of women in Amsterdam, and he had realized that despite the baroque superficiality of some of Rubens's work the *poignant pathos and intimacy* were not always lacking, and that this made him the equal of the greatest.

In the last letter that he wrote to Theo from Nuenen, Vincent mentioned how much he was looking forward to seeing paintings by Rubens, even though he thought him inferior to Rembrandt: *Do you object to my thinking Rubens's conception and sentiment of his religious subjects theatrical, often even badly theatrical in the worst sense of the word? Look here—take Rembrandt, Michelangelo—take the "Penseroso" by Michelangelo. It represents a thinker doesn't it? But his feet are small and swift, his hand has something of the lightning, quickness of a lion's claw and—that thinker is at the same time a man of action, one sees that his thinking is a concentration, but—in order to jump up and act in some way or other. Rembrandt does it differently. Especially his Christ in the "Men of Emmaus" is more a soul in a body, which is surely different from a torso by Michelangelo, but still—there is something powerful in the gesture of persuasion.*

Vincent went on to analyze Rubens very pertinently: *Now put a Rubens beside it, one of the many figures of meditative persons—and they become people who have retired into a corner in order to further their digestion. That's how it is in everything religious or philosophical he does, it is flat and hollow ; but what he can paint is—women—like Boucher and better—there especially he gives one most to think about and there he is at his deepest. What he can do—thanks to his combinations of colour—what he can do is paint a queen, a statesman, well analyzed, just as they are. But the supernatural—where magic begins, no—unless one counts putting something infinite into a woman's expression, which, however, is not dramatic.*

The most important point here is *combinations of colour*. The great Flemish master's technique differed in this respect from the Dutch painters. Neither Rembrandt nor Hals ever succeeded in portraying the colour of flesh so well as Rubens, especially in paintings of women. Vincent wanted to study this secret more thoroughly than he could at Amsterdam; and Antwerp, which is Rubens's city *par excellence*, provided him with an opportunity. There is no doubt that the desire to solve the mystery of Rubens's portrayal of human flesh was one of the chief motives that decided Vincent to go to Antwerp.

The first sentence of his account of his visit to the Musée d'Art Ancien is very revealing: *I agree with you that the figures on the first plane, those heads in "Christ in Purgatory", are very beautiful, finer than the rest, and than the principal figure ; those two blonde women's heads especially are Rubens at his best.*

It was the combination of colour in these two heads that particularly attracted Vincent.

## ADMIRATION FOR RUBENS

Many passages in Vincent's correspondence confirm the impression that Rubens made upon him: *I am quite carried away by his way of drawing the lines in a face with streaks of pure red.* He went back to the museum from time to time, and looked at little else besides Rubens—*in themselves those heads are so alive.* The blonde heads in *St Theresa in Purgatory* particularly attracted him. He explained his admiration in a letter to Theo: *I like Rubens just for his ingenuous way of painting, his working with the simplest means. . . . But as to the portraits—those I remember best are the "Fisherboy" by Franz Hals, "Saskia" by Rembrandt, a number of smiling or weeping faces by Rubens. Ah, a picture must be painted—and then why not simply? Now when I look into real life—I get the same kind of impressions. I see the people in the street very well, but I often think the servant girls so much more interesting and beautiful than the ladies, the workmen more interesting than the gentlemen ; and in those common girls and fellows I find a power and vitality which, if one wants to express them in their peculiar character, ought to be painted with a firm brush stroke, with a simple technique. Wauters understood this, used to at least, for so far*

166

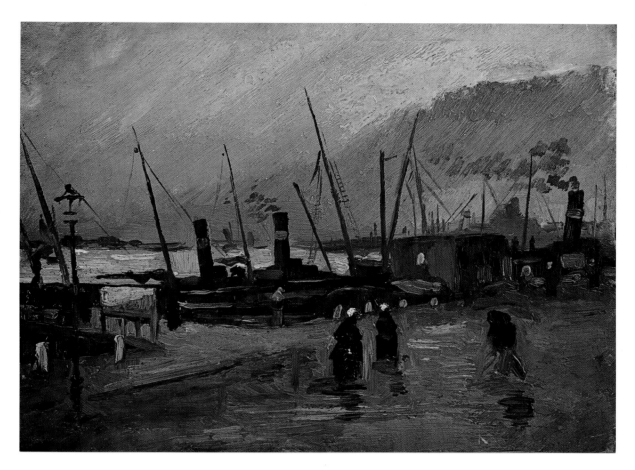

THE QUAY. Antwerp, early December 1885, oil on wood, 20.5 × 27 cm, F 211, H 226. Vincent van Gogh Foundation, Amsterdam.—This picture was painted from the bend of the Scheldt below Royers lock.

*I haven't seen any work of his here. What I admire so much in Delacroix, too, is that he makes us feel the life of things, and the expression, and the movement, that he absolutely dominates his colours. And in a great many of the good things I saw, though I admire them, there is often far too much paint. At present I am getting more and more in the habit of talking to the models while painting, to keep their faces animated.*

Every letter that Vincent wrote during his first six weeks in Antwerp includes a reference to Rubens. What effect did the Flemish master have on Vincent's own pictures?

As soon as Vincent had arrived in Antwerp, he set to work painting as usual. From his window he could see the backs of old houses; he painted them in such an uninhibited manner and in such light colours that de la Faille thought that BACKS OF OLD HOUSES belonged to Vincent's Paris period.

What can have made Vincent lighten his palette but the influence of Rubens? After the dark tones of THE POTATO-EATERS he felt an overpowering need to turn to lighter colours. *It is curious*, he noted, *that my painted studies seem darker in the city than in the country. Is that because the light is less bright everywhere in the city? I don't know but it may make a greater difference than one would say offhand; it struck me, and I could understand that things you have look darker than I in the country thought they were.* Though Vincent would not give up painting town views and still-lives, his chief ambition was now to increase his skill as a portrait-painter. The fifty or so studies of the heads of peasant men and women that he painted for THE POTATO-EATERS show that he had been interested in portraiture for some months and explain why Rubens appealed to him so much.

He soon found that it was not easy to get women to sit to him in a city that he did not know. But he managed to make a bargain with two women in a dockside tavern: they would sit to him, he would paint several portraits of each, and give them one portrait by way of payment.

## THE RIGHT COMBINATION

Vincent thought he might make some money from these portraits. *My best chance*, he wrote, *is in the figure, because there are relatively very few who do it, and I must seize the opportunity. I must work myself into it here, until I get into touch with good figure painters—Verhaert, for instance, and then I imagine portrait painting is the way to earn the means for greater things. I feel a power within me to do something, I see that my work holds its own against other work, and that gives me a great craving for work. . . . I also have an idea for a kind of signboard, which I hope to carry out. I mean, for instance, for a fishmonger, still-life of fishes, for flowers, for vegetables, for restaurants.*

There were few pictures on the walls of the restaurants and *cafés-chantants*, and he felt that still-lives or even portraits of prostitutes would make splendid decorations if only he could persuade the proprietors to buy.

He tried to get some art-dealers to agree to take a picture of THE STEEN that he had painted. It occurred to him that this sort of thing would probably appeal to foreigners visiting the city and who might want to take away with them a souvenir of their stay. But this idea was as unfruitful as the others he had.

Although Vincent needed to make money, it was not fashionable portrait-painting that he was aiming at. Nor was he interested in mere photographic realism. There were many photographers busy in Antwerp, he noticed. But he did not like their work: *always those same conventional eyes, noses, mouths — waxlike and smooth and cold. It cannot but always remain lifeless. And the painted portraits have a life of their own, coming straight from the painter's soul, which the machine cannot reach. The more one looks at photographs, the more one feels this, I think.*

At this time he was so desperate to get money from his work somehow or other, for he was *literally starving, that he considered that he might try to get employment at a photographer's, which I would not like to do permanently but only in time of need. The photographers seem to be quite flourishing here. One also finds painted portraits in their studios, which are obviously painted on a photographed background, which is of course both weak and ineffective to anybody who knows anything about painting.*

He tried to portray the real character of his sitters, not their superficial finery, not their dresses, their jewels, their furs, their hats, their powder and paint, not all the artificial trappings that disguised their true bodies and souls. There is no doubt that his portraits were realistic—as he intended them to be. One is at once reminded of Toulouse-Lautrec's remark to Madame Nathanson, who asked him why he always made his women so ugly. "Because they *are* ugly, madame," Lautrec replied. For Vincent the beauty or ugliness of his model was of secondary importance. He had a higher aim than merely to catch a likeness or an expression. *I prefer painting people's eyes to cathedrals*, he wrote, *however solemn and imposing the latter may be—a human soul, be it that of a poor beggar or of a streetwalker, is more interesting to me.*

And in painting these portraits Vincent wanted to make use of the lesson he had learnt from Rubens.

The lightening of his palette which was already noticeable in BACKS OF OLD HOUSES IN ANTWERP now became much more marked in his portraits of women from the docks. From studying the heads in Rubens's portraits, he realized that he had mixed white with carmine, a colour which Vincent had hitherto deliberately avoided, limiting himself to nine colours on his austere palette.

Vincent was so pleased with the results that he used this technique in all his portraits, even when he was painting men's faces, as in HEAD OF AN OLD MAN LIKE VICTOR HUGO. It also appears in two paintings of girls of the streets: WOMAN FROM THE CAFÉ-CHANTANT, and particularly WOMAN IN BLUE.

A letter written to Theo in the first half of December 1885, when Vincent had been in Antwerp two weeks, began: *I must write you again to tell you that I have succeeded in finding a model. I have made two fairly big heads, by way of trial for a portrait. First, that old man whom I wrote you about, a kind of head like Hugo's; then also a study of a woman. In the*

THE CATHEDRAL TOWER. Antwerp, December 1885, black chalk on Ingres paper, 30 × 22.5 cm, F 1356. Vincent van Gogh Foundation, Amsterdam.—The very top of the cathedral tower, which was not within his angle of vision when he drew the Grand-Place, has been drawn separately. Despite its somewhat crude style, the painter has rendered the delicacy of the gothic architecture very successfully.

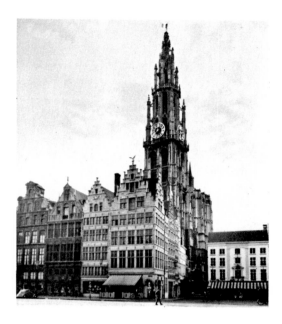

THE GRAND-PLACE (below). Antwerp, December 1885, white crayon on Ingres paper, 22.5 × 30 cm, F 1352. Vincent van Gogh Foundation, Amsterdam.—In a house called "The Winkler house" in this historic square, Vincent went to a drawing club every evening from 8 to 10 p.m. This drawing was done soon after his arrival in Antwerp, as we learn from his letters to Theo. The photograph (A.I.v.G.) was taken in 1958. The roof of the house on the corner has been restored.

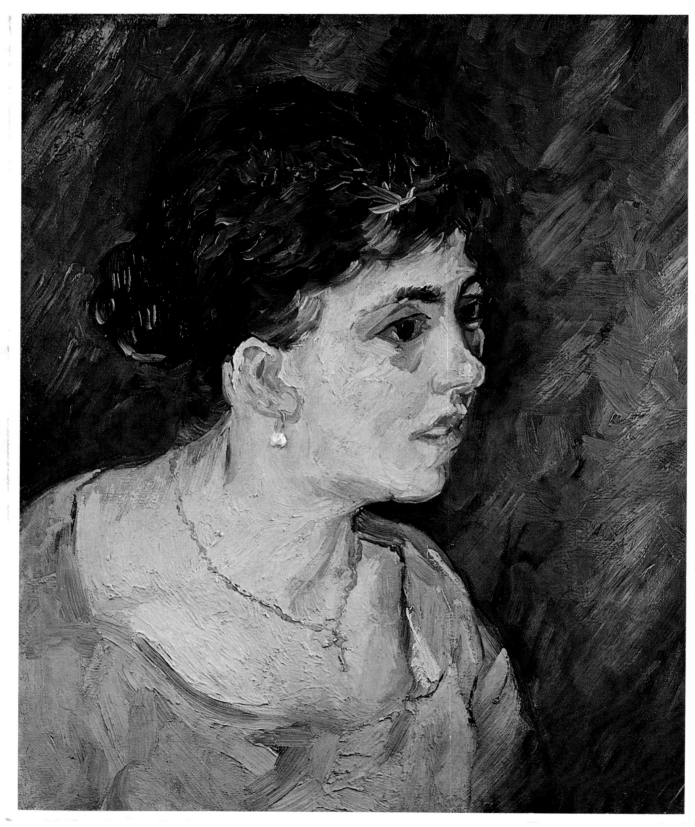

WOMAN IN BLUE. Antwerp, December 1885, oil on canvas, 46 × 38 cm. Vincent van Gogh Foundation, Amsterdam.—The colouring shows that van Gogh had already began to lighten his palette at Antwerp. The influence of Rubens is clearly seen in the colour of the flesh. "I am quite carried away," Vincent wrote, "by his way of drawing the lines in a face with streaks of pure red."

170

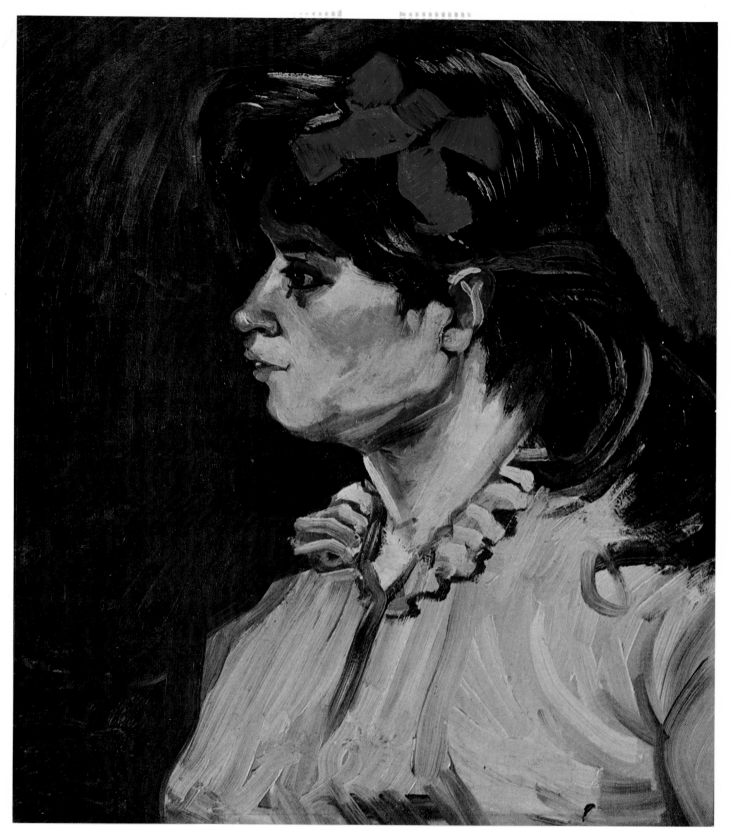

PORTRAIT OF A WOMAN IN PROFILE. Antwerp, end of December 1885, oil on canvas, 60 × 50 cm, F 207, H 223. Collection of A. Wyler, New York, U.S.A.—When the model said to Vincent: "As for me champagne does not cheer me up, it makes me quite sad" he understood and "tried to express something voluptuous and at the same time cruelly tormented".

*woman's portrait I have brought lighter tones into the flesh, white tinted with carmine, vermilion, yellow and a light background of grey-yellow, from which the face is separated only by the black hair. Lilac tones in the dress.* The next paragraph began: *Rubens is certainly making a strong impression on me.* And a little later in the same letter he said: *I made the acquaintance of Tyck, the best colour manufacturer here, and he was very kind in giving me information about some colours. About green colours, for instance, that are fast. I also asked him things about Rubens's technique, which he answered in a way that proved to me how well he analyzes the material used, which not everybody does....* One could not wish for clearer statements of his inspiration.

It soon had practical consequences. In the same letter he wrote: *I am now looking for a blonde model just because of Rubens.* He found her. She is the model for WOMAN IN BLUE. It can be clearly seen from the colour of the cheeks in both portraits of women how Vincent has lightened his palette.

In my monograph, *Vincent van Gogh in zijn Antwerpse Periode*, I reproduced the portrait of the WOMAN IN BLUE, a title I gave it when I saw it on the wall in the house at Laren where Vincent's nephew, Dr V. W. van Gogh, lived. Hitherto this important picture had not appeared in de la Faille's catalogue or in any other work upon Vincent, and art-historians were inclined to deny its existence.

The influence of Rubens had determined Vincent to discard his dark Nuenen palette and adopt a much lighter one, which was still characteristically his own. *It is a real delight to me,* he wrote to Theo on December 19, *to work with a better kind of brush, and to have cobalt and carmine, and the right kind of brilliant yellow and vermilion.* He had thus added four new bright colours to the nine that he had used at Nuenen.

This technical development was accompanied by a much more profound spiritual advance. In a most interesting passage he justified his pictures of *those tarts. To paint human beings, he declared that was the old Italian art, that is what Millet did and what Breton does. The question is only whether one starts from the soul or from the clothes, and whether the form serves as a clothes-hanger for ribbons and bows or if one considers the form as the means of*

WOMEN WALTZING. Antwerp, early December 1885, coloured crayons, 9 × 16 cm. Vincent van Gogh Foundation, Amsterdam. — In this sketch, which was drawn on another page of his sketchbook, Vincent has succeeded in giving the two dancers a dynamic movement which could only have been produced by an exceptionally gifted artist.

*rendering impression and sentiment, or if one models for the sake of modelling, because it is so infinitely beautiful in itself. Only the first is transitory, and the latter two are both high art.*

Vincent had always been a naturalistic painter. *One models for the sake of modelling* is, like "art for art's sake", a new sentiment for him, one for which his reading of the Goncourt brothers had perhaps prepared him. Under Rubens's influence it was now also work for work's sake.

## THE FRUIT OF HIS TOIL

The moment he arrived in Antwerp Vincent began to work like fury, using large quantities of canvases, paint and brushes. To keep himself supplied with all this material he had to dig deep into the slender allowance that Theo was able to afford him. He was at too important a turning-point for half-measures. He was aiming not only to reach perfection, but to reach it as quickly as possible. Rather than buy food he would fast so that he could afford his paints.

He might go for several days on dry bread and milk, and in the end he drove himself to physical exhaustion. Early in December 1885 he was already writing: *Today for the first time I feel rather faint.* He had only had three hot meals since he had been in Antwerp. It was all right so long as he was painting, but not when he tried to hawk his work round the dealers and found they were all out or complaining bitterly about lack of custom, *especially when the weather is chilly and gloomy, and when one has changed one's last 5-franc piece and doesn't know how to get through the next two weeks. Do try to keep me afloat these two weeks, for I want to paint more figures.*

His condition soon deteriorated. *I am sorry,* he wrote to Theo in February 1886, *to have to tell you more categorically that I am literally worn out and overworked. Just think, I went to live in my own studio (in Nuenen) on May 1, and I have not had a hot dinner more than perhaps six or seven times since. . . . But I have lived then, and I do here, without any money for a dinner, because the work costs me too much, and I have relied too much on my being strong enough to stand it.*

THE NURSE. Antwerp, December 1885, canvas, 50 × 40 cm, F 174, H 147. Vincent van Gogh Foundation, Amsterdam.—
Here again Vincent has experimented with Rubens's technique of obtaining the colour of flesh by mixing white with carmine.

HEAD OF AN OLD MAN LIKE VICTOR HUGO. Antwerp, December 1885, oil on canvas, 44 × 33.5 cm, F 205, H 225. Vincent van Gogh Foundation, Amsterdam.—The resemblance to the French writer was pointed out by Vincent himself.

SKULL WITH A CIGARETTE. Antwerp, early January 1886, oil on canvas, 32.5 × 24 cm, F 212, H 221. Vincent van Gogh Foundation, Amsterdam.—What is the explanation of this grim conceit, which is unique in Vincent's work? Whether interpreted as an act of defiance, sarcasm or fear, there is no doubt that it is an example of surrealism before its time.

HANGING SKELETON. Antwerp, February 1886, pencil 10.5 × 6 cm, F 1361. Vincent van Gogh Foundation, Amsterdam.—Vincent, who did nothing unpremeditated, seems to have had some hidden intention when he sketched this mysterious scene of a cat looking at a skeleton. Clearly this drawing is related to the SKULL WITH A CIGARETTE. They were both born of the same strange spiritual mood.

Vincent had driven himself too hard; and his letters tell how weak he was when he arrived at Antwerp. When Theo sent money for food he was too weak to digest it properly. And he made things worse by smoking too much to soothe his empty stomach. The results were disastrous. At the age of thirty-two he found that he had lost (or would have to lose) at least ten teeth; his stomach was in a bad way, and he was coughing up grey phlegm.

Vincent's illness in The Hague has been described in an earlier chapter. Shortly before coming to Antwerp he had been sufficiently concerned about his health to go and see Dr van der Loo at Eindhoven, who had been called in when Margot Begemann tried to commit suicide, and had also been consulted at some length when Vincent's mother's health seemed to be failing. The results were reassuring: *Dr van der Loo told me that I am fairly strong after all. That I need not despair of reaching the age which is necessary for producing a life's work. I told him that I knew of several painters who, notwithstanding all their nervousness, etc., had reached the age of sixty or seventy even, fortunately for themselves, and that I should like to do the same.* It was a modest ambition, if an ironic one.

He was delighted when he consulted a doctor about *a small complaint*, being anxious perhaps that he had not been cured of the disease he had at The Hague,

and the doctor remarked: "I suppose you are an ironworker." *That is just what I have tried to change in myself; when I was younger, I looked like one who was intellectually overwrought, and now I look like a bargeman or an ironworker.*

## THE DENTIST AND THE DOCTOR

As his teeth were painful Vincent used always to swallow his food without chewing. It was only when his teeth started to crack that he began to worry, and consulted a dentist. We do not know the dentist's name, but only that Vincent paid him the vast sum of 50 francs (more than a teacher earned in a month) for what must have been a serious and painful operation on his mouth. A. S. Hartrick's portrait of him painted in Paris shows how his moustache overhung but failed to hide his partly toothless mouth, and in the following year he spoke of himself to Wilhemien as *a little old man . . . with wrinkles, and a tough beard and a number of false teeth.* The dentist in Antwerp also advised Vincent to see a doctor about his stomach.

Vincent does not mention the doctor's name in his letters. But it can be discovered from the smallest of the two sketchbooks that he carried about with him while he was in Antwerp, in which there is a note: *A Cavenaile, Rue de Hollande, 2 consultations: 8 à 9, 1 ½ à 3.* Consultations at eight o'clock in the morning show that this was an appointment with a doctor rather than, say, a lawyer. There were a whole dynasty of Antwerp doctors called Cavenaille (not as in the note "Cavenaile"). The one Vincent consulted was Hubertus Amadeus Cavenaille, who was born at Oudenarde in 1841 and who established himself in Antwerp in 1883.

## A SIGNIFICANT PRESCRIPTION

There are other notes referring to Vincent's health in the same notebook. They too were written in French, which was natural enough, since Vincent knew the language well, and it was what the doctor would have spoken. One reads: *demain midi huile de ricin* ("tomorrow noon castor-oil"); another: *alum 20c pinte ou ½ temps à autre 10 h. bain de siège*

("alum 20c pint or ½ time to time 10 a.m. sitz-bath"); and lower on the same page the word *Stuyvenberg*.

The castor-oil was probably a prescription for his stomach trouble. But what about the alum and the sitz-baths? Vincent, who rarely concealed anything from Theo, said nothing about baths in his letters.

Stuyvenberg is a large hospital at the end of the rue des Images, only a few hundred yards from where Vincent lived. The building had been begun barely a year earlier, on January 1, 1885, and it was not yet finished, but out-patients could already be treated. Dr Cavenaille probably sent his patient to the hospital for the sitz-bath treatment because Vincent could not arrange it himself in his lodgings.

Dr Cavenaille's grandson still lives at Antwerp, and, like his father and grandfather before him, he is also

a doctor. When Vincent began to be famous (a very important exhibition of his work was held at Antwerp in 1914) the Cavenailles sometimes discussed him in the family. Old Dr Cavenaille told his grandson that Vincent had come to him because the dockside quarter was then very close to the rue de Hollande where the doctor lived, and many of his patients came from the waterfront. Vincent was probably sent by one of the women whose portraits he had been painting.

Dr Cavenaille clearly remembered the "queer dauber" in disreputable clothes who told him straight off that he had no money but would paint his portrait instead. Vincent often did business in this way, exchanging a drawing for a hunk of bread. The doctor agreed, but unfortunately the picture has been lost. It was inherited by one of the doctor's daughters, who married a Russian corn-merchant and emigrated to England before the First World War. She took the portrait with her, and the Cavenailles do not know what has become of her or of it.

Dr Cavenaille made no secret of the fact that he had treated Vincent for syphilis, and this explains the nature of the prescriptions. How and where he caught it we can only guess.

## SURREALISM BEFORE ITS TIME

Vincent did not conceal from Theo that he was seriously ill and much worried about his health: *You see I am not stronger than other people in that if I neglected myself too much, it would be the same with me as with so many painters (so very many if one thinks it over), I should drop dead, or worse still— become insane or an idiot.*

He was afraid of dying before his talent was recognized—and he was afraid of madness. This fear inspired his neglected masterpiece SKULL WITH A CIGARETTE. And there is also a wonderful little drawing of the same period, HANGING SKELETON, in which the disintegrating bones of a hanged man in the foreground are calmly contemplated by a mysterious black cat in a window behind. Where, one wonders, did Vincent find these skulls and bones?

The sudden appearance of this theme, unlike anything in his work hitherto, was linked with the threat of death. Yet Vincent was not trying to arouse fear

in the spectator, nor to transfer to him his own anxiety. The cigarette rules out any such simple interpretation. It burns, which may symbolize life, and it mitigates the spell of death.

Perhaps Vincent was for once trying to imitate Hoffmann's *Tales* by painting the fantastic in a matter-of-fact way. Even Dr F. W. S. Thienen, who has discussed this picture in some detail and has suggested that it should be called "A silent statement" has not fully explained the obscure motives behind it. Though it may appear at first sight to be a grim joke, it has a tragic dimension. It is a poem to death, one of the most remarkable pictures ever painted on the theme that "All is vanity". And, while THE POTATO-EATERS was the recognized origin of the Expressionist movement, this bizarre painting may be said to be an unrecognized precursor of the Surrealists.

During his three months in Antwerp Vincent showed an increasing interest in his own face. He told Theo he was worried about his appearance. His lost teeth made him look as if he were over forty, and he felt as stiff and awkward as if he had been in prison for ten years. Now that he was living in a city and trying to sell his pictures to dealers or at least have them exhibited, he felt that he had to look respectable in a way that he never would have done at Nuenen or even in The Hague.

Vincent's new self-concern—on a profound as well as a superficial level—may explain why he now began to take an interest in painting self-portraits. While he was in Antwerp, van Gogh produced at least four self-portraits, two in oil on canvas and two in pencil in his sketchbooks. These pictures provide a record of how his face was changing at this time, and how it had been affected by his illness.

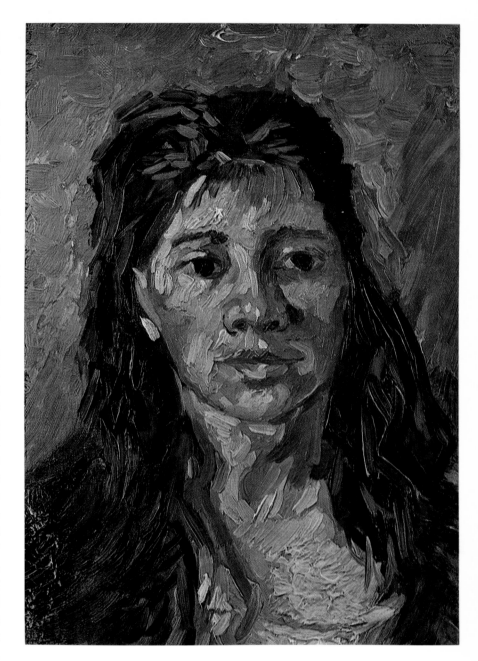

WORKING GIRL. Antwerp, December 1885, oil on canvas, 35 × 24 cm, F 206, H 222. Vincent van Gogh Foundation, Amsterdam.

## AN ECCENTRIC PUPIL

Vincent was in severe financial straits. He had little enough to pay for his subsistence. He could hardly afford to buy his materials. To pay models was even more difficult, even if he could persuade them to sit to him at all.

In similar circumstances at Brussels Vincent had been obliged to enter the Academy, only to be repelled by the rigid conservatism that always pre-

vailed there. In November and December 1881, when Vincent was at Etten, he wrote passionate letters to van Rappard, who had returned to the Academy at Brussels which they had both left that spring, urging him to abandon academic studies and follow "Dame Nature". *This academy*, he wrote, *is a mistress who prevents a more serious, a warmer, a more fruitful love from awakening in you.* But, as

at Brussels, Vincent needed models, and once again he had to make a virtue of the same necessity.

He knocked at the door of the Academy, and, remarkable as it seems, he was admitted. Had he been rash enough to show them THE POTATO-EATERS such a thing could never have happened. But on January 18, 1886, he was given an entry permit by Charles Verlat, a historical and animal painter of sixty-one who had once disgraced himself by painting thirteen spokes on a chariot wheel and who was then director of the Academy.

When Verlat saw two landscapes and a still-life that Vincent had brought from Nuenen he said: "Yes, but that does not concern me." Vincent then showed him two portraits, and he said: "That is different, if it is figure painting, you may come." Vincent also made arrangements with Frans Vinck, a pupil of Leys who like him specialized in medieval subjects; and as a result he went in the evenings to draw from the antique.

In my youth I knew several artists who had been students at the Academy when Vincent arrived. Their accounts of life there agree. In his class there were at least sixty beginners. These included two Flemings from Antwerp: Richard Baseleer, who later taught at the same academy, and Karel Berckmans, who sang Tamino in *The Magic Flute* at the Opéra Flamand. There were Victor Hageman and Arthur

Briët, both Dutch, and an Englishman called Pimm who used to teach his fellow-students to box when the teachers' backs were turned.

Richard Baseleer has said that Vincent looked exactly like the water-colour that H. M. Livens, an English student in the same class, painted of him— the first time his portrait had been painted by another artist. It shows a flat pink head with yellow hair, an angular profile and sharp nose, with a stumpy pipe emerging from a rough ill-shaven beard.

## THE OBSTINATE ACADEMICS

Vincent's fellow-pupils were much struck by what they felt were his eccentricities. This was inevitable. Any man of thirty-two would have been conspicuous among a group of students mostly in their late teens and their attitude probably made him even more so, besides causing him to be a likely butt of the instructors' sarcasm.

Hageman has described to Louis Piérard the occasion when Vincent entered the Academy. He was wearing a blue smock such as Flemish cattle-dealers wore, and he had a fur cap on his head. He unpacked his drawings while everybody stared at him, for his palette was made of a piece of an old packing-case. Then he set about painting the two nudes which had

180

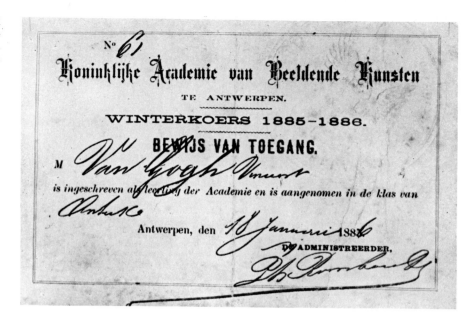

been posed before the class. *This week*, he told Theo, *I painted a large thing with two nude torsos—two wrestlers posed by Verlat, and I like that very much.* Hageman has told how Vincent "laid on his paint so thickly that his colours literally dripped on to the floor"—as with the snowscape he painted from Kerssemakers's window. At Antwerp Vincent was still apt to use his fingers instead of his brushes. When Mauve had told him not to finger his pictures, he had lost his temper and said: *Why not? I shall use my heels if it gives the right effect.*

Vincent painted "feverishly, furiously, with a rapidity that stupefied his fellow-students" said Victor Hageman. He seemed to be visibly suffering in the effort to grasp his subject. He made no corrections, and often tore up his drawings or threw them on the floor. He drew everything in the hall, pupils, clothes, furniture—everything but the plaster cast he was supposed to be copying. Sometimes he would do the same drawing ten or fifteen times over.

Piet van Havermaet, one of the teachers who often took Verlat's place, thought Vincent needed more instruction in drawing before he painted in oils. "That won't do at all, my lad," he said. "Go and take the course in drawing from the antique." Then, in Baseleer's words, "Vincent, who was amenable enough, whatever people say, moved into another class, where he had to draw the Venus of Milo."

Things soon took a turn for the worse. Vincent had the same argument with Eugeen Siberdt that he had once had with Mauve. He was obliged to draw plaster casts of antique sculpture. He no longer objected to this on principle. Drawing from casts, he now began to think, might be useful, if only it were done for the right reasons, in the right way and with real insight: *I have been drawing there for two evenings already, and I must say that I believe that just for the making of, for instance, peasant figures, it is very useful to draw from the plaster casts. But for goodness' sake, not the way it is usually done. In fact, in my opinion the drawings that I see there are all hopelessly bad and absolutely wrong, and I know for sure that mine are totally different. Time must show who is right. The feeling of what ancient sculpture is, damn it, not one of them has it.*

The trouble was that Vincent could not bring himself to adopt their system of drawing the outline first before attempting any of the modelling. In the spring of 1885 he had already come to the conclusion that this was a mistaken and outdated dogma. He had been drawing figures starting from the torso, for this seemed to make them fuller and broader, and was determined to go on until he succeeded. *If fifty are not enough, I shall draw a hundred, and if that is still not enough, even more till I have exactly what I want, namely that everything is round, and that there*

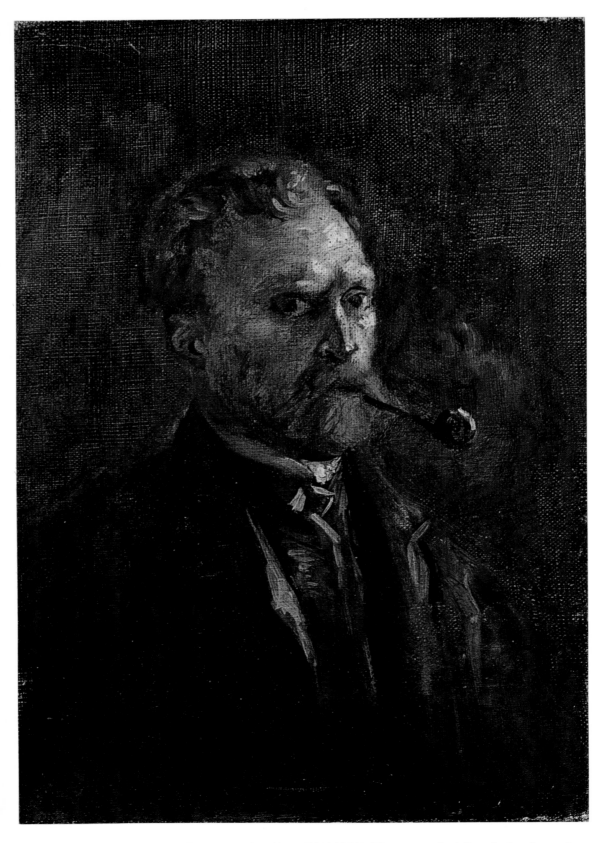

SELF-PORTRAIT. Antwerp, 1885, oil on canvas, 27 × 19 cm, F 208, H 224. Vincent van Gogh Foundation, Amsterdam.

182

Vincent as seen by a friend. Photograph A.I.v.G.—At the Academy of Antwerp Vincent met an English painter, H. M. Livens, who did a water-colour of him in profile. It was reproduced in a special number of a Flemish periodical that was devoted to van Gogh in 1893. This is the earliest known portrait of van Gogh by another painter.

STANDING FEMALE NUDE, THREE-QUARTER BACK VIEW. Antwerp, end of January 1886, black chalk, 19.5 × 11 cm, F 1353. Vincent van Gogh Foundation, Amsterdam.—This drawing of a nude appears in a sketchbook that Vincent carried when he was at Antwerp; it is the largest sketchbook he is known to have had. The study enables us to judge Vincent's skill as a draughtsman, even if the subject is rather academic.

STUDIES OF HANDS. Antwerp, January 1886, black crayon, 32 × 24 cm. Vincent van Gogh Foundation, Amsterdam.—While he was in Antwerp, van Gogh often drew hands. In the second edition of my monograph on this period I included no less than five examples.

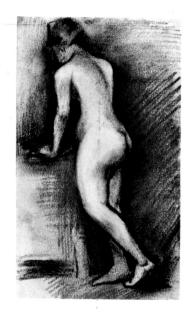

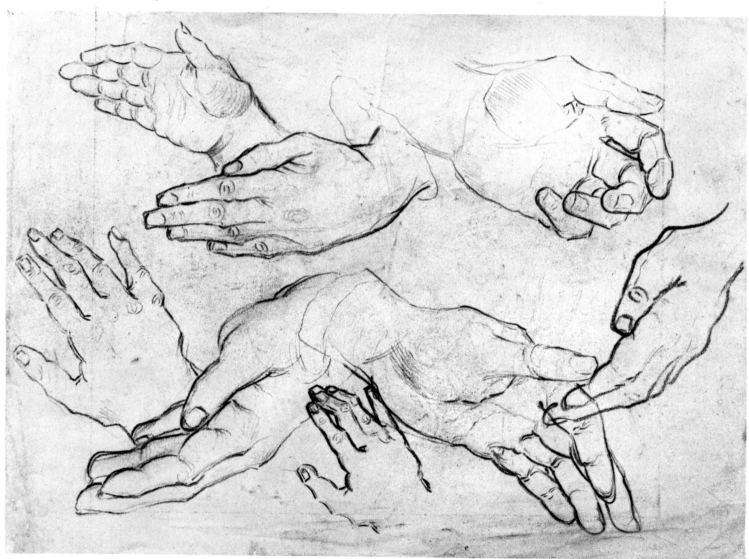

People Vincent met at the Antwerp Academy. Pictures A.I.v.G.—From left to right, starting at the top: Karel Verlat, already a well-known painter and director of the Academy; Eugeen Siberdt, one of the professors with whom Vincent had violent arguments; Piet van Havermaet, whose course of life and antique drawing Vincent attended; Victor Hageman, a Dutchman like Vincent, who has left us a very objective account of Vincent's period at the Antwerp Academy.

is, so to speak, neither beginning nor end to the figure anywhere, but that it makes one harmonious lifelike whole. He quoted with approval J. F. Gigoux's maxim, "ne pas prendre par la ligne, mais par le milieu", adding: And then again there are people who assert that all dogmas are practically absurd. It is a pity that this is again a dogma in itself. Now, in Antwerp, he was being forced to obey a dogma that he thought was nonsense.

He not only disapproved of their method. He felt that he was beginning to master a totally different one that was giving far better results. He had been struck by the way that Millet and Delacroix and especially Géricault painted figures that seemed to emerge from the paint. The figures have backs, as he put it, even when one sees them from the front. He was trying to find this secret, which he rightly felt that Vinck and Verlat could not begin to teach him, and which their pupils were not even attempting.

When I compare a study of mine with one of those of the other fellows, he wrote, it is curious to see that they have almost nothing in common. Theirs have about the same colour as the flesh, so, seen close up, they are very correct—but if one stands back a little, they appear painfully flat—all that pink and delicate yellow, etc., etc., soft in itself, produces a harsh effect. The way I do it, from near by it is greenish-red, yellowish-grey, white-black and many neutral tints and most of them colours one cannot define. But when one stands back a little it emerges from the paint, and there is airiness around it, and a certain vibrating light falls on it. At the same time, the least little touch of colour which one may use as highlight is effective in it. But what I lack is practice, I must paint about fifty of them.

The teachers must have felt that they had a traitor in their midst, for the heresy spread. One of the other pupils, who was much impressed by Vincent's drawings of Dutch peasants, started at once to draw the model in the nude class with a much more vigorous modelling, putting the shadows down firmly. Vincent was extremely taken with the drawing, and he told Theo, it was full of life, and it was the finest drawing

184

*I have seen here by any of the fellows.* But those in authority did not think so: *The teacher Siberdt express- ly sent for him, and told him that if he dared to do it again in the same way he would be considered to be mocking his teacher.*

Vincent was philosophical about this, and he realized that the only thing to do was to pretend that his own preferred method was a bad habit which he would like to cure but kept finding himself slipping back into. In this way he managed to avoid the worst of the teachers' censure for some time. But then there was an incident that clearly impressed itself upon his fellow-students' memories and became something of a legend. In drawing the Venus of Milo he was struck by the breadth of her hips, and he exaggerated what he felt was an essential characteristic, distorting her in just the same way as he did in his copies of Millet's *Sower* and Dela- croix's *Good Samaritan*. "The beautiful Greek goddess", said Hageman, "had become a robust Flemish matron." When Siberdt saw it he slashed it with strokes of his crayon. Vincent flew into a rage: *So you don't know what a young woman is like, God damn you! A woman must have hips and buttocks and a pelvis in which she can hold a child!*

## FAREWELL TO THE ACADEMICIANS

Hageman said that this was the last lesson Vincent took—or gave—at the Antwerp Academy. But Vin- cent's own letters seem to show that he went on drawing from the antique at the Academy from time to time, and there is no doubt that his views about working from casts had radically altered since his outburst to Mauve. Now he wanted to draw from the antique—but in his own way.

Meanwhile he had been told at the Academy that there were two drawing clubs in Antwerp which met in the evenings, one from eight to ten, the other from ten to midnight. These clubs had started as a result of the students' exasperation with Verlat— whom they nevertheless much admired and liked— for constantly giving them the same models. They were also formed as a gesture of protest against the reactionary rules of the Academy, where drawing from the female nude was exceptionally rare if not totally forbidden; they drew from models who were really

HOW VAN GOGH DREW THE VENUS OF MILO. Antwerp, February 1886, black crayon, 11.5 × 9 cm. Vincent van Gogh Foundation, Amster- dam.—In his smallest pocket sketch-book is this drawing, the front view of a nude torso, probably after a plaster cast such as Venus of Milo. It shows Vincent's very personal view of the female nude, which was the origin of his arguments with the professors at the Academy.

naked. One of these clubs met in "Winkler's House" in the Grote Markt (or Grand-Place), a historic build- ing which Vincent had already drawn a few days after he arrived in Antwerp.

Vincent joined both clubs in his eagerness to improve his technique. One of his drawings was the beautiful nude reproduced on page 183, which shows that when he saw the real thing he could tell the difference between a woman with wide hips and a slim model seen largely from behind.

The clubs were totally unorganized and kept no written records. The members shared the cost of the model, and there were no other expenses except for the beer the students drank. There is therefore

little chance of finding any positive evidence, other than the memories of the people who worked there.

But Vincent soon came to feel that these clubs were not an adequate compensation for the unsympathetic attitude of the Academy, and that he would do better elsewhere, so he decided to leave Antwerp altogether. In one of his two sketchbooks there is a note on a leaf which has self-portraits drawn on both sides of it. This reads: *Quévy 10.14 | 6.40 | 6.50* and it refers to the station on the frontier between Belgium and France and the times of the trains. Although he had intended to stay in Antwerp permanently when he arrived in December 1885, he had already made up his mind to leave by the following March.

Vincent never regretted having come to Antwerp. He often admitted that his visit had been valuable from many points of view. There are few letters that he wrote from that city in which he did not say how glad he was that he came. He was only dissatisfied about the pictures he had produced. Otherwise, he wrote: *My main impression of my stay here is unaltered : my ideas have changed and have been refreshed, and that was my purpose in coming here.* In the postscript to the last letter but one from Antwerp he wrote: *Because I think that after all my stay in Antwerp has been useful to me, I believe that we must go straight on.*

He was aware that he had not seen Antwerp at its best, and that it had once been much more lively than it was then. But he had enjoyed it, and found life there *free and artistic.* It was in his opinion far more like Paris than Brussels had been. He hoped one day to come back there again.

A HAPPY MEMORY

Several months before he died, when he was in the asylum at Saint-Rémy-de-Provence at the beginning of 1890, Vincent learnt that Gauguin intended to settle in Antwerp. The dramatic events of Christmas Eve, 1888, at Arles passed from his mind, and he thought once more of his dream of working with another artist.

In a letter of February 12, 1890, he discussed with Theo the risks of going to Antwerp and being exposed to the scorn of established painters. *In going to Antwerp, I should fear more for Gauguin than for myself, for naturally I'd shift for myself with the Flemings, I should again take up the peasant studies started some time ago, and very regretfully abandoned. There is no need to tell you that I have a strong affection for the Campine.*

Three days later he wrote to his mother on the same subject: *It is curious that my friend with whom I worked for some time in Arles should want to go to Antwerp, and that way I should be a little nearer to all of you. But I am afraid this is not quite practicable, also because I think it would be more expensive, and when one is used to the climate here, perhaps one's health might not be able to stand being back in the North.*

In his first letter from Antwerp Vincent had written rather sceptically: *It will probably prove to be like everything everywhere, namely disillusioning.* But when he eventually wrote of returning there it was clear that he had not been entirely disillusioned.

The fate of the pictures that he painted in Antwerp must now be considered. When he was thinking that Gauguin would have to leave his pictures as a pledge for his debts in order to come and join him at Arles, Vincent wrote: *I was obliged to do the same thing in order to come to Paris, and though I lost a lot of stuff, it is the only thing you can do in a case like that.* In his notes on the letters written from Antwerp Georges Charensol draws the following conclusion from this remark: "It is probable that when Vincent left suddenly for Paris he left his studies in his room in the Longue rue des Images."

In my catalogue of the Antwerp period, which is necessarily incomplete, I have listed sixty-four works, fifteen of them paintings, which either still exist or are explicitly mentioned in his letters.

Now Vincent stayed in Antwerp for only three months; he was ill and could not work as much as he wished; he spent a good deal of time at the Academy and the drawing clubs, where most of what he did would have been rough sketches that he would not have thought were worth keeping. He could not therefore have left very much behind in Antwerp.

Charensol's remark seems to me misleading.

Before he left Antwerp Vincent left Nuenen. When he claimed that he had *lost a lot of stuff*, he could well have been thinking of the vast mass of his work done during his stay in North Brabant, and not of his Antwerp pictures at all.

186

# A STUDIO IN MONTMARTRE

An unexpected letter. Vincent van Gogh Foundation, Amsterdam.—The letter which Vincent sent Theo as soon as he arrived in Paris.

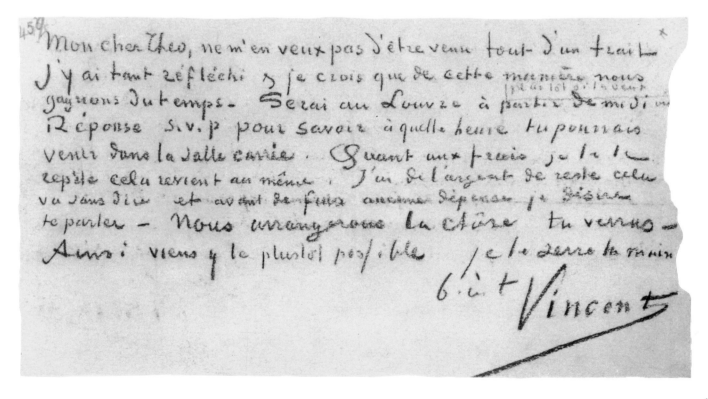

One day at the beginning of March 1886 a note was delivered to Boussod, Valadon & Cie, Goupil's successors in the boulevard Montmartre in Paris. It was addressed to Theo van Gogh, and it had been hastily scrawled in black crayon by his brother. It read: *My dear Theo, Do not be cross with me for having come all at once like this; I have thought about it so much, and I believe that in this way we shall save time. Shall be at the Louvre from midday on or sooner if you like. Please let me know at what time you could come to the Salle Carrée.... We'll fix things up, you'll see. So, come as soon as possible.*

Vincent had arrived in Paris the day after he had left Antwerp so hastily, and once again Theo, who had been trying to persuade Vincent to stay there until June, was presented with a *fait accompli*. As usual, Vincent had tried out the ground some time before. In the first letter that he wrote in January, Vincent had warned Theo: *I must also tell you that in view of that longing to study the figure, in case I should not succeed here, I should rather go farther away than go back to Holland before I had worked for a time at some studio. That "farther" might perhaps be Paris, without any hesitation. You may be of the opinion that I am an impossible character—but that's absolutely your own business. For instance, I need not care, and I am not going to. I know that there are times when you think differently and better of me, but I know too that your business routine induces you again and again to lapse into the old evil with regard to me. What I seek is so straightforward that in the end you cannot but give in.*

Vincent's unjust reproaches to Theo for not trying harder to sell his work arose from his desperate longing to stand on his own feet and to earn his own livelihood by his painting. This might depend on making his own contacts with the art trade in Antwerp or Paris, rather than retreating, say, to Nuenen. In his next letter he wrote: *I do not think you can reasonably expect me to go back to the country for the sake of perhaps 50 fr. a month less, seeing that the whole series of future years will depend so much on the relations I must establish in town, either here in Antwerp or later on in Paris.*

The "relations" he had in mind were with other painters as well as with those who might be induced to buy his work. He had learned about Paris from his friends in Antwerp. For instance, there were *those two English fellows*—presumably Livens and Pimm—who had been in Gérôme's and Cabanel's studios in Paris, and they had told him *that one is relatively freer in Paris and, for instance, one can choose subjects more freely than one can here....*

Vincent wanted to be admitted to one of the more important Paris studios. He realized that this would depend upon the work he had already done elsewhere, and also that he would have to *change my outward appearance somewhat*. He told Theo he would be glad to live in a small and cheap room or even a garret in a Paris hotel.

In February he wrote to Theo: *I am free to leave here whenever I like. Let's say in the first days of March.* And he cited the example of Israëls who, *though he was so poor he had nothing to eat but dry bread, still wanted to go to Paris.* He set about painting some pictures that he could take with him to show in Paris. He also suggested to his brother that they should take a studio where they could live together and entertain their friends. Vincent had more than once tried to persuade Theo to become an artist too, and he may still have had this idea partly in mind. Fortunately for them both Theo stuck doggedly to the profession which enabled him to keep them both alive.

Vincent was *longing terribly* to see the Louvre and the Luxembourg, for, although he had visited them before, he had changed so much that *everything will be new to me*. He could draw from the antique there, even if he failed to get into a studio or academy.

His plan was clear: *As to a studio, if we can find in one and the same house a room with an alcove and a garret or corner of an attic, then you could have that room and alcove, and we could make ourselves as comfortable as can be. And during the daytime the room might serve as a studio, and the garret would serve for various more or less unsightly implements, and for dirty work; besides, I could sleep there, and you in the alcove of the studio.*

A SURPRISING SELF-PORTRAIT. Paris, 1887, oil on canvas, 41 × 32.5 cm. Vincent van Gogh Foundation, Amsterdam.—Here we have an unexpected view of Vincent van Gogh in respectable middle-class attire— very different from his artist's blue smock and straw hat.

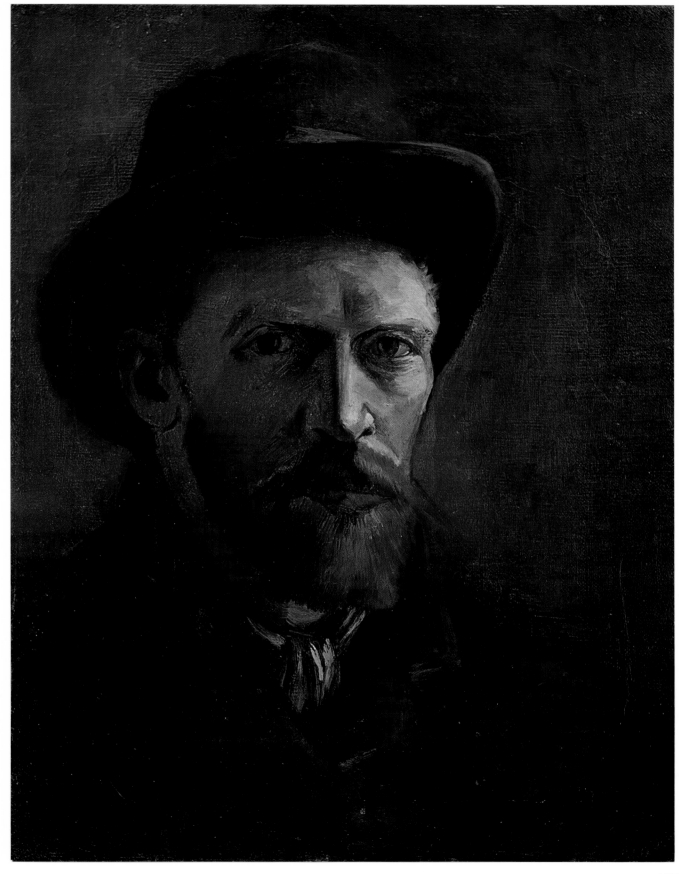

189

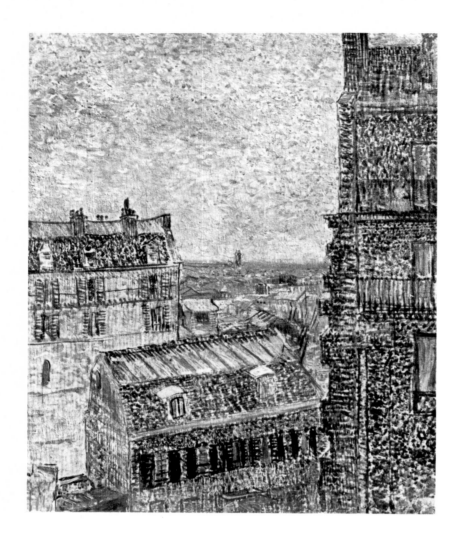

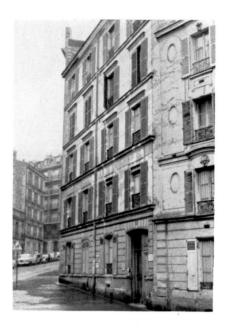

54 rue Lepic. Photograph A.I.v.G.—
During most of his stay in Paris, that
is from June 1886 to February 1888,
Vincent lived with his brother Théo in
an appartment in this building, which
now bears a commemorative plaque.

THE VIEW FROM THE WINDOW OF VINCENT'S ROOM. Paris,
1887, oil on canvas, 46 × 38 cm, F 341. H 392. Vincent van
Gogh Foundation, Amsterdam.—Vincent gave an almost
identical picture to his friend Henri de Toulouse-Lautrec.

## THE GROWTH OF AN OBSESSION

The following letter begins: *I decidedly want to tell you that it would make me feel much better if you would approve of my coming to Paris much earlier than June or July. The more I think about it, the more anxious I am to do so.*

He was not getting on with his work at Antwerp as fast as he hoped, partly because he was husbanding his strength for Paris. He ended his next letter: *I am greatly longing to know your decision, if perhaps you would approve of my coming to Paris already about April 1.* But Theo did not give a definite answer, and Vincent pleaded with him again to let *me go to Paris not later than when the course here ends— that is March 31.* Theo still did not reply, and Vincent wrote yet again: *I am longing very much to hear from you, for the time has come for me to make a decision . . . . If you approve of the plan of my coming to Paris as soon as possible . . . . The sooner and the more energetically we go through that period of drawing in Paris, the better it will be for the future.*

On February 18 he could not bear to wait any longer and wrote in despair: *At the moment that all my money is gone, absolutely gone, I write you once again. If you can send anything, even if it's only 5 fr., do so. There are still ten days left in the month, and how am I to get through them? For I have absolutely*

SUNNY DAY (JULY 14). Paris, 1887, pencil, pen, watercolour and gouache, 31 × 24 cm. Vincent van Gogh Foundation, Amsterdam.—Vincent, who was at this time living in the rue Lepic in Montmartre, was to take up this theme again, in oil, fifteen days before his death in Auvers.

190

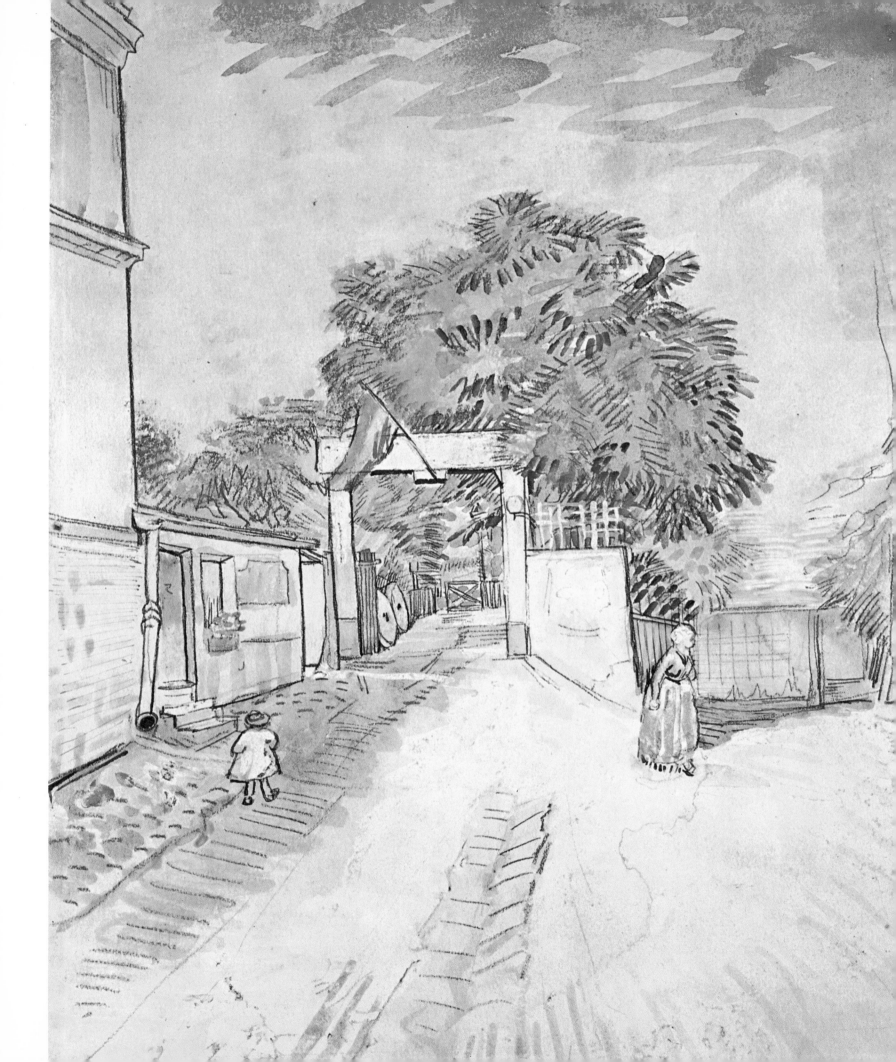

*nothing left. Even at the baker's nothing. I know only one thing, that everything decidedly points to my not acting otherwise than as I wrote you—namely—to my not postponing going to Paris. . . . And as to my going straight to Paris, I tell you it will be less expensive for you, for what with travelling to and fro, and starting relatively expensive work in Brabant, we should not be able to manage with the usual allowance, and in Paris we can. And if we can manage with the money, so much the better, then we shall not be so hard up and might stock up on painting materials before summer, so that everything will not come at once. Don't be offended if I too calculate for once what is possible and what is not. . . . I feel that you do not approve of my going straight to Paris, otherwise you would have answered me. And yet it is better to do it at once. Here I have the opportunity to consult people who work quite seriously, and I am fully convinced it will be the best thing to do. In fact, we ought to have done it long ago.*

When at last Theo's reply came saying that it was impossible for Vincent to come to Paris yet, he was so angry that he wrote a letter which even he regretted. He tore it up before he had posted it, and managed to write in a soberer mood. But in his following letter he began: *I write to you once again because at all events my time here has almost come to an end, and I have to go back one of these days.* He ended by asking Theo to consider if there were not some means *that would render it possible for me to come to Paris before June,* and he added, very significantly: *I think we can discuss taking a studio in June so much better if we are in Paris beforehand and can investigate the pros and cons.* Theo had been given fair warning of what he might expect.

In the last fifteen letters that Vincent wrote to Theo from Antwerp in less than two months, he harped on this subject at least forty times, his references to it becoming more and more frequent towards the end.

But despite Vincent's insistence Theo continued to say no. Exactly what reasons Theo gave we do not know, but it is easy to guess that he could well have thought that Vincent's presence in Paris might prove financially, socially and perhaps even personally embarrassing. He could only postpone, and not prevent, his brother coming to Paris; for Vincent had already made up his mind when he wrote: *And if I should like to live again in the city for some time, and*

Cormon's studio. Photograph A.I.v.G.—"I have been in Cormon's studio three or four months," Vincent wrote in a letter to Livens, "but I did not find that so useful as I expected it to be." Among the young students gathered round their distinguished *maître* sitting in front of his easel are Emile Bernard at the top right, shown by the arrow, and, on the left on the stool, Toulouse-Lautrec.

afterward perhaps to work in a studio in Paris too, would you try to prevent this? Be honest enough to let me go my own way, for I tell you that I do not want to quarrel, and I will not quarrel, but I will not be hampered in my career. And what can I do in the country, unless I go there with money for models and colour? There is no chance, absolutely none, of making money with my work in the country, and there is such a chance in the city. So I am not safe before I have made friends in the city—and that comes first. For the moment this may complicate things somewhat, but after all it is the only way, and going back to the country now would end in stagnation.

The elder brother's will was always stronger than the younger's. Vincent had decided that he must come to Paris to pursue his career, and there was nothing Theo could do to stop him.

THE HOPE OF FAME

Vincent did not want to come to Paris because he shared Nietzsche's view that it was every artist's true home, or Emerson's that a visit to Paris was a dose of morphine that would soothe any pain. He had already lived there for ten months, he knew the city well, and his reasons were much more specific and realistic. They were also the consequence of long and careful thought. Despite his disagreements with Siberdt about technique, he had come to the conclusion that drawing from the antique was very important after all, and he felt sure that in Paris he would find the best models for doing so. Unwittingly he was following the example of all the great artists. All the older masters, however creative, had felt the need of this discipline, and had learned to express themselves perfectly, even if they had abandoned this classical technique afterwards.

When Vincent had been obliged to draw the Venus of Milo, the foot of the Farnese Hercules, Niobe's head and Germanicus at Antwerp Academy, he had realized there was a serious gap in his education. As he explained to Theo: I, who for years had not seen any good plaster casts of ancient sculptures—and those they have here are very good—and who during all these years have always had the living model before me, on looking at them carefully again, I am amazed at the ancients' wonderful knowledge and the correctness of their sentiment. Well, probably the academic gentlemen will accuse me of heresy, but never mind. Yet he remained faithful to Millet: The ancients will not prevent us from being realistic, on the contrary.

His dispute with his instructors at the Antwerp Academy was not about the need for drawing from the antique, but about the method, which he felt certain was hopelessly bad and absolutely wrong. Now he had learned that in Paris the pupils were freer and not forced to begin their drawings par le contour, as the phrase was. They could begin par le milieu if they wished. He had heard of Fernand Cormon's studio when he was at the Antwerp Academy; it was the most famous in Paris, and it was where his friend Breitner had finished his studies.

When L. J. Bonnat, who was the reigning official portraitist in Paris, closed his studio, he advised his pupils to go to Cormon, who had a reputation as a master of composition. Vincent also learned that at Cormon's studio he would be expected to work four hours in the morning, but he could have the rest of the day to work at the Louvre or at some other museum or gallery as he wished.

THE SHORTEST WAY

When Vincent first mentioned the idea of going to Cormon's studio, he found to his delight that Theo approved of it—without perhaps realizing how impatient Vincent would be to begin. You speak of clever fellows in that studio of Cormon's, Vincent wrote at once, just because I would damn well like to be one

192

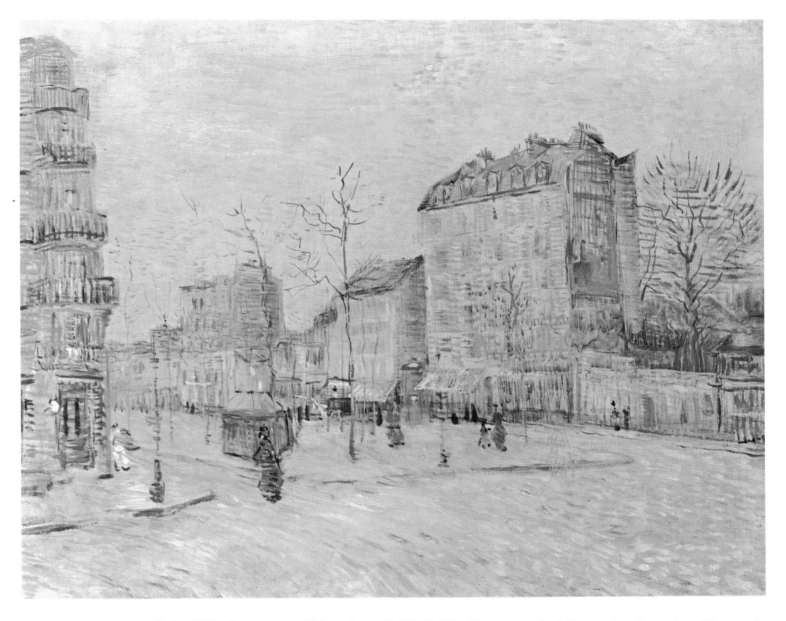

BOULEVARD DE CLICHY. Paris, 1887, oil on canvas, 46.5 × 55 cm, F 292, H 374. Vincent van Gogh Foundation, Amsterdam (Photograph A.I.v.G.).—Vincent both drew and painted the boulevard de Clichy, which has changed little since 1887, from a point almost opposite the Moulin Rouge. These two pictures, only one of which is reproduced here, show that Vincent was already thoroughly grounded in his profession as a painter.

*of them, I feel that I must insist on devoting at least a year in Paris to drawing from the nude and from plaster casts.* Theo need not worry if Vincent did not get on at the studio. *I can tell you,* Vincent wrote, *if I went to Cormon, and if sooner or later I got into trouble either with the teacher or with the pupils, I should not mind it a bit.*

Vincent often spoke in his letters of the beneficial effects of a change of atmosphere. He had even mentioned the new project to Siberdt, who urged him to remain at Antwerp and told him that many good painters had been trained by Verlat.

But Vincent continued his plan of going to Paris and wrote to Theo: *If I rent a garret in Paris, and bring my paintbox and drawing materials with me, then I can finish what is most pressing at once—those studies from the ancients, which certainly will help me a great deal when I go to Cormon's.*

He had come to feel that in Paris he could find everything that Antwerp lacked. For instance at the Academy: *Even in the antiquities class there are ten men's figures to one woman's figure. That is easy enough. In Paris, of course, this will be better, and it seems to me that, in fact, one learns so much from the constant comparing of the male figure with the female, which are always and to everybody so totally different.*

*Let me draw for a year at Cormon's.* This was the theme to which he constantly returned, occasionally several times in one letter: *For the rest, it is only natural that there cannot be any objection to finding a garret in Paris at once, on the very first day of my arrival, and then I can go and draw at the Louvre or the Ecole des Beaux-Arts, so that I shall be quite prepared for Cormon. So don't let's hesitate or take too long to decide.*

Vincent had already decided, and Theo eventually gave way as he always did. Theo's patience and kindness were almost inexhaustible, and now his ability to help his brother was slowly increasing. Unlike Vincent, but like his merchant ancestors, Theo had considerable business acumen. He had joined Goupil & Cie, as a junior employee. The firm had become Boussod, Valadon & Cie, and he was manager of one of its branches. This enabled him to support almost all his family.

Theo realized that there would be several advantages if Vincent lived with him. They would not have to pay two lots of rent, and their subsistence would be cheaper, and, of course, they would have one another's company.

They decided to stay for the moment in Theo's modest apartment in the rue Laval (now rue Victor Massé) south of the boulevard de Clichy and the place Pigalle, even though there was not room for two people, let alone a studio. But it would do until they could find something larger.

## AT CORMON'S AT LAST

Vincent did not wait to find new quarters, but at once went and entered his name at Cormon's studio, which was at No. 104 boulevard de Clichy. Once again he had managed to get what he wanted.

Fernand Cormon, who was described by Toulouse-Lautrec as the thinnest and ugliest man in Paris, had gained a certain reputation from his large pre-historic compositions, which are now completely forgotten. He was an indifferent painter, but he was a good teacher whose kindness and patience made up for his lack of talent and imagination. And he was not prejudiced against innovation.

Robert Fernier, the painter, who was one of his pupils, has published a volume of his recollections of Cormon's studio. He recalls that all along one wall, a dozen feet from the ground, a quotation from Robert Kant was written in capital letters: "The new must wait their turn to speak, and their turn never comes." Elsewhere the grey walls were thickly covered, as high as a man could reach, with old palette-scrapings—an unpleasant form of décor. For years there had hung about the place a stale and repulsive smell of fusty lukewarm oil, dust and tobacco-smoke. In these unpromising surroundings there were usually sixty pupils or more working cheerfully from the model.

In this studio Gauguin and Toulouse-Lautrec served part of their apprenticeship, as well as other painters who later became famous.

Shortly before Vincent arrived in Paris, an eighteen-year-old pupil of Cormon's had amused himself during the master's absence by painting red and green stripes on the old brown backcloth which hung behind the models. Cormon was shocked by the garish sight. He took offence, and summoned the pupil's father to remove his son.

The culprit was Emile Bernard, the only painter with whom Vincent ever had a completely unclouded friendship. Vincent's thirty-two letters to Bernard are evidence of his affection and admiration, and they are also an invaluable and unusually frank record of Vincent's artistic life.

Vincent later wrote that in Bernard's paintings there was *something essentially French and sincere of rare quality.* The same was true of Emile himself.

The striped backcloth was only one of Bernard's many acts of rebellion. His father's patience was exhausted, and he decided that his son should go into business. But Bernard refused, and set out on foot for Normandy and Brittany. Before leaving, he returned to Cormon's studio to say goodbye to his friends, and there he saw Vincent for the first time. The painter was hard at work brushing in a coloured background behind his model instead of the dreary

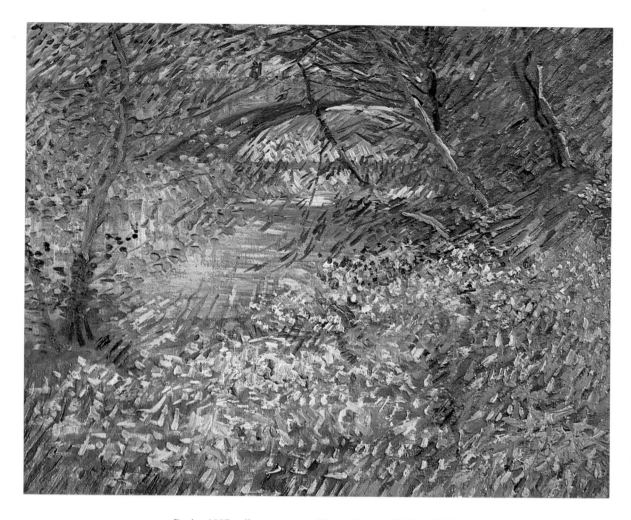

THE RIVERSIDE IN SPRING. Paris, 1887, oil on canvas, 50 × 60 cm, F 352, H 366. Private collection, Paris.

brown backcloth. He was doing what Emile Bernard had intended to do; and this may well have set them on the road to friendship.

Bernard later described how "Everyone was laughing at Vincent behind his back, but he did not deign to take any notice of them." He was used to the situation, for it had been the same at Antwerp; he was an experienced eccentric of thirty-three among a lot of callow beginners.

## CREATIVE PASSION

Emile Bernard saw Vincent again at Cormon's studio that afternoon, when it was almost empty. Vincent was sitting in front of an antique sculpture and patiently copying it. He was determined to grasp every line and surface of its form, correcting his study, scrapping it and beginning again, and finally rubbing so hard that his eraser went right through the paper.

Some of Vincent's contemporaries at the studio saw him paint those worn-out BOOTS, which seem to have been cast off by some down-and-out tramp. What could be more ordinary, and yet what a beautiful and dignified picture he has made of them! It is hardly surprising that much has been written about this still-life which, according to the psychiatrists, is a mirror of his psyche.

Perhaps the most ingenious of these is Heinz Graetz. Noticing that they seem not to be a pair, but two left boots, he has interpreted them as symbolic portraits of Vincent and Theo. The lace of the left-hand boot (Vincent) falling accidentally on that of

SEATED NUDE CHILD. Paris, 1886, black crayon, 30 × 23.5 cm, F 1367. Vincent van Gogh Foundation, Amsterdam.—This is one of the six known studies of this seated little girl or of her head. The difference in style between the Nuenen and the Paris drawings is very marked. Not only has Vincent adapted himself to his new models, but he has also made notable progress. In spite of everything he has learned something from drawing from the antique.

When he reopened Vincent did not return. During his two or three months there he had gained a reputation for working like a demon and doing three studies at a sitting. He was constantly beginning new ones, painting the model from every angle. He did not take kindly to instruction, however hard he tried, and the fact that Cormon's corrections were "kindly" did not make them any more palatable to him. Toulouse-Lautrec likewise revolted against this very "kindliness", and Frantz Jourdain tells how he said to Cormon: "I am here to learn my trade, not to have it spoon-fed to me."

When Cormon saw that Vincent was an experienced and self-confident painter he soon stopped giving him instruction. Yet despite Vincent's contempt for what Toulouse-Lautrec called "wretched academic perfection, which has more than once bankrupted art", he made great progress in a very short time. Some of his drawings done at this time can not only justly claim to be academically correct, but also show that Vincent had succeeded in applying *the ancients' wonderful knowledge and the correctness of their sentiment* to his drawings of the nude.

It is not surprising that in the end Vincent remembered Cormon with affection—Toulouse-Lautrec was another pupil who did the same. But he afterwards considered, a little unjustly, that his period in the studio had been not merely a waste of time, but also a pernicious influence. He wrote to Bernard in the summer of 1887: *I persist in believing that you will discover that in the studios one not only does not learn much about painting, but not even much good about the art of living; and that one finds oneself forced to learn how to live in the same way one must learn to paint, without recourse to the old tricks and eye-deceiving devices of intriguers.*

the right-hand one (Theo) symbolizes not only the bond between the brothers, but also the elder's gratitude to the younger.

Emile Bernard says that Vincent stayed at Cormon's for only two months, and Vincent himself wrote to Livens: *I have been in Cormon's studio three or four months but I did not find that so useful as I had expected it to be.*

In the summer of 1886 Cormon suddenly closed his studio after having difficulties with his students.

## A FORGOTTEN VERDICT

Before the evening class at the Antwerp Academy came to the end of its term, a competition had been organized. Although he had already decided to leave, and did not care overmuch for the judges' good

NUDE STUDY OF YOUNG GIRL. Paris, 1886, black chalk and charcoal, 73,5 × 59 cm. F 1368. Vincent van Gogh Foundation, Amsterdam.—This study shows the considerable mastery of figure drawing that Vincent had already achieved. It is surprising this was not recognized at the time.

VIEW OF PARIS. Paris, 1887, oil on canvas, 37.5 × 61.5 cm, F 262, H 258. Collection of Nathan. Right: enlarged detail (A.I.v.G.).— The rue Lepic, where Vincent and Theo lived, was quite close to the Butte Montmartre, and it had—and still has—a magnificent view looking right out over Paris. It is easy to see why Vincent—and so many other painters—set up their easels there.

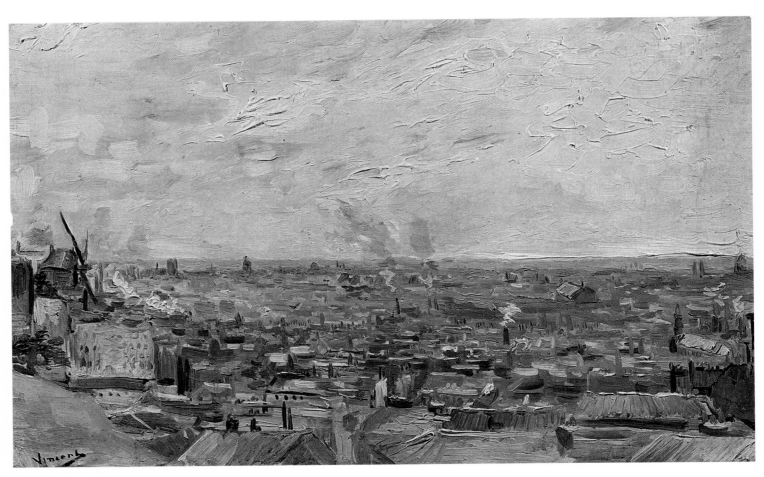

opinion, Vincent told Theo that he had entered a drawing for it: *It is the figure of Germanicus that you know*, he wrote.

Vincent had been working in Cormon's studio for a month, and had probably forgotten all about it, when the administrative council of the Academy turned out in full force to judge the entries. This was the only item on the agenda, but it required the attention of Verlat presiding, with twenty-three instructors and the administrator.

Although Vincent had been temperamentally averse to much of the doctrine taught at the Academy, he did his best to conform. He was clearly at loggerheads with Siberdt, but he had refused to quarrel openly with him, saying: *Why do you pick a quarrel with me, I don't want to quarrel, and in any case I don't desire the least bit to contradict you.*

He told Theo that if this went on he would be forced to say to Siberdt in front of all the class: *I am quite willing to do all that you tell me to do mechanically, because, if necessary, I particularly want to give you your due, if you desire it, but as for mechanizing me as you mechanize the others, I assure you it will not influence me in the least.* But whether he actually did so we do not know. Certainly the hostility continued, and Vincent wrote: *That nagging of those fellows at the academy is often almost unbearable, for they remain positively spiteful. But I try systematically to avoid all quarrels, and go my own way.*

It was hardly to be expected that the Academy would think well of Vincent's entry in the competition. He did not expect it himself: *I am sure I shall place last, because all the drawings of the others are exactly alike, and mine is absolutely different. But I saw how that drawing they will think best was made. I was sitting just behind it, and it is correct, it is whatever you like, but it is dead, and that's what all the drawings I saw are. Enough of this, but let it annoy us so much that it makes us enthusiastic for something nobler, and that we hasten to achieve this.*

And so it proved. The twenty-five judges unanimously decided to put Vincent back twenty-five years into the lowest class among children of eight to ten. There is no point in arraigning these judges by citing the names that they recorded on their verdict. For every one of their names has deservedly been forgotten. Vincent himself probably never knew their judgement, and posterity has firmly reversed it.

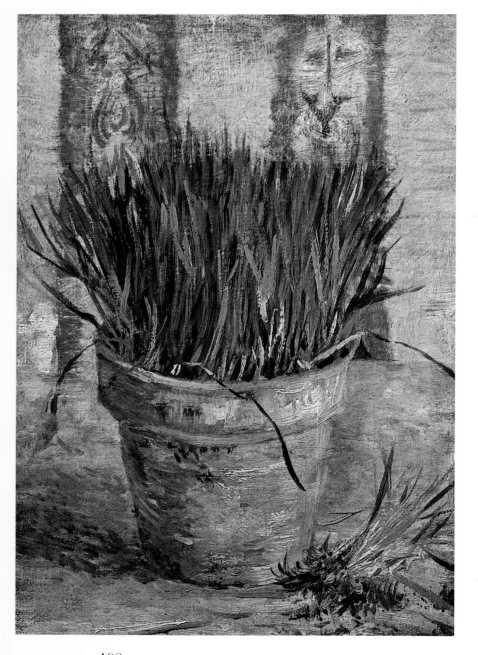

FLOWER-POT WITH GRASS. Paris, 1887, oil on canvas, 32 × 22 cm, F 337, H 315. Vincent van Gogh Foundation, Amsterdam.—One may speculate whether in painting this quiet, even humble, still-life Vincent was not consciously or unconsciously producing a sort of symbolic self-portrait. For what can be more modest than a flower-pot full of grass that never flowers? And he may well have feared that he would never come to flower, a man without wife or children and an artist whose works would perhaps never be understood or even known.

## A NEW HOME

In June, three months after Vincent had arrived, the two brothers moved into a new apartment on the third floor of a building at No. 54 rue Lepic, in Montmartre not far from the boulevard Clichy, which Vincent was to draw and paint. Their new apartment looked out over much of Paris, but the many views of the city which are often said to have been painted from its windows were actually done from the place du Calvaire near the place du Tertre. And if one stands at that point one can compare the reality with Vincent's interpretation of it.

The apartment consisted of a comfortable living-room, with Theo's old cupboard, a sofa and a fire that was always burning, a room for Theo, a bedroom for Vincent, and a studio which did not really provide what he needed for his work. As a result Vincent painted in all sorts of places: in the basement of the house, and at a house in the place Saint-Pierre belonging to a friend that he had made at Cormon's.

The change in atmosphere, and his happier life without material worries, did Vincent good. During the summer of 1886 Theo wrote to his mother: "We like the new apartment very much; you would not recognize Vincent, he has changed so much, and it strikes other people more than it does me. He has undergone an important operation in his mouth, for he had lost almost all his teeth through the bad condition of his stomach. The doctor says that he has now quite recovered his health; he makes great progress in his work and has begun to have some success. He is in much better spirits than before and many people here like him. . . . If we can continue to live together like this, I think the most difficult period is past, and he will find his way."

Vincent realized that his health was better, and he admitted to Livens: *I was rather low down in health when in Antwerp but got better here.*

On the other hand Andries Bonger wrote to his parents in Amsterdam: "Theo is still looking frightfully ill; he literally has no face left at all. The poor

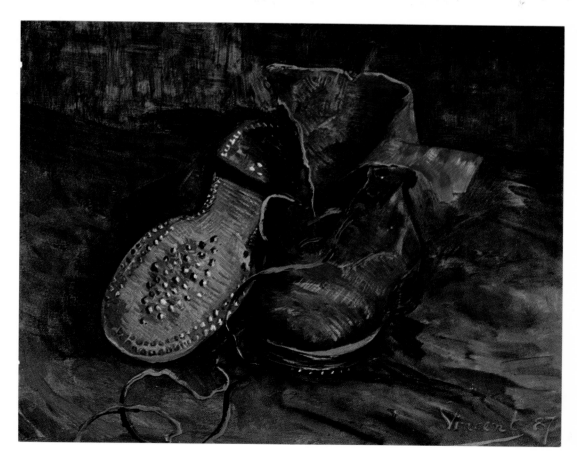

BOOTS. Paris, 1887, oil on canvas, 33 × 41 cm, F 333, H 251. Baltimore Museum, U.S.A.—From childhood Vincent had always been a great walker; it was not surprising that now that he had become a rootless traveller he often painted his companions on these wanderings. Boots and clogs inspired several pictures. Heidegger commented: "Engraved in the intimate obscurity of the hollow of a boot is the weariness of the steps of work. The rough and solid weight of the clog tells of the slow and obstinate trudge across the fields".

fellow has many cares. Moreover, his brother is making life rather a burden to him, and reproaches him with all kinds of things of which he is quite innocent." And in another letter: "I think I told you last summer what a queer life this brother has led. The man hasn't the slightest notion of social conditions. He is always quarrelling with everybody. Consequently Theo has a lot of trouble getting along with him."

When Emile Bernard visited Vincent he saw a collection of fairly good Romantic pictures in the living-room, and a good many Japanese prints, Chinese drawings and engravings after Millet. The drawers were full of tangled balls of wool forming unexpected combinations of colours.

One of their neighbours, M. Fourmentin, who lived in an apartment on the floor below, said that nobody in the building knew the names of the two gentlemen on the floor upstairs; he guessed they must be brothers because they looked so alike. The one who always took a paint-box when he went out looked rather an awkward customer, and he thought they must be foreigners.

## WITH SUZANNE IN THE LIONS' DEN

When Emile Bernard first saw Vincent they were not yet friends. They met again later in 1887 when Bernard returned from Normandy and Brittany. This meeting took place in that "little mortuary chapel", Père Tanguy's shop.

When Bernard saw Vincent coming out the back of the shop, with his high broad forehead like that in A. S. Hartrick's portrait of him, he admitted later that he was almost afraid of this man, who looked as if he were wasting away.

A year after Vincent died, Emile Bernard wrote an article in which he gave the following portrait of him: "Red-haired, with a goatee, rough moustache, shaven skull, eagle eye, and incisive mouth as if he were about to speak; medium height, stocky without being in the least fat, lively gestures, jerky step, such was van Gogh, with his everlasting pipe, canvas, engraving or sketch. He was vehement in speech,

interminable in explaining and developing his ideas, but not very ready to argue. And what dreams he had: gigantic exhibitions, philanthropic communities of artists, colonies to be founded to the south, and the conquest of public media to re-educate the masses —who used to understand art in the past...."

They soon became friends, and Vincent invited Bernard to come and see him in his studio in the rue Lepic. There he showed him his boxes from Holland and his portfolios of studies. Bernard was very much impressed by these pictures and by the work he had already done in Paris. This included the sad funeral processions under grey skies, the two versions of the common grave, the views of fortifications painted in extremely light colours and with a conspicuous perspective of straight lines, and the Moulin de la Galette with its grim sails against the sky.

What struck Bernard most of all was a "fearful canvas of remarkable ugliness and yet with a disturbing life.... Poor folk at a meal in a primitive hovel, under a dreary lamplight, with astonishing labourers' faces with enormous noses, thick lips, and with vacuous and wild expressions. Vincent called it THE POTATO-EATERS. And after he had shown it all to me he shut the drawers and the boxes again."

Soon Vincent was confiding all his plans to his young friend. The thing that discouraged him most, and which he complained about bitterly, was not that his own work was not appreciated, but that Pissarro, Guillaumin and Gauguin were in such trouble that it was hindering their work and paralyzing their creative efforts.

As soon as Vincent had left Cormon's studio, he forgot all about drawing from the antique—to which he had intended to devote himself for at least a year. At first he was content to paint what he saw out of his studio's single window. He did two pictures of this view, one of which he gave to Toulouse-Lautrec, who lived in the rue Tourlaque, where Suzanne Valadon had also been living since 1883 with her mother and her child, Maurice Utrillo.

Suzanne Valadon sat to artists from many countries. She had been painted by a Czech named Inais, an American named Howland, and a Swiss named Steinlen, as well as a Dutchman named van Gogh

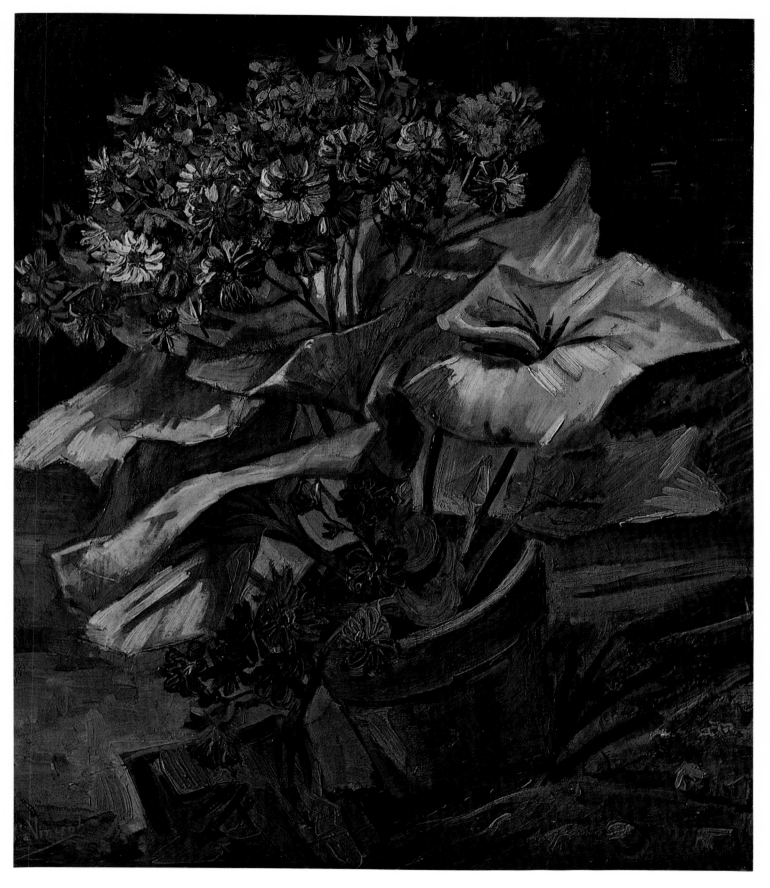

whom she had met at Toulouse-Lautrec's. This beautiful and fascinating woman, whom Degas christened "the terrible Maria" in affectionate awe, was often to be seen at Toulouse-Lautrec's, where her lively mind was much in evidence, as well as her skill with brush and pencil.

Nesto Jacometti, in his life of Suzanne Valadon, has described how at Lautrec's they drank a hellish brew while the talk soared to intoxicating and rarefied heights. It was a world of bearded shaggy men, a proud and select company who were always talking and arguing and whose wit was as bright as their clothes were shabby. One Sunday Suzanne watched the arrival of a red-headed Dutchman called Vincent. He brought a strange package out of which he took some canvases and showed them to the company, no doubt spreading them on the floor as was his usual habit and as he had done at the Antwerp Academy in front of Baseleer, Hageman and Berckmans. There the young painters had been dumbfounded by the audacity of his work. Here in Paris, Jacometti relates, there was the same frozen silence, with no word of praise or even attempt to understand. They might all have been turned to marble. Vincent packed up his pictures again, moving as awkwardly as a rusty automaton, and went as he had come, without saying a word.

Suzanne was furious at the heartless way her friends had treated this strange man. She had understood him as a painter as well as a man, and from then onwards her work shows how much she was impressed by the pictures which had just been so shamefully received. Part of her work, as all critics are agreed, was strongly influenced by that of Vincent van Gogh.

## EXCURSIONS AROUND PARIS

At first Vincent found his subjects close at hand on the Butte Montmartre. It was not far down the winding cobbled slope of the rue Lepic, which leads from the rue des Abbesses to the Moulin de la Galette, before he came to the old village of Montmartre. There he would paint the little plots of garden and park, and also from several points of view the Moulin de la Galette which Corot had already made famous many years before.

Later he went out into the suburbs and beyond, to Asnières, Joinville, Suresnes and Chatou; and like Seurat he visited the Ile de la Grande Jatte. Every man, it is said, finds his own Paris, and we can discover Vincent's by tracing these places that he went to. He still loved walking as much as ever and tought nothing of going long distances on foot. He painted incessantly, making his studies ever more lively and striking as the weeks went by.

Bridges, which the psychoanalysts tell us are a symbol of union, were a favourite subject of Vincent's at this time. Usually it was those at Asnières, near where Bernard lived, that he painted. Vincent often went to see his friend in his studio, which had been built of wood in his parents' garden. It was there that they both painted Père Tanguy and that Vincent began a portrait of Bernard. But one day Vincent quarrelled with Emile's father about the young man's future, and was so angry that he left the picture unfinished and never returned to the Bernards' house.

Before this storm blew up, he had painted in Bernard's studio some still-lives, first in a rather uncertain *pointilliste* style, and then in stripes of complementary colours. It was there that he executed his famous YELLOW BOOKS which was shown at the Salon des Indépendants in 1888.

Bernard has early described how Vincent would set off with a large canvas on his back. When he reached the place where he was going to work, he would divide it up into compartments, one for each subject. By the evening the canvas was painted all over and looked like a miniature museum in which the events and emotions of the day were all separately recorded. There would be reaches of the Seine with boats, islands with blue swing-boats, a restaurant with coloured awnings decorated with oleanders, forgotten corners of the public gardens or houses that were up for sale.

Emile Bernard, who knew these places well from his own solitary walks, remarked that "These fragments were lifted with the end of his brush and stolen, as it were, from the fleeting hour, and one can feel their poetry because they have been painted with the soul that experienced them."

Vincent had good reason to be interested in Bernard, whose undoubted talent as a painter he quickly recognized. His admiration did not depend in the least on the help they had given one another

202

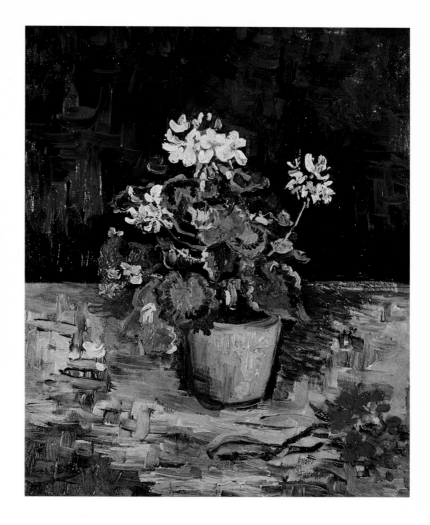

GERANIUM IN A POT. Paris, 1886, oil on canvas, 46 × 38 cm, F 201, H 218. Collection of Pastor J. P. Scholte-van Houten, Lochem, Netherlands; detail A.I.v.G.—The enlarged detail emphasizes the painter's powerful and controlled brushstrokes.

but upon the true value of and original nature of Bernard's work. He suggested to Theo that he should buy Bernard's portrait of his grandmother; and later, when he was in the asylum at Saint-Rémy-de-Provence, he urged Theo once again to add one of Bernard's works to his collections. *I should like you*, he wrote in November 1889, *to have one good thing of his besides the portrait of his grandmother.*

CREATIVE FERMENT

When he was in Paris Vincent went regularly to the Louvre, which Cezanne called "a book in which we learned to read". Before long Vincent claimed that he knew the book by heart, voluminous though it was. Sometimes he would go there only to look at a single picture.

When one considers the work that Vincent produced after he left Cormon's studio in its chronological order—in so far as this is ascertainable—it is clear that the Antwerp Academy had taught him to appreciate a classic outline at its true value. One can also see how he was trying to get rid of the type of local colour which he had been so enthusiastic about when he was in Drenthe.

Gradually his colours became lighter and lighter. These subtle changes are instructive in indicating the way Vincent tried to solve the problems he had set himself. It was impossible for him to continue for ever this process which he had begun so strikingly and effectively in WOMAN IN BLUE. The gradual lightening of his palette is seen in a series of paintings of similar subjects: the landscapes of the Butte Montmartre, and the flowers in the still-lives he painted from the summer of 1886 on.

THE MOULIN DE LA GALETTE SEEN FROM
THE RUE GIRARDON. Paris, 1886, oil on
canvas, 38 × 46.5 cm, F 228. H 268.
State Museum, Berlin, German Federal
Republic. Photograph A.I.v.G.—This
picturesque corner of Montmartre still
exists, but has lost its old rural quality.

At some time during the second half of the following year Vincent wrote to his sister Wilhelmien a long letter in which he set forth his views on life, religion and art. About colour he wrote: *always remember that what is required in art nowadays is something very much alive, very strong in colour, very much intensified. . . . Last year I painted hardly anything but flowers in order to get accustomed to using a scale of colours other than grey—pink, soft and vivid green, light blue, violet, yellow, orange, rich red.*

This slow climb towards a more expressive manner, with the light tones ringing like a clarion, immediately strikes the spectator, and one is reminded of Vincent's passion for Monticelli.

Adolphe Joseph Thomas Monticelli was a superb colourist, though his subjects, which often consisted of mysterious regal figures almost invisible in backgrounds of warm and luxurious colour, were not such as one might expect to appeal to Vincent. Monticelli died in poverty in Marseilles in June 1886, just at the time when Vincent was at the height of his campaign to lighten his palette and brighten his

colours. Two years later Vincent wrote to Wilhelmien from Arles: *I think of Monticelli terribly often here. He was a strong man—a little cracked, or rather very much so—dreaming of the sun and of love and gaiety, but always harassed by poverty—of an extremely refined taste as a colourist, a thorough bred man of a rare race, continuing the best traditions of the past. . . . Now listen, for myself I am sure that I am continuing his work here, as if I were his son or his brother.*

In his new phase in Paris Vincent had now turned against art for art's sake, and seemed at first to be revelling in the sheer pleasure of the interplay of colour. Yet beneath it all was his old boyhood desire to penetrate the secrets of nature.

SOME UNEXPECTED PORTRAITS

"Many people here like him," Theo had written to his mother about Vincent in the summer of 1886. And as evidence of this he added: "He has friends who send him every week a lot of beautiful flowers

204

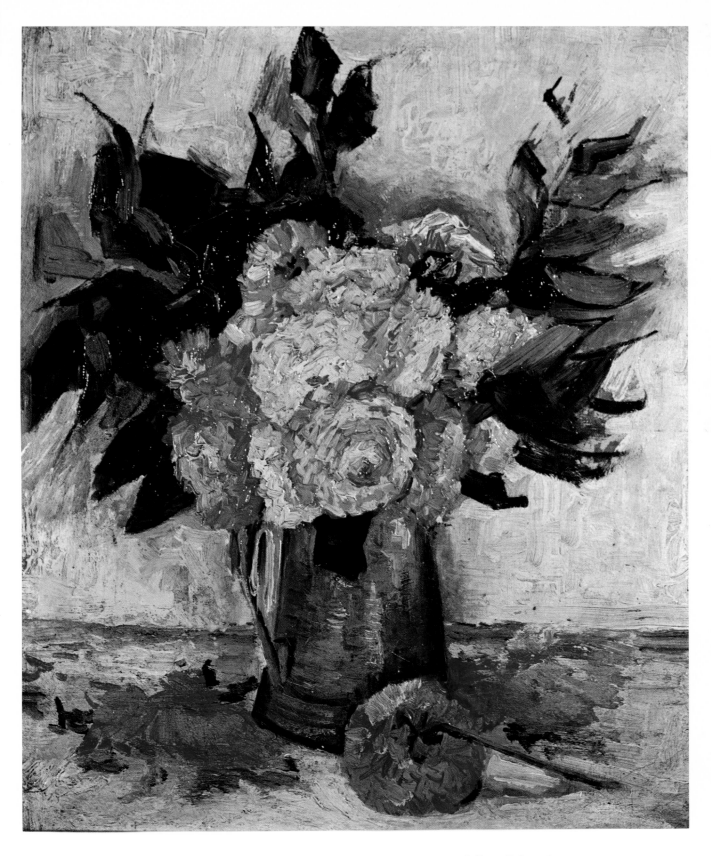

FLOWERS. Paris, oil on canvas, 46.5 × 38.5 cm. Bridgestone Gallery, Tokyo, Japan.

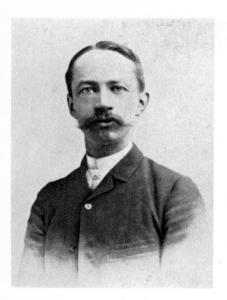

Andries Bonger. Photograph in the collection of his widow, Baroness van Verwolde, Almen, Netherlands.—It was taken by a Paris photographer at the time when he was seeing the van Gogh brothers. His resemblance to his sister, Johanna van Gogh-Bonger is striking. Theo van Gogh, drawing by Meyer de Haan, Paris, 1889, black chalk. Vincent van Gogh Foundation, Amsterdam.—Before his marriage Theo had a small beard. This was how he must have looked when the Impressionists met him at Boussod, Valadon & Cie's gallery.

THE WINDOW AT BATAILLE'S. Paris, 1887, pen and coloured chalk, 53.5 × 39.5 cm, F 1392, inscribed at the bottom right: "La fenêtre chez Bataille, Vincent, 1887". Vincent van Gogh Foundation, Amsterdam.—The little restaurant of this name no longer exists where the two van Gogh brothers used to dine, usually with their compatriot Andries Bonger, who was to become Theo's brother-in-law; it has been replaced by business premises. "Chez Bataille", in the rue des Abbesses, almost opposite the church of Saint-Jean and next to the passage des Abbesses, was not far from the rue Lepic.

Vincent van Gogh by Henri de Toulouse-Lautrec, Paris, 1887, pastel and water-colour, 54 × 47 cm. Vincent van Gogh Foundation, Amsterdam.—When Vincent was working at Cormon's studio in March 1886, he met Toulouse-Lautrec, and remained on friendly terms with him till his death. When Vincent returned from Saint-Rémy-de-Provence, some years later, he met his old friend again at Theo's apartment in the Cité Pigalle in Paris; Johanna van Gogh-Bonger tells us that he was in an excellent humour that day.

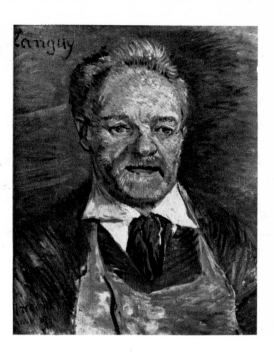
"LE PÈRE TANGUY". Paris, 1887, oil on canvas, 47 × 38.5 cm, F 263, H 416, Glyptothek, Copenhagen, Denmark.

This bill of April 1884 is in fact a list of van Gogh's pictures which Theo's widow left with Tanguy for him to sell after her husband had died. Collection of Baroness van Verwolde, Almen, Netherlands.

Two pages of a letter written by Tanguy to André Bonger on September 6, 1894. Collection of Baroness van Verwolde, Almen, Netherlands.—Tanguy complains that business is so bad in Paris that he has not sold a single picture this year, not even the most interesting ones such as the van Goghs, which everyone admired. He had been planning, he says, to increase the price of Vincent's paintings because he is confident that one day they will be recognized for their true worth.

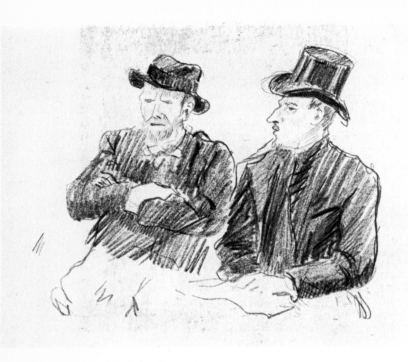

Vincent in conversation with Félix Fénéon. Drawing by Lucien Pissarro, the son of Camille, black crayon, 22 ×17.5 cm. Ashmolean Museum, Oxford, England.—Vincent wears a black hat similar to that in his portrait on page 189. Félix Fénéon, the art critic, who was as serious as he was competent, wears a fashionable top-hat. This drawing was given by Lucien's widow to the Ashmolean

which he uses for still-life." At about this time we begin to find Vincent painting little portraits of women who surely belong to quite a different world from that which he had frequented hitherto. It is difficult to tell who they are. They do not seem to be members of the Delarbeyrette family, who were Theo's friends rather than Vincent's.

At the same time, possibly for lack of models who would sit to him, Vincent painted a number of self-portraits. Among them is one that seems to reveal the painter's character more fully than any other. His expression shows both his gentleness and immense kindness towards the humble and their human frailty, and at the same time an extraordinary power of penetration that is not to be thwarted by any obstacle. In this picture Vincent looks at himself without pity, and nothing escapes him. It needed all his sincerity, courage and magnanimity to lay himself so bare.

This portrait also shows that Theo was right in saying that Vincent had changed. No longer is he

a peasant or a bohemian but a respectable gentleman, decently dressed. He calls no attention to himself by any extravagant clothes or artistic eccentricity.

Moreover it would seem from its style that the portrait was painted at about the same time as those of the young women that I have just mentioned, and that therefore he was mixing in middle-class society. Further evidence of this is provided by the unexpected, and very beautiful, picture of a distinguished-looking lady beside a cradle—an old and favourite subject—in a thoroughly middle-class interior. It all confirms Theo's account.

As there is virtually no correspondence during this period (the only opportunities Vincent had to write were when Theo was visiting his mother in Holland) and none of the letters can be accurately dated, we have no evidence upon which to date the pictures except their style—which historians have learned to distrust. This is especially unfortunate, as it was at this time that Vincent made the all-important transition from his previous chiaroscuro to his subsequent luminous manner. But it was not a sudden change, for it took place gradually over two years.

Even though it is impossible to establish an exact chronological sequence, it is easy to see how much the achievements of the Impressionists stimulated his work, especially as he was temperamentally attracted to everything new.

CHARTING A NEW COURSE

Vincent was living at the heart of an artistic movement which he had disdained when Theo first mentioned it to him. In July 1884 at Nuenen, when he was still shackled to Dutch traditionalism, he wrote to Theo: *I have read "Les Maitres d'Autrefois" by Fromentin with great pleasure. And that book frequently deals with the same questions which have greatly preoccupied me of late, and which, in fact, I am continually thinking of, especially because when I was last in The Hague I heard things Israëls had said about starting with a deep colour scheme, thus making even relatively dark colours seem light. In short, to express light by opposing it to black. I already know what you're going to say about "too black", but at the same time I am not quite convinced*

Vincent van Gogh by John P. Russell, the Australian painter, Paris, 1886, oil on canvas, 60 × 45 cm. Vincent van Gogh Foundation, Amsterdam.—Vincent got to know this painter in Paris and wrote a series of letters to him.

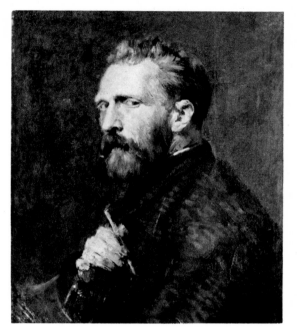

THE COMMON GRAVE. Paris, 1886, pen, brush and pastel heightened with colour, 36.5 × 48 cm. Kröller-Müller State Museum, Otterlo.—There is another version of this (F 1399).

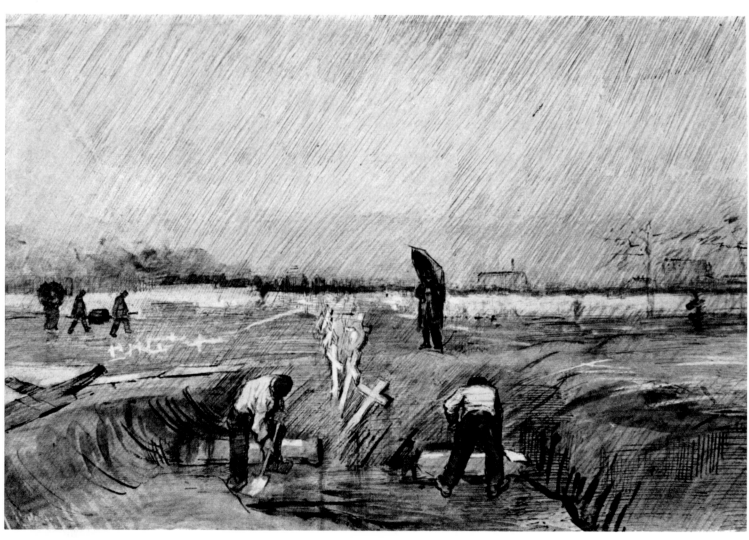

Vincent painting at Asnières. Drawing by Emile Bernard, 1887, conté crayon, 21.5 × 21.5 cm, Collection of M. Altariba (Emile Bernard's son-in-law), Paris.—The portable easel (photograph below) seen in the drawing still exists and belongs to the Archives Internationales de van Gogh. It was an accessory to much of the painter's artistic activity, and after his death it remained with Dr Gachet at Auvers-sur-Oise.

Emile Bernard with Vincent. Photograph estate of Emile Bernard, Paris.—This photograph was taken with the aid of an automatic shutter-release at the time when the two friends were at Asnières, where Emile Bernard lived. Unfortunately we can only see Vincent's back.

Self-portrait of Emile Bernard. Bernard-Fort Collection, Paris.—This picture was painted in Fernand Cormon's studio in 1886.

210

The bridge at Chatou. Photograph A.I.v.G.—After Vincent's death the picture below was entitled THE BRIDGE AT CHATOU, until one of van Gogh's biographers claimed some time ago that it was really the bridge at Asnières. The photograph of the bridge at Chatou reproduced here explains the origin of the mistake, due perhaps to a slip in the memory of one of van Gogh's old friends.

THE BRIDGE AT ASNIÈRES. Paris, 1887, oil on canvas, 52 × 65 cm, F 301, H 380. Collection of Madame C. Bührle, Zürich, Switzerland.

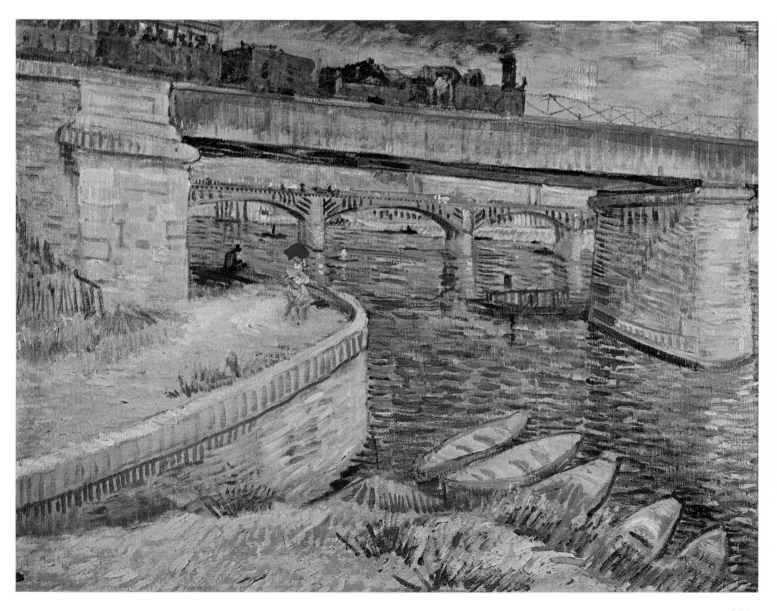

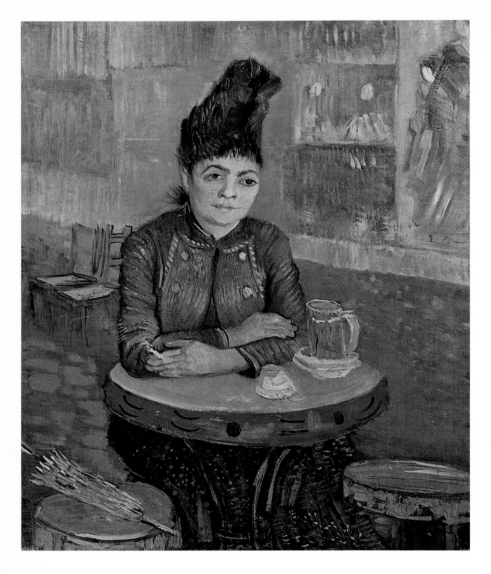

THE WOMAN AT "LE TAMBOURIN". Paris, early 1888, oil on canvas, 55.5 × 46.5 cm, F 370, H 299. Vincent van Gogh Foundation, Amsterdam.— Vincent used to go at one time to a café called "Le Tambourin". This is probably a picture of the proprietress, known as Agostina Segatori, with whom he may have had an affair. The Japanese colourprints on the wall are incidentally an indication of his interest in Japanese art. He also wrote to Theo that the Japanese *crépons* pinned up in "Le Tambourin" had influenced Bernard and Anquetin.

*yet that a grey sky, for instance, must always be painted in the local tone. Mauve does it, but Ruysdael does not, Dupré does not. Corot and Daubigny??? Well, it is the same with figure painting as it is with landscape. I mean Israëls paints a white wall quite differently from Regnault or Fortuny. And consequently, the figure stands out quite differently against it. When I hear you mention so many new names, it is not always easy for me to understand because I have seen absolutely nothing of them. And from what you told me about "Impressionism", I have indeed concluded that it is different from what I thought, but it's not quite clear to me what it really is. . . . It has already annoyed me for a long time, Theo, that some of the present-day painters rob us of the bistre and the bitumen,* *with which surely so many splendid things have been painted, and which, well applied, make the colouring ripe and mellow and generous, and at the same time are so distinguished and possess such very remarkable and peculiar qualities. But at the same time they require some effort in learning to use them, for they must be used differently from the ordinary colours, and I think it quite possible that many are discouraged by the experiments one must make first and which, of course, do not succeed on the very first day one begins to use them . . . at first I was awfully disappointed in them, but I could not forget the beautiful things I had seen made with them.*

By the time he reached Paris, and was in the centre of the Impressionist movement, Vincent knew

rather more about it, and in a letter to Livens he described how he had benefited from it: *In Antwerp I did not even know what the Impressionists were, now I have seen them and though not being one of the club yet I have much admired certain Impressionists' pictures—Degas nude figure—Claude Monet landscape.*

His friendships with painters in Paris enabled Vincent to enjoy the climate of the new movement and set him firmly in the wake of Manet. There is a painting of some *guinguettes* and several other similar canvases in which he has completely abandoned his old chiaroscuro and which could almost be mistaken for works by Pissarro or Sisley.

At Cormon's studio Vincent had made friends with Toulouse-Lautrec, who, though eleven years younger than himself, was far more experienced in the latest artistic developments in Paris, and brought him into contact with them. Vincent was still working on his own lines. His brilliant painting of the battered BOOTS which expressed what he called *les petites misères de la vie humaine*—a favourite French phrase of his—created a furore at Cormon's studio, for at that time the Impressionists were working towards rather far-fetched effects in landscape.

Within a few months Vincent had joined the *avant-garde*, with Toulouse-Lautrec, Bernard, Gauguin, Anquetin, Signac and Seurat. His passionate temperament and natural pugnacity soon made him one of the leaders of this new movement. Van Gogh felt that Impressionism had had its day, and he urged that the movement should take a new direction; it had to have a name, and was provisionally called Post-Impressionism.

These pioneers would meet at two or three taverns in Montmartre, where they would sit before their mugs of beer or glasses of wine and argue over their plans. Vincent was sitting in one of these *bistros* looking straight ahead over his glass of absinthe when Toulouse-Lautrec drew a pastel portrait of him in profile. Shortly before this his portrait was painted in oils by John P. Russell, an Australian who was then living in Paris and with whom Vincent was on very friendly terms. They went on writing to one another long after Vincent had left Paris.

Vincent had had many artist friends at The Hague and Antwerp—though few at Nuenen or in Drenthe—but never before had they been so outspoken, so enterprising and so talented as these new friends.

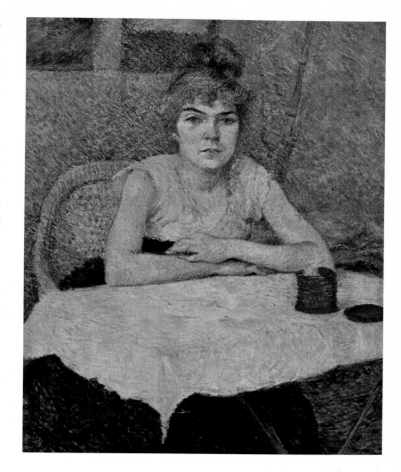

"Poudre-de-Riz" by Toulouse-Lautrec, Paris, 1884, oil on canvas, 36 × 46 cm. Vincent van Gogh Foundation, Amsterdam.—A comparison between this woman and the one who posed in "Le Tambourin" shows that the two faces have several features in common. Toulouse-Lautrec also contributed to the exhibition hung in "Le Tambourin".

INHIBITIONS OVERCOME

This was the society of artists that Vincent had dreamed of enjoying. He was constantly deep in passionate if not very fluently expressed argument. This lack of fluency was temperamental and not due to any ignorance of French. He had long been writing to Theo in that language.

In Paris Vincent was quite different from what he had been in Antwerp. He had recovered from his depression and physical debility; he was strong and confident; he no longer seemed undernourished and sickly. The anti-social pessimist had become a lively and agreeable talker who was given to a savage humour and could entertain intelligent company.

His considerable experience enabled him to draw original and striking comparisons between the work of different artists. In Paris he flourished, he seemed to have got rid of the inhibitions and complexes that had so handicapped him in the past and which had to some extend hidden his talents.

In 1887 the *avant-garde* held an exhibition in one of the cafés-restaurants where they used to meet. This was «Le Tambourin» in the boulevard de Clichy. As a result they came to be known as the painters of the Petit Boulevard, to distinguish them from the painters of the Grand Boulevard. The latter was the boulevard Montmartre, in which stood the galleries of Boussod, Valadon & Cie—run by Theo—at which Monet, Sisley, Pissarro, Raffaelli, Degas, Seurat and others exhibited.

Vincent seems to have had a fairly brief affair with the proprietress of "Le Tambourin", who was called Agostina Segatori. He mentioned her in letters written from Paris and Arles, but chiefly in connection with a dispute with her because she had failed to return some pictures.

He may have been referring to her when he wrote to his sister Wilhelmien: *As far as I myself am concerned, I still go on having the most impossible, and not very seemly, love affairs, from which I emerge as a rule damaged and shamed and little else.*

Vincent painted her portrait, and it is a very fine picture, known as THE WOMAN AT "LE TAMBOURIN". Toulouse-Lautrec painted her also, and he called his picture *Poudre-de-Riz*—"Face-powder".

There is no record of subjects discussed on the Petit Boulevard, but one of the topics about which Vincent must certainly have often held forth to Bernard, Toulouse-Lautrec, Gauguin and the others was certainly Japanese art. Japanese prints were very popular at this time, and they had a considerable effect on the development of Impressionism and the trends that were to emerge thereafter. These decorative pictures, printed in clear flat colour from several wood-blocks, attracted Vincent greatly, and he pinned them up in his room wherever he went. Their influence upon his work at a superficial level is obvious: he copied some of them, and they appeared in the background of his paintings. To discuss their profounder influence as fully as it deserves is impossible here, and I therefore propose to write about it in a separate work.

## BROTHERS IN ARMS

Vincent's life with Theo provides little of interest to the art historian. The brothers saw one another every day, and they left no letters as evidence except when Theo visited Holland. Therefore Vincent's Paris period is the least documented in his career. It represents a fifth of his working life as a painter, and it yielded at least two hundred paintings and fifty drawings; but, for lack of letters, we know very little about it. Only seven letters have been preserved from the whole of his two years in Paris.

For the rest we must rely on Bernard's and Gustave Coquiot's memoirs, casual references by Gauguin, Toulouse-Lautrec and Suzanne Valadon, and, of course, Johanna van Gogh-Bonger's introduction to the *Letters*. These accounts confirm what Theo's friend Andries Bonger told his parents, namely that when Vincent found the novelty of Paris beginning to wear off, he fell into his old bad-tempered ways. Bonger also mentioned that Vincent was taken ill, which is not surprising, for it seems unlikely that he could have been completely cured by Dr Cavenaille's treatment in Antwerp.

During the winter of 1886-1887, Vincent became more difficult and disagreeable than ever. Sometimes when Theo came home in the evening tired after a long day at the gallery in the boulevard Montmartre, Vincent would buttonhole him and hold forth about the theory of art and the sins of the art trade until late at night. Even when Theo had retired to bed, Vincent would sit in a chair at his bedside and go on talking to him until his brother was quite exhausted.

Theo, who was far from well, wrote to Wilhelmien: "My home life is almost unbearable. No one wants to come and see me any more because it always ends in quarrels, and besides, he is so untidy that the room looks far from attractive. I wish he would go and live by himself. He sometimes mentions it, but if I were to tell him to go away, it would just give him a reason to stay; and it seems I do him no good. I ask only one thing of him, to do me no harm; yet by his staying he does so, for I can hardly bear it. . . . It seems as if he were two persons: one, marvellously gifted, tender and refined, the other, egoistic and hard-hearted. They present themselves in turns, so that one hears him talk first in one way, then in the

other, and always with argument on both sides. It is a pity that he is his own enemy, for he makes life hard not only for others but also for himself."

When Wilhelmien advised Theo to "leave Vincent for God's sake," he gave his usual answer: "It is such a peculiar case. If only he had another profession, I would long ago have done what you advise me. I have often asked myself if I have not been wrong in helping him continually, and have often been on the point of leaving him to his own devices. After receiving your letter I have thought it over again, but I think in this case I must continue in the same way. He is certainly an artist, and if what he makes now is not always beautiful, it will certainly be of use to him later; then his work will perhaps be sublime, and it would be a shame to have kept him from his regular study. However unpractical he may be, if he succeeds in his work there will certainly come a day when he will begin to sell his pictures. . . . I am firmly resolved to continue in the same way as till now, but I do hope that he will change his lodgings in some way or other."

LANDSCAPE NEAR PARIS. Paris, early September 1887, oil on canvas, 73 × 92 cm.  Private collection, Basle, Switzerland.

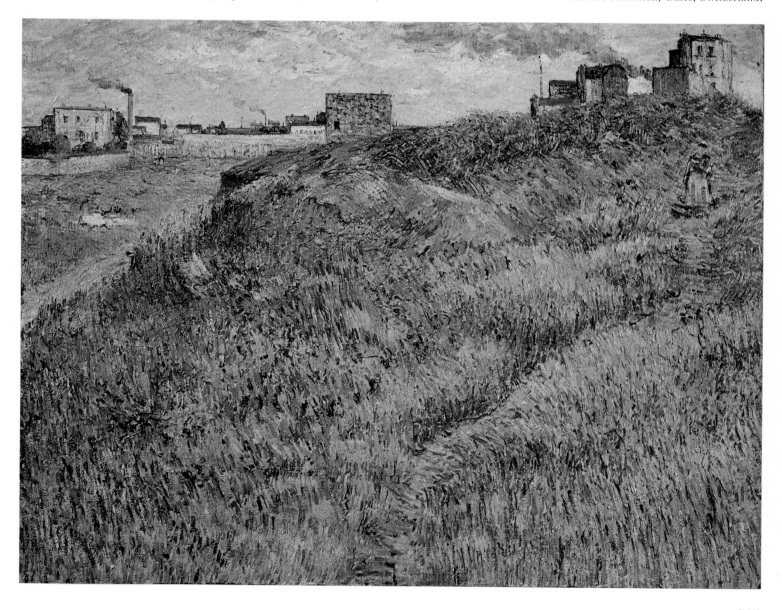

PLUM-TREES IN BLOSSOM (after Hiroshige). Paris, 1888, oil on canvas, 55 × 46 cm, F 371, H II. Vincent van Gogh Foundation, Amsterdam.

## AT BREAKING POINT

This continual and increasing tension between the two brothers had serious consequences. On December 31, 1886, Andries Bonger sent a letter to his parents which has not hitherto been published: "It is quite possible I have missed the news," he wrote, "because owing to van Gogh's illness I have had little time to read. He has had such serious nervous complaints that he has been unable to move. To my great astonishment I found yesterday that he was as he had been before it occurred; he still felt stiff, as if he had had a fall, but it had left no other consequences. He has now decided at last that he

must take care of his health. He is in great need of doing so. He has decided to leave Vincent; living together is impossible. As I said before, it would be best to say nothing to Madame, should you chance to see her; she knows nothing about it." By "Madame" he meant Theo's and Vincent's mother.

The importance of this letter is that it shows that Theo had already begun to suffer from the illness from which he was to die only four years later. From it we learn that the two brothers found their life together intolerable by the end of December 1886, and from the phrase "As I said before" it is clear that this was not the first time that Theo had had a nervous attack.

Six weeks later, on February 18, 1887, Andries Bonger wrote to his parents again: "Van Gogh... stands in great need of being renovated. He continues to look sick and emaciated, and he is feeling weak." Theo had taken on much more than his health could stand, and Johanna van Gogh-Bonger considers that living for two years with Vincent was the greatest of all the sacrifices that Theo made for his brother.

But, in spite of everything, the threatened separation did not take place. The bond between the brothers was too strong. Later on Theo told his mother that he had recovered his strength and was very hopeful of improving his relations with Vincent.

In the spring Vincent once again began to walk round and about Paris and to paint landscapes of what he saw; and relations between the two brothers were happy again. There is evidence of this in his splendidly light and radiant YELLOW STILL-LIFE, on which he has painted in red: "To my brother Theo".

In the end Vincent wearied of Paris. He was suffering from nervous strain and began to find it difficult to work there. City life was exhausting, and the winter skies depressed him. He needed peace and quiet and the clear light of the southern sun.

One evening he said to Bernard: *I am leaving tomorrow, let us arrange the studio so that my brother will think me still here.* Then Vincent pinned Japanese prints upon the walls, and put some canvases on easels and others in heaps on the floor. He explained that he was going south to Arles and hoped that Bernard would join him there. They walked together to the avenue de Clichy. There they shook hands, never to meet again.

# JAPAN IN THE SOUTH

On February 20, 1888, Vincent left Paris by train, and arrived at Arles the same day. Vincent had reason enough for leaving Paris. The desire to find a clearer and brighter light than the city could provide in February was one of them. Of course, a painter needs to change his surroundings from time to time in order to renew his inspiration, and Vincent was always avid for new experiences. In a letter to Henry Livens he spoke of *adventurers like myself* who *lose nothing by risking more.* And he added: *Especially as in my case I am not an adventurer by choice but by fate, and feeling nowhere so much myself a stranger as in my family and country.*

But none of this explains his choice of destination. Georges Charensol in his annotations to the French edition of the letters considers the question worth examining. "Was it really on Lautrec's advice" he asks, "that Vincent left Paris in February 1888 to go and settle in that distant town where he knew nobody?" He rashly adds: "No one surely, can answer this question." But François Gauzi, who was one of Toulouse-Lautrec's oldest friends, has answered in his book *Lautrec et son temps.* "In February 1888," he wrote, "on Lautrec's advice, Vincent went to Provence, where the brilliant Midi light enchanted and dazzled him." This is corroborated by Emile Schaub-Koch. In his *Psychanalyse d'un peintre*

*moderne : Toulouse-Lautrec,* published in 1935, he says that "French painting owes Vincent's most beautiful paintings and drawings to Toulouse-Lautrec's acumen and enterprise." It seems that Vincent was convinced that since Toulouse-Lautrec was of noble birth he must be very rich, and he therefore plagued him with plans for artists' cooperative enterprises of various kinds. But Toulouse-Lautrec loathed such cultural "good works"; so he decided to get rid of his importunate friend in a tactful, indeed benevolent, way by giving him lyrical descriptions of the colour, atmosphere and light in Provence, especially at Arles, and insisting that it would help van Gogh's talent to develop.

Thus from basically personal motives, and without perhaps realizing it, Toulouse-Lautrec may have helped Vincent enormously by sending him to a place which provided him with the stimulus he needed.

It is a good story, but there was a great deal more to it than that.

## TOWARDS THE LIGHT

Toulouse-Lautrec's advice would hardly have persuaded Vincent unless he had already begun to feel that he needed to leave the city for the country,

and that his work needed subjects bathed in a clearer and more brilliant light than he could find in Paris.

Whatever Toulouse-Lautrec may have said, Vincent had long been considering going to the south. Even in 1886 he had written to Henry Livens: *In spring— say February or even sooner I may be going to the South of France, the land of the blue tones and gay colours.*

And in the autumn of 1887 he wrote to his sister Wilhelmien: *One must be strong to stand life in Paris . . . . It is my intention as soon as possible to go temporarily to the south, where there is even more colour, even more sun.*

As usual, it was no sudden impulse but had been long premeditated. Moreover Vincent was to set down clearly his reasons for the move: *I came to the south for a thousand reasons. I wanted to see a different light, I believed that by looking at nature under a brighter sky one might gain a truer idea of the Japanese way of feeling and drawing. Finally I wanted to see this stronger sun, because I felt that without seeing it I could not understand the execution and technique of Delacroix's pictures, and because I felt that the colours of the spectrum are misted over in the north.*

ARLES

Despite the strain of living together for two years, the brothers were not glad to part. In his first letter to Theo from Arles, Vincent wrote: *During the journey I thought of you at least as much as I did of the new country I was seeing. Only I said to myself that perhaps later on you will often be coming here yourself.*

But it was not until seven months later, in a letter that Dr Jan Hulsker attributes to September 29, 1888, that Vincent told Gauguin: *When I left Paris, seriously sick at heart and in body, and nearly an alcoholic because of my rising fury at my strength failing me—then I shut myself up within myself, without having the courage to hope.*

It was not Theo that he was trying to get away from—quite the contrary.

Vincent has left a record of what he saw when he left the railway station and made his way into the town of Arles. In a letter to Theo (dated by Hulsker March 17, 1888), he described a picture that he had just finished as *an avenue of plane trees near the*

*station.* This picture, which belongs to the Musée Rodin in Paris, was therefore painted during his first three weeks at Arles. Vincent would have passed under these planes on the way from the station and then have crossed the public gardens, with its three clumps of trees. There were planes, firs, bushes, a weeping willow and stretches of green grass. The gardens have all gone now, but from the fine pictures that Vincent painted we can get an idea of what the place was once like.

From the gardens Vincent would have passed through the gateway of the Porte de la Cavalerie, with its two round towers built of red stone, which was destroyed in the Second World War so that nothing but ruins now remain. The road through the gate leads to the centre of the town and is similarly named the rue de la Cavalerie. It was at No 30 in this road that the Hôtel-Restaurant Carrel stood. There Vincent found himself lodgings consisting of a little attic room from which he could see the arena and several churches. As usual he drew what he saw, and although the hotel was destroyed in 1944, one can see that his record was accurate.

Arles, which straddles the wide swift torrent of the lower Rhône, was then a little town no bigger than Breda or Mons, according to Vincent. When he arrived, the landscape can hardly have been what Toulouse-Lautrec had led him to expect. *There's about two feet of snow everywhere*, he wrote, *and more is still falling*—most unusual weather for Provence. Vincent was not put out by this and immediately thought of Japan: *The landscapes in the snow, with the summits white against a sky as luminous as the snow, were just like the winter landscapes the Japanese have painted.* He promptly did likewise, and the result was an unusual picture, EFFECT OF SNOW AT ARLES, which he described as *a study of a landscape in white with the town in the background.* It is very little known and seems never to have been exhibited, but nearly twenty years ago I was fortunate enough to be able to see it in London when its owners returned from South America, and I shall never forget its astonishing freshness. Arles, with its ancient church-towers of Saint-Jean-de-Mousquier and Saint-Trophime, stands on the horizon in the wintry air, with the clouds above ready to break.

Vincent had begun working as soon as he arrived. A few yards from his lodgings in the rue de la Cava-

218

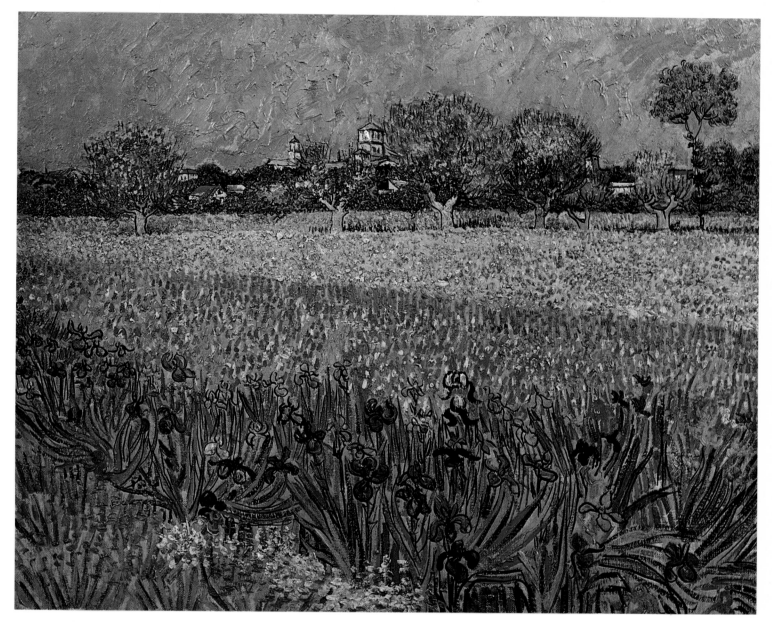

VIEW OF ARLES WITH IRISES IN THE FOREGROUND. Arles, May 1888, canvas, 54 × 65 cm, F 409, H 442. Vincent van Gogh Foundation, Amsterdam.—Vincent himself described it thus: "A meadow full of very yellow buttercups, a ditch with irises, green leaves and purple flowers, the town in the background, some gray willows, and a strip of blue sky ... the subject was very beautiful and I had some trouble getting the composition."

lerie he painted a picture of a section of pavement with a charcuterie beyond it. It is hardly a conventional view, since the shop is seen through the window of the café on the opposite side of the road. It is reproduced on page 221.

It is interesting to find when one compares THE CHARCUTERIE with the *japonaiserie* usually mistakenly called THE ACTOR, that the colours used here are the same ones that Vincent arranged so carefully with his combinations of pieces of wool in Paris and that there is no perceptible break between the colours used there and at the beginning of his Arles period. But THE CHARCUTERIE does differ in one important way from Vincent's previous work in that it has been drawn directly with the brush and not based on any preliminary drawing or study.

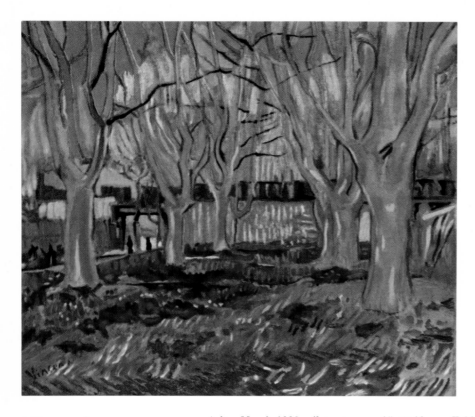

THE VIADUCT NEAR THE STATION. Arles, March 1888, oil on canvas, 45 × 49 cm, F 398, H 439. Musée Rodin, Paris. Photograph A.I.v.G.—Today all that remains of this place is part of the viaduct and a few trees, as is seen from the photograph.

The first lodging. Photographs A.I.v.G.—When he first arrived in Arles, Vincent lived at the Hôtel-Restaurant Carrel, 30 rue Cavalerie. During the Second World War the building was destroyed by bombing. When it was rebuilt the rue Cavalerie was widened.

ROOFS. Arles, February 1888, pen, 25 × 34 cm. Private collection, London. Photograph A.I.v.G.—Vincent drew this view of Arles from his window, which was probably an attic-window. In order to take a photograph to compare with the drawing it was necessary to go about fifty feet above street-level.

THE CHARCUTERIE. Arles, February 1888, oil on canvas on board, 39.5 × 32.5 cm, F 389, H 428. Vincent van Gogh Foundation, Amsterdam. Photograph A.I.v.G.—The charcuterie that Vincent painted still exists in the street which was then called the rue Cavalerie, a few yards from where the Hôtel-Restaurant Carrel then was. The front has since been modernized, but the proportions have not been changed. The colouring of this picture is like that of the last pictures Vincent painted in Paris before going south.

221

PEACH TREES IN BLOSSOM "SOUVENIR DE MAUVE". Arles, April 1888, oil on canvas, 73 × 59.5 cm, F 394, H 431. Kröller-Müller State Museum, Otterlo. Photograph (left) A.I.v.G. —When Vincent took this canvas home to his lodgings he found a letter from his sister with news of Mauve's death. He told Theo: "Something—I don't know what—took hold of me and brought a lump to my throat, and I wrote on my picture: Souvenir de Mauve, Vincent." When Vincent arrived at Arles in February 1888, the orchards were already blossoming.

## AWAKENING NATURE

Vincent the countryman was delighted with what he found at Arles, and he had dreams of sharing it with other artists. He wrote to Theo about the commercial advantages of an artists' cooperative that would prevent the dealers from making all the profits, and he suggested to Bernard that: *It might be a real advantage to quite a number of artists who love the sun and colours to settle in the south.* Already he was beginning to feel the need of artistic companionship.

Meanwhile he continued to explore the neighbourhood and to paint. In Provence the fruit-trees come into blossom very early: the almond trees which are planted out of the reach of strong winds usually come into leaf by the Feast of the Conversion of St Paul on January 25. And by the beginning of March almost all the orchards are loaded with white, pink and purple blossom.

Vincent, who was more devoted to nature than ever, had come to the right place; and he began to work at a feverish rate on a whole series of pictures of fruit trees in blossom. They are a procession of colour: almond trees, cherries, apricots, peaches, plums, pears and apples. All this radiant blossom, with its subtle shades of white and pink, seemed to exert a benign influence upon Vincent.

The consequences of the debauched life he had led in Paris did not disappear at once. At Antwerp, where he had gone with prostitutes in the docks, Vincent had already begun to dent his ascetism. With his uninhibited artist friends in Paris he abandoned it altogether.

His diet still consisted mainly of bread and cheese, but red wine took the place of milk and water. There is a record of this in his fine still-life of French bread, Gruyère cheese and a bottle of claret. There is also another still-life entitled ABSINTHE. All his still-lives were a form of self-portraiture; these two were perhaps also exercises in self-reproach.

In Paris he changed his habits to suit those of his companions. Toulouse-Lautrec and Gauguin were not afraid of alcohol, so why should he be? He would have cut a strange figure drinking milk with them at "Le Tambourin" or at any of the other convivial meeting-places.

## A BREATH OF FRESH AIR

Many of the women who sat to Vincent were prostitutes. Most of middle-class society had closed its doors to him when he was in Holland, and he had no choice. It was much the same in Belgium and France, and it was natural enough that Vincent, who had never enjoyed normal marital relations, should have sought in the brothels what he was denied by a series of unfortunate circumstances.

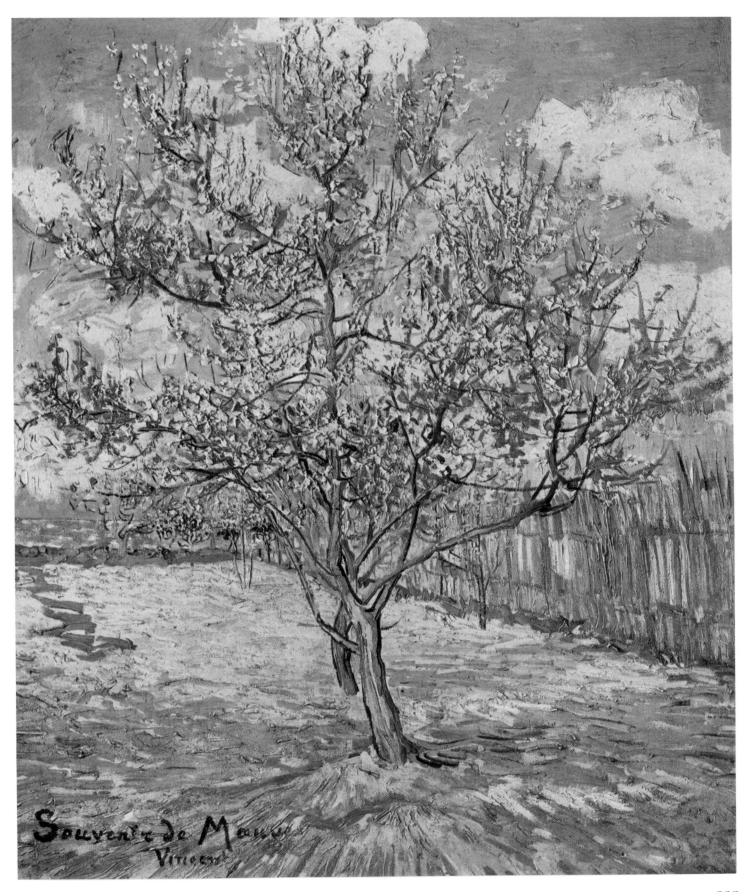

An echo of this low life and perhaps of their adventures together is to be found in an album of water-colours which Emile Bernard gave to him. It was entitled "At the Brothel" and it has never been published. It now belongs to Dr V. W. van Gogh.

This background of wine and women explains why he wrote to Theo in his second letter from Arles: *I have thought now and then that my blood is actually beginning to think of circulating, which is more than it ever did during that last period in Paris. I could not have stood it much longer.*

Working alone was the best cure for the results of this debauchery. Vincent realized this and immersed himself in painting the orchards in bloom. As he explored around Arles, he was constantly seeing new sights which in due course gave him ideas for new pictures. He had once been thought awkward and unskilled; now he had complete mastery over his materials and an extraordinary freedom of conception. It was as though his personality had long been imprisoned, but had now burst out of its chains. Everything that his spirit had wanted to create was within his power.

## SOARING SPIRITS

*I'm up to my ears in work, for the trees are in blossom and I want to paint a Provençal orchard of astounding gaiety,* Vincent wrote a few weeks later. He had begun with *a group of apricot trees in bloom in a little orchard of fresh green* and by April 20 he was able to tell Theo that he had already painted ten pictures of orchards, besides three small studies and one large one of a cherry tree which he maintained he had spoiled.

One day he was out of doors painting an orchard, a lilac ploughed field, a reed fence and *two pink peach trees against a sky of glorious blue and white* which he told Theo was *probably the best landscape I have done.* When he got home with it he found a letter from Wilhelmien with a Dutch obituary of Mauve. *Something—I don't know what—he wrote, took hold of me and brought a lump to my throat, and I wrote on my picture "SOUVENIR DE MAUVE—VINCENT THEO" and if you agree we two will send it, such as it is, to Mrs Mauve. I chose the best study I've painted here purposely; I don't know what they'll say about it at home, but that does not matter to us; it seemed to me that everything in memory of Mauve must be at once tender and very gay, and not a study in any graver key.*

It is a magnificent and unforgettable landscape. Vincent did not in fact put Theo's name on it as well as his own, he forgot to do so or thought better of it. The characteristically generous impulse remains.

## HIS OWN MASTER

While Vincent was in Paris he had been much interested in the various *avant-garde* movements, and had even been influenced by them, but he had committed himself to none. He avoided easy imitation because he wanted to be original in his own way. Moreover he considered that the theories that his contemporaries adopted were already out of date. He would take his own road, using only such elements of others' work which would help him on his way.

With great patience and determination he had overcome all technical barriers, and could now happily adopt the rule that all rules might be broken, provided only that the result succeeded in conveying what he had set out to express. This was not a new attitude, it was what he had said to Mauve long ago.

Van Gogh was the only artist to exploit Seurat's *pointilliste* technique thoroughly, carrying it to its culmination with his savage yet strictly controlled and closely-knit brush-strokes. His talents burst into flower, and he was able to enjoy a renewed energy and a mastery that he had always longed for.

Vincent's paradox was that he had taken every painter—and no single painter—as his master. At the beginning this had certain disadvantages, for Vincent suffered the limitations of a self-taught artist who has come to drawing and painting late in life. But afterwards it gave him incomparable strength, for he was unhampered by the doctrine of any other painter or school and could subordinate all their influences to his own.

## THE JOYS AND SADNESSES OF PAINTING

When Vincent painted his orchards he seemed to be looking at a new and better world. They are full of joy and an affirmation of life. *Colour in a picture,*

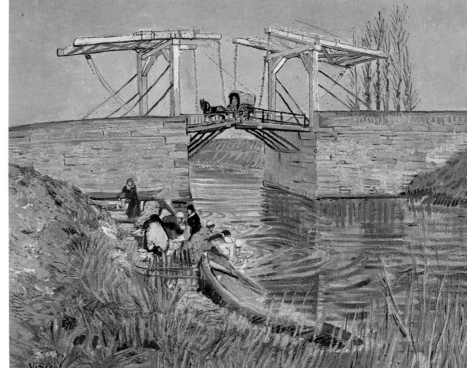

"LE PONT DE LANGLOIS" (popularly called "LE PONT DE L'AN-
GLAIS"). Arles, March 1888, oil on canvas, 54 × 65 cm, F 397,
H 435. Kröller-Müller State Museum, Otterlo. Photograph
A.I.v.G.—This little lifting bridge was destroyed during the
Second World War. The one in the photograph is only a recent
reconstruction and is in a different position from the original.

Vincent wrote to Theo, *is like enthusiasm in life*.
His own enthusiasm for life was greater than it had
ever been before, and he seized it while he could.
Such was his perception that his mind was not
merely contemplating the outward forms of the
things around him, but somehow sensing the mys-
teries of creation.

On various earlier occasions Vincent had moment-
arily enjoyed that balance of heart and mind which
enabled him to produce his highest art. He had
touched on it when he painted THE POTATO-EATERS.
But at Arles it was sure and certain, and it resulted in
a series of masterpieces.

André Malraux once said to Claude de Mars that
"Van Gogh is the sadness of painting; Renoir is the
joy of painting." But such generalizations can be
misleading. At first sight the equation of van Gogh
with sadness and Renoir with joy seems sound
enough. But it is not. When Vincent was painting
he was just as happy as Renoir. Both were inspired
by the joy of creating beauty. There are many works
of Vincent's in which the joy experienced while the
picture was being created is at least as evident as
it is in Renoir's happy canvases.

Meyer Schapiro has truly said: "If the sombre
peasant-painting in Holland pictured man after the
expulsion, doomed to a wearisome labour, the paint-
ing of Arles was a return to Eden."

But Vincent's happiness was clouded from time to
time by returning anxiety which arose from deep
within him. And this was reflected in his work.
He once painted the corner of an orchard which he
described thus: *The ground violet, in the background
a wall with straight poplars and a very blue sky. The
little pear tree has a violet trunk and white flowers, with
a big yellow butterfly on one of the clusters. To the left
in the corner, a little garden with a fence of yellow reeds,
and green bushes, and a flower bed. A little pink house.*

EVIDENCE OF THE UNCONSCIOUS

In this canvas, which is entitled PEAR-TREE IN
BLOSSOM, one is at once struck by a stump on the
right of the tree, a trunk that has been cut off some
three feet above the ground so that it is shorn of
all the branches that would carry its leaves and
blossom. There is thus a painful contrast between

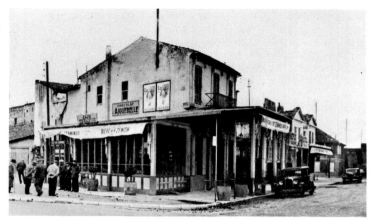

The Yellow House. Photographs A.I.v.G.—On a postcard which was sold at Arles a quarter of a century ago is printed: "This house was inhabited by the Dutch painter Vincent van Gogh in 1887-1888." The dates are wrong and should be "in 1888-1889". In the photograph on the right, the house where Vincent stayed is easily recognizable by the two triangular pediments. On the left is the beginning of the road which leads to the station and in this road lived a friend of Vincent's called Roulin, who was a post-office official, and his family. The artist painted portraits of them all.

the two trees, one of which is at the height of its fertility and beauty, while the other is mutilated and will never come into flower or leaf.

Now one branch of the tree in blossom is not reaching up towards the sun, but it stretches down towards the dry and lifeless stump beside it. In his description Vincent does not mention the little trunk on the right, though he has shown it in the pen sketch which he included in the letter. This drawing, on the other hand, does not show the hanging branch reaching out towards it.

Although Vincent was a realist in his painting, he could still express abstract ideas by the choice of subjects he saw around him. The contrast in this picture may be entirely due to chance. It could equally well be an unconscious expression of his haunting fear that he would be a failure whose work would never be appreciated.

Whatever the truth of the matter may be, there is no doubt that the more one studies this picture the more one's curiosity is aroused about the stump, which has certainly not been included in the composition only for reasons of design. It has not been painted as distinctly as the rest of the landscape, and its volume has been left in doubt. Its indistinctness inevitably makes one suspect that it has not been drawn from nature. And when one recalls that this picture was intended for Theo, it is hard to avoid the conclusion that it is a symbolic portrait of the

two brothers. Although this interpretation is entirely conjectural, it may perhaps reveal something about the psychology of artistic creation.

The radiating spots of colour, so subtly mingled and lyrically effusive, and all the masterly painting of this picture seem to be a hymn to love and friendship utterly devoid of pessimism. But the real origin is hidden, for although these paintings give us no hint of uneasiness or disillusion they are born at moments of extreme tension.

## "AN ODD THING"

Vincent had immediately found the south to be a potent source of inspiration, and was enchanted by the Provençal spring as it warmed the orchards into blossom. The world around him seemed fertile and flamboyant and he analyzed its colour as if into the spectrum of which it was composed. In his little painting of LE PONT DE LANGLOIS which is reproduced on page 225 he has left an even clearer record than in his orchards of the pleasures of pure, strong and vibrant colour.

Though almost everything about the Provençal landscape was so different from Holland with its overcast skies and level horizon, he did come upon one thing that reminded him of home; it was this little wooden lifting bridge.

226

VINCENT'S BEDROOM. Arles, 1888, pen, 13.2 × 20.5 cm. Vincent van Gogh Foundation, Amsterdam.—When he had done this drawing Vincent wrote to Theo, "I will make you sketches of the other rooms too some day", but he does not seem to have kept his promise.

VINCENT'S HOUSE. Arles, May 1888, water-colour and reed, 24.5 × 30.5 cm, F 1413. Vincent van Gogh Foundation, Amsterdam.—Vincent also depicted it in oils, 76 × 94 cm, F 464, H 489, and in ink, 13 × 20.5 cm, F 1453.

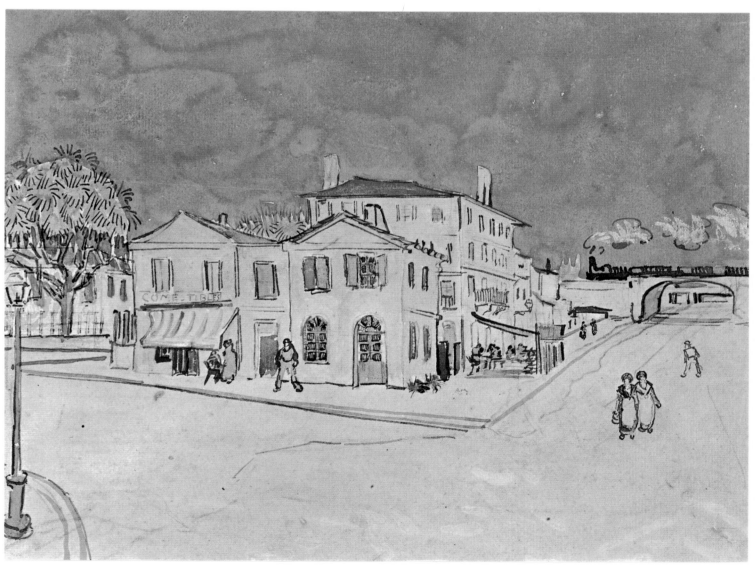

In the third decade of the nineteenth century a canal was cut from Arles to Fos, and it was crossed by no less than eleven lifting bridges, which were built by a Dutch engineer in the traditional way that Vincent knew so well. When he painted this particular one there was a bridge-keeper called Langlois, who also looked after the sluices at La Cavalerie. Hence the bridge came to be called the "Pont de Langlois"—or more often miscalled the "Pont de l'Anglais".

Vincent wrote to Theo: *As for my work, I brought back a size 15 canvas today. It is a drawbridge with a little cart going over it, outlined against a blue sky—the river blue as well, the banks orange coloured with green grass and a group of women washing linen.*

A few days later he wrote that Tersteeg should have one of his pictures for an Impressionist Exhibition: *I have been turning it over in my mind these days and I have thought of an odd thing, not like what I generally do. It is the drawbridge with the little yellow cart and the group of women washing linen, a study in which the ground is bright orange, the grass bright green and the sky and water blue.*

The orchards had increased his fondness for very light colours. Now he tried to go even further, and to conjure up a world without weight. His vision is so fresh, and his serenity so clear and childlike, that the result is immensely appealing. Rozelaar Green, the painter, once remarked to Jean de Beucken, the author of *Un Portrait de Vincent,* that: "Vincent thought Provence was very colourful. It isn't. But as he was a genius he was right." There is much truth in this witticism.

Anyone who has lived in Provence long enough to know it well can confirm that one never sees the brilliant colours there that Vincent has imagined. This is true of the three versions of «LE PONT DE LANGLOIS». Neither the stones nor the wooden structure were ever so dazzlingly fresh in colour.

## AT THE BULLFIGHT

Early in April 1888, probably on the 8th, Vincent wrote to Theo: *Yesterday I saw another bullfight, where five men played the bull with darts and cockades. One toreador crushed one of his balls jumping the barricade. He was a fair man with grey eyes,* *plenty of sang-froid; people said he'll be ill long enough. He was dressed in sky blue and gold, just like the little horseman in our Monticelli, the three figures in a wood. The arenas are a fine sight when there's sunshine and a crowd.*

He also wrote to Emile Bernard in April 1888 about a bullfight: *By the way, I have seen bullfights in the arena, or rather sham fights, seeing that the bulls were numerous but there was nobody to fight them. However, the crowd was magnificent, those great colourful multitudes piled up one above the other on two or three galleries, with the effect of sun and shade and the shadow cast by the enormous ring.*

These two letters seem to describe two different events, and Vincent implies that he saw more than one bullfight. The first included a toreador in sky-blue and gold and seems to have been a fight in which a single bull was killed after having been baited by banderillos. The second was what is called a *course aux taureaux*, a form of sport which is still popular in Provence. In this "mock-fight" several bulls are usually let loose together, and the *razeteurs*, as the young athletes are called, try to get close enough to the bulls to remove the cocades on their horns. The *razeteurs* often have to leap over the barricade and can sometimes take refuge behind small wooden shelters; they usually wear white shirts and trousers and never dress themselves up in a toreador's gaudy clothes.

Vincent does not specifically mention that he had painted or intended to do a picture of the arena, but he has nevertheless given a fairly detailed description of his painting VIEW OF THE ARENA, which was bought in Paris before the First World War by Sergei Shchukin, a rich importer who lived in the Troubetskoy Palace in Moscow, and which is now publicly owned in the U.S.S.R.

The last relic of the Yellow House. A.I.v.G.—When Vincent left Arles of his own will in order to enter the Saint-Paul-de-Mausole asylum at Saint-Rémy-de-Provence, he asked the Ginouxs, from whom he had rented the Yellow House, to take the furniture he had left. He authorized them to sell everything except the rustic armchair in which Roulin and "La Mousmé" had sat for him. The Ginouxs kept it for him, but Vincent left it behind when he went north; and when they died their niece, Madame Domergue-Ginoux, took charge of it. The unusual shape of this chair helped to give an effect of "enlargement of form" which the Fauves—so Picasso told me—thought was a daring experiment by van Gogh, when in fact he had depicted the reality exactly.

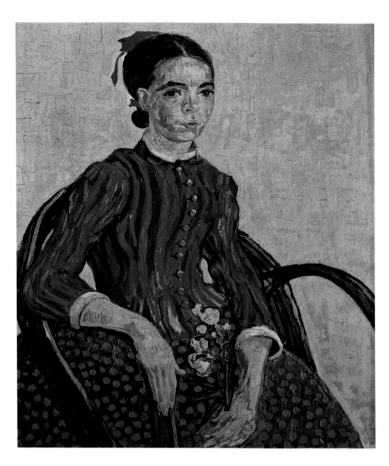

ROULIN THE POSTMAN. Arles, August 1888, oil on canvas, 79.5 × 63.5 cm, F 432, H 461. Collection of Robert Treat Paine, Boston, U.S.A. Photograph A.I.v.G.—Roulin was not in fact a postman but a postal official at Arles station. He was photographed in Marseilles in 1902.

"LA MOUSMÉ". Arles, July 1888, oil on canvas, 74 × 60 cm, F 431, H 460. Collection of Chester Dale, New York, U.S.A.—"Mousmé" is the French form of the Japanese word for "girl". In a letter to Emile Bernard, Vincent described this portrait thus: "I have just finished a portrait of a girl of twelve, brown eyes, black hair and eyebrows, grey-yellow flesh... an oleander flower in the charming little hand."

229

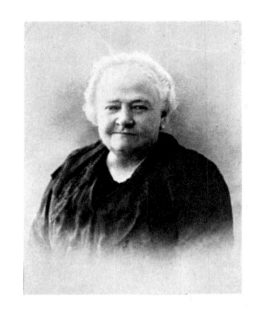

Madame Roulin (top right). "LA BERCEUSE" at the age of seventy. At top left is Marcelle, the Roulin "baby", photographed in 1955 in front of portraits of her parents. Photographs A.I.v.G.

THE BABY: MARCELLE ROULIN (left). Arles, November 1888, oil on canvas, 35.5 × 24.5 cm, F 441, H 476. Vincent van Gogh Foundation, Amsterdam. MADAME ROULIN AND HER BABY (below). Arles, 1888, oil on canvas, 63.5 × 51 cm, F 519. Collection Lehman, New York, U.S.A.

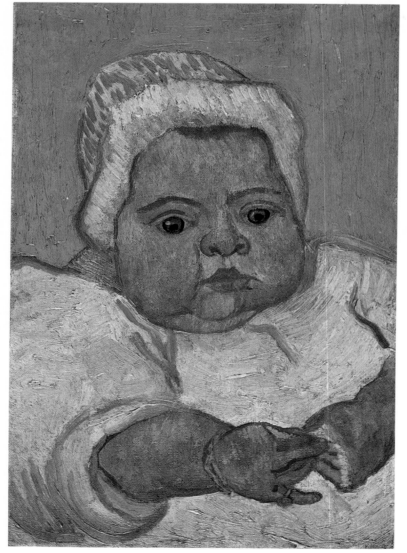

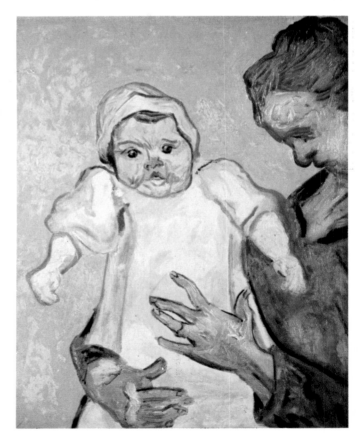

230

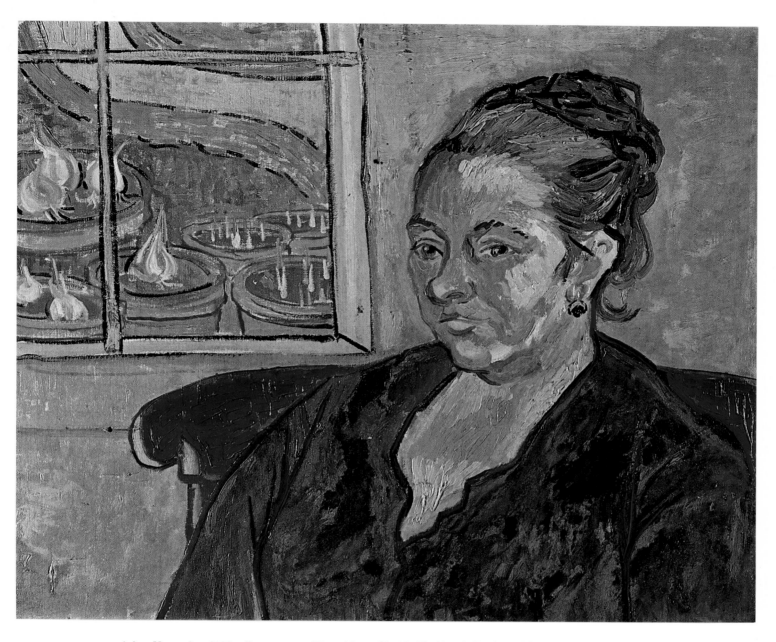

MADAME ROULIN. Arles, November 1888, oil on canvas, 55 × 65 cm, F 503, H 524. Collection of Oskar Reinhart, Winterthur, Switzerland.—In a letter to Emile Bernard, Vincent wrote: "I want to do figures, figures and more figures. I cannot resist that series of bipeds from the baby to Socrates, and from the woman with black hair and white skin to the woman with yellow hair and sunburned brick-red face."

The first thing that strikes one about this picture is the general atmosphere, the ancient Roman arena has been brought to life by the sun and the crowd. The sun has enlivened the yellow sand in the centre of the amphitheatre; two women are protecting themselves against its burning heat under a red parasol, and other sunshades can be seen among the crowd, which is packed into the seats like ants in a nest.

Vincent's letter and his picture agree so well that it seems likely that when he wrote to Theo he also sent a sketch or a study of the painting, if not the finished work itself.

At first sight VIEW OF THE ARENA seems puzzling and even out of character to anyone who has studied van Gogh's temperament and psychology. Vincent's love and compassion for animals, especially those in

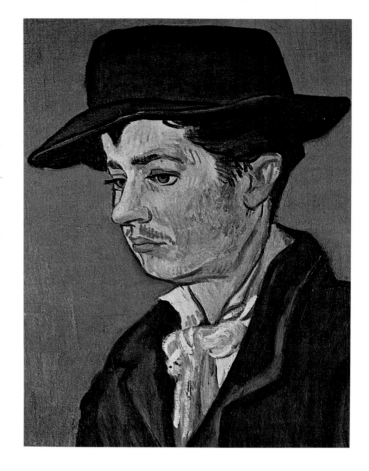

Armand Roulin. Photograph A.I.v.G.—This picture was taken thirty-three years after Vincent painted his portrait.

ARMAND ROULIN. Arles, November 1888, oil on canvas, 65 × 54 cm, F 493, H 518. Boymans-van Beuningen Museum, Rotterdam. Opposite page: oil on canvas, 55 × 66 cm, F 492, H XIII, Folkwang Museum, Essen-Ruhr, German Federal Republic.—Vincent painted Armand Roulin twice in the same period, once in profile and once full-face.

distress, was not only a facet of his youth and his periods of religious enthusiasm but a fundamental aspect of his character. For Vincent to celebrate a bullfight would seem hypocritical, yet at first sight this painting has something of a holiday air.

The bull itself, barely brushed in with a few strokes of dull grey, hardly stands out from the orange-yellow arena. It seems to have been drawn with exaggerated and deliberate vagueness, and all one can say for certain is that it is looking towards one over the packed arena full of excited spectators. The details of the fight to the death can only be guessed at, especially as Vincent has enveloped it in a cloud of dust scuffed up by the bull's hooves. It is quite clear that Vincent has deliberately decided not to emphasize this aspect of his subject, and to concentrate on the reaction of the crowd.

Although most of the crowd are waving their arms or brandishing their hats in their enthusiasm, not all the spectators are rejoicing in the carnage. One or two of them have turned their backs on it.

In composing this picture Vincent used a technical device that he had learned from the Japanese masters of the Ukiyo-ye school. In front of the sharply falling perspective of the arena he placed several large figures in the foreground, so big that they are cut off by the frame. These figures in the foreground have the effect of pushing the rest of the picture into the distance.

In the bottom left-hand corner, right in the foreground, there is a group of women who are far from joining in the general jubilation. They have turned away from the arena, and there is no doubt about the expression on their faces.

There are four of these women, all turning away, but it is the nearest one, whose head and shoulders are all that can be seen, whose face most clearly reveals her shame and disgust. This is seen not so much in her expression, but in the livid blue that he has painted her face, not because it is in the shade —there was no shade in the arena or on the other faces—but as an indication of her state of mind

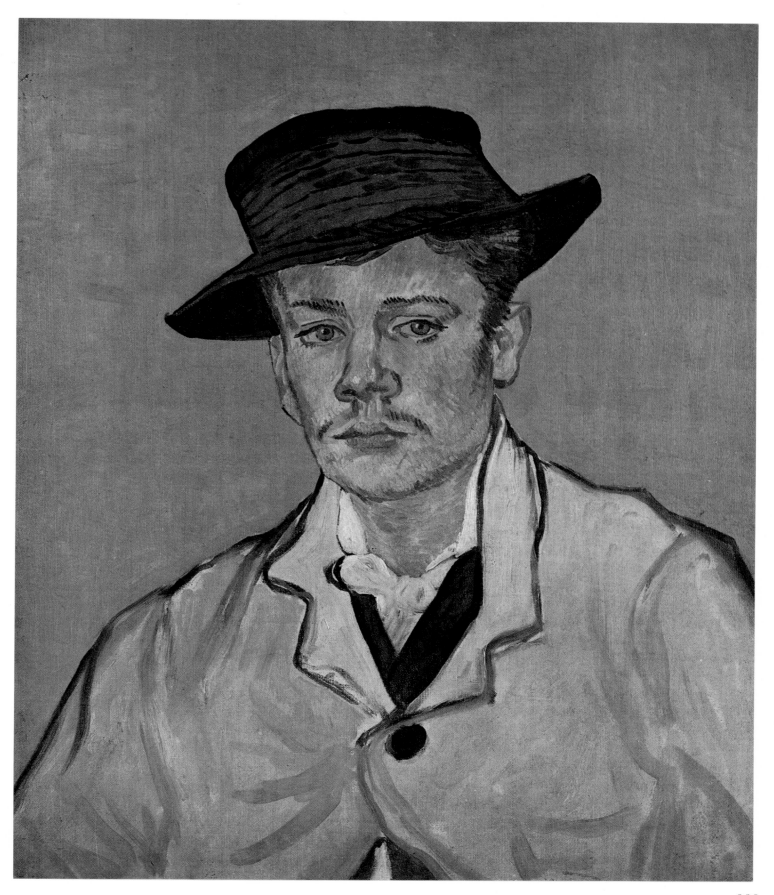

233

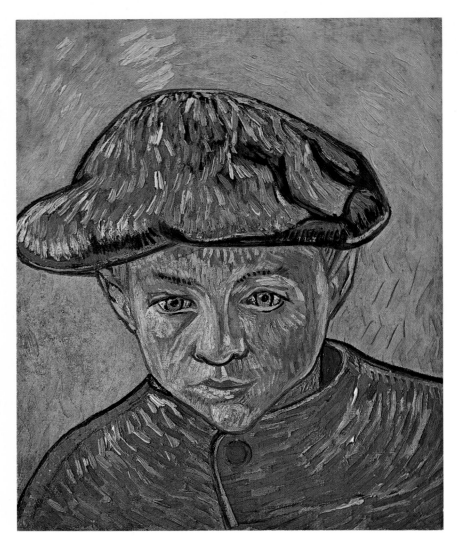

"LA MAISON DE LA CRAU" OR THE OLD MILL. Arles, September 1888, oil on canvas, 64.5 × 54 cm, F 550, H 561. Albright Knox Art Gallery, Buffalo, U.S.A. Photograph A.I.v.G.—The old mill, once known as Jonquet tower—some old people in Arles still know it only by this name—has since been much altered.

CAMILLE ROULIN. Arles, November 1888, oil on canvas, 37.5 × 32.5 cm, F 538, H 543. Vincent van Gogh Foundation, Amsterdam. — Another of the postman's sons.

and of one aspect of his own. The purely visual aspect of the occasion attracted him: the vast arena, the gaily dressed crowd in the bright sun, the toreador in his sky-blue clothes. But his feelings about the the inherent cruelty are shown in the woman's face.

IMPRESSIONS OF THE CAMARGUE

In the middle of June 1888 Vincent spent a week at Saintes-Maries-de-la-Mer, a fishing-village twenty-four miles south of Arles. He travelled there in a coach, crossing the Camargue, *with its vineyards, marshes and flat fields like Holland.* He was surprised to see how the light affected the colour of the sea. *The Mediterranean,* he declared, *has the colours of mackerel, changeable I mean. You don't always know if it is green or violet, you can't even say it's blue, because the next moment the changing light has taken on a tinge of pink or grey.*

He was also surprised to find himself thinking of his sailor uncle *who must have seen the shores of this sea many a time.* He watched the sea being whipped up by the Mistral and breaking on the flat sandy shore. He admired the picturesque cottages in which the cowherds lived who tended the small Camargue cattle and he painted an exotic picture of them and drew them in reed and Indian ink.

But it was the little wooden fishing-boats that enchanted him most of all: *On the perfectly flat, sandy beach little green, red, blue boats, so pretty in shape and colour that they made one think of flowers.*

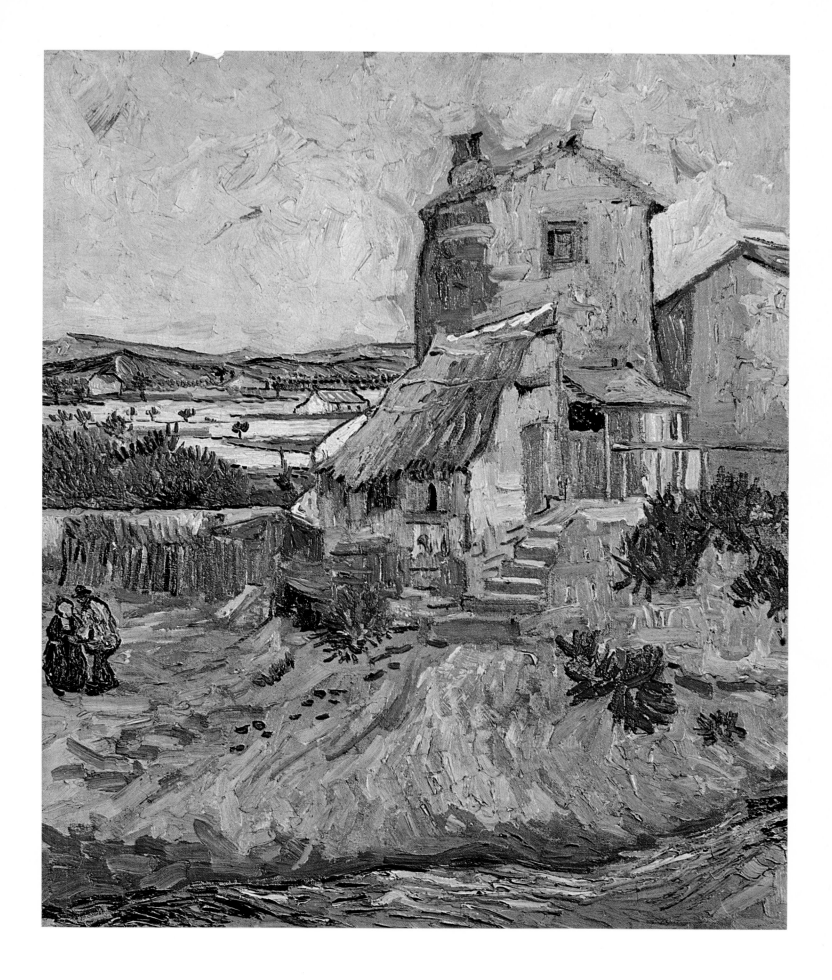

*A single man is their whole crew, for these boats hardly venture on the high seas. They are off when there is no wind, and make for the shore when there is too much of it.*

As he had done with "LE PONT DE LANGLOIS", Vincent transformed these little boats into things of magical brilliance.

Every day he rose early and watched the fishing-boats putting out to sea. He was pleased with his drawing of them, and wrote to Theo: *I have only been here a few months, but tell me this—could I, in Paris, have done the drawing of the boats in an hour? Even without the perspective frame, I do it now without measuring, just by letting my pen go.*

The speed with which he worked is irrelevant. It is the result that counts. And in this case the result is one of his most attractive masterpieces. Vincent, by some magic of eye and mind, has transformed the fairly commonplace objects before him into an enchanting lie which he has made as convincing as truth.

My old friend Paul van Ostaijen, the Flemish expressionist poet, said that the art of the poet was: "To look at the world with the wonder of a child who sees the things around him for the first time." This is what Vincent did.

Van Gogh's pictures of Saintes-Maries-de-la-Mer show very convincingly how much his style had been influenced by the popular Japanese artists such as Hokusai. Moreover he had at last satisfied an old ambition, he had created a body of work of his own, in his own style, of which he could be really proud.

From now on his paintings were really drawings done with a brush and oils, while his drawings were pictures drawn with black chalk or with a reed pen and Indian ink, as in COWHERDS' COTTAGES shown on page 240. Now that he was aware of his powers, he was encouraged to produce more and more.

## A HOME TO HIMSELF

Vincent was not happy with his first lodging in Arles. It was not as cheap as he had hoped, and he did not like to see a large part of his monthly allowance disappearing in rent, when he needed to buy quantities of paint and canvas. By the end of April he felt he really must move. *The people here*, he wrote to Theo, *are trying to take advantage of me so as to make me pay high for everything, on the pretext that I take up a little more room with my pictures than their other clients, who are not painters.*

It was extraordinary how much he had already managed to get done without a proper studio. He spent some time looking for somewhere suitable, and eventually he found it. On May 1 he sent Theo *a roll of small pen-and-ink drawings* among which there was a hasty sketch on yellow paper of a patch of grass in the square with a building behind it. *Well*, he wrote, *today I've taken the right wing of this complex, which contains four rooms, or rather two with two cabinets. It is painted yellow outside, whitewashed inside, on the sunny side. I have taken it for 15 fr. a month. Now my idea would be to furnish one room, the one on the first floor, so as to be able to sleep there. This house will remain the studio and the storehouse for the whole campaign, as long as it lasts in the south.*

There was only one inconvenience: the privy was next door in a hotel belonging to the same proprietor. Vincent did not complain, since as a rule in southern towns *these offices are few and dirty, and*

THE RHÔNE BY DAY. Arles, summer 1888, reed and Indian ink, 25.5 × 34.5 cm, F 1472. Neue Staatsgalerie, Munich, German Federal Republic. Photograph A.I.v.G.—Left: a photograph taken from the point where Vincent did his drawing. In the background: Trinquetaille bridge; on the right can be seen the quay where Vincent drew and painted pictures of the sand-boats (see page 251).

THE STARRY NIGHT. Arles, September 1888, oil on canvas, 72.5 × 92 cm, F 474, H 500. Moch collection, Paris. Photograph A.I.v.G.—Left: the Rhône at night, photographed from the where Vincent painted THE STARRY NIGHT. In the background is Trinquetaille bridge.

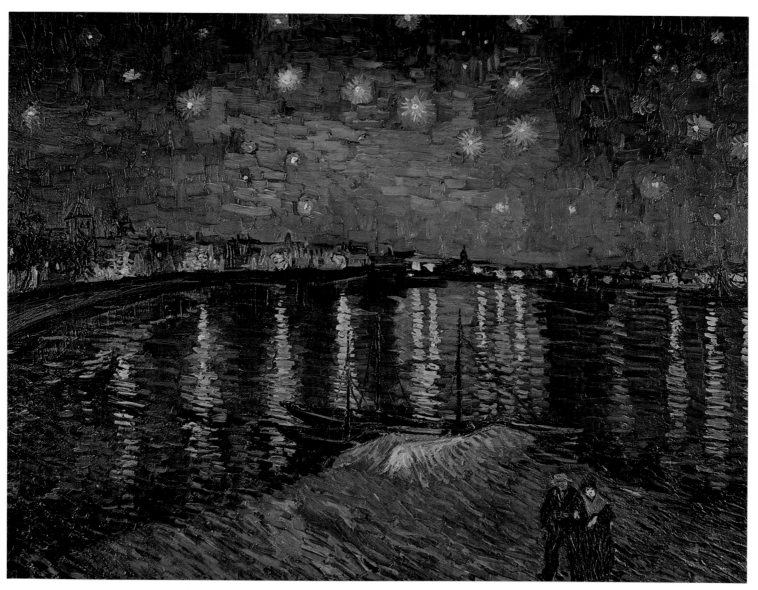

one cannot help thinking of them as nests of microbes. He called his new home "The Yellow House" from the colour that it was painted outside. And yellow for him was the colour of friendship. Now that he had a home of his own he began to think of indulging his friendship, rather than saving his expenses, and having his artist friends to stay with him so that he could begin the sort of colony that he had spoken of to Toulouse-Lautrec.

He had already written to Theo on March 10 about a complex scheme for a picture-selling cooperative. But it came to nothing.

If he could not have a cooperative or a colony he might at least have companionship, and he began to furnish "The Yellow House" for a visitor. He described how he did so in his letters, but we can also see what it was like from his pictures, in particular the one of his bedroom with the wooden bed, washstand and two chairs. It has long been one of his best known and most popular works.

While he was getting ready for visitors, Vincent tried to make up for their absence by filling his rooms with objects that would remind him of his friends. Thus he wrote to Theo: *And after this I*

can venture to tell you that I mean to invite Bernard and others to send me pictures, to show them here if there is an opportunity.

When he had finished "The Yellow House" he also hung on his bedroom wall portraits of Eugène Boch, the Belgian poet and painter, and of Second Lieutenant Milliet of the Zouaves; and in exchange for his own paintings he obtained self-portraits by Bernard, Charles Laval and Gauguin.

While all these domestic preparations were going on, Vincent took his meals at the Café de la Gare run by M. Ginoux and his wife, and slept at the Café de l'Alcazar, where he was later to paint his famous picture THE NIGHT-CAFÉ. He did not finally move into "The Yellow House" until September 18.

### A NEW PUPIL

In the second half of June, Vincent wrote to Bernard, who was about to leave to do his compulsory military service: *I am acquainted with a second lieutenant of the Zouaves here, called Milliet. I give him drawing lessons—with my perspective frame—and*

ROAD NEAR ARLES. Arles, July 1888, crayon, reed and sepia, 24.6 × 23.9 cm. Albertina, Bienna.—In the background the ruins of the Abbey of Montmajour can be seen.

A VIEW OF ARLES. Arles, April 1888, oil on canvas, 72 × 92 cm, F 516, H 534. Neue Staatsgalerie, Munich.—The tree-trunks, drawn like vertical bars right across the picture, divide the composition in the same way as on "LES ALYSCAMPS" (see page 252). This unexpected effect, which had not been seen before in Vincent's work, is probably due to the influence of Japanese colour prints.

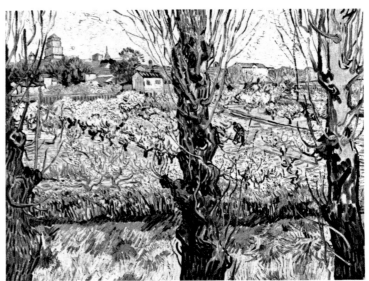

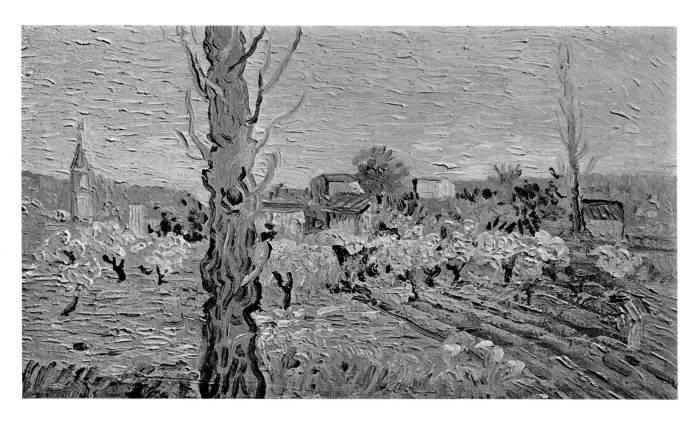

COUNTRYSIDE AROUND ARLES. Arles 1888, study in oil, 10.5 × 17.5 cm. Collection of George Renand, Paris.—Vincent painted this view of Arles from almost the same spot from which he did the picture on the preceding page. The two canvases have a marked affinity of style, notably in the execution of the trees in the foreground.

*he is beginning to make drawings; by God, I've seen worse! He is zealously intent upon learning . . . If you were in the Zouaves he would take you under his wing, and would guarantee you a relatively large margin of free time for painting, at any rate if you were willing to help him with his artistic blunderings.*

When Milliet went north on leave he took a consignment of Vincent's pictures to Theo. And in September Vincent wrote: *Milliet today was pleased with what I had done—the* PLOUGHED FIELD; *generally he does not like what I do, but because the colour of the lumps of earth is as soft as a pair of sabots, it did not offend him, with the forget-me-not blue sky flecked with white clouds. If he posed better, he would give me great pleasure, and he would have a more distinctive portrait than I can manage now, though the subject is good—the mat pale tints of his face, the red soldier's cap against an emerald background.*

Paul-Eugène Milliet was the son of a military policeman. He was brought up in barracks as a soldier and became an officer, earning his promotion on the battlefields of Tonking. Vincent thought him handsome and attractive, and told Theo that Milliet could have as many women as he liked.

Milliet's subsequent career took him to Tunisia, Algeria and Morocco, and through the First World War. After the war was over he retired with the rank of lieutenant-colonel and with the decoration of Commander of the Légion d'Honneur. He died in Paris during the German occupation.

His face as a young man, with its military moustache and little pointed beard is now very familiar because of Vincent's excellent portrait of him. Milliet has the Tonking medal pinned on his chest and wears his cap at a rakish angle, as was the fashion in the colonial armies. In the upper right-hand corner of the canvas Vincent painted the emblem of the French troops in Africa.

Several years before the Second World War Pierre Weiller happened to meet Vincent's old friend and

239

pupil and learnt something about him. Besides commanding Zouaves and riflemen Milliet drew in his spare time with pencil, pen or charcoal. In his conversations with Weiller he insisted that drawing was a basic necessity for an artist, and he would say: "An artist who does not draw is no artist." Milliet gave a frank description of the painter.

"He was an odd fellow," he said. "His face was a bit sunburnt, as if he had been serving up-country in Africa. But of course he hadn't; he had none of the makings of a soldier, not one. An artist? Of course he was an artist, he drew very well indeed. He was a charming companion when he wanted to be—which didn't happen every day. We often went on good walks around Arles, and in the country we would make no end of sketches. Sometimes he would set up his canvas and start daubing away. After that there was no budging him. The fellow had talent in his drawing, but he became quite different when he picked up his brushes. As soon as he started painting I would leave him alone, otherwise I should either have to refuse to tell him what I thought, or we would start arguing. He hadn't got an easy nature, and when he lost his temper you'd think he'd gone mad."

Pierre Weiller asked Milliet what it was that he didn't like about Vincent's painting, and the soldier answered: "It was that his pictures weren't drawn. He painted too big, he didn't pay any attention to details, he didn't draw, you know. All the same, when he wanted to, he knew how to draw all right. He tried to use colours instead of drawing—which is nonsense if you ask me, for colour complements drawing, it doesn't take its place. Drawing must support colour. And then his colours . . . they were quite extreme, out of the ordinary, impossible. The tones were too warm, too violent, with no moderation. An artist should paint a picture with love, not with passion. A canvas should be 'stroked'. Vincent attacked it. Sometimes he was a real savage."

Weiller asked if Vincent were bad-tempered, and Milliet replied: "Yes and no. Pleasant enough on the whole, but too apt to be changeable. Very nervous. Furious when I criticized his pictures. But that didn't last, and we always made it up in the end. He was exceptionally sensitive. Reacted like a woman sometimes. Aware that he was a great artist. He had faith in his talent, rather a blind faith. And pride. His health didn't seem very strong. He complained of his stomach. But on the whole he was a good friend and not a bad fellow."

## A CONFIRMATION OF HIS QUALITIES

Milliet's account is valuable in its honesty, and it confirms other views of Vincent's character. Vincent liked the soldier as a man as well as being interested

COWHERDS' COTTAGES AT SAINTES-MARIES-DE-LA-MER. Arles, June 1888, reed and Indian ink, 30 × 47 cm, F 1438. Vincent van Gogh Foundation, Amsterdam. Photograph A.I.v.G.—I found a photograph at Saintes-Maries of the cottages in Vincent's day, and seen from the same spot.

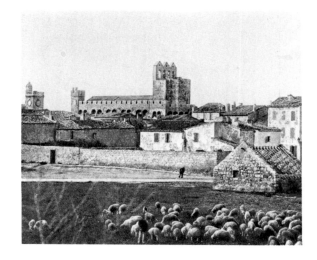

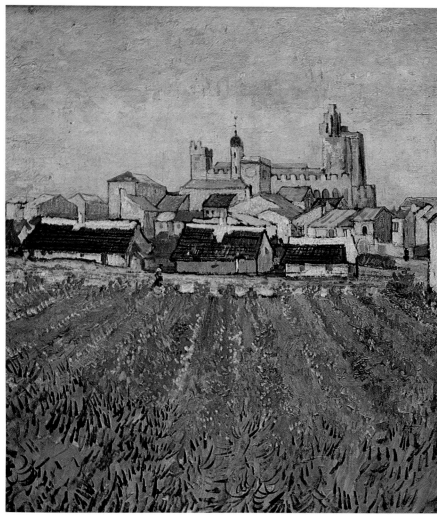

VIEW OF SAINTES-MARIES-DE-LA-MER. Arles, June 1888, oil on canvas, 64 × 53 cm, F 416, H 456. Kröller-Müller State Museum, Otterlo. Postcard A.I.v.G.—In his letters the painter wrote: "The chief building, after the old church and the ancient fortress, is the barracks. And the houses—like the ones on our heaths and peat bogs in Drenthe..." On a picture-postcard of the period one can not only see the church, and the clock-tower to the left of it, but also some cowherds' cottages on the right, like the ones Vincent drew.

in him as a type, though he was not an ideal sitter. Vincent wrote to Theo: *I am also working on a portrait of Milliet, but he poses badly, or I may be at fault myself, which however, I do not believe, as I am sorely in want of some studies of him, for he is a good-looking boy, very unconcerned and easygoing in his behaviour, and he would suit me damned well for the picture of a lover ... I only know one serious fault in his character, which is that he likes "L'Abbé Constantin" by Georges Ohnet, and I have told him that he had a thousand times better read "Bel Ami" by Guy de Maupassant.*

Vincent did not mind Milliet's criticism, because he felt the soldier was only an amateur who did not know any better. He was not hurt as he had been by Mauve or Siberdt. This friendship with Milliet was only one of many which show that Vincent was not necessarily impossible to remain on good terms with.

Milliet's picture was painted in September 1888, and was not the first of the series of Arles portraits. The sequence ran as follows: THE ZOUAVE BUGLER in June; "LA MOUSMÉ" (page 229) in July; A YOUNG GIRL, ROULIN THE POSTMAN (page 229) and PATIENCE ESCALIER in August; EUGÈNE BOCH (page 249) and LIEUTENANT MILLIET in September; THE ARTIST'S MOTHER (page 271) after a photograph in October; "L'ARLÉSIENNE" (page 264), ARMAND ROULIN (pages 232-3), and CAMILLE ROULIN (page 234) and MADAME ROULIN (page 231) in November; THE ACTOR (not to be confused with the copy of Kesai Yesen's print, sometimes given this title) in December; DOCTOR REY (page 267) in January.

241

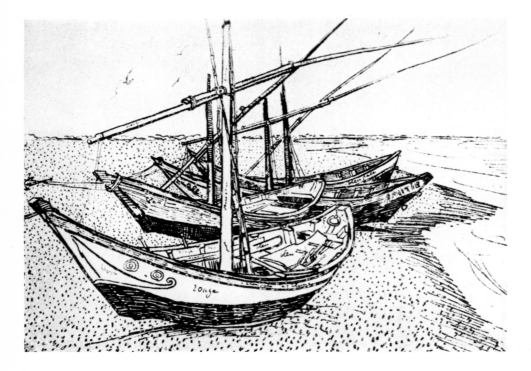

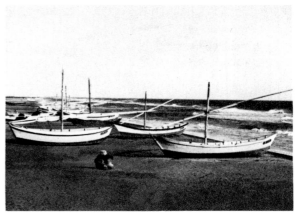

BOATS ON THE BEACH. Arles, June 1888, reed and Indian ink, 39.5 × 53.5 cm, F 1438. Private collection, Germany. Photograph R. Descharnes—The third of the four boats drawn upon the sand is called *Amitié*. On the different parts of the boats Vincent has noted the colours to appear in the painting, which is now in the Vincent van Gogh Foundation (F 413, H 451).

## THE PORTRAITIST OF THE COMMON PEOPLE

Except for Eugène Boch and Doctor Rey, Vincent's sitters at Arles were, as usual, ordinary, even humble, people. This meant that he could not spend a long time over his portraits even if he wished to do so. But now he had learned to paint so fast that he was able to produce excellent likenesses and penetrating studies without haste or fuss.

Vincent never painted Gauguin's portrait. One reason for this was that he was never able to penetrate the armour behind which Gauguin hid his real and complex nature. But with these candid and humble sitters he attained that deceptively simple technique which helps to make the portraits so striking. This aspect of Vincent's portraiture is so evident that he might be considered the originator of the subsequent school of so-called "naïve" painting. There had been a foretaste of it in his portrait of Père Tanguy, and ROULIN THE POSTMAN is a masterpiece of this kind.

Vincent had never cared much for what is called "fine painting". He worked straight on to the canvas with great vitality, without neglecting either the emotional or the rational elements in his painting and keeping them perfectly balanced.

In seeking his personal conception which was based upon intuition, he upset all the theoretical principles of portraiture which had gone before. He was thus an unwitting prophet, for he was to inspire thousands of painters who came later. Maurice de Vlaminck very justly wrote: "In reality the most commonplace theme can provide the artist with the materials for a very great subject, if he knows how to make it live intensely, if he knows how to make it interpret his emotion. This is the whole mystery of art. The simple portrait of a postman by Vincent van Gogh, which is of such great and vital interest, is a sure manifestation of genius."

Jean Cocteau once said: "Molière did not want to write masterpieces. That is why he wrote them." This paradox also applies to Vincent's portraits.

The most striking example of this is his portrait of "LA BERCEUSE", of which he wrote: *I have just said to Gauguin about this picture that when he and I were talking about the fishermen of Iceland and of their mournful isolation, exposed to all dangers, alone on the sad sea . . . the idea came to me to paint a picture in such a way that sailors, who are at once children and martyrs, seeing it in the cabin of their Icelandic fishing-boat, would feel the old sense of being rocked come over them and remember their own lullabies.*

"One might say that every one of us writers", wrote François Mauriac, "has come into the world with the mission of expressing a certain truth and devoting his life to doing so." But writers are not the only ones who have been charged with this mission. All artists share it, and none more so than painters. "LA BERCEUSE" has spread "a certain truth" of Vincent's all over the world.

As Milliet remarked, Vincent was nevertheless aware that he was working for posterity. And when he had finished his portrait of Madame Ginoux, he said: *Madame Ginoux, one day your portrait will hang in the Louvre.* This portrait happens not to be in the Louvre, but there are versions of it in the Van Gogh State Museum in Amsterdam, in the Kröller-Müller State Museum at Otterlo and in Sam A. Lewisohn's collection in New York.

The psychology of this attitude, in which both doubt and certainty about the future are compounded, is not difficult to understand. Man unconsciously sees love as a means of survival. But the bachelor artist like Vincent can survive only in his work. Without this hope, which he expressed in his letters, he would have put an end to his life even earlier than he eventually did.

## BIRTH OF AN INCOMPARABLE DRAUGHTSMAN

Vincent explored all the neighbourhood around Arles, and among his favourite haunts was the Abbey of Montmajour.

The Abbey was a splendid pile of ruins, dominated by an 85-foot tower, and built on an outcrop of rock rising out of the marshy plain. The limestone plateaux on which Arles stands, and out of which Montmajour and the Montagne de Cordes rise, were once islands surrounded by the swirling estuaries of the Rhône and the Durance. From Montmajour Vincent could enjoy a magnificent view over the vast plain of the Crau.

From the rocks of Montmajour Vincent must have had an experience of nature—no new sensation for him—similar to that of those earlier visionary realists Rembrandt and Hercules Seghers. It was moreover the technique of drawing with a reed-pen employed by these painters that he was now to adopt. With this new tool Vincent became an extraordi-

narily skilful and expressive draughtsman. The small dots and the strong lines drawn on the paper with a cut reed and Indian ink constitute an admirable and original calligraphy. They seem to express not only his subject but also his joy at having complete mastery over his medium.

Never before had Vincent achieved such purity of expression; indeed one would have to look back a long way to find comparable work. With Seghers the similarity was more apparent than real, since in his case there is a marked difference between his method of painting and his type of drawing, whereas this is not so at all with Vincent. No European artist before Vincent had used this technique so successfully. Hokusai had done so, but his skill was acquired only with great pains.

THE PAINTER ON THE ROAD TO TARASCON. Arles, August 1888, oil on canvas, 48 × 44 cm, F 448, H 474.—Before the Second World War this picture was at the Kaiser Friedrich Museum at Magdeburg, but during the brutal destruction of war it was burnt. In Autumn 1888, Vincent sent Theo thirty-six pictures, among them, as he said "a rough sketch I made of myself laden with boxes, props, and canvas on the sunny road to Tarascon".

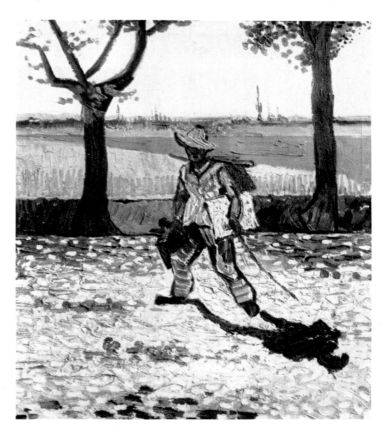

Enlarged detail (× 3.5 linear) of HARVESTING WHEAT ON THE ALPILLES PLAIN. A.I.v.G.—Nowhere is Vincent's virtuosity in handling paint greater or his touch more precise, as can be seen in this detail of the masterpiece reproduced on the opposite page.

One can see from the letters that Vincent wrote to Theo and Bernard at this time that he drew as easily as he wrote. Even in the most hasty and trivial scribbles with the crudest of means there are signs of quite exceptional talent, if not of genius.

His drawing of WASHERWOMEN ON THE CANAL ("LA ROUBINE DU ROY") marks the achievement of a masterly draughtsmanship, which was to flourish in THE ROCK and the views of Montmajour. His virtuosity is at once apparent even in such hasty sketches as the splendid views that he sent Paul Signac after Signac had paid Vincent a visit in the sanitorium at Arles.

## THE SUN ON THE PLAIN

Vincent's painting and drawing evolved on parallel lines. One painting is very instructive in this respect. It is THE HARVEST, which Vincent described as: *wide landscape with the ruin in the background and the Alpilles range.*

This was painted from the opposite side of the Crau from the ruins of Montmajour, which can be seen with their tower on the top left-hand corner of the picture. Many years ago I sought out the point where Vincent set up his easel. This entailed half an hour's stiff climb up the hillside, and it cannot have been easy for him to find so perfect a viewpoint; for he had chosen the best possible angle from which to look down on the plain. The genius of this painter did not consist only in interpreting what he saw, but also in carefully choosing the sights that he would see.

*I think it has a little too much style* was Vincent's modest comment on THE HARVEST, but in fact he has succeeded admirably in conveying a strong and disturbing emotion. The vast foreground and the thin low sky create an extraordinary effect of distance in this dazzling rendering of the Provençal plain. Every one of the thousands of little brushstrokes is exactly right. To add one more would destroy the harmony of the picture.

Vincent underwent two emotional experiences that marked him for the rest of his life. In the mine in the Borinage he discovered that mysterious lighting that he had already seen in Rembrandt's pictures; and he created his own version of it in THE POTATO-EATERS. In Provence he saw the sunlight fall in incandescent fragments on the level plains of the Crau. And like Prometheus he stole this divine fire to light his picture.

## BY CANDLE-LIGHT

One evening in September, as Vincent was walking through the centre of Arles, he was suddenly struck by a café where the tables and chairs on the terrace outside were lit by a gas-jet, and he determined to paint a picture of it.

Now that he had seen the effect of the Provençal light on the town and the country landscapes, under

244

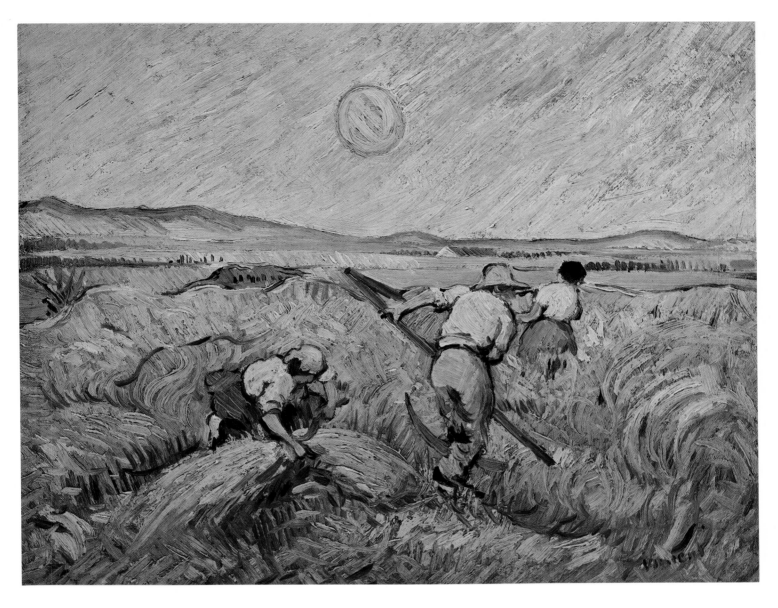

HARVESTING WHEAT IN THE ALPILLES PLAIN. Arles, June 1888, oil on canvas, 30 × 40 cm. Private collection, Los Angeles, U.S.A.—In 1968 I had the good fortune to discover this masterpiece by van Gogh. The three figures in action in the foreground are exceptional in his work.

the starry night sky as well as the sun, he believed that he could apply to these subjects the violent contrasts of colour found in the Japanese engravings and produce something of far greater beauty because oil paint was so much richer and more subtle than the flat colours in the prints. He wanted to accentuate the contrast between the dark blue and the light yellow on the engravings in painting the velvety night sky and the twinkling stars above the golden light outside the café in the place du Forum.

But how was he to see the subtle shades of colour on his palette and his canvas in the dark? His picture had to be painted from life if it were to succeed. Late one evening a strange figure could be seen making his way along the narrow, winding, ill-lit streets. He had a bundle of gear under his arm and a wooden box slung on his back. On his head he wore a capacious hat on to whose broad brim were fixed a number of candles. When he reached the place du Forum, he set up his easel in front of the

THE RUINS OF MONTMAJOUR. Arles, May 1888, reed and Indian ink, 46 × 29 cm, F 1423; and 31 × 47.5 cm, F 1417. Vincent van Gogh Foundation, Amsterdam. Photographs A.I.v.G.—The resemblance between the photographs and the drawings is striking. Although these are rapid sketches drawn with a reed, in the manner of the Japanese masters, the accuracy of line is remarkable.

VIEW OF THE PLAIN FROM MONTMAJOUR. Arles, May-June 1888, pen, rush and black crayon, 28 × 47 cm, F 1419. Folkwang Museum, Essen-Ruhr, German Federal Republic. Photograph A.I.v.G.—This picture might equally well be called "Montagne de Corde", since it is this mountain which dominates the plain, and is seen by the artist and the photographer from the ruin of Montmajour; the rocks beside the ruin are seen in the foreground.

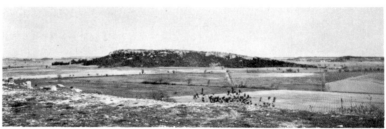

THE ROCK. Arles, July 1888, rush, Indian ink and touches of pencil, 49 × 61 cm, F 1447. Vincent van Gogh Foundation, Amsterdam. Photograph A.I.v.G.—Since Vincent drew this landscape it has hardly changed; only the trees have grown.

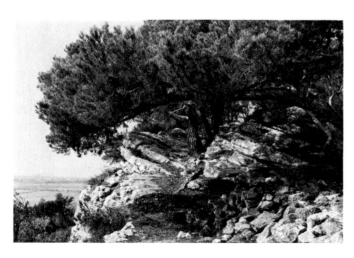

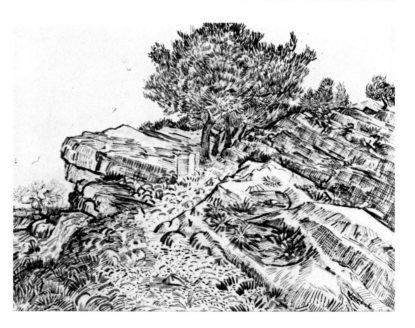

café and put a blank canvas on it. The canvas was also decorated with candles above and beside it. He then lit the candles and started to paint. The next day the whole of Arles had heard of this crazy sight and had concluded that the painter was mad. They did not guess that this "madman" had just painted a masterpiece.

Vincent was so enthusiastic about the results of this experiment that he thought of another subject that he could tackle with the aid of his birthday-cake hat. One evening as he was walking along the bank of the Rhône he had been even more struck than usual by the splendour of the blue starry sky.

The idea of painting the night sky as a vast bowl of stars over a wide mirror of water was not a new one. Two months earlier, at Saintes-Maries-de-la-Mer, Vincent had walked at night on the empty beach beside the sea. He sent Theo a description of what he had seen: *It was not gay, but neither was it sad—it was—beautiful. The deep blue sky was flecked with clouds of a blue deeper than the fundamental blue of intense cobalt, and others of a clearer blue, like the blue*

## Translation of letter from Vincent to Eugène Boch

*My dear friend Boch, Many thanks for your letter which pleased me very much. I congratulate you on not having hesitated this time and on having attacked the Borinage. There you have a field where you will be able to work all your life [illegible]—the extraordinary scenery [as well] as the figure.*

*The tip girls in their pit rags especially are superb. If you should ever go to Petit Wasmes, please inquire whether Jean-Baptiste Denis, farmer, and Joseph Quinet, miner, are still living there, and tell them from me that I have never forgotten the Borinage and that I should still be delighted to see it again.*

*Now I must tell you a piece of news, namely that I have furnished the house at last and that I have immediately furnished a bedroom for Gauguin or for anyone who should come.*

*The house is a lot brighter now that it is furnished. After that I have worked like blazes, for the autumn is without wind and superb. I am also working on seven square size 30 canvases. In the first place the night café where I stayed with lamp light effect, painted in the night-time.*

*Three views of the public garden in front of the house.*

*This is one of these views. A cypress or cedar shrub in a bottle-green tub on a citron hued green lawn. In the background a row of oleanders and two statuettes. The sky a raw cobalt blue. You see, it is even a lot simpler than formerly.*

*Then ploughed fields; a scenery with nothing but lumps of earth, the furrows the colour of an old wooden shoe under a forget-me-not blue sky with white cloud flocks.*

*Further a view of my house and its surroundings in a sulphur sun. The sky a hard and bright cobalt. —A difficult job, I tell you!*

*Then a view of the café on Forum Square where we used to go, painted by night.*

*And lastly a study of the Rhône—of the town lighted with gas reflected in the blue river.*

*Over it the starry sky with the Great Bear—a sparkling of pink and green on the cobalt blue field of the night sky, whereas the lights of the town and its ruthless reflections are red gold and bronzed green.*

*The garden with the oleanders and the shrub in a tub has an impasto like painted porcelain.*

*Your portrait is in my bedroom along with that of Milliet, the Zouave, which I have just finished. I should like to ask you to exchange one of your studies of the coal-mines for something of mine,—but stop !—I myself am going to send you a study first, when I am sure it is one which will seem wholly unknown to you. For if you saw the night studies you might like them better than the sunlight studies. Well, leave it to me. For I hope that our intercourse once started will last forever.*

*Everything you'll do will interest me extraordinarily, because I love that dismal country of the Borinage, which will always remain unforgettable to me, so much.*

*I have nearly made up my mind, when I go to Paris next year, to push on as far as Mons. And perhaps even as far as my native country to do some spots that I know already. In the same way in the Borinage Marcusse, or from Antoine to Petit Wasmes. And further the Cour de l'Agrappe in Frameries where you are now. As a matter of fact it was in the Borinage that I first started to work from nature. But of course I destroyed it all a long time ago.*

*But it stirs my heart that these spots are going to be painted at last.*

*You will see how easily ideas will come to you.*

*I am writing you in a great hurry, but I wanted to answer your letter at once.*

*Enclosed a pretty bad sketch of the starry night. All these pictures are square size 30 canvases. If you had stayed here until now, you would have taken along other studies! For I tell you the scenery has been extraordinarily beautiful.*

*More than once I have done a size 30 canvas in one day, but then I did not stir from the spot from morning till sunset except to eat a morsel. My brother wrote me he saw you in passing. Well, I hope we'll meet again next year. Above all don't forget to let me have your address when you move, or to give me your exact permanent address in La Louviere, if my memory serves me well, for it will be excellent to work continuously in the mining district, and also to see something quite different come to the country of the oleanders and the sulphur sun.*

*Is your sister going to do the miners too? Surely there is work enough for two. I think it is a very pleasant thing for you to be both painting in the same house.*

*Well, I must go out to work in the vineyard near Montmajour. It is all purple and yellow-green under the blue sky, a beautiful colour motif.*

*A hearty handshake and good courage and a lot of success with your work.*

*Sincerely Vincent.*

*Excuse my great hurry; I haven't even time to read this letter over.*

THE BELGIAN PAINTER EUGÈNE BOCH. Arles, September 1888, oil on canvas, 60 × 45 cm, F 462, H 490. Jeu de Paume, Louvre, Paris.—It is interesting to compare Vincent's canvas (right) with the photograph of the same model taken at the same period, as well as with Émile Bernard's portrait of him. Vincent's painting is a striking likeness, despite its imaginative and technical liberties. One can also see that Vincent was justified in thinking Bernard had talent.

Facsimile of a letter from Vincent to Eugène Boch, written from "the Yellow House" a few weeks after Boch had left Provence for the Borinage.

*whiteness of the Milky Way. In the blue depth the stars were sparkling, greenish, yellow, white, pink, more brilliant, more sparkling gemlike than at home— even in Paris: opals you might call them, emeralds, lapis lazuli, rubies, sapphires. The sea was very deep ultramarine—the shore a sort of violet and faint russet as I saw it, and on the dunes (they are about seventeen feet high) some bushes Prussian blue.* This is a clear anticipation of the Arles STARRY NIGHT.

## REPEATING THE EXPERIMENT

Vincent described another night sky to Theo. This time it was over Arles: *The sky is greenish-blue, the water royal blue, the ground mauve. The town is blue and violet, the gas is yellow and the reflections are russet-gold down to greenish-bronze. On the blue-green expanse of sky the Great Bear sparkles green and pink, its discreet pallor contrasts with the harsh gold of the gas. Two colourful little figures of lovers in the foreground.*

One night in September he crossed the place Lamartine and set up his easel under a street lamp to paint what he called *the starry sky actually painted at night under a gas jet.* This has sometimes been taken to mean that he had no other illumination, and that the charming story of the candles on the hat-brim is no more than a myth.

In point of fact the street lamps, both at the café and on the banks of the Rhône, would light the subject that Vincent was painting, but they would not light his canvas and palette. In the place du Forum he was some distance from the light, so that it would be very weak, even if the canvas did not throw its own shadow on to the surface to be painted. Vincent's illuminated hat would have been an efficient, if bizarre, necessity.

I investigated the lamp by the Rhône some forty years ago, before it was replaced by electricity. It was fairly high, and threw enough light on to the left bank of the river to prevent passers-by from falling into the water. But there was nothing like enough light for one to distinguish or to mix colours.

249

Vincent left many belongings including the hat with Madame Ginoux, and long after he died her niece and other Arles children used to play with it, without realizing the purpose that it had once served.

## FROM OBJECTIVITY TO SUBJECTIVITY

It is impossible to analyze or even to mention every picture that Vincent painted during this extremely creative period of his life, but there are one or two which cannot be omitted, in particular the SAND-BOAT UNLOADING. In this picture Vincent has carried his predilection for light colours to an extreme and has ended by squeezing his oil-paint directly on to the canvas.

This did not detract from the majesty of his vision and sense of form, for he had an unfailing sense of the correct balance between the tones. With every brush-stroke that he applied to the canvas Vincent expressed his emotional involvement with his subject, yet they all combined into a harmonious and brilliant whole. His mastery of line and colour was such that it is hard to remember how hesitant his work had once been.

Each stroke of his brush was simultaneously drawing and painting his subject, and his impasto was so thick that he was nearly sculpting it too. From the enlarged details one might almost think it was a work of abstract art—and with some justice. When Vincent analyzed the way the light was reflected on the men and the objects before him, he discovered thousands of minute coloured shapes whose existence one would never suspect from looking at the subject as a whole.

THE NIGHT-CAFÉ must also be mentioned. It represents the inside of the Café de l'Alcazar. Vincent explained to Theo that at Arles there were several of these cafés which remained open all night so that night-prowlers could take refuge there if they were too drunk or too poor for a proper lodging.

Vincent wrote to Theo: *Then to the great joy of the landlord, of the postman whom I had already painted, of the visiting night-prowlers and of myself, for three nights running I sat up to paint and went to bed during the day. I often think that the night is more alive and more richly coloured than the day. Now, as for getting back the money I have paid to the landlord by means of my painting, I do not dwell on that, for the picture is one of the ugliest I have done.*

Details A.I.v.G.—Two enlargements of the man pushing the barrow in the painting of the sand-boats on the opposite page. One shows the whole man, the other his upper half further enlarged.

SAND-BOAT UNLOADING (BOATS AT ANCHOR). Arles, August 1888, oil on canvas, 55 × 66 cm, F 449, H 485. Folkwang Museum, Essen-Ruhr, German Federal Republic. Pen sketch, 7 × 10 cm, Vincent van Gogh Foundation, Amsterdam.—Vincent wrote to Theo: "Just now I am working on a study like this, of boats seen from the quay above" and he drew a sketch of it in his letter.

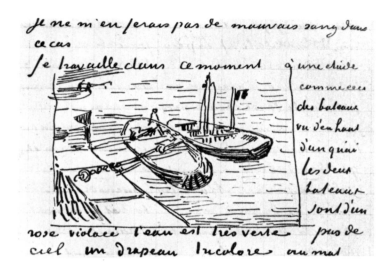

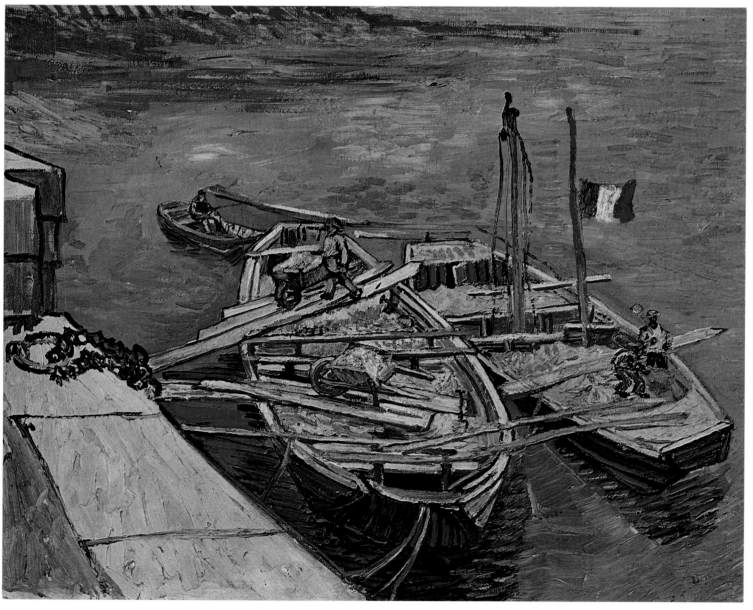

*It is the equivalent, though different, of* THE POTATO-EATERS. *I have tried to express the terrible passions of humanity by means of red and green. The room is blood red and dark yellow with a green billiard table in the middle; there are four citron-yellow lamps with a glow of orange and green. Everywhere there is a clash and contrast of the most disparate reds and greens in the figures of little sleeping hooligans, in the empty, dreary room, in violet and blue. The blood-red and the yellow-green of the billiard table, for instance, contrast with the soft tender Louis XV green of the counter, on which there is a pink nosegay. The white coat of the landlord, awake in a corner of that furnace, turns citron-yellow, or pale luminous green. . . .* THE NIGHT-CAFÉ *carries on the style of the* SOWER, *as do the head of the old peasant and of the poet also, if I manage to do this latter picture. It is colour not locally true from the point of view of the delusive realist, but colour suggesting some emotion of an ardent temperament. When Paul Mantz saw at the exhibition the violent and inspired sketch by Delacroix that we saw at the* Champs Elysées—*"The Barque of Christ"*—*he turned away from it, exclaiming, "I did not know that one could be so terrible with a little blue and green." Hokusai wrings the same cry from you, but he does it by his line, his drawing, just as you say in your letter—"the waves are claws and the ship is caught in them, you feel it." Well, if you make the colour exact or the drawing exact, it won't give you sensations like that.*

Vincent was no longer content to observe with his eyes, but was expressing what he felt with all his soul. He had abandoned objective vision, and his work was to become increasingly subjective.

### NEW FRIENDS

At Arles Vincent had so far managed to avoid the loneliness which he had previously felt when he lived in the country, and which after a month or two generally became more than he could bear. He was much too busy painting—and painting too confi-

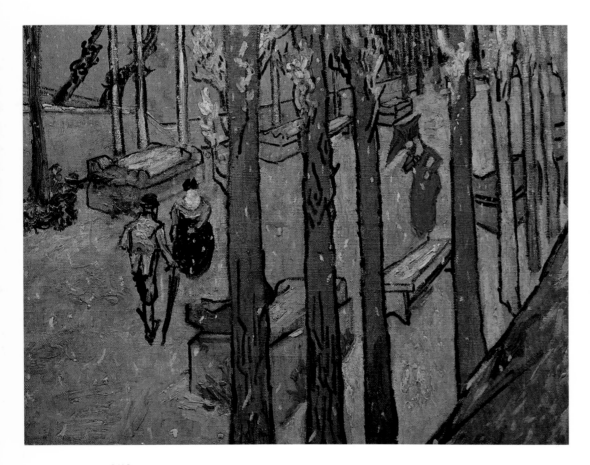

"LES ALYSCAMPS", FALLING LEAVES. Arles, November 1888, oil on canvas, 73 × 92 cm, F 468, H 513. Kröller-Müller State Museum, Otterlo. Photograph A.I.v.G.—Vincent wrote to Theo: "I think you will like the falling leaves I have done. It is some poplar trunks in lilac cut by the frame where the leaves begin." The influence of Japanese art, for which Vincent had a passion, is to be seen in the unusual way the frame cuts the picture and in the almost oriental choice of colour. The old wall on the left is still there, as are a few of the old trees.

dently—to feel a strong need to discuss his work with another artist. And in any case, he was keeping up a lively correspondence with Emile Bernard.

He had also had the good fortune to make friends with a post-office official called Roulin. When Vincent's day's work was over he would relax in conversation with this handsome man with a Socratic beard, who was also a friendly and hospitable neighbour, living only a few steps from "The Yellow House". When Vincent found his usual difficulty in getting people to sit to him, Roulin was happy to spend many hours doing so, and was the subject of several portraits. The postman arranged for all his family, his wife, his sons and even his baby, to sit for their portraits too.

In September Vincent also met a Belgian poet and painter of thirty-three who had already been working in Paris for ten years. His name was Eugène Boch, he had green eyes and a thin face. Vincent thought he had *the look of Dante* and added that *he is very distinguished-looking, and will become so, I think, in his painting.* He had been staying at Fontvieille, a little further from Arles than Montmajour, and they arranged to meet as soon as Theo told Vincent that Boch was living near by.

Boch and Vincent went for several walks together, and Vincent painted the Belgian's portrait. He gave Theo a remarkable account of his conception of this picture: *I want to put my appreciation, the love I have for him, into the picture. So I paint him as he is, as faithfully as I can, to begin with. But the picture is not yet finished. To finish it I am now going to be the arbitrary colourist. I exaggerate the fairness of the hair, I even get to orange tones, chromes and pale citron-yellow. Behind the head, instead of painting the ordinary wall of the mean room, I paint infinity, a plain background of the richest, intensest blue that I can contrive, and by this simple combination of the bright head against the rich blue background, I get a mysterious effect, like a star in the depths of an azure sky.*

Vincent had much fruitful conversation with Boch, whom he found a much more sympathetic companion than Dodge MacKnight, an American water-colourist who had been at Cormon's studio, and who was the only other painter Vincent had seen since he left Paris. Boch's conversation was a great help to Vincent, but he was making only a short stay in Provence, and soon he had to return to La Louvière in the Borinage that Vincent remembered so well.

When Boch left, Vincent's old nightmare of having no other artist with whom he could discuss his work returned to haunt "The Yellow House".

AN UNFORTUNATE INVITATION

When they had been discussing art over their drinks in the Paris *bistros*, Vincent had been much impressed by Gauguin, whom he thought of from the beginning as the leader of the new movement. When Gauguin wrote his memoirs, which he entitled *Avant et après*, he said of van Gogh that "one of the things that angered him was being forced to recognize my great intelligence".

Whether or not such an assertion is evidence of Gauguin's intelligence, there is no doubt that Vincent respected it—perhaps unduly so.

Gauguin was born in Paris in 1848 and was five years older than Vincent. His father was a Breton and his mother a Creole. After an adventurous childhood Gauguin was a cabin-boy on a ship and then a stockbroker. When he decided to devote the rest of his life to art he abandoned his wife and children and went to Martinique in the West Indies.

This background earned him the respect of the other painters of the Petit Boulevard; even Vincent, who was not a novice like Bernard, was impressed by his obvious maturity and experience. And Vincent's own inability to express himself fluently only increased his admiration for Gauguin's eloquent and often wittily ironical conversation.

It was therefore not surprising that Vincent should have chosen Gauguin as the artist he would like to come and share his quarters in "The Yellow House". Emile Bernard, who might have proved more sympathetic, was doing his military service and was therefore out of the question.

But Vincent was very much mistaken in thinking that Gauguin would be a suitable companion with whom to set up the kind of artists' colony of which he had always dreamed. If both men had been equally sincere in the venture it might have succeeded. But they were not; and, whatever Gauguin may have said later, he had a very poor opinion of Vincent and was quite unaware of his talent, let alone his genius.

After Vincent died he gave ample proof of this which none of his subsequent assertions could contradict.

Several months after Vincent's death Theo asked Bernard to organize a commemorative exhibition of van Gogh's work. When Gauguin learnt of this project from Bernard he did all in his power to stop this mark of respect to the dead man from ever taking place. He not only sent Meyer de Haan to Paris to try to prevent it, but he also wrote to Bernard and said that "it was not really very wise to exhibit the works of a madman" and that Bernard would risk everything by acting so thoughtlessly.

All that Gauguin and Vincent really had in common was a firm intention to escape from the impasse they were in because they both found Impressionism inadequate. Gauguin was driven by great ambition which he pursued with more intellectual erudition than with truly pictorial inspiration. Gauguin's chief interests were decorative, and he was little fitted to understand or appreciate Vincent's work which was always basically naturalistic.

## A GENIUS WITH FEET OF CLAY

Vincent's belief that universal goodness would eventually triumph and his unshakable fidelity to reality as the starting point of his pictures must have seemed somewhat naïve to Gauguin, who had seen much of life, destroyed all his family ties, and had a keen taste for the darker sides of life. Vincent's choice of Gauguin was not a happy one.

Vincent was in fact no less intelligent than Gauguin, and it may therefore seem strange that he did not see more clearly how things would be. But the attraction of Gauguin for Vincent was probably largely unconscious and arose because the older man satisfied the younger's need for a father-figure.

When he first arrived at Arles, Vincent was anxious about Gauguin's appalling financial difficulties. In the letter in which Vincent told Theo that he had taken "The Yellow House", he wrote: *I could quite well share the new studio with someone, and I should like to. Perhaps Gauguin will come south? Perhaps I could come to some arrangement with MacKnight. Then the cooking could be done in one's own place.*

On May 22, 1888, Gauguin wrote to Theo that he had been living on credit at the inn at Pont-Aven for two months and that he saw no way out of his difficulties. When Vincent learnt of this he wrote to Theo: *My dear Theo, I have been thinking about Gauguin. If Gauguin wants to come here, there is Gauguin's journey, and there are two beds or two mattresses, which in that case we absolutely must buy. But afterward, as Gauguin is a sailor, we shall probably manage to eat at home. And the two of us will live on the same money that I now spend by myself.*

From then onwards Vincent reiterated with increasing frequency that Gauguin should come and live with him at "The Yellow House", and, after a very great deal of correspondence between Theo and the two of them, Gauguin eventually came to Arles and occupied the quarters that Vincent had prepared for a second painter.

Gauguin's own account of the situation was that, "Perhaps because I somehow instinctively foresaw that there was something abnormal, I resisted Vincent's sincere protestations of friendship for a long time before I eventually set off." Meanwhile, although Gauguin did not really care for Vincent, it had been Vincent who had persuaded Theo to rescue Gauguin from his serious financial difficulties and to send him to Arles.

A WALK IN ARLES (RECOLLECTIONS OF THE GARDEN AT ETTEN). Arles, November 1888, oil on canvas, 73 × 92 cm, F 496, H 516. The Hermitage, Leningrad, U.S.S.R.—The detail on the right shows that Vincent had achieved complete mastery of his art. The richness of the colouring reminds one of a stained-glass window in a gothic church.

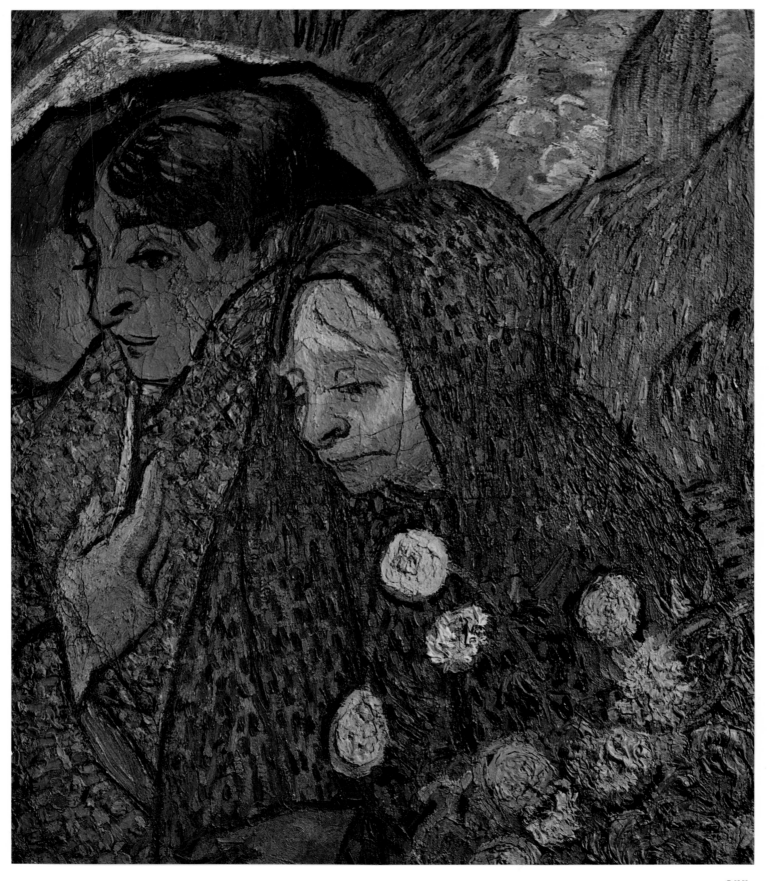

Theo thought that it would make his brother very happy if he could persuade Gauguin to take the train to Arles. He therefore paid all Gauguin's debts, taking pictures in exchange. Gauguin came to Arles not out of affection for Vincent, but because of his situation at Pont-Aven, and because he thought he owed it to Theo, who was trying to sell his pictures at good prices. It was the only thing he could do.

## THE CALM BEFORE THE STORM

"The day after I arrived," Gauguin wrote, "we set to work." At first all seemed to be going well, although Gauguin claimed in his memoirs that he was shocked by the confusion in the house. He was probably right, since Theo had already complained to Wilhelmien about Vincent's untidiness, and that in no time he had turned their apartment in the rue Lepic into a pigsty.

Vincent and Gauguin took turns at cooking and washing up. During the day they painted both indoors and out. They both painted Les Alyscamps, where they once found themselves working side by side, but looking in the opposite direction. In the evening they went to the brothels in the little garrison town. Gauguin called these excursions "nocturnal promenades for reasons of hygiene".

Vincent already knew the "Maison Tutelle" in a little street called the rue des Ricolettes. He was not much given to debauchery, but Gauguin was a great womanizer and certainly encouraged him to pay more frequent visits to what was called the "Hot Quarter" of Arles.

At first the relations between the two painters were excellent, and they went on an excursion together to Montpellier in order to visit the museum. There they saw Courbet's *Bonjour, Monsieur Courbet*, which was later to inspire Gauguin's *Bonjour, Monsieur Gauguin*. At "The Yellow House" Gauguin did a portrait of Vincent while he was painting his famous sunflowers.

But on December 23 Vincent wrote to Theo: *I think myself that Gauguin was a little out of sorts with the good town of Arles, the little yellow house where we work, and especially with me. As a matter of fact, there are bound to be grave difficulties to overcome here too, for him as well as for me. But these difficul-ties are more within ourselves than outside. Altogether I think that either he will definitely go, or else definitely stay. I told him to think it over and make his calculations all over again before doing anything. Gauguin is very powerful, strongly creative, but just because of that he must have peace. Will he find it anywhere if he does not find it here? I am waiting for him to make a decision with absolute serenity.*

Vincent cannot have known that Theo had received a letter from Gauguin which began as follows: "Dear Mr van Gogh, I would be greatly obliged to you for sending me part of the money for the pictures sold. After all, I must go back to Paris. Vincent and I simply cannot live together in peace because of incompatibility of temper, and we both need quiet for our work. He is a man of remarkable intelligence; I respect him highly, and regret leaving; but I repeat, it is necessary. I appreciate all the delicacy in your conduct toward me and I beg you to excuse my decision."

Only a few hours after he had posted this letter, Gauguin thought better of this decision and begged Theo to think of it as "something imaginary" and "a bad dream". But the calm did not last long.

Vincent's correspondence gives only the vaguest indications of the reason for their disagreement. All that Gauguin said in *Avant et après* was: "Be-tween two beings, him and me, the one all volcano and the other also boiling, but inwardly, there was a conflict as it were brewing up." But one need only consider the characters of these two impetuous men to see how easily a gulf could have appeared between them.

## MOTIVE FOR ATTEMPTED MURDER

Gauguin like Mauve, Breitner and even Cézanne was never aware of Vincent's genius. He knew well enough that Vincent was an enterprising pioneer and an industrious worker, who had original ideas, and who sometimes hit upon a curious discovery, which Gauguin did not scruple to appropriate and pass off as his own, as he had done with Emile Bernard's *cloisonné* effects.

Vincent's sensitive nature made him an easy target for Gauguin's instinctive provocation and habitual smiling sarcasm which had already shocked Bernard.

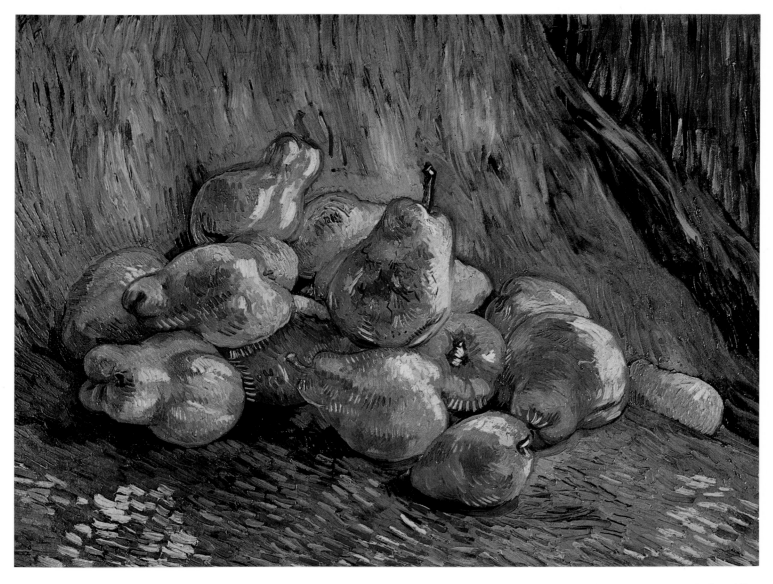

STILL LIFE: PEARS.  Arles, 1888, oil on canvas, 46 × 59.5 cm, F 602, H 599.  Gallery of Modern Painting, Dresden, German Democratic Republic.

Vincent could not help being wounded by Gauguin's sardonic raillery, especially as it was not always devoid of malice.

In *Avant et après*, Gauguin made a significant admission: "It was surely by chance that in the course of my life several men with whom I spent much time in conversation afterwards went mad."  There was so little in common between Gauguin's and Vincent's artistic point of view that it is difficult to see how they could have had any sane and productive conversation about their art.  Gauguin's artistic conceptions were compounded of natural elements mingled with products of his imagination; Vincent was always very closely linked to reality as his inspiration.  They were too far apart to understand one another, though Vincent did not realize this, nor that his art owed nothing to Gauguin's.

Gauguin was a most remarkable painter, but he was in no way responsible for beginning the revolution which shook Western painting as a consequence of Vincent's innovations.  A comparison between the pictures that they both painted of the same subject in "The Yellow House" shows Vincent's indisputable superiority and creative virtuosity.

257

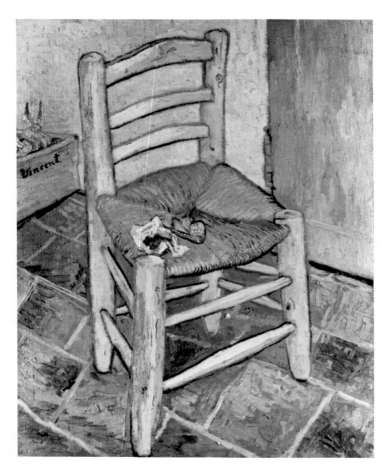

THE CHAIR AND THE PIPE. Arles, December 1888, oil, 92.5 × 73.5 cm. F 498, H 521. National Gallery, London.

Among the dozen subjects that they both painted there is one that particularly deserves closer analysis. This is THE ACTOR, painted full face by Vincent and in profile by Gauguin. It is no exaggeration to say that Vincent's is a successful work of genius, while Gauguin's cannot really be called more than good student's work. In THE ACTOR Vincent foreshadows Expressionism in the enlargement and daring variation of form, while Gauguin sticks to a stale and impersonal academic manner.

Gauguin still hesitates before using light colours, while Vincent is absolutely unfettered in this respect. Vincent's portrait is therefore far better than Gauguin's, which is disappointingly flabby. It is hard to understand how Vincent could have been so blinded by his admiration for Gauguin that he felt an inferiority complex in his relations with him.

## THE OTHER SIDE OF THE PICTURE

It is only fair to admit that Vincent's own character must have contributed considerably to the discord at "The Yellow House". He could be extremely contrary and obstinate, and was apt to contradict people in a disagreeable manner. Even Theo had found it almost impossible to live with him in Paris and had sometimes wished he would leave.

One might be tempted to think that Vincent treated Gauguin in the brusque manner that he often adopted towards others. But it seems more likely that his respect for Gauguin and sense of inferiority compared with the "painter of the future" made him refrain from replying to his companion's taunts and provocations, rather than dispute with him openly. Gauguin's silence on this point seems to argue in Vincent's favour, for if Vincent had been obstinate and aggressive Gauguin would surely have mentioned such a good excuse for his own behaviour.

Vincent was very much more highly strung than Gauguin, and the time came when his nerves broke. The explosion occurred on the very day when Vincent told Theo that Gauguin was *a little out of sorts*.

It is impossible now to ascertain exactly what happened that evening. Gauguin's version must be treated with considerable reserve. The account that he gave fifteen years later in *Avant et après* is open to criticism. In 1914 Johanna van Gogh-Bonger called it "a mixture of truth and fiction". This is borne out by some of Gauguin's other assertions. For instance he even had the audacity to write that Vincent "was only producing incomplete and monotonous harmonies; the clarion-call was lacking. I undertook the task of enlightening him, which was easy for me to do, because I found a rich and fertile soil. He found my instruction very fruitful."

Most experts have rejected Gauguin's account, or accepted it only with great caution.

## THE FIRST ACT OF THE TRAGEDY

Gauguin tells how Vincent suddenly threw a glass at his head when they were drinking together at a bar, but his account of the incident is very suspect. Vincent never mentioned what happened, though he later regretted it deeply and unreservedly.

Absinthe and tobacco may have been contributory cause. Over-indulgence in either can make a man take leave of his senses. When I was making my inquiries in Arles town archives some fifteen years ago, I found that at the time of Vincent's visit hardly a week went by without somebody in the town having an attack of madness and being confined in an institution. These lunatics must have formed a surprisingly high percentage of the town's small population. And Gauguin and Vincent may likewise have had their wits impaired by alcohol and tobacco.

"One witness is no witness" is a sound legal maxim, and in this case we have only one, because the other people in the brothel who could have given their version of the quarrel have left no record of it. The authorities seem never to have made any serious inquiry into the matter, and French officials say that the police files no longer exist.

The sequel to this incident took place the next day, by Gauguin's account, in the place Lamartine. He wrote in *Avant et après* as follows: "In the evening I had a snack for supper and felt the need to go out alone to take the air that was laden with the scent of oleanders in bloom. I had crossed almost the whole of the place Victor Hugo, when I heard behind me a light step. It was rapid and abrupt, and I knew it well. I turned round just as Vincent was coming at me with an open razor in his hand. I must have looked at him then with a very commanding eye, for he stopped, lowered his head, and turned round and ran back towards the house."

This was the second act of this mysterious tragedy. Even if Gauguin's account is accurate, we do not know what Vincent's motives were and whether he really intended to murder him.

The third act was the most important, and it created a greater scandal than any of the many events in his previous life that had so shocked respectable opinion in three countries.

A NEWSPAPER CUTTING

Hitherto even the most bizarre of Vincent's actions had not attained public notoriety. But this time the police were called in, and the press reported the event. In the local weekly paper, *Le Forum Républicain* of December 30, 1888, a short item appeared

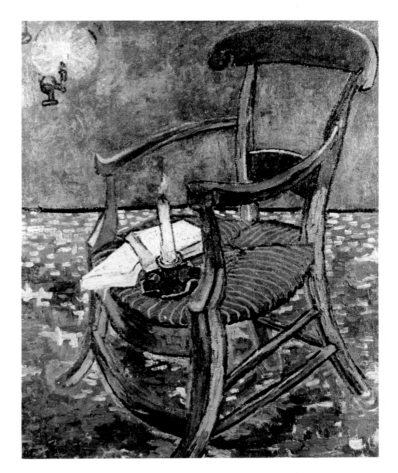

GAUGUIN'S ARMCHAIR. Arles, December 1888, oil, 90.5 × 72 cm. F 499, H 522. Collection of V. W. van Gogh, Amsterdam.

(reproduced with a translation on page 268) telling how Vincent had appeared at a brothel in the town and given his ear to a woman called Rachel, saying "Guard this object carefully." The police were informed and the next morning they went to Vincent's house where, according to the report, they found him unconscious in bed and took him to the hospital.

This was not, alas, the last time that Vincent would provide material for a sensational news item. This one is confirmed in two respects by well-established fact. Vincent did have a mutilated ear and he was taken to hospital. The rest of the story does not at first seem to have anything to do with Vincent's quarrel with Gauguin and is less easy to confirm. It was an exaggeration to say that Vincent offered his ear to Rachel. Despite Gauguin's assertion that Vincent "cut off his ear flush with

his head" he actually severed only the lower lobe as shown in the diagram that is reproduced on page 268.

The newspaper account of the *maison de tolérance* No. 1 at which Rachel was to be found can be confirmed from the town archives. She lived at No. 1 rue du Bout d'Arles. Dr Leroy, director of the asylum at Saint-Rémy-de-Provence, has stated that Vincent and Gauguin often went to see the woman who was offered such a grim present. Vincent wrote to Theo in a letter of February 3, 1889: *Yesterday I went to see the girl I had gone to when I was out of my wits. They told me there that in this country things like that are not out of the ordinary. She had been upset by it and had fainted but had recovered her calm. And they spoke well of her, too.*

In recent years various ingenious explanations of Vincent's behaviour have been put forward. His present of a lobe of his ear to a prostitute has been compared to a custom in the arena. After the bull has been killed the toreador cuts off one of the bull's ears and presents it to his love.

It has also been pointed out that in Vincent's portrait with his ear bandaged (reproduced on page 269) his fur hat is very like the caps worn by toreadors. This is true, but he had already begun wearing this fur cap at Nuenen.

Another even more ingenious explanation has been suggested. According to this version Vincent was subject to aural hallucinations and heard imaginary voices. This is borne out by his own letters from the asylum at Saint-Rémy. While arguing with Gauguin he heard a voice in his ear whispering, "Kill him!" So he attacked his friend with a razor, but then he realized his folly and recalled the injunction in the Bible: "And if thine eye offend thee, pluck it out...." His ear had offended him, and so he punished it to expiate his sin against his friend.

HEADLONG TO DISASTER

It is not difficult to reconstruct Vincent's movements on that disastrous Christmas Eve. He did not have to go far. "The Yellow House" was only a hundred and fifty yards from the brothel. Although a cut ear bleeds very freely he need not have lost a very great deal of blood, certainly not enough to make him lose consciousness.

As Vincent went from "The Yellow House" to the brothel and back he would have twice passed the police-station, which was beside the Café de l'Alcazar, immortalized in THE NIGHT-CAFÉ. As yet the police were unaware of what was going on.

Vincent's mental processes are much harder to reconstruct. The important fact is that Vincent was at the peak of his career when his mind gave way. Even before the crisis and Dr Rey's diagnosis of his condition, there were certain signs that Vincent's condition was deteriorating.

Ever since he was a boy Vincent had been in search of himself, and the strain of years of effort was bound to make itself felt sooner or later.

The feverish enthusiasm with which he applied himself to his work, so that he was now able to express himself with almost incredible facility in his paintings and drawings, would gradually have undermined the strongest constitution. Every time his brush put paint on his canvas or his reed marked his paper with ink it was the result of an extremely swift, but none the less precise mental effort, as his mind decided how best to keep the balance of all the elements in the picture, and at the same time make them express his own feelings about the subject and the work that he was creating.

Oblivious to mental and physical fatigue, Vincent did not rest for a moment but worked incessantly from morning to night, abandoning himself completely to what he had now decided was his ultimate vocation. As a result Vincent exhausted much of his strength, but he was still determined to make even more super-human efforts before Gauguin arrived.

His letters that autumn showed an obsession with Gauguin and an exaggerated respect for his good opinion. He admitted to Theo: *Well, yes, I am ashamed of it, but I am vain enough to want to make a certain impression on Gauguin with my work, so I cannot help wanting to do as much work as possible alone before he comes. His coming will alter my manner of painting and I shall gain by it, I believe.*

And just before Gauguin arrived, Vincent wrote: *I have nevertheless pushed what I was working on as far as I could in my great desire to be able to show him something new, and not to be subjected to his influence (for he will certainly influence me, I hope) before I can show him indubitably my own individuality.* The results speak for themselves. Most of

the pictures that Vincent painted in the last few weeks before Gauguin arrived are now internationally famous masterpieces.

But the constant effort could only produce mental exhaustion. Only an iron constitution could survive working in the baking Provençal sun, and it was little wonder that Vincent wrote: *I have been and still am nearly half dead from the past week's work. I cannot do any more yet, and besides, there is a very violent Mistral that raises clouds of dust which whiten the trees on the plain from top to bottom. So I am forced to be quiet. I have just slept sixteen hours at a stretch, and it has restored me considerably.*

And in his last letter before Gauguin's arrival he wrote prophetically: *I am not ill, but without the slightest doubt I'd get ill if I did not eat plenty of food and if I did not stop painting for a few days. As a matter of fact, I am again pretty nearly reduced to the madness of Hugo van der Goes in Emil Wauters's picture. And if it were not that I have almost a double nature, that of a monk and that of a painter, as it were, I should have been reduced, and that long ago, completely and utterly, to the aforesaid condition. Yet even then I do not think that my madness could take the form of persecution mania, since when in a state of excitement my feelings lead me rather to the contemplation of eternity, and eternal life. But in any case I must beware of my nerves, etc.*

This was the inevitable price to pay for nine months of extraordinary activity and mental tension, during which he had produced a body of work that most artists would have taken several years to complete after a far more thorough preparation than Vincent had been able to enjoy. It is no exaggeration to say that his output during these few months was one of the most extraordinary explosions of artistic energy the world has ever seen. On some days he seemed to be creating masterpieces as fast as he could paint.

Matthijs Vermeulen, the Dutch art critic, wrote of Mozart "this exceptionally remarkable human organism secreted music—and what music!—as if it were a natural production." The same was now true of Vincent's painting. In the period leading up to Gauguin's arrival at Arles, Vincent produced more works of genius than even Rubens had done in the same time, if one takes into account that Rubens had a whole studio of assistants, while Vincent was working quite alone.

## THE WAY TO MADNESS

Vincent's northern temperament was inspired and intoxicated by the brilliant southern sun. In the end the violent confrontation of Apollo and Dionysus was more than his sanity could stand, as it had been for Nietzsche and Hölderlin and so many others.

Van Rappard, who knew Vincent well, whatever misunderstandings he may have had with him, said: "What Vincent wanted was art in the grand manner, and his colossal struggle to express it would, I think, have undermined any artist. I do not think that a single temperament could have withstood this emotional and nervous tension, being constantly on the point of breaking."

Gauguin's sarcastic remarks relentlessly destroyed Vincent's self-confidence. His constant fear of being a failure led him to drown his cares in drink. His over-indulgence in absinthe, which was supposed to relax the nerves, destroyed his health instead of restoring it. His habit of going almost without food had made him weaker and more susceptible to alcohol than Gauguin, who was large and robust. At Arles Vincent often complained in his letters of being utterly exhausted.

Moreover, Vincent had caught syphilis, probably at Antwerp, and this certainly contributed to his physical and mental condition. When on top of all this there was the tension between him and Gauguin, a mental breakdown was inevitable.

At the hospital, the inner courtyard of which was later to inspire a remarkable painting and an interesting reed-and-ink drawing, he was shut up in the cell allocated to dangerous lunatics, or raving madmen as they were then commonly called. Vincent suffered something worse and more cruel than mere confinement. The cell has now gone as a result of alterations to the building, but we know that its only window was high up, near the ceiling, and Vincent could not possibly see out of it.

Theo took the first train from Paris to Arles and found Vincent in a pitiful condition suffering from an acute nervous breakdown. The doctor was quite seriously worried about him. Theo spent Christmas with the patient, and he told Johanna Bonger, to whom he had just become engaged, that Vincent seemed lucid at times, and then, a few moments later, he would ramble off into philosophical and theological

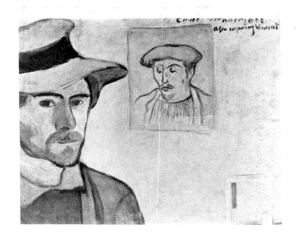

How Emile Bernard saw himself. Brittany, 1888, oil on canvas, 46 × 55 cm, signed at top right, "Emile Bernard 1888, à son copaing Vincent". Vincent van Gogh Foundation Amsterdam.—In the background is a full-face portrait of Gauguin in his beret.

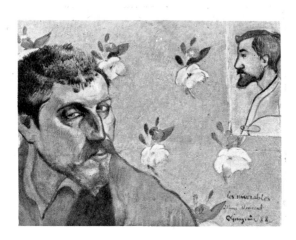

How Gauguin saw himself. Brittany, 1888, oil on canvas, 43 × 54 cm, signed at bottom right: "Les misérables à l'ami Vincent, P. Gauguin, 88."—In the top right-hand corner is a portrait of Emile Bernard.

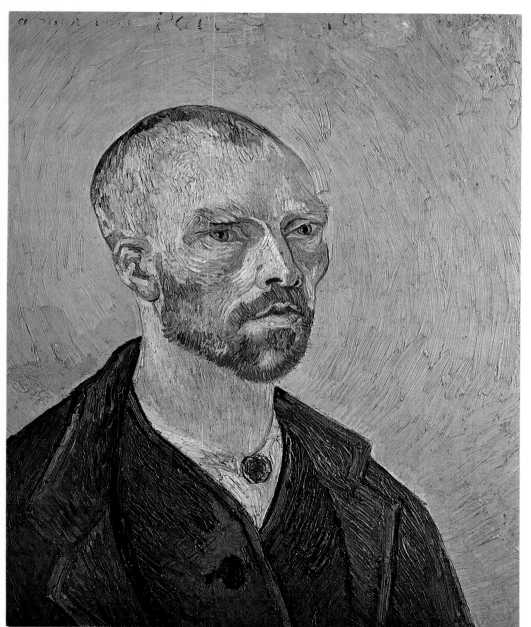

HOW VINCENT SAW HIMSELF. Arles, September 1888, oil on canvas, 62 × 52 cm, inscribed at top left: "To my friend Paul Gauguin"; signed at bottom right "Vincent". Fogg Art Museum, Cambridge, Mass., U.S.A.—Vincent's passion for things Japanese was such that he not only imagined himself living in a Japan in Provence, but even gave himself an Asiatic face with slanting eyes.

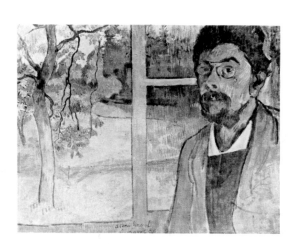

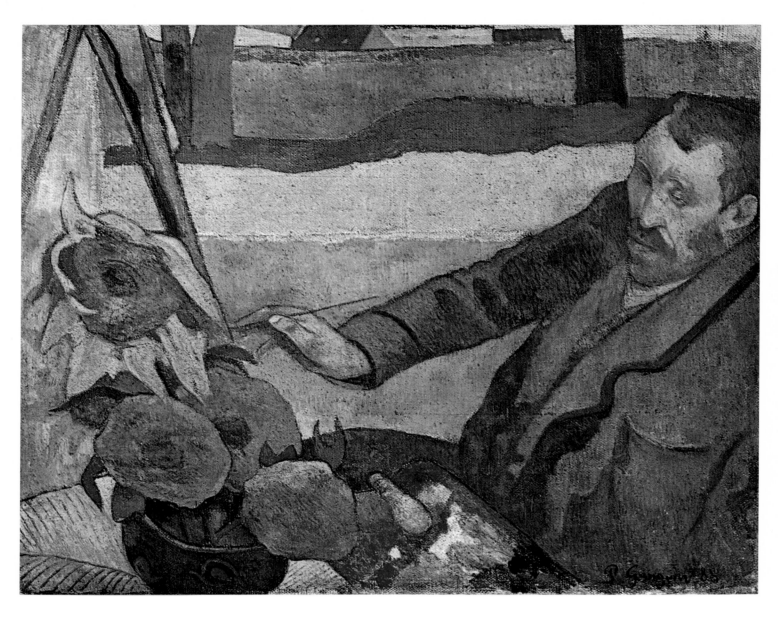

How Gauguin saw him. Arles, November 1888, oil on canvas, 73 × 91 cm, Vincent van Gogh Foundation, Amsterdam.—Vincent had no illusions about the countenance that Gauguin had given him. "It is certainly me," he said severely, "but me gone mad." Later, however, he admitted, "but it was me very weary and charged with electricity, as I was then".

Self-portrait of C. Laval (opposite page). Martinique, 1888, oil on canvas, 50 × 60 cm, inscribed bottom right: "To my friend Vincent, C. Laval, 88." Left: sketch by van Gogh. Vincent van Gogh Foundation, Amsterdam.—When Vincent received this portrait from Laval he wrote to Theo: "You will also be pleased to hear that we have an addition to the collection of portraits of artists. A self-portrait by Laval, extremely good." And he added a sketch of it.

WASHERWOMEN ON THE CANAL. Arles, summer 1888, reed and Indian ink, 31.5 × 24 cm, F 1444. Kröller-Müller State Museum, Otterlo. Photograph A.I.v.G. The point from which Vincent made his drawing is called "La Roubine du Roy". The wooden bridge over the canal and the little terraces for the washerwomen have gone now, and a gasometer has reared up in place of the chimney.

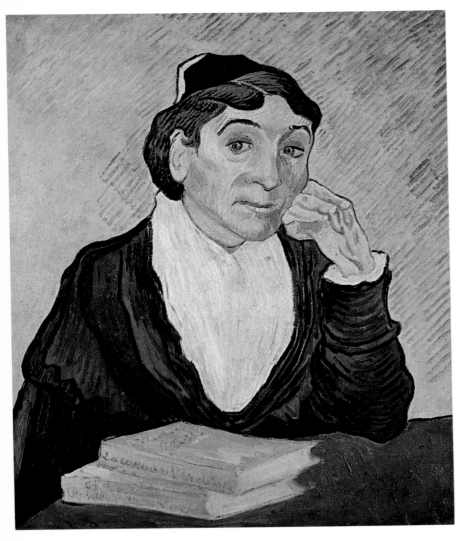

"L'ARLÉSIENNE". Saint-Rémy-de-Provence, January-February 1890, oil on canvas, 64 × 49 cm, F 541, H 710. Art Museum, Sao Paolo, Brazil. Photograph A.I.v.G.—There are several versions of this portrait. This one was conceived at Arles, but painted afterwards in the asylum of Saint-Paul-de-Mausole. The photograph shows Madame Ginoux, who was the model for "L'ARLÉSIENNE". Although it was taken long after the picture was painted one sees that her eyes are lively and piercing as ever.

argument. Sometimes all the miseries of his past would well up in him; he wanted to cry, but he could not do so.

Theo had to return to Paris, and Gauguin had also prudently left. By New Year's Day of 1889, Vincent had recovered enough to write to Theo: *I hope that Gauguin will reassure you completely, and also a little about the painting business. I expect to start work again soon.* And he added a postscript: *Write a line to Mother for me too, so that no one will be worried.* And on the back of the letter Vincent wrote in pencil: *My dear friend Gauguin, I take the opportunity of my first absence from the hospital to write you a few words of very deep and sincere friendship. I often thought of you in the hospital, even at the height of fever and comparative weakness.*

The following day, January 2, 1889, Vincent wrote to his brother again: *So as to reassure you completely on my account, I write you these few lines in the office of M. Rey, the house surgeon, whom you met yourself. I shall stay here at the hopital a few days more, then I can count on returning to the house very quietly. Now I beg one thing of you, not to worry, that would cause me one worry too many.*

## MUCH BETTER NEWS

On the back of Vincent's letter of January 2 Dr Rey had written his own note to Theo: "I add a few words to your brother's letter to reassure you in my turn on his account. I am happy to inform you that my predictions have been realized, and that the over-excitement has been only temporary. I am firmly convinced that he will be himself again in a few days. I made a point of his writing to you himself, so as to give you a better idea of his condition. I have made him come down to my office for a chat. It will entertain me and be good for him."

Dr Salles, the Protestant pastor at Arles, who regularly visited Vincent in hospital, also reassured Theo that his brother had become quite calm and was very eager to begin work again. As a result Vincent was allowed to leave the hospital on January 7 and to return to "The Yellow House". Until his maimed ear should be fully healed, Vincent had to keep his head bandaged, as one can see in the magnificent self-portrait painted at this time.

Back in "The Yellow House" he immediately wrote a letter jointly to his mother and to Wilhelmien to reassure them that all was well and that he had completely recovered. He went on with surprising optimism: *As for myself, my having been indisposed for a few days has in fact refreshed me considerably, and I think there is a chance that there will be nothing the matter with me for a long time to come.*

Vincent wrote that *Roulin has been splendid to me, and I dare say he will remain a lasting friend.* The good postman had not only been the one to put Vincent to bed at the time of his first attack. He also helped to persuade the authorities to let Vincent come home to "The Yellow House".

Wilhelmien wrote to thank Joseph Roulin for all that he had done, and the postman replied: "I make haste to answer you that your amiable brother Vincent has quite recovered; he left the asylum today, the 7th inst.... I have not let him read your letter, for he would be too chagrined to know that he has caused you so much grief.... We talked at great length about you as well as about your mother today.... Please set your mind quite at ease as to the health of my good friend Vincent; I go to see him as often as my work permits, and if something should happen again, I should inform you as soon as possible. I do not think I deserve all the words of gratitude which you address to me, but I shall always do my utmost to deserve the esteem of my friend Vincent as well as of those who are dear to him."

Vincent felt so well recovered that only ten days after he had left hospital he started on a portrait of Dr Félix Rey, who was still treating his ear. He liked the doctor and felt very grateful to him. While he was still in hospital Vincent wrote to Theo: *If you ever want to make the house surgeon Rey very happy, this is what would please him hugely. He has heard of a picture by Rembrandt, the "Anatomy Lesson". I told him we would get the engraving after it for his study. As soon as I feel somewhat up to it, I hope to do his portrait.*

Two days after he came out of hospital he reminded Theo again: *Don't forget the "Anatomy Lesson".* Vincent's painting of the doctor is one of his best portraits and is an excellent likeness, as one can see by comparing it with a contemporary photograph.

Some twenty years ago the late Dr Picard of Arles, who had known Rey when he was a young man of

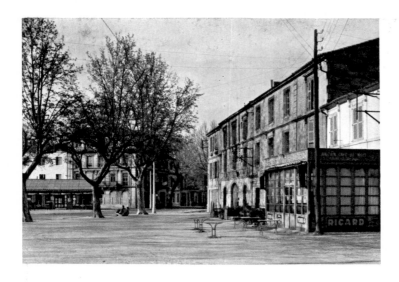

The Alcazar. Photograph A.I.v.G.—This was where Vincent painted his famous picture, THE NIGHT-CAFÉ. Beside the Alcazar there was a police station. On that tragic day before Christmas Eve, after his quarrel with Gauguin, he went past the police station twice when he took the lobe of his ear to Rachel at brothel no. 1.

THE NIGHT-CAFÉ. Arles, September 1888, oil on canvas, 70 × 89 cm, F 463, H 491. Clark Collection, New York, U.S.A.—"In my picture of the 'Night-Café' "he wrote," I have tried to express the idea that the café is a place where one can ruin oneself, go mad, or commit a crime."

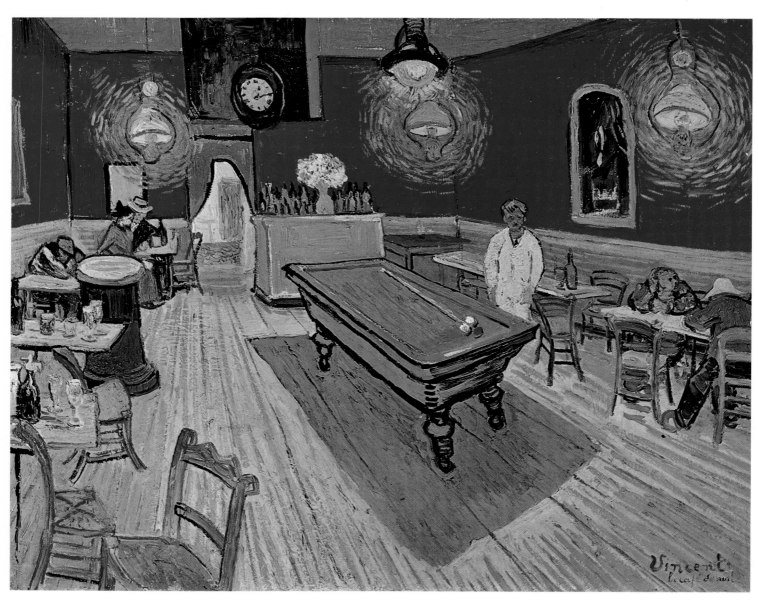

GARDEN OF THE HOSPITAL AT ARLES. Arles, May 1889, oil on canvas, 73 × 92 cm, F 519, H 536. Collection of Oskar Reinhardt, Winterthur, Switzerland.—Besides this masterly picture, the garden also inspired a remarkable drawing which Vincent did from the opposite side.

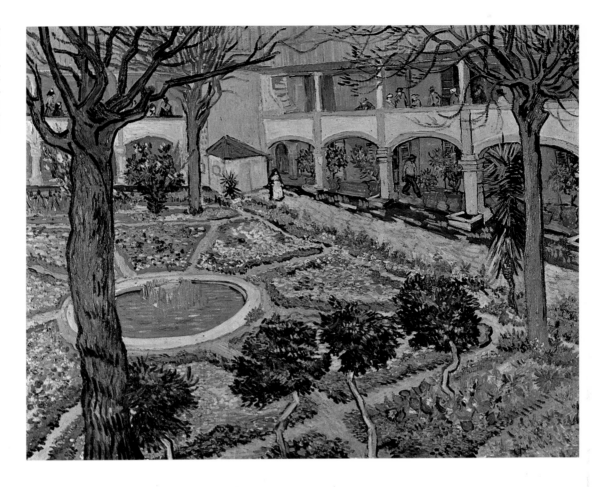

The hospital where Vincent was interned after the incident with Gauguin. Photograph A.I.v.G. —This place still exists, but the garden has been somewhat changed, smaller trees having taken the place of the original large ones.

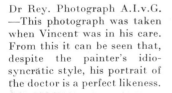

Dr Rey. Photograph A.I.v.G. —This photograph was taken when Vincent was in his care. From this it can be seen that, despite the painter's idiosyncratic style, his portrait of the doctor is a perfect likeness.

PORTRAIT OF DR REY. Arles, January 1889, oil on canvas, 64 × 53 cm, F 500, H 526. Pushkin Museum, Moscow, U.S.S.R.—When some doctors who had been contemporaries of the young house-surgeon in Arles forty years earlier, saw this portrait in Russia, they were astonished at its likeness to the young man they had known.

267

## Chronique locale

—

— Dimanche dernier, à 11 heures 1|2 du soir, le nommé Vincent Vaugogh, peintre, originaire de Hollande, s'est présenté à la maison de tolérance nᵒ 1, a demandé la nommée Rachel, et lui a remis. . . . son oreille en lui disant : « Gardez cet objet précieusement. Puis il a disparu. Informée de ce fait qui ne pouvait être que celui d'un pauvre aliéné, la police s'est rendue le lendemain matin chez cet individu qu'elle a trouvé couché dans son lit, ne donnant presque plus signe de vie.

Ce malheureux a été admis d'urgence à l'hospice.

How much of the ear was cut off? Illustration A.I.v.G.—Contrary to what is usually said, Vincent did not cut off his whole ear, but only the lower part, as shown by the arrow.

A historic news item. Principal library, Arles.—The report published in the local paper when Vincent mutilated his ear.

Translation of the newspaper report from the *Forum Républicain*, December 30, 1880, "Local News". *Last Sunday at 11.30 p.m., one Vincent Vaugogh* [sic] *painter, of Dutch origin, presented himself at the maison de tolérance, No. 1, asked for one Rachel, and gaver her . . . his ear, saying "Guard this object carefully". Then he disappeared. When informed of this act, which could only be that of a poor lunatic, the police went next morning to this person's house, and found him lying in bed giving no sign of life. The unfortunate man was admitted to hospital at once.*

twenty-four and for thirty years afterwards, went to an international congress in Moscow. The portrait of Rey had been in Russia since 1908, and Dr Picard decided to go and see it. When he came back to Arles he was enthusiastic about it and told Dr Rey's old friends what a speaking likeness it was.

Van Gogh's portrait of himself with the bandaged ear succeeds in being extraordinarily expressive using only the simplest means. He could hardly have painted so well if his mind were still disturbed.

Vincent has left other pictorial records of his illness and the period of his recovery. There is the resplendent GARDEN OF THE HOSPITAL AT ARLES already mentioned. It provides a striking contrast with what he must have seen inside his cell, which was dark and gloomy enough to send a sane man mad, for it blazes with sun and colour like a dream of the Arabian Nights.

Two weeks after painting Dr Rey, Vincent completed the fourth version of "LA BERCEUSE", for which Roulin's wife had sat as usual. His account of what he wanted to express in this picture has already been quoted. Now he himself was exiled and lonely like the imaginary fisherman of Iceland for whom he conceived this reminder of home. He suffered as men suffer at sea, and his own mother was more than five hundred miles away.

### A SHADOW ON THE FUTURE

Vincent had been working at "The Yellow House" for more than a month. The crisis on Christmas Eve had apparently been a passing affliction. But on February 9 he had a relapse and was obliged to return to hospital a second time.

This recurrence, which Dr Rey attributed chiefly to Vincent's fear of suffering from another bout of nervous over-excitement, was fortunately this time not preceded by any sensational overt act. But Vincent's relapse shook his faith in the future. Besides his fear that his illness would become worse,

there was another reason why he was distressed. He found when he came out of hospital the first time that he spread panic wherever he went. The townspeople were hostile and even aggressive towards him.

Like barnyard fowls which peck at a sick hen until they kill it, the people of Arles pursued Vincent and egged the street-urchins on to torment him. Vincent's persecution at this point in his life is a fact, and not a subsequent distortion by sensational biographers. I have been given first-hand evidence of this by the late M. Jullian, the municipal librarian of Arles, who was a patriarchal Provençal with a deep knowledge of the local literature, when I met him and examined his papers on the subject.

M. Jullian was seventeen years old when he saw Vincent. He never spoke to him, probably because Vincent never spoke either. And he has written this account of the matter: "I was one of the 'flash lads' of the time. We were a gang of young people between sixteen and twenty, and like a lot of young imbeciles we used to amuse ourselves by shouting abuse at this man when he went past, alone and silent, in his long smock and wearing one of those cheap straw hats that you could buy everywhere. But he had decorated his with ribbons, sometimes blue, sometimes yellow. I remember—and I am bitterly ashamed of it now—how I threw cabbage-stalks at him! What do you expect? We were young, and

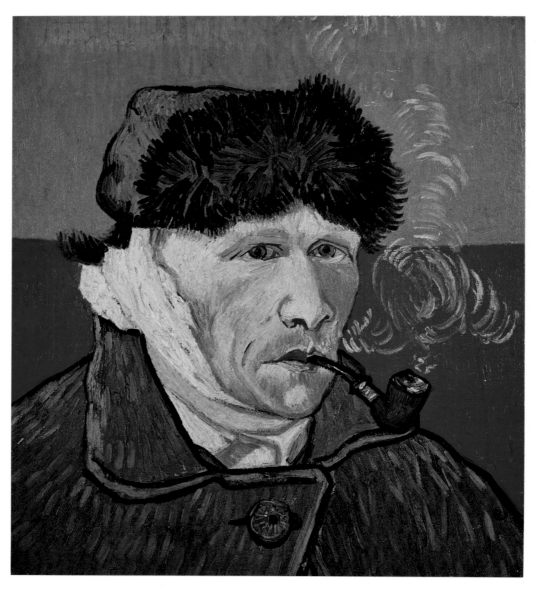

THE MAN WITH THE PIPE. Arles January-February 1889, oil on canvas, 51 × 45 cm, F 529, H XII. Collection of Leigh B. Block, Chicago, U.S.A. —This self-portrait has given rise to an unfortunate misunderstanding. Some people, forgetting that Vincent was painting himself in the mirror, have thought that he cut off the lobe of his right ear. But it was certainly the left.

he was odd, going out to paint in the country, his pipe between his teeth, his big body a bit hunched, a mad look in his eye. He always looked as if he were running away, without daring to look at anyone. Perhaps this was why we used to pursue him with our insults. He never made any scandal, except when he had been drinking, which happened often. We only became afraid of him after he had maimed himself, because then we realized that he really was mad! I have often thought about him. He was really a gentle person, a creature who would probably have liked us to like him, and we left him in his terrifying isolation, the terrible loneliness of genius."

What could Vincent do? He fled like a hunted animal, maddened at being so misunderstood. Though his pictures and his efforts were ridiculed he followed the path which his artistic conscience had set him upon. In August he had written: *If you are a painter, they think you are either a fool or a rich man.*

## THE JACKALS GATHER

The final piece of malice on the part of the people of Arles was to petition the mayor that the poor wretch should be confined in hospital. When Vincent learned of this he wrote in anguish to Theo: *I write to you in the full possession of my faculties and not as a madman, but as the brother you know. This is the truth. A certain number of people here (there were more than 80 signatures) addressed a petition to the Mayor (I think his name is M. Tardieu), describing me as a man not fit to be at liberty, or something like that. The commissioner of police or the chief commissioner then gave the order to shut me up again. Anyhow, here I am, shut up in a cell all the livelong day, under lock and key and with keepers, without my guilt being proved or even open to proof.* As a result "The Yellow House" was closed by the police.

When I examined the petition and various other papers, minutes and official reports, I saw that the accusations on the strength of which Vincent was confined were founded solely on very vague statements and dubious gossip. The number of

signatories was much exaggerated; there were barely thirty, and some of the signatures were so illegible that their authenticity is doubtful. Vincent called them the *80 anthropophagi of Arles*. This would have made a splendidly apt—if somewhat unwieldy—subject for a monumental sculpture by Rodin, the converse of *The Burghers of Calais* as it were, for the sculptor much admired Vincent and bought there of his pictures including the portrait of "LE PÈRE TANGUY".

Pastor Salles, who kept Theo informed of the situation, wrote to him on March 12: "The neighbours worked upon one another's feelings. The acts for which your brother has been blamed (supposing that there are true) are not the sort of things for which you can certify a man to be insane or canvass for his confinement. Unfortunately the act of madness which made it necessary to go into hospital the first time has made people put an unfavourable interpretation on every act in the least odd that this unfortunate young man has committed. In someone else they would perhaps not be noticed, but in him they at once take on a particular importance." Fortunately for Vincent he never underestimated the strength of human folly.

After the crisis, Vincent was alone and friendless again. Though he sent many friendly and apologetic messages to Gauguin through Theo, he had given up hope of companionship with another painter.

Henceforward he would be surrounded only by strangers, and his brother would not be able to join him. *If I did not have your friendship*, he told Theo, *I should be remorselessly driven to suicide, and, cowardly as I am, I should commit it in the end.*

His hope for the future was shaken, if only for a while; for his love of art and his creative passion would eventually prove stronger than the destructive forces that had taken hold of him again.

With his health broken and his nerves strained, with nothing to fall back upon, and believing that he was thought to be mad or dangerously eccentric, Vincent was lost. Fear and doubt drove him into another nervous collapse, and he wanted only to flee from society and to leave Arles.

PARK OF THE SAINT-PAUL-DE-MAUSOLE ASYLUM. Saint-Rémy-de-Provence, 1889, watercolour, 62 × 44.5 cm. F. 1535.—Although under the constant surveillance of a warder, Vincent was free to devote himself to his passion for painting during his stay in the asylum. In this restricted area of the Provencal countryside, the painter was already showing signs of his taste for exoticism.

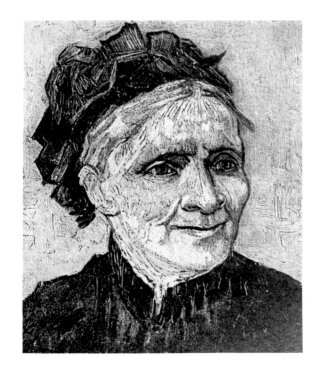

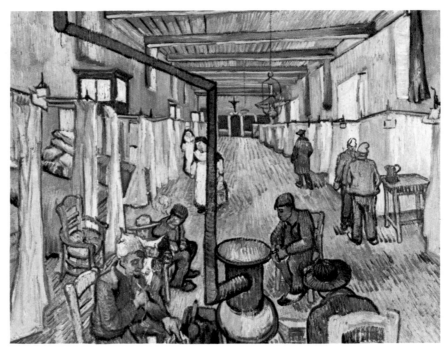

On March 18 Pastor Salles wrote to Theo: "Your brother has spoken to me with perfect calmness and lucidity about his condition and also about the petition signed by his neighbours. The petition grieves him very much. *If the police*, he says, *had protected my liberty by preventing the children and even the grown-ups from crowding around my house and climbing the windows as they have done (as if I were a curious animal), I should have more easily retained my self-possession; in any event I have done no harm to anyone.*"

But though the good pastor said that "there can be no question of interning him in an asylum; nobody, so far as I know, would have this sinister courage". Vincent wrote to Theo a few days later to say: *For the time being I should prefer to remain inside as much for my own peace of mind as for other people's.* Salles therefore found him a new lodging in another part of the town, but Vincent was too shaken to set up house there, and told Theo: *I am much less able to manage practical things than hitherto. I am absent-minded and could not direct my own life just now.*

Salles then made inquiries, as a result of which he advised Vincent to go to Saint-Rémy-de-Provence, where there was an institution which might serve his purpose. And the doctors at Arles also agreed

THE ARTIST'S MOTHER. Arles, October 1888, oil on canvas, 40.5 × 32.5 cm, F 477, H 502. Simon Foundation, Los Angeles, U.S.A.—The painter wrote: "I am doing a portrait of Mother for myself. I cannot stand the colourless photograph."

THE HOSPITAL IN ARLES. Saint-Rémy-de-Provence, October 1889, oil on canvas, 74 × 92 cm, F 646, H 645. Collection of Oskar Reinhart, Winterthur, Switzerland.—This picture was not painted at Arles but at Saint-Rémy-de-Provence from memory.

The special bed. Photograph A.I.v.G.—This cruel contraption was fastened to the walls and the floor and was fitted with holes and rings, to which the patient could be fastened down with leather straps. The cell had only a little barred window, high in the wall so that the person confined in it could not see the world outside.

that this would be better than living alone in the town. "As for me," wrote Theo, "I attribute a large part of your disease to the fact that your material existence has been too neglected. In an establishment like the one at Saint-Rémy there will be approximately the same regularity in the mealtimes and so on, and I think this regularity will do you no harm—on the contrary.... What you ought to know is that from one point of view you are not to be pitied, though it may not seem so."

At last, on May 3, Vincent wrote that he would go to Saint-Rémy, though he was still toying with the wild idea of joining the army, and he added: *And so, though I am very, very glad to be going to Saint-Rémy, nevertheless it would be really fairer to men like myself to shove them into the Legion.*

## IN THE DEPTH OF THE SOUL

I have already discussed the paintings of THE CHAIR AND THE PIPE and GAUGUIN'S CHAIR. They were painted soon after what Gauguin called the "attack of high fever" and Dr Humberto Nagera has considered their significance as various other writers have done. Nagera has noted a connection between the sight of Vincent's father's chair standing empty after he left and the pastor's death. He puts forward a close and lucid argument to show that the books on GAUGUIN'S CHAIR were an echo of the books that Vincent and his father had been looking at together, and that they represent an unconscious wish for Gauguin's death.

Nagera goes on to show that Vincent's aggressive action against Gauguin was inspired by his old hostility towards his father, which had led him to wish unconsciously that his father was dead, and now made him hostile to Gauguin as a father-substitute. In the picture of Vincent's empty chair, there are the same other objects as he had painted after his father's death, the pipe and tobacco-pouch. But this time they symbolize Vincent's own death, for the premeditated if unsuccessful crime against Gauguin had to be punished.

Dr Nagera points out that Vincent did die not so very long after painting the two empty chairs. But before Vincent killed himself he suffered a symbolic death by going mad. This flight into madness en-

abled him to postpone his physical death for a time. This is not the end of Nagera's thesis about what Anna Freud in her foreword to his book calls "a high-minded individual's struggle against the pressures within himself, an image which would command our attention even if the man whose fate is traced were not one of the admired creative geniuses of the last century". It will be recalled how, when Vincent was in The Hague, Theo warned his brother that the Pastor Theodoros had plans of putting his son in the lunatic asylum at Geel in Belgium. Nagera points out that in losing his reason and entering what he called the madhouse of his own free will Vincent was acting strictly in accordance with his father's will. "The father was right after all," writes Nagera, "he was mad and dangerous. He should be under care, especially after the attack on Gauguin. He was imposing on himself the punishment he thought the father had ready for him when he rebelled against authority."

The more deeply one goes into the events of Christmas Eve 1888, the more one finds that Vincent's behaviour arises from unconscious reactions. All the new interpretations of the few facts that there are merely confirm this view. Even Gauguin in his memoirs, unreliable though they are, has unwittingly emphasized the unconscious origin of Vincent's actions at this time.

Gauguin wrote that: "On several nights I surprised Vincent who had got up and was coming towards my bed. Why did I wake up at that very moment? Every time I had only to say to him very gravely: 'What's the matter, Vincent?' And he would go back to bed and sleep like a log."

Gauguin described later how: "Suddenly he threw a glass and its contents at my head. I avoided it and seizing him round his body I went out of the café, crossed the place Victor Hugo, and a few minutes afterwards Vincent was on his bed where he went to sleep and did not wake up until morning."

There is also his remark about the razor attack: "I must have looked at him then with a very commanding eye, for he stopped, lowered his head, and turned round and ran back towards the house."

Three times Gauguin describes his attacker as a sort of sleepwalker who has momentarily emerged from a nightmare. This is too significant to be mere coincidence.

272

# VOLUNTARY CONFINEMENT

Theo, who was much concerned about the condition of his sick and unhappy brother, had made careful preparations for the little journey of barely fifteen miles from Arles to Saint-Rémy-de-Provence. The Saint-Paul-de-Mausole asylum was about a mile from the centre of this little town, on the road to Maussane and near two celebrated monuments: Marius's triumphal arch and the Tomb of the Julii.

On April 24, 1889, Theo wrote to the director of the asylum asking him to admit Vincent as an inmate. He explained his brother's condition and expressed the hope that Vincent would be allowed to paint outside the asylum whenever he wished. (A reproduction and translation of the letter appear on page 275.) In accordance with the rules of the asylum he enclosed with this letter a copy of Vincent's birth certificate issued on September 12, 1887.

Theo had left the rue Lepic and was writing from No. 8 Cité Pigalle. He had recently married Johanna Bonger and they were now expecting a child.

Although it is not mentioned in the letter, he had arranged that Vincent should have two rooms, one to be used as a bedroom and the other as a studio, so that the voluntary inmate should not feel that he was "a madman like other madmen". These two rooms were, as we shall see, mere cells, with bars like all the other cells had.

On May 8, 1889, Vincent went to the asylum, accompanied by Pastor Salles, who wrote to Theo the next day to tell him how things had gone: "Our journey to Saint-Rémy has been accomplished under the most excellent conditions. Vincent was perfectly calm and explained his case himself to the director as a man fully conscious of his condition. He remained with me till my departure, and when I took leave of him he thanked me warmly and seemed somewhat moved, thinking of the new life he was going to lead in that house. Monsieur Peyron has assured me that he will show him all the kindness and consideration which his condition demands." Upon which Johanna van Gogh-Bonger later commented: "How touching sounds that 'somewhat moved' at the departure of the faithful companion! His leave-taking broke the last tie that united Vincent with the outer world; he stayed behind in what was worse than the greatest loneliness, surrounded by neurotics and lunatics, with nobody to whom he could talk, nobody who understood him. Dr Peyron was kindly disposed, but he was reserved and silent; the monthly letters by which he kept Theo informed of the situation lacked the warm sympathy of the doctors in the hospital at Arles."

Vincent, who had hitherto been ridiculed by the supposedly right-minded, was now confined with the

A little advertisement and a prospectus. Documents A.I.v.G.—The advertisement (left) for the Saint-Paul-de-Mausole asylum, dates from before Vincent's admission there; it shows the building seen from the Alpilles at the foot of Mont Gaussier. The prospectus (above) illustrates the male inmates' building.

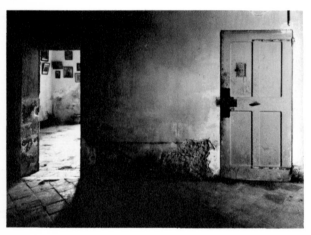

All modern conveniences... Photograph A.I.v.G.—The little cell on the ground floor which is shown to tourists is not the one which Vincent actually occupied; the real one, which was less accessible, no longer exists.

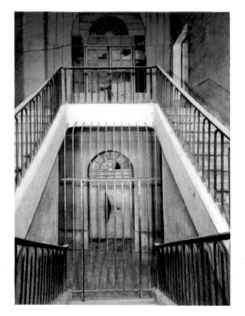

The staircase. Photograph A.I.v.G.—Vincent's cell was on the first floor. He therefore had to go several times a day up and down this staircase, which was barred and bolted on all sides. The staircase was at the end of a long and forbidding corridor.

The baths. Photograph A.I.v.G.—Hydrotherapy was the chief treatment in the asylum, and Vincent spent much of his time in these baths. The room shown here was pulled down in 1965 during a period of modernization.

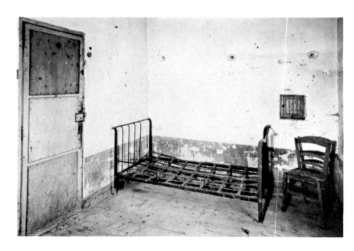

The true cell. Photograph A.I.v.G.—This is the real cell with its bed and chair as it was when the artist lived there. It is quite different from the one now shown to tourists.

274

Paris le 24 Avril 1889

Monsieur le Directeur,

*[handwritten letter in French]*

A dramatic request. Document A.I.v.G.—The letter written by Theo to the director of the Saint-Paul-de-Mausole asylum.

*With the consent of the person concernd, who is my brother, I would like to ask you to admit to your establishment Vincent Willem van Gogh, artist, aged 36 years, born at Groot-Zundert (Netherlands), at present living at Arles. I beg you to admit him as one of your third-class inmates. As his confinement is required more to prevent a recurrence of previous attacks than because his mental condition is at present affected, I hope that you will find no inconvenience in granting him the liberty to paint outside the establishment when he wishes to do so. Moreover, without insisting on the treatment that he needs, for I presume he will be treated with the same care as all your other inmates, I would ask you to be so kind as to let him have at least half a litre of wine with his meals. I remain, sir, yours sincerely, Theo van Gogh, 8 Cité Pigalle, Paris.*

mad, where for the first time in his life he could be different from other people without troubling them. By a strange paradox the man who had never been able to adapt himself to other people managed to adapt himself to his confinement.

## GENIUS BEHIND BARS

Vincent, who had been so wayward and uncontrollable in the past, resigned himself to his fate; when he entered what he called *this menagerie*, he considered the bars as a symbol of his fate.

He proposed to carry on his profession as madman, as he put it, and to try to forget the bars and bolts around him. Perhaps he realized that his genius could survive them unchanged. Dreadful though the reality might be, it was less so than his fear of madness had been, and he wrote to his new sister-in-law: *Though here there are some patients very seriously ill, the fear and horror of madness that I used to have has already lessened a great deal. And though here you continually hear terrible cries and howls like beasts in a menagerie, in spite of that people get to know each other very well and help each other when their attacks come on. When I am working in the garden, they all come to look, and I assure you they have the discretion and manners to leave me alone—more than the good people of the town of Arles, for instance.*

In the register of voluntary confinements there is a certificate dated May 7, 1889, signed by Dr Urpar, director of the hospital at Arles, and containing a vague diagnosis of Vincent's condition. This entry seems only to show that Dr Urpar was not personally

Admission register. Archives of Saint-Paul-de-Mausole asylum, Saint-Rémy-de-Provence, France. — On page 142 of the register, there is a certificate signed by Dr Urpar, in charge of the hospital at Arles. This says that Vincent had been suffering from acute mania with generalized delirium and although his condition had much improved it was advisable for him to be looked after in the asylum. There is also a report by Dr Peyron which ends, "I consider...that M. van Gogh is subject to attacks of epilepsy...and that there are grounds for putting him under observation for a long time in this establishment."

concerned with the progress of the disease. The following day Dr Peyron entered in the fourth column of the register the "twenty-four-hour" report, as it was called, stating that Vincent had been suffering acute mania, with hallucinations of sight and hearing, and that it was necessary for him to be kept under observation in the asylum for a long period.

Below, in the "fortnightly" report, Dr Peyron stated on May 25, 1889, that the patient had shown a marked improvement in his condition, but there

were good grounds for keeping him in the establishment to continue his treatment. An additional note in column 6, which was reserved for the asylum doctor's monthly remarks, reads: "He [Vincent] told us that his mother's sister was epileptic, and that there were many cases in this family. What has happened to this patient would only be a continuation of what has happened to several members of his family."

Vincent's statement was made soon after he had written to Theo from Arles that he was mad *or an epileptic probably for good (though according to what I have heard, there are 50,000 epileptics in France, only 4000 of whom are confined . . .).*

The treatment at Saint-Rémy-de-Provence for epilepsy, as for other mental disorder, was hydropathic. This entailed long hours spent in the public bathroom. Even after Vincent had recovered from his first attack, he wrote: *I take a bath twice a week now, and stay in it for two hours; my stomach is infinitely better than it was a year ago; so as far as I know, I have only to go on.*

It cannot have been comfortable, even by Vincent's standards. *The food is so-so,* he wrote to Theo. *Naturally it tastes rather mouldy, like in a cockroach-infested restaurant in Paris or in a boarding-house. But even that must have been welcomed by the inmates: As these poor souls do absolutely nothing (not a book, nothing to distract them but a game of bowls and a game of checkers) they have no other daily distraction than to stuff themselves with chick peas, beans, lentils, and other groceries and merchandise from the colonies in fixed quantities and at regular hours.*

In some respects the reality was not so distressing as he had feared, and he gave Theo a very explicit account of his state of mind: *I am again—speaking of my condition—so grateful for another thing. I gather from others that during their attacks they have also heard strange sounds and voices as I did, and that in their eyes too things seemed to be changing. And that lessens the horror that I retained at first of the attack I have had, and which, when it comes on you unawares, cannot but frighten you beyond measure. Once you know that it is part of the disease, you take it like anything else. If I had not seen other lunatics close up, I should not have been able to free myself from dwelling on it constantly. For the anguish and suffering are no joke once you are caught by an attack. Most epileptics bite*

276

*their tongue and injure themselves. Rey told me that he had seen a case where someone had mutilated his own ear, as I did, and I think I heard a doctor here say, when he came to see me with the director, that he also had seen it before. I really think that once you know what it is, once you are conscious of your condition and of being subject to attacks, then you can do something yourself to prevent your being taken unawares by the suffering or the terror. Now that it has gone on decreasing for five months, I have good hope of getting over it, or at least of not having such violent attacks.*

Despite Vincent's optimism he was soon to suffer further attacks, no less severe than before.

## MIRACULOUS COURAGE

When Vincent crossed the threshold of the asylum, he felt at first that he had said good-bye to the world of normal men. He soon found that he was mistaken, for he could not escape from external impressions, let alone suppress his artistic passion. He had recognized this earlier when he wrote to Wilhelmien in the autumn of 1887: *if one has fire within oneself and a soul, they cannot be hidden under a bushel, and—one prefers being scorched to being suffocated. Because what one has within oneself "will out".*

This feeling returned to him, and provided the best remedy to alleviate his mental suffering. His letter to Wilhelmien had continued: *for me, for instance, it is a relief to paint a picture, and without it I should be more miserable than I am.*

From the asylum Vincent wrote to Theo: *Extreme enervation is, in my opinion, what most of those who have been here for years suffer from. Now my work will preserve me from that to a certain extent. . . . I have work in prospect again, for the scenery is lovely.*

Vincent's escape into his art still left him without intellectual links with his fellow-men. To compensate for this he now became even closer to nature than he had been in the past. The day after he arrived at the asylum he started painting. In the asylum garden he at once found some excellent subjects: some violet irises and a lilac bush. *The idea of work as a duty*, he wrote, *is coming back to me very strongly, and I think that all my faculties for work will come back to me fairly quickly.*

Release. Archives of Saint-Paul-de-Mausole asylum: Saint-Rémy-de-Provence, France. — Register with notes by the asylum doctor. Here Dr Peyron gives a résumé of Vincent's actions and mental condition from the time of his first attack of madness at Arles, when he cut off his ear, to the attack that took place after his trip to Arles from Saint-Rémy-de-Provence to collect his paintings and visit some friends. The last sentence of the report reads: "Today (May 16, 1890) he (Vincent van Gogh) requests his release to go and live in the north of France, in the hope that the climate will prove more favourable."

Vincent had, as I have mentioned, two cells. The cell that constituted his "bedroom" has no connection with what has been called "Van Gogh's Cell" and which has been shown to tourists as such. He himself described it as: *a little room with greenish-grey paper with two curtains of sea-green with a design of very pale roses, brightened by slight touches of blood-red.* He thought the curtains must be relics of *some rich and ruined deceased* and that a very worn but colourful armchair could be explained in the same

way. He added that: *Through the iron-barred window I see a square field of wheat in an enclosure, a perspective like van Goyen, above which I see the morning sun rising in all its glory.*

The other room, in which Vincent worked, was on the first floor, and from it he had a splendid view of the asylum garden and of the mountain range of the Alpilles, which stood out against the sky in a wildly jagged line.

Vincent painted what he could see framed in the window, but he left out the bars. This is one of the reasons why he returned to this subject so often. He looked out at the view to the left and to the right and painted in good and bad weather. The rain did not trouble him when he wanted to follow the example of Hiroshige's *Rain on the Bridge*, for he could easily keep his canvas and paper in the dry.

If Vincent's paintings and drawings are compared with the actual views, one can see how exactly he has placed each detail in its right place. Moreover these pictures convince one that they could only have been created when Vincent was in possession of all his faculties. He was not mistaken when he wrote to Theo: *I have some hope that with all that I know of my art there may come a time when I shall produce again, even though in an asylum.*

## WHEN THE STARS DANCED

I remember reading many years ago a remark by a Flemish art critic who complained that although such painters as Cézanne, van Gogh, and Gauguin were so well known they were really very little understood. "Even Vincent van Gogh," he wrote, "whose dramatic life has often been romanticized in a most appalling way, still holds surprises for us of a strictly artistic nature."

THE STARRY NIGHT (reproduced on page 302), a new version of an old subject, which Vincent painted soon after the landscapes I have just mentioned, is a striking confirmation of this. On June 19, 1889, Vincent wrote to Theo: *I have a landscape with olive trees and also a new study of a starry sky.* This was a culmination of his interest in the night sky that had begun in Arles with the painting of the place du Forum and the stars over the Rhône. Now, when Vincent was not suffering one of his attacks, he could watch the sky on a clear night through the window of his cell. It was the sky of his dreams. He longed for the freedom of the infinite, and saw not only with his eyes but with his whole being.

W. Jos de Gruyter, the Dutch art critic and great expert on Vincent's work, has well described THE

OLIVE PLANTATION. Saint-Rémy-de-Provence, 1889, oil on canvas, 72 × 92 cm, F 585, H 708. Kröller-Müller State Museum, Otterlo. Photograph A.I.v.G.—"Now the olive and the cypress," wrote Vincent, "have exactly the same significance here as the willow has at home."

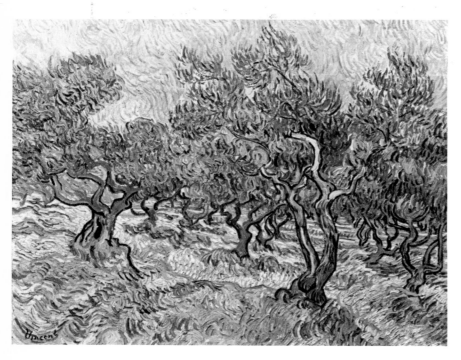

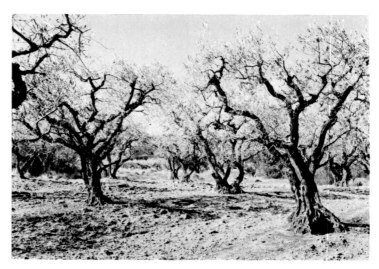

278

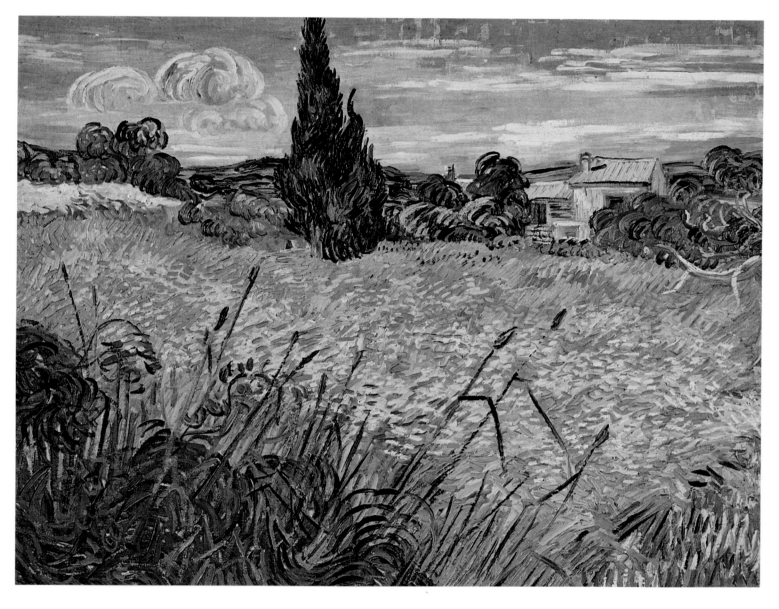

GREEN CORN. Saint-Rémy-de-Provence, June 1889, oil on canvas, 73 × 92 cm, F 719, H 610. National Gallery, Prague, Czechoslovakia.—Corn-fields have often inspired Vincent's work: he had painted them numerous times before, at Nuenen and at Arles. He was to draw inspiration from the same theme again the following year during the few weeks at Auvers-sur-Oise, notably for the famous CROWS ON THE CORNFIELD.

STARRY NIGHT: "From inner suffering this artist has expressed with overwhelming power the mysticism which was the supreme mark of his genius."

In the Arles version of THE STARRY NIGHT his vision had remained stable; in a peaceful firmament of deep blue the stars twinkled, but were motionless in space. In THE STARRY NIGHT painted at Saint-Rémy-de-Provence the stars join in a series of movements, they no longer twinkle gently in a quiet firmament, but dance like the currents in a tideway.

FROM REALITY TO FICTION

When Vincent created THE STARRY NIGHT he bridged the gap between reality and dream. If one compares what Vincent actually saw, and which is still to be seen at Saint-Rémy, with the poetic flight that he derived from it, one sees that reality, without any loss of truth, has given way to a new dimension, the dimension of dreams and of harmony in all things. The top of the cypress on the left of the picture

A WINDOW IN THE ASYLUM. Saint-Rémy-de-Provence, 1889, pencil. Vincent van Gogh Foundation, Amsterdam. Note the window-bars.

With bars. Photograph A.I.v.G.—This view, taken from the very spot where he was, shows that it was impossible for van Gogh to look out on the landscape, which he painted so often, except through bars.

Without bars. Photograph A.I.v.G.—From his cell Vincent could see the walled garden of the cloister, with the Alpilles in the background.

belongs to the real Provençal landscape. Vincent placed it where he did in order to form a sort of corridor and to push the roofs of the houses and the church tower back as far as possible into the distance. He experimented with this device in Paris in the views out of the window of his studio in the rue Lepic, influenced no doubt by the perspectives in Japanese prints; and he used it in composing his VIEW OF THE ARENA at Arles.

The panorama of the town as he has depicted it existed only in his imagination, for the church tower was not as pointed as he has painted it. Perhaps it is a reminiscence of the spires in the north. This transposition, which is certainly deliberate, is a gentle reminder of Vincent's homesickness, which he did not openly admit, though he was soon to call several works REMINISCENCE OF THE NORTH.

Beyond the objects in the foreground of THE STARRY NIGHT rise the mountains. But they are not the Alpilles, which are really on the other side, they are imaginary mountains. The landscape is no more real than the sky that Vincent has imagined above it.

The centre of the firmament is dominated by an eddying spiral nebula surrounded by eleven brilliant stars, and in the top right-hand corner there is a shining globe that sets a riddle. Is it the moon or the sun—or both at once? Meyer Schapiro, who considers that this picture is inspired by a religious mood, says it is "a confused memory, perhaps, of an eclipse" and recalls that Vincent had quoted Hugo's dictum, "God is a lighthouse in eclipse."

It seems rather to be the union of the two heavenly bodies in a single image. Heinz Graetz has devoted a lengthy chapter to THE STARRY NIGHT in which he considers that both the spiral nebula and the crescent moon symbolize the love between man and woman.

Graetz maintains that the crescent moon is merely a confirmation of the two clouds in the centre. Moreover the strange shape of the moon recalls an old Chinese symbol, known as the Yin and the Yang, which represents the union between opposites.

Be that as it may, it was undoubtedly at this moment of Vincent's career, during his "visionary madness" that this whirling firmament of suns and wandering tumbled landscape reveals most clearly the extraordinary penetration of his art. A freedom of spirit is joined to a freedom of expression so daring that it would never be surpassed.

280

THE WALLED GARDEN OF THE CLOISTER. Saint-Rémy-de-Provence, 1889, reed and Indian ink, 47.5 × 56 cm. Middelburg Museum, Netherlands.

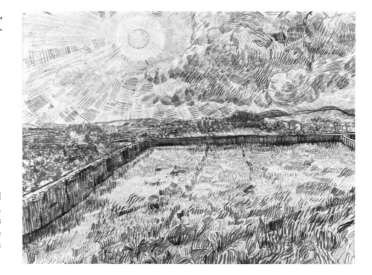

FIELD OF SPRING WHEAT AT SUNRISE. Saint-Rémy-de-Provence, March-April 1890, oil on canvas, 72 × 92 cm, F 720, H 662. Kröller-Müller State Museum, Otterlo.—In no other landscape has Vincent laid such a strong stress as he has done here on the line of the wall enclosing the cloister garden; the diagonal dominates the picture. It is one of Vincent's works which shows him anticipating Fauvism—or Expressionism both French and German.

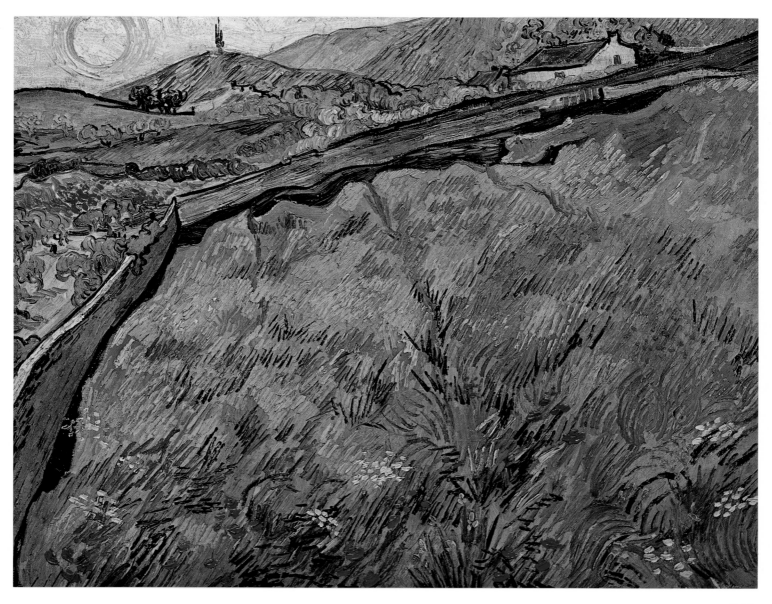

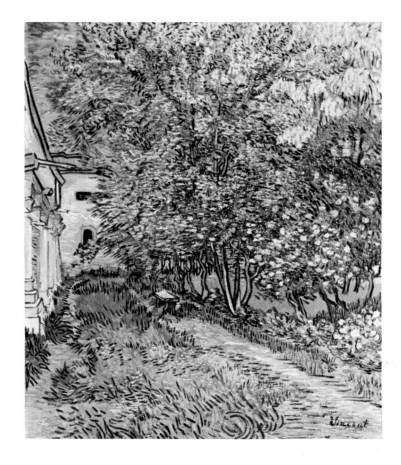

THE PARK OF THE ASYLUM (RIGHT-HAND SIDE). Saint-Rémy-de-Provence, May-June 1889, oil on canvas, 95 × 75 cm, F 734, H 741. Kröller-Müller State Museum, Otterlo. Photograph A.I.v.G.—The photograph shows the difference between the camera's eye and the poet's.

## RETURN TO THE SOURCE

In this picture Vincent has exalted real elements and carried them beyond our experience. He has thrown matter and light into the crucible and revealed the vast movement of the birth of a universe. He was undertaking something which most of his fellow-artists could not have conceived, and in doing so he became one of the greatest painters of the nineteenth century and perhaps of all time.

Yet the origin of this "apocalyptic fantasy", as Meyer Schapiro called it, may have been due to a literary influence. In a letter to Wilhelmien written in September or early October 1888, shortly before Gauguin arrived at Arles, Vincent wrote: *Have you read the American poems by Whitman? I am sure Theo has them, and I strongly advise you to read them, because to begin with they are really fine, and the English speak about them a good deal. He sees in the future, and even in the present, a world of healthy, carnal love, strong and frank—of friend-ship—of work—under the great starlit vault of heaven a something which after all one can only call God—and eternity in its place above this world.*

Vincent could hardly have provided a better description of his picture than that key phrase: *under the great starlit vault of heaven something which after all one can only call God.* This also seems to show that Whitman may have provided the germ of inspiration for this painting, a view that I first discussed with Paul van Ostaijen, the poet, in 1918, forty years before I first had a chance to read Vincent's letter to Wilhelmien.

## A GLIMPSE OF DEATH IN THE SKY

In his contemplation of the starry skies, which he had attempted to fathom just as he had tried to penetrate every other natural object, he had begun to feel that there was some intangible association between stars and death.

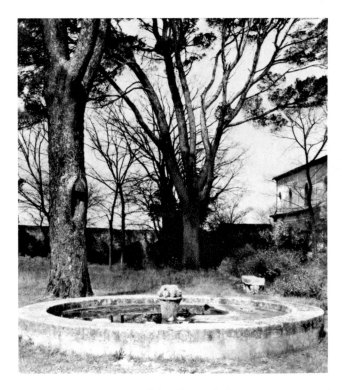

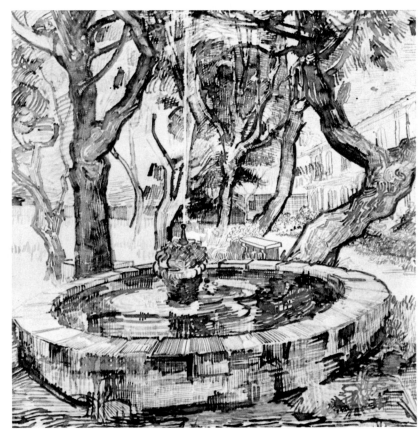

FOUNTAIN IN THE PARK. Saint-Rémy-de-Provence, 1889, reed and Indian ink, 45 × 48 cm, F 1531. Vincent van Gogh Foundation, Amsterdam. Photograph A.I.v.G.—The fountain still exists, though it has suffered over the years.

In a letter to Theo written the previous July he had been considering how all artists in all the arts were unfortunate in material things, and he went on: *That brings up again the eternal question: Is the whole of life visible to us, or isn't it rather that this side of death we see only one hemisphere? Painters—to take them alone—dead and buried speak to the next generation or to several succeeding generations through their work. Is that all, or is there more to come? Perhaps death is not the hardest thing in a painter's life. For my own part, I declare I know nothing whatever about it, but looking at the stars always makes me dream, as simply as I dream over the black dots representing towns and villages on a map. Why, I ask myself, shouldn't the shining dots of the sky be as accessible as the black dots on the map of France? Just as we take the train to Tarascon or Rouen, we take death to reach a star.*

Looking at the stars made him dream, not that man might soon reach some of the heavenly bodies as prosaically as if he had taken a train, but mystical, metaphysical dreams. These had their repercussions in the first version of THE STARRY NIGHT, which he painted only a few weeks after he wrote this letter, and even more in the Saint-Rémy version.

The Arles picture was Vincent's first venture into a new territory and led the way to the second version, which would have been inconceivable if Vincent had not suffered visions of death after his attack on Christmas Eve 1888.

In the letter in which Vincent first mentioned the Saint-Rémy-de-Provence version of THE STARRY NIGHT to Theo, he went on to write: *Though I have not seen either Gauguin's or Bernard's last canvases, I am pretty well convinced that these two studies I've spoken of are parallel in feeling.* (The second of these studies was a landscape with olive trees.)

In the last chapter I described Gauguin's pictorial conception as "compounded of natural elements mingled with products of his imagination". In the Saint-Rémy-de-Provence version of THE STARRY NIGHT Vincent's method was the same. His picture was an amalgam of fact and fiction.

## A PRAYER TO THE RAYS OF THE SUN

All men, and artists particularly, are inclined to consider themselves as the principal object of their labours. Vincent was no exception, and his work, more than that of any other painter, must be studied in the light of his unusual character.

The olive trees, which he painted at about the same time as THE STARRY NIGHT, provides a convincing example of this. Van Gogh felt perhaps that he was a brother of the tree that Rodin said had been so battered by the wind that it was the very silhouette of misery. When one studies the recurrent features in Vincent's work one finds that he preferred to draw and paint trees that had been scarred by the weather; this was in the tradition of the great Dutch landscape-painters.

This cultural heritage may have led him to become a specialist in olive trees, for no one ever painted this typically meridional tree better. Whether he

THE PARK OF THE ASYLUM (LEFT-HAND SIDE). Saint-Rémy-de-Provence, October 1889, oil on canvas, 73 × 92 cm, F 660, H 669. Folkwang Museum, Essen-Ruhr, German Federal Republic. Photograph A.I.v.G.—The photograph on page 285, which was taken from exactly where the painter stood, shows every detail: the front of the building, the trees, the seat, the wall and the Alpilles.

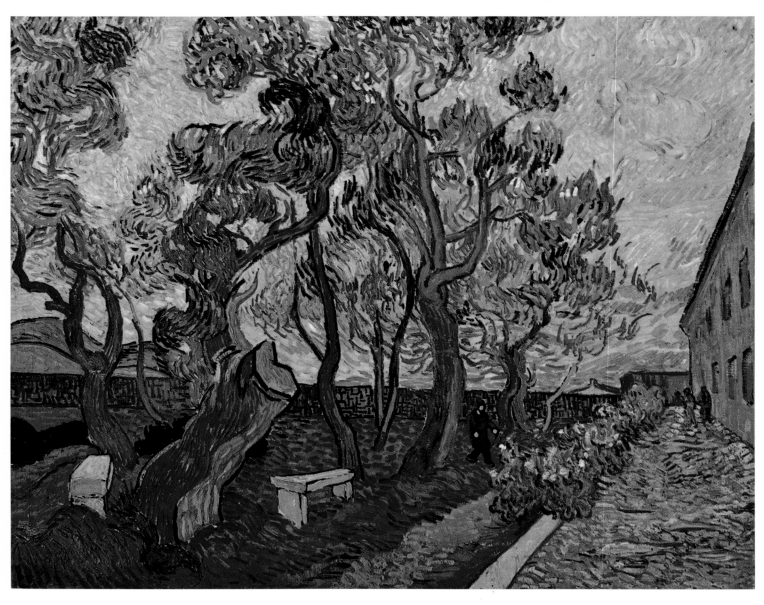

was fascinated by the ancient knotty trunk or enchanted by the solemn poetry of the silver branches, the olives held a particular spell for him.

When Vincent looked at these "warm and gentle wisps of vapour" as Renoir called them, he was so enamoured of the sun and aware of it flaming among the twisted olive trees, brandishing their branches like tormented giants, that he also saw the heat. He tried to make this intangible quality visible by showing the sun burning through the branches threatened by gusts of wind. He was expressing the heat and light of the sun and the force of the wind which struck at his own senses and depicting the way they seized the whole of nature.

Vincent did not have to go far from the asylum to see the olive trees in all their glory. As soon as he left the building he saw two fields to left and to right of him, each containing hundreds of splendid trees. And it was probably there, only a few yards from the door, that he set up his easel.

Intoxicated by the tormented shapes and almost indefinable colours, Vincent strove to possess these new wonders of creation that he had just discovered; and with his infallible eye he succeeded in making them seem like visions of heaven. No painter before him had evoked the beauty of Provence with such telling vigour. And nowhere else is his undulating line, so characteristic of his draughtsmanship at this period, so strong and authoritative.

Vincent seized on that part of the universe outside himself which was mingled with his own image. His search for God had led him along strange paths, and, beyond the frontiers of reason, he had discovered and expressed the ecstasies that he was unaware were within him.

Vincent had the faculty of registering what he saw around him in a completely personal way. To do this required long experience, for seeing in this sense is much more than opening one's eyes and looking at a thing or a scene. "Man sees only what he imagines," wrote Paul Valéry. Truly to see is both to understand and to be aware.

At such a moment the artist has an imperative need to communicate his emotion, man being but a lonely island in the vast ocean. To do so, he must speak in a universal language, unrestricted by frontiers or by time. When Vincent did this he united man with the world, and man to man; and after Provi-

dence had at first led him mysteriously out of his way, he at last carried out his initial religious ideal.

His lack of eloquence had prevented him from expressing from a pulpit in the Borinage his emotions, his beliefs, his elevation of mind and his devotion to beauty. But, with rare powers of expression, he had succeeded in doing so in his pictures.

Martin Buber tells how a devout father asked his son: "What do you pray with?" And the son replied: "What do you do, father?" The father answered: "I pray with the floor and the bench." This exactly applies to Vincent's religious state of mind during the last years of his life. He no longer went to church, but he prayed wherever he happened to be, with the chairs in "The Yellow House" at Arles, and with those in the cells of the asylum at Saint-Rémy-de-Provence, with the olive trees in the Alpilles and with the wheatfields at Auvers-sur-Oise.

## PSYCHIATRIC DIAGNOSES

Vincent adapted himself far better than one would ever have expected to his new surroundings. He told Theo that his work was going well, and he was not easily content with what he had done; he also said that he had discovered things for which he had searched in vain for many years. The work he did during his first weeks at Saint-Rémy confirms this.

But this creative period did not last long. On July 6, Vincent was allowed to spend a day at Arles; as usual he was accompanied by a warder. He

collected a number of canvases to send to Theo. He had also hoped to see Pastor Salles and Dr Rey, but the pastor had gone on holiday and the doctor was not to be found.

A few days after this outing, Vincent felt his mind give way once more. While he was working on a subject for a landscape in the fields he was suddenly smitten by a new crisis. The acute phase of this attack lasted until the end of July, but the period of prostration and mental despair which usually followed the initial period lasted well into August.

From Vincent's letters to Theo, his mother and his sister, as well as from Theo's letters to him, we learn that Vincent suffered three attacks at Arles. These covered the periods from December 24, 1888 to January 19, 1889; from February 4 to 18,

PRISONERS EXERCISING (AFTER GUSTAVE DORÉ). Saint-Rémy-de-Provence, February 1890, oil on canvas, 80 × 64 cm, F 669, H 690. Pushkin Museum, Moscow, U.S.S.R.—This picture was painted from an engraving by Gustave Doré in his book, *London*. The face of the prisoner in the centre of the picture and looking towards one is Vincent's.

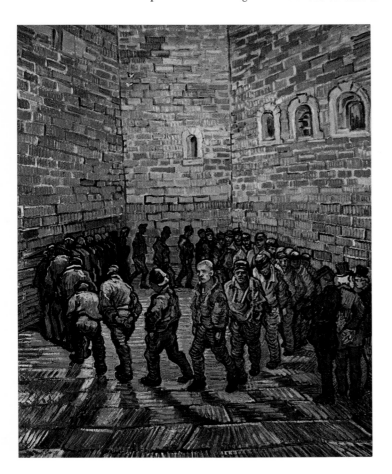

and February 26 to mid-April, 1889. There were four crises at Saint-Rémy-de-Provence; these lasted from July 8 to the middle of August, 1889; December 24, 1889, to January 1, 1890; January 23 to 30, and mid-February to mid-April, 1890. Each time Vincent seemed for a few days as if he was quite distracted. Then, little by little, his mental and physical forces would return, until sometimes they seemed almost too strong.

It is interesting to consider the question of Theo's health and its relevance to Vincent's. In a lecture to the French Language Congress of Psychiatry and Neurology at the Hôtel de Sade at Saint-Rémy-de-Provence on September 10, 1964, I was able to show that Vincent's and Theo's mental and physical disabilities were similar in every respect. Moreover their younger sister Wilhelmien spent most of her life in establishments for neuropaths. There were therefore three members of the family who exhibited symptoms of varying degrees of mental disorder. The significance of this is inescapable. Even if we take into account that both brothers contracted venereal disease (Vincent in Antwerp, and Theo in Paris), the probability of hereditary influences seems to be overwhelming.

This very important factor of heredity may explain why Vincent's nervous attack on Christmas Eve was not as harmless as it seemed at first from the initial reports of Dr Rey, whose diagnosis was far too optimistic. But to give a final answer to this question is difficult for even today the experts are far from agreeing about Vincent's illness. When my late friend Dr G. Kraus, Professor of Psychiatry at Groningen, and chief doctor at the hospitals and clinics of that town, published his well-documented essay "Vincent van Gogh en de Psychiatrie" in *Psychiatrische en Neurologische Bladen* in 1941, the bibliography concerning the diagnosis of Vincent's mental disorder included more than a hundred titles. Since then the number has increased considerably.

EPILEPSY OR SCHIZOPHRENIA?

The experts are still interested in the problem, and young students are still awarded doctorates for theses on this complicated question. I will summarize the diagnoses that have been put forward:

Epilepsy by Birnbaum, Evensen, Leroy, Doiteau, Koopman, Minkowska and Mayer-Grosz. Schizophrenia by Jaspers, Westerman Holstijn, Riese, Prinzhorn and Schilder.

Other experts have made more complex diagnoses: Thurler speaks of a suppressed form of epilepsy, Riese of episodic twilight states, Doiteau and Leroy of epileptoid psychosis, Prinzhorn of a singular case of dementia, Boiten of psychopathy, Hutter of a psychosis of degeneration and Kahn's schizoform reaction, Bader of a cerebral tumour, Lange Eichbaum of an active luetic schizoid and epileptoid disposition, Rose and Mannheim of phasic schizophrenia, Bychowski of dementia praecox, Dupinet of meningo-encephalitis luetica, Vinchon of a psychotic-exhaustion caused by great creative effort, Storch of an atypical psychosis heterogeneously compounded of elements of epileptic and schizoid disposition, Stertz of phasic hallucinatory psychosis, Kerschbaumer of schizophrenia—probably of a paranoid type, Fels and Grey of neurasthenia, Grey of chronic sunstroke and the influence of yellow, Gastaut of psychomotor epilepsy.

Other doctors have spoken of dromomania, maniacal excitement, turpentine poisoning, the influence of the Provençal sun and hypertrophy of the creative forces. To all this we should add the diagnoses of the doctors who treated Vincent in 1888, 1889 and 1890: Dr Urpar, director of the hospital at Arles, spoke of "acute mania with generalized delirium"; Dr Rey, the house-surgeon in the same hospital, found there were "epileptic crises" and Dr Peyron, director of the Saint-Paul-de-Mausole asylum at Saint-Rémy, spoke of "attacks of epilepsy".

This welter of medical and psychiatric opinion hardly helps to elucidate the nature of Vincent's illness, indeed it is a warning to be extremely cautious about expressing any definite diagnosis.

Georges Charensol seems to me to be right when he says that Vincent's own analysis of his illness is the most perceptive and informative. There are also his works of art, which show that after his attacks Vincent became astonishingly lucid again and was thus able to create pictures of a serenity that cannot fail to strike the spectator.

Inside the asylum buildings, and within its southward-facing park and its kitchen garden, Vincent enjoyed relative freedom. He could paint wherever he liked within these precincts, and several canvases of different parts of the park were the result. Some are among the most representative of his works.

## HE WHO GETS KICKED

Dr Peyron kept his promise to allow Vincent to paint in the neighbourhood of the asylum. He was therefore able to get right away from the big common hall, which he compared in his letters to *a third-class waiting room in some stagnant village, the more so as there are some distinguished lunatics who always wear a hat, spectacles, and a cane, and travelling cloak, almost like at a watering place, and they represent the passengers.*

ON THE THRESHOLD OF ETERNITY. Saint-Rémy-de-Provence, May 1890, oil on canvas, 81 × 65 cm, F 702, H 719. Kröller-Müller State Museum, Otterlo.—A memory of an old idea: Vincent had drawn two pictures on the same theme while at The Hague, and there is also a lithograph entitled "AT ETERNITY'S GATE".

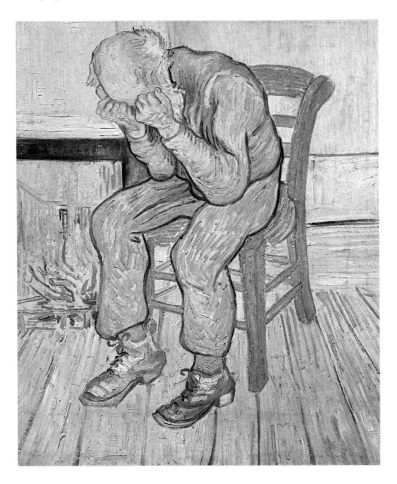

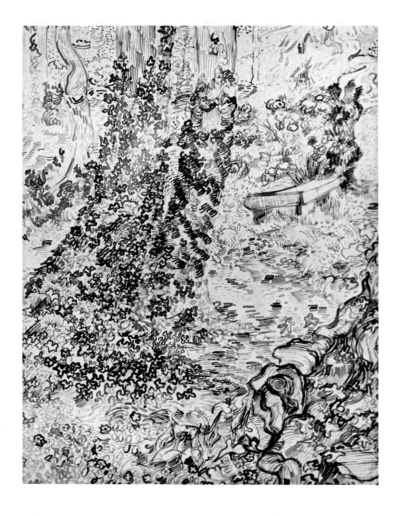

TREES AND IVY. Saint-Rémy-de-Provence, 1889, reed and Indian ink, 62.5 × 47 cm, F 1522. Vincent van Gogh Foundation, Amsterdam. Photograph A.I.v.G.—The big trees now standing in the park of the asylum are still covered with ivy.

The doctor insisted that to begin with Vincent should be accompanied on his excursions by one of the asylum warders. The man detailed for this task was Jean-François Poulet, who was then aged twenty-seven. Thanks to this guide, who knew Saint-Rémy-de-Provence and the surrounding countryside well, Vincent's outings proved very profitable.

Vincent's chaperon was amenable and willing, and as a result Vincent sometimes went a considerable distance from the asylum, as far for instance as "Les Peyroulets" west of the Alpilles, which are the subject of the picture seen on page 291. It is surely not merely due to chance that the background of Vincent's painting of THE GOOD SAMARITAN after Eugène Delacroix somewhat resembles the valley of "Les Peyroulets".

I met Poulet at Saint-Rémy-de-Provence some years ago. He was then a sturdy and alert old man of ninety who had become a roadmender in 1890,

and in his retirement he was to be found every day sitting on a stone bench in the plateau des Antiques, just opposite the asylum. He was a picturesque figure, especially when he wore his shepherd's cloak.

"Vincent was a good fellow," he would reply when asked about the painter, "though he was strange and silent. When he was painting he forgot his sufferings and scorned all the rest."

An odd thing happened one day. Van Gogh and Poulet were coming back from an outing; they were just going up the stairs, when Vincent, who was in front, suddenly turned round and gave Poulet an almighty kick in the stomach. Poulet, who was used to the odd habits of the asylum inmates, said nothing about it. Next day Vincent said: *Yesterday, chief, I swung a kick at you. Please forgive me, I had the Arles police after me.*

Another day, when he went to fetch Vincent for dinner, Poulet found him with staring eyes and foam-

CORRIDOR IN THE ASYLUM. Saint Rémy-de-Provence, 1889, gouache and water-colour, 65 × 49 cm, F 1529. Museum of Modern Art, New York.—In the photograph one can see bars on the right and a grille in the corridor, but in his water-colour Vincent has deliberately omitted them.

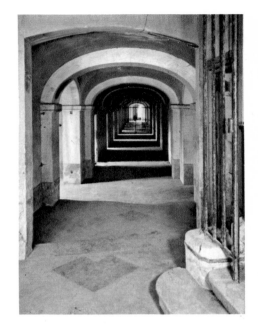

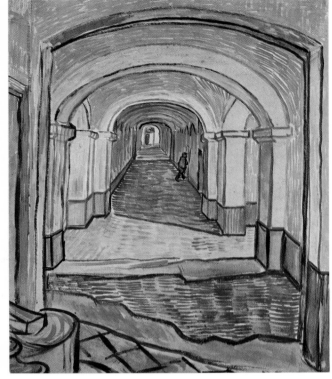

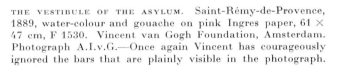

THE VESTIBULE OF THE ASYLUM. Saint-Rémy-de-Provence, 1889, water-colour and gouache on pink Ingres paper, 61 × 47 cm, F 1530. Vincent van Gogh Foundation, Amsterdam. Photograph A.I.v.G.—Once again Vincent has courageously ignored the bars that are plainly visible in the photograph.

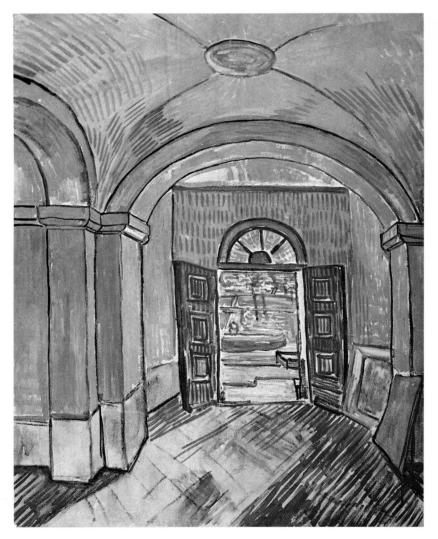

PIETÀ (after Eugène Delacroix). Saint-Rémy-de-Provence, September 1889, oil on canvas, 73 × 60.5 cm, F 630, H 625. Vincent van Gogh Foundation, Amsterdam. Photograph A.I.v.G.—Vincent has given Christ his own features and the Mater Dolorosa those of Sister Epiphany (Madame Deschanel) the Mother Superior of the cloister, thus paying tribute to her goodness.

Les Fontettes. Photograph A.I.v.G.—Before the place was identified in which Vincent painted the picture (opposite) now known as "LES PEYROULETS" ("little saucepans" in Provençal), the work was entitled THE RAVINE or "LES FONTETTES".

THE WINDOW. Saint-Rémy-de-Provence, 1889, water-colour, gouache, oil and charcoal on pink Ingres paper, 61 × 47 cm, F 1528. Vincent van Gogh Foundation, Amsterdam. Photograph A.I.v.G.—Until the recent rebuilding of the asylum this window could still be seen as it was when Vincent painted it.

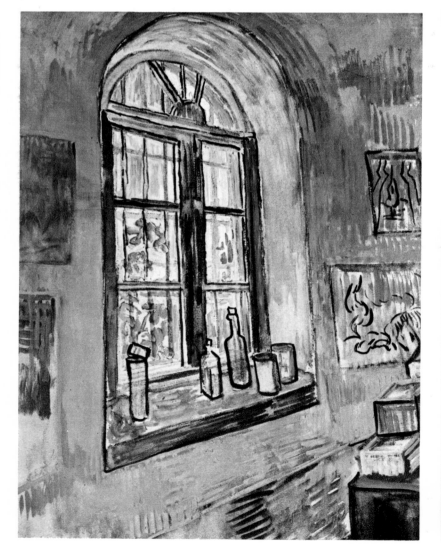

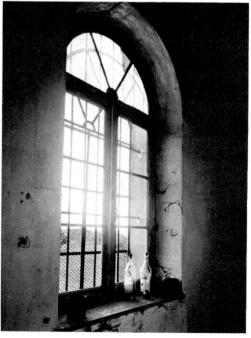

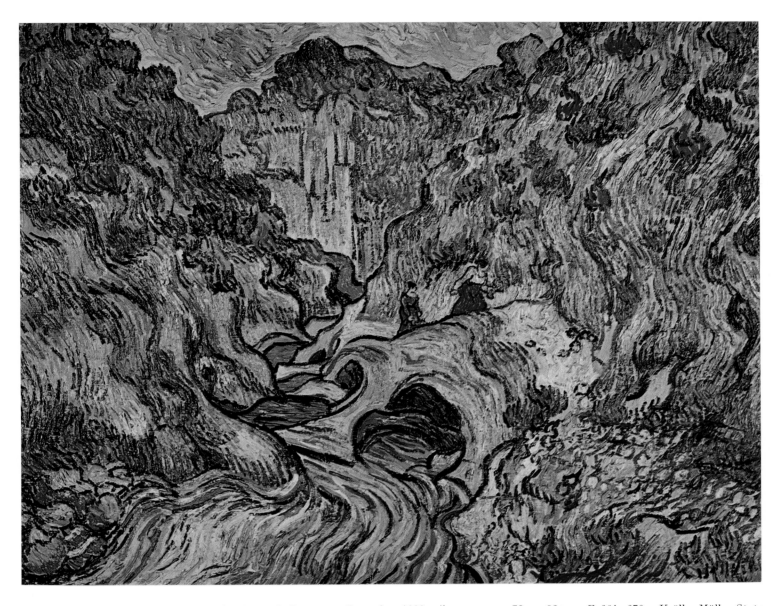

THE RAVINE ("LES PEYROULETS"). Saint-Rémy-de-Provence, December 1889, oil on canvas, 72 × 92 cm, F 661, 670. Kröller-Müller State Museum, Otterlo.—The wild landscape, which can also be seen in the photograph, is a long way from the asylum, and one wonders how Vincent was able to find it. Perhaps the warder who went with him on his walks showed him the way there.

ing lips: Vincent had been trying to eat his paints. Three tubes of them! Dr Peyron and Trabu (the chief superintendent of whom Vincent painted a remarkable portrait) and Poulet only just managed to save him. This was not the only incident of the kind. In the report that he wrote when Vincent left, Dr Peyron said: "He tried on several occasions to poison himself, either by swallowing the oil-colour he used for painting, or by drinking kerosene which he stole from the boy when he was filling the lamps."

When Vincent and Poulet went out together they would sometimes go into the town. There Vincent painted THE ROADMENDERS in the cour Mirabeau. It was probably inspired by Auguste Lançon's drawing, *A Party of Snow-Sweepers*, though Meyer Schapiro mentions that Manet had also painted men paving a road.

Poulet said that Vincent's greatest ambition was to sell one of his pictures, even if it were only for a miserable price. But nobody would buy. Vincent

told Poulet: *Before I came here, I offered pictures to butchers and grocers in exchange for something to eat. One or two of them gave me something, but they wouldn't take the pictures.*

When Vincent eventually went from Saint-Rémy-de-Provence to Paris and Auvers-sur-Oise, he left behind a few canvases in a case. Poulet saw what happened to them. Dr Peyron's son found the case and showed the canvases to his friend Henri Vanel. "What shall we do with them?" he asked. "We could use them as targets," Vanel replied. So the two young vandals stood the paintings up on the steps and shot holes in them. Only much later did they realize that they had destroyed a fortune.

## WITNESSES OF HIS MENTAL BREAKDOWN

One can follow the progress of Vincent's mental condition from his paintings of cypresses no less than from those of olive trees, for the cypress is also one of the beauties of Provence. The dark alleys between these tall trees, with the branches like black flames quivering under the heat of the southern sun, perhaps took the place of the pointed Dutch church spires in Vincent's mind.

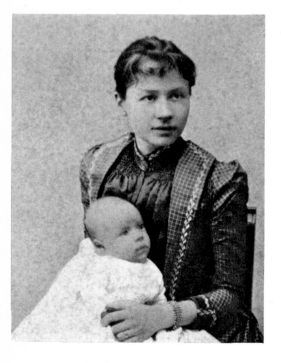

Johanna with her baby son. Photograph in the collection of Pastor J. P. Scholte-van Houten, Lochem, Netherlands.—This portrait was in a family album belonging to Wilhelmien and Anna van Gogh. After her husband died, Johanna, who was a most remarkable woman, devoted herself body and soul to ensuring that her brother-in-law's genius should be recognized. She prepared the editions of Vincent's letters to Theo entirely on her own, and even translated this vast correspondence into English herself. After her death, her son, Dr V. W. van Gogh, the painter's nephew and name-sake, has continued her work.

These flamboyant trees inspired Vincent to paint several remarkable pictures. At first, when he was at Arles, they did not play an important part in his landscapes. But at Saint-Rémy-de-Provence they suddenly began to dominate his compositions. On June 25, 1889, Vincent wrote to Theo that he had done two studies of cypresses in *that difficult bottle-green hue*, working their foregrounds thickly with white lead to give firmness to the ground. He added that: *The cypresses are always occupying my thoughts, I should like to make something of them like the canvases of the sunflowers, because it astonishes me that they have not yet been done as I see them. It is as beautiful of line and proportion as an Egyptian obelisk. And the green has a quality of such distinction.* Later in the same letter he wrote: *I think that of the two canvases of cypresses, the one I am making this sketch of will be the best. The trees in it are very big and massive. The foreground, very low with brambles and brushwood. Behind some violet hills, a green and pink sky with a crescent moon. The foreground especially is painted very thick, clumps of brambles with touches of yellow, violet and green.*

These remarkable pictures show how right Vincent was to paint cypresses under the watery sky one day when the Mistral blew a gale driving all before it. With masterly skill he has placed hundreds of small round brush-strokes in a rich impasto, so that these trees communicate something quite different from their purely decorative aspect.

They help us to penetrate the artist's inner life. The fire that smouldered within him and broke out in hallucinations of the senses has here been set down on canvas in a most striking fashion. The cypresses beating their branches like flames were for him not only an incarnation of demonic events, but also a deliverance from his misery. They sang to him through his pain.

The more Vincent was depressed, discouraged and wretched, the more dramatic the cypresses seem to become; in the end they cover the whole surface of the canvas, threatening to obliterate the beautiful landscape and almost to destroy it.

The brilliant yellows have been superseded by blue-greens which are so dark that Vincent wrote to Theo: *It is a splash of black in a sunny landscape, but it is one of the most interesting black notes, and the most difficult to hit off exactly that I can imagine.*

292

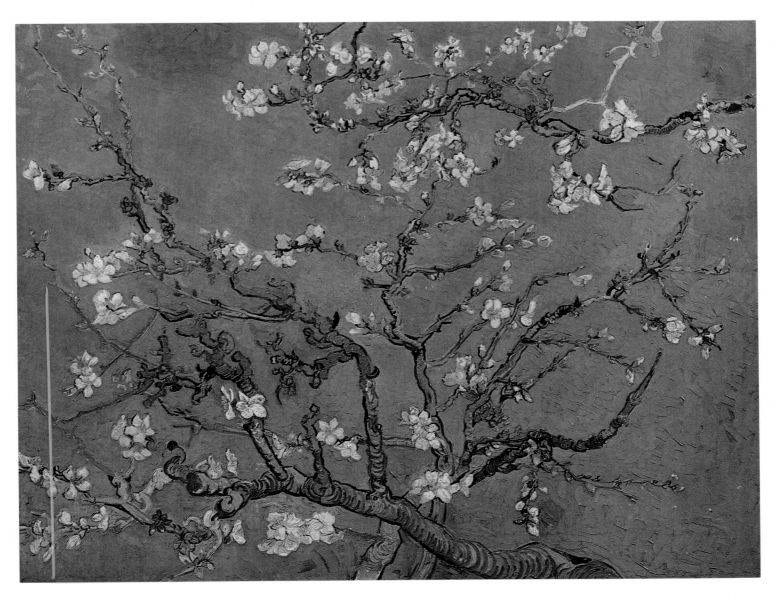

ALMOND-TREE BRANCH IN BLOSSOM. Saint-Rémy-de-Provence, February 1890, oil on canvas, 73 × 92 cm, F 671, H 688. Vincent van Gogh Foundation, Amsterdam.—After Theo's and Johanna's child was born, Vincent wrote to his old mother: "I imagine that, like me, your thoughts are much with Jo and Theo: how glad I was when the news came that it had ended well: it was a good thing that Wil stayed on. I should have greatly preferred him to call the boy after Father, of whom I have been thinking so much these days, instead of after me; but seeing it has now been done, I started right away to make a picture for him, to hang in their bedroom, big branches of white almond blossom against a blue sky."

## JOY IN THE STORM

For Vincent 1890 began under a happy sign. Never before had he felt so peaceful as he painted his pictures, and he told Theo so in the first letter he wrote that January: *I have never worked with more calm than in my last canvases—I hope you will receive some at the same time as this letter. . . .*

*Just now some pictures are ripe in my head, I see in advance the places that I still want to do in these months.* After the periodic relapses he had suffered in the previous months, these were hopeful signs, even though Vincent admitted in the same letter that he was *overcome with discouragement.* Yet he patiently worked on, almost resigned to the prospect of his work never being appreciated in his lifetime.

293

## Translation of letter from Vincent to Albert Aurier:

Dear M. Aurier, Many thanks for your article in the "Mercure de France", which greatly surprised me. I like it very much as a work of art in itself, in my opinion your words produce colour, in short, I rediscover my canvases in your article, but better than they are, richer, more full of meaning. However, I feel uneasy in my mind when I reflect that what you say is due to others rather than to myself. For example, Monticelli in particular. Saying as you do : "As far as I know, he is the only painter to perceive the chromatism of things with such intensity, with such a metallic, gemlike lustre", be so kind as to go and see a certain bouquet by Monticelli at my brother's—a bouquet in white, forget-me-not blue and orange—then you will feel what I want to say. But the best, the most amazing Monticellis have long been in Scotland and England. In a museum in the North—the one in Lille, I believe—there is said to be a very marvel, rich in another way and certainly no less French than Watteau's "Départ pour Cythère". At the moment M. Lauzet is engaged in reproducing some thirty works of Monticelli's.

Here you are ; as far as I know, there is no colourist who is descended so straightly and directly from Delacroix, and yet I am of the opinion that Monticelli probably had Delacroix's colour theories only at secondhand ; that is to say, that he got them more particularly from Diaz and Ziem. It seems to me that Monticelli's personal artistic temperament is exactly the same as that of the author of the "Decameron"—Boccaccio—a melancholic, somewhat resigned, unhappy man, who saw the wedding party of the world pass by, painting and analyzing the lovers of his time—he, the one who had been left out of things. Oh ! he no more imitated Boccaccio than Henri Leys imitated the primitives. You see, what I mean to say is that it seems there are things which have found their way to my name, which you could better say of Monticelli, to whom I owe so much. And further, I owe much to Paul Gauguin, with whom I worked in Arles for some months, and whom I already knew in Paris, for that matter.

Gauguin, that curious artist, that alien whose mien and the look in whose eyes vaguely remind one of Rembrandt's "Portrait of a Man" in the Galerie Lacaze—this friend of mine likes to make one feel that a good picture is equivalent to a good deed ; not that he says so, but it is difficult to be on intimate terms with him without being aware of a certain moral responsibility. A few days before parting company, when my disease forced me to go into a lunatic asylum, I tried to paint "his empty seat".

It is a study of his armchair of sombre reddish-brown wood, the seat of greenish straw, and in the absent one's place there is a lighted torch and modern novels.

If an opportunity presents itself, be so kind as to have a look at this study, by way of a memento of him ; it is done entirely in broken tones of green and red. Then you will perceive that your article would have been fairer, and consequently more powerful, I think, if, when discussing the question of the future of "tropical painting" and of colours, you had done justice to Gauguin and Monticelli before speaking of me. For the part which is allotted to me, or will be allotted to me, will remain, I assure you, very secondary.

And then there is another question I want to ask you. Suppose that the two pictures of sunflowers, which are now at the Vingtistes' exhibition, have certain qualities of colour, and that they also express an idea symbolizing "gratitude". Is this different from so many flower pieces, more skilfully painted, and which are not yet sufficiently appreciated, such as "Hollyhocks", "Yellow Irises" by Father Quost? The magnificent bouquets of peonies which Jeannin produces so abundantly? You see, it seems so difficult to me to distinguish between Impressionism and [other things].

THE ROADMENDERS. Saint-Rémy-de-Provence, November 1899, oil on canvas, 74 × 93 cm, F 657, Museum of Fine Art, Cleveland, U.S.A. Photograph A.I.v.G.—The place painted by Vincent was the cour or the boulevard Mirabeau, and it still exists at Saint-Rémy-de-Provence. The trees are still there, enabling one to see how he created a special tension in the picture by giving them a wayward form.

Albert Aurier. This art critic wrote in the *Mercure de France*, and he was the first person outside the Netherlands to bring van Gogh's original talent to the notice of the public. Below is reproduced a letter written by Vincent in February 1890 thanking Aurier for his article. (See the translation on the opposite page.) Photograph and document in the collection of J. Williame, Châteauroux, France.

Cher Monsieur Aurier

Then one day Theo sent him an article which had appeared in the January number of the *Mercure de France* and in which Albert Aurier, a young poet and art-critic, had written a long and intelligent appreciation of a certain Vincent van Gogh. Was this recognition at last? Vincent was no doubt agreeably surprised by this belated discovery, but his reactions seem rather evasive, almost as if he was trying not to be involved even though it was a happy occasion.

He wrote to Theo on February 1: *I was extremely surprised at the article on my pictures which you sent me. I needn't tell you that I hope to go on thinking that I do not paint like that, but I do see in it how I ought to paint. For the article is very right as far as indicating the gap to be filled, and I think that the writer really wrote it more to guide, not only me, but the other Impressionists as well, and even partly to make the breach at a good place.*

A few days later Vincent wrote a letter to Aurier (see reproduction and translation on pages 294-295) in which he said: *However, I feel uneasy in my mind when I reflect that what you say is due to others rather than to myself.* When talking of "tropical" painting, Vincent added, he considered his role secondary to that of Monticelli or Gauguin.

These lines, written in humility and from a sense of justice, show that Vincent did not let his sudden, if small, taste of fame go to his head. His attitude, which is otherwise not easily explicable, has been analyzed by Dr Humberto Nagera, who explains that Vincent still unconsciously wished to identify himself with his father's image, even though he had at one time come to despise what he had once idealized.

"To be successful as a painter", wrote Nagera, "acquired the meaning of an aggressive act against his father especially after the innumerable quarrels between them. He felt that he must never do better or be more successful than his oedipal rival. On the other hand there was the fact that the Reverend did think that nothing very much would come of Vincent generally, or of his work as a painter in particular. And Vincent's work had to comply with these predictions, in part out of a childhood fear of the powerful father. His success would be like a terrible blow to his father who would thus be proved wrong for everybody to see ... by now, after his mental breakdowns, he was again thinking a great deal about his father and regretted much of his behaviour towards him."

## THE SUBCONSCIOUS SYLLOGISM

This piece of encouraging news was accompanied by another no less happy. The letter in which Vincent acknowledged the receipt of Aurier's article began with the words: *Today I received your good news that you are at last a father, that the most critical time is over for Jo, and finally that the little boy is well. That has done me more good and given me more pleasure than I can put into words. Bravo—and how pleased Mother is going to be.*

Vincent, who had always loved children, would be godfather to his little nephew, who would bear his name. But his satisfaction, although it was great and sincere, was not entirely unmingled. At the end of this letter Vincent wrote a sentence which from a psychoanalytical point of view is much more important than it at first appears: *Now as for the little boy, why don't you call him Theo in memory of our father, it would certainly give a great deal of pleasure to me.*

Dr Nagera points out that after the successive crises of the previous months the image of his father began once again to dominate Vincent's unconscious mind as it had done before. As Vincent still held Pastor Theodorus in very high regard, and did not forgive himself for having acted wrongly towards him, he resented the fact that his nephew was called Vincent instead of Theo, even though he did not reveal the true reasons for his disappointment.

Vincent seems to have suffered unconsciously at having missed a unique opportunity to link his deep gratitude to his brother with the rehabilitation of his father. His concern on this point continued.

A fortnight later, on February 15, he wrote to his old mother: *I should have greatly preferred him to call the boy after Father, of whom I have been think-*

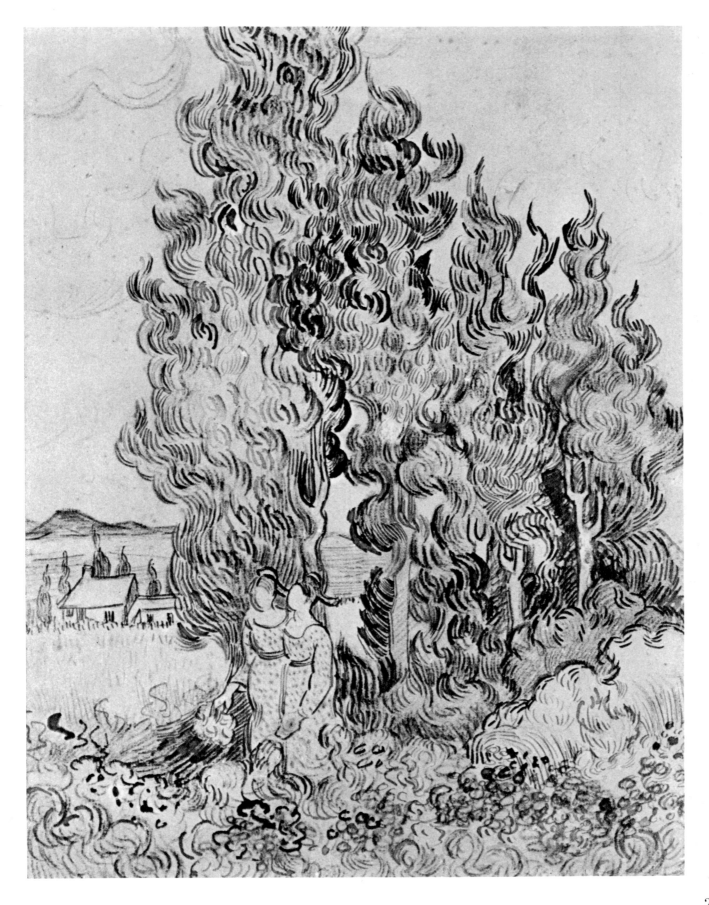

*ing so much these days, instead of after me; but seeing it has now been done, I started right away to make a picture for him, to hang in their bedroom, big branches of white almond blossom against a blue sky.*

This stress seems to have been too much for Vincent's nerves. At all events he suffered another attack which lasted until the middle of April. His lucidity returned by degrees, and in the first letter that he wrote to Theo after two months of insanity he said: *My work was going well, the last canvas of branches in bloom—you will see that it was perhaps the best, the most patiently worked thing I had done, painted with calm and with a greater firmness of touch. And the next day, down like a brute.*

On March 31, 1953, the centenary of Vincent's birth, my late friend, the philosopher and psychoanalyst Professor Charles Mauron of the University of Aix-en-Provence, gave a memorable lecture at the Municipal Museum of Amsterdam. He spoke of the symbiosis between the van Gogh brothers and the connection between certain events in Theo's life and the onset of the severest crises that struck Vincent.

Thus the depression that I have just mentioned occurred immediately after the birth of Theo's child. Mauron maintained, and the chronology of the facts seems to support his argument, that the dates of the crises at Arles and Saint-Rémy-de-Provence coincide with the arrival of the letters announcing Theo's engagement, his marriage and the birth of his child. The first mental breakdown on December 24, 1888, occurred on the very day of Theo's engagement, the last attack came after the birth of Theo's son.

Charles Mauron maintained that this was simply because on each of the occasions Vincent unconsciously formulated the syllogism: you are getting married, it is right that you should offer your love and your money to your wife and child, therefore I must withdraw, and withdrawal in the end means death. Theo cannot, of course, be blamed for the disastrous consequences of his acts, because he was quite unaware of his brother's unconscious processes.

Anna Boch. Photograph A.I.v.G.—The painter Anna Boch was the sister of Eugène, the Belgian painter whom Vincent visited at Fontvieille. At the exhibition of the XX at Brussels in 1889, she bought the now famous painting of THE RED VINES for hour hundred Belgian francs. Contrary to what is often said this was not the first picture that van Gogh sold, nor the only one sold during his lifetime.

## A LEGEND COLLAPSES

Only two weeks after Theo and Jo's child was born, Vincent had a letter from his brother with yet more good news. On February 15, 1890, Vincent wrote to his mother: *yesterday Theo wrote me that they had sold one of my pictures at Brussels for 400 francs.*

It had come about thus. In November Vincent chose the pictures that he wanted Theo to send to be exhibited with those of the XX (also known as the Vingtistes) a group of artists who exhibited in Brussels. *As for the Vingtistes,* he wrote, *here is what I'd like to exhibit: 1 and 2. The two companion pictures of Sunflowers. 3. The Ivy, perpendicular. 4. Orchard in Bloom (the one Tanguy is exhibiting just now), with a row of poplars across the canvas. 5. The Red Vineyard. 6. Wheat Field at Sunrise, on which I am working at the moment.*

In her book, *Trente années de lutte pour l'art*, Madeleine Octave Maus wrote of the XX Exhibition in 1890: "The pride of the group, Cézanne, went almost unnoticed, and van Gogh had the honour of attracting a scurrilously abusive press—what a

noise it made! On the other hand van Gogh made a profound impression on most of the Vingtistes."

One of Vincent's six pictures found a buyer. It was THE RED VINES, now in the Hermitage at Leningrad, which was bought by Anna Boch, the sister of Eugène who had visited Vincent at Arles. This sale greatly encouraged Vincent, especially when he learnt that it was his friend's sister, herself a painter, who had bought the picture.

On March 19, 1890, Theo told Vincent: "I received the money for your picture from Brussels, and Maus writes me, 'As soon as an opportunity presents itself please tell your brother that I was extremely glad of his participation in the Salon of the "XX", where he has found many lively artistic sympathies in the confusion of the discussions.'" Octave Maus and his colleagues did not forget Vincent. In 1891 they organized a "retrospective exhibition of the late

THE RED VINES. Arles, November 1888, oil on canvas, 73 × 92 cm, F 495, H 512. The Hermitage, Leningrad, U.S.S.R.—"But on Sunday if you had been with us," Vincent wrote to Theo, "you would have seen a red vineyard, all red like red wine. In the distance it turned to yellow, and then a green sky with the sun, the earth after the rain violet, sparkling yellow here and there where it caught the reflection of the setting sun."

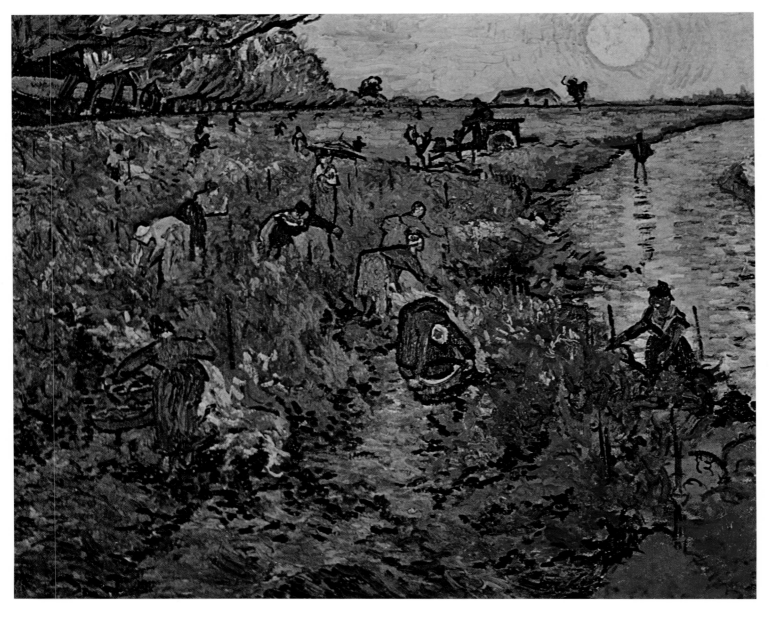

Vincent van Gogh" consisting of eight paintings and seven drawings. Even this modest offering of his work was enough to arouse a fanatically hostile press, so crudely vituperative that Octave Maus did not dare to send Johanna van Gogh-Bonger the press-cuttings, despite her repeated requests.

It had always been thought that THE RED VINES was the first and only picture that Vincent ever sold. But in 1964, when Zadkine's monument to Vincent and Theo was inaugurated at Zundert, I published in *De Gebroeders van Gogh* a letter which proved that this was not the case.

On October 3, 1888, Theo wrote to the London art-dealers, Sulley & Lori. In this letter he said: "We have the honour to inform you that we have sent you the two pictures you have bought and duly paid for: a landscape by Camille Corot, . . . a self-portrait by V. van Gogh." Another picture was therefore sold in England nearly fifteen months before Anna Boch bought THE RED VINES.

## SPIRITUAL RETURN TO THE NORTH

Despite all this good news, Vincent was plunged into dreadful despair. In the postscript to a letter to his mother and sister he wrote: *As soon as I heard that my work was having some success, and read the article in question, I feared at once that I should be punished for it; this is how things nearly always go in a painter's life: success is about the worst thing that can happen.*

The end of this revealing confession is a remarkable instance of what Dr Nagera called "Fear of success and fear of failure". If Vincent's artistic career proved to be a signal success, it would be a conclusive proof that his father had been wrong to oppose that career. But his father was still a taboo figure, and he must not be attacked in any way.

*What am I to say about these last two months?* wrote Vincent. *Things didn't go well at all. I am sadder and more wretched than I can say, and I do not know at all where I have got to.* And he added: *While*

REMINISCENCE OF THE NORTH. Saint-Rémy-de-Provence, April 1890, oil on wood, 29 × 36.5 cm, F 675, H 693. Drawing in black crayon, 31.5 × 24 cm, F 1593. Vincent van Gogh Foundation, Amsterdam.—"While I was ill," Vincent told Theo, "I nevertheless did some little canvases from memory which you will see later, memories of the North...."

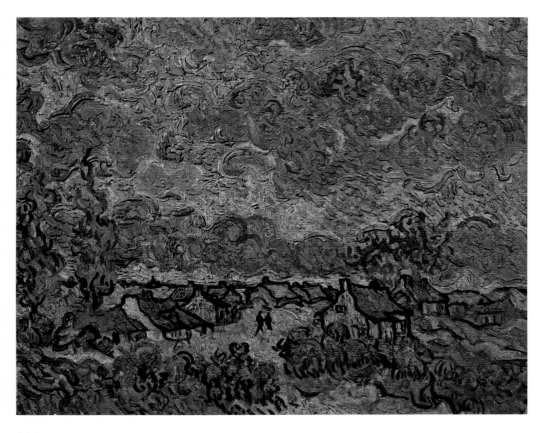

This splendid drawing, which de la Faille calls LANDSCAPE AT SAINT-RÉMY, was inspired by the same feeling of nostalgia. It is strange to see thatched roofs, unknown in Provence, together with cypresses, unknown in the north.

300

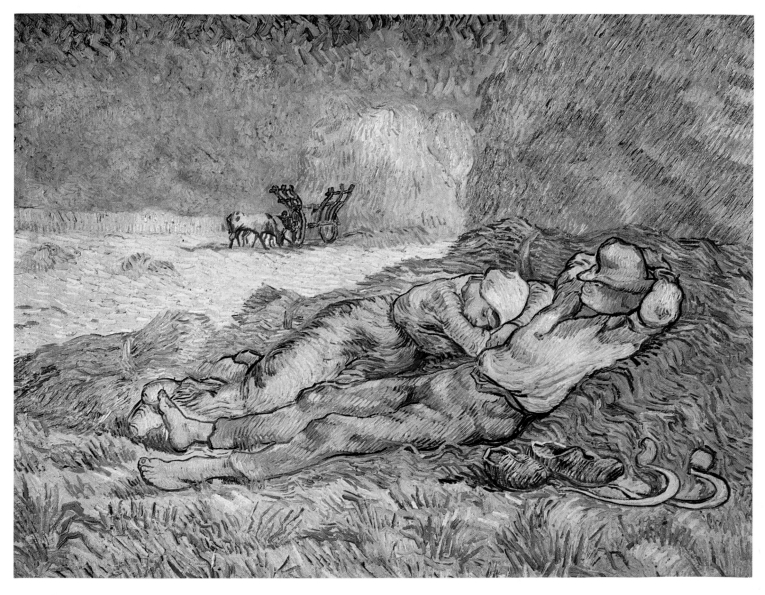

THE SIESTA. Saint-Rémy-de-Provence, December 1889, oil on canvas, 73 × 91 cm, F 686, H 677. Louvre, Paris.—A copy by Vincent of a wood-engraving by Lavieille after "The Four Hours of the Day" by Millet. It was "done out of a profound and sincere admiration for Millet".

*I was ill I nevertheless did some little canvases from memory which you will see later, memories of the North.*

Van Gogh described the pictures in a letter to his mother and sister: *I continued painting even when my illness was at its height, among other things a memory of Brabant, hovels with moss-covered roofs and beech hedges on an autumn evening with a stormy sky, the sun setting amid ruddy clouds. Also a turnip field with women gathering green stuff in the snow.*

Vincent started drawing and painting thatched cottages set in the Provençal landscape. The risk of

fire is far too great for anyone in Provence ever to think of thatching a cottage, nor are there turnip fields in the snow. In Vincent's mind the once-idealized father, the young man and the mature artist met as he surveyed the past. One remarkable feature of these pictures must be stressed. Although they reflect the artist's mental illness, so clearly described in his letters, they have been executed by a sane mind in full possession of its skills and faculties.

Vincent wrote to Theo: *Please send me what you can find of figure among my old drawings. I am*

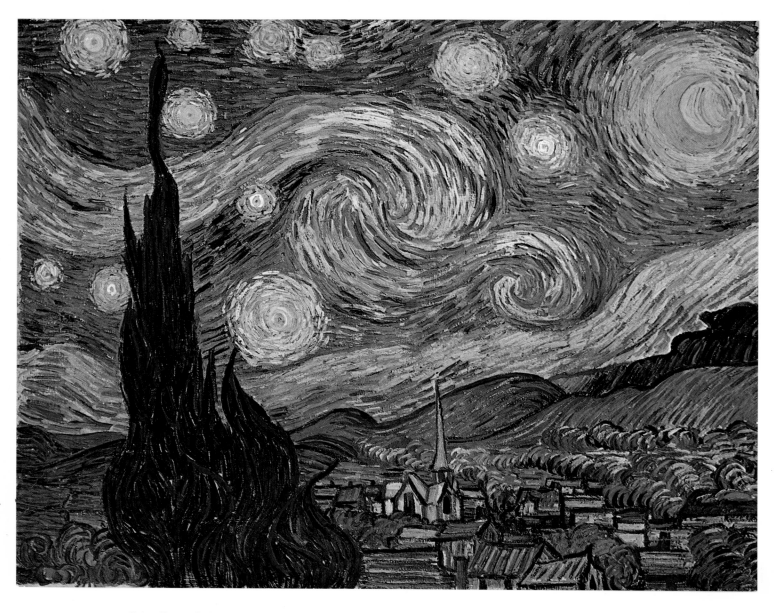

THE STARRY NIGHT. Saint-Rémy-de-Provence, June 1889, oil on canvas, 73 × 92 cm, F 612, H 612. Museum of Modern Art, New York.—Several of Vincent's biographers have attempted to explain the origin of this mysterious picture, but it seems that we shall never know the true answer.

*thinking of doing the picture of the peasants at dinner* [THE POTATO-EATERS], *with the lamplight effect again. That canvas must be quite black now, perhaps I could do it again altogether from memory.* He was feeling homesick for his native land, and did not conceal from his mother that he wanted to return to the north. He talked of going to Antwerp, as I have mentioned in the chapter on that city. He had already begun to think of going home, and soon he succeeded in moving to the north.

It is not difficult to understand Vincent's desire to leave the asylum as quickly as possible. When the "anthropophagi of Arles" seemed to be closing in around him, Vincent felt like a hunted animal that does not know where to hide. Then he was glad to exchange his liberty for the safety of the asylum. But as the threat retreated his longing for freedom returned and grew stronger. He wanted to be rid of the unhealthy atmosphere of his prison and to be a free man once again.

# NORTH TOWARD HOME

For a long time Theo had been trying to find another place where Vincent could live in the country nearer Paris. At one time he had thought of appealing to Pissarro, who was understanding and hospitable. Vincent approved of this idea enthusiastically, for he saw it as an opportunity to make contact with another talented painter. *It is queer*, Vincent told Theo in the postscript of a letter written in the first half of September 1889, *that already, two or three times before, I had had the idea of going to Pissarro's; this time, after your telling me of his recent misfortunes, I do not hesitate to ask him.* He was replying to a letter of September 5, in which Theo had written: "A short time ago he [Pissarro] lost his mother, who was very old, and yet it was a hard blow for him; he also had an operation performed on one of his eyes, but I do not think it was improved by it. He is still wearing some kind of blinkers, which bothers him a good deal."

Once again the question of Vincent moving had arisen. He felt overwhelmed by being surrounded by madmen, and had decided it was time to leave the asylum. In the letter quoted above he left the matter in no doubt when he wrote: *Yes, we must be done with this place, I cannot do the two things at once, work and take no end of pains to live with these queer patients here—it is upsetting.* But Vincent was prepared to be patient; he was in no hurry, for Dr Peyron had warned him that an attack of madness was likely to return. And Vincent admitted *I myself rather expect it to return.* He looked forward to the approach of Christmas with some apprehension, and on September 4 or 5 he had written: *I will go on working very hard and then we shall see if the attack returns about Christmas, and that over, I can see nothing to stop my telling the management here to go to blazes, and returning to the North for a longer or shorter time. To leave now, when I judge a new attack next winter probable would perhaps be too risky.*

The attack which Vincent had expected duly took place, but it did not last long. After a week, Vincent had recovered, but it was only a short remission. Three weeks later he was struck down by a new attack which lasted until the end of January. A third attack of madness lasted from the middle of February to the middle of April. This last attack came on during a visit to Arles, where he wanted to say goodbye to the Ginoux and to see a sick friend. On February 24, Dr Peyron told Theo that Vincent had had to be brought home in a coach, because he had no memory at all of where he had spent the night, although he had been away for two days. These successive attacks prevented Vincent from journeying northward, but the idea was not ruled out altogether.

AT THE COUNTER. Auvers-sur-Oise, June 1890, pencil, 13.3 × 33 cm, F 1654. Collection of E. Buckman, Richmond, U.S.A.—A page from Vincent's last drawing-book.

Ravoux's restaurant in 1890. Photograph A.I.v.G.—The proprietor of the restaurant, Arthur Gustave Ravoux, is sitting at the far left and his daughter Adeline is standing in the doorway of the café.

ADELINE RAVOUX. Auvers-sur-Oise, June 1890, oil on canvas, 67 × 55 cm, F 768, 767. Coll. of J. R. Oppenheimer, New York.

Adeline Ravoux. Photograph A.I.v.G.—This photograph was taken when she was thirteen. She sat for Vincent several times. Many years later, when she was over seventy years old, one could still recognize her as the woman that Vincent had once painted. She died in 1965 at the age of 88.

Arthur Gustave Ravoux. Photograph A.I.v.G.—Shortly after Vincent's death he left Auvers-sur-Oise and settled at Meulan.

304

Meanwhile Theo had not been idle. Pissarro had told him of a doctor who spent his spare time painting, drawing and engraving. He was a man of unusual character named Paul-Ferdinand Gachet. In the art world he was better known by his pseudonym, Paul van Ryssel, derived from the Flemish name of Lille, where he was born. He claimed descent through his paternal grandmother, Thérèse Gossart, from Jan Mabuse, the sixteenth-century Flemish master, which may perhaps help to explain his artistic leanings.

Dr Gachet had been born on July 30, 1828, and he was sixty-two when Pissarro, who had known him for some twenty-five years, first spoke to him about Vincent. Dr Gachet had once lived at Mechelen, the town from which Vincent's great-grandmother had come; and, though he had left Flanders in 1845, he still spoke Flemish fluently. He would be able to converse with Vincent in his native language. He never forgot his life at Mechelen, and Vincent noted how: *When he spoke of Belgium and the days of the old painters, his grief-hardened face grew smiling again, and I really think that I shall go on being friends with him and that I shall do his portrait.*

Dr Gachet's father owned a spinning mill and intended his son to go into industry, but the boy was more interested in books and pictures. In the end he became a doctor, submitting a thesis on melancholia to the faculty at Montpellier. In 1852 he made many friends in bohemian circles in Paris. These included Chintreuil, Bonvin, Bresdin, Murger, Champfleury, Courbet and Proudhon. In 1858 he began his first medical practice at 9 rue Montholon in Paris; four years later he moved to 78 Faubourg Saint-Denis, where he practised as a specialist in nervous diseases for fifty years until he died on January 9, 1909.

Paul-Ferdinand Gachet always had close relations with painters, and before he left Montpellier he had already made friends with Bruyas, Monticelli and Guigou. On his way to Paris he passed through Aix-en-Provence, where he met Auguste Cézanne, and thus made friends with Paul Cézanne, who was then completely unknown. He was with Guillaumin in the valley of the Bièvre in 1872 when he engraved the first of some hundred etchings. It was at this time that he met Daumier, whom he already knew, at

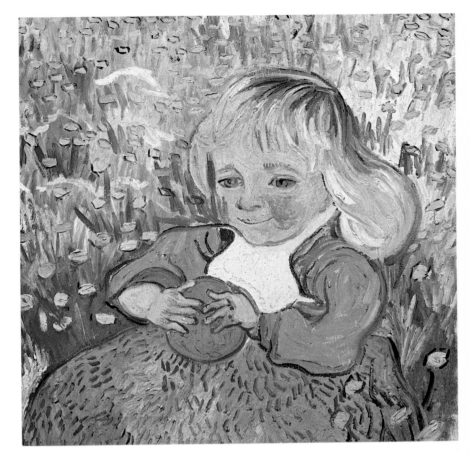

THE CHILD WITH THE ORANGE. Auvers-sur-Oise, 1890, oil on canvas, 50 × 51 cm, F 785, H 777. Collection of Ch. Jaeggli-Hahnloser, Winterthur, Switzerland. — The baby, Levert Ravoux, can be seen in the photograph of the restaurant standing in front of his sister Adeline.

Valmondois not far from Auvers-sur-Oise and tried to prevent him from going blind. In the following year Cézanne settled in a little house very near to Gachet's. Another of the doctor's patients was Manet, whose career he had followed ever since the "Salon des Refusés" in 1863.

Without being a remarkable artist, Dr Gachet was by no means without talent. Both in medicine and in art he was an innovator. As a doctor, he was one of the first to practise homœopathic medicine and to use the therapeutic properties of electricity. As an amateur of the arts he was among the first and warmest admirers of Impressionist painting. His own artistic leanings explain why so many of his friends and acquaintances were artists. Besides those already mentioned, one must also add the names Sisley, Renoir and Monet.

305

Photograph A.I.v.G.—Dr Gachet's house where Vincent painted the portraits of the doctor and one of his daughter, Marguerite.

DR PAUL GACHET. Auvers-sur-Oise, May 25, 1890, etching, 17.5 × 14.5 cm, F 1664. Photographs A.I.v.G.—The portrait opposite is the only etching Vincent ever did.

Because of the specialized nature of his practice Dr Gachet had only a limited number of patients, and he held a surgery in Paris only on Mondays, Wednesdays and Fridays. He was thus able to live at Auvers-sur-Oise in the rue des Vessenots (now renamed rue Gachet). His delightful old house behind a garden and terrace looked out over the lovely valley of the Oise. In these idyllic surroundings the doctor spent all the time he could spare from his professional duties in painting and etching.

## A VERY PLEASANT PROSPECT

Pissarro's suggestion that Dr Gachet would be a good friend as well as a competent medical adviser to Vincent turned out to be an excellent one. And Vincent's reaction to Theo's first mention of it could hardly have been more favourable.

*What you say of Auvers,* he wrote, *is nevertheless a very pleasant prospect, and either sooner or later —without looking further—we must fix on that. If I come north, even supposing that there were no room at this doctor's house, it is probable that after your recommendation and old Pissarro's he would find me board either with a family or quite simply at an inn. The main thing is to know the doctor, so that in case of an attack I do not fall into the hands of the police and*

*get carried off to an asylum by force. And I assure you that the north will interest me like a new country.*

Towards the end of April Vincent's health improved, and on May 1 or 2 he wrote a long letter to his brother, in which he said: *I have talked to M. Peyron about the situation and I told him that it was almost impossible for me to endure my lot here, and that not knowing at all with any clearness what line to take, I thought it preferable to return north.* He underlined the next sentence: *If you think well of it and if you mention a date on which you would expect me in Paris, I will have myself accompanied part of the way, either to Tarascon, or to Lyons, by someone from here. Then you can wait for me or get someone to wait for me at the station in Paris.* And he added: *Do what seems best to you.... As soon as I got out into the park, I got back all my lucidity for work; I have more ideas in my head than I could ever carry out, but without it clouding my mind. The brush strokes come like clockwork.*

Theo's reply was as amenable and helpful as ever: "I am very happy that you feel strong enough to attempt a change, and I approve absolutely of your coming as soon as possible, but you say that you want me to fix the date of your coming. I will not venture to make a decision, for, after taking Dr Peyron's advice, only you can bear the responsibility. Your trip to Arles was definitely disastrous; is it certain that travelling will do you no harm this time? If

I were in your place I should only act in conformity with Dr Peyron's views, and in any case as soon as you have decided to come here, it will be absolutely necessary for you to get somebody you trust to accompany you during the whole journey.''

Vincent answered by return: *Look here, I shall be very simple and as practical as possible in my reply. First, I reject categorically what you say about it being necessary to have me accompanied all the way. Once on the train I run no more risk, I am not one of those who are dangerous—even supposing an attack comes on—aren't there other passengers in the coach and don't they know at every station what to do in such a case?*

He pointed out that his attacks were followed by three or four months of complete calm, and that he ought to take advantage of this period to move elsewhere. *My wish to leave here is now imperative*, he wrote. He had decided that he would have someone accompany him as far as Tarascon, or even for one or two stations further if Theo insisted. As soon as he left Saint-Rémy-de-Provence he would send Theo a telegram so that he could meet him at the Gare de Lyon in Paris.

But Vincent's departure could not be arranged in a couple of days. It took a fortnight before all was settled, though Vincent had hoped to leave in a week. On May 14 he sent off his luggage by *petite vitesse* and wrote Theo his last letter from Saint-Rémy-de-Provence, in which he said: *In any case I hope to be in Paris before Sunday so as to spend your free day quietly with you all.*

## A REMARKABLE CHANGE

In her introduction to Vincent's letters to Theo, Johanna van Gogh-Bonger tells how Vincent arrived in Paris on May 17. A telegram from Tarascon had warned Theo that Vincent would be travelling by night and would arrive at ten in the morning. That night Theo did not sleep for fear that something might happen to Vincent, who was making such a long journey unaccompanied and so soon after a serious attack of madness.

It was a great relief to Theo when the time came for him to go to the station. Then it was Johanna's turn to be anxious. It seemed an eternity to her before they returned from the Gare de Lyon to the

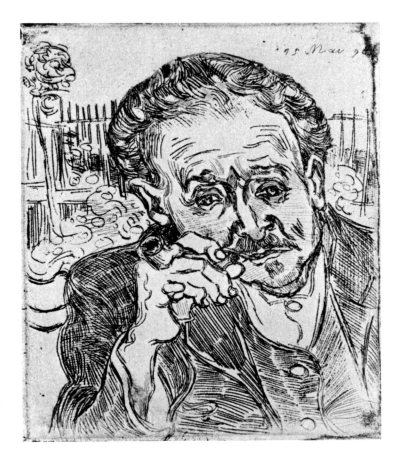

Cité Pigalle. She had begun to fear the worst, when at last she saw an open fiacre enter the Cité with two men who nodded and waved happily to her.

A moment later Vincent stood before her. "I had expected a sick man," she wrote, "but here was a sturdy, broad-shouldered man, with a healthy colour, a smile on his face, and a very resolute appearance; of all the self-portraits, the one before the easel is most like him at that period. Apparently there had again come the sudden puzzling change in his condition that the Reverend Mr Salles had already observed to his great surprise at Arles. 'He seems perfectly well; he looks much stronger than Theo,' was my first thought.''

Vincent seemed perfectly fresh and fit, although he had just recovered from a serious nervous crisis and had undertaken a journey that might have exhausted any man in perfect health. He had had no qualms about travelling alone, and felt that he could go about the world like other people. He considered himself that he could fit into social life again,

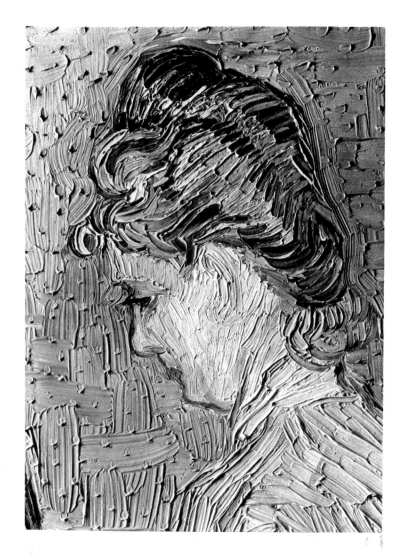

Marguerite Gachet. Photograph and details A.I.v.G.—The photograph and the enlargement enable one to see the striking likeness. The other detail shows the great power and confidence of Vincent's brush-strokes.

and that his old fear of being pursued by other people was an illusion. His self-confidence had recovered, and his persecution mania had gone. His period in the asylum had done him good, and he felt regenerated.

In one of his letters Vincent told Theo: *I stayed there [at Arles] for two days, not yet knowing what to do in the future; it is a good thing to show yourself there from time to time, so that the same story doesn't start among people again. At present no one has any antipathy to me, as far as I can see: on the contrary, I should have a chance to acclimatize myself little by little, which is hardly easy for strangers and would have its use when painting here.* This shows that Vincent had completely recovered from his inferiority complex. Now, with a new self-awareness Vincent rejoiced in his return to freedom.

### INTERLUDE WITH THEO AND JO

Before he came to Paris, Vincent had seen nothing of his sister-in-law except for a photograph. Now he met Johanna for the first time. He also met the third member of the family. Theo took his brother by the arm and led him into the room where the baby was sleeping who bore his own name. Johanna van Gogh-Bonger tells how the two brothers had tears in their eyes as they looked at the child in his cradle. Then Vincent smiled and turned to her, pointing at the crocheted cover on the cradle, and said: *You mustn't spoil him too much, little sister.*

*I stayed in Paris only three days,* Vincent wrote in an unfinished letter to Gauguin that was found among his papers. Johanna van Gogh-Bonger has

described the visit as follows: "He stayed with us three days, and was cheerful and lively all the time. Saint-Rémy was not mentioned. He went out by himself to buy olives, which he used to eat every day and which he insisted on our eating too. The first morning he was up very early and was standing in his shirt-sleeves looking at his pictures, of which our apartment was full. The walls were covered with them—in the bedroom, the orchards in bloom; in the dining-room over the mantelpiece, THE POTATO-EATERS; in the sitting-room (salon was too solemn a name for that cosy little room), the great landscape from Arles and the night view on the Rhône. Besides, to the great despair of our femme de ménage, there were under the bed, under the sofa, under the cupboards in the little spare room, huge piles of unframed canvases; they were now spread out on the ground and studied with great attention. We also had many visitors, but Vincent soon perceived that the bustle of Paris did him no good, and he longed to set to work again." And to Gauguin Vincent wrote that the noise of Paris *had such a bad effect on me that I thought it wise for my head's sake to fly to the country.*

Johanna van Gogh-Bonger says that Vincent left for Auvers on May 21, but this date has been disputed by Dr Jan Hulsker, who argues, I think rightly, that the date of Vincent's departure from Paris and arrival at Auvers-sur-Oise must have been May 20.

Vincent travelled to Auvers-sur-Oise on a hot and sunny day. His first impression when he arrived was excellent: *Auvers is very beautiful, among other things a lot of old thatched roofs, which are getting rare.*

## THE SICK PHYSICIAN

Vincent went straight to Dr Gachet and gave him a letter of introduction from Theo. Like Cézanne, Pissarro and so many others, Vincent was going to live in Auvers-sur-Oise, and like them he would become a close friend of the doctor.

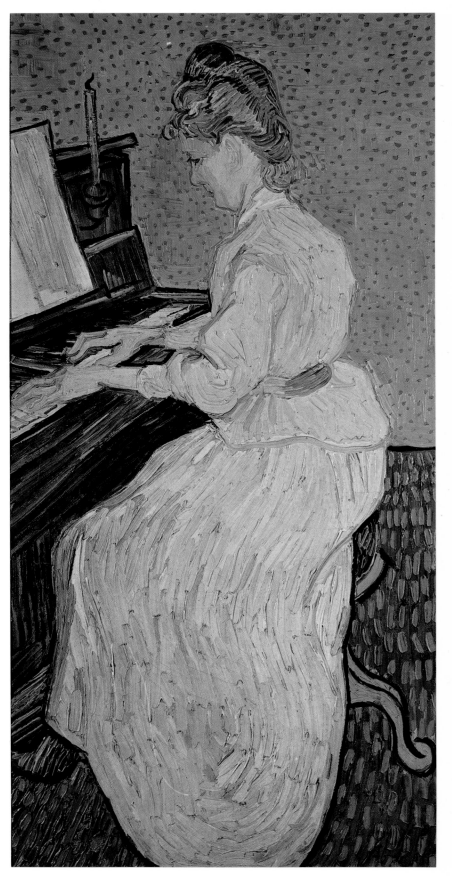

MADEMOISELLE GACHET AT THE PIANO. Auvers-sur-Oise, June 1890, oil on canvas, 102 × 50 cm, F 772, H 769. Basle Museum, Switzerland.—Some time between June 24 and 30, Vincent wrote to Theo: "Yesterday and the day before I painted Mlle Gachet's portrait...."

He was much taken with the doctor's house and his considerable art collection: *He has a very fine Pissarro, winter with a red house in the snow, and two fine flower pieces by Cézanne*, he observed. *Also another Cézanne, of the village.* But otherwise, he said: *His house is full of black antiques, black, black, black, except for the Impressionist pictures.* This does scant justice to Dr Gachet's collection; having visited it many times, I can add that it also included fine works by Renoir, Monet, Manet, Guillaumin, Sisley and Daumier.

As soon as he had seen the doctor who was to take charge of him, Vincent wrote to Theo and Johanna, for it now seemed natural to write to both of them together: *I have seen Dr Gachet, who gives me the impression of being rather eccentric, but his experience as a doctor must keep him balanced enough to combat the nervous trouble from which he certainly seems to me to be suffering at least as seriously as I.*

Dr Gachet had suggested an inn at the end of the rue des Vessenots where Vincent could lodge. But Vincent thought that the six francs a day that it charged was too much. He went instead to Ravoux's little eating-house—it hardly deserves to be called a café-restaurant—just opposite the town hall. He took an attic room for which he was charged only three francs fifty centimes a day.

The inside of Ravoux's establishment with its stove, rush-seated chairs and billiard-table recalled the "Night-café" at Arles. It was only five minutes' walk from Dr Gachet's house. Vincent was soon to know that stretch of road well. On May 25, only five days after he arrived in Auvers, Vincent wrote to Theo and Jo: *Today I saw Dr Gachet again, and I am going to paint at his house on Tuesday morning; then I shall dine with him, and afterward he will come to see my painting.* He had not wasted much time.

We can follow the growth of Vincent's feelings towards Dr Gachet in his letters from Auvers-sur-Oise. In the first of them he wrote: *The impression I got of him was not unfavourable.* In the fourth he said: *He seems very sensible . . . I am ready to believe that I shall end up being friends with him.* But one remembers the course that Vincent's friendships had taken in the past, with his initial enthusiasm leading eventually to an irremediable break. Emile Bernard was the exception to this rule, because he

was a much younger man and was far away when Vincent began to suffer from nervous hypertension.

Vincent's need to compare his artistic conceptions with those of other painters is familiar. Dr Gachet's companionship and his collection were invaluable in this respect, and Vincent's joy is manifest in his letters to Theo and Jo. For once Vincent seemed to have fallen on his feet.

AN UNEXPECTED ADVANTAGE

He had hardly been in Auvers-sur-Oise for a day when he wrote that a man in whom he had particular reason to be interested had been in the village: *It seems that Desmoulins, the man who did Japan, has been here, but has gone again.* This was actually Louis Dumoulin, an artist who quickly became famous because he painted one of those panoramas which were all the rage after the Franco-Prussian War. He belonged to a group of artists who were centred on Auvers-sur-Oise.

A few days later, in a letter which Johanna van Gogh-Bonger attributes to June 4, but which Dr Jan Hulsker places twenty-four hours earlier, Vincent wrote to Theo: *Desmoulins, the man who has some Japanese pictures at the Champ de Mars, has come back here and I hope to meet him.* Vincent, I need hardly say, could not rest until he had done so.

They met soon afterwards. Dumoulin had just been asked to make another journey to Japan, and it is easy to imagine Vincent's interest in the project after he had been devoted for so long to Hokusai, Utamaro, Hiroshige and the other masters of the Ukiyo-ye school.

By a cruel irony of fate Louis Dumoulin left Auvers-sur-Oise for Japan at the very moment when Vincent departed for another world.

More than a decade later, in 1901, when Vincent's fame was beginning to rise in the West as a result of the Bernheim Jeune exhibition, Louis Dumoulin lived on the corner of the rue des Martyrs and the rue Condorcet, and people used to call on him and ask if it was true that he had once known Vincent van Gogh at Auvers-sur-Oise. Dumoulin told them what he could about Vincent, and his visitors left without asking once about his own work, which had once been so fashionable.

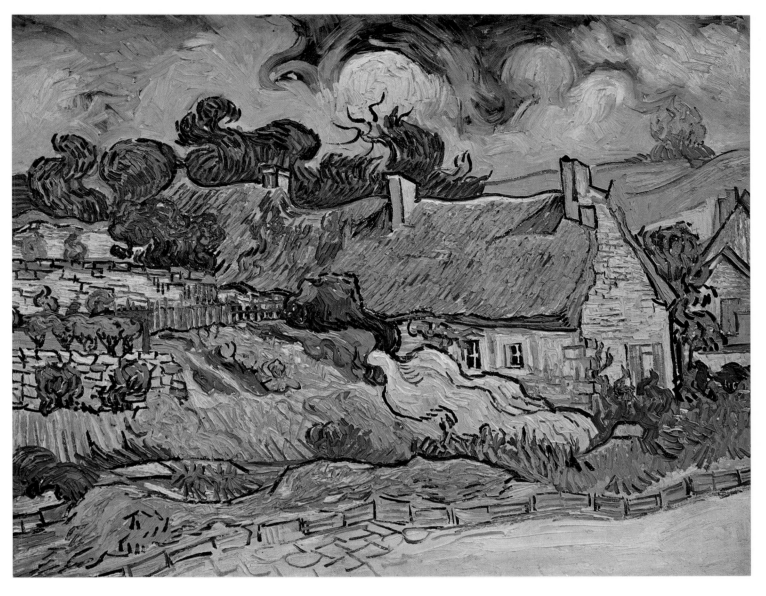

THATCHED ROOFS AT MONTCEL. Auvers-sur-Oise, June 1890, oil on canvas, 72 × 90 cm, F792 H779. Private collection, U.S.A.—On May 21, 1890, the very day of his arrival at Auvers-sur-Oise, Vincent wrote to his brother that the place "is very beautiful, among other things a lot of old thatched roofs, which are getting rare", and he added that he hoped to do some paintings of them.

## ABUNDANT INSPIRATION

As soon as he arrived at Auvers, Vincent began to explore the country. It stimulated his desire to paint, and before he had spent two days on the banks of the Oise he had done *one study of old thatched roofs with a field of peas in flower in the foreground and some wheat, background of hills.*

By the time Vincent had been at Auvers a month he had produced not only the portraits of Dr Gachet and of his daughter Marguerite at the piano, but also an impressive series of landscapes in which his colour was rejuvenated and his technique new.

The tormented patterns of dots and lines have been almost discarded, and only rare traces remain. Little white clouds begin to appear in the sky, the same clouds no doubt that Boudin and Corot had seen and painted. But Vincent saw them differently from his predecessors. He linked these clouds into rings, and made them reveal even more strongly the

force that was driving them like the sails of a ship. His own experience had taught him that the old adage that colour was the beginning and end of painting was not the whole truth. Beyond colour was the great phenomenon of the cosmos. The firmament and the planets were only the preliminary stages of a more general conception, embracing the whole of nature in all its manifestations. Only the commanding breath that animates and pervades everything remains . . . and matters.

René Huyghe once wrote that Vincent "expressed his independence from the universe by remaking it in his own image, docile clay which he fired only to imprint it with the mark of his thumb". This is manifestly true, and Vincent affirms it in his spirit of revolt against all conformity. His canvases in their range from 1882 to 1890 clearly show the progress of this daring development.

He wanted those who looked at his landscapes to feel that they were witnesses of a "second of eternity", raising their vision to a level outside the confines of time.

Vincent's tumultuous artistic expression inaugurated Expressionism, although he did not invent this name for his pictorial freedom. By this victory over matter—for he was the first and the foremost to preach "colour before all things", and was inspired by the imperceptible secrets of visible phenomena— he proved himself to be the first and indeed the greatest of the Fauves.

Ineluctably following his bent, Vincent approached the great mystery with which his artist's soul was in danger of identifying itself so completely that it would destroy its own existence. He was already contemplating everything around him with the eyes of a visionary. Behind their apparent stability, commonplace things revealed to him their precarious balance in the great vortex of creation.

When one looks at Vincent's last pictures one feels that he is trying to initiate us into his quest for the absolute. To the very end he pursued the great mystery that hides beneath the appearances of created things.

In *Les Deux Sources de la morale et de la religion* Bergson wrote: "A work of genius which begins by disconcerting may by its mere presence create little by little a conception of art and an artistic atmosphere which enable it to be understood; it will then become a work of genius in retrospect; otherwise it remains what it was in the beginning: merely disconcerting." Upon which Dr Willem Sandberg has commented: "Bergson could have been thinking of van Gogh."

André Lhote has also pointed out the remarkable similarity between Vincent's work in painting and Bergson's in metaphysics. "But van Gogh," he wrote, "the prince of penetrating sensation, who did not even know Bergson's name, carried to its highest degree the method of knowing that the philosopher established permanently. This was to shut out all *a priori* knowledge, to be oblivious to the canons beloved of the academy, to be oblivious even of reason, to be lost entirely in seeing, so that he saw nothing around him except the moving scene which he embraced in its indivisible totality. His sympathy with nature was so great that he lost himself in it, and as any sort of analysis would destroy it, he was able to penetrate it only by sensing the pulse of the universe."

## THE OUTPUT OF A GENIUS

Vincent had always been a prodigious worker who painted from morning to night; at Auvers-sur-Oise he worked at an even faster rate than ever before. Dr Jan Hulsker has pointed out that Vincent spent no more than seventy days at Auvers-sur-Oise, and that during this time he produced seventy paintings and more than thirty drawings—a quite astonishing output. He painted landscapes, portraits, and then more landscapes. He sometimes began a new canvas when he had only just put the last touch to the previous one.

His little still-life FLOWERS AND FOLIAGE in the Nationalmuseum in Stockholm is a typical example. Many years ago Paul Gachet the younger described to me how he saw it being painted. He even remembered the date: Saturday June 7, 1890. He could not be mistaken, he said, because he remembered that Vincent had just told Dr Gachet that on the following day, which was a Sunday, Theo was coming to visit him with his wife and child.

Paul Gachet the younger was positive. "I have another reason for being sure about the date," he said. "On that day, Saturday June 7, Vincent had

HORSE. Auvers-sur-Oise, June 1890, pencil, 33 × 13.3 cm. Vincent van Gogh Foundation, Amsterdam.—A drawing on a page of the pocket sketchbook that Vincent carried with him. Strength of expression is to be seen in every line of his pencil.

A COCK AND A HEN. Auvers-sur-Oise, June 1890, pencil, 33 × 13 cm. Collection of E. Buckman, Richmond, U.S.A.—This was drawn on the back of AT THE COUNTER reproduced on page 304.

HEN. Auvers-sur-Oise, June 1890, pencil, 13.3 × 33 cm. Vincent van Gogh Foundation, Amsterdam.—This drawing was on the page of Vincent's drawing-book facing AT THE COUNTER.

just put the finishing touches to the portrait of my father. Not the first one, mind you, with the books on the table, which he had finished a few days earlier, but the second one with only three buttons on the jacket. That is to say the one that Vincent painted specially to please my father, and after all it's not a copy, but another version, which is why it, too, had to be painted from the model.

"After this sitting, which did not last long, Vincent did not go. He had noticed when he came that the acacias in the garden were at that very moment in full bloom, so he went and set up his folding easel that I showed you right underneath them. There was no room to stand back. It was very odd to watch him. Every time he put his little strokes of paint on the canvas he would first of all lean his head back to look up with half-closed eyes at the flowers that were on top of him and the sky that could be seen here and there through the thick foliage.

"Although I am a painter's son, I had never seen anyone paint like that, and I thought: I only hope he can keep it up without getting a stiff neck. For it would take quite a while, and he would surely get a pain in the neck. Perhaps he did, but he was too carried away with trying to paint it straight off in one go to worry about that.

"I suppose that the almond branch in blossom must have been painted in exactly the same manner. If I had not seen Vincent at work in our garden I would have had no idea of this rather comic way of painting. But, after all, it's only the result that counts, and if you didn't know differently you would think that this little picture was painted from straight in front."

Although Paul Gachet the younger told me in these words, transcribed from my notes before the Second World War, that Vincent painted FLOWERS AND FOLIAGE from underneath, this is only partly true. Vincent stood his easel in front of the acacias, but so close that he was obliged to lean his head back to look at the upper part of the branch, the top of which was indeed over his head. Gachet's account must not be taken too literally, for Vincent could only have seen sunlit flowers and foliage if they were more or less in front of him. If he were right underneath the leaves he would only have seen the underside of them in shadow.

But this anecdote does show that Vincent began his little still-life immediately after finishing the second portrait of Dr Gachet, and moreover that he painted it with incredible speed, for he had it finished by lunchtime.

A VERY SPECIAL SUNDAY

Vincent seemed to be in good health again, and to be doing well. His health had improved since he gave up alcohol. He wrote to the Ginoux at Arles: *It is a certain fact that I have done better work than before I stopped drinking.*

Artistically he had never been in better form. Everything seemed to be turning out well. Theo was only an hour's train journey away. The brothers could meet easily, and they did not fail to do so.

Dr Jan Hulsker's researches have shown that an interesting letter from Vincent to his brother was wrongly dated by Johanna van Gogh-Bonger. When it is put in its correct position, around May 23 instead of in July, we learn a great deal.

Vincent was much worried because he had not received the note and remittance of money which usually welcomed him when he moved to a new place. Moreover things in Paris had not gone as well as they had seemed at first, though Vincent was, as he wrote in his first letter from Auvers-sur-Oise, *so glad to have seen Jo and the little one and your apartment, which is certainly better than the other one.*

In the letter of May 23 or thereabouts he wrote: *But considering how things have happened—honestly— I think that Theo, Jo and the little one are a little on edge and are worn out—and besides, I myself am also far from having reached any kind of tranquillity.*

Vincent had further reason to be depressed. He had been to see Dr Gachet and had found that he was not in, and this at once threw him into the blackest gloom. *I think we must not count on Dr Gachet at all,* he wrote. *First of all, he is sicker than I am, I think, or shall we say just as much, so that's that. Now when one blind man leads another blind man, don't they both fall into the ditch?*

He was also upset because during his three days in Paris he had seen pictures by Prévost, Russell, Guillaumin, Jeannin and even some of his own mouldering away in *the bedbug-infested hole at Tanguy's.*

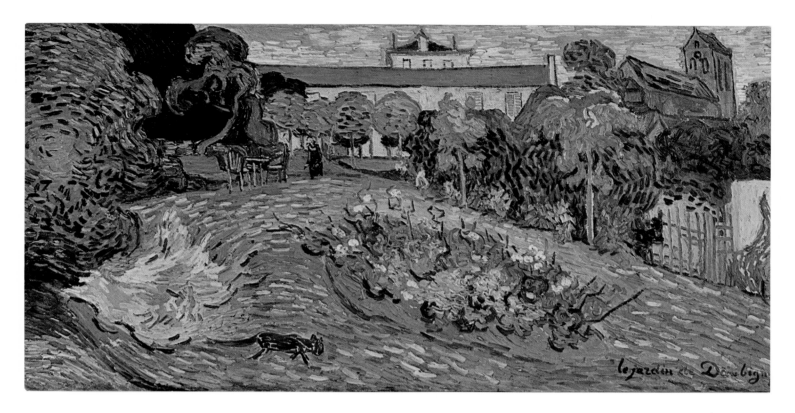

He wanted to find a lodging as quickly as possible where he could take care of these pictures, retouch them and put them in order—as well as finding peace for himself. He was exhausted and wrote: *I feel that I have failed. So much for me—I feel that this is the lot which I accept and which will not change.* And later: *And the prospect grows darker, I see no happy future at all.*

In the last sentence of the letter, recalling the three rather unsatisfactory days he had spent in Paris, he wrote: *I wish there were a possibility of seeing each other again soon with more collected minds.* Fortunately he did not have to wait long for an opportunity. Dr Gachet, wishing the two brothers to meet again as soon as possible, invited Theo and his family down for the day. They would all spend Sunday June 8 together at the good doctor's house at Auvers-sur-Oise.

Vincent looked forward to seeing them again and met them at the station. He had brought a present for his little nephew; it was a bird's nest—a symbolic gift, perhaps, that was intended to wish that his namesake should have what Vincent himself had never had, the warmth and love of a happy family home. Vincent insisted upon carrying the baby himself, and when they reached Dr Gachet's house, he showed all the animals in the yard to the child, until the cock crowed so loud that little Vincent began to cry despite all his uncle's attempts to explain to him what a cockcrow was. Vincent was delighted to have been able to show the animals to his godson.

Several days later Vincent described this visit to his mother in a letter written in the middle of June: *There my little namesake made the acquaintance of the animal world for the first time, for at that house there are 8 cats, 8 dogs, besides chickens, rabbits, ducks, pigeons, etc., in great numbers. But he did not understand much of it all as yet, I think.*

### THE HOUSE OF GHOSTS

Dr Gachet's house reflected its owner's somewhat eccentric personality. The room where he had his etchings was like an alchemist's cell in the middle ages. Behind the building was a large yard in which

all sorts of animals lived together higgledy-piggledy. Besides those Vincent had listed in his letter to his mother there were turkeys, peacocks, goats and even sheep. There were also two large caves dug deep into the rock. The sun never penetrated them, and they were as cold as an icehouse.

On that Sunday, Dr Gachet and his guests had lunch out of doors, where they enjoyed a magnificent view across the valley of the Oise towards Paris; in the afternoon they went for a long walk in the neighbourhood. Johanna van Gogh-Bonger has described how she was struck by the remarkable resemblance between Vincent and Dr Gachet, though the doctor was much older. Similarly young Paul Gachet was extraordinarily like Theo.

The clouds which had threatened the relations between the two brothers over the last weeks seemed to have rolled away once and for all. Vincent was delighted by the meeting and later wrote to Theo: *Sunday has left me a very pleasant memory; in this way we feel that we are not so far from one another, and I hope that we shall often see each other again.* And he wrote to his mother: *For me it is a very reassuring feeling to be living so much nearer to them.*

Johanna van Gogh-Bonger also reports that he spent such a happy day, in such calm and peace, that no one could have guessed how tragically their happiness would be destroyed not long afterwards.

In the days following the visit of Theo and his family Vincent's health continued to improve and he became quite optimist. He made plans to exhibit his work in Paris and even to travel abroad with Gauguin. Then Theo wrote to his brother with disturbing news. Little Vincent Willem had fallen sick and he and Jo were exhausted from many sleepless nights nursing the child. Theo had, moreover, had a row with his employers and was even thinking of resigning and setting up as an independent art-dealer. This would be a risky undertaking and would put them all in a precarious financial position. But in spite of his own very real worries Theo did all he could to ease his brother's mind: "Don't bother your head about me or about us, old fellow, but remember that what gives me the greatest pleasure is the knowledge that you are in good health and busy with your work, which is admirable. You already have too much fire and we must be in good shape to fight for a long time yet, for we shall have to battle all our lives rather

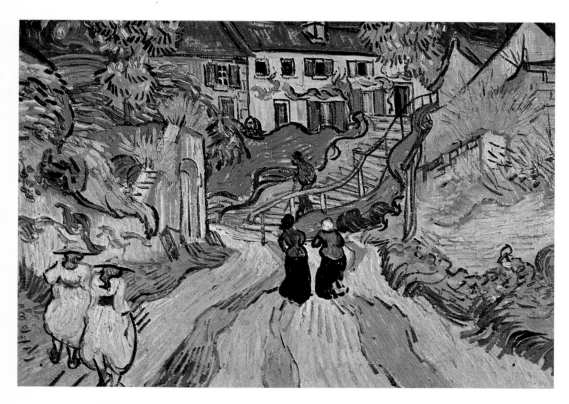

THE STEPS AT AUVERS. Auvers-sur-Oise, June 1890, oil on canvas, 48 × 70 cm, F 795, H 783. City Art Museum, St Louis, U.S.A. Photograph A.I.v.G.—The walls still exist, as can be seen in the photograph, but the steps have gone.

than eat the oats of charity they give to old horses in the stables of the great. We shall draw the plough until our strength forsakes us, and we shall still look with admiration at the sun or the moon."

Vincent was not reassured, however, and continued to be depressed even though his nephew's health improved. His next reunion with his brother and sister-in-law was in Paris on Sunday July 6.

On Saturday July 5, Theo had written to Vincent: "So please come next Sunday by the first train; in the morning you will meet Walpole Brooke, who has just seen your pictures at Tanguy's, and after that we are going to look at a Japanese Buddha at a curio dealer's and then we are going to lunch at home in order to see your studies. You will stay with us as long as you like, and you are going to advise us with regard to the arrangement of our new apartment. It is probable that Dries and Annie will take the ground floor, and they will have a little garden, which we shall make good use of, of course." Dries and Annie were Johanna's brother, Andries Bonger, and his wife. And Walpole Brooke was an Australian artist whom Vincent had met at Auvers-sur-Oise and had introduced to Theo.

An extraordinarily full programme had been arranged for the Sunday— too much excitement in one day surely for a man whose nerves soon became overstrained. After all it was only two months since Vincent had been living in the greatest solitude in a lunatic asylum, out of touch with the world outside.

At his brother's apartment Vincent was host to Albert Aurier, with whom he had a friendly and interesting conversation about art and especially about painting. Then Toulouse-Lautrec came to lunch with him. It was a pleasant surprise—arranged no doubt by Theo—for Vincent to see his old friend of Montmartre days again. They had a good deal of fun at the expense of an undertaker's mute they had just met on the stairs. What a day for Vincent!

Wilhelmien also promised to come, but Vincent suddenly felt that he must leave as quickly as possible, without waiting for her to arrive. He left so quickly that it was almost as if he were running away from something. Did he merely want to get back to work at once? Was he suddenly exhausted by so much excitement after months in his barred and lonely cell? Or was there another reason that nobody could guess?

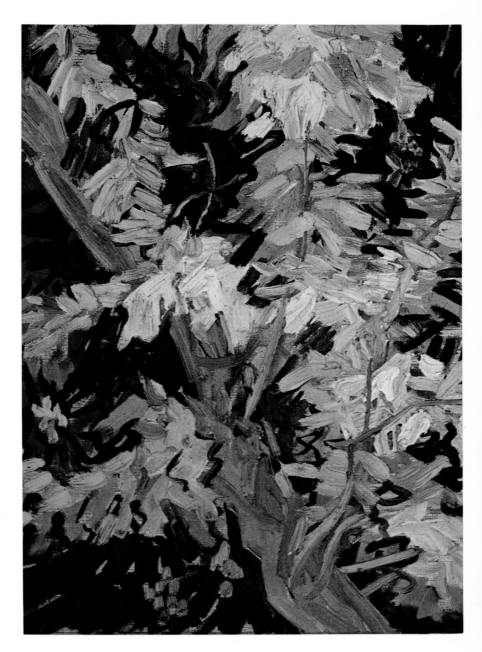

FLOWERS AND FOLIAGE. Auvers-sur-Oise, June 7, 1890, oil on canvas, 33.5 × 24.5 cm, F 821. Nationalmuseum, Stockholm, Sweden.—This picture of acacias in blossom was painted in Dr Gachet's garden.

## LASTING LIKENESSES

At Auvers-sur-Oise, Vincent went on tirelessly producing canvases and drawings. His inspiration seemed more inexhaustible and his energy more indefatigable than ever before. An idea of this output can be gained from a brief chronological summary, based on the only information that he has given us.

May 24: a study of old thatched roofs. May 25: a drawing of an old vine, of which Vincent proposed to paint a size 30 canvas; a study of pink chestnuts; a study of white chestnuts. June 4: the portrait of Dr Gachet, and then a second version; a study of aloes, marigolds and cypresses; a study of white roses and vines. June 14: a study of a harvest; a village with a little coach; a field of poppies; a study of a vine. June 17: a study of a bunch of wild plants; a study of a white house; a study of the Jardin de Daubigny. June 16-23: a study of ears of wheat. June 24: the portrait of Adeline Ravoux, then a second and third version; a field of wheat; a copse; the Château d'Auvers. June 29: the portrait of Mademoiselle Gachet at the piano. June 30: a figure of a peasant woman; a landscape with fields;

an undergrowth. July 9: two fields of wheat under troubled skies; the Jardin de Daubigny. July 23: old thatched cottages.

Besides these two dozen paintings mentioned by Vincent in his letters, another three dozen canvases are known to exist which he painted at Auvers-sur-Oise. In all of them there is the same vigorous simplicity and disciplined passion of his creative spirit.

They are among his most admired works, and hold places of honour in the world's galleries. They include THE MAN WITH THE KINGFISHER, PÈRE PILON'S FARM, THE STEPS AT AUVERS, THE PLAIN NEAR AUVERS, THE MAIRIE IN AUVERS ON JULY 14, CROWS ON THE CORNFIELDS, and THE CHURCH AT AUVERS.

Let us return for a moment to the two girls who sat for their portraits, Adeline Ravoux and Mademoi-

THE CHATEAU OF AUVERS. Auvers-sur-Oise, June 1890, oil on canvas, 50 × 100 cm, F 770, H 762. Vincent van Gogh Foundation, Amsterdam. Photograph A.I.v.G.—Since 1890 the landscape has changed considerably; but after identifying the spot where Vincent placed his easel it is easy to see how close his picture comes to reality.

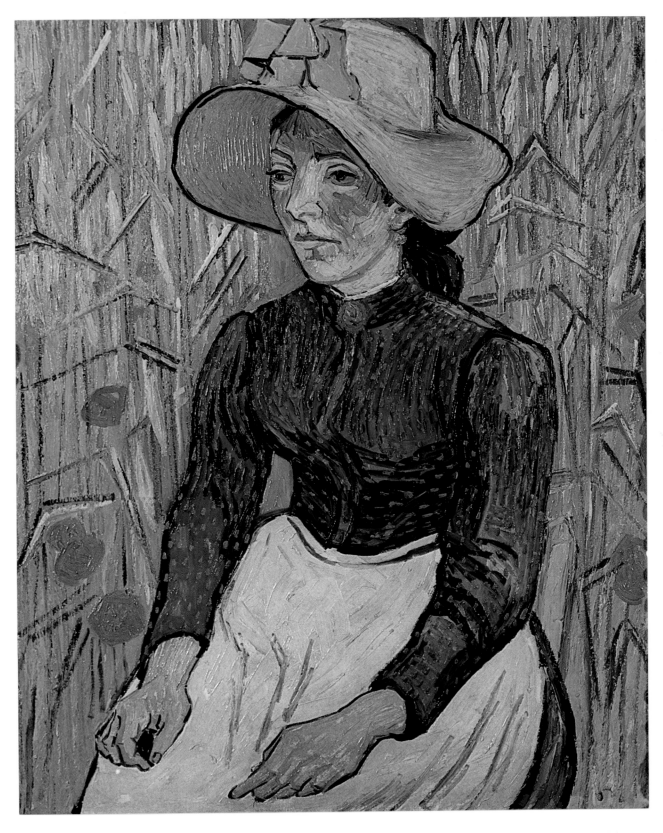

YOUNG PEASANT GIRL.   Auvers-sur-Oise, June 1890, oil on canvas 92 × 73 cm, F 774, H 766.—In a letter to Theo, Vincent describes this picture as: "one of a peasant woman, big yellow hat with a knot of sky-blue ribbons, very red face, rich blue blouse with orange spots, background of ears of wheat.  It is a size 30 canvas, but I am afraid it's really a bit coarse".

selle Gachet. On June 24, Vincent told his brother: *Last week I did a portrait of a girl of about sixteen, in blue against a blue background, the daughter of the people with whom I am staying. I have given her this portrait, but I made a variant of it for you, a size 15 canvas.* Towards the end of June he wrote to Theo: *Yesterday and the day before I painted Mlle Gachet's portrait, which I hope you will see soon; the dress is red, the wall in the background green with orange spots, the carpet red with green spots, the piano dark violet; it is 40 inches high by 20 inches wide. It is a figure that I enjoyed painting—but it is difficult.*

The reason I have chosen to discuss these portraits rather than the ones of Dr Gachet is simple. Dr Gachet was certainly more interesting than either of these young women, but alas, I never met him, and cannot compare the portraits with the original.

But I often met Marguerite Gachet and Adeline Ravoux. The first died on November 8, 1949, at the age of 78; the second died on May 3, 1965, at the age of 88 at Martin Léglise, near Dieppe.

When I was with Marguerite Gachet or Adeline Ravoux, I had exactly the same sensation that Dr Picard of Arles had when he saw the portrait of Dr Rey, and I was invariably struck by the remarkable resemblance between the portraits and their originals. The likeness only increased with the years, as age exaggerated the features which the artist had caught

so strongly. Adeline Ravoux once told Maximilien Gauthier: "His painting frightened me a little, it was so violent, and I did not find it a good likeness at all. It was only much later, when I was looking at reproductions of it, that I realized that he had been able to see in the young girl that I was then the woman I was to become."

This is so true that all the characteristic features of both faces in the oil-paintings can be seen in photographs, even though they were taken much later. This is a remarkable tribute to Vincent's genius as a portrait-painter.

## RECOLLECTIONS OF A MODEL

I have often questioned Adeline Ravoux and her sister Germaine, who by that time had both married and been widowed and were Madame Carrié and Madame Guilloux. Adeline gave only five or six sittings for one of her three portraits, that of her in her white dress, the first grown-up dress she ever had.

Vincent smoked his pipe incessantly while he worked at his canvas. He was so absorbed in his task that he did not speak a word. Adeline did not think him attractive, but said that you soon forgot his lack of charm when you watched him amusing the children. Then you realized instinctively that he was a good man. She saw Vincent spoiling her baby brother Levert when he was painting the portrait of him that was to be known as THE CHILD WITH THE ORANGE.

"After all," Adeline told me, "I was only a child at the time. But he used to amuse me before I went to bed in the evenings by taking a piece of chalk and drawing a funny picture of a little old man. This would soon have become tedious if the old man had always been the same, but he wasn't. Every time he surprised me with a new version of the fellow.

"He was rather withdrawn by nature, and consequently hardly talked at all, but he always had a slight smile on his lips, which sometimes—but very rarely—broke into a frank and jovial laugh. When

THE CHURCH AT AUVERS (opposite page). Auvers-sur-Oise, June 1890, oil on canvas, 51×51 cm, F 789. Jeu de Paume, Louvre, Paris. Photograph A.I.v.G.

320

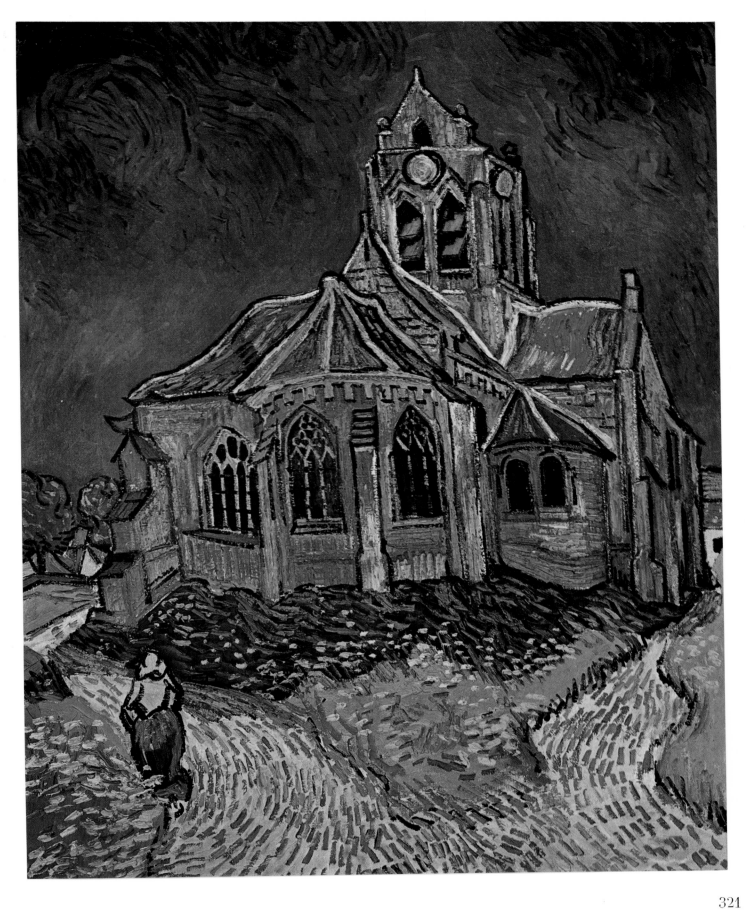

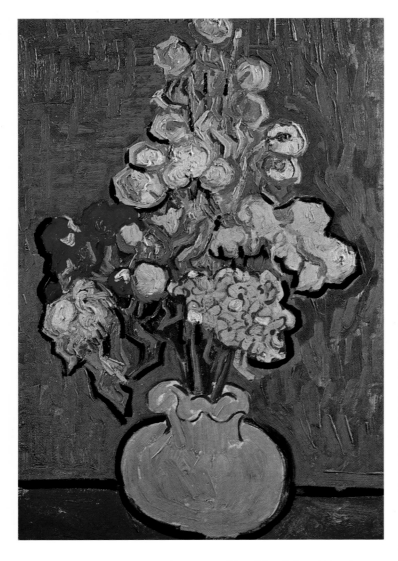

LITTLE VASE OF FLOWERS. Auvers-sur-Oise, May-July 1890, oil on canvas, 41 × 28 cm. Vincent van Gogh Foundation, Amsterdam.

that happened, Monsieur Vincent, as we all used to call him, suddenly became quite a different man.

"We were constantly having lodgers who had come to paint in the district. When Monsieur Vincent was staying at the inn, we also had another Dutch lodger, Tommy Hirschig. They were joined at meals at their table—the last at the back on the left parallel to the staircase wall—by a Spaniard called Martinez de Valdivieldo. . . . At the back on the right was a room which my parents allowed artists to use when they were staying with us. It was there that I sat for my portrait. Monsieur Vincent also used to put his canvases in this back room to dry.

"Of all the artists that I used to know in those days, none h saleft such an indelible memory as Monsieur Vincent; he was so different from all the others. Perhaps I was too young—for I was only seventeen—to realize that this 'difference' was due to his state of health. Later I learned, as we all did, that he had been in an asylum for mental cases. But if I had been told then that he was mad, I just would not have believed it.

"Soon after he died, my parents sold their business and moved to Meulan, where they ran another café. Opposite us was the Hôtel Pinchon, where many foreign painters stayed. Most of these artists would come and drink an apéritif at our café. One day three of them, an American, a Dutchman and a German, found two of Vincent's pictures in a back room; they were THE MAIRIE AT AUVERS ON JULY 14, that Monsieur Vincent's brother had given to my father after the funeral, and my portrait which Monsieur Vincent had given to me himself. One of these three painters, the American Harry Haranson, offered my father forty francs for the two pictures. My father, who knew nothing about art, thought at first that he was joking, but when he realized that the American was serious he hurriedly clinched the deal. My father was so simple that he thought that it was the buyer who had got a bad bargain. . . ."

AN UNFRAMED PAINTING

In his letter of June 3, Vincent wrote to Theo: *And I am well. I go to bed at nine o'clock, but get up at five most of the time. I hope that it will not be unpleasant to meet oneself again after a long absence. And I also hope that this feeling I have of being much more master of my brush than before I went to Arles will last. And M. Gachet says that he thinks it most improbable that it will return, and that things are going on quite well.* Obviously Dr Gachet, like any good physician, reassured Vincent about the risk of his crises recurring, for he realized that otherwise he would only excite the patient unnecessarily. But it is hard to believe that he did not suspect that Vincent's calm was only temporary, and that it was distinctly misleading.

Among Dr Gachet's pictures was a famous nude by Guillaumin which is now in the Jeu de Paume

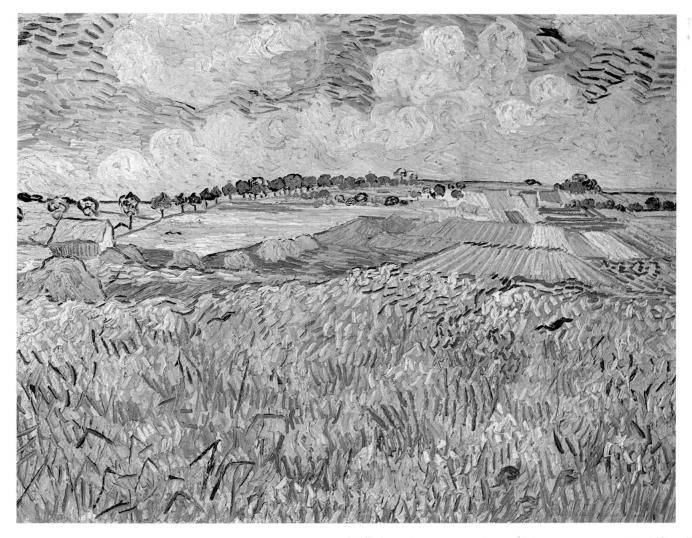

museum in Paris. Vincent had always greatly admired the artist, whom he had known when he lived in Paris. They had met in this way: Père Portier, a picture-dealer who lived on the first floor of the same house as Theo and Vincent at 54 rue Lepic, showed Guillaumin Vincent's pictures which Theo had left with him. Guillaumin was much impressed by them, so Portier took him up to the third floor, where they found Vincent busy painting THE YELLOW BOOKS, with its scattered books and rose in a glass. Gustave Coquiot, who tells this story, relates that Vincent often went to Guillaumin's studio in the quai d'Anjou after that. Once, in order to prove a point in an argument there, Vincent

undressed and went down on his knees, for he was so deep in argument nothing could stop him. Guillaumin said that Vincent on his knees reminded him of Delacroix's *Tasso Among the Madmen.*

The first time that Vincent went into Dr Gachet's living-room, he immediately noticed one particular canvas among all the others on the walls. It was Guillaumin's picture of a woman naked to the waist lying on a bed and holding a little Japanese fan. For some reason, perhaps merely because there had not yet been time to do so, the picture had not been framed.

This apparent lack of respect for Guillaumin made Vincent furious, and he angrily told the doctor to

323

order a frame from the village carpenter at once. Gachet thought that this anger would not recur, but he was wrong. A few days later Vincent returned to the attack. When he saw that the picture still had no frame, he suddenly became angry again and put his hand into his pocket as if to take something out. It is not difficult to guess his intention. Gachet looked at Vincent so firmly and commandingly that he took his hand out of his pocket empty. Vincent was defeated, and like a naughty child caught in some act of mischief, he lowered his head, turned and slunk away.

Young Paul and his sister Marguerite, who were then seventeen and nineteen years old, have told me how they were present, in the wings as it were, during this little drama. They experienced a few moments of extreme tension and anxiety that they would never forget. Nobody had expected such an explosion of hostility to be produced by such a trivial cause.

They were too young to realize exactly what Vincent's anger was all about, and they were convinced that they would not see him again after he had shown himself so hostile to their father. They were astonished to see him turn up the next day as if nothing had happened! Vincent offered no excuses. He did not even mention the way he had behaved the day before. Paul and Marguerite began to wonder whether he really had no memory at all of the painful scene or whether he was just pretending.

A.I.v.G.—This enlarged photograph of the picture on the opposite page shows the broad and firm brush-strokes with which Vincent painted such details as the features on the little girl's face.

TO SHOOT THE CROWS

On July 20 Theo had taken his wife and child to Holland, but he had had to come back for a short period in Paris before he could join them for his annual holiday. Five days after he returned to Paris he wrote to Jo: "I have a letter from Vincent which seems quite incomprehensible; when will there come a happy time for him? He is so thoroughly good."

Two days later, towards the end of the afternoon of Sunday July 27, the Gachets watched Vincent leave. He seemed perfectly calm, but they nevertheless felt uneasy about him. Something was wrong. Vincent seemed to have some hidden intention.

An earlier incident had begun to give Dr Gachet some concern. One Sunday, when he was lunching with the Gachets, Vincent had suddenly thrown down his napkin and left in order to go back to his paints. There had also been the threat to Dr Gachet over the unframed picture.

A few hours later the Gachets learned how Vincent had returned to the Ravoux. This is how Adeline Ravoux described the occasion: "Monsieur Vincent had lunch at midday, and then he went out at once. Nobody thought anything of it, for he came and went all the time, and neither my parents nor I had noticed anything odd about his behaviour. But in the evening he didn't come home as usual. Until then he had never been late to supper, for he liked to go to bed with the sun. Since he had been with us he had never failed to come to a meal. When they found that he didn't turn up, my parents finally decided to

324

THATCHED SANDSTONE COTTAGES AT CHAPONVAL. Auvers-sur-Oise, July 1890, oil on canvas, 65 × 81 cm, F 780, H 770. Kunsthaus Zürich, Switzerland.—Chaponval is a hamlet near Auvers-sur-Oise. Vincent painted this "sketch of some old thatched roofs" within a month of his death.

start supper without him. When we had finished he still hadn't come home. The day had been very hot and we were glad to take the air on the doorstep until closing time. My parents were becoming more and more anxious at not seeing Monsieur Vincent, for his supper had been ready long ago. After a while, we saw him coming in the distance, but he was moving in a strange way, it was funny to watch. He was staggering along in big strides, with his head tilted a little towards the side of his maimed ear. You might have thought that he had been drinking.

But though they have said Monsieur Vincent was an alcoholic, I can swear he never drank anything when he was with us.

"Night was falling," Adeline Ravoux's account continues, "and in the half-light only my mother noticed that Monsieur Vincent was holding his belly and that he seemed to be limping. His jacket was buttoned up. When he came near us he passed like a shadow, without saying 'Good evening'. My mother said to him: 'Monsieur Vincent, we were worried at not seeing you. What happened to you?' He leant

for a few moments against the billiard table in order not to lose his balance, and replied in a low voice: *Oh nothing, I am wounded*. Then he slowly climbed the seventeen twisting steps up to his little attic room with its whitewashed walls and its skylight looking up to heaven. We wondered what he meant. Would he come down to supper or not? I was curious, as any girl might be, and I went to the foot of the stairs to listen. There I really heard him groan, and I told my parents at once. Then my mother said to my father: 'You'd better go and see, Gustave. Perhaps Monsieur Vincent is not well.' My father went up. He also heard a faint groan. The door was not locked, and my father went in and saw Monsieur Vincent lying on his narrow iron bedstead with his face turned to the wall. My father gently asked him to come and eat downstairs. There was no answer. 'What is the matter with you?' my father went on. Then Monsieur Vincent turned carefully over towards my father. *Look* . . . he began, and taking his hand he showed him the place on his body at the bottom of his chest where there was a small bleeding hole. Once again my father asked: 'But what have you done?' And this time Monsieur Vincent replied: *I shot myself . . . I only hope I haven't botched it*.

"My father was alarmed and called my mother. He understood what was wrong, and that he must get a doctor at once. They sent at once for the doctor who came to Auvers twice a week and treated all the village. His name was Dr Mazery." This was the story Adeline Ravoux told me.

Ravoux was so upset that he did not at once remember that he had lent his pistol to Monsieur Vincent, who said that he wanted it to scare away the crows which came too close to his canvas when he was painting in the country. It was never found again.

WHERE WAS THE PISTOL FIRED?

The evidence for Vincent's movements between the time he left the Gachets and returned home to the Ravoux consists of the following items: the death certificate, a news item in a local weekly newspaper, the spoken and written evidence of Dr Gachet, Theo, Johanna van Gogh-Bonger, Emile Bernard and various others.

One thing is certain: Vincent attempted to kill himself. All the evidence is positive on this point. It is also certain that he used a pistol. But there is some doubt about the part of his body that he wounded. Some say that the bullet went into his belly, others that it was his chest. As the wound was mortal, wherever it was, this would be a quibbling point, if it were not for Vincent's passion for all things Japanese. A shot in the belly might indicate that he was following the ancient tradition of hara-kiri. Where the deed took place is even more problematical.

*L'Echo Pontoisien* of August 7, 1890, merely said vaguely "in the fields" in its little paragraph (which is reproduced on page 333 with a translation).

One place sometimes mentioned is Commency, a hamlet near Auvers-sur-Oise, not far from the old church that Vincent painted. According to this version, Vincent walked towards the pont de Méry. When he reached the station and had passed the Jardin de Daubigny, which had once belonged to Charles Daubigny the famous landscape-painter, he turned left towards the church and then went on towards the cemetery.

This version could agree with the phrase "in the fields". Behind the cemetery were the vast wheat-fields. The famous canvas with the crows was painted not very far from there. This is the usually accepted version.

But there is another one, which for some reason has hitherto been largely overlooked or disbelieved. It differs considerably from the first. The source seems to be perfectly reliable, for it derives from the owner of the left half of the Jardin de Daubigny, which was divided in two as a result of an inheritance after Daubigny died in 1878. The gentleman who owned it in Vincent's day had a daughter who was about the same age as Marguerite Gachet and who was a friend of hers. Later she married a Dr Liberge.

Madame Liberge had heard her father talk about Vincent's suicide in these terms: "I don't know why people don't tell the true story. It was not over there, by the cemetery, that the poor fellow put a bullet in his chest. He left the Ravoux' inn in the direction of the hamlet of Chaponval. At the rue Boucher he entered a small farmyard. There he hid behind the dunghill. Then he committed the act that led to his death a few hours later."

FIELDS UNDER A STORMY SKY. Auvers-sur-Oise, July 1890, oil on canvas, 50 × 100 cm, F 778, H 806.   Vincent van Gogh Foundation, Amsterdam.— "I did not have to go out of my way", Vincent wrote of his work at this time, "to try to express sadness and extreme loneliness."

Madame Liberge added: "These were my father's very words. Why should he have wanted to invent such an absurd story and falsify history? Anyone who knew my father could tell you that he was always to be trusted." The puzzle remains: why has this account, which is more than ninety years old, never appeared in any biography of Vincent?

## NO WILL TO LIVE

Vincent had never seen Dr Mazery before, and asked that they should call Dr Gachet because he was a friend. Gachet and his son hastened to the Ravoux', with his emergency bag and a little induction coil because of his belief in electrical therapy. By the weak light of a candle held by his son, Dr Gachet examined the wound.

Dr Leroy and Dr Doiteau report that they were told by Gachet's son thirty years after the event "that his father then saw that level with the edge of the left ribs, a little in front of the axillary line, the wound formed a little circle of dark red, almost black, surrounded by a purple halo, and bled with a thin stream of blood. The shot had been fired too low and too far out. The heart had not been hurt, nor, it seemed, had any other vital organ. The bullet must have gone through the left pleural cavity and had come to rest in the posterior mediastinum, in the neighbourhood of the large blood vessels, the spinal column, and the diaphragm. At all events, Vincent showed none of the symptoms of a serious chest wound, there was no hematopsy, no suffocation, and no appreciable shock."

After Dr Gachet had applied a dressing in Dr Mazery's presence, the two doctors went into another room. There they quickly agreed that it was impossible to extract the bullet, which had lodged in a very inaccessible place. As there were no very serious symptoms, they decided to mitigate his wound as best they could and hope that in time it might eventually heal.

Dr Mazery left. Dr Gachet returned to the bedside. Vincent did not seem to be in pain. With almost unbelievable calm, he asked if he might smoke. Dr Gachet did not object. Vincent asked

CROWS ON THE CORNFIELDS. Auvers-sur-Oise, July 1890, oil on canvas, 50.5 × 100.5 cm, F 775, H 808. Vincent van Gogh Foundation, Amsterdam. Photograph A.I.v.G.—It is often said that this was the last picture that Vincent painted before he took his own life, but there is no evidence for this in his correspondence. Vincent set up his easel in the exact spot from which this photograph was taken. The little path on the right can no longer be seen because it has now been ploughed up.

the doctor to give him his pipe and tobacco, which were in a pocket of the blue blouse that he had always liked to wear since he became a painter. Dr Gachet filled the pipe, lit it and put it in the patient's mouth. Vincent began to smoke. Gachet told him that he still hoped to cure him. Vincent at once replied: *I will do it all over again.*

When Dr Gachet asked Vincent what Theo's private address was, he firmly refused to give it. It was logical enough, Vincent wanted at all costs to avoid a last meeting with Theo, knowing how much it would hurt him. Besides, if only he had not missed, his death would have made such a meeting impossible. Dr Gachet seems to have understood. He did not insist. He went home, but so that there would be someone to watch Vincent at night, his son stayed behind, sitting on the one rush-seated chair in the room. Vincent smoked his pipe and said nothing.

After Dr Gachet had left, Anton Hirschig went to Vincent's bedside. Hirschig was to write a letter to Dr A. Bredius, who published it in *Oud-Holland* in 1934, in which he said: "I can still see him, with his maimed ear and his wild eyes which had a touch of madness in them, so that I did not like to look at them, as he sat on a bench in front of the café window. And I shall never forget him coming

in, with his hand on his stomach, after we had waited for him at supper. I can see him in his little bed in his little attic, in the grip of terrible pain. *I couldn't stick it any longer, so I shot myself,* he said. *But will nobody cut my belly open for me?* It was swelteringly hot up there under the roof."

By a strange coincidence the incident of the cut ear at Arles and the attempted suicide at Auvers-sur-Oise both took place on a Sunday. There is another, and perhaps less coincidental, similarity. Apparently Dr Gachet had pointed out to his family, when Vincent threatened him over the Guillaumin nude, that there was an analogy with the attempt to attack Gauguin. The only difference was in the weapon. But there may also be another similarity between the two abortive attacks.

In Gauguin's case, Vincent first threatened him with a razor and then cut off the lobe of his own ear with the same weapon. In Dr Gachet's Vincent first threatened him with a pistol (or so the doctor firmly believed) and then shot himself with the same weapon. Each time he tried to attack someone else and ended by wounding himself. If the assailant identified himself with his victim, psychiatrists would surely conclude that it was a clear case of split personality.

## THE DYING GIANT

As soon as he returned home, Dr Gachet wrote to Theo: "With the greatest regret I must disturb your repose. Yet I think it my duty to write to you immediately. At nine o'clock in the evening of today, Sunday, I was sent for by your brother Vincent, who wanted to see me at once. I went there and found him very ill. He has wounded himself . . . as I did not know your address and he refused to give it to me, this note will reach you through Goupil."

During the evening two policemen arrived to make the regulation enquiries. One of them was called Rigaumont. Ravoux was present during the questioning which had to take place. Vincent obstinately refused to give the least explanation. Very calmly he replied: *What I have done is nobody else's business. I am free to do what I like with my own body.*

Rigaumont, who had begun in a threatening manner, then tried talking to him more kindly and asked him: "Where did the pistol come from?" Vincent said nothing, but Ravoux hastened to explain that it was he who had lent it. Rigaumont tried to get Vincent to confirm this. But Vincent stared in front of him as if nobody else was present, and puffed away at his pipe.

Rigaumont made one last attempt: "I can understand that you don't want to compromise M. Ravoux, but it can do no harm to anyone if you tell me what you have done with the pistol." The result was the same. Finally the policemen realized that they would learn nothing from him. They went back to Pontoise, leaving Vincent to wait patiently for the end. His courage was magnificent.

The following morning, July 28, a messenger brought Dr Gachet's note to Theo at his office. He went to Auvers-sur-Oise at once, where, with tears in his eyes and a breaking heart, he embraced his poor brother on the bed.

Vincent said: *I've botched it again.* . . . He had tried more than once before, for there had been the paints that he had tried to eat at Saint-Rémy-de-Provence as well as the razor at Arles. And now he had failed once more. When he saw Theo's misery he said: *Don't cry, I have done it for the good of us all.* . . . At one point Vincent asked what the doctors thought of his condition, and, when Theo assured him that they thought there was a very good chance he would recover, he replied: *It's no use.* . . . *Misery lasts all one's life.* . . .

On that same day, July 28, Theo wrote to Johanna: "This morning a Dutch painter who also lives in

Auvers [Hirschig] brought me a letter from Dr Gachet that contained bad news about Vincent and asked me to come. Leaving everything, I went and found him somewhat better than I expected. I will not write the particulars, they are too sad, but you must know, dearest, that his life may be in danger. . . . He was glad that I came and we are together all the time . . . poor fellow, very little happiness fell to his share, and no illusions are left him. The burden grows too heavy at times, he feels so alone. He often asks after you and the baby, and said that you could not imagine there was so much sorrow in life. Oh! if we could only give him some new courage to live. Don't get too anxious; his condition has been just as hopeless before, but his strong constitution deceived the doctors."

This was a vain hope. Night came, and at about one o'clock in the morning, on Tuesday July 29, 1890, Vincent suddenly lost consciousness and soon afterwards died in his brother's arms. Theo had not left him for a moment. Thus, in Stefan Zweig's words, "all that was mortal of Vincent passed away". His eyes were closed for ever.

Vincent never broke the strange silence that had come upon him in his last hours. With calm courage he was ready for death. Cicero said: "We know that we shall die, but we do not know whether it will be today." But Vincent knew. He had chosen his own time to go.

Vincent had run himself through on the grim reaper's scythe, and brought to an end his unloved life, in which visionary ecstasies were broken by terrible misery. He was thirty-seven years old, the age at which Raphael, Watteau and Toulouse-Lautrec died. He had nothing more to fear in this world.

At his father's deathbed Vincent had said: *To die is hard; but to live is even harder.* After all his sorrows and all the obstacles in his way that had poisoned his wretched life, it became in the end easier to die.

Although he had lost everything, Vincent had made no concessions: he had never taken the safe or easy road in his life or in his painting. He had always scorned and defied traditions and dogmas and refused to identify himself completely with any movement. His life had not been in vain, for the history of art would feel the mark of his genius.

## A SYMBOLIC CANVAS

Among the canvases painted in the last days of his life there is one that is full of meaning. It is his study of the Gothic church at Auvers-sur-Oise (reproduced on page 321). This masterpiece is a well-known and moving picture. Its symbolic importance is considerable when it is explained in relation to the painter's last days.

THE MAIRIE IN AUVERS ON JULY 14. Auvers-sur-Oise, July 14, 1890, oil on canvas, 72 × 93 cm, F 790, H XVI, Collection of Leigh B. Block, Chicago, U.S.A. Photograph A.I.v.G.—Below left: Vincent also did a drawing of the same subject in black chalk, 21 × 31 cm (Vincent van Gogh Foundation, Amsterdam). His death was registered there just over a fortnight later. The photograph was taken in 1956.

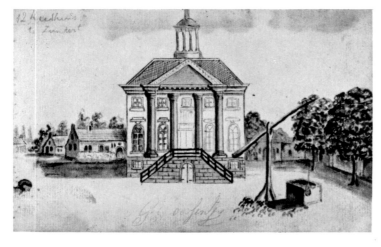
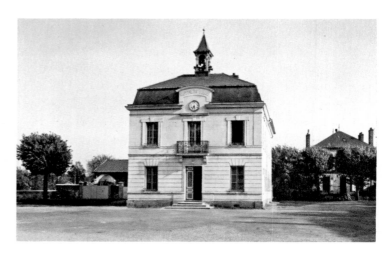

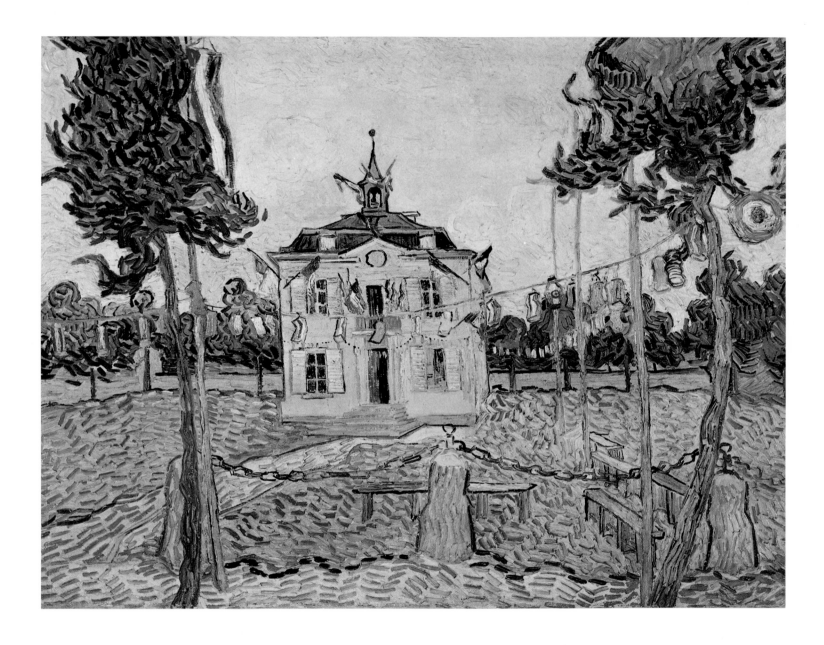

In order to paint this picture, Vincent had to sit with his back to a wall, and contrary to usual habit he had his subject directly in front of him.

The church dominates the composition, for it covers two-thirds of the area of the canvas. Vincent has painted the apse and not the front of the church, and the porch is out of sight. This church without a door reminds us that Vincent was no longer a member of the Church, either as minister or worshipper. But the Church existed, and in its existence it represented an ideal, a perfect unity of thought and action concealed within the vicissitudes of a tumultuous life: the ideal of serving mankind, whether by religion or by art. When Vincent painted this canvas the portals of the church were apparently inaccessible to him, and this suggests that he was to some extent conscious that the artist's way was barred to him.

In the foreground the road divides in two. On the left a woman is walking away with her back to the painter. She is more than a casual Auvers peasant, and seems to be a nameless symbol representing Ursula Loyer, Kee Vos, Sien and Margot Begemann. On the right the road leads towards the graveyard. Above the church and this dividing of the ways a violently blue sky seems to threaten a storm. Vincent could not remain where he was. He must

Register of death. Municipal archives, Auvers-sur-Oise.—This document was signed by the mayor, Alexandre Caffin, the deceased's brother, Theo van Gogh, and Arthur Gustave Ravoux, restaurateur. Theo van Gogh gives his profession as picture-dealer's employee. Vincent died on July 29, 1890 at 1.30 a.m.

Dr Paul Gachet Jr. Photograph A.I.v.G.—Dr Gachet's son, seen here with the author, was sixteen when Vincent used to visit his father, who was an amateur painter and engraver, and who signed his work with the pseudonym van Ryssel.

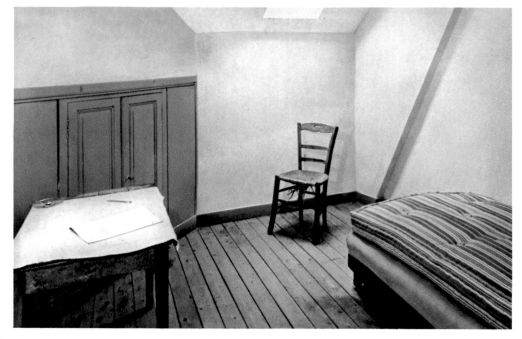

The room in which Vincent died. Photograph A.I.v.G.—During the two days that he was dying Vincent remained in this attic-room at Ravoux's hotel-restaurant. While he was waiting for the end, and was in very great pain, he calmly smoked his pipe. Theo came at once and, much distressed, tried to comfort his brother.

News item. Document A.I.v.G.—After the Second World War I found a copy of *L'Echo Pontoisien* for August 7, 1890 in a printer's loft. The item reads: "Auvers-sur-Oise.—On Sunday July 27, one van Gogh, aged thirty-seven, a Dutch painter staying at Auvers, shot himself with a revolver in the fields, but, being only wounded, returned to his room, where he died two days later."

**— AUVERS-SUR-OISE. —** Dimanche 27 juillet, un nommé Van Gogh, âgé de 37 ans, sujet hollandais, artiste peintre, de passage à Auvers, s'est tiré un coup de revolver dans les champs et, n'étant que blessé, il est rentré à sa chambre où il est mort le surlendemain.

Notification to his friends. Document A.I.v.G.—Theo, on behalf of all his family, announces his brother's death. At the bottom right is his address, "Paris, 8, Cité Pigalle" and his old mother's "Leiden, Heerengracht, Holland".

Death-portrait. Jeu de Paume, Louvre, Paris.—Dr Paul Gachet, who was born in Lille and took its Flemish name, Ryssel, as his pseudonym, made this charcoal drawing of Vincent on his deathbed. His son, Dr Paul Gachet Jr, presented it to the Louvre in 1952. From this drawing Dr Gachet made an etching, but was less successful in capturing the expression of the face.

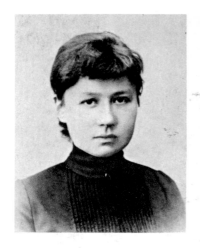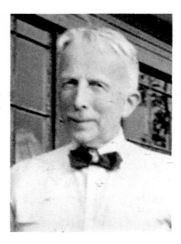

Johanna Bonger. Photograph Vincent van Gogh Foundation, Amsterdam.—This is what Vincent's sister-in-law looked like when he met her for the first time in Paris on his way back from Saint-Rémy-de-Provence to Auvers-sur-Oise. On the right, Vincent-Willem van Gogh, her son. Photograph Vincent van Gogh Foundation, Amsterdam.—He continued untiringly the efforts of his mother to safeguard the collection of his uncle's works for posterity.

decide whether he would go back—but it is impossible to have one's life over again—or to turn left, towards the village and towards life, or to turn right towards the graveyard.

It was this very road to the right which the little funeral procession took when Vincent was borne to his grave. He was not even permitted to enter the church.

## PEACE AT LAST

In August 1883 Vincent told van Rappard that he was convinced that there was a profound truth in the words of the Bible "For whosoever would save his life shall lose it: and whosoever shall lose his life for my sake shall find it." Vincent thought that this was true even if it was applied to other ideals besides those of the Gospels. On the day when he shot himself Vincent had a letter on him which included the words: *Well, my own work, I am risking my life for it and my reason has half-foundered because of it.* It complements what he had already said to Anthon van Rappard.

At the end of a letter dated May 8, 1875, the last that he wrote before leaving London for Paris,

Vincent appended a quotation from Ernest Renan: "To act well in this world one must sacrifice all personal desires. The people who become the missionary of a religious thought have no other fatherland than this thought. Man is not on this earth merely to be happy, nor even to be simply honest. He is there to realize great things for humanity, to attain nobility and to surmount the vulgarity of nearly every individual."

Vincent had fulfilled this demand. Millions of people who recognize beauty and nobility of spirit now recognize that Vincent has done great things for humanity.

When he died in his brother's arms, Vincent asked his forgiveness for all the trouble he had caused him, all the money he had cost him. Perhaps for the first time in his life he was about to break into a smile of real happiness. One seems to see a ghost of it in the drawing which Gachet did of him on his deathbed, but whether it is the smile of a child freed of his cares or the smile of reason that one sees on the busts of the old philosophers we cannot tell.

Vincent, "that solitary and astounding star" as Vercors called him, was not afraid of the unknown ahead of him. He just smoked his pipe with almost unbelievable calm.

In his first letter to Johanna after Vincent died, Theo wrote: "One of the last things he said was, *I wish I could pass away like this*, and his wish was fulfilled. A few moments and all was over. He had found the rest he could not find on earth...." And to his mother Theo confessed: "One cannot write how grieved one is nor find any comfort. It is a grief that will last and which I certainly shall never forget as long as I live; the only thing one might say is that he himself has the rest he was longing for.... Life was such a burden to him; but now, as often happens, everybody is full of praise for his talents.... Oh Mother! he was so my own, own brother."

Anna Freud has written that the life of Vincent van Gogh shows that "even the highly prized and universally envied gift of creative activity may fail tragically to provide sufficient outlets or acceptable solutions for the relief of intolerable internal conflicts and overwhelming destructive powers active within the personality". Yet such figures have rightly been considered to be the salt of the earth.

334

"In order to put the corpse in his coffin," Adeline Ravoux told me, "the undertaker and his mutes set it up on trestles and then put it on the billiard-table in the big room on the right where Monsieur Vincent painted my portrait. Over it all they draped a simple white sheet. My father, with the help of Monsieur Vincent's brother, then turned the little room into a mortuary chapel with candles and flowers. At the foot of the coffin, among the flowers on the floor, my parents arranged his easel, his folding stool, his palette and his paints.

"Soon a second team of workers went into action. These were his friends, who had come from Paris and elsewhere. They brought a profusion of yellow flowers, chiefly dahlias and sunflowers, because Monsieur Vincent had a great fondness for them."

Adeline Ravoux said that there were ten friends, Theo that there were eight. On the walls of this mortuary room they hung the dead man's best canvases. These pictures had been the silent witnesses of his joy when he created a little beauty for his friends. They had also been witnesses of his sorrow when he struggled to be understood. Now they kept watch at his bedside, once again silent witnesses of the man who signed himself Vincent.

In order to decorate the room, they used many flowers and wreaths, and there was masses of yellow, Vincent's favourite colour. Theo wrote to Johanna: "Dr Gachet was the first to bring a large bunch of sunflowers, because Vincent was so fond of them."

At ten o'clock in the morning the people there besides Theo were: Dr Gachet, Ravoux, Père Tanguy, Emile Bernard and his friend Charles Laval. Unfortunately Bernard did not arrive in time to see his great friend again: the coffin had already been closed. Ravoux told him the whole story of the suicide, and Bernard was particularly incensed at the visit from the policemen. Then, as Bernard told Albert Aurier the next day, many people poured in, most of them artists, and among them were Lucien Pissarro and Lauzet.

The burial took place on Wednesday July 30, at three o'clock in the afternoon. Vincent's life had always been beset with difficulties. At the last moment even his burial threatened to cause trouble. The curé of Auvers-sur-Oise, the abbé Teissier,

The funeral. Collection estate of Emile Bernard, Paris.—In 1893, three years after Vincent had died, his young friend Emile Bernard painted a picture of his funeral from memory. Unfortunately the picture remained unfinished. Behind the coffin, half hidden by the black drapery, his friends file past: Theo, Charles Laval, Andries Bonger, Lucien Pissarro, Bernard, Lauzet, Tanguy, Ravoux, Dr Gachet and several other artists and people from Auvers-sur-Oise. Bernard put in the lemon and the yellow wreath in symbolic homage to "the man who (as his own works show) so loved that brilliant colour".

refused point-blank to lend the parish hearse on the grounds that the deceased had committed suicide. The neighbouring township of Méry was more tolerant and gladly provided one. Otherwise the burial could not have taken place at the appointed hour.

## TOWARDS THE LAST RESTING-PLACE

For the first time for thirty-seven years something quite ordinary and commonplace happened to Vincent. He was buried just like any other dead man. His friends carried him to the hearse. Several people were in tears and Theo was said to have "sobbed pitifully without cease".

In his account intended for Albert Aurier, Emile Bernard wrote: "Outside the sun was fearful. We climbed up the side of Auvers talking of him, of the bold thrust he had made for art, of the great plans he always had in his head, of the good that he had done to each of us. We reached the cemetery, a little new cemetery, gleaming with new tombstones.

Then we lowered him into the grave. Dr Gachet wanted to speak a few words that he had prepared about Vincent's life, but he too was weeping so much that he could only say a very halting farewell. 'He was,' he said, 'an honest man and a great artist. He had only two aims, mankind and art. Art he loved above everything, and it will make him live.'"

Gachet's son says that his father wept so much beside the open tomb that nobody could make out the few sentences that he spoke. After this Theo said a few words of thanks. Among those present were the Dutch painter Maurits Willem van der Valk and his future wife, who was also a painter. There were a number of people from Auvers-sur-Oise, for they did not persecute him as those of Arles had done. They were all much moved. Some went home by country lanes. Others made their way back to the station.

From birth to death Vincent's life was out of the ordinary. Only at the very end was he like other men. But not for long. Instead of being forgotten, his fame grew and he was reborn. As light transforms all that it shines upon, so Vincent's genius was to influence all the artistic movements that were to follow.

Vincent's soul had at last found peace after all the persecution and inner torment that it had suffered. Theo managed to arrange that Vincent should have a tombstone of his own, even though he had ended his own life—a greater honour than was accorded to Mozart who was thrown into the common grave.

Theo's health was broken, and six months later he joined his brother in death. In 1914 his remains were moved to Auvers-sur-Oise, and now the two brothers lie side by side, as united as they had been in life. Two identical tombstones stand against the wall of the country graveyard in the middle of the cornfields which remind the summer visitor of Vincent.

Theo was the only one to believe that Vincent would sooner or later find fame. He had always told his father and mother, his sisters and his younger brother that Vincent was "different" because he had an extraordinary vocation. But from time to time he said more to other people who understood him better because they were more closely concerned with art.

One evening, long before Vincent's death, Theo was walking the streets of Paris with his friend, the Dutch painter J. J. Isaäcson, who later told Just Havelaar, the Dutch poet and art critic, that they had talked of Vincent and Theo had said: "I should not be surprised if my brother were one of the great geniuses and will one day be compared to someone like Beethoven." Theo was not mistaken.

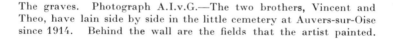

The graves. Photograph A.I.v.G.—The two brothers, Vincent and Theo, have lain side by side in the little cemetery at Auvers-sur-Oise since 1914. Behind the wall are the fields that the artist painted.

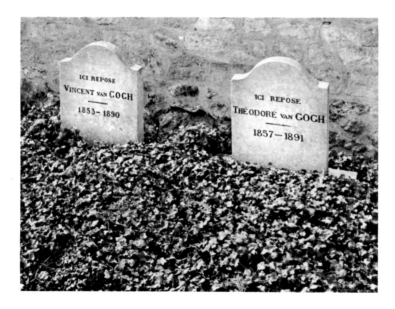

# THE MOTIVES FOR SUICIDE

Vincent's suicide raises the question: why did he end his life? His letters and pictures are an open record of his life. Yet neither help to enlighten us about the motives for his suicide. His letters contain no warning of his decision.

The first possible motive is that Vincent despaired of ever being able to earn his living. Now that his brother had a family to support, Vincent could not accept that Theo should go on feeding him at the expense of his wife and child. Some have therefore interpreted it as an act of despair due to his powerlessness to repay all that Theo had done for him.

Germain Bazin thinks that Vincent yielded to a self-punishment complex and killed himself in order not to kill Theo, and he has argued this case well. There is good evidence to support him. In one of his last letters Vincent admitted: *I feared—not altogether but yet a little—that being a burden to you, you felt me to be rather a thing to be dreaded.* But a letter from Jo had reassured his anxiety or remorse. He replied: *Dear brother and sister, Jo's letter was really like a gospel to me, a deliverance from the agony which had been caused by the hours I had shared with you which were a bit too difficult and trying for us all. It was no slight thing when we all felt our daily bread was in danger.*

In writing of his most recent pictures at this time Vincent said: *They are vast fields of wheat under troubled skies, and I did not need to go out of my way to try to express sadness and extreme loneliness.* This is certainly a confirmation of Vincent's depressed mood, but it does not help us very much, because these pictures were not the last that Vincent painted, though they are usually held to be.

This letter was written on July 9, eighteen days before Vincent shot himself. At this time he had already painted CROWS ON THE CORNFIELDS and FIELDS UNDER A STORMY SKY. Yet five days later he painted THE MAIRIE IN AUVERS ON JULY 14 (see page 331) with the little town hall that he could see out of Ravoux's window, and which, no doubt, reminded him of the town hall at Zundert which he had known in his childhood.

## MISLEADING STABILITY

Vincent's last pictures are no more explicit. It is true that CROWS ON THE CORNFIELDS has long been thought to be Vincent's last picture, but for no better reason than that it makes one almost hear the wing-beats of those birds of ill-omen. The black flock has been seen as a portent of his inevitable fate, and the impression that the picture makes has become a reason for thinking it prophetic. Yet it was painted eighteen days before the suicide, and during that time nothing in Vincent's behaviour hinted that he had taken his decision. Vincent saw everything around him with the eyes of a visionary. This was as true of CROWS ON THE CORNFIELDS as it was of THE MAIRIE IN AUVERS ON JULY 14, which is certainly the later of the two pictures. Behind the apparent stability of the town hall at Auvers, he perceived the real instability of the whole of creation. This picture has a secret affinity with what Bergson called "the vital movement of things and of the universe in its totality". But it is not a portent of some dark event in the way that a picture like CROWS ON THE CORNFIELDS is. Vincent, perhaps as a result of what he had learned from the Japanese, could, of course, hide the worst misery under an appearance of serenity. But once again this leads to more theorizing. The last paintings provide no more satisfactory explanation of the motives for Vincent's suicide than his letters do.

## AN OLD RUMOUR

Another explanation of Vincent's suicide that has been put forward is that he was in love with Marguerite Gachet, but her father was resolutely opposed to their love. Thus Vincent would have seen himself losing his last opportunity of founding a family, as Theo had just done, and have felt that it was not worth going on living alone.

Gachet's son never openly supported this theory, but he never contradicted it either. In fact I believe

that the truth was the other way round. Marguerite had a close friend in whom she confided. This friend was Madame Liberge, and she confirms this view.

"Mind you, she never admitted that she had fallen in love with the painter," Madame Liberge told me. "She was too proud to do so. But her whole attitude and everything she told me betrayed her true feelings about him."

Marguerite's depression became so serious that she practically never went out, and neglected her closest friend more and more. She was never able to get over the shock she had suffered, and she never married. Even long afterwards she lived as a recluse. The inhabitants of Auvers-sur-Oise, even those who were her neighbours, rarely saw her go out.

When I used to go and see her brother, Marguerite would emerge from her isolation. She did not speak, but when we talked about Vincent, she listened intently, and I noticed that each time he was mentioned there was a light in the eyes that were usually so dull. This is obviously not much in the way of evidence. It was only natural that she should take an interest in a conversation about someone she had known; and she had also witnessed certain events in her parents' house. Yet, although Marguerite never confided in anyone, I am inclined to think that Madame Liberge has given us a glimpse of the truth.

## TO GO OUT ON THE CREST

A third explanation is based on Vincent's artistic vitality. It has also been suggested that Vincent's creative powers had reached their peak at Auvers-sur-Oise and now threatened to decline. According to this theory Vincent had a presentiment of this decline, and rather than face a future in which he was less than himself, he gave up the struggle when he was at the height of his powers.

Of course it would be painful for him to find his creative genius failing before the end of his life. Vincent could certainly not have borne it. But how could he be sure he had come to the end of his career and that he had really said all that he had to say? The argument of those who support this theory is that some of the paintings done in the last weeks of his life are below his usual standard: the drawing is weak and the colour is poor and not at all striking. Several critics have even doubted the authenticity of some of them. There is no proof, but one can argue that Vincent might have deliberately destroyed himself at his fullest maturity because he felt that he was going to suffer a terrible decline. There are passages in the letters which seem to support this view. Vincent had given himself ten years in which to succeed. This period had almost run its course. On June 11 or 12 he wrote to the Ginoux: *Twice they have written articles on my pictures. Once in a Paris newspaper, and the other time in a newspaper in Brussels, where I had an exhibition, and now, a very short time ago, there was an article in a paper of my native country, Holland, and the consequence was that many people went to look at my pictures.* It was true that he was at last beginning to be talked about. On August 17, 1889, about six months before Albert Aurier's article in the *Mercure de France*, an Amsterdam weekly called *De Portefeuille* wrote: "Who is it, that with form and colour, interprets for us the powerful life, the great and now conscious life, of the nineteenth century?" And J. J. Isaäcson replied unequivocally: "I know one who does, he is a unique pioneer, and he is struggling alone in the vast night. His name is Vincent, and it is destined for posterity." And in a note he added: "I hope to say more about this remarkable hero later; he is a Dutchman."

We know what Vincent felt about this from a letter to Theo in which he wrote: *In some Dutch newspaper which you put in with the Millets—I notice some Paris letters that I attribute to Isaäcson. No need to tell you that I think what he says of me in a note extremely exaggerated, and that's another reason why I should prefer him to say nothing about me.*

Besides this theory that Vincent was afraid of his genius being exhausted, there is also the theory that he was afraid of his own success. As Dr Nagera has pointed out the two fears existed side by side. Yet this theory of suicide due to fear of failure or fear of success is a weak one. The large number of pictures painted during Vincent's short time at

SELF-PORTRAIT. Saint-Rémy-de-Provence, May 1890, oil on canvas, 65 × 54 cm, F 627, H 748. Jeu de Paume, Louvre, Paris.

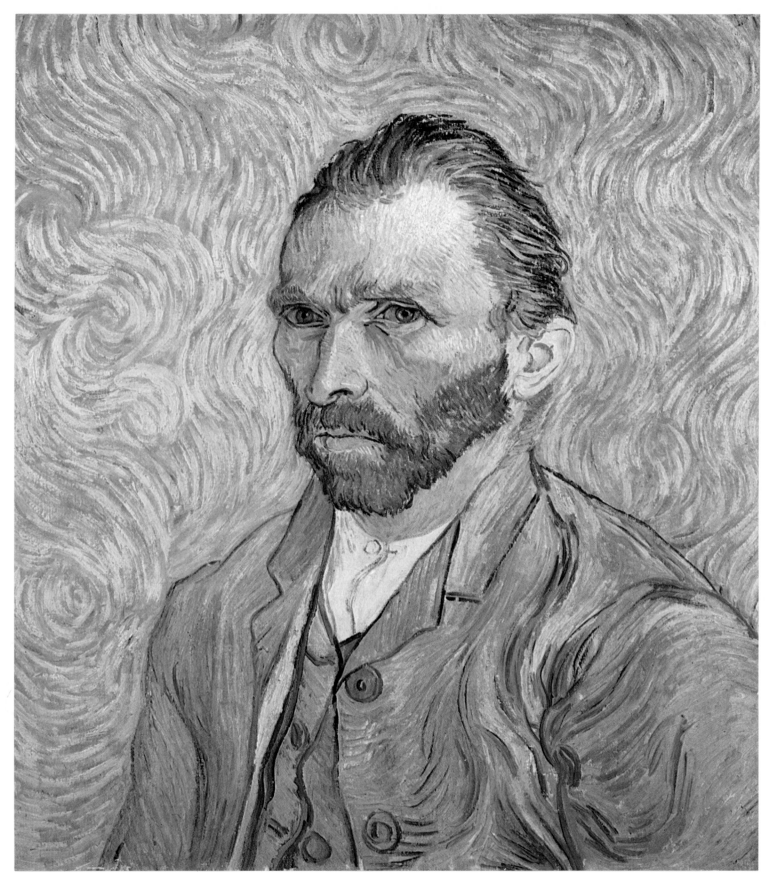

339

Auvers, the impossibility of dating them by any consistent change in style and Vincent's absence of any real fame before his death all tend to disprove it.

## THE FEAR OF ANOTHER ATTACK

Yet another theory is that Vincent feared a new attack of madness, and that he took his own life in order to avoid it. This theory has some basis, but the facts contradict it. Nothing in Vincent's behaviour at Auvers-sur-Oise indicated that another attack was imminent. Some critics looking for a sensational theory and not minding where they found it, have taken the line that Vincent's suicide was the logical fate of a painter struck by madness. Genius, like madness, is not normal, it is true. But the two are not the same, and it is absurd to look for signs of madness in the hundreds of his canvases which are recognized as masterpieces. Vincent had always been an exceptional person, but this did not make him a madman. Krafelin the psychologist said to Franz Muncker the historian that Goethe had never been normal and that such a term was out of place when one was discussing a genius. The same could be said of Vincent. The theory that Vincent suffered a new attack of madness, or was crazed by the fear of it, will not bear analysis, for he was extraordinarily lucid up to the last moment.

## A PAINFUL CASE OF CONSCIENCE

I would like to suggest a last theory which nobody has put forward before. Throughout his life Vincent was unloved, and he always hoped to find a woman who would share his daily life and his artistic adventure. This happiness was denied to him. One can imagine the shock he had when he found himself with Theo, Johanna and the baby Vincent: it was the picture of what he had dreamed of but had never been able to attain.

During the few days that Johanna saw Vincent in Paris and at Auvers-sur-Oise, she was an affectionate sister-in-law to him; she offered him real sympathy, she admired his talent and she understood his difficulties. As Vincent's heart was easily touched, it is not unreasonable to suppose that Johanna's presence caused him a serious inner crisis. Theo, the brother whom he loved more than all the world, had found a young woman who could have made Vincent himself happy. Fate once again seemed to have denied him his happiness when it was not far from his grasp.

Among the many secrets that Vincent carried to the tomb are the real motives for his suicide. I am convinced that there was not one but many. Vincent's resistance to them had been eaten away by a life that made him, as André Lhote said, "not merely the most accursed of modern painters, but the only one who was accursed in every way."

## TRIUMPH OR DEFEAT OF DEATH

Whatever Vincent's reasons may have been, they could only lead to death, not as the end of a wretched life, but as the way to a new life. It was not many months since Vincent had written to Theo: *We take death to reach a star*. Death was not a defeat, but the means, just like taking the train to Tarascon or Rouen, of going to the *other hemisphere*—the only means of understanding the greatest secret that he had tried to penetrate behind the appearances of things here on earth.

In 1951 my late friend Jacques Latour organized a fine exhibition of Vincent's work at the Musée Réattu at Arles, of which he was a director. One day a visitor asked him if the pictures could be removed from the wall so that he could take them in his hands and look at them from close to, as was his habit. On the last day, just before the exhibition closed, the visitor came again and Latour let him have several pictures to hold. While he was looking at the second picture—it was VINCENT'S BEDROOM— and admiring it, he said: "He was a fantastic fellow: at a time when all the roads were closed he managed to break through and make a broad path to all the possibilities in the future. I felt this and understood it at once when I saw his work for the first time at Bernheim's in Paris in 1901."

The visitor was a painter. I met him in 1958 at his villa on the Côte d'Azur, and we had a long talk about Vincent. Once again he said what a fantastic fellow Vincent had been. And Picasso, I felt, should know.

# CHRONOLOGICAL TABLE

## I. A SENSITIVE AND SOLITARY CHILD

*Zundert : April 1849—December 1861*

1849   April 1: Pastor Theodorus van Gogh is inducted at Groot-Zundert.

1851   Theodorus van Gogh marries Anna Cornelia Carbentus.

1852   March 30: Vincent Willem I born dead.

1853   March 30: Vincent Willem II, the painter, born.

1857   May 1: Vincent's brother Theo born.

1861   January 1: Vincent goes to the village school during 1861.

*Zevenbergen : October 1, 1864—August 31, 1866*

1864   October 1: Vincent goes to Jan Provily's boarding school at Zevenbergen.

*Tilburg : September 15, 1866—March 19, 1868*

1866   September 15: Vincent lives with Hannik at Korvel 57 at Tilburg where he studies.

*Zundert : March 14, 1868—July 30, 1869*

March 14: Vincent returns to Zundert.

## II. GOUPIL'S APPRENTICE

*The Hague : July 30, 1869—June 13, 1873*

1869   July 30: Vincent leaves Zundert for ever; he is taken on by Goupil's gallery at The Hague.

1871   January 29: The van Goghs leave Zundert and move to Helvoirt, where Theodorus van Gogh is appointed pastor.

1872   August: Vincent begins to correspond with Theo, who is at school at Oisterwijk.

1873   January 1: Vincent starts work at the Brussels branch of Goupil & Cie.

*London : June 13, 1873—October 1874*

1873   June 13: Vincent is sent to the London branch of Goupil & Cie; he lodges with Mrs Loyer and falls in love with her daughter Ursula.

1874   June: Vincent learns from Ursula that she is already secretly engaged.

*Paris : October—December 1874*

1874   October: Vincent is sent to the Goupil head office in Paris.

*London : December 1874—May 15, 1875*

December: Vincent returns to the London branch of Goupil & Cie.

*Paris : May 15, 1875—April 4, 1876*

1875   May 15: Vincent is sent back to the head office of Goupil & Cie in Paris against his will. After Ursula refuses him, he writes melancholy letters. He ceases to be interested in art-dealing, cuts himself off completely and is absorbed in studying the Bible.

1876   March: Vincent is given notice from April 1.

## III. BACK TO SCHOOL

*Ramsgate : April 17—June 1876*

1876   April 17: Vincent arrives at Ramsgate, where Mr William P. Stokes employs hims as an assistant teacher.

*Isleworth : June—December 1876*

1876   June: Vincent leaves his post at Ramsgate and walks to London.

June 17: He walks from London to visit his sister Anna who is working at a private school at Welwyn.

July 1: Vincent becomes a "sort of curate" under Mr Jones, a methodist minister at Isleworth.

*Etten : December 31, 1876—January 1877*

1876   December 31: Vincent is on a return visit to his parents at Etten.

*Dordrecht : January—May 1877*

1877   January: Vincent takes a job with Blussé and van Braam's bookshop at Dordrecht.

*Amsterdam : May 9, 1877—July 1878*

1877   May 9: Vincent arrives in Amsterdam, where he prepares for the entrance examinations to the faculty of theology at the University. He lives with his Uncle Jan, commander of the naval dockyard.

1878   July: Vincent abandons his studies of Latin and Greek, which do not interest him.

## IV. THE COURAGE OF DESPAIR

*Etten : July—August 1878*

1878   July: Vincent returns to his parents and spends a month preparing to be admitted to the mission school in Brussels.

      July 15: Vincent goes to Brussel with his father and the Rev. Mr Jones who happens to be visiting Etten.

*Brussels : August 25—November 1878*

1878   August 25: Vincent goes to Laeken to attend the mission school.

*Etten : November—December 26, 1878*

1878   November: After a three-months' trial period at Laeken he fails to qualify and returns to Etten.

*Borinage : December 26, 1878—October 15, 1880*

1878   December 26: Vincent leaves for the Borinage, the coal-mining district of Belgium, where he lives with a pedlar called van der Haegen at Pâturages.

1879   January: Vincent is appointed mission preacher at Wasmes in the Borinage. After a serious explosion in the local mine and a miners' strike Vincent tends the injured and the sick. He lives in a poor worker's house where he lacks everything.

      July: At the end of the month he is dismissed by his superiors because he is sacrificing himself too much to his fellows and not troubling to look respectable.

      August: Vincent moves to Cuesmes, where he remains until August 1880; he continues his mission work on his own account.

1880   August: Vincent finds his real vocation: he begins to draw.

Besides the Bible and Hendrik Conscience, he has hitherto read: Harriet Beecher Stowe, Dickens, Michelet, Victor Hugo and Shakespeare and has taken an interest in works by Charles de Groux, Leys, Rembrandt, Corot, Dürer, Israëls, Maris, Mauve, Michel, Ruysdael, Daubigny, Millet, Dupré, Jules Breton, Daumier, Doré and Rops.

## V. BEGINNINGS AS AN ARTIST

*Brussels : October 1880—April 12, 1881*

1880   October: Vincent leaves the Borinage and stays in Brussels.

      November 1: He visits the Dutch painter van Rappard.

*Etten : April 12—November 1881*

1881   April 12: Vincent learns from his father that Theo is coming home to Etten for Easter; he goes home too and stays there.

During the summer Vincent meets his widowed cousin Kee Vos; he falls in love but she refuses him.

At Etten he reads books by or about Charlotte Brontë, George Eliot, Balzac, Michelet and Carlyle; he also becomes interested in Gavarni's drawings.

## VI. A BREAK WITH THE PAST

*The Hague : November 28, 1881—September 1883*

1881   November 28: Vincent spends a month at The Hague with his cousin Anton Mauve, an important artist in The Hague School.

      December 25: Vincent has a bitter argument with his father on Christmas Day about going to church.

      December 31: Vincent leaves the presbytery at Etten and stays at The Hague where he is given lessons by Mauve.

1882   Vincent lives with Clasina Maria Hoornik, known as Sien. April: Vincent breaks with Mauve.

      June 7: Vincent is admitted to hospital, where he remains undergoing treatment for several weeks.

      July 1: He leaves hospital; he has already done much drawing and now begins to paint.

      August 4: Pastor van Gogh and his family move from Etten to Nuenen.

      August: Vincent becomes seriously interested in oil painting.

At The Hague Vincent reads books by or about Zola, Erckmann-Chatrian, Daudet, Reuter, Monnier, Taine, Murger, Edmond and Jules Goncourt. He becomes interested in the black-and-white artists in *Harper's Weekly*, *The Graphic* and *The Illustrated London News* and in the work of Millet, Daumier, de Groux, Franz Hals, Rembrandt, Ruysdael, Chardin and Lhermitte. Besides seeing van Rappard, Mauve and Breitner, he also meets Weissenbruch, van der Weele, de Bock and Blommers.

## VII. AUTUMN IN DRENTHE

*Drenthe : September 11—November 30, 1883*

1883   September 11: Vincent breaks with Sien and leaves The Hague to go to Drenthe where he lodges with Albertus Hartsuiker at Hoogeveen.

      September 24: He thinks of settling permanently in Drenthe.

      Beginning of October: Vincent leaves Hoogeveen and goes by barge to Nieuw-Amsterdam where he lodges with Hendrick Scholte.

      November 22: Vincent pays a short visit to Zweeloo where he hopes to meet Max Liebermann, but this German artist has already left; he draws the old church.

      December: He can bear the loneliness no longer and he returns to Nuenen, where he will remain for two years.

## VIII. RETURN TO NUENEN

*Nuenen : December 1883—November 27, 1885*

1884    January 17: When she is getting off the train at Helmond, Vincent's mother breaks her leg. In order to amuse her with what he calls "trifles" he paints her a picture of the little Protestant church with the hedge and trees around it.
July: Anthon van Rappard stays with Vincent at Nuenen for about ten days.

August: Vincent's neighbour, Margot Begemann, falls in love with him, and tries to poison herself because her family oppose the marriage. Vincent is deeply distressed.

September 30: Vincent works on designs for decorative panels in the house of Hermans, a retired goldsmith.

October 22: Van Rappard stays with Vincent again.

November: Vincent teaches painting to three people who live at Eindhoven.

December: At Eindhoven Vincent makes friends with Kerssemakers, *who passionately wants to learn to paint.*

1885    February: Vincent plans to paint fifty heads before the winter is over.

March 26: Vincent's father dies suddenly of a heart attack.

April: Vincent paints a still-life of a vase of honesty with his father's tobacco-pouch and pipe in front of it. He is very busy working on THE POTATO-EATERS.

September: He paints a basket of potatoes, a copper pot and some birds' nests.

October: He spends three days visiting the State Museum at Amsterdam.

November 4: He studies the theory of colour and is deep in the work of the Goncourts.

About November 27: He leaves Nuenen.

At Nuenen Vincent reads works by or about Fromentin, Gigoux, Blanc, Bracquemond, Delacroix and Coppée. He continues to be interested in Delacroix, de Groux, Lhermitte, Jules Breton, Millet, Israëls, Chardin and of course Rembrandt and Hals. He makes friends with Dimmen Gestel and van de Wakker, and continues to see van Rappard, Hermans and Anton Kerssemakers.

## IX. THE ANTWERP PERIOD

*Antwerp : November 28, 1885—February 28, 1886*

1885    November 28: Vincent is in Antwerp.

December: He buys Japanese colour prints in the docks and nails them to the walls of his room at 194 (now 224) Longue rue des Images.

December 18: He draws the cathedral and Grand-Place.

December 28: He paints the portrait of a woman with a red ribbon in her hair and begins to use carmine, cobalt and emerald green.

1886    January: Vincent studies Rubens.

January 18: He is registered as a pupil at the Academy where he meets the English painter H. M. Livens who paints his portrait in water-colour.
February: Vincent leaves Antwerp towards the end of the month.
He begins reading books by and about Dumas and Turgenev and he is interested in Henri de Braekeleer and Géricault.

## X. A STUDIO IN MONTMARTRE

*Paris : March 1886—February 21, 1888*

1886    March: Vincent goes to Paris and lives with Theo in the rue Laval (now rue Victor-Massé).

March 31: The governing body of the Academy at Antwerp decides to relegate Vincent to the beginners' class, to learn to draw, but he is in Paris and unaware of this. He attends Cormon's studio and makes friends with Toulouse-Lautrec and Emile Bernard. He lightens his palette under the influence of the Impressionists.

June: Theo and Vincent move to 54 rue Lepic in Montmartre where Vincent has a studio. Meanwhile he has left Cormon's establishment. His work is influenced by the *pointillisme* of Seurat and Signac.

1887    Spring: Vincent paints out-of-doors at Asnières, along the Seine and at Joinville. He has much talk with Gauguin and Bernard about what will be called Post-Impressionism. He paints his self-portrait in front of the easel. He is interested in Japanese colour prints and paints three pictures after them. He exhibits pictures in "Le Tambourin", a restaurant in the boulevard de Clichy, along with other painters of the "Petite Boulevard".

He reads Maupassant and Walt Whitman. He is interested in Monticelli, who influences his work, especially his still-lives of flowers, and also in the Ukiyo-ye school. He meets Degas, Pissarro, Guillaumin, Anquetin, Russell, Reid, Bernard, Gauguin, Toulouse-Lautrec, Seurat and Signac.

## XI. JAPAN IN THE SOUTH

*Arles : February 20, 1888—May 3, 1889*

1888    February 20: Vincent leaves Paris and goes to Arles. He is much impressed by the silver light and warm colours. He takes a room at the Hôtel-Restaurant Carrel at 30, rue Cavalerie.

March 10: He plans an artists' cooperative.

March: He paints a large number of orchards in bloom.

April: He produces many important paintings: "LE PONT DE L'ANGLOIS", PEACH TREES IN BLOSSOM and PEAR TREE IN BLOSSOM

May: He rents the right wing of "The Yellow House" at 2, place Lamartine for fifteen francs a month, but does not move in completely until September.

May 29: He visits Saintes-Maries-de-la-Mer.

June: He makes friends with Lieutenant Milliet who wishes to learn painting, and together they go on excursions around Arles.

Mid-June: He works at Saintes-Maries-de-la-Mer.

July: He stays a long time working at Montmajour and sends Theo a series of drawings of it.

July 29: He reads Loti's *Madame Chrysanthème* and paints "LA MOUSMÉ" sitting in a cane armchair.

August: In the second half of the month he paints a study of boats on the Rhône and a man unloading sand with a wheel-barrow.

September 8: He has just had several visits from Eugène Boch, a Belgian painter and poet of thirty-three whose sister is also a painter and belongs to the "XX".

September 9: He paints the terrace of a café in the place du Forum in the evening and sends Theo a study of it.

September 10: He writes to Gauguin and suggests that they exchange portraits.

September 11: Meanwhile he receives letters from Gauguin and Bernard.

September 17: He paints a self-portrait, for lack of models.

September 20: Gauguin arrives at Arles.

December: Vincent and Gauguin visit the museum at Montpellier.

December 23: He admits that Gauguin is *a little out of sorts with the good town of Arles, the little yellow house where we work, and especially with me.* The tension between Vincent and Gauguin reaches its crisis.

December 24: Early in the morning the police find Vincent in bed with the lobe of his left ear cut off and take him to hospital. Gauguin leaves Arles.

1889    January 1: Vincent writes to Theo to reassure him and sends warm greetings to Gauguin.

January 2: He tells Theo that he will stay a few days more in hospital but that he is well.

January 7: Vincent returns to "The Yellow House" and writes reassuring letters to his mother and sister.

January 17: He paints a portrait of Dr Rey and three studies of his studio.

February 3: He paints a fourth version of Madame Roulin, who posed for "LA BERCEUSE".

February 9: Vincent has a relapse and has to return to hospital for a time.

March 19: As a result of a petition signed by the *81 anthropophagi of Arles* Vincent is again put in a cell in hospital.

March 24: Vincent tells Theo that he has had a visit from Signac to whom he has given a still-life of bloaters.

April 21: He says that he will stay in confinement for the time being as much for the peace of mind of others as for his own.

May 2: He sends Theo two crates of pictures all of which are masterpieces.

Vincent suffers three attacks of madness during this period: from December 24, 1888 to January 19, 1889; from February 4 to 18, and February 26 to mid-April, 1889.

At Arles Vincent reads books by and about Coppée, Paul Alexis, Dostoevsky, Tolstoy, Wagner, Petrarch, Dante, Botticelli, Giotto, Richepin, Flaubert, Huysmans, Lemonnier and Renan. Besides the artists already mentioned, he is interested in Renoir, Manet and Puvis de Chavannes. He makes friends with Dodge MacKnight, the Roulins, the Ginoux and Pastor Salles.

## XII. VOLUNTARY CONFINEMENT

*Saint-Rémy-de-Provence: May 1889—February 1890*

1889    About May 8: Vincent, of his own will, goes to the Saint-Paul-de-Mausole asylum at Saint-Rémy-de-Provence.

June 25: He paints cypresses.

December: He paints the asylum garden at the beginning of the month.

1890    January: He tells his brother that he has never worked in greater calm. In an article entitled "Les Isolés" in the *Mercure de France* of January Albert Aurier publishes perceptive praise of Vincent's work. This is the first time that he has been written about outside Holland.

February 1: Theo's son is born.

February 14: Theo writes that the exhibition of the "XX" at Brussels has sold one of his pictures, THE RED VINES, to Anna Boch for 400 francs.

February 15: Vincent writes to his mother and says that he is longing to return to the north.

May 14: Vincent tells Theo that he is leaving for Paris.

While he is under observation in the asylum Vincent suffers four further attacks of madness: from July 8 to mid-August, 1889; December 24, 1889 to January 1, 1890: January 23 to 30, and mid-February to mid-April, 1890.

At Saint-Rémy-de-Provence Vincent reads Voltaire and is interested in Rousseau. He copies engravings of Rembrandt, Millet, Delacroix, Daumier, Doré and Lavieille.

## XIII. NORTH TOWARD HOME

*Paris: May 17—20, 1890*

1890    May 17: Vincent arrives in Paris

*Auvers-sur-Oise: May 20—July 29, 1890*

1890    May 21: Vincent takes lodgings with Ravoux opposite the little town hall.

June 4: He works on Dr Gachet's portrait and plans also to paint his nineteen-year-old daughter Marguerite.

June 8: Theo, his wife and child visit the Gachets with Vincent on Sunday.

About June 29: Vincent paints MADEMOISELLE GACHET AT THE PIANO.

July 6: Vincent spends Sunday in Paris with Theo and sees Aurier and Toulouse-Lautrec. He returns hastily to Auvers.

July 23: Vincent sends his last letter from Auvers in which he includes a sketch of his painting of "LE JARDIN DE DAUBIGNY".

July 27: He shoots himself in the chest but manages to get back to the Ravoux', seriously wounded.

July 29: Vincent dies at dawn.

# DIMENSIONS IN INCHES OF VAN GOGH'S WORKS

## PLATES IN THE TEXT

| | | |
|---|---|---|
| 31 | Farm and Wagon-Shed | 7 7/8 × 10 5/8 |
| 32 | The Dog | 7 1/8 × 11 1/4 |
| 33 | The Milk-Jug | 11 × 8 5/8 |
| 34 | The Bridge | 4 3/4 × 14 3/8 |
| 41 | Het Binnenhof, The Hague | 8 5/8 × 6 5/8 |
| 42 | Wagtail on its Nest | 7 × 4 |
| 42 | Spider on its Web, Bees and Flies | 6 3/8 × 4 |
| 43 | Horse-drawn Coach and, on the right, Man Leading a Horse by the Bridle | 7 × 4 |
| 45 | The Canal | 9 7/8 × 10 |
| 49 | Square at Ramsgate | 2 1/8 × 2 1/8 |
| 52 | Austin Friars Church | 4 × 6 5/8 |
| 55 | Chapels at Petersham and Turnham Green | 1 5/8 × 4 |
| 62 | Zandmennik's House | 9 × 11 5/8 |
| 63 | Magrot's House | 9 × 11 5/8 |
| 68 | Miner with Shovel on his Shoulder | 19 1/2 × 10 3/4 |
| 69 | The Miners' Return | 17 × 23 5/8 |
| 70 | Men and Women Miners Going to Work | 17 1/2 × 21 1/4 |
| 71 | "Au Charbonnage" | 5 1/2 × 5 1/2 |
| 72 | Old Breton Woman Sleeping in Church | 10 1/2 × 7 5/8 |
| 73 | Diggers | 14 5/8 × 24 1/2 |
| 75 | On the Road | 3 3/4 × 2 1/8 |
| 76 | The Presbytery at Etten | 3 1/2 × 5 1/2 |
| 77 | The Church and Presbytery at Etten | 3 1/2 × 6 7/8 |
| 79 | Theodorus van Gogh | 13 × 9 7/8 |
| 80 | The Sower | 23 5/8 × 17 3/4 |
| 81 | "Worn Out" | 9 1/4 × 12 1/4 |
| 81 | Road in the Snow at Etten | 15 3/8 × 23 5/8 |
| 82 | Portrait of Kee Vos-Stricker | 13 3/4 × 9 1/2 |
| 84 | "The Great Lady" | 7 1/2 × 4 1/8 |
| 85 | "Sorrow" | 18 1/8 × 12 |
| 85 | Woman Peeling Potatoes | 23 1/4 × 14 3/4 |
| 88 | Man with a Walking-Stick | 19 × 10 1/8 |
| 88 | Old Pensioner | 18 3/4 × 10 1/8 |
| 88 | Old Pensioner Holding a Glass in his Right Hand and a Handkerchief in the Left Hand | 19 1/8 × 9 7/8 |
| 89 | Man with Clay Pipe and Bandaged Eye | 17 3/4 × 10 7/8 |
| 90 | Mother with her Child on her Right Arm | 16 × 9 1/2 |
| 90 | Mother Seated on an Upturned Basket and Crying | 18 3/4 × 11 5/8 |
| 90 | Mother with Child on her Knee | 16 1/8 × 10 5/8 |
| 91 | Mother and Child | 21 × 13 3/4 |
| 92 | Men and Women Working | 4 3/8 × 8 1/4 |
| 93 | The Sand-Pit with Men at Work | 4 1/8 × 8 1/4 |
| 94 | Loosduinen seen from a Sand-Dune | 10 1/2 × 18 |
| 95 | Washing at Scheveningen | 12 5/8 × 21 1/4 |
| 98 | Fish-drying at Scheveningen | 14 × 20 1/2 |
| 99 | Mr Enthoven's Factory | 14 × 19 1/2 |
| 101 | Vincent's Perspective Frame | 2 1/8 × 4 1/4 |
| 101 | The Beach at Scheveningen | 3 3/8 × 2 3/8 |
| 102 | Woman in the Woods | 13 5/8 × 9 1/2 |
| 103 | Woman on a Path through the Woods | 12 1/4 × 9 5/8 |
| 105 | Lying Cow | 11 7/8 × 19 5/8 |
| 106 | The Sand Dune | 9 1/2 × 12 5/8 |
| 109 | Young Girl in the Wood at the Hague | 15 3/8 × 23 1/4 |
| 110 | Fisherwoman on the Beach | 20 1/8 × 13 |
| 110 | Peasant at Work | 12 1/4 × 11 5/8 |
| 113 | The Heath | 13 × 19 |
| 114 | Little Cottage | 1 3/4 × 2 |
| 114 | The Peat-Boat | 13 × 17 3/4 |
| 115 | The Jewish Cemetery | 4 × 5 1/2 |
| 115 | Peasant Burning Weeds | 12 × 15 5/8 |
| 115 | Pen sketch of above | 1 3/4 × 2 1/8 |
| 116 | In the Field | 10 5/8 × 14 |
| 117 | Farm Labourers | 2 × 5 1/8 |
| 118 | Man with Harrow | 3 1/2 × 5 1/8 |
| 119 | Lifting Bridge | 15 1/8 × 31 7/8 |
| 121 | The Little Church at Zweeloo | 9 1/2 × 11 7/8 |
| 122 | Sunrise on the Plain | 11 × 15 3/4 |
| 124 | The Presbytery at Nuenen | 13 × 17 |
| 127 | Coming out of the Church at Nuenen | 16 1/8 × 12 5/8 |
| 128 | Behind the Presbytery Garden | 15 3/4 × 20 7/8 |
| 129 | Autumn Landscape | 25 1/4 × 35 |
| 131 | Spring (The Sower) | 2 3/8 × 5 1/2 |
| 131 | Summer (Harvesting Potatoes) | 2 3/8 × 5 1/4 |
| 131 | Autumn (The Plough) | 2 5/8 × 6 1/2 |
| 131 | Winter | 2 × 5 1/8 |
| 132 | The Loom | 27 5/8 × 33 1/2 |
| 133 | Interior of Weaver's House | 12 5/8 × 15 3/4 |
| 135 | The Watermill at Opwetten | 17 3/4 × 22 7/8 |
| 136 | Gennep Watermill | 34 1/4 × 59 1/2 |
| 137 | Kollen Watermill | 22 7/8 × 30 3/4 |
| 139 | The Old Station at Eindhoven | 5 7/8 × 10 1/8 |
| 141 | Still-Life with Earthenware Pot, Bottle and Clogs | 15 3/8 × 16 1/4 |
| 142 | Woman in a Red Bonnet | 16 3/4 × 11 5/8 |
| 143 | Head of a Young Peasant in a Peaked Cap | 14 1/8 × 10 1/4 |
| 144 | Work in the Fields | 12 1/4 × 15 5/8 |
| 146 | Peasant Mowing | 16 1/8 × 20 1/8 |
| 147 | Peasant Woman Putting Corn in Sheaves | 17 1/8 × 21 1/4 |
| 148 | Still-Life: Open Bible and Candle | 25 5/8 × 33 1/2 |
| 151 | Brabant Peasant Woman | 6 1/8 × 5 1/8 |
| 153 | The Cottage at Nightfall | 25 1/8 × 30 3/4 |
| 154 | Sketch of a Masterpiece | 2 × 3 3/8 |
| 155 | The Potato-Eaters | 32 1/4 × 44 7/8 |
| 157 | Vincent as Lithographer | 10 × 12 |
| 159 | Birds' Nest | 5 1/8 × 6 1/2 |
| 162 | Self-Portrait | 7 5/8 × 4 1/4 |
| 163 | Backs of Old Houses in Antwerp | 17 3/8 × 13 1/4 |
| 164 | The Steen | 3 3/4 × 6 1/2 |
| 165 | The Steen | 5 1/8 × 8 1/4 |
| 167 | The Quay | 8 × 10 5/8 |
| 169 | The Cathedral Tower | 11 7/8 × 8 7/8 |
| 169 | The Grand-Place | 8 7/8 × 11 7/8 |
| 170 | Woman in Blue | 18 1/8 × 15 |
| 171 | Portrait of a Woman in Profile | 23 5/8 × 19 5/8 |
| 172 | Popular Dance in the Bargees' Quarter | 3 1/2 × 5 7/8 |
| 173 | Women Waltzing | 3 1/2 × 6 1/4 |
| 174 | The Nurse | 19 5/8 × 15 3/4 |
| 175 | Head of an Old Man Like Victor Hugo | 17 3/8 × 13 1/8 |
| 176 | Skull with a Cigarette | 12 3/4 × 9 1/2 |
| 177 | Hanging Skeleton | 4 1/8 × 2 3/8 |
| 178 | Sketch of Working Girl | 5 1/8 × 3 3/8 |
| 179 | Working Girl | 13 3/4 × 9 1/2 |
| 182 | Self-Portrait | 10 5/8 × 7 1/2 |
| 183 | Standing Female Nude, Three-Quarter Back View | 7 5/8 × 4 1/4 |
| 183 | Studies of Hands | 12 5/8 × 9 1/2 |

## PLATES

# INDEX OF PERSONS

# SELECT BIBLIOGRAPHY

Bremmer, H. P.: *Vincent van Gogh, Inleidende Beschouwingen*, 282 pp., 29 ills. (Amsterdam, 1911).

Cain, Albert C. and Barbara S.: "On Replacing a Child", *Journal of the American Academy of Child Psychiatry*, July, 1964.

Coquiot, Gustave: *Vincent van Gogh*, 336 pp., 24 ills. (Paris 1923).

Doiteau, V. and Leroy, E.: *La Folie de Vincent van Gogh*, Preface by Paul Gachet, 142 pp., 47 ills. (Paris, 1928).

Faille, J. B. de la: *L'Œuvre de Vincent van Gogh, catalogue raisonné*, 4 vols (Paris and Brussels, 1928).
— *Vincent van Gogh*, Preface by Charles Terrasse, 594 pp., (Paris, 1939).

Graetz, Heinz P.: *The Symbolic Language of Vincent van Gogh*, Preface by Gustav Bally, 315 pp., 115 ills. (New York, 1963).

Hammacher, A. M.: *Vincent van Gogh*, 60 pp., 62 ills. (Amsterdam, 1930).

Hulsker, Jan: "Van Gogh's Dramatische Jaren in Den Haag", *Maatstaf*, 6, 401-23, 1958.
— "Van Gogh's Opstandige Jaren in Nuenen", *Maatstaf*, 7, no. 2, 77-98, 1959.
— "Van Gogh's Extatische Maanden in Arles", *Maatstaf*, 8, nos. 5-6, 315-35, 1960.
— "Van Gogh's Bedreigde Leven in St. Rémy en Auvers", *Maatstaf*, 8, no. 10, 639-64, 1961.

Huyghe, René: *Van Gogh*, 95 pp., 82 ills. (Paris, 1958).

Jaspers, Karl: *Strindberg und van Gogh, Versuch einer pathographischen Analyse unter vergleichender Heranziehung von Swedenborg und Hölderlin*, 183 pp. (Berlin, 1922).

Kraus, G.: "Vincent van Gogh en de Psychiatrie", *Psychiatrische en Neurologische Bladen*, 50, 1941.
— *De Verhouding van Theo en Vincent van Gogh*, 40 pp., 6 ills. (Amsterdam-Otterlo, 1954).

Leymarie, Jean: *Van Gogh*, 164 pp., 172 ills. (Paris, 1951).
— *Qui était van Gogh?* 212 pp., 196 ills. (Geneva, 1968). Trans., *Who was van Gogh?* (London, 1968).

Mauron, Charles: "Notes sur la structure de l'inconscient chez Vincent van Gogh", *Psyché*, Paris 38, 1953.
— *Vincent et Théo van Gogh, une symbiose*, 15 pp., (Amsterdam, 1953).

Meerloo, J. A. M.: "De Diagnostische Strijd om Vincent van Gogh", *Psychiatrische en Neurologische Bladen*, 34, 1931.
— "Vincent van Gogh's Quest for Identity", *Netherlands Year Book for the History of Art*, 183-97, 5 ills., 1963.

Minkowska, F.: *Van Gogh, sa vie, sa maladie et son œuvre*, Preface by E. Minowska, 88 pp., 8 ills. (Paris, 1963).

Nagera, Humberto: *Vincent van Gogh, A Psychological Study*, Foreword by Anna Freud, 182 pp., 17 ills. (London and New York, 1967).

Piérard, Louis: *La Vie tragique de Vincent van Gogh*, 206 pp., 15 ills. (Paris, 1924).

Quesne-van Gogh, Elizabeth Huberta du: *Persoonlijke Herinneringen aan Vincent van Gogh*, 106 pp., 1 ill. (Baarn, 1913).

Robert, Marthe: "Vincent van Gogh, le génie et son double", *Preuves*, no. 204, 3-16, 1968.

Schapiro, Meyer: *Vincent van Gogh*, 132 pp., 150 ills. (New York and London, 1950).

Scherjon, W. and Gruyter, J. de: *Vincent van Gogh's Great Period, Arles, St. Remy and Auvers-sur-Oise, Complete catalogue*, 400 pp., 420 ills. (Amsterdam, 1937).

Stokvis, Benno J.: *Nasporingen omtrent Vincent van Gogh in Brabant*, 39 pp., 5 ills. (Leiden-Amsterdam, 1926).

Szymanska, Anna: *Unbekannte Jugendzeichnungen Vincent van Goghs, und das Schaffen des Künstlers in den Jahren 1870-1880*, 76 pp., 74 ills. (Berlin, 1967).

Vanbeselaere, Walther: *De Hollandse Periode in het werk van Vincent van Gogh*, Foreword by Prof. Dr A. Vermeylen, 464 pp., 51 ills. (Antwerp, 1937).

Westerman Holstijn, A. J.: "The Psychological Development of Vincent van Gogh", *Journal of Mental Science*, 103, 1957.

Ziegler, E. von: "Vincent van Gogh und seine Aerzte", *Medizinische Wochenschrift*, Switzerland, 91, 1961.

Vincent van Gogh: *Verzamelde Brieven*, edited by his sister-in-law, J. van Gogh-Bonger, 4 vols, 1600 pp. (Amsterdam-Antwerp, 1952-3). Trans. *Complete Letters*, 3 vols., 1977 pp. (London and New York, 1958).

This book, created and published by Edita S.A. in Lausanne,
was produced under the direction of
Ami Guichard, Joseph Jobé and Charles Riesen

The text and the black and white illustrations were printed
in Lausanne by Presses Centrales Lausanne S.A.,
and the colour illustrations by
Presses Centrales S.A. and Offset Litho Jean Genoud S.A. Lausanne

The four-colour engravings were made by Actual S.A., Bienne

Bound by Maurice Busenhart, Lausanne

Printed in Switzerland